THE DRAWINGS OF THE FLORENTINE PAINTERS

Volume 2

Catalogue

THE DRAWINGS OF THE FLORENTINE PAINTERS

Bernard Berenson

Volume 2

Catalogue

THE UNIVERSITY OF CHICAGO PRESS
Chicago and London

Collector's Edition

International Standard Book Number: 0-226-04357-6
Library of Congress Catalog Card Number: 73-114808

The University of Chicago Press, Chicago 60637
The University of Chicago Press, Ltd., London

Published 1938 by The University of Chicago Press
Second Impression 1970

Printed in the United States of America

SIGNS AND ABBREVIATIONS

Drawings that were not included in my First Edition are here distinguished by the black-face type of their entry numbers.

In the cataloguing of drawings already included in my First Edition, new information is enclosed within brackets: []

Following the artist's name at the beginning of each section of the Catalogue is a citation of the pages in the Text volume that treat of the artist in question; and wherever a page citation follows immediately after the subject of a drawing, this is a reference to the page or pages in the Text volume treating of this drawing. Measurements are given in centimeters.

Albertina Cat. I = Franz Wickhoff, *Die italienischen Handzeichnungen der Albertina,* II: *Die römische Schule,* in *Jahrbuch der Kunsthistorischen Sammlungen,* XIII, Vienna, 1892.

Albertina Cat. III = Alfred Stix and L. Frölich-Bum, *Beschreibender Katalog der Handzeichnungen in der…. Albertina,* III: *Die Toskanischen, umbrischen und römischen Schulen,* Vienna, Schroll, 1932.

Albertina N. F. I = Joseph Meder, *Handzeichnungen alter Meister aus der Albertina und aus Privatbesitz,* Neue Folge I, Vienna, Schroll, 1922.

Albertina N. F. II = Alfred Stix, *Handzeichnungen aus der Albertina,* Neue Folge II: *Italienische Meister des XIV. bis XVI. Jahrhunderts,* Vienna, Schroll, 1925.

A. M. = Ashmolean Museum, Oxford.

Amsterdam Exh. Cat. = *Italiaansche Kunst in Nederlandsch Bezit,* Amsterdam, Staedelijk Museum, 1934.

Amtl. Ber. = *Amtliche Berichte aus den Königlichen Kunstsammlungen,* Berlin, Grote, 1880-1919.

Arch. Ph. = Archives Photographiques d'Art et d'Histoire, Paris.

Art Bulletin = *The Art Bulletin: An Illustrated Quarterly Published by the College Art Association of America,* Chicago, University of Chicago, 1913—current.

L'Arte = *L'Arte: Rivista di storia dell'arte medioevale e moderna,* Rome and Turin, 1898—current.

Ascr. = ascribed.

Attr. = attributed.

Becker, *Handz.* = Felix Becker, *Handzeichnungen alter Meister in Privatsammlungen,* Leipzig, Tauchnitz, 1922.

Bell = C. F. Bell, *Drawings of the Old Masters in the Library of Christ Church, Oxford,* Oxford, Clarendon Press, 1914.

Belvedere = *Belvedere: Monatsschrift für Sammler und Kunstfreunde,* Vienna, Amalthea-Verlag, 1922—current.

Berlin Publ. = *Zeichnungen alter Meister im Kupferstichkabinett der K. Museen zu Berlin,* Berlin, Grote, 1910.

Bernardini = Giorgio Bernardini, *Sebastiano del Piombo,* Bergamo, Arti Grafiche, 1908.

Bl. ch. = black chalk.

SIGNS AND ABBREVIATIONS

B. M. = British Museum, London.

B. M. Quarterly = The British Museum Quarterly, London, British Museum, 1926—current.

Bode, *Klass. d. K.* = Wilhelm von Bode, *Sandro Botticelli (Klassiker der Kunst,*Vol. 30), Stuttgart, Deutsche Verlags-Anstalt, 1926.

Bode, *L.* = Wilhelm von Bode, *Studien über Leonardo da Vinci*, Berlin, Grote, 1921.

Bodmer = Heinrich Bodmer, *Leonardo da Vinci (Klassiker der Kunst,* Vol. 37), Stuttgart, Deutsche Verlags-Anstalt, 1931.

Boll. d'A. = *Bollettino d'Arte del Ministero della Pubblica Istruzione*, Rome, 1907—current.

Bonnat Publ. = *Les Dessins de la collection Léon Bonnat au Musée de Bayonne*, Les Presses Universitaires de France, 1924-1926.

Brinckmann = A. E. Brinckmann, *Michelangelo Zeichnungen*, Munich, Piper, 1925.

Buffalo Exh. Cat. = *Master Drawings Selected from the Museums and Private Collections of America*, Buffalo, Buffalo Fine Arts Academy, 1935.

Burl. Mag. = *The Burlington Magazine*, London, 1903—current.

Cat. = Catalogue.

Cavalcaselle = J. A. Crowe and G. B. Cavalcaselle, *A History of Painting in Italy*, New York, Scribners, and London, Murray, 1903-1914.

C. B. = Casa Buonarroti.

Chatsworth Dr. = S. A. Strong, *Reproductions of Drawings by Old Masters in the Collection of the Duke of Devonshire at Chatsworth*, London, Duckworth, 1902.

Clapp, *Dessins* = F. M. Clapp, *Les Dessins de Pontormo,* Paris, Champion, 1914.

Clapp, *Life* = F. M. Clapp, *Jacopo Carucci da Pontormo: His Life and Work*, New Haven, Yale University Press, 1916.

Clark = Kenneth Clark, *A Catalogue of the Drawings of Leonardo da Vinci in the Collection of His Majesty the King at Windsor Castle*, Cambridge, University Press, 1935.

Colvin = Sidney Colvin, *Drawings of the Old Masters in the University Galleries and in the Library of Christ Church Oxford*, Oxford, Clarendon Press, 1903-1907.

Colvin, *Guide* = Sidney Colvin, *Guide to an Exhibition of Drawings and Engravings by the Old Masters*, London, British Museum, 1895.

Colvin, *Maso Finiguerra* = Sidney Colvin, *A Florentine Picture-Chronicle.... by Maso Finiguerra*, London, Quaritch, 1898.

Comm. Vinc. I, II, III = R. Commissione Vinciana, *I Manoscritti e i disegni di Leonardo da Vinci*, Rome, Danesi, 1928-1934.

Comm. Vinc. C. A. = *I Manoscritti e i disegni di Leonardo da Vinci*, Vol. I: *Il Codice Arundel 263*, Parts I-III, Rome, Danesi, 1923-1928.

Comm. Vinc. C. F. = *Il Codice Forster, nel Victoria and Albert Museum*, Rome, Libreria dello Stato, 1934.

SIGNS AND ABBREVIATIONS

D'Achiardi = Pietro d'Achiardi, *Sebastiano del Piombo*, Rome, Casa Editrice de "L'Arte," 1908.

Dedalo = *Dedalo: Rassegna d'Arte*, Milan and Rome, Treves..., 1920-1933.

Delacre = M. Delacre and P. Lavallée, *Dessins de maîtres anciens*, Paris, Van Oest, 1927.

Demonts, *L.* = Louis Demonts, *Les Dessins de Léonard de Vinci (Musée du Louvre)*, Paris, Morancé, 1922.

Demonts, *M.* = Louis Demonts, *Les Dessins de Michel-Ange (Musée du Louvre)*, Paris, Morancé, 1922.

De Rinaldis = Aldo de Rinaldis, *Storia dell'opera pittorica di Leonardo da Vinci*, Bologna, Zanichelli, 1926.

Dessins de Maîtres = *Société de reproduction des dessins de maîtres*, Paris, Marty, 1909-1912.

De Toni = Giambattista de Toni, *Le Piante e gli animali in Leonardo da Vinci*, Bologna, Zanichelli, 1922.

Di Pietro = F. di Pietro, *I Disegni di Andrea del Sarto negli Uffizi (Biblioteca della Rivista "Vita d'Arte,"* Vol. 6), Siena, 1910.

Düsseldorf Cat. = Illa Budde, *Beschreibender Katalog der Handzeichnungen in der Staatl. Kunstakademie Düsseldorf*, Düsseldorf, Schwann, 1930.

Dussler = Luitpold Dussler, *Signorelli (Klassiker der Kunst*, Vol. 34), Stuttgart, Deutsche Verlags-Anstalt, 1927.

E. d. B. A. Exh. Cat. = P. Lavallée, *École des Beaux-Arts: Exposition d'art italien des XVe et XVIe siècles*, Paris, 1935.

Ede = H. S. Ede, *Florentine Drawings of the Quattrocento*, London, Benn, 1926.

Emporium = *Emporium: Rivista mensile illustrata d'arte, letteratura, scienze e varietà*, Bergamo, Istituto Italiano d'Arti Grafiche—current.

Exh. = Exhibition.

F. E. = First Edition of B. Berenson, *The Drawings of the Florentine Painters*, London, Murray, 1903.

Fenwick Cat. = A. E. Popham, *Catalogue of Drawings in the Collection formed by Sir Thomas Phillipps..., now in the Possession of.... T. Fitzroy Phillipps Fenwick...*, London, Privately Printed, 1935.

Fischel = Oskar Fischel, *Die Zeichnungen der Umbrer*, in *Jahrb. der Kgl. Preuss. Kunstsamml.*, 1917.

Fogolari = G. Fogolari, *I Disegni delle R. Gallerie dell'Accademia (Venezia)*, Milan, Alfieri e Lacroix, 1913.

Fototeca = Former designation for the Gabinetto Fotografico della Soprintendenza, Florence.

Frey = Karl Frey, *Die Handzeichnungen Michelagniolos Buonarroti*, Berlin, Bard, 1909-1911. Nachtrag herausgegeben von Fritz Knapp, Berlin, Bard, 1925.

Frey, *Briefe* = Karl Frey, *Sammlung ausgewählter Briefe an Michelagniolo Buonarroti*, Berlin, Siegismund, 1899.

Frey, *Dichtungen* = Karl Frey, *Die Dichtungen des Michelagniolo Buonarroti*, Berlin, Grote, 1897.

Gabelentz = Hans von der Gabelentz, *Fra Bartolommeo und die Florentiner Renaissance*, Leipzig, Hiersemann, 1922.

SIGNS AND ABBREVIATIONS

Gaye, *Carteggio* = Giovanni Gaye, *Carteggio d'artisti dei secoli XIV, XV, XVI*, Florence, Molini, 1839-1840.

Gaz. d. B. A. = *Gazette des Beaux-Arts*, Paris — current.

Geiger Dr. = Leo Planiczig and Hermann Voss, *Drawings of Old Masters from the Collection of Dr. Benno Geiger*, Vienna, Amalthea Verlag, n. d.

Geymüller = Carl von Stegmann and Heinrich von Geymüller, *Die Architektur der Renaissance in Toscana*, Munich, Bruckmann, 1885-1908.

Gijón Dr. = J. Moreno Villa, *Dibujos del Instituto de Gijón*, Madrid, Artes de La Ilustracion, 1926.

Goldschmidt = Fritz Goldschmidt, *Pontormo, Rosso und Bronzino*, Leipzig, Klinkhardt & Biermann, 1911.

Gotti = Aurelio Gotti, *Vita di Michelangelo Buonarroti*, Florence, Tip. della Gazzetta d'Italia, 1875.

Height. = heightened.

Haseltine Cat. = *Original Drawings by Old Masters of the Italian School, forming Part of the Collection of J. P. H.*, London, Waddington, 1913.
 Some Original Drawings by Ancient and Modern Artists of Various Schools remaining in the Collection of J. P. H., London, Waddington, 1917.

Hind = Arthur M. Hind, *Catalogue of Early Italian Engravings in the British Museum*, London, British Museum, 1901-1910.

Jahrb. K. H. Inst. = *Jahrbuch des kunsthistorischen Instituts...*, Vienna, Schroll, 1903-1922.

Jahrb. K. H. Samml. = *Jahrbuch der kunsthistorischen Sammlungen*, Vienna, 1883 — current.

Jahrb. Kunstw. = *Jahrbuch für Kunstwissenschaft*, Leipzig, Klinkhardt & Biermann, 1923-1930.

Jahrb. Pr. K. S. = *Jahrbuch der preussischen Kunstsammlungen*, Berlin, 1880 — current.

Jacobsen and Ferri = Emil Jacobsen and P. Ferri, *Dessins inconnus de Michel-ange*, Leipzig, Hiersemann, 1905.

Knapp = Fritz Knapp, *Fra Bartolommeo della Porta und die Schule von San Marco*, Halle, W. Knapp, 1903.

Knapp, *A. d. S.* = Fritz Knapp, *Andrea del Sarto*, Leipzig, Velhagen & Klasing, 1907.

Knapp, *Kl. d. K.* = Fritz Knapp, *Michelangelo* (*Klassiker der Kunst*, Vol. 7), Stuttgart, Deutsche Verlags-Anstalt, 1906.

Knapp, *M.* = Fritz Knapp, *Michelangelo*, Munich, Bruckmann, 1923.

Knapp, *P. d. C.* = Fritz Knapp, *Piero di Cosimo*, Halle, W. Knapp, 1899.

Köhler = Wilhelm Köhler, *Michelangelos Schlachtkarton*, in *Kunstgeschichtliches Jahrbuch*, Vienna, Schroll, 1907, pp. 115-172.

Kristeller = Paul Kristeller, *Early Florentine Woodcuts*, London, Kegan Paul, Trench, Trübner, 1897.

Küppers = Paul Erich Küppers, *Domenico Ghirlandajo*, Strassburg, Heitz, 1916.

SIGNS AND ABBREVIATIONS

Kunstchr. (see Morelli, *Kunstchr.*).

Kusenberg = Kurt Kusenberg, *Le Rosso*, Paris, Michel, 1931.

L. = left.

"Lawrence Gallery" = *A Series of Fac-similes of Original Drawings.... from the Matchless Collection formed by Sir Thomas Lawrence*, London, Woodburn, 1841.

Lees = F. Lees, *The Art of the Great Masters, as exemplified by Drawings in the Collection of Emile Wauters*, London, Sampson, Low, Marston, 1913.

Malaguzzi Valeri = Francesco Malaguzzi Valeri, *Leonardo da Vinci e la scultura*, Bologna, Zanichelli, 1922.

Malcolm Cat. = J. C. Robinson, *Descriptive Catalogue of Drawings by the Old Masters, forming the Collection of John Malcolm of Poltalloch, Esq.*, London, Whittingham, 1876.

Marcuard = Publication of the Michelangelo Drawings at Haarlem by Bruckmann, with Notes by F. von Marcuard, Munich.

McComb = Arthur McComb, *Agnolo Bronzino: His Life and Works*, Cambridge, Harvard University Press, 1928.

Meder, *Handz.* = Joseph Meder, *Die Handzeichnung, ihre Technik und Entwicklung*, Vienna, Schroll, 1919.

Metr. Mus. Bull. = *The Bulletin of the Metropolitan Museum of Art, New York*, New York, Metropolitan Museum, 1905—current.

Milanesi, *Lettere* = Gaetano Milanesi, *Le Lettere di Michelangelo Buonarroti*, Florence, Le Monnier, 1875.

Milanesi, *S. d. P.* = Gaetano Milanesi, *Les Correspondants di Michel-ange. I: Sebastiano del Piombo*, Paris, Librairie de l'Art, 1890.

Mitt. d. K. H. Inst. Florenz = *Mitteilungen des Kunsthistorischen Instituts in Florenz*, Florence, 1911—current.

Monatsh. f. K. W. = *Monatshefte für Kunstwissenschaft*, Leipzig, Klinkhardt & Biermann, 1908-1922.

Mond Cat. = Tancred Borenius and Rudolf Wittkower, *Catalogue of the Collection of Drawings by the Old Masters formed by Sir Robert Mond*, London, Eyre & Spottiswoode, n. d. (1937).

Morelli, *Doria e Borghese* = Giovanni Morelli (Ivan Lermolieff), *Die Gallerien Borghese und Doria Panfili in Rom*, Leipzig, Brockhaus, 1890.

Morelli Dr. = Gustavo Frizzoni, *Collezione di quaranta disegni scelti dalla raccolta del Senatore Giovanni Morelli*, Milan, Hoepli, 1886.

Morelli, *Kunstchr.* = Giovanni Morelli, *Handzeichnungen italienischer Meister in photographischen Aufnahmen von Braun und Co.*, in *Kunstchronik*, N. F. III (1891/92), und N. F. IV (1892/93).

Morelli, *Pittura* = Giovanni Morelli, *Della Pittura italiana*, Milan, Treves, 1897.

Morgan Dr. = *A Selection from the Collection of Drawings by the Old Masters, formed by C. Fairfax Murray*, London, Privately Printed—1912.

Müller-Walde = Paul Müller-Walde, *Leonardo da Vinci*, Munich, 1889.

ix

SIGNS AND ABBREVIATIONS

Müller-Walde, *Beiträge* = Paul Müller-Walde, *Beiträge zur Kenntniss des Leonardo da Vinci*. I: *Jahrb. Pr. K. S.*, 1897, pp. 92-169; II: *ibid.*, 1898, pp. 225-266; III: *ibid.*, 1899, pp. 54-116.

Münch. Jahrb. = *Münchner Jahrbuch der bildenden Kunst*, Munich, Knorr & Hirth, 1924—current.

Müntz = Eugène Müntz, *Léonard de Vinci*, Paris, Hachette, 1899.

N. G. = National Gallery, London.

O. M. D. = *Old Master Drawings: A Quarterly Magazine for Students and Collectors*, London, Batsford, 1926—current.

Oppenheimer Cat. = *Catalogue of Old Master Drawings formed by the late Henry Oppenheimer*, Christie, Manson and Woods, July 10-14, 1936.

Ottley = William Young Ottley, *The Italian School of Design*, London, Taylor & Hessey, 1823.

Paris Exh. Cat. = Gabriel Rouchès, *Exposition de dessins italiens (Musée de l'Orangerie*, Nov. et Déc., 1931), Paris, Musées Nationaux, 1931.

Pembroke Dr. = S. A. Strong, *Drawings by the Old Masters in the Collection of the Earl of Pembroke and Montgomery at Wilton House*, London, Colnaghi, 1900.

Pf. = Portfolio.

Pl. = Plate.

Polifilo = Luca Beltrami, *Leonardo e i disfattisti suoi*, Milan, Treves, 1919.

Popham Cat. = A. E. Popham, *Italian Drawings exhibited at the Royal Academy, Burlington House, London, 1930*, Oxford University Press, 1931.

Popp = A. E. Popp, *Leonardo da Vinci Zeichnungen*, Munich, Piper, 1928.

Popp, *M. K.* = A. E. Popp, *Die Medici-Kapelle Michelangelos*, Munich, Recht, 1922

Prestel Publ. B. = G. Pauli, *Zeichnungen alter Meister in der Kunsthalle zu Bremen*, Frankfurt a/M., Voigtländer-Tetzner, 1914-1915.

Prestel Publ. H. = G. Pauli, *Zeichnungen alter Meister in der Kunsthalle zu Hamburg: Italiener*, Frankfurt a/M., Prestel-Verlag, 1927.

R. = right.

Rass. d'A. = *Rassegna d'Arte*, Milan and Rome, Alfieri & Lacroix, 1901-1922.

R. ch. = red chalk.

Rep. f. K. W. = *Repertorium für Kunstwissenschaft*, Berlin and Leipzig, De Gruyter, 1875-1931.

Revue de l'A. = *Revue de l'Art ancien et moderne*, Paris, 1897—current.

Richter = Jean Paul Richter, *The Literary Works of Leonardo da Vinci*, London, Sampson, Low..., 1883.

Riv. d'A. = *Rivista d'Arte*, Florence, Olschki, 1904—current.

SIGNS AND ABBREVIATIONS

R. L. = Royal Library, Windsor.

Robinson = J. C. Robinson, *A Critical Account of the Drawings by Michel Angelo and Raffaello in the University Galleries, Oxford*, Oxford, Clarendon Press, 1870.

Scharf = Alfred Scharf, *Filippino Lippi*, Vienna, Schroll, 1935.

Schönbrunner & Meder = J. Schönbrunner and J. Meder, *Handzeichnungen alter Meister aus der Albertina und anderen Sammlungen*, Vienna, 1896-1908.

Schottmüller = Frida Schottmüller, *Fra Angelico da Fiesole* (*Klassiker der Kunst*, Vol. 18), Stuttgart, Deutsche Verlags-Anstalt, 1911.

Seidlitz = Woldemar von Seidlitz, *Leonardo da Vinci*, Berlin, Julius Bard, 1909.

S. I. = Soprintendenza ai Monumenti, Gabinetto Fotografico.

Sirén = Osvald Sirén, *Léonard de Vinci*, Paris and Brussels, Van Oest, 1928.

Sirén Cat. = Osvald Sirén, *Italienska Handteckningar fran 1400- och 1500-Talen i Nationalmuseum*, Stockholm, 1917.

Sirén, *Dessins* = Osvald Sirén, *Dessins et tableaux de la Renaissance italienne dans les collections de Suède*, Stockholm, Tullberg, 1902.

Sirén, *Lorenzo Monaco* = Osvald Sirén, *Don Lorenzo Monaco*, Strassburg, Heitz, 1905.

Solmi = Edmondo Solmi, *Le Fonti dei manoscritti di Leonardo da Vinci*, Turin, Loescher, 1908.

Sp. = silverpoint.

Städel Dr. = *Handzeichnungen alter Meister im Städelschen Kunstinstitut*, Frankfurt a/M., 1908-1914.

Steinmann = Ernst Steinmann, *Die Sixtinische Kapelle*, Munich, Bruckmann, 1901-1905.

Steinmann, *M. P.* = Ernst Steinmann, *Die Portraitdarstellungen des Michelangelo*, Leipzig, Klinkhardt & Biermann, 1913.

Stift und Feder = Rudolf Schrey, *Zeichnungen aller Zeiten und Länder in Nachbildungen*, Frankfurt a/M., 1926-1930.

Stockholm Dr. = C. F. Lindberg, *Handzeichnungen alter Meister* (*Nationalmuseum, Stockholm*), Stockholm, Blaedel, 1889.

Suida = Wilhelm Suida, *Leonardo und sein Kreis*, Munich, Bruckmann, 1929.

Symonds = John Addington Symonds, *The Life of Michelangelo Buonarroti*, London, Nimmo, 1899.

Thiis = Jens Thiis, *Leonardo da Vinci*, London, Herbert Jenkins, n. d.

Thode = Henry Thode, *Michelangelo und das Ende der Renaissance*, Berlin, Grote, 1902-1912.

Thode, *Kr. U.* = Henry Thode, *Michelangelo: Kritische Untersuchungen über seine Werke*, Berlin, Grote, 1908-1913.

Toesca, *E. I.* = Pietro Toesca, *Michelangelo Buonarroti*, in *Enciclopedia Italiana*, Vol. XXIII, pp. 165-191.

SIGNS AND ABBREVIATIONS

Uffizi Publ. = *I Disegni della R. Galleria degli Uffizi in Firenze*, Florence, Olschki, 1912-1921.

Van Marle = Raimond van Marle, *The Development of the Italian Schools of Painting*, The Hague, 1923-1937.

Vasari = Giorgio Vasari, *Le Vite de' più eccellenti pittori, scultori ed architettori* (Milanesi), Florence, Sansoni, 1878-1885.

Vasari Soc. = *The Vasari Society for the Reproduction of Drawing by Old Masters*, Oxford, 1st Series, 1905-1915; 2nd Series, 1920-1935.

Venturi = Adolfo Venturi, *Storia dell'arte italiana*, Milan, Hoepli, 1901-1936.

Venturi, *Botticelli* = Adolfo Venturi, *Il Botticelli, Interprete di Dante*, Florence, 1921.

Venturi, *Gr. A. I.* = Adolfo Venturi, *Grandi artisti italiani*, Bologna, Zanichelli, 1925.

Venturi, *L.* = Adolfo Venturi, *Leonardo da Vinci pittore*, Bologna, Zanichelli, 1920.

Venturi, *M.* = Adolfo Venturi, *Michelangelo,* Valori Plastici, 1926.

Venturi, *Studi* = Adolfo Venturi, *Studi dal vero*, Milan, Hoepli, 1927.

Voss = Hermann Voss, *Die Malerei der Spätrenaissance in Rom und Florenz*, Berlin, Grote, 1920.

Voss, *Zeichn.* = Hermann Voss, *Zeichnungen der italienischen Spätrenaissance,* Munich, Delphin Verlag, 1928.

Wh. = white.

Yashiro = Yukio Yashiro, *Sandro Botticelli*, London and Boston, Medici Society, 1925.

Zeitschr. f. B. K. = *Zeitschrift für bildende Kunst,* N. F., Leipzig, Seemann, 1890-1932.

Zeitschr. f. Kunstg. = *Zeitschrift für Kunstgeschichte*, Berlin, De Gruyter, 1932—current.

Mariotto Albertinelli (pp. 161-163)

1 AMSTERDAM, Fodor Museum, No. 872 —Madonna with two angels, and studies of children. Sp. and wh. on brown paper. 18 by 11.5. Ascr. to Leonardo.

2 BERLIN, Print Room, No. 2309 —Two nude women and two nude children. Pen. 22 by 27. [Berlin Publ., 31.] Verso : Six *putti* in various attitudes. Coarser than Fra Bartolommeo, and done with a more stubby pen.

3 No. 5037—Figure for the Uffizi Visitation. Bl. ch. and wh. on buff ground. 28 by 21.

4 No. 5140—Sheet of studies for Madonna and Child (p. 162). Wash and wh. on greyish green ground. 26 by 19. [Berlin Publ., 30.] The best in these materials.

5 FLORENCE, Uffizi, No. 177E —Madonna and Child. Pen on pink ground. 11 by 8. [Uffizi Publ., IV, i, 7.] Ascr. to Fra Bartolommeo, but the coarse features and the fumbling stroke make it more probable that this drawing is A.'s.

 [The late Mr. Charles Loeser, in the Uffizi publication just referred to, would ascribe this little sketch to Piero di Cosimo. Much could be adduced in favour of this attribution as the likeness in the hatching and stroke between this sketch and others by Piero is undeniable. It can, however, be accounted for by A.'s having been taught drawing in Piero's studio. The round head and deep-set eyes of the Child, so much like my 1852, could be explained in the same way. But, above all, I do not remember any composition of Piero's so close in pattern and *contrapposto* to both Fra Bartolommeo and Raphael. It looks like a drawing done in 1505 or 1506.]

6 No. 308F — Annunciation (p. 163). R. ch. 23 by 36. Pl. xcv of F. E. [Venturi, IX, i, p. 381.
 Fig. 458 Alinari 356.]

7 No. 512E —Angel for Annunciation in Cathedral at Volterra (p. 162). Sp., wash and wh. on
 Fig. 459 pinkish ground. 22 by 18. Brogi 1640. [Knapp, fig. 12.] Ascr. to Credi.

 [The folds in this sketch as in some of A.'s paintings (notably the Volterra picture or the Pitti Nativity, No. 365) would tend to prove that A. was not at the start the pupil of Credi, but of " Tommaso." If, however, "Tommaso" was only a phase of Piero di Cosimo, as seems more and more likely, then he would have been Piero di Cosimo's pupil all along.]

8 No. 546E—Monk with book in hand. Pen. Pricked. 22 by 15. Brogi 1825.

9 No. 547E—Madonna for an Annunciation (p. 162). Pen. Pricked. 21 by 15. Brogi 1716.
 Fig. 456

10 No. 548E – Studies of angels walking up steps. Pen. 20 by 15. Brogi 1721.

11 (see 275A)

12 No. 550E—Christ in glory with Madonna and St. John. Pen. 22 by 17. Brogi 1718.

13 No. 556E—Trinity with cherubs and saints (p. 162). Pen. 21 by 19. Pl. xciii of F. E.
 Fig. 457 Kindred in subject but scarcely a study for the Trinity at the Accademia (No. 8660).

14 No. 560E—Angel with cross and lance. Sp. and wh. on yellowish paper. 26 by 20.5. Brogi 1822. Study for the fresco of the Last Judgement. Verso: Angel blowing trumpet. Brogi 1823. [Knapp, fig. 8.] Study for same.

15 FLORENCE, Uffizi, No. 561E—Two angels sounding trumpets. Sp. and wh. on tinted ground. 17 by 26. Brogi 1824. Study for same.

15A LONDON, British Museum, Sketch for a *Noli me tangere.* Pen and bistre. 11.5 by 12. Poor and perhaps only a copy.

16 (see 463A)

17 PARIS, Louvre, No. 4.—Virgin for Annunciation (p. 162).
 Fig. 460 Sp. and. wh. on yellowish paper. 27.5 by 19. Pl. xciv of F. E. [Early.]

18 ROME, Corsini, Print Room, No. 130506—Study for Nativity. Pen and wh. on pink ground. 20 by 13. [Most characteristic.]

19 (see 1006)

20 No. 130507. Kneeling elderly monk. Ink and wh. on pink prep. paper. 20 by 18. Good. Verso: Landscape.

Alunno di Benozzo (pp. 11-13)

To avoid confusion the drawings formerly attributed to Pier Francesco Fiorentino have been left where they were in the first edition, i. e. 1864 *et seq.*

Alunno di Domenico (pp. 123-130)

20A CAMBRIDGE (Mass.), Fogg Museum, Paul J. Sachs Collection—Study for St. Jerome in cardinal's robes reading. Bistre and wh. Pricked. 21 by 10.5. Goes with my 30, 31, 32, 33, and with paintings like the altar-piece in the Cook Collection, Richmond (No. 61), or the Mannelli Pietà (*Burl. Mag.*, I, 1903, opp. p. 17).

21 DRESDEN, Print Room—Study for half-length figure of St. Sigismund (p. 130). Sp. and wh. on tinted paper. Circular, diameter 9.5. Braun 67083. Ascr. to Garbo.

22 FLORENCE, Uffizi, No. 79E—Study for St. Jerome kneeling in profile to r. Sp. and. wh. on pale grey ground. 17 by 12.5. Ascr. to Filippino, and originally perhaps on same sheet with my 29.

23 (see 36A)

24 No. 223E—Draped figure seen from behind. Sp. and wh. on purplish buff ground. 24 by 20. [Verso: Heavily draped youngish man conversing. Close to David Ghirlandajo.]

25 No. 224E—Two draped figures, one seated and the other standing. Sp. height. with wh. on pinkish ground. 20 by 18. [Fototeca 12623.] Ascr. like my 35 to Ghirlandajo, and of same character.

26 No. 242E—Draped figure see from behind. Sp. and wh. on pink prep. paper. 22 by 11. Ascr. to Filippino, but see my 27.

27 No. 244E—Draped male figure in profile to l. Sp. and wh. on pink prep. paper. 23 by 11. Ascr. to Filippino, but in the character of A.'s drawing at Munich.

28 No. 318E—Study for drapery of lower part of seated figure. Pen and wash height. with wh. on pinkish ground. 20 by 18. [Brogi 1753.] Catalogued as Ghirlandajo's.

29 FLORENCE, UFFIZI, No. 320^E—Two youths draped (p. 130). Sp. and wh. on pale grey ground. 20 by 18. [Fototeca 12626.] Ascr. "Maniera di Filippino."

30 No. 339^E—Four half-length figures in prayer (p. 130). Pen and bistre height. with wh. on
Fig. 280 pink prep. paper. Pricked. 17 by 24. Brogi 1630. Ascr. to Garbo.

31 No. 350^E—Bishop blessing two youths (p. 130). Pen and bistre height. with wh. on pale
Fig. 282 buff ground. Pricked. 21 by 28. Brogi 1629. Braun 76223. [Van Marle, XIII, p. 261.] Ascr. to Garbo.

32 No. 351^E—Three youths, one of whom cooks a fish (p. 130). Pen and wash on pale buff ground. Pricked. 20 by 18. Pl. LXIV of F. E. Brogi 1631. Ascr. to Garbo.

33 No. 352^E—Bishop chasing away demon (p. 130). Pen and bistre on pale buff ground. Pricked. 21 by 18. Brogi 1632. Braun 76225. Ascr. to Garbo.

34 No. 356^E—Two figures draped; vague outlines for Madonna and *putti* (p. 129). Sp. and wh.
Fig. 279 on pink ground. 19 by 24. [Fototeca 13133.] Ascr. to Domenico Ghirlandajo. [Verso: Sketch for draped youth turning to r. Rather early.]

35 No. 387^E—Two draped figures, one seated and one standing. Sp. and wh. on pinkish prep. paper. 19.5 by 21. [Fototeca 13134.] Ascr. to Ghirlandajo, but the heads betray A.

36 No. 1118^E—Funeral of St. Zenobius (p. 130). Pen and wash on wh. paper. Pricked. 27 by 34.
Fig. 281 Brogi 1884. Braun 76217. [Van Marle, XIII, p. 260.] Ascr. to Garbo.

36^A (former 23) No. 123^F—Angel leading Peter out of prison (p. 129). Sp. height. with wh. on deep pink
Fig. 278 ground. 17 by 12. [Fototeca 12649.] Ascr. to Ghirlandajo [and corresponding with episode in predella by A. to Domenico Ghirlandajo's altar-piece in sacristy of Lucca cathedral].

37 No. 125^F—Draped figure in hood, in profile to l. Sp. and wh. on brown ground. 16 by 11.
Fig. 275 Verso: Charming sketch for Madonna. Pen and wh. on pinkish ground. [Fototeca 12740 and 13141.] The attribution I suggest does not wholly satisfy me, yet it is probable.

37^A (former 1857) No. 157^F—Elaborate composition for Conversion of Paul. Whatever qualities this may have
Fig. 283 as drawing have disappeared under the pricking of the outlines. Pen and bistre and wh. on pinkish ground. 26.5 by 36.5. [Fototeca 12652.]

 [I used to ascribe to Piero di Cosimo this design inspired no doubt by the earlier Florentine engraving reproduced on p. 14 of Colvin's *Maso Finiguerra*, but landscape apart I no longer see justification for this attribution. The types and the action both have the character intermediate between Ghirlandajo and Botticelli which mark A. One is the more disposed to assign it to him as it served for the famous plate engraved by Matteo di Giovanni Dei in the Bargello. A niello print of it till recently in Paul Kristeller's Collection is reproduced on p. 20 of Knoedler's *Engravings and Etchings* for 1931. A., as I have long ago insisted, made a business of furnishing drawings to the engravers. I am indebted to Mr. John Walker for pointing out the connection between this Conversion and the Bargello plate.]

37^B (former 971) No. 163^F—Draped figure seated in profile to l. Sp. and wh. on pinkish ground. 20.5 by 14. [Fototeca 12653.] Ascr. to Fra Filippo. [With hand cf. that of the saint, No. 29, Kleinberger Exhibition, New York, 1917, opp. p. 85 of catalogue.]

38 (see 1341^A)

39 GENOA, Palazzo Rosso, 2770—Six graceful kneeling male figures, the most important of whom are a bishop and a saint to whom he hands a mitre. Background, a wall with an arched opening (p. 130). Pen and wh. on pink prep. paper. 17 by 29. [Photo. Gab. Fot. Municipale.] Of the same set as the cartoons for embroideries, ascribed in the Uffizi to Garbo. Same size of figures.

39A
Fig. 276
3105—Joachim and Anna clasp hands in front of a niche. Pen wash and wh. Pricked for transfer. 28 by 16. Photo. Gab. Fot. Municipale.

I owe my acquaintance with this drawing to Mr. Byam Shaw. It is attributed to Perugino and is inscribed by a later hand on the cornices of the pillars with the words "Raffaelo del Garbo" for no other reason, probably, than that Baldinucci or whoever it was who inscribed it with these words supposed that all Florentine cartoons for embroideries of about 1500 were made by Garbo.

40 (see 849)

40A (former 851) LONDON, Oppenheimer Collection (formerly)—Study for Adoration of Magi. Pen and
Fig. 284
bistre. 20 by 26. [Vasari Soc., I, vii, 1. G. Francovich, *Boll. d'A.*, 1926/27, p. 88.

In the first edition I catalogued this delightful sketch as David Ghirlandajo's, saying that if his it was his finest pen-drawing. Not many years later I began to feel that it was at once too Botticellian and too Peruginesque, for David. The type as well as the folds of the Virgin are distinctly Peruginesque, the second king is all but a copy of Sandro, and the standing figures behind are Botticellian. The combination of elements pointed to A. Looking closer I perceived that the faces and the draperies were certainly his. Later still I realized that this drawing must have served for the fresco in Sala V, "dei Misteri" of the Borgia Apartments. In the *Boll. d'A.*, 1926/27, pp. 88-89, Francovich arrived at the same conclusion independently. So did my friend John Walker. The differences between the sketch and the painting are interesting. It would seem as if Pintoricchio found that the design was too Florentine and insisted on bringing the fresco into closer harmony with his own style. The effort accounts for the inferiority of the finished work.]

41 MUNICH, Print Room, 2150—Two draped figures (p. 129). Sp. and wh. on pinkish ground. 21 by 18.
Fig. 277
Bruckmann 140. Ascr. to Domenico Ghirlandajo. [Verso: Faint sketch for Virgin Annunciate seated. The writing in l. corner looks like Baldinucci's.]

41A PARIS, École des Beaux-Arts, Valori Collection—Dancing male nude. Pen and ink. 16.5 by 9.5.
Fig. 274
Discussed by Byam Shaw in *O. M. D.*, VII (1932/33), pp. 21-22, and repr. as pl. 30. Arch. Ph. A brilliant attribution and certainly A.'s finest drawing.

41B (former 2391) VIENNA, Albertina, S. R., 48—Study for Nativity with St. Jerome kneeling and adoring the Child. Pen and bistre height. with wh. on buff prep. paper. 18 by 24. [Attr. by Wickhoff to Cosimo Rosselli.] Pl. 582 of Schönbrunner & Meder [as School of Cosimo Rosselli, as which it was catalogued in my first edition. It now seems probable that it was done by A. in one of his more eclectic and less happy moments. The draperies are his, and Jerome's eye is unmistakable.]

42 (see 862)

Amico di Sandro (pp. 336-338)

43 (see 570B)

44 (see 1271B)

45 (see 1303A)

46 (see 576A)

47 (see 1313ᴬ)

48 (see 1313ᴮ)

49 (see 1321ᴬ)

50 (see 567ᴬ)

51 (see 1341ᴮ)

52 (see 1359ᴬ)

53 (see 591ᴬ)

54 (see 1362ᴬ)

Andrea del Sarto (pp. 269-294)

55 (see 141ᴱ)

55ᴬ BAYONNE, Bonnat Museum, No. 147—Study for draped male figure in profile to r. R. ch. 12.5 by 16.5.

55ᴮ BERLIN, Print Room — Profile to r. of elderly man inspired perhaps by some version of the well-known antique bust of Homer. To l. bust of young man with elaborately draped sleeve. R. ch. 25.5 by 28. Verso: Profile of bald clean-shaven bull-necked middle-aged man in red and bl. ch. and smaller profile of young man with chin resting in hand.

Dr. Fröhlich Bum, who first published these sketches, in *Belvedere,* 1929, I, pp. 148-149, connects the two figures with the Poggio a Cajano fresco, the draped bust with the young man next to the grey-beard who stands erect to our r. of Caesar and the one holding his chin in his hand with the man on the extreme r. of the same composition. These last have nothing in common but the action, which is not surprising seeing that this part of the fresco was finished by Allori. The heads have a certain likeness to this or that in his works of about 1520 but identity with none.

55ᶜ CAMBRIDGE, Fitzwilliam Museum, Ricketts and Shannon Collection—Draped male figure leaning with l. elbow on parapet and pointing down with r. hand. R. ch. 25.5 by 17. Possibly for one of the figures on the terrace in the background of the Pitti Annunciation (Venturi, IX, i, fig. 400).

55ᴰ CAMBRIDGE (Mass.), Fogg Museum, Charles Loeser Bequest, No. 138—Study for male figure.
Fig. 845 Nude except for loin cloth, walking towards r. in humble attitude; in r. upper corner rapid sketch for head in profile to r. (p. 273, note). R. ch. 39 by 24.5.

Quite early and very likely for the nude leper in the first of the Filippo Benizzi Miracles (Venturi, IX, i, fig. 392).

55ᴱ CHELTENHAM, Fitzroy Fenwick Collection — View of walled-in town. R. ch. 27 by 39.5. Framed by Vasari. On back "Antonio di Donnino" scratched out and under it "Michele di Ridolfo."

55ᶠ CRACOW, Czartoryski Museum—Studies for two draped figures. R. ch. 20 by 14. Hans Tietze published this sheet in *O. M. D.,* II, pp. 55-56, pl. 58, as copies after Dürer's woodcut of the Circumcision (B. 86). We thus catch him in the act of pilfering the great German.

55ᴳ DARMSTADT, Landesmuseum, No. 132—Young man in profile to r. carrying heavy drapery on r. arm. R. ch. 20 by 9.5. Squared for enlargment. *Stift und Feder,* 1929, 36. Verso: draped male figure.

The recto looks like other sketches for the Scalzo frescoes, but the figure does not actually occur in any of the compositions, although close to the man on the r. in the frescoes representing Zacharias in the Temple.

55H (former 1958) DIJON, MUSEUM—Study for head and l. hand of Zacharias in the Scalzo Visitation (p. 280).
Fig. 858 R. ch. 19.5 by 11.5. Reappears in finished work with no change. A copy of the entire composition that may prove of interest is in Dublin (No. 2272).

56 DÜSSELDORF, ACADEMY, No. 17—Study from model for St. Francis in the *Madonna delle Arpie* (p.290).
Fig. 894 R. ch. 34.5 by 23.5. Schaarschmidt, *Zeitschr. f. B. K.*, 1900, p. 214. [Photo. Söhn. Düsseldorf Cat., pl. 6.]

57 (see 108A)

58 (see 108C)

59 (see 109A)

60 (see 109B)

61 (see 110B)

62 (see 110C)

63 (see 110D)

64 (see 110E)

65 (see 110F)

66 (see 110G)

67 (see 110I)

68 (see 110J)

69 (see 110K)

70 (see 113A)

71 (see 747A)

72 (see 113B)

73 (see 113C)

74 (see 115A)

75 (see 115B)

76 (see 117A)

77 (see 117B)

78 (see 118A)

79 (see 118B)

80 (see 118C)

81 (see 118D)

82 (see 119A)

83 (see 119B)

84 (see 119C)

85 (see 119D)

86 FLORENCE, UFFIZI, No. 626E—Head of boy looking up in profile to l. R. ch. 19.5 by 14. Braun 76384. Its purpose I cannot discover; the date is probably about 1517; the quality [is not of the best. Verso: *Putto* diving down. Roughly sketched and hasty.]

87 FLORENCE, Uffizi, No. 627E—Study for Angel Gabriel in the Pitti Annunciation (No. 97) (p. 291).
 Fig. 897 R. ch. 27 by 14.5. Brogi 1744. [Photo. Mannelli. Di Pietro, fig. 8. Knapp, *A. d. S.*, fig. 110.]

88 No. 628E—Study for the l. hand of the *Madonna delle Arpie* (p. 290). Bl. ch. 27 by 21.
 Fig. 892 Braun 76386. [Photo. Mannelli. Uffizi Publ., IV, iv, 4. Venturi, IX, i, fig. 431. Di Pietro, fig. 19.]

89 No. 630E – Sketch for a Resurrection (pp. 270, 286). Christ in mid-air looks down upon
 Fig. 874 group of sleeping soldiers, while on neighbouring knoll the Magdalen kneels in adoration.
 R. ch. 22 by 18.5. Braun 76414. [Photo. Mannelli. U. Middeldorf, *Mitt. des K. H. Inst.*
 Florenz, III, p. 536. Di Pietro, fig. 65.]
 A dainty design of almost Venetian feeling, dating probably from A.'s middle period.

90 No. 631E—Head of child in profile to r. doubtless for infant Baptist [and used for the one
 in the Metropolitan Museum at New York (see also my 127 and p. 294, note)]. Braun
 76413. Excellent. Verso: Lower part of nude child not unlike in attitude to the sleeping
 child in the Louvre Charity, but reversed—a leg and two arms [with hands holding scrolls].
 R. ch. 24 by 18. Brogi 1739. [Di Pietro, figs. 63 and 64.]

91 No. 632E—Head of Child looking to r. and beside it a somewhat larger, less finished study
 Fig. 902 for same (p. 292). Both were for the Child in the Madrid altar-piece (No. 334). R. ch. 24.5 by 18.
 Braun 76412. [Uffizi Publ., IV, iii, 9. Di Pietro, fig. 41. Knapp, *A. d. S.*, fig. 115.] Verso:
 Study of hand.

92 No. 639E—Head of youth, with long hair parted in middle and streaming over shoulder.
 R. ch. 19 by 15.5. Braun 76392. [Photo. Mannelli. Uffizi Publ., IV, iii, 2. Di Pietro, fig. 12.]
 A gracious face that should and yet will not be identified as a St. Michael or kindred
 figure in some work of A.'s earlier middle period.

93 No. 640E—Study from model for head of St. Bernard in the Uffizi picture of Four Saints
 (p. 293). Bl. ch. 18 by 15. Braun 76393. [Uffizi Publ., IV, iii, 16. Venturi, IX, i, fig. 465.]
 Verso: Nude bust.

94 No 644E—Study for head of Magdalen in the Pitti Pietà (No. 58) (p. 288). R. ch. 21.5
 Fig. 885 by 16.5. Braun 76397. [Uffizi Publ., IV, iii, 7. Venturi, IX, i, fig. 447. Di Pietro, fig. 38.]

95 No. 647E—Portrait of Lady seen nearly full face, sitting in chair with her arms resting
 Fig. 890 on it, her hands holding book on her crossed knees (p. 289). R. ch. 24 by 20. Pl. CLXII
 of F. E. [Photo. Mannelli. Popham Cat., No. 203. Uffizi Publ., IV, iii, 6. Venturi, IX, i,
 fig. 457. Di Pietro, fig. 26.]

96 No. 648E – Bust of unkempt man (p. 293). Study perhaps for St. Mark in the Berlin altar-
 Fig. 908 piece (No. 246), and at all events of that period. R. ch. 23 by 14. Braun 76382. [Photo.
 Mannelli. Uffizi Publ., IV, iii, 23. Verso: Study of a l. forearm and hand and a l. elbow.]

97 No. 652E—Rapid study probably for commanding officer in the Scalzo Decapitation of the
 Fig. 855 Baptist (p. 279). R. ch. 26 by 17. Braun 76410. [Venturi, IX, i, fig. 420. Fototeca 4720.
 Photo. Mannelli. Di Pietro, fig. 35.]

98 No. 653E—Study of young woman, possibly Lucrezia del Fede and suggesting both the
 Fig. 884 Catherine in the Pitti Pietà (No. 58) (p. 288) [and the later Borgherini Madonna, now in
 the Metropolitan Museum]. R. ch. 13.5 by 11. Braun 76411.

99 No. 655E—Study for a St. Cosmas or Damian, with mortar and pestle in his hands. R. ch.
 27 by 12. Braun 76409. [Photo. Mannelli.] Bears so strong a resemblance to the second
 erect figure on the r. in the Scalzo fresco of the Baptist preaching that we may assign it
 to the same date, 1515.

100 FLORENCE, Uffizi, No. 657E —Study for youth on extreme l. in the Scalzo Baptism of the Multitude
Fig. 849 (p. 279). Bl. ch. 29 by 15. Braun 76387. [Venturi, IX, i, fig. 411. Di Pietro, fig. 13.]

101 . . . No. 658E —Tall, monumental female, her r. hand falling to side and holding drapery, her
Fig. 846 l. held across breast (p. 277). R. ch. 29 by 17. Braun 76406. [Photo. Mannelli.] A study it
would seem for an allegorical figure, perhaps for a Fides, and of early date, scarcely much
later than 1511.

102 . . . No. 659E —Study for executioner in the Scalzo fresco of the Baptist seized by Herod
Fig. 852 (p. 279). R. ch. 27 by 12. Braun 76407. [Photo. Mannelli. Venturi, IX, i, fig. 413. Di Pietro,
fig. 15. Knapp, A. d. S., fig. 105.]

103 . . . No. 661E —Youth seated looking to r. with r. arm resting on book. R. ch. 18.5 by 11.5.
Braun 76403. [Photo. Mannelli. Venturi, IX, i, fig. 422. Same model apparently as the
pen sketch, my 108A. I cannot discover the purpose of this sketch, which would seem of
A.'s middle period. Verso: Two rapid scrawls of heads. Fototeca 4743. Di Pietro, figs. 21, 22.]

104 . . . No. 662E —Study from model for pose of the Christ in the S. Salvi Last Supper (p. 281).
Fig. 864 R. ch. 19 by 15. Braun 76402. [Photo. Mannelli. Uffizi Publ., IV, iii, 11. Di Pietro, fig. 45.]

105 . . . No. 663E —Similar study of apostle for same fresco (p. 281). R. ch. 19 by 9.5. Braun 76401.
Fig. 861 [Photo. Mannelli.]

106 . . . No. 664E —Other study for four further apostles in same fresco (p. 281). R. ch. 25 by 36.
Fig. 862 Pl. CLVII of F. E. [Popham Cat., No. 198. Uffizi Publ., IV, iii, 13.] Verso: Study for Judas
in same. The female bust is not by A. [Fototeca 4745 and 4746. Photo. Mannelli. Di
Pietro, figs. 50 and 51.]

107 . . . No. 667E —Design for Epiphany (pp. 270, 274). R. ch. 36.5 by 31. Braun 76408. Alinari 667.
Fig. 847 Perhaps the earliest of A.'s extant drawings. The Virgin's head is indicated in a way that
vividly recalls P. di Cosimo.

108 . . . No. 669E —Study of life-size head, of firm, plastic type, done doubtless from model, yet
Fig. 906 suggesting a Roman bronze. Bl. ch. 36 by 24. Braun 76394. [Uffizi Publ., IV, iv, 5. Venturi,
IX, i, fig. 438. Di Pietro, fig. 16. Knapp, A. d. S., fig. 106.
 In the first edition I failed to connect this head with that of the Peter Martyr in
the Pitti *Disputa* over the Trinity (Venturi, IX, i, p. 574), for the reason, perhaps, that
in the painting so little of it's heroic vitality remains.]

108A (former 57) No. 34F —Head of youth (p. 269). 9.5 by 8. [Photo. Mannelli.] Dating from A.'s earlier
Fig. 841 middle period, and so far as I know his only pen drawing. [Cf. my 103.]

108B . . . No. 270F —Head of woman looking up in profile to r. Bl. ch. 36 by 21.5. Brogi 1263. Ali-
nari 755. Photo. Mannelli. Venturi, IX, i, fig. 398. Knapp, A. d. S., fig. 102.
 May be connected with the *Noli me tangere* in the Uffizi (No. 216) and like others of
A.'s earliest works close to Franciabigio, differing only in quality of modelling and touch.

108C (former 58) No. 273F —Study for Angel Gabriel in the Pitti Annunciation (No. 124) (pp. 286-287).
Fig. 878 R. ch. 34.5 by 29.5. Braun 76405. [Uffizi Publ., IV, iii, 1. Venturi, IX, i, fig. 401. Di Pietro,
fig. 6.]

109 . . . No. 275F —Male head to r. R. ch. 9 by 7.

109A (former 59) No. 276F —Head of youth in profile to l. R. ch. 9 by 7.

109B (former 60) No. 278F —Head with face turned up to l. (p. 292). R. ch. 9 by 7.

110 . . . No. 279F —Male head to l. R. ch. 9 by 7.

110^A FLORENCE, UFFIZI, No. 280^F — Study for head of *putto* in oval. R. ch. 8.5 by 6.5.

110^B (former 61) No. 282^F — Study for first figure on l. in the Scalzo Dance of Salome (p. 279). R. ch.
Fig. 854 24 by 17. [Verso: Rapid sketch for young man with lute. Photo. Mannelli. Fototeca 4720 and 4264. Di Pietro, figs. 32 and 33. The sketch on the verso was probably intended for the same composition, but not used as not severe enough for the classical austerity of the representation.]

110^C (former 62) No. 288^F — Study from model for pose of St. Michael in the Uffizi Four Saints (No. 8395)
Fig. 913 (p. 293). R. ch. 26 by 18.5. [Fototeca 4605. Photo. Mannelli. Uffizi Publ., IV, iii, 15. Di Pietro, fig. 71.]

110^D (former 63) No. 289^F — Head of elderly man in profile to r. [and study of an eye in profile] (p. 293).
Fig. 907 Bl. ch. 22 by 18. Alinari 249. [Photo Mannelli. Uffizi Publ., IV, iii, 12. Di Pietro, fig. 47.]
Its precise destination is not clear. Even as a drawing the same head with slight variations recurs, as for instance in the Louvre. In painting, to mention conspicuous instances only, we find it in the Last Supper, in the Scalzo Visitation, in the Pitti altar-piece (No. 307), and in the Berlin altar-piece. This particular study may have served for any one of these pictures.

110^E (former 64) No. 291^F — Study for the Child in the Madrid altar-piece (No. 334) (p. 292). R. ch. 25 by 16.5. [Popham Cat., No. 205. Uffizi Publ., IV, iii, 8. Di Pietro, fig. 40.]

110^F (former 65) No. 292^F — Bust of man looking a little to l. (pp. 279, 280). Bl. ch. 25 by 18.5. [Photo.
Fig. 860 Mannelli. Di Pietro, fig. 48.] Excellent, and of familiar type in A.'s later works; yet not to be exactly identified, although conceivably for the Herod in the Scalzo fresco of the Feast, or more likely still for the third apostle on the l. in the S. Salvi Last Supper.

110^G (former 66) No. 293^F — Studies for hands of St. John Gualbert and of S. Fedele in the Madonna with
Fig. 915 Four Saints, now in the Pitti (No. 123) (p. 293). R. ch. 28 by 20. Alinari 342. [Popham Cat., No. 206. Uffizi Publ., IV, iii, 17. Venturi, IX, i, fig. 480. Di Pietro, fig. 78.] Verso: Rapid sketch for the S. Fedele in same work.

110^H No. 249^F — Small sketch of draped figure kneeling to l. 11.5 by 5.5.

110^I (former 67) No. 297^F — Study for the two *putti* in the Uffizi Four Saints (No. 8395) (p. 293). R. ch.
Fig. 914 28 by 20. [Photo. Mannelli. Venturi, IX, i, fig. 466. Di Pietro, fig. 73. Verso: Two rough studies for Madonna with the two Children. Fototeca 15656. Possibly first ideas for composition like the one in the Pitti (Venturi, IX, i, fig. 473) or in the Louvre (*ibid.*, fig. 439).]

110^J (former 68) No. 301^F — Bust of youth, rapidly sketched. R. ch. 13 by 12. Verso: Bust of young man seen from behind, but face in profile. Ascr. to Pontormo, but the stroke is A.'s. Besides, the youth on the front is companion to the one on my 103, correctly ascr. to A. [Fototeca 4266 and 4267. Di Pietro, figs. 23 and 24.]

110^K (former 69) No. 302^F — Study from nude model for the Virgin in the Pitti Assumption (No. 191), and of arms and feet for same (p. 292). R. ch. 28 by 20.5. Alinari 81. [Photo. Mannelli. Knapp, *A. d. S.*, fig. 121.]

111 No. 303^F — Study from nude model for the Virgin in the Pitti Assumption (No. 191) and
Fig. 899 of foot for same (p. 292). Bl. ch. 26 by 19. [Photo. Mannelli. Uffizi Publ., IV, iii, 24. Di Pietro, fig. 76.]

112 No. 305^F — Studies of drapery. Bl. ch. 20 by 34. [Fototeca 4268. Photo. Mannelli. Di Pietro, fig. 30.]

113 FLORENCE, Uffizi, No. 306F —Head of woman and studies of drapery (p. 293, note). R. ch. 28 by 21.
Verso: [Study for figure seated at table, probably for the Last Supper. And vertically to
Fig. 911 it study for saint. Photo. Mannelli. Fototeca 4269 and 4270. Di Pietro, figs. 53 and 54, is
perfectly right in connecting both head and drapery with the St. Catherine in the Berlin
altar-piece and the saint on the verso with the St. Benedict in the same picture.]

113A (former 70) No. 307F —Study from model for angel on our r. in the Pietà engraved by Agostino
Fig. 877 Veneziano, and larger study of draped torso seen from back, for same (p. 287). R. ch.
27 by 34. Alinari 383. [Photo. Mannelli. Uffizi Publ., IV, iii, 3. Di Pietro, fig. 10. Knapp,
A. d. S., fig. 107.] Verso: Drapery for same.

113B (former 72) No. 313F —Study for r. arm of figure in profile to r. seated on bench which he presses
Fig. 866 with hand as if he were about to get up (p. 282). R. ch. 21 by 19. [Uffizi Publ., IV, iii, 14.
Di Pietro, fig. 49.] Sketched from model for arm of Apostle Philip on extreme l. in the
S. Salvi Last Supper.

113C (number omitted)

113D (former 73) No. 314F —Three *putti* in various attitudes (pp. 270; 292, note). R. ch. 27.5 by 20. Pl. CLV
of F. E. [Photo. Mannelli. Popham Cat., No. 199. Uffizi Publ., IV, iii, 25.] Verso: Two
putti sitting. Probable date soon after 1520. [Di Pietro connects both sketches with the
cherubs holding the tablets of the law in the Pitti Assumption (No. 191).]

113E No. 317F —Seated nude youth seen from behind. R. ch. 26.5 by 18. Photo. S. I. Verso: Draped
figure (p. 291, note). Photo. Mannelli. Knapp connects the recto with the figure kneeling
to l. in the *Disputa* and the verso with the Evangelist in the Madonna of the Harpies.
The second suggestion seems to me more likely than the first.

114 No. 318F —Studies from model for angel, and his l. arm, in the Madrid altar-piece
Fig. 903 (No. 334) (p. 292). R. ch. 26.5 by 20. [Uffizi Publ., IV, iii, 10. Di Pietro, fig. 43. Knapp,
A. d. S., fig. 113. Verso: Study of drapery. Correctly identified by Knapp, *ibid.*, fig. 112, as
for the St. Joseph in the same picture.]

115 No. 319F —Study of youngish man in romantic attitude, and elaborately draped. R. ch.
32 by 15.5. [Photo. Mannelli. Verso: Rapid sketch of bearded figure which according to
Knapp and Di Pietro served for the Honophrius in the Pitti Madonna and Saints (No. 307);
also the young man on the recto is by them connected with the second saint to l. in the
same altar-piece.]

115A (former 74) No. 320F —Studies for hands and legs of Baptist in the Cathedral of Pisa (p. 293). R. ch.
26 by 18.

115B (former 75) No. 321F —Slight but exquisite sketch for the Scalzo Decapitation of the Baptist (pp. 270,
Fig. 848 277, 279). Bl. ch. 10 by 12. [Fototeca 2090. Di Pietro, fig. 36.]

116 No. 323F —Study for drapery of the Virgin in the Pitti Assumption (No. 191) (p. 292).
Bl. ch. 23.5 by 18. [Verso: Study for same picture (p. 292). Knapp, *A. d. S.*, fig. 122.
Fototeca 15936 and 15661.]

117 No. 324F —Study for torso and legs, and also for l. arm of the angel in the Madrid altar-
Fig. 904 piece (No. 334), and for hands that I cannot identifiy (p. 292). Torso and legs in r., the
rest in bl. ch. 26 by 20. [Knapp, *A. d. S.*, fig. 114. Verso: Studies for a draped and for a
nude figure, also, as Knapp (*ibid.*, p. 133) has correctly observed, for the Madonna and the
angel in the same altar-piece (p. 292, note). R. ch. Fototeca 15662.]

10

ANDREA DEL SARTO

117ᴬ (former 76) FLORENCE, Uffizi, No. 325ᶠ —Young man draped down to knees, seen full face, but
 Fig. 876 standing little to r. with r. hand across his breast pointing, his l. falling to side (p. 286).
 Bl. ch. 40.5 by 17. [Photo. Mannelli. Fototeca 194.] Of the period of the Annunziata frescoes,
 where one expects to find this figure, although one searches in vain. An admirable draw-
 ing [of the kind that greatly influenced Puligo].

117ᴮ (former 77) No. 326ᶠ —Study for soldier standing in profile to l., dressed in costume of time. Bl. ch.
 28 by 13. [Photo. Mannelli. Knapp (A. d. S., p. 133) connects this with the Vallombrosa
 altar-piece.]

118 No. 327ᶠ —Study for drapery of the Virgin in the Pitti Assumption (No. 191) (p. 292). Bl.
 ch. 26.5 by 21. [Photo. Mannelli. Verso: Study of drapery for same subject (p. 292). Knapp,
 A. d. S., fig. 120.]

118ᴬ (former 78) No. 328ᶠ —Soldier clothed, hanging by leg with sprawling arms – study for one of captains
 to be painted in 1530 as hanging in effigy (p. 294). R. ch. 27 by 20. [Photo. Mannelli.]

118ᴮ (former 79) No. 329ᶠ —Study for same purpose for nude hanging by r. leg (p. 294). R. ch. 24.5 by 12.
 [Photo. Mannelli. Uffizi Publ., IV, iii, 21. Di Pietro, fig. 80.]

118ᶜ (former 80) No. 330ᶠ —Study for same figure, clothed (p. 294). R. ch. 24.5 by 12. [Photo. Mannelli.
 Uffizi Publ., IV, iii, 22. Di Pietro, fig. 81.]

118ᴰ (former 81) No. 333ᶠ Study for head, and another for lower part of drapery of St. Francis in the
 Fig. 893 Madonna delle Arpie (p. 290). R. ch. 26 by 21. [Photo. Mannelli.] Schaarschmidt, Zeitschr.
 f. B. K., 1900, p. 215. [Di Pietro, fig. 18.]

119 No. 334ᶠ —Slight but delightful sketch for the Annunziata Procession of the Magi
 Fig. 843 (pp. 270, 274). R. ch. 16.5 by 23. [Photo. Mannelli.]

119ᴬ (former 82) No. 336ᶠ —Slight and unimportant sketches for the Last Supper. [Photo Mannelli.] R. ch.
 19 by 15.

119ᴮ (former 83) No. 337ᶠ —Studies for five hands. R. ch. 20 by 13.5. [Fototeca 4273. Uffizi Publ., IV, iii, 19.
 Di Pietro, fig. 56. A.'s but feeble. As Knapp (A. d. S., p. 134) points out, for the St. Agnes
 in the Pisa Cathedral, a picture also rather feeble in execution.]

119ᶜ (former 84) No. 339ᶠ —Three studies after lower part of figure on our r. in the group of the Laocoön.
 A. may have drawn them in connection with his Sacrifice of Isaac. R. ch. 28 by 21.5.
 [Brogi 1331. Photo. Mannelli. Venturi, Archivio storico dell'arte, 1889, p. 109. Uffizi Publ.,
 IV, iii, 20. Di Pietro, fig. 66.]

119ᴰ (former 85) No. 340ᶠ —Boy seated on bank, with legs wide apart, between which he reaches down with
 his l. hand. R. ch. 25 by 23. [Photo. Mannelli.] Dating from about 1517, and perhaps for the
 Scalzo Baptism (p. 279).

120 No. 1486ᶠ —Studies for putti holding tablets in the Pitti Assumption (No. 191) (p. 292).
 R. ch. 27.5 by 19. [Fototeca 4805. Photo. Mannelli. Di Pietro, fig. 75. Knapp. A. d. S.,
 fig. 118.]

120ᴬ No. 6423ᶠ —Studies for skulls, on recto and verso. R. ch. 28 by 20. [Fototeca 4352. Ac-
 cording to Knapp (A. d. S, fig. 104) for the decoration of the cloister of the Scalzo.]

121 No. 6424ᶠ —Study of drapery. R. ch. 21 by 15.

122 No. 6425ᶠ —Studies for knees. Verso: Rough sketch for drapery. R. ch. 22 by 15.

123 FLORENCE, Uffizi, No. 6431F — Study for draped r. arm of figure in profile to l. (p. 292, note). Bl. ch. 9.5 by 15.5. [Photo Mannelli. Knapp (*A. d. S.*, p. 134) has identified it as a study for the arm of St. Thomas in the Pitti Assumption (No. 225).]

124 No. 6432F — Excellent study for draped r. arm falling to side. Bl. ch. 19.5 by 11. From A.'s best years. [May be connected with *Madonna delle Arpie*.] Ascr. to Fra Bartolommeo.

125 No. 6433F — Study for soldier in profile to l. dashing forward (p. 293). Bl. ch. 28 by 20.
Fig. 916 [Fototeca 15938.] This really must form part of a series with my 118A-C.

126 No. 6435F — Rough study for heavily draped male figure with hands in hieratic Florentine
Fig. 842 attitude across his stomach (p. 274, note). Bl. ch. and wh. 31 by 21.5. [Fototeca 4353. Photo. Mannelli. Di Pietro, fig. 4.] For full-length portrait of Jacopo Sansovino in the Annunziata Procession of the Magi.

127 No. 6444F — Study for drapery around waist of Madonna holding the Child, who looks to
Fig. 918 l. (p. 294, note). R. ch. 19 by 14. [Verso: Study for head and bust of Madonna in same picture. For the picture painted for Giovanni Borgherini now in the Metropolitan Museum (p. 294, note). Fototeca 4354 and 4355. Photo. Mannelli. Di Pietro, figs. 60 and 61.]

128 No. 6453F — Study for drapery of figure intended to decorate r. spandrel over an arch. Bl. ch. 27 by 18. [Photo. Mannelli.] Excellent.

128A No. 6454F — Study for drapery over lower part of kneeling figure (p. 292, note). Bl. ch. 16.5
Fig. 905 by 16.5. Fototeca 4356. Di Pietro, fig. 42. Verso: Sketch for figure facing front and for arm leaning on pedestal. The recto may be as Knapp (*A. d. S.*, p. 134) observes, for the Madonna in the Madrid picture (No. 334).

129 No. 6455F — Drapery for lower part of figure. Bl. ch. 23 by 25. [Di Pietro, fig. 31.]

129A THE HAGUE, Fritz Lugt Collection — Study of youthful male head looking up in profile to r. (p. 292, note). Bl. ch. 31.5 by 23. Vasari Soc., I, x, 5. Popham Cat., No. 204. Oppenheimer Cat., pl. 43. Verso: Study for horse with rider in r. ch. The head on the recto is generally connected with the St. John in the two Pitti Assumptions.

130 LOCKO PARK, Drury Lowe Collection (formerly), No. 68 — Curly head of youth seen nearly full face, and looking out trifle to l. Ch. 33 by 23. See J. P. Richter's *Catalogue of the Pictures at Locko Park*, London, 1901. Study for the favourite, once most beautiful, now frayed and ruined, youthful Baptist in the Pitti Gallery.

131 LONDON, British Museum, 1896-8-10-1 — Several studies for boy (p. 290). In one we see outlines
Fig. 891 of a boy looking up, in another the head fairly elaborated looking at us over the shoulder, in a third the same head and shoulders highly finished. Yet another study is for the upper part of a boy in profile to r. The two more finished heads are among A.'s more pleasant productions. R. ch. 25.5 by 37. Pl. CLXIII of F. E. Alinari 1660. Verso: Nine other studies in various degrees of finish, after a boy, mostly in profile to r.

All these studies are for the Holy Children in various Holy Families of A.'s earlier middle years. The two more finished ones are certainly for the infant Baptist in the Madonna at Hertford House.

132 Ital. Sch. Vol. 48, Unnumbered — Two *putti* embracing, torso and arm of another, and sketch of third in profile; also a hand. R. ch. 20 by 25. Studies, not quite of best quality; either for the Vallombrosa altar-piece, or for the Pitti Assumption (No. 191). [Verso: Skull and r. thigh bone. Campbell Dodgson, *O. M. D.*, I, pls. 8, 9.]

133 LONDON, British Museum, 1896-11-18-1—Studies from model for Giovanni Gualberto and Onofrio
Fig. 909 in the Berlin altar-piece [Venturi, IX, i, fig. 462] (p. 293). R. ch. 28 by 20. [Alinari 1608.
 Vasari Soc., II, xvi, 5.]

134 British Museum, Fawkener, 5210-33—Study from nude model for youth seen in the Poggio
Fig. 867 a Cajano fresco, leaning against the parapet in the middle distance, with his back turned to
 us; also for the head and shoulders of the same youth draped (p. 282). R. ch. 28.5 by 17.5.
 [Alinari 1665.]

135 5211-19—Saddled ass browsing [for the background of the Dresden Sacrifice of Isaac
 (Venturi, IX, i, fig. 477)]. R. ch. 17 by 19. [Alinari 1662. Vasari Soc., I, v, 2.]

136 British Museum, 1860-6-16-92—Head of youth (p. 288). Apparently for Baptist in the
Fig. 882 Vienna Pietà [(Venturi, IX, i, fig. 402)]. Bl. ch. 27 by 20. Alinari 1655. Of his best quality.

137 (see 141 A)

138 [1912-12-14-1]—First draft for the once famous *Madonna di Porta a Pinti* (pp. 283-284),
Fig. 871 of which fresco no trace now remains. R. ch. 28 by 18.5. Pl. CLX of F. E. [Vasari
 Soc., I, ix, 5. Heseltine Cat., 1913, 3.]

138 A (former 141) [1910-2-12-37]—Studies of children and limbs for the Assumption in the Pitti Gallery
 (No. 191). R. and bl. ch. 20 by 25.5. [Vasari Soc., I, vii, 5.] Verso: Nude female tied to
 tree (in bl. ch.), and dragon and one or two slight figures (in r. ch.).

139 (see 141 B)

140 Oppenheimer Collection (formerly)—Five sketches for Madonna seated or kneeling within
Fig. 873 lunette. Doubtless studies for the *Madonna del Sacco* (p. 285). R. ch. 29 by 26. [Heseltine
 Cat., 1913, 5. Meder, *Handz.*, fig. 98.]

140 A No. 264—Study for woman's head, perhaps for one of Lucrezia del Fede's portraits. Bl.
 ch. 34.5 by 23.5 Photo. Cooper. Heseltine Cat., 1913, 1. Suggests in type and expression
 the French pastellists of the 18th century.

140 B Sotheby Sale of Russell Collection, May 9, 1929, lot 18—Sketch for portrait of
 young man in loose gown, wearing small cap. Bl. ch. on pink prep. paper. 21 by 17.
 Sale Cat., opp. p. 13. Ascr. to Pontormo, but decidedly A.'s.

141 (see 138 A)

141 A (former 137) MELBOURNE (Australia), Museum—Rapid sketch for Baptist in the Scalzo fresco of
Fig. 851 the Baptism (p. 279). Verso: Two hands [very similar in type to the hands in the Pitti
 Disputa]. R. ch. 38.5 by 19.5. [Popham Cat., No. 197. Vasari Soc., II, ii, 3 and 4. Heseltine
 Cat., 1913, 2. Oppenheimer Cat., pl. 45.]

141 B (former 139) Sketch for head of infant Baptist in the *Madonna di Porta a Pinti*, resembling the
 first draft neither in pose nor expression, but as in the finished work (p. 284, note).
 Bl. ch. 26.5 by 21.5. [Popham Cat., No. 200. Vasari Soc., II, ii, 5. Heseltine Cat., 1913, 4.
 Oppenheimer Cat., pl. 44.]

141 C MUNICH, Print Room—Study for St. Bernard in the Pitti Assumption (No. 123; Venturi, IX, i,
 fig. 479) (p. 293, note). Bl. ch. 32 by 15.5. O. Weigmann, *Monatsh. f. Kw.*, 1909, p. 7.

141 D NAPLES, Royal Picture Gallery, Print Room, No. 265—Studies on front and back for kneeling
Fig. 917 St. Catherine in the Pitti Assumption (No. 123) (p. 293, note). R. ch. 26.5 by 20. 5. Photos.
 S. I. Publ. and recto repr. by Corrado Ricci, *Riv. d'A.*, 1905, opp. p. 143.

13

ANDREA DEL SARTO

141E (former 55) [NEW YORK, MORGAN LIBRARY]—Study for boy carrying sack on his head in the Scalzo fresco representing the Visitation (p. 279). Bl. and r. ch. 27 by 13.5. [Morgan Dr., I, 30. Verso: Rapid sketch for same figure in r. and bl. ch. Morgan Dr., IV, 14.]

141F Study for St. Michael in the Uffizi Four Saints (No. 8395) (p. 293). R. ch. 22.5 by 14. Morgan Dr., I, 31. What this sketch gains in finish, it looses in spontaneity and directness when compared with the sketch for the same figure in the Uffizi (my 110C).

141G OXFORD, ASHMOLEAN MUSEUM, R. 130—Study for head of old woman, probably for St. Elizabeth in a composition like the one in the Pitti (Venturi, IX, i, fig. 473). R. ch. 25 by 18.5. Photo. Museum.

142 PARIS, LOUVRE, No. 1678—Study for head of St. Francis in the *Madonna delle Arpie* (p. 291). Bl.
Fig. 895 ch. Oval, 29.5 by 23. [Venturi, IX, i, fig. 432. Except for quality of structure singularly like a Lo Spagna. Verso: Study of hand. Bl. ch. 13 by 11.5. Alinari 1269 and 1273.]

142A No. 1672—Head of old man in profile to l. Framed by Vasari along with 3 sketches by Fra Bartolommeo (see my 464A). Bl. ch. Alinari 1474. May be for Zacharias in the Scalzo fresco representing him in the temple.

143 No. 1675—Youthful nude, seated in profile to r. behind sack against which he leans with
Fig. 875 his arm while he reads in book which he holds with l. hand (p. 285). R. ch. 14.5 by 15.5. Pl. CLXI of F. E. Braun 62118. [Popham Cat., No. 202. Alinari 1274. Knapp, *A. d. S.*, fig. 116.] Study from model for Joseph in the *Madonna del Sacco*. A nearly contemporary copy of this is at the British Museum (Alinari 1664).

144 No. 1679—Study of feet. Bl. ch. 28 by 22.

145 No. 1680—Study for Zacharias in the Scalzo Birth of the Baptist (p. 280). Bl. ch. 25 by 15.
Fig. 859 Braun 62120. [Venturi, IX, i, fig. 429. Alinari 1284. Knapp, fig. 119.] Verso: Bald head of elderly man in profile to l. done from same model, and, except for being turned in opposite direction, almost identical with my 152. R. ch. [Arch. Ph.]

146 No. 1681—Study of draped male figure standing in profile to l. for the Scalzo Dance of
Fig. 856 Salome (p. 279). Bl. ch. 28 by 17. Braun 62121. [Alinari 1282. Venturi, IX, i, fig. 418. Knapp, *A. d. S.*, fig. 109.]

147 No. 1682—Two drawings on same mount: (1) Two joined hands (p. 288) [for the Pitti
Fig. 880 Pietà]. R. ch. 9.5 by 15.5. [Venturi, IX, i, fig. 451. Alinari 1281.] Verso: Hands drawing aside a curtain. (2) Hand holding fruit. Bl. ch. 16.5 by 15.

148 No. 1684—Life-size shaggy head of youngish man, and same on smaller scale (p. 282).
Fig. 869 R. ch. 33 by 26. Pl. CLIX of F. E. [Popham Cat., No. 201. Alinari 1265. Venturi, IX, i, fig. 470.] Verso: Two other studies for same head (p. 282). These are studies for the head of the man who on the first step of the Poggio a Cajano fresco stoops to take an animal by its leg.

149 No. 1685—Head of man looking up in profile to r. (p. 292). [For Joseph in the Madrid
Fig. 901 altar-piece.] R. ch. 19.5 by 15.5. Braun 62126. [Alinari 1283.]

150 No. 1686—Bust of woman almost in profile to l., bending her head a little (p. 293). R.
Fig. 910 ch. 24.5 by 20. Pl. CLXIV of F. E. Braun 62127. [Alinari 1268. Venturi, IX, i, fig. 416. Knapp, *A. d. S.*, fig. 108. Paris Exh. Cat., pl. VII.] Study for St. Catherine in the Berlin altar-piece.

150A No. 1687—Various studies on front and back for dog that jumps down from steps of Caesar's
Fig. 868 throne in the Poggio a Cajano fresco (p. 282, note). R. ch. 19.5 by 25. Arch. Ph.

14

151 PARIS, Louvre, No. 1689—Study from model of young man nude but for cap on his head, standing in
 Fig. 844 profile to l., with his r. hand touching his l. shoulder (p. 273). R. ch. 39.5 by 20. Pl. CLVI
 of. F. E. [Alinari 1275.] This served for a figure in the Annunziata fresco, representing
 St. Philip exorcising a possessed woman.

152 No. 1690—Profile to r. of bald-headed elderly man (p. 282). R. ch. 19.5 by 15. Pl. CLVIII
 Fig. 865 of F. E. [Alinari 1278. Arch. Ph. Verso: Study of man seated, draped across the chest,
 drapery and hands highly finished, legs slightly indicated. Bl. ch. Below, two feet in r. ch.]
 The head on the recto which in different positions A. drew more than once, probably
 was not made, as the Louvre catalogue states, for the Zacharias in the Scalzo Visitation,
 nor, as might occur to others, for one of the apostles on l. in the Last Supper. It is much
 more likely that A., whose habit it was to make almost no change from a study of a
 detail to its final form in the finished work, intended this head for that of the old man
 kneeling before Caesar in the Poggio a Cajano fresco.

153 No. 1692—Bust of child turning a little to r. with hands joined in prayer (p. 292). R.
 Fig. 900 ch. 18.5 by 13.5. Braun 62130. [Alinari 1286.] In every probability a study for one of the
 cherubs in the Pitti Assumption (No. 225). [On the verso, which is stuck down, a similar
 baby's head is visible.]

154 No. 1714—Five drawings on same mount. (1) Study for hands of fifth apostle on our r. in
 Fig. 863 the Last Supper, and for another hand, probably for that work, but discarded. R. ch.
 Verso: Study of draperies. (2) Various studies of hands. (3, 4, 5) Various studies of legs
 and feet for the Last Supper (p. 281). Braun 62129. [Alinari 1267.]

155 No. 1715. Study from model for Dead Christ in the Pitti Pietà (No. 58) (p. 288). R. ch.
 Fig. 881 20 by 26. Braun 62128. [Alinari 1285. Knapp, *A. d. S.*, fig. 111. Venturi, IX, i, fig. 450.]

156 No. 1716—Two drawings on same mount. (1) Head of Girl of eighteen or nineteen (p. 289).
 Fig. 886 Bl. ch. 13 by 11. Later middle period. Braun 62134. (2) Head of young woman with loose
 Fig. 887 flowing hair (p. 289). Bl. ch. 13 by 11. Braun 62135. [Alinari 1280 and 1281.]

157 No. 1717—Head of laughing child in profile to r. (p. 291). R. ch. and touches of wh.
 Fig. 896 25.5 by 19. Braun 62125. Giraudon 42. [Alinari 1270. Venturi, IX, i, fig. 441.] Study for
 one of the children in the Louvre Charity.

157A No. 1726—Profile of middle-aged man looking devoutly to l. The back of the head from
 crown to base has been added and the profile cut out and pasted on, so that the outlines
 have lost nearly all vitality. R. ch. Alinari 1272.

158 No. 212—Study of elderly man's head, turned nearly to l. with mouth half open and eyes
 Fig. 883 half closed (p. 289). He is smooth shaved, and has a wart on his cheek. Evidently from
 model. Ascr. to Fra Bartolommeo. R. ch. 13.5 by 16.5. Braun 62022.

158A No. 232—Young man turning violently round and looking over his shoulder. R. ch.
 25.5 by 16. Verso: Studies of drapery.

159 École des Beaux-Arts, No. 10—Study from model, perhaps Lucrezia del Fede, of youngish
 Fig. 888 woman, looking down a little to l. (p. 289). Possibly to be connected with the Pitti Pietà,
 and at all events of nearly that period. R. ch. 23.5 by 17.5. Braun 65087. [Venturi, IX, i,
 fig. 463. Knapp, *A. d. S.*, fig. 117. E. d. B. A. Exh. Cat., opp. p. 56.]

159A École des Beaux-Arts, Armand Valton Collection—Bust of young woman (p. 289).
 R. ch. 27.5 by 20.5. Publ. and repr. by Fischel in *Belvedere*, 1922, i, p. 32, as sketch for
 the Uffizi portrait of Lady with Petrarch's Sonnets in hands (No. 783). Verso: Slight sketch
 of same figure.

I am not acquainted with the original but assuming as we may on Fishel's authority that it is an autograph, the sketch on the recto is of great interest. Impossible not to connect it with one of A.'s finest achievements, the Uffizi portrait just mentioned. And yet the difference is puzzling. The sketch seems to be of a younger person and of one nearer the people than the lady in the picture, who looks mature, cultivated, and clever. Did the artist use a model with fourtuitous likeness to the lady or is the latter only the image, the *Wunschbild*—the wish fulfilment—of the other?

159B PLYMOUTH, ART GALLERY—Study for Gabriel in the Pitti Annunciation (No. 124). R. ch. 20.5 by 14. Photo. Cooper. Popham Cat., No. 196. Vasari Soc., II, ix, 5. Probably right but in present condition unsatisfactory.

159C ROME, CORSINI, PRINT ROOM, No. 124156—Study for head of Apostle Thomas in the Pitti Assumption (No. 225). R. ch. 27 by 21. Publ. by Ingeborg. Fraenkel in *O. M. D.*, IX (1933/34), pp. 8-10 and pl. 10.

159D No. 130494—Two studies for kneeling female figure, one naked, and one draped, for the Madonna in the Madrid altar-piece (No. 334) (p. 292, note). R. ch. Publ. and repr. by Corrado Ricci in the *Riv. d'A.*, 1907, p. 133.

160 VIENNA, ALBERTINA, S. R., 177A—Kerchiefed female head, looking down slightly (p. 289). For the
Fig. 889 Madonna in the Pitti Pietà. R. ch. 12.5 by 14. Schönbrunner & Meder, pl. 562. [Albertina Cat., III, No. 163.]

161 S. R., 284—Two Horsemen in costume of time. R. ch. 29 by 20.5. Braun 70178. [Albertina Cat., III, No. 77. Venturi, IX, i, fig. 414.]

Formerly ascribed to Raphael, because both figures occur in the *Spasimo di Sicilia*, but already correctly attr. by Wickhoff to A. A. doubtless drew them, making such changes as pleased him, after Agostino Veneziano's engraving directly this was published in 1517. The style of the drawing does not admit of a much later date.

Fra Angelico (pp. 4-6)

161A CAMBRIDGE, FITZWILLIAM MUSEUM—St. Matthew (pp. 5, note; 9, note). Bistre height. with wh. on green prep. ground. 16 by 15. Verso: St. Luke. Bistre and wash on wh. paper. Vasari Soc., II, v, 1A and 1B. Popham Cat., No. 25. J. W. Goodison, *Burl. Mag.*, LIX (1931), opp. p. 214.

In the text to this publication, A. M. Hind gives an exhaustive account of this sheet, and correctly relates it to the figure of the Evangelist in the ceiling of the Vatican chapel erected by Nicholas V. He pleads that we should accept both sides as autographs by F. A. There is little trouble in agreeing with him about the Luke, which is ample, free, and natural. Indeed the head reminds one of an obvious portrait in the Stoning of Stephen in the same chapel, and the difference between the crafts would account for the interesting divergence between the freedom of the drawing and the relative tightness of the painted figure.

The sketch of the Matthew, on the other hand, is stiffer, flatter, more stilted than in the fresco, and the draperies take on a more angular twist. For these reasons this side of the sheet may be assigned to Benozzo while working under F. A.

162 LONDON, BRITISH MUSEUM, MALCOLM, No. 1—Youthful David with crown on his curly head, sitting
Fig. 17 on settle, singing and playing on psaltery (p. 4). Pen and purple wash on vellum. 20.5 by 17.5. Pl. II of F. E. [Schottmüller, p. xxx.] Verso: Verses of a psalm.

163 WINDSOR, Royal Library, 12812—Bust of St. Lawrence (pp. 4-5). Sp. and wh. on buff prep.
Fig. 19 paper. 18 by 16. Pl. iii of F. E. [Photo. Cooper 58509. Schottmüller, p. xxviii. Popham
 Cat., No. 22. Van Marle, X, p. 127.] Verso: St. Lawrence, woman holding child, and youth
Fig. 20 with clasped hands. Pl. iv of F. E. [Schottmüller, 202.]

School of Fra Angelico (p. 6)

164 (see 546 A)

164A (number omitted)

164B BERLIN, Print Room, No. 5173—Youthful Dominican saint expounds to group of friars sitting in
 garden of cloister. Pen on parchment. Grass and trees coloured green. 24 by 19. Ede,
 pl. V. Berlin Publ. I, 2. By a crude follower, perhaps not a painter.

164C CAMBRIDGE, Sir Sidney C. Cockerell—Eight leaves of a picture chronicle. Tinted on vellum.
Fig. 27 Each 31 by 20. By a finer artist than Domenico di Michelino or Strozzi, and more delicate
 than Benozzo and on a level with Pesellino, whom these miniatures most resemble, athough
 almost certainly not by him. There are reminders as well of Domenico Veneziano.

165 FLORENCE, Uffizi, No. 47 E—Bust of monk looking up little to r. Below, a dove. Bl. ch. and wh.
 on buff ground. 17 by 12. Fair quality and of a certain independence.

165A No. 66 E— Monk seated reading. Bistre wash and wh. on green paper. 15 by 8. Foto-
 teca 12542. Ascr. to Finiguerra, but by follower of F. A. The modelling of the face and
 the lighting of the folds suggest the possibility that this sketch may be by the Master of
 the Castello Nativity.

166 No. 95 E—Three medallions with Evangelists or Fathers in each. Bistre on parchment.
 11 by 4. Braun 76012.

167 No. 96 E—Three medallions with Evangelists or Fathers in each, almost effaced (p. 6).
 Bistre on parchment. 11 by 3. Braun 76012.

168 No. 97 E—Saint expounding to three monks (p. 6). Pen on wh. paper. 15 by 12.
Fig. 25 Braun 76015.

169 No. 98 E—Half-length figure of Evangelist in medallion. Pen on parchment. 4 by 3.5.
 Braun 76014.

170 Nos. 99 E and 100 E—Annunciation in two medallions. Pen on parchment. Each 3.5 by 3.5.
 Braun 76013.

171 (see 534 B)

172 No. 102 E—Four angels supporting *mandorla*, wherein sits Madonna. Bistre wash. 10.5
 by 9.5. Brogi 1608. [Fototeca 2085.] This feeble sketch is not necessarily more of F. A.'s
 than of Fra Filippo's following. [Probably by Andrea di Giusto.]

173 No. 103 E—Angel in profile to r., holding trumpet, and below to r., Christ in *mandorla*.
 Pen and bistre. 13.5 by 10. Brogi 1609. Braun 71618.

173A No. 104 E—Three figures representing St. Dominic disputing with heretic. Sp. on purplish
 prep. paper. 14 by 12.5. Copy by slightly later hand of episode in predella to F. A.'s
 Coronation in Louvre (No. 1290; Schottmüller, 52).

3

174 FLORENCE, Uffizi, No. 105^E—Youth breaking staff across r. knee. Sp. on pink prep. paper. 12 by 7.5. Copy by a close follower after a figure in a *Sposalizio* by F. A., perhaps after the one in the predella to the Madrid Annunciation (Schottmüller, 67).

175 No. 106^E—Monk in profile to l., and charming young woman intended probably for allegorical figure sitting by table with her l. arm resting on it. Pen and bistre. 12 by 12. [Van Marle, X, p. 187.]

175^A No. 111^F—Youth seated in profile to r. sewing a garment thrown over his knee. Bistre and wash. 7.5 by 5.5. Fototeca 12648. May be by Andrea di Giusto but much more likely by the master of the Carrand triptych.

175^B HAARLEM, Franz Koenigs Collection—Friar trying to kill snake with stone. Pen and watercolour on vellum. 10.5 by 13.5. Close to Domenico di Michelino.

175^C Hermit receiving novice, Moses receiving tables of Law, St. Catherine's body on Mount Sinai while her soul is carried by angels to heaven. Pen and watercolour on vellum. 20 by 13.5. Close to Domenico di Michelino.

175^D Three highly finished miniature compositions done with bistre and wh. on red ground: Presentation in the Temple, Christ before Pilate and Crucifixion. 8 by 6. Pl. viii of Boerner Sale Cat., May 12, 1930.

 Unacquainted with the originals, I can say no more than this: If these miniatures are of the 15th century they may be careful copies by an Umbrian, perhaps Caporali after a series of panels by F. A., not identical with any known at present but which may have existed and probably in Umbria. The same miniatures appeared at the Mensing Sale, Amsterdam, July, 1927, and are repr. in catalogue as No. 249 along with a Christ among the Doctors, a Washing of Feet, which, however, may be, as the catalogue says, by a stiffer and it seems to me more Florentine hand. Text of same catalogue says there were ten of these miniatures in 18th century binding with royal crest. (As far as I know there are seven in the Koenigs Collection at present—1937.)

176 LONDON, British Museum, 1895-9-15-437—Well-proportioned youth seated, looking down, with r. hand on his knee, which is drawn up over the thigh of the other leg, and his l. hand touching his foot. Also the head of a youth in profile to l. Sp. height. with wh. and washed with bistre, on purplish prep. paper. 20 by 12.5. Braun 73041. [Van Marle, X, p. 197.]

 If one were tempted to ascribe the nude to F. A., the head of the youth would quickly put one off. As for the nude, it must be a copy by a pupil of a study made by the master, apparently from the model, for an apostle drawing off his hose in a Christ Washing the Feet of his Disciples. It is quite likely even that the original study served for the little picture in the Florence Academy. The present sketch is at all events precious in that it reveals, what perhaps few have suspected, that F. A. practised drawing from the nude.[1] [A copy of the nude occurs on folio 10 of the Koenigs sketch-book (my 558^B, *O. M. D.*, IV, 1929/30, pl. 55) most of the drawings in which are copies after Benozzo. Yet I cannot believe this is by Benozzo himself. The author of the sketch-book must have copied a version by Benozzo after the same original by F. A.]

 Verso: Two youthful saints seated, one with his hands held in astonishment, and the other with his hand to his cheek. Pen and bistre. Braun 73089. Copies by a pupil after original drawings, perhaps for figures on the l. in a Last Judgement. Also the head of an ox—the symbol of St. Luke. It is possible, but not likely, that this sheet is by Domenico di Michelino.

1. [This is less surprising now that we recognize as his the nudes in the Epiphany of the Cook Collection hitherto ascribed to Fra Filippo (see *Boll. d'Arte*, 1932/33, pp. 1-7).]

176A LONDON, British Museum, Malcom, 3—Draped youthful saint seen from behind but the curly-headed
Fig. 24 profile sharp to r. holding book. He stands on a curious circular plinth. Sp., bistre and wh.
on ground tinted olive green. 25.5 by 14. Verso: Youthful female nude standing to r. On
her head the basketlike construction which supported the tall head-dress worn toward
1440-50. In her l. hand a double torch, her r. spread out. Van Marle, *Iconographie de l'art
profane* (The Hague, 1931), I, p. 493. Ascr. to Ghiberti, and no doubt closer to him, but in
our present state of ignorance it is safer to catalogue it with the following (in the widest
sense of the word) of F. A.

176B MILAN, Ambrosiana (in turnstand near window)—Study for monk kneeling before cross with r.
hand to cheek and l. on girdle. Bistre wash and wh. on pink prep. paper. Old copy.

177 MUNICH, Print Room—Stoning of St. Stephen (p. 5, note). R. ch. and ink. 16 by 22. Bruckmann 136.
Ascr. to F. A., but early 16th century copy after the Vatican fresco, perhaps by Leonardo
da Pistoia. The same hand, at all events, is responsible for the Uffizi drawing No. 116F.
(*q. v.* under R. Ghirlandajo School).

177A STOCKHOLM, Print Room, Inv. 32—Study for Virgin in Coronation. Bistre wash and wh. on
greenish ground. 20 by 14. Close to Benozzo and perhaps Umbrian.

177B VENICE, Academy, No. 9—Faint sketch for St. Francis receiving Stigmata. Bistre and slight wash
on wh. paper. 10.5 by 10.

178 VIENNA, Albertina, S. R., 30—Study for Christ on the Cross (p. 5). Bistre wash, but halo and blood
Fig. 18 coloured red. 29 by 19. Schönbrunner & Meder, No. 702. [Albertina Cat., III, No. 9.
Schottmüller, p. xxvi.] To what I have said in the text regarding this design, I may add
that it possibly might be ascribed to Domenico di Michelino.

178A Inv. 25450—Heavily draped youngish man with short beard and hair parted in middle
Fig. 26 looking down to r. with r. hand exposed and l. extended under mantle—study no doubt for
an apostle. To r. a youthful nude seated on cloth which drapes his r. leg only, his r. arm
held up and his l. grasping the cloth. Pen. 18 by 16. Jenö Lanyi, *Jahrb. Kunstw.*, 1930,
pl. 7, opp. p. 56. Albertina Cat., III, No. 5. Verso: Four studies for entablatures. Alber-
tina Cat., III, No. 5R. Meticulous and dainty, this sketch betrays in the nude figure the
inspiration of F. A. and the young Benozzo. The draped study is as close to Masaccio.
As the only painter of note who imitated all those masters just mentioned was Andrea di
Giusto, we may propose him as the author of this drawing. But for the Masacciesque
apostle, one would be tempted to ascribe it to the youthful Benozzo.

179 S. D., 139—Sketch of youthful bishop. Pen. 19.5 by 14.5 [Albertina Cat., III, No. 10.]
Certainly not F. A.'s, to whom it was ascribed by Prof. Wickhoff, but by a follower of no
signal merit.

Bacchiacca (pp. 297-299)

180 FLORENCE, Uffizi, No. 225 F—Fortune's Wheel (p. 299). Bl. ch. Circular, diameter 28 cm. [Uffizi
Fig. 933 Publ., IV, iv, 13.]

180A No. 1926F—Satyr carrying goat on his shoulders. Bl. ch., pricked for transfer. 36 by 15. On verso
the contours gone over with pen. Giglioli reproduces it in *Boll. d'A.*, 1936/37, p. 537, and
proves it to have served for the border of a tapestry in the Uffizi (No. 524) representing
the months June-July, which was finished by the Flemish weaver Rost in 1553.

181 No. 350F—Study for the Judah in the National Gallery panel representing the arrest of
Fig. 931 Benjamin and his Brethren, and their appearance before Joseph (p. 299). R. ch. 28 by 18.5.
[Fototeca 4276.]

182 FLORENCE, Uffizi, No. 350ᵇⁱˢᶠ—Child supported on a sack, and same child sitting with hands on mouth of a sack (p. 299). R. ch. 15.5 by 22.5. Morelli Dr., pl. X. Studies for the Borghese pictures (Nos. 440, 442).

182ᴬ Uffizi, Santarelli, No. 718—Study for young man walking towards r. and carrying vase
Fig. 930 on his shoulder (p. 298). R. ch. 25.5 by 18.5. Fototeca 15941. For the young man in background of the picture formerly in the Bardini Collection at Florence, representing the Gathering of Manna.

183 LONDON, British Museum, 1860-6-16-74—Design for a composition representing Mucius Scaevola
Fig. 932 (p. 298). Bl. ch., pricked for transfer. 27 by 27. Pl. clxviii of F. E. [Mc Comb, *Art Bulletin,* VIII (1925/26), p. 156.] Wickhoff was the first to ascribe this sheet to B.

183ᴬ MILAN, Ambrosiana, Cassetta 3—Two figures in very bulging draperies. Bl. ch.

184 OXFORD, Christ Church, B. 26—Four sprawling children of type of infant Baptist in the Holy Family of the Cook Collection at Richmond (p. 298). R. ch. 21 by 26. Ascr. to Fra Bartolommeo.

185 B. 28—Cartoon for episode of the Departure in the N. G. picture (No. 1219) (p. 299). Bistre wash and wh., pricked for transfer. 34 by 32. [Bell, pl. 2.]

186 PARIS, Louvre, No. 1966—Arrest of Benjamin and his Brethren (p. 299). Bl. ch. and wh., pricked for transfer. 34 by 70. Giraudon 374. [Venturi, IX, i, fig. 349.]

187 No. 1967—Benjamin and his Brethren at Joseph's Feet (p. 299). Bl. ch. and wh., pricked
Fig. 934 for transfer. 33 by 69. Giraudon 375. [Venturi, IX, i, fig. 350.] These two drawings together form the cartoon for the N. G. picture (No. 1218).

188 No. 9874—Finding of the Cup in Benjamin's Sack (p. 299, note). Bistre and wh., pricked for transfer. 23 by 19. Cartoon for the small picture in the Borghese Gallery (No. 440).

189 VIENNA, Albertina, S. R., 190, 191—Two separate studies, one for guard under portico in the N. G. picture (No. 1219), the other for a figure in the companion panel (No. 1218) (p. 299). R. ch. 27.5 by 11, 23.5 by 9.5. Schönbrunner & Meder, pl. 71. [Albertina Cat., III, Nos. 166, 167.]

Alesso Baldovinetti (pp. 131-132)

190 FLORENCE, Uffizi, 61ᴱ—Tall slender young man in hose and short tunic tied in at waist with
Fig. 290 sword at side, and soft cap on shaggy head looks up to r. with hands folded held up close to chest. Perhaps for a figure in an Adoration of Magi. Pen on wh. paper. 15.5 by 6. Fototeca 12495.

 Inscribed at top in Baldinucci's hand "Pisello," which certainly is much nearer than the current attribution to Parri Spinello. It is perhaps as clearly by B. as any, and if not his it could only be Domenico Veneziano's. It is too substantial and firm, although elegant enough, to be by the Carrand Master.

191 No. 90ᴱ—Youthful but rather thick-set figure seated, with head in profile to r. (p. 131).
Fig. 287 10 by 3.5. [Fototeca 15968.] This and my 192, 194, and 195 are companions, and may originally have been on the same sheet. All are with pen, bistre and wash and wh. on paper slightly prep. with pink. Ascr. to Fra Angelico. To what has been said about these figures in the text, it should be added that their folds and hatching connect them with the two sheets after Alesso (see below) which have passed for centuries as that artist's own work.

192 FLORENCE, Uffizi, No. 91E—Youth seated with crossed legs, playing on lute (p. 131). 10 by 5.5.
Fig. 288 Pl. lxv of F. E. [Fototeca 15969.]

193 No. 92E—Angel seated, playing on viol (p. 132). Pen on wh. paper. 10 by 5.5. Braun 76019.
Fig. 285 [Fototeca 15970. Van Marle, XI, p. 266.]

194 No. 93E—Youth seated, playing on viol (p. 131). 10 by 5.5. Pl. lxv of F. E. [Foto-
Fig. 286 teca 15971. Van Marle, XI, p. 267.]

195 No. 94E—Almost nude lad with body turned slightly to r., and head in opposite direction
Fig. 289 (p. 131) 10 by 5.5. Pl. lxv of F. E. [Fototeca 15972. Van Marle, XI, p. 268.]

196 1095E—Three youths addressed by young woman, who offers garland (p. 132). Pen on wh.
Fig. 291 paper. 11.5 by 13. Pl. lxv of F. E. [Fototeca 2104.] Ascr. to Masolino. To what has
been said in the text it should be added that the young woman vividly recalls Domenico
Veneziano's St. Lucy in the Uffizi altar-piece as well as in the Berlin predella.

196A Uffizi, Santarelli, 50—Youthful nude asleep on his r. side. Bistre and wh. on wh. paper.
8.5 by 14.5. Fototeca 12676. Likely by B. himself.

196B 51—Slender youngish man kneeling in prayer in profile r. Bistre and wash on wh. paper.
12 by 8. Fototeca 12677. Catalogued as School of Pollajuolo. Probably by B.

196C STOCKHOLM, Print Room, Inv. 113—Young man seated reclining asleep on r. arm; older man
Fig. 292 looking up with hands clasped. Pen on brown paper. 21.5 by 14.5. In every way charac-
teristic of B. and worthy of him. Inscribed in 18th century hand *Tomaso finiguera a
gravé ces deux figures.*

196D Inv. 114—Youth in long tunic wringing his hands. Pen on brown paper. 21.5 by 14.5.
Same kind and quality as last.

School of Baldovinetti

196E ASCHAFFENBURG, Print Room—Two kneeling figures. Pen on wh. paper. 24 by 16. Repr. and
Fig. 297 publ. in *Burl. Mag.,* LXI (1932), opp. p. 11 by Bernard Degenhart as Cosimo Rosselli and
for the Annunziata fresco. The only likeness is a generic one in pose between the
kneeling youth there and the one here. Spirit and technique are different and close to B.
O. Weigmann, *Münch. Jahrb.,* 1932, p. 84.

196F DÜSSELDORF, Academy, No. 6—Woman seen from back in long garment tucked in at waist
and covering arms and head. Bistre wash and pen on wh. paper. 14.5 by 7. Düsseldorf
Cat., pl. 2. Probably by hand that did my 200B and 203A, but later, and in a phase
which brings it close to Maso Finiguerra.

196G FLORENCE, Uffizi, No. 21E—Study in tiny figures of Procession to Calvary starting from town
gate and winding up escarped terraces to Golgotha, where the Crucifixion takes place.
Pen on parchment. 26 by 22. Fototeca 12487.
Spirited sketch closer perhaps to B. than to any other known artist, but at the same
time suggesting Antonio Pollajuolo and even the youthful Botticelli. Interesting to compare
this with Jacopo Bellini's drawings. The difference between Florence and Venice in the
middle decades of the Quattrocento could scarcely be better exemplified. A kindred
composition but on a lower level of artistic quality used by the engraver of B. M. A. II, 4:
Hind, p. 38, pl. IX.

197 No. 68 E—Two peasants, one youthful with r. hand on hip, the other middle-aged leaning
Fig. 295 with folded arms on club. Pen. 17.5 by 16. These would seem to be very close to B.,
but are scarcely of a quality to permit the belief that they are his own. More probably
they are school copies after a drawing by the master. [Verso: Youth with folded hands
standing in profile to l. and boy bending to pick up stool. Poorer than recto. Fototeca 12497.
and 12498. May be autographs (1931).]

198 and 199 Nos. 137 E and 138 E—Four figures in various attitudes. Pen and bistre wash. 19 by 36.
Fig. 293 Braun 27037, 27038. [Fototeca 12618. Brogi 1330. Van Marle, XI, p. 287] Of the same
kind as the last, but less excellent copies. Verso: [Five similar figures with pen only.
Closer to B. than on observe. Fototeca 12619.]

200 No. 136 E—Study for Deposition. Pen and wash. Braun 27039. [Ede, pl. 19.]
Fig. 296 The motive is admirable, and anticipates the Cinquecento treatment of the subject
under the inspiration of Michelangelo. A careful comparison with the other drawings here
ascribed to B. has ended by persuading me that this design must be a close copy—and
I may add a contemporary one—of an original by that painter.

200A No. 3 F—Mourning over Dead Christ. Pen and wash. 18 by 21. Fototeca 12547. See my 203.

200B No. 85 F—Youthful monastic saint with palm in r. hand standing on round pedestal. Pen
and bistre on wh. paper. 15 by 5.5. Pricked, probably for embroidery. Close to B. and
possibly an autograph.

201 No. 88 F—Old man walking toward r. with sack thrown over shoulder. Pen. 11 by 6.
Fig. 294 [Fototeca 12646.] Very close to B., and probably an almost contemporary copy of an
early drawing by him. [May be an original (1931).]

202 (see 2780D)

203 UFFIZI, SANTARELLI, 2—Design for Mourning over Dead Christ. Pen and bistre wash.
27 by 19.5.
The scene, which comprises saints of all epochs, takes place in the foreground of an
interesting landscape. Copy after B. by a somewhat later hand, conceivably by G. B.
Utili. Another copy exists of the lower part only of the same composition (my 200A).

203A 4—Graceful youth wrapt in mantle wearing turbanlike cap. Pen. 17 by 7. Fototeca 12518.
Same hand as my 200 B, in more advanced phase.

203B LENINGRAD, STROGANOFF COLLECTION (formerly)—Bust of S. Antonino. I find in my portfolios a
copy in outline of a portrait of this saint with the indication that it passed in that
collection for Antonio Pollajuolo's. In the copy it looks far more like B.'s.

203C LONDON, BRITISH MUSEUM, 1898-11-23-4—Moses on Sinai and the Brazen Serpent. Pen and bistre
wash on vellum. 28 by 41.
Corresponds to a well-known engraving described by Hind, p. 124. The drawing,
although in execution perhaps by Finiguerra, is close enough to B. to make one wonder
whether it may not be a transcript of a B. Indeed, the question of this artist's relation
to the engravers of his time will repay all the trouble that a competent student can give it.

203D MUNICH, FRAU ERWIN ROSENTHAL—Bearded elderly man wrapped in mantle, seated as if asleep.
Bistre and wash on wh. paper. 13.5 by 7. Same hand and same phase as my 196 F.

203E PARIS, LOUVRE, EDMOND DE ROTHSCHILD BEQUEST—Three men endeavouring to lift up an ass.
Pen. Obviously copied from a design that B. must have made for the niello in the same
collection. Both niello and drawing reproduced in André Blum's article, *Gaz. d. B. A.,*
1933, i, p. 224.

203[F] VIENNA, ALBERTINA, Sc. R., 46 — Announcing Angel. Pen, bistre and wash. 20.5 by 17.8. Cut out and pasted on paper on which lily and pavement have been added by another hand. Also the pen-strokes on drapery and on wings gone over later. Albertina Cat., III, No. 16. Ascr. doubtfully to Fra Filippo, but by a decorative designer under B.'s influence.

203[G] WASHINGTON, D. C., CORCORAN GALLERY, W. A. CLARK COLLECTION, 2196 — Young man in short tunic and loose turban with r. hand on belt and l. extended. Pen and bistre. 18.5 by 10.5. Photo. Woltz. Ascr. to Uccello but nearer to B. and not far from Maso Finiguerra.

203[H] HOMELESS — Two male figures. One in profile r. in attitude of lifting the cover from a bin or box. The other, very slender, stands with r. arm akimbo as if posing for his picture. Pen. 28 by 20. Same hand as my 198 and 199 verso.

203[I] (number omitted)

Fra Bartolommeo (pp. 155-161)[1]

203[J] AMSTERDAM, BELLINGHAM-SMITH SALE (Müller, July 5-6, 1927), No. 115 — Studies of heads on recto and verso. R. ch. 27 by 19.5. Repr. in Sale Cat. Attr. to Andrea. For the Madonna of Mercy at Lucca (Gabelentz, I, fig. 16). A sketch of similar quality for same subject from the Weimar, now Koenigs, sketch-books is repr. in Knapp as fig. 73.

203[K] EMILE WAUTERS SALE (Müller, June 15-16, 1926), No. 14 — *Putto* running towards left, perhaps for infant Baptist in Panshanger Holy Family (Venturi, IX, i, p. 287). Bl. ch. 28 by 16. Lees, fig. 27.

203[L] No. 15 — Study for saint with r. hand raised in gesture of blessing. R. ch. 23 by 12. Lees, fig. 28.

203[M] (former 494) [BAYONNE, BONNAT MUSEUM], No. 120, 1 — Two studies for [a Madonna seated on ground, in one instance nude, in the other draped and with infant Baptist]. Bl. ch. 11 by 16.5. [Arch. Ph.]

203[N] (former 494) No. 120, 2 — [Study for Madonna hugging the Child and one for the Child seated on mother's lap.] Bl. ch. 10 by 17. [Arch. Ph.]

204 BERLIN, PRINT ROOM, No. 480 — Head of monk, looking down. Bl. ch. on brown paper. 35 by 25. [Berlin Publ., 29. Gabelentz, II, pl. 37. For Eternal in Lucca Gallery altar-piece of 1509 (Gabelentz, I, fig. 8).] Verso: Hand, fingers and foot.

204[A] No. 4198 — Youthful profile looking up to r. with hair vigorously drawn. Bl. ch. and wh. 23 by 19.5.

205 No. 1545 — Madonna erect holding the Child. Pen. 12 by 5.

206 No. 1546 — Madonna with two angels and the two holy Children. Pen. 16.5 by 14.5. [Knapp, fig. 64. One of the artist's most charming compositions.]

207 No. 1547 — Holy Family, erect figures. Pen. 14.5 by 10. [Gabelentz, II, pl. 31. Berlin Publ., 25.] Verso: Medallion with Meeting of Francis and Dominic. Here the affinity of origin with Ghirlandajo is quite obvious.

208 No. 1548 — Angel holding the Child, and studies for drapery. Pen. 15 by 23. [Berlin Publ., 26. Gabelentz, II, pl. 28.]

1. [Students desiring excellent reproductions and more detailed account of the drawings are referred to Herr von der Gabelentz's *Fra Bartolommeo*, Leipzig, 1922.]

209 BERLIN, Print Room, No. 5190 – Study for Crucifixion, Entombment, and Peter Martyr. Also various words and letters in F. B.'s hand. Pen. 14 by 20. [Gabelentz, II, pl. 14. Berlin Publ., 27 B. Knapp, fig. 118.] The sketch for an Entombment may have had some connection with the Pitti Pietà. Verso: Assassination of Peter Martyr. *Putti* with symbols of Passion. Kneeling Magdalen. Also words and phrases. Berlin Publ., 27 A.

210 No. 5079 – Young woman standing in profile to l., and another kneeling, being studies for Catherine and the other female saint in the Louvre Marriage of Catherine [(Gabelentz, I, fig. 10).] Bl. ch. and wh. on brown paper. 33 by 25. [Knapp, fig. 48.]

210A No. 5115 – Female figure in profile to l. holding up heavily draped skirt with both hands. Bl. ch. and wh. on brown paper. 19 by 29. Gabelentz, II, pl. 43.

210B (former 426) [BIRMINGHAM, Institute of Arts] – Sketch for the altar-piece at S. Marco [(Gabelentz, I, fig. 9)]. Bl. ch. and wh. 26 by 20. [Heseltine Cat., 1913, No. 12. Oppenheimer Sale Cat., pl. 2.] Verso: A slight study of two figures.

210C BLENHEIM, Duke of Marlborough – Study for Christ and woman of Samaria. Pen and bistre. 14 by 9.5. Verso: Two studies for Madonnas and part of figure of draped man. Vasari Soc., I, viii, 4 A, 4 B.

211 BRUNSWICK, Print Room – Profile bust of child. Bl. ch. and wh. 15.5 by 22. [Gabelentz, II, pl. 53.]

212 BUDAPEST, National Gallery – Two monks kneeling in attitudes of pity and contrition; smaller sketch for one of monks. Bl. ch. on brownish paper. Schönbrunner & Meder, pl. 526.

212A (former 425) [CAMBRIDGE, Fitzwilliam Museum] (G. T. Clough Gift) – Children of Israel marching
Fig. 450 through Desert (p. 159). Bl. ch. 20 by 29.5. Photo. Museum. Most charming composition, lightly and delicately executed.

212B (former 435) [CAMBRIDGE (Mass.), Fogg Museum, Paul J. Sachs Collection] – Madonna seated in profile to r. playing with Child, whom kneeling angel has just presented to her. Pen. 15 by 20. [Buffalo Exh. Cat., pl. 19.]

212C Study for angel with fluttering draperies seen in profile. Bl. ch. Very likely for an angel holding up curtains of baldachin of the Virgin's throne in an altar-piece.

212D (former 439) [Fogg Museum, Charles Loeser Bequest, No. 137] – Head of monk, drawn probably
Fig. 451 from life and having in pose a likeness to the head of Joseph in a *tondo* belonging to Marchese Visconti Venosta in Rome (pp. 158, 163). Bl. ch. 23 by 18. Morelli Dr., pl. iv.

212E (former 441) [No. 140] – Five draped figures in profile to l., probably for the unfinished altar-piece in the S. Marco Museum [(Gabelentz, I, fig. 12)]. Bl. ch. 22 by 18.5. Verso: Three studies of infant John for same work. Morelli Dr., pl. vi.

213 No. 141 – Two studies for nude young woman in attitude of crouching Venus. Bl. ch. 20 by 29.5. Verso: Two studies for half-reclining *putto* and traces of head for a third. R. ch.

214 CHANTILLY, Musée Condé, No. 38 – Study for *Salvator Mundi* in the Pitti Gallery [(Gabelentz, I, fig. 20)]. Bl. ch. on pink ground. 21 by 17. Verso: Study for a roundel containing Madonna with two Infants, four standing and two kneeling saints.

215 No. 39 – Madonna enthroned, old saint and angel (p. 157). Pen. 15 by 23.5. Braun 65078.
Fig. 442 [Knapp, fig. 41.]

216 (former 1771) CHANTILLY, Musée Condé, No. 37—Sketch for Madonna enthroned. Bl. ch. and wh. on brown paper. 29 by 15.5. [Verso: Sketch for St. Sebastian.]

217 No. 40—Michael driving damned before him. Bistre, pen and wash. 16 by 23. Braun 65077. [A. Maurel, *Revue de l'A.*, 1922, i, p. 59.] Verso: Michael and two saints. [Giraudon 1026. Both studies for the Last Judgement formerly at S. Maria Nuova, now in Museo di S. Marco (Gabelentz, I, fig. 3).]

218 No. 41—(1) Woman standing, heavily draped, in profile to r. 10 by 8.5. (2) Saint looking up. Study for Assumption. [Giraudon 7863.] Pen. 11.5 by 9.5. Verso: Flagellation.

219 No. 103—Winged *putto* carrying vase on shoulders (p. 159). R. ch. on wh. paper. 17 by 9.5
Fig. 449 Braun 65085. Ascr. to Andrea, but spirit, technique and forms establish the authorship of F. B.

219ᴬ CHATSWORTH, Duke of Devonshire—Child's head in profile to l. looking down. Bl. ch. 21 by 18. Chatsworth Dr., pl. 30. For Infant Christ or Baptist in a later picture.

219ᴮ Youthful monk kneeling in more than profile to l. with hands folded in prayer. Bistre and wash on pearl grey ground. 23 by 18. Chatsworth Dr., pl. 3. Precise as becomes a very early effort, which it probably was.

219ᶜ COPENHAGEN, Print Room, Case I, No. 2—Christ crucified. Bl. and r. ch. 28 by 20.5.

219ᴰ DARMSTADT, Landesmuseum, No. 173—Sketch for the four saints in the *Salvator Mundi* altar-piece at the Pitti Gallery (Gabelentz, I, fig. 20). Bl. ch. 15.5 by 18. *Stift und Feder*, 1929, No. 77. Verso: Angel making music and other small studies.

219ᴱ DIJON, Museum, No. 770—Four studies for Holy Families, two on recto, two on verso. Bl. ch. 18 by 26. Late.

220 DRESDEN, Print Room—Resurrected Christ and three saints. Bl. ch. 25 by 15.5. Braun 67007. Study for the Pitti *Salvator Mundi*.

221 No. 143—Study for Temptation of St. Anthony. Pen. 24 by 17. Ascribed to Plautilla Nelli, but certainly F. B.'s.

221ᴬ DUBLIN, National Gallery. Head of friar slightly turned to r. and bent down. Bl. ch. Not quite satisfactory, but may be his.

221ᴮ (former 867) FLORENCE, Uffizi, No. 284ᴱ—Kneeling man turning to l. draped but for bare shoulder. Pen and wh. on yellowish paper. 21.5 by 14.5. Braun 76249. [I used to ascribe this to Domenico Ghirlandajo. Correctly ascr. to F. B. by O. H. Giglioli in *Boll. d'A.*, 1935/36, p. 490. There also the verso is reproduced which was until a short time ago invisible and therefore unknown to me. It is a slight sketch in pencil for the same figure without the drapery. Both apparently studies for a St. Jerome in penitence.]

221ᶜ (former 870) No. 290ᴱ—Kneeling male figure, seen from behind, draped. Pen and wh. on yellowish paper. 23 by 16. Braun 76241. Küppers, pl. VIII. See my 221ᴮ. Verso: Draped figure kneeling in profile to r., same medium as recto but freer handling. [I used to ascribe this to Domenico Ghirlandajo but find Giglioli's attribution to F. B. in *Boll. d'A.*, 1935/36, p. 489, absolutely convincing.]

222 (see 325ᴬ)

223 (see 2545ᴬ)

224 (see 337ᴬ)

225 (see 339 A)

226 (see 341 A)

227 (see 342 B)

228 (see 337 A)

229 (see 339 A)

230 (see 342 A)

231 (see 352 A)

232 (see 353 A)

233 (see 354 A)

234 (see 358 A)

235 FLORENCE, Uffizi, No. 452 E—Adoration of the Magi (p. 157). Pen height. with wh. 23.5 by 15.5.
Fig. 439 [Uffizi Publ., II, ii, 1.] Brogi 1972. Braun 76061. [Venturi, IX, i, p. 250.] Verso: Virgin adoring
Holy Child in presence of Joseph and three angels; at right angles to this group, standing
figure of Evangelist. [Knapp, figs. 21 and 26.] The Adoration is an early drawing with
Leonardesque reminiscences, never, to my knowledge, used by F. B., but adopted later
by Bacchiacca in a picture formerly in the Habich Collection, and later in the B. Crespi
Collection of Milan, now dispersed.

236 No. 453 E—Two studies for Annunciation, the upper one having a certain resemblance to
the small monochrome [(Gabelentz, I, fig. 1)]. Pen and wh. 23.5 by 15.5. Braun 76060.
[Gabelentz, II, pl. 12. Alinari 287. Venturi, IX, i, p. 234.] Early.

237 No. 454 E—Prophet Job. Study for painting in the Uffizi [(Gabelentz, I, fig. 21)]. Bl. ch.
and wh. on tinted ground. 27 by 18.5. Braun 76076. [Uffizi Publ., II, ii, 23. Knapp,
fig. 83. Venturi, IX, i, p. 234.]

238 No. 455 E—Christ as Judge. Study for fresco of Last Judgement, formerly at S. Maria
Nuova, now in the S. Marco Museum [(Gabelentz, I, fig. 3)]. Bl. ch. partly effaced. 27 by 19.
Braun 76075. [Gabelentz, II, pl. 9. Knapp, fig. 10.]

239 No. 457 E—Two studies for Charity (p. 157). Pen on pink rubbed paper. 23 by 15.5.
Pl. LXXXVIII of F. E. [Alinari 413.] Verso: In a sweet landscape, a kneeling angel offers
the Child to the Madonna, while other angels stand about making music, and the infant
John runs up to look. As exquisite as the Charities on the other side. [Gabelentz, II,
pls. 29 and 30.]

240 No. 458 E—Baptist (p. 159) Bl. ch. and wh. Brogi 1446. Braun 76085. [Gabelentz, II, pl. 36.
Venturi, IX, i, p. 274.] Study for figure in the altar-piece at S. Martino in Lucca [(Gabelentz, I,
fig. 7.]

241 No. 459 E—Virgin and Holy Women at Sepulchre. Pen and wh. 11 by 23. [Gabelentz, II,
pl. 19. Knapp, fig. 29.]

242 No. 462 E—Angel of Annunciation. Companion to next. Bl. ch. and wh. 23.5 by 19. [Knapp,
fig. 75. According to Knapp this and the next are studies for the frescoes at Pian di
Mugnone.]

243 No. 463 E—Virgin for Annunciation. Companion to last. Bl. ch. and wh. 25 by 18. Brogi
1961. [Knapp, fig. 76.]

244 FLORENCE, Uffizi, No. 464E —Assumption of Virgin, with angels dancing about her in ring (p. 156). Pen. 24 by 22.5. Pl. LXXXVI of F. E. [Uffizi Publ., II, ii, 11. Knapp, fig. 37. Venturi, IX, i, p. 245.

245 No. 465E —Study for Circumcision (p. 162). Pen. 15.5 by 23. Braun 76113. [Uffizi Publ., II, ii, 2.] Verso: Annunciation and angels.

 Apparently the recto is not for either of the extant versions of the Circumcision although contemporary with the early one at the Uffizi. This sketch was used, however, by Albertinelli in the predella to his Visitation (Uffizi), and was perhaps made for that purpose.

246 No. 467E —Madonna standing by throne with three saints on either side, two standing, one kneeling (p. 163). Bl. ch. and wh. 28.5 by 22. Brogi 1959. [Knapp, fig. 79.] Study from F. B.'s later years for an altar-piece. Verso: Copy of a Castagno head.

247 No. 468E —Dead Christ supported on tomb (in bl. ch. almost effaced), adored by Madonna and saints. Pen and wh. on pink prep. paper. 15.5 by 23. Verso: *Noli me tangere*. [Gabelentz, II, pls. 20 and 21. Uffizi Publ., II, ii, 12.]

248 No. 469E —Christ calling children unto Him. Pen on pink prep. paper. 15.5 by 23.5. Brogi 1981. Verso: Five draped figures. [Knapp, fig. 30.] Brogi 1982. Early.

249 No. 470E —Two nude women seated, each with child in lap. Study for the unfinished altarpiece at the S. Marco Museum. R. ch. 21.5 by 19. Brogi 1967. [Gabelentz, II, pl. 48.] Verso: Two *putti* for the two in foreground of same.

250 No. 471E —Female in ample sleeves and trailing robes, seen from behind. Bl. ch. and wh. on tinted ground. 28 by 19. Brogi 1971. Study for figure in Rape of Dinah, designed by F. B., but executed later by Bugiardini, and now at Vienna (No. 36).

251 No. 472E —Christ in Garden (p. 157). Pen on pale grey prep. ground. 23.5 by 16. Brogi 1942.
Fig. 441 Braun 76057. [One of his earliest drawings.]

252 No. 473E —Female head size of life, almost in profile to l. Bl. ch. 40 by 28. Study for fresco in the S. Marco Museum [(Knapp, fig. 68)].

253 No. 474E —Various studies and scrawls, including one for *Salvator Mundi* in the Pitti, another for Madonna, and one for the Paul in the Vatican Pinacoteca. Pen and r. ch. 28 by 19.5. Brogi 1957. [Knapp, fig. 78.] Verso: Creation of Eve and other sketches. Brogi 1665.

254 No. 475E —Study for Virgin and the part to r. in *Madonna della Misericordia* at Lucca [(Gabelentz, I, fig. 16)] (p. 158). Bistre and r. ch. 27 by 20. Brogi 1953. [Gabelentz, II, pl. 57. Venturi, IX, i, fig. 231.] Verso: Various studies, including one for perhaps the Rape of Dinah (see my 250). Brogi 1954.

255 No. 478E —Head of woman larger than life, turned slightly to r. Bl. ch. on tinted ground. 40 by 28. Brogi 1934. [Uffizi Publ., II, ii, 20.] Study perhaps for the Madonna in the Uffizi Marriage of St. Cetherine [(Gabelentz, I, fig. 11)].

256 No. 479E —Madonna enthroned with angels and saints (p. 157). Pen and wh. on greyish
Fig. 437 prep. ground. 19.5 by 16. Pl. LXXXVII of F. E. [Gabelentz, II, pl. 32. Uffizi Publ., II, ii, 8, Venturi, IX, i, p. 344. Early.]

257 No. 480E —Madonna adoring Child in presence of St. Joseph and angels. Pen and wh. on greyish tinted paper. 16 by 15.5. Alinari 123. [Venturi, IX, i, p. 235.]

258 FLORENCE, Uffizi, No. 481E—Study for donor and protector in *Madonna della Misericordia* at Lucca [(Gabelentz, I, fig. 16)]. R. ch. 27.5 by 18. Verso: Two young men marching, and busts of two young women with arms about each other's shoulders. [Gabelentz, II, pls. 59 and 60.]

259 No. 482E —Madonna, in profile to l. Pen on pinkish prep. paper. 23 by 14.5. Brogi 1983. [E. Sandberg Vavalà, *Burl. Mag.*, LV (1929), p. 5. Venturi, IX, i, p. 259 (but reversed.] Early. Verso: Six *putti* reclining. [Gabelentz, II, pl. 8.]

260 No. 483E —St. Stephen (p. 159). Bl. ch. and. wh. on tinted ground, squared for enlarging. 35 by 18.5. Brogi 1940. Braun 76066. [Uffizi Publ., II, ii, 14. Knapp, fig. 38. Venturi, IX, i, p. 273.] Study for altar-piece in S. Martino at Lucca [(Gabelentz, I, fig. 7)].

261 484E —Two studies for *Noli me tangere*. Bistre and wh. on pink prep. paper. 14.5 by 22.5. Certainly early, and in every probability for the picture in the Louvre [(Gabelentz, I, fig. 5). Knapp, fig. 31. Venturi, IX, i, p. 258. Popham Cat., No. 193.] Verso: Christ in the air with two angels—study for an Ascension. Brogi 1984. [Gabelentz, II, pl. 18.]

262 No. 485E —Apostle standing with book in left hand. Bl. ch. and wh. 38.5 by 24.5. [Foto-teca 4732. Knapp, fig. 71.] First study for St. Paul now in the Vatican Pinacoteca [(Gabelentz, I, fig. 14)].

263 No. 486E —[Study for one of damned in Last Judgement (Gabelentz, I, fig. 3).] Pen on grey prep. ground. 10 by 7.5. Brogi 1436. [O. Fischel, *O. M. D.*, IV (1929/30), p. 35. Early.]

264 No. 487E —Study for kneeling Samaritan woman. Pen. 11.5 by 11. Brogi 1986. Early and charming. Cf. my 281.

265 No. 488E —Life-size head of bald smooth-faced man. Bl. ch. 35 by 26. [Uffizi Publ., II, ii, 15. Of the period of the unfinished altar-piece at the S. Marco Museum (Gabelentz, I, fig. 12) and perhaps done in connection with it.]

266 No. 489E —Madonna standing in midst of kneeling saints and angels. Another Madonna. Pen and brown ink. 15 by 23. Brogi 1987. [Uffizi Publ., II, ii, 5. Venturi IX, i, fig. 181.] Early. Verso: Madonna, infant John and angel.

267 No. 490E —Annunciation. Bistre and wh. on pink prep. paper. 13.5 by 20. Brogi 1988. [Gabelentz, II, pl. 6. Uffizi Publ., II, ii, 3. Popham Cat., No. 192.] Early.

268 No. 491E —Two exquisite studies for kneeling Samaritan woman [the one on the left almost Japanese in quality]. Pen. 14 by 21.5. Brogi 1990. Early. See my 281. Verso: Two sketches for the Madonna and kneeling saints. (Cf. my 266.) Brogi 1989.

269 No. 492E —Madonna and Child and *putto* (p. 159). R. ch. 17 by 26. Brogi 1969. Verso: Two *putti*. Brogi 1970. [For the Hermitage Madonna as Knapp (figs. 88 and 89) was the first to observe.]

270 No. 494E —Study for kneeling Evangelist in unfinished altar-piece at the S. Marco Museum. Bl. ch. and wh. on tinted ground, squared for enlarging. 33 by 25. Brogi 1645. Braun 76070.

271 No. 495E —Study for Pitti St. Mark [(Gabelentz, I, fig. 15)]. Bl. ch. on tinted ground, squared for enlarging. 33.5 by 25. Brogi 1646. Braun 76068.

272 No. 517E —Study for young bishop, standing in profile to r. Bl. ch. and wh. on tinted ground. 28.5 by 20.5. Brogi 1748. [Possibly for the figure to extreme l. in the unifinished altar-piece in the S. Marco Museum (Gabelentz, I, fig. 12).]

273 FLORENCE, Uffizi, No. 518^E—Old man, draped, seen from behind. Bl. ch. and wh. on tinted ground. 28.5 by 21. Brogi 1749. [Slight variant of my 393 and like that for the early monochrome Circumcision (Gabelentz, I, fig. 2).]

274 No. 522^E—Study for Madonna in altar-piece at Besançon (Gabelentz, I, fig. 13). Bl. ch. and wh. on tinted ground, squared for enlarging. 36 by 25. Alinari 233. [Uffizi Publ., II, ii, 17. Gabelentz, II, pl. 50. Venturi, IX, i, p. 306.]

275 No. 523^E—Study for Madonna and Child in unfinished altar-piece in the S. Marco Museum. Bl. ch. and wh., squared for enlarging. 34 by 23. Alinari 256. Far from satisfactory, but probably F. B.'s and not Fra Paolino's.

275^A (former 11) No. 549^E—Two *putti* and study of garment. Pen. 20 by 16. Brogi 1722. [The garment may have been intended for a St. Michael in the Last Judgement. Compare with my 463^A, which I also used to attribute to Albertinelli.]

276 No. 1139^E—Two further studies for kneeling Samaritan; on smaller scale, running figure. Bistre and wh. on pinkish prep. ground. 14.5 by 22. Brogi 1991. [Gabelentz, II, pl. 22.] Early, see my 281. Verso: The Samaritan at the Well.

277 No. 1141^E—Study from life for head and figure of St. Bartholomew in Uffizi Marriage of St. Catherine [(Gabelentz, I, fig. 11)] and two studies of hands and feet. R. ch. 27.5 by 18.5. Braun 76077. Schönbrunner & Meder, pl. 86. [Uffizi Publ., II, ii, 19, Venturi, IX, i, p. 296 (detail).] Compare with my 464 and 511.

278 No. 1159^E—Two studies after antique statue of Venus. Bl. ch. and wh. on tinted ground. 29 by 20. Brogi 1944. [Knapp, fig. 16.] Early.

279 No. 1203^E—Angels in air dancing and making music (p. 157). Study probably for Coronation.
Fig. 436 Pen and wh. on yellowish paper. 16 by 23. Brogi 1992. [Ede, pl. 68. Venturi, IX, i, p. 248.] Verso: Two studies for a Nativity. Brogi 1443. Early.

280 No. 1204^E—Study composed of nude figures for unfinished altar-piece in the S. Marco
Fig. 443 Museum (p. 157). Pen. 26 by 25. Brogi 1495. Braun 76053. [Knapp, fig. 53. Venturi, IX, i, p. 300.]

281 No. 1205^E—Two studies for Christ and Samaritan (p. 157). Pen, bistre and wash. 23 by 15.
Fig. 438 Braun 76062. [Knapp, fig. 94. Uffizi Publ., II, ii, 24.] Verso: Christ as Judge and two other figures in r. ch. The studies on the recto, as my 264, 268, 276 and 276 verso, 408 verso, 409 verso, 448, 490—all among F. B.'s most dainty pen-drawings—must have been made in connection with a Christ at the Well which was bought by Girolamo Casio (the well-known Bolognese patron of Boltraffio). From Casio's collection it passed over almost immediately to the Duke of Mantua's. I have never come across it, and am not aware that it is supposed to be still existing. It seems to have been a pendant to the *Noli me tangere* of the Louvre. See Marchese, *Memorie dei.... pittori.... domenicani*, 3rd ed., Genoa, 1869, II, 198.

282 No. 1206^E—Study in nude figures of Madonna and Children and angel, for unfinished altar-piece in S. Marco Museum [(Gabelentz, I, fig. 12)]. R. ch. on yellowish paper. 25 by 20. Brogi 1968. [Knapp, fig. 47. In this as in the next the female nude is more inspired by Raphael than by a model.]

283 No. 1207^E—Two studies on same mount of nude figures, for same Madonna and Child. R. ch. 22 by 20. Brogi 1966. [Gabelentz, II, pl. 49.]

284 No. 1208^E—Madonna embracing Child, and a *putto* [like the Hermitage Madonna]. R. ch. 21.5 by 25. Brogi 1958.

285 FLORENCE, Uffizi, No. 1233E —Old man with staff. Infant John, three octaves of a prayer by Savonarola in F. B.'s hand. Pen and bistre. 20 by 14. Brogi 1994. Braun 76103. Verso: Various studies for infant John, and for swaddled Innocents, probably for some work connected with the Foundling Hospital at Florence. Brogi 1996.

286 No. 1234E —Madonna and infant John, and other studies. Pen. 16 by 22. Pl. 85 of Schönbrunner & Meder. [E. Sandberg Vavalà, *Burl. Mag.*, LV (1929), p. 8. Very close to Albertinelli, particularly the two children.] Verso: St. Jerome kneeling in profile to l. [Gabelentz, II. pl. 5.]

287 No. 1235E —Agony in the Garden. Pen. 21 by 14. Brogi 1978. Verso: Way to Golgotha (p. 157), and small sketches possibly for an Adoration of the Magi, and of a Coronation. Fig. 440 This last probably for the top of the Besançon picture, now at Stuttgart [(Knapp, fig. 58)]. Brogi 1977. [Gabelentz, II, pl. 10.]

288 No. 1236E —Way to Golgotha, and Madonna. Pen. 23 by 15. Braun 76102. [Gabelentz, II, pl. 11. Uffizi Publ., II, ii, 4.] Verso: Madonna. Brogi 1997.

289 No. 1237E —Ascension. Pen and wh. on pinkish prep. paper. 23 by 15.5. Brogi 1508. [Gabelentz, II, pl. 17.] Early and most charming. Verso: Christ resurrected. Brogi 1998.

290 No. 1238E —Two studies for Madonna with infant John. Pen on yellowish paper. 16 by 21. Brogi 1979. Verso: Two male figures and angel. Brogi 1980.

291 No. 1239E —Study for a Deposition, possibly the one in the Pitti [(Gabelentz, I, fig. 19)], and other figures. The Deposition with the pen, the rest in bl. ch. 21.5 by 15. Brogi 1974. The Pietà would seem more likely for the picture now in the Academy painted by Fra Paolino, but perhaps designed by F. B.

292 No. 1240E —Three *putti*. Pen, coarser than usual, on yellow paper. 22 by 15. Brogi 1497. [E. Sandberg Vavalà, *Burl. Mag.*, LV (1929), p. 14.]

293 No. 1241E —Christ on the Cross. Pen on bluish paper. 15 by 11.5. Brogi 1882.

294 No. 1242E —Madonna. Pen. 9 by 7. Brogi 1882.

294A No. 1244E —Sheet of studies for Nativity, Holy Family, two Madonnas, two babies and for prostrate figure. Pen. 28 by 20.5. Verso: Three studies for a naked female figure and an old man kneeling in profile to r., possibly for Epiphany. The recto squared for enlargement. Brogi 1955 and 1956. Very early and, as might be expected, close to his teacher, Piero di Cosimo.

295 No. 1245E —Female figures in trailing robes, in profile to l. Bl. ch. on tinted ground. 27.5 by 17. Brogi 1950. Cf. my 250, like which it is a study, but reversed for a figure in the Rape of Dinah.

296 No. 1260E —Study for some such Holy Family as the one now in the Pitti [(Alinari 20401)]. Bl. ch. on tinted ground, squared for enlarging. 25.5 by 23. Brogi 1065.

297 No. 1261E —Studies for man supporting fainting woman. R. ch. on tinted ground. 23 by 28. Brogi 1949. [Uffizi Publ., II, ii, 25. Gabelentz, II, pl. 61. Knapp, fig. 96. Like my 250, 254 verso, for the Rape of Dinah executed by Bugiardini.]

298 No. 1262E —Deposition. Bl. ch. and. wh. on tinted ground. 24 by 34. Brogi 1964. Braun 76093. [Venturi, IX, i, p. 241.] Rather early.

299 FLORENCE, Uffizi, No. 1264ᴱ—Cardinal kneeling in profile to l., for an altar-piece. Bl. ch. and wh. on tinted ground. 24 by 34. Brogi 1937. [Uffizi Publ., II, ii, 18. Venturi, IX, i, p. 288. Possibly done in connection with the donor in the Besançon altarpiece, but in the abstract, before turning into the portrait of Carondelet.]

300 No. 1265ᴱ—Madonna enthroned between Jerome and Stephen, with angels above, and one on steps playing. Bl. ch. 24 by 21.5. Brogi 1963. [Knapp, fig. 39. Venturi, IX, i, p. 281.]

301 No. 1267ᴱ—Half-nude kneeling figure, and satyr pursuing nymph (p. 159). Bl. ch. on tinted
Fig. 455 ground. 27 by 38. Brogi 1936.

302 No. 1269ᴱ—Venus on pedestal and women and children grouped about her (p. 159). Bl.
Fig. 454 ch. on tinted ground. 22 by 29. Brogi 1947. [Uffizi Publ., II, ii, 22.]

303 No. 1270ᴱ—Small study for St. Paul now in the Vatican Pinacoteca (p. 158). Bl. ch. on
Fig. 448 tinted ground. 16 by 11.5. Brogi 1458. Braun 76092. [Venturi, IX, i, p. 314.]

304 No. 1271ᴱ—Expulsion of Hagar (p. 159). Bl. ch. on tinted ground. 20.5 by 28.5. Brogi 1948. Late.

305 No. 1273ᴱ—Study for Madonna and three saints. Bl. ch. on tinted ground. 17 by 20. Brogi 1976. Verso: Two *putti* and figure almost effaced. Late.

306 No. 1274ᴱ—Michael slaying Dragon. Pen on greyish prep. ground. 10 by 12. Brogi 1435. Early.

307 No. 1280ᴱ—Study of *putti*. Bl. ch. 13 by 18. Brogi 1440.

308 No. 1281ᴱ—Two studies for drapery of arm and bust, probably for Bartholomew in the Uffizi Marriage of St. Catherine [(Gabelentz, I, fig. 11)]. Bl. ch. and wh. 12.5 by 21. Brogi 1441. Braun 76081.

309 No. 1282ᴱ—Studies for St. Bartholomew. Bl. ch. 13 by 17.5.

310 No. 1283ᴱ—Study for St. John, close to figure in the Louvre Annunciation [(Gabelentz, I, fig. 17)], and small sketch for same below. Bl. ch. and wh., squared for enlarging. 36 by 22. Brogi 1934. Braun 76086.

311 No. 1284ᴱ—Study for God the Father in the Lucca altar-piece with Catherine and the Magdalen [(Gabelentz, I, fig. 8)]. Bl. ch. and wh. on tinted ground, squared for enlarging. 36 by 26. Brogi 1935. [Knapp, fig. 45.]

312 No. 1285ᴱ—Study for female martyr in the Louvre Marriage of St. Catherine [(Gabelentz, I, fig. 10)]. Bl. ch. and wh. on tinted ground, squared for enlarging. 38 by 23. Brogi 1938. [Uffizi Publ., II, ii, 16. Knapp, fig. 50. Venturi, IX, i, p. 291.]

313 No. 1777ᴱ—Magdalen, cartoon for the Lucca picture representing God the Father, the Magdalen and St. Catherine (p. 158). Bl. ch. and wh. 1m. 50 by 1m. 10. Alinari 387. [Venturi, IX, i, p. 277.]

314 No. 1778ᴱ—St. Catherine, cartoon for the same picture (p. 158). Bl. ch. and wh. 1m. 50 by
Fig. 445 1m. 10. Alinari 388. [Venturi, IX, i, p. 278.] This might almost have served for Beccafumi's Stgimatization of St. Catherine in Siena.

315 No. 1779ᴱ—Cartoon for Holy Family belonging to Marchese Visconti Venosta [in Rome (Venturi, IX, i, p. 284)]. Bl. ch. and wh. Circular, diameter 85 cm. Alinari 385. [Uffizi Publ., II, ii, 10. Knapp, fig. 60. Venturi, IX, i, p. 283.]

316 FLORENCE, Uffizi, No. 1780^E—St. Jerome and Evangelist. Cartoon for unknown picture. [As Gabelentz suggests, perhaps for a Crucifixion.] Bl. ch. and wh. 1m. 92 by 1m. 33. Alinari 386.

317 No. 1781^E—Cartoon for St. Paul, now in the Vatican Pinacoteca (p. 158). Bl. ch. and
Fig. 446 wh. 2m. 15 by 1m. 5. Alinari 393.

318 No. 1782^E—Cartoon for St. Peter now in the Vatican Pinacoteca [(Gabelentz, I, fig. 14)] (p. 158). Bl. ch. and wh. 2m. 15 by 1m. 5. Alinari 394. This in for the picture which, as Vasari tells us, F. B. left to be completed by Raphael. It is obvious that the finished panel is much more the work of the latter and his assistants than of the former.

319 No. 352^F—Head of young woman (p. 163). Bl. ch. 19.5 by 16. Pl. xcii of F. E. [Gabelentz, II, pl. 40.]

320 No. 353^F—Head of woman, smiling. Bl. ch. 35 by 22.

321 No. 356^F—Study for St. Paul, now in the Vatican Pinacoteca [(Gabelentz, I, fig. 14)]. Bl. ch., squared for enlarging. 36 by 24.

322 No. 357^F—Two draped figures, and another drawn at right angles to them. Bl. ch. 39 by 27. [Gabelentz, II, pl. 44.]

323 No. 358^F—Half-nude figure, possibly for St. Sebastian, and part of another. Bl. ch. 38 by 20. [Fototeca 9177.]

324 No. 360^F—Two male nudes with hands tied behind them—studies for St. Sebastian. Bl. ch. 29 by 20. [Fototeca 6129. Distinctly Peruginesque.]

325 No. 361^F—Two children facing one another—studies for young Baptist in the unfinished altar-piece at the S. Marco Museum [(Gabelentz, I, fig. 12)]. Bl. ch. 29 by 26.

325^A (former 222) No. 362^F—Study for figure of the Dead Christ in the Pitti Deposition [(Gabelentz, I, fig. 19)]. Bl. ch. 20 by 30.

326 No. 363^F—Kneeling figure to l. Bl. ch. and wh. 18.5 by 18.

327 No. 364^F—Two nudes—pendants to my 324. Bl. ch. 29.5 by 18. [Fototeca 6130.]

328 No. 367^F—Youth on horseback—study for more finished sketch at Weimar [(Knapp, fig. 97)]. Bl. ch. and wh. 33 by 27.5. Squared for enlargement.

329 No. 368^F—Two *putti*—studies for Baptist in Lord Cowper's Holy Family at Panshanger [(Knapp, fig. 63)]. Bl. ch. 26 by 22.

330 No. 369^F—Nude, seen from behind. Bl. ch. 31 by 12.5.

331 No. 370^F—Nude, kneeling. Bl. ch. 23.5 by 19.5.

332 No. 371^F—Female figure, similar to but smaller than my 312, the drawing for the young female saint in the Louvre Marriage of Catherine [(Gabelentz, I, fig. 10)]. Bl. ch. 12 by 12.

333 No. 372^F—Half-nude figure, standing. Bl. ch. 34 by 17.

334 No. 373^F—Nude in profile, kneeling. Bl. ch. 24 by 18.

335 No. 374^F—Nude male figure in profile to l. Bl. ch., squared. 34 by 15. [Fototeca 9178. Very close to my 323.]

336 FLORENCE, Uffizi, No. 376F—Nude in profile to l., with arms tied behind him, for St. Sebastian, probably the one in the Besançon altar-piece [(Gabelentz, I, fig. 13)]. Bl. ch. 30 by 8. [Fototeca 6131.]

337 No. 378F—St. Paul kneeling. Bl. ch. 23 by 19.

337A (former 224) No. 379F—Woman half kneeling, half seated on ground in profile to l. with r. hand stretched out, and study for her r. knee. Bl. ch. and wh. 21 by 24. [Gabelentz, II, pl. 45.] Very likely, as Gabelentz suggests, for the woman on the steps to r. in the Madonna of Mercy at Lucca [(Gabelentz, I, fig. 16)].

338 No. 380F—Nude holding book and sword, and draped figure holding his own hand over him. Bl. ch. 23 by 20.5.

339 No. 381F—Two apostles standing in profile. Bl. ch. and wh. 27 by 34.

339A (former 225 and 229) No. 382F—Young woman seated, study for Nativity. Bl. ch. and wh., squared for enlarging. 35 by 27. Early and fine.

340 No. 383F—Study for Holy Family. Bl. ch. 17 by 15.

341 No. 384F—Study for figure of Joseph in F. B.'s Vienna Circumcision [(Gabelentz, I, fig. 22)]. Bl. ch. and wh. 29 by 20.

341A (former 226) No. 385F—Rapidly drawn but interesting small design for Adoration of the Magi. Bl. ch. 18 by 16.5. [Gabelentz, II, pl. 63. Fototeca 12546.] The arrangement is very original in that it approaches as closely as possible to the ordinary altar-piece of the Madonna enthroned in the midst of saints.

341B No. 386F—Heavily draped male figure in profile to r. carrying two doves by their wings in r. hand. Bl. ch. 30 by 19. Gabelentz, II, pl. 58. According to him for the St. Joseph in the Vienna Presentation in the Temple (Gabelentz, I, fig. 22).

342 No. 387F—Two studies for Madonna. Bl. ch. and wh. on brown paper. 21.5 by 27.5. Verso: Holy Family.

342A (former 230) No. 389F—Ecstatic angel kneeling, profile to l. Bistre and wh. on greyish prep. paper. 15 by 17. Verso: Christ in Limbo. [Gabelentz, II, pls. 15 and 16. Fototeca 12547 and 12548. Venturi, IX, i, pp. 251, 253.]

342B (former 227) No. 390F—Madonna; John baptizing. Bl. ch. and wh. on bronze paper. 28 by 17. Early. Verso: Madonna.

343 No. 393F—Holy Family. Bl. ch. and wh. 26 by 19. Verso: Holy Family.

344 No. 394F—Draped figure blessing. Bl. ch. and wh. 40 by 26.

345 No. 395F—Baptist in profile to r. Bl. ch. and wh., squared. 40 by 22.

346 No. 396F—Apostle in profile to l. Bl. ch. and wh. 38 by 22. Verso: Apostle.

347 No. 397F—St. Bartholomew. Bl. ch. and wh. 39.5 by 23.

348 No. 398F—St. Paul. Bl. ch. and wh., squared. 39 by 27.

349 No. 399F—St. Bartholomew. Bl. ch. and wh. 38 by 23.

350 No. 400F—Evangelist. Bl. ch. and wh. 28 by 17.

5

351 FLORENCE, Uffizi, No. 401^F —Madonna, St. Anne and *putti*, for the unfinished altar-piece in the S. Marco Museum. Bl. ch. and wh. 28 by 18.

352 No. 402^F—Two studies for Holy Families. Bl. ch. 26 by 17.5.

352^A (former 231) No. 403^F—Judas Iscariot seated, seen from back. Study for Last Supper. Bl. ch. 28 by 19. [Fototeca 11244. Uffizi Publ., II, ii, 21. Gabelentz, II, pl. 42.]

353 No. 404^F—Two draped kneeling figures. Bl. ch. and wh. 38 by 28. Verso: Study for Carondelet in F. B.'s altar-piece at Besançon [(Gabelentz, I, fig. 13)].

353^A (former 232) No. 405^F—Study for St. Mark in the Pitti [(Gabelentz, I, fig. 15)]. Bl. ch. and wh. 28 by 19. [Alinari 330.]

354 No. 406^F—Sketch for Charity. R. ch. 27.5 by 15.

354^A (former 233) No. 407^F—Study for St. Bartholomew in the Uffizi Marriage of St. Catherine [(Gabelentz, I, fig. 11)]. Bl. ch. and wh. 28 by 18. [Alinari 331. Gabelentz, II, pl. 46. Venturi, IX, i, p. 297.]

355 No. 408^F—Small study for altar-piece representing Madonna with various saints, among them Francis and Dominic kneeling in the foreground—an early stage, perhaps, for the Louvre Marriage of St. Catherine [(Gabelentz, I, fig. 10)]. Bl. ch. and wh. 23 by 16.

356 No. 409^F—Winged *putti* flying to r., study for the Uffizi Marriage of St. Catherine [(Gabelentz, I, fig. 11)]. Bl. ch. and wh. 19 by 16.5.

357 No. 410^F—*Putto* for same picture. Bl. ch. 12.5 by 17.5.

358 No. 411^F—Winged *putto* beating on tambourine. Bl. ch. 18.5 by 15.5. [Gabelentz, II, pl. 38.]

358^A (former 234) No. 412^F—Two winged *putti* in the air. Bl. ch. and wh. on tinted ground. 23 by 33. [Alinari 389, 391. Uffizi Publ., II, ii, 13. Meder, *Handz.*, fig. 160.]

359 No. 413^F—Various *putti* for unfinished altar-piece at the S. Marco Museum [and head of a bearded man]. R. ch. and pen on grey paper. 27.5 by 18. [Gabelentz, II, pl. 54. Verso: Two draped figures. Bl. ch.]

360, 361, 362, 363, 364, 365, 366, 367 Nos. 415^F, 417^F, 418^F, 419^F, 420^F, 421^F, 424^F, 425^F— Various *putti* for same work, or for the Lucca God the Father. R. or bl. ch.

368 No. 1334^F—*Putto* sleeping in reclining attitude. Bl. and yellow ch. Excellent action.

369 No. 1478^F—*Putto* bending down to r. R. ch.

370 No. 1479^F—*Putto* reclining to r. R. ch.

371 No. 1480^F—*Putto* seated on parapet. R. ch.

372 No. 1473^F—*Putto* seated on parapet, turning to l. R. ch.

373 No. 6418^F—Study from model of nude who stands in profile to l., leaning on staff, with r. foot resting on block. Head and l. foot repeated. R. ch. 29 by 20. Ascribed to Andrea, but certainly F. B.'s. His most serious and ablest drawing of the nude.

374 No. 6790^F—Three small draped figures. Bl. ch.

375 FLORENCE, Uffizi, No. 6833F—Male nude [seated in profile to l.]. Bl. and yellow ch. 28 by 18.5. [Gabelentz, II, pl. 34. Gabelentz suggests that this may be a sketch for the Adam in the Johnson Collection at Philadelphia (Venturi, IX, i, p. 263).]

376 No. 6816F—Study of nude for Christ on the Cross. Bl. and yellow ch. 33.5 by 21.

376A No. 6825F—Study for youthful head of monk in profile to l. Bl. ch. and wh. 22 by 24. Not unlikely, as Gabelentz suggests, for St. Bernard in the Besançon altar-piece.

377 No. 6829F—Study for Holy Family. Bl. ch. and wh. 11 by 13.5. Verso: Draped figure.

378 No. 6837F—Studies for Holy Family. Bl. ch. and wh. 27.5 by 20.5.

379 No. 6850F—Design consisting of a number of figures for Entombment. Fine landscape. Bl. ch. 26.5 by 21.5.

380 No. 6852F—Nude walking to r., pointing. Bl. ch. 34 by 15.5.

381 No. 6857F—Nude sprawling. Bl. and yellow chalk. 19.5 by 22.5.

382 No. 6858F—Nude reclining, with hands in prayer. Bl. and yellow ch. 17 by 30.

383 No. 14550F—Study for infant John in the Panshanger Holy Family [(Knapp, fig. 63)]. Bl. ch. 24.5 by 14.5.

384 No. 14551F—Study for one of winged *putti* in unfinished altar-piece at the S. Marco Museum. Bl. ch. 19 by 16.5.

385 No. 14552F—*Putto* for the Uffizi Marriage of St. Catherine. Bl. ch. and wh. 13.5 by 14.

385A No. 45P—View of church of the Annunziata and of Foundling Hospital, probably taken from the grounds around the convent of S. Marco. Pen. 30 by 28.5. Uffizi Publ., II, ii, 7. Giglioli, *Dedalo*, IX (1928-19), p. 177.

386 Uffizi, Santarelli, No. 230—Study for Nativity, and two other figures, perhaps for Assumption. Bl. ch. and wh. 30 by 20.5. Early and fine. [Verso: Very unusual com-
Fig. 453 position for Nativity; St. Joseph holding Child which kneeling Madonna adores. Fototeca 15939 and 15940.]

387 No. 241—Woman in long robe, in profile to r. Pen, but in places gone over. 17.5 by 13.5.

388 No. 242—Madonna and angel holding between them the two Holy Children. Pen. 19 by 16.5. [Gabelentz, II, pl. 27.]

389 Museo di S. Marco, Cell of S. Antonino—Head of S. Antonino. Bl. ch. 27 by 20. [Gabelentz, II, pl. 52.] Probably worked over; at all events, poor.

390 FRANKFORT, Städel Museum—Sheet with various studies mounted by Vasari: two heads and headless figure, both in r. ch. Five hands holding books, in bl. ch. 29.5 by 18.5. [Gabelentz, II, pl. 56. One of the heads seems to be for the Pitti St. Mark.]

390A HAARLEM, Tyler Museum, K. IX, 43—Heavily draped figure kneeling in profile to l. with r. hand stretched out and l. hand holding drapery. Bistre and wash strengthened with body colour. 26 by 16.

390B (former 513) Koenigs Collection, Inv. 14—Head in profile to l. of man looking up (p. 159).
Fig. 452 R. ch. 38 by 26.5. Braun 79520. Study for donor in the Lucca Madonna della Misericordia. Morelli (*Kunstchr.*) regarded this as a copy, but it would seem he was mistaken.

390C HAARLEM, KOENIGS COLLECTION, Inv. 383—Head of friar turned slightly to l. Bl. and r. ch. 33.5 by 23.5. Almost Sogliani.

390D Two volumes of sketches formerly in the Granducal Collection at Weimar (one sketch
Fig 447 reproduced as Fig. 447) (pp. 158, 159). In my first edition some of the best leaves from them (photographed by Braun) are catalogued as Nos. 512, 514-518. I shall, however, not attempt to enumerate them again, and refer students to Gabelentz (pp. 178-190) where each sketch is fully described and discussed. See also repr. in Venturi, IX i, pp. 317, 329; Knapp, figs. 24, 73, 97.

390E (former 429) THE HAGUE, FRITZ LUGT COLLECTION—Woman carrying child, and another leaping up to her. Pen. 12 by 8.5.

391 HAMBURG, KUNSTHALLE, No. 21147—Sketch for Evangelist. Bl. ch. 40 by 24.

392 No. 21242—Two announcing angels, and facing them a draped figure seen from back. Pen on brown paper. 14 by 18.5. [Verso: Two studies for John the Baptist. Prestel Publ., 13 and 14.]

392A No. 21371—Study for Nativity. Pen. 16 by 12. Verso: Study for female nude, cast of drapery and some writing of about 1700. Prestel Publ., 12 and fig. C. in text.

393 LILLE, MUSÉE WICAR, No. 34—Old man seen from back but standing in profile to l.; study for drapery, differing but slightly from No. 273. Bl. ch. and wh. 28 by 15. Braun 72029. [Knapp, fig. 14. Venturi, IX, i, p. 233. Study for Joseph in the Presentation at the Uffizi (Gabelentz, I, fig. 2).]

394 Nos. 36 and 39—St. Francis embracing St. Dominic. The latter alone. Study of drapery. Figure reclining. The two first are studies for the Louvre Marriage of Catherine (Gabelentz, I, fig. 10). Bl. ch. and wh. on tinted paper. 21.5 by 28. Braun 72031. [Venturi, IX, i, p. 292. Verso: Study for figure seated towards r.]

395 No. 40—Holy Women at Tomb. Bl. ch. (considerably effaced) on tinted paper. 21.5 by 21.

396 No. 41—Holy Women at Tomb. Bl. ch. (effaced) on tinted paper. 23 by 22.5.

397 No. 42—Madonna enthroned and saints. Bl. ch. on tinted paper. 36 by 29. Verso: Child's head.

398 No. 43—Madonna and saints—sketch for the Louvre Marriage of St. Catherine [(Gabelentz, I, fig. 10)]. Bl. ch. on tinted paper. 35.5 by 22.5.

399 LONDON, BRITISH MUSEUM, Pp. I-55 —Large study, once in Vasari's collection, for Madonna appearing to St. Bernard [(Gabelentz, I, fig. 4)]. Bistre, ink and wh. on greyish prep. paper. 35 by 27.

400 1860-6-16-7—Madonna seated on ground with saint kneeling beside her, and two angels standing over her. Bl. ch. and wh. 15.5 by 14.

401 1893-7-31-11—Madonna and angels, and a profile. Pen on pink prep. paper. 12 by 16.5.

402 Pp. I-56—Apostle in niche, holding open large book—study for St. Mark in the Pitti Gallery. Pen. 25 by 17. [Gabelentz, II, pl. 55. Anderson 18756.] Summary and rough, but good.

403 1835-5-9-34—Three young men, one seated, the others standing—studies for unfinished altar-piece in the S. Marco Museum. R. ch. 20 by 26.

404 LONDON, British Museum, 1860-6-16-103—Madonna with the two Holy Children—pyramidal group, such as we have in more than one Holy Family by F. B. Bl. ch. 13.5 by 10.5.

404A 1860-6-16-104—Madonna with the two Children. Bl. ch. 14 by 12.5.

405 Pp. I-52—Madonna with infant John and angel. Pen. 18.5 by 15.5. Braun 73002. [Knapp, fig. 17. Early.]

406 Pp. I-51—Madonna and infant John with two angels and two young saints. Pen. 18.5 by 16. [Anderson 18753. Knapp, fig. 18. Early.]

407 1875-6-12-1—Madonna, a male and a female saint, angels and both Infants. Pen, bistre and wh. on pink prep. paper. 15 by 22.

408 Pp. I-54—Coronation of Virgin. Pen. 22 by 14. [Gabelentz, II, fig. 26. Verso: Christ at the Well. Cf. my 281 (Fig. 438). Anderson 18754 and 18755. The Coronation seems too early to have been used for the one in Stuttgart (Knapp, fig. 58) which belonged to the Besançon altar-piece (Gabelentz, I, fig. 13).]

409 Pp. I-53 – Baptist preaching. Madonna for Nativity [Infant Christ blessing, St. Jerome] and other figures. Pen. 21 by 41. [Knapp, fig. 5.] Verso: Baptist preaching, Christ at the Well. Kneeling elderly woman. Braun 73001 and 73004. Middle period.

410 1856-6-14-71—Winged *putto* sitting with legs crossed—elaborated, but free and large cartoon for, if I do not mistake, the altar-piece for the Palazzo Vecchio, never completed, and now in the S. Marco Museum [(Gabelentz, I, fig. 12)]. Bl. ch. 81 by 40.

410A 1889-8-12-218—Two studies for apostles or saints. Pen, bistre and wash. 13.5 by 15.5.

410B 1889-8-12-219—Three studies for apostles or saints and kneeling donor. Pen, bistre and wash. 13 by 26.5.

411 British Museum, Malcolm, No. 84—Angel blowing trumpet, and draped figure of saint for Ascension. Pen and bistre. 11 by 15.

412 No. 85—Standing draped figure of angel. Bistre. 12 by 5. Early.

413 No. 87—Holy Family with infant John. Bl. ch. on pink paper. 15.5 by 18.

414 No. 88—Virgin standing. Several sketches of standing saints with books in hand. Also a lamb. Pen and bistre. 20 by 28. Verso: Diagram for sun dial.

415 No. 89—Hercules and David. Bl. ch. and wh. on brown tinted paper. 20 by 19. Michelangelesque, yet pretty.

 I am aware that other attributions have been suggested for this drawing, and there is indeed something here that calls to mind Puligo; but careful study convinces me that it is nevertheless by F. B. Two nudes in attitudes of a satyr seizing a nymph, probably as Gabelentz suggests, for the Rape of Dinah. Other figures appear dimly. Swift, spirited, and unquestionably F. B.'s.

416 No. 82—Two studies for draped male figures. Pen and bistre, and wh. 18 by 13.

417 No. 91—Christ resurrected standing on pedestal, with angels below—study for the Pitti *Salvator Mundi* [(Gabelentz, I, fig. 20)]. Bl. ch. and wh. on brown paper. 28.5 by 17. Braun 65081. Spirited, but very poor as treatment of the nude.

418 LONDON, British Museum, Malcolm, No. 92—Christ resurrected seated on Sepulchre. Below, angels. Another drawing for the same Pitti picture. Bl. ch. and wh. on brown tinted paper. 25 by 15.5. Braun 65082. Even less satisfactory than the last.

419 No. 93—Nude standing figure of Saviour—yet another study for the same Pitti picture. R. ch. 20.5 by 10.

420 No. 94—Virgin presenting Infant Christ to Simeon—study for the Circumcision now at Vienna [(Gabelentz, I, fig. 22)]. Bl. ch. and a little wh. on light brown tinted paper. 27 by 15.5.

421 No. 96—Standing nude figure of Infant Christ, perhaps for the Louvre Marriage of St. Catherine. Bl. and wh. ch. on brown tinted paper. 20.5 by 17.

422 No. 97—Kneeling Magdalen [for Lucca altar-piece (Gabelentz, I, fig. 8)]. Bl. ch. on brown tinted paper. 22 by 18. [Verso: Sketch of saint looking upwards.]

423 No. 99—Two heads, one of Virgin, the other of veiled nun. R. ch. 12 by 17.5. Verso: Child, probably like the head of the Virgin, for the unfinished altar-piece at the S. Marco Museum [(Gabelentz, I, fig. 12)].

424 No. 100—Study for mystical composition. Bl. ch. and wh. on brown paper. 56.5 by 44.5. Excellent.

424A (former 436) British Museum, 1910-2-12-12—Three studies for Madonna, standing with Child in her arms. 20 by 27.

424B (former 437) 1910-2-12-11—Study for the Pitti *Salvator Mundi* [(Gabelentz, I, fig. 20)]—resembling the Malcolm and other sketches for the same composition. Bl. ch. and. wh. 28.5 by 20.

424C (former 428)—Studies perhaps for background of Besançon altar-piece [(Gabelentz, I, fig. 13)]. Bistre. 16 by 19. [Heseltine Cat., 1913, No. 9].

425 (see 212A)

426 (see 210B)

427 Oppenheimer Collection (formerly), No. 249—*Putto*, and head of another. Bl. ch. 25 by 17.

427A Study for *Santa Conversazione*. Pen and wh. on pinkish paper. 22 by 15.5. Verso: Angel kneeling.

428 (see 424C)

428A No 254—Elaborate design for the unfinished altar-piece at the S. Marco Museum (Gabelentz, I, fig. 12), and there are certain differences from the picture:—On each side there are but two saints erect; the children below are making music and sitting further apart. Bl. ch. and wh. 36.5 by 27. Heseltine Cat., 1913, No. 11. Oppenheimer Sale Cat., pl. 4.

429 (see 390E)

430 (see 459G)

431 No. 250—Angel of Annunciation. Pen. 10 by 8.5. Verso: Nude man.

432 No. 253—Landscape with mill in foreground. Pen. 15 by 22.5. [Ede, pl. 67. Heseltine Cat., 1913. No. 10.] Verso: Roof of domed church.

433 LONDON, OPPENHEIMER COLLECTION (formerly), No. 246—Two angels, perhaps for Coronation. Pen. 17 by 13. [Popham Cat., No. 191. Oppenheimer Sale Cat., pl. 5.

433A No. 254—Study for palm tree. Bl. ch. 35 by 24. Ede, pl. 72. Popham Cat., No. 195. Oppenheimer Sale Cat., pl. 3. It has been suggested that this sketch served for the Panshanger Madonna (Knapp, fig. 63).

433B RICKETTS AND SHANNON COLLECTION – Fragment of study for naked child seated in mother's lap. Bl. ch. 26.5 by 23.5. Vasari Soc., II, iii, 2. Popham Cat., No. 55. Photo. Cooper. Leonardesque of course as in Leonardo's Virgin and St. Anne, with the cartoon for which F. B. could scarcely help being well acquainted.

433C D'HENDECOURT SALE (Sotheby, May 8-10, 1929), No. 150—Study for kneeling female saint, in profile to l. Bl. ch. and wh. 19.5 by 13. Repr. in Sale Cat.; T. Borenius, O. M. D., III (1928/29), pl. 9.

433D RUSSELL SALE (Sotheby, May 9, 1929), lot 9—Study for full–length Madonna with Child bending down and blessing infant Baptist and St. Elizabeth. Pen. 19 by 13. Verso: Another study for full-length Madonna. Repr. in Sale Cat.

434 (see 428A)

435 (see 212B)

436 (see 424A)

437 (see 424B)

438 [LORD SPENCER COMPTON], formerly SIR CHARLES ROBINSON—Elaborate study for Adoration of the Magi. The Madonna is seated on a platform with Joseph standing beside her. The crowd surges up from r. and to l. Pen. 28 by 24.5. [Vasari Soc., I, x, 2.] A remarkable composition inspired by Leonardo and Botticelli, and most daintily penned. Cf. my 235 (Fig. 439).

439 (see 212D)

439A MILAN, AMBROSIANA—Study for nude male figure running forward with both hands lifted to face. Ascr. to Dosso Dossi. Bl. ch. and wh. Braun 75302. See O. Fischel, O. M. D., IV (1929/30), pl. 39. Venturi, IX, i, p. 239. For one of the damned in the Last Judgement (Gabelentz, I, fig. 3).

440 (see 2740A)

440A PRIVATE COLLECTION (formerly)—Head of bald man facing front, probably connected with head of Joseph in the Holy Family from the Mond Collection (Knapp, fig. 62). Bl. ch. 19 by 15. Frizzoni, *Rass. d'A.*, 1911, opp. p. 43. Erroneously labelled as forming part of the Mond Collection while Frizzoni on p. 46 only speaks of its connection with the Mond picture.

441 (see 212E)

442, 443 MUNICH, PRINT ROOM, Nos. 2174 and 2169—Two studies of *putti*. Both for unfinished altarpiece at the S. Marco Museum [(Gabelentz, I, fig. 12)]. Bl. ch. 15.5 by 19.7; 18.5 by 18.5 Bruckmann 23, 24.

444 No. 2160—Madonna fondling infant John. Pen. 20 by 15.3. Bruckmann 20. [Gabelentz, II, pl. 7. E. Sandberg Vavalà, *Burl. Mag.*, LV (1929), p. 11.] Verso: Tnree female figures running.

445 MUNICH, PRINT ROOM, No. 2172 — Angel blowing trumpet, for fresco of Last Judgement [(Gabelentz, I, fig. 3)]. Pen. 16.5 by 12.5. Bruckmann 22. [Knapp, fig. 7.]

446 No. 2166 — Madonna. Pen. 17 by 12. Bruckmann 26. [Gabelentz, II, pl. 1. E. Sandberg Vavalà, *Burl. Mag.*, LV (1929), p. 11. Early.]

447 No. 2171 — Madonna. Pen. 11.5 by 16.5. Bruckmann 151. [Gabelentz, II, pl. 2. Early.]

448 No. 2165 — Two studies of Samaritan Woman kneeling (see my 281, Fig. 438). Pen, bistre and wh. 14 by 19. Bruckmann 21. [Verso: Madonna seated on ground. Gabelentz, II, pls. 23 and 24.]

449 No. 2167 — Head of saint. Charcoal. 37.5 by 26. [Gabelentz, II, pl. 47. Verso: Spirited studies of horsemen and female figures. Very Leonardesque. Bl. ch., rubbed.]

450 No. 2185 — Three studies from model, dressed only in hose, for the Madonna in the unfinished altar-piece in the S. Marco Museum. R. ch., effaced and gone over. 18 by 25. Bruckmann 19. [Knapp, fig. 54. Meder, *Handz.*, fig. 261.]

451 No. 2163 — Madonna with Catherine, Francis, Sebastian and other saints, and below two *putti*, sketch for the Uffizi Marriage of Catherine [(Gabelentz, I, fig. 11)]. Bl. ch. and wh. 19.5 by 20.5. [O. Weigmann, *Monatsh. f. K. W.*, II (1909), p. 3. Verso: Male nude walking towards r.

452 No. 2173 — Sebastian and a female saint. Bistre on pinkish prep. paper. 16 by 11. [Gabelentz, II, pl. 4. Dainty. Early.]

453 No. 2175 — Madonna with Lucy and Sebastian. Pen and wh. 10.5 by 12. [Gabelentz, II, pl. 3. About 1506.] Very sweet. [Verso: Madonna and Child.]

453A No. 2176 — Profile of nun to r. Bl. ch. and wh. 27 by 17.5. O. Weigmann, *Monatsh. f. K. W.*, 1909, pp. 4 and 5. Verso: Study for angel playing viol and, on larger scale, for hands in act of playing. Gabelentz (No. 335) considers them to be studies for the Uffizi Marriage of Catherine.

453B No. 2177 — Study for saint in ample draperies with r. hand raised to breast and holding staff with l. Also studies of hand and drapery for same figure. Bl. ch. and wh. 28 by 20.5. O. Weigmann, *Monatsh. f. K. W.*, 1909, p. 2. For the saint with flag on the unfinished altar-piece at S. Marco.

454 No. 34576 — Bust of woman, head turned down little to l. Bl. ch. and wh. 37 by 26. Pretty in type, and admirable in handling. Scarcely later than 1509. The type of drawing that may have inspired Sogliani.

455 No. 3144 — Holy Family with St. Elizabeth. Bl. ch. 20 by 15. Study for some such picture as the one belonging to Sir Frederick Cook, at Richmond [(Gabelentz, I, fig. 24)].

456 No. 2158 — Study for Assumption, Madonna ascending to l. Bl. ch. and wh. on pinkish paper. 21.5 by 16.5. Bruckmann 28. [Gabelentz, II, pl. 64.]

457 No. 2159 — Study for Assumption. Bl. ch. and wh. on pinkish paper. 22 by 16.5. Bruckmann 27.

458 No. 2164 — Deposition. Bl. ch. and touch of wh. Almost effaced. 21 by 19.

459 No. 2181 — Madonna enthroned; Paul and other saints, and infant John on steps — sketch for some such altar-piece as the unfinished one in the S. Marco Museum. Slight bl. ch. on pink prep. paper. 22 by 17.

459[A] NAPLES, Pinacoteca, Print Room, No. 13178—Study for draped figure in profile to r. holding open book in both hands. Bl. ch. and. wh. on brown paper. 29 by 18.5. Photo. S. I.

459[B] NEW YORK, Metropolitan Museum—Study for announcing angel. Pen and bistre. 10.5 by 13.5. Photo. Museum 55283.

459[C] Holy Family with infant Baptist. Bl. ch. and wh. 13.5 by 12. Photo. Museum 6482. Nearest to a group in lower r.-hand corner of Lucca Mother of Mercy (Gabelentz, I, fig. 16), but intended for a painting of the same period representing some such Holy Family as those in the Corsini, Rome (Gabelentz, I, fig. 23), or in the Cook Collection, Richmond (Gabelentz, I, fig. 24), or best of all one at Panshanger (Knapp, fig. 63).

459[D] Morgan Library—Study for monk seated in profile to r. and for female figure in fluttering draperies running in profile to l. Pen. and wh. 10.5 by 17. Morgan Dr., I, 28. Early idea for the Madonna appearing to St. Bernard (Gabelentz, I, fig. 4), ordered in Nov., 1504.

There is almost nothing in common with the finished masterpiece: instead of the ecstasy rewarded by the vision splendid of Heaven's Queen we see a bearded old monk who does not look up from writing because he has not yet become aware of the young woman's tripping approach.

459[E] Study for Madonna with infant Baptist. Bl. ch. with touches of wh. 13.5 by 9.5. Morgan Dr., IV, 8.

559[F] Kneeling female nude with r. arm stretched out. Bl. ch. 26 by 19. Verso: Seated female nude. Morgan Dr., IV, 9 and 10.

The kneeling figure was probably done in connection with an early work representing the Creation of Eve published by L. Sambon in the *Musée*, VII (1924), pl. opp. p. 10, and by R. Fry in the *Burl. Mag.*, XLIV (1924), p. 115, also by Venturi, IX, i, p. 261, as belonging to Mme. La Durée, Paris. (Another sketch for the same subject, but done much later, is to be found in the Uffizi—see my 253 verso.) The seated nude may have been intended for an Eve spinning. One is tempted to believe the improbable, namely that F. B. had done these figures after the living model. The kneeling nude is perhaps as feminine as any in the whole of Florentine art.

459[G] (former 430) [NEW YORK, Mr. Robert Lehman]—Madonna with the Holy Children. Pen. 19 by 16.5. [Popham Cat., No. 190. Oppenheimer Sale Cat., pl. 6.] Verso: Other study for same.

460 OXFORD, Christ Church, A. 22—In a lunette, bust of Madonna in profile, perhaps for Annunciation. R. ch. 14 by 10.

461 A. 23—Madonna seated holding Child on her knee. Pen on pinkish prep. paper. 20 by 15. [Bell, pl. V.] Raphaelesque, and rather unusual, but probably genuine.

462 A. 24—Free and rapid sketch for the Pitti *Salvator Mundi*. Bl. ch. on pink prep. paper. 20.5 by 16.5. [Bell, pl. VI.]

462[A] A. 20—Madonna and St. Elizabeth. Bistre and wh. on brown washed paper. 16 by 13.5. Ascr. to Albertinelli.

462[B] A. 25—Study for apostle looking to l. with r. foot on pedestal. 17.5 by 8.

463 Ashmolean Museum, Chambers Hall Collection—Head of Saviour in profile to r. R. ch. 25.5 by 21.

463[A] (former 16) Ashmolean Museum, No. 169—[Various studies for St. Michael in the Last Judgement (Gabelentz, I, fig. 3).] Sp. washed with bistre and height. with wh. 20.5 by 23.5. [Ascr. to Raphael. *O. M. D.*, IV (1929/30) pl. 38 and pp. 33-36, where Professor Fischel pleads that it is by F. B. and seems, on the whole, to be right.]

6

463^B PARIS, Louvre, No. 48, 1870—Study for Madonna with the two Children. Bl. ch. and wh. 14.5 by 9.

464 No. 1691—Half-length figure of youngish man holding heavy book. R. ch. 9.5 by 7. Braun 62133. Catalogued as Andrea del Sarto's and as such accepted even by Morelli (*Kunstchr.*) but obviously F. B.'s, and in the same technique, same pose, and after the same model as the two studies in the Albertina for St. Bartholomew in the Uffizi Marriage of Catherine [(Gabelentz, I, fig. 11). Compare with my 277 and 511.]

464^A No. 1672—Study for Dead Christ in the Pitti Pietà [(Gabelentz, I, fig. 19)]. Bl. ch. 15 by 23. [Alinari 1474. Knapp, fig. 86. Venturi, IX, i, p. 327.] Clearly F. B.'s, but ascribed to Andrea del Sarto [to whom only the bearded profile in the same Vasari frame (see my 142^A) can be attributed.]

465 No. 202—Kneeling woman adoring—study for Madonna in Nativity. Bl. ch. and wh. on greyish paper. 25 by 16. Braun 62018. [Alinari 1476. Knapp (figs. 61 and 62) connects it with the Holy Family in the Mond Collection.]

466 No. 208—Madonna standing in the air, and Infant Christ blessing; perhaps a discarded study for the Besançon altar-piece. Bl. ch. on greyish paper, pricked. 22.5 by 18.

467 No. 211—Flight into Egypt. Bl. ch. on greyish paper. 25 by 20. [Alinari 1470. Venturi, IX, i, p. 346.]

468 No. 214—Madonna seated, visible to below knees with Child in her lap (p. 159), study for the altar-piece in S. Martino at Lucca [(Gabelentz, I, fig. 7)]. Bl. ch. and wh. on greyish brown paper. Squared for enlarging. 30 by 22. Pl. xci of F. E. [Gabelentz, II, pl. 35. Braun 62019. Alinari 1469.]

469 No. 215—Madonna seated, two saints kneeling, and four others standing—study for a picture of about 1515 (p. 159). R. ch. 19.5 by 16. Braun 62020.

470 No. 216—Draped youngish man, standing, supporting a heavy book on hip—study from life perhaps for figure on the r. in the Pitti *Salvator Mundi* [(Gabelentz, I, fig. 20)]. Bl. ch. and wh. on greyish brown paper. 33.5 by 16. Braun 62021. [Verso: Studies for a child on mother's left knee. Bl. ch. I cannot understand Gabelentz doubting the attribution of this drawing.]

471 No. 218—Study for Holy Family, close to the picture now in the Corsini Gallery at Rome [(Gabelentz, I, fig. 23)]. Bl. ch. on pink prep. paper. 15.5 by 20. Alinari 1472. [Gabelentz, II, pl. 62.]

472 No. 224—Draped figure, holding sword (p. 158).—study from life for St. Paul now in the Vatican Pinacoteca [(Gabelentz, I, fig. 14)]. Bl. ch. and wh. on grey paper. 38 by 21. Braun 62023. [Alinari 1479.] Verso: Three other studies for the figure, and one of drapery.

473 No. 227—Study for Holy Family. 11.5 by 10.5. Braun 62025. [Alinari 1475.] Charming and playful.

474 No. 228—Madonna enthroned, two saints and infant John. Bl. ch. and wh. on pink prep. paper. 21 by 16.5. Braun 62025. [Alinari 1471. Knapp, fig. 121. Venturi, IX, i, p. 345.]

475 No. 1526—Holy Family. Bl. ch. and wh. 14 by 20.

476 No. 1962—Madonna, young woman running away in attitude reminding one of Greek archaic figures. The latter figure has a certain correspondence to one in the Chantilly sketch for the Last Judgement. Pen. 16 by 23.5. Braun 62031. [Alinari 1473. E. Sandberg Vavalà, *Burl. Mag.*, LV (1929), p. 14. Knapp, fig. 19.] Verso: Woman in long trailing robe, walking to r., and skeleton.

477 PARIS, Louvre, No. 203—Studies for Holy Family with two angels; and two separate sketches for Madonna. Pen. 22.5 by 15.5. Braun 62030. [Alinari 1478. Venturi, IX, i, p. 236.] Rather early.

478 No. 204—Study for Coronation of the Virgin. Pen. 23 by 16.5. Braun 62028. [Alinari 1477. Knapp, fig. 119. Venturi, IX, i, p. 247.] Very early.

479 (see 1828)

480 No. 209—Holy Family. Bl. ch. 14 by 10.

480A No. 210—Madonna seated on ground with the two Children. Bl. ch. and wh. 14 bv 11. Fine motive, unenergetically treated.

481 No. 220—Madonna with Child in arms. Bl. ch. 13.5 by 9.5. Braun 62026. [Venturi, IX, i, p. 318. Verso: Two saints for an altar-piece, torn at top. Late and certainly not Fra Paolino.]

482 No. 221—Sketch for an altar-piece, and above it [stuck on], two saints [or angels] in the air. Bl. ch. and wh. 24.5 by 15. [Verso: Man seated on saddle, with staff. Very weak and scarcely by F. B.]

482A No. 222—Madonna, Evangelist, and Magdalen at foot of Cross. Bl. ch. and wh. 13.5 by 22.5. Very weak, yet probably his.

483 No. 223—Madonna for Assumption. Bl. ch. and wh. 29.5 by 21.5. Braun 62027. [Knapp, fig. 36. Probably connected with the Berlin Assumption (Gabelentz, I, fig. 6).]

483A No. 225—Study for Christ Crucified, with long waist like archaic Apollo. Bl. ch. 31 by 24.

483B No. 226—Three studies for Madonna with infant Baptist. Pen. 18.5 by 20.5. Very free and charming.

484 No. 229—Madonna holding Child, to Whom two angels are introducing infant John; on the
Fig. 435 l. Joseph (p. 156; 156, note). Pen on pinkish prep. paper. 21 by 17.5. Braun 62032. Very early. [Verso: Two draped figures in pen and wash. Weak.]

484A . . . No. 236—Holy Family. Bl. ch. and wh. 15.5 by 14.5. Verso: Study for a saint with hammer. Ascr. to Puligo in old handwriting.

484B No. 237—Draped figure kneeling towards l. Bl. ch. and wh. 20.5 by 28.5.

484C No. 238—Madonna with the two Children. Verso: A draped and a naked male figure, possibly study for doubting Thomas. Bl. ch. and wh. 13.5 by 10.

484D No. 240—Draped male figure kneeling in profile to l. Bl. ch. and wh. 22.5 by 15.

484E No. 242—Christ among the Doctors. Bistre and bl. ch. 23.5 by 14. Very realistic Jewish types and hats.

485 No. 472—Sketch for the Louvre *Noli me tangere* [(Gabelentz, I, fig. 5)]. Ascr. to Albertinelli. 19 by 21.5. Braun 63516. [Alinari 1252. Venturi, IX, i, p. 257.] Advanced variant of the Uffizi sketch, my 247 verso.

486 No. 2187—(His de la Salle, No. 5)—Sketch for Circumcision. Pen. 16 by 20. Verso: Five studies for flying and dancing angels. Braun 63752/3. I cannot believe that these are, as Gabelentz suggests, copies by Albertinelli after two sheets in the Uffizi (see my 245 and 279, Fig. 436).

487 PARIS, Louvre, No. 2189 (His de la Salle, No. 7)—Madonna. Pen and wash height. with wh. on pink prep. paper. 22 by 16. [Giraudon, 7.] Very early. Verso: Madonna standing with infant John. [E. Sandberg Vavalà, *Burl. Mag.*, LV (1929), p. 14. Alinari 1251.]

488 No. 471—Way to Golgotha—after Schongauer. 14 by 20. Braun 63642.

489 No. 470—Two drawings on same mount, female saints, copied from some German master. 15 by 12; 15 by 11.

490 No. 469—Christ at the Well. See my 281 (Fig. 438). Verso: Two Madonnas. 13 by 11. Braun 63751.

490A No. 1808—Naked *putto* running from r. to l. Bl. ch. 25.5 by 17. Ascr. to Sogliani. Arch. Ph. Probably for an infant Baptist as in the Panshanger Madonna (Knapp, fig. 63).

490B No. 1104—Four studies for infant Baptist. Bl. ch. and wh. 19 by 26.5. Verso: Saint turned to r. Rather weak in quality.

491, 492, 493—Not to be traced.

494 (see 203M and 203N)

Louvre (formerly Bonnat Collection)—A number of sketches bound in a book, nearly all with the pen and ink, and averaging about 20 by 15 cm. in size. The following are the more important (these are now in the Louvre, numbered R. F. 5549-5572):

495 Apostle and monks. Pen. 11 by 16.5. Verso: Flagellation.

496 Entombment (p. 157). Pen. 16.5 by 23. Pl. LXXXIX of F. E. Verso: Holy Family and angels.

497 Visitation. Pen. 11 by 16.5. Verso: Two draped figures.

498 Annunciation. Pen. 11 by 16.5. Verso: Visitation.

499 Annunciation. Pen. 14 by 14. Ede, pl. 71. Verso: St. John in the Wilderness (p. 157). Pl. xc of F. E.

500 Expulsion. Pen. 20.5 by 16. Verso: Crucifixion.

501 Various studies. Pen. 23 by 16. Verso: Visitation and an angel.

501A Studies on back and front of angels for the S. Maria Nuova fresco of the Last Judgement. Pen and bl. ch. 16.5 by 22.5.

502 The two Holy Children in landscape—a Leonardesque motive well known through two versions by Marco d'Oggiono, one at Hampton Court, the other in the collection of Mr. Ludwig Mond of London. R. ch. 22.5 by 16. Verso: *Noli me tangere.*

503 Study for Entombment. Verso: Holy Family and angel.

503A Louvre, Edmond de Rothschild Bequest—Angel for an Annunciation. Pen and ink on wh. paper. 16 by 11.5.

503B École des Beaux-Arts—Study for figure seated on ground, possibly for St. Joseph in Rest in the Flight. Bl. ch. and wh. 24.5 by 18.5. Giraudon 28124.

503C Studies for *putti* in various attitudes, one dancing, one playing on cornemuse, one crouching on ground. Bl. ch. and wh. 19.5 by 15. Giraudon 28123.

504 ROME, Corsini, Print Room, No. 127618—Madonna enthroned, with Catherine kneeling to l., a saint standing beside her, and to r. St. Stephen recommending a prelate as donor. Bl. ch. and wh. 25.5 by 19. Anderson 2817. [Rusconi, *Emporium*, 1907, p. 275.] Possibly an early sketch for the Louvre Marriage of Catherine [(Gabelentz, I, fig. 10)] which, however, is more crowded, and lacks the donor. It suggests the Besançon picture [(Gabelentz, I, fig. 13)]. Summary, but in essentials excellent.

505 No. 130496—Study for the very early miniature-like Circumcision in the Uffizi [(Gabelentz, I, fig. 2)]. Pen and wash. [Anderson 31344. Not in F. B.'s ordinary technique, more pictorial, in short more like Rosso Fiorentino or Beccafumi. Not impossibly copy by a master of their type, though I still think it more likely by F. B.] Verso: Three figures.

506 No. 124058—S. Antonino giving alms (p. 158). Pen and wh. 32 by 21.5. Anderson 2816.
Fig. 444 [Rusconi, *Emporium*, 1907, p. 269.]
 A subject, to my knowledge, treated but once again, and that by the one Venetian whom F. B. so frequently and so singularly recalls, Lorenzo Lotto. The latter's version is more animated and dramatic. The drawing, as befits the more academic traditions of Florence, is clearer and more harmonious in arrangement.

506A STOCKHOLM, Print Room, Inv. 140—Apse of Romanesque church and other buildings on hill, also a steep path leading through arch. R. ch. 11.5 by 25.5. According to Professor Hülsen, view of SS. Giovanni and Paolo taken from the Palatine.

506B Inv. 280, 282—View of town with Renaissance buildings by river. Pen and bistre. 16 by 22. Schönbrunner & Meder, 1194. Sirén, *Dessins*, opp. p. 43. Verso: Two studies for Christ on the Cross.

506C Inv. 284—Landscape with mountains in background, fortified town by river in middle distance, ruin and tiny figures in foreground. Pen and bistre. 14.5 by 16. Sirén, *Dessins*, opp. p. 42.

506D TURIN, Royal Library, 15615—Two studies for kneeling saints. Bl. ch. 38 by 25. Anderson 9805. Verso: Study for Christ carrying Cross and another person's hand supporting it.

507 (see 2754L)

508 (see 2754M)

508A (former 2765) VENICE, Academy, No. 64—[Study from model for figure] kneeling to r. with long robe dragging behind. Catalogued as "Ignoto secolo xiv." Bistre and wh. and pink ground. 20 by 24. [Photo. S. I. May be for Magdalen at foot of Cross.
 The fact that I ascribed this sheet 35 years ago to "Tommaso" is interesting in connection with the problem of this Anonimo's identity. It would seem to encourage those inclined to hold that he was Piero di Cosimo. Other traces of "Tommaso" that appear in early drawings by both F. B. and Albertinelli point to the same conclusion.]

509 VIENNA, Albertina, S. R., 111—Angel, and St. Catherine (p. 158). Bl. ch. and wh. on brown paper. 30 by 42. Braun 70016. Pls. 61 and 433 of Schönbrunner & Meder. [Albertina Cat., III, Nos. 151, 152. Venturi, IX, i, p. 279.] Two separate drawings mounted together.
 The angel, as Professor Wickhoff already observed, is a study for the one in the lower l.-hand corner of the Vision of St. Bernard [(Gabelentz, I, fig. 4)]. The saint is for the picture at Lucca, representing God the Father with the Magdalen and St. Catherine [(Gabelentz, I, fig. 8)].

510 S. R., 115—Assumption of the Virgin. Red ch. and wh. on pink prep. paper. 21.5 by 16. Pl. 565 of Schönbrunner & Meder. [Albertina Cat., III, No. 155. Late.]

511 VIENNA, Albertina, S. R., 119—Two sketches of young man holding book. R. ch. 25.5 by 19. Braun 70017. [Albertina Cat., III, No. 153. Knapp, fig. 52. Venturi, IX, i, p. 295.] Studies from the life for St. Bartholomew in the Uffizi Marriage of St. Catherine [(Gabelentz, I, fig. 11). Compare with my 464 and 277.]

511A S. R., 322, 323, 324—Three landscapes with buildings and trees in pen and bistre. 10.5 by 21, 11 by 21, 26 by 21. Albertina Cat., III, Nos. 148, 149, 150. Schönbrunner & Meder, Pl. 1655 reproduces 322; also Knapp, fig. 44.

511B Inv. 24526—Study for St. Mark in the *Salvator Mundi* altar-piece at the Pitti (Gabelentz, I, fig. 20). Bl. and r. ch. and wh. Squared for transfer. 28.5 by 20. Albertina, II, pl. 42; Cat., III, No. 154.

512 (see 390D)

513 (see 390B)

514 (see 390D)

515 (see 390D)

516 (see 390D)

517 (see 390D)

518 (see 390D)

519 WINDSOR, Royal Library, No. 12783—Madonna standing in midst of five kneeling angels, a monk and the infant John. Pen. 22 by 16. Braun 79092. Early.

520 No. 12782—Madonna standing in midst of [five] kneeling angels, and the infant John. Pen. 22 by 16. Braun 62093. Early. Verso: Madonna with two kneeling angels. Braun 79090. [Knapp, fig. 20. Venturi, IX, i, p. 249.]

521 No. 12785—Floating angel seen in profile to r. Pen and wh. 12 by 15.

522 No. 12784—Temptation of St. Anthony. Pen. 16 by 22. Braun 79096. [Knapp, fig. 65.] Verso: Woman with child flung over her shoulder, running before a horseman. Braun 79095. Rather tame. Early.

523 No. 12786—Madonna seated, and kneeling Joseph presents infant John. Pen. 22 by 16. Braun 79094. Early. Verso: Baptist and another saint conversing.

524 No. 12787—Study for altar-piece. Madonna enthroned with four saints standing, and two angels seated on steps. Pen. 20 by 16. Braun 79091. [Knapp, fig. 120.] Verso: Madonna seated. [From the Venetian period.]

525 No. 12781.—Madonna draped in Venetian fashion, with Child on lap. Pen. 16 by 11.

526 No. 12788—Madonna with Child. Pen. 16.5 by 11.

527 No. 12789—Five saints, three male and two female, in conversation. Pen. 16 by 22. Braun 79098. [Knapp, fig. 6.] Early.

528 No. 12779—Verso: Madonna in r. ch., and draped female in pen. 15.5 by 10. [The drawing on recto by another hand.]

528ᴬ WINDSOR, Rᴏʏᴀʟ Lɪʙʀᴀʀʏ, No. 12780—Female figure draped in antique fashion with torch in r. hand and water-spouting Dolphin at her feet. Pen. 22 by 15.5. Braun 79097. Verso: Similar figure with r. arm raised. Rather feeble but interesting for being such close copies of classical motives.

School of Fra Bartolommeo

528ᴮ CAMBRIDGE (Mass.), Fᴏɢɢ. Mᴜsᴇᴜᴍ, Lᴏᴇsᴇʀ Bᴇǫᴜᴇsᴛ.—Angel of Annunciation kneeling in profile to r. with lily in r. hand and l. hand held up. R. ch. on buff ground, pricked for transfer. 20.5 by 15. It is possible that this pleasant drawing is by Tommaso di Stefano Lunatti, known by a large Nativity in the Capponi Villa at Arcetri (*Dedalo*, 1929, p. 468), and more than one signed portrait. The little known about him will be found in Vasari, IV, p. 570; V, p. 129.

529 FLORENCE, Uғғɪᴢɪ, No. 344ꜰ—Madonna seated; on r. two angels presenting infant John, and on
Fig. 434 the l. an angel and Joseph kneeling (p. 156, note). Pen, wash and wh. on bluish prep. paper. Diameter 16.5. Braun 76112. Verso: Virgin seated with the two Infants at her knee, Joseph and Elizabeth. Pen on wh. paper. Brogi 1891. This leaflet is ascr. to P. di Cosimo, but a comparison with any of F. B.'s early drawings must convince one that it is an old copy after an original by the same hand.

529ᴬ LONDON, Oᴘᴘᴇɴʜᴇɪᴍᴇʀ Cᴏʟʟᴇᴄᴛɪᴏɴ (formerly) No. 100—Madonna enthroned with angel and Tobias and Augustine. Pen and bistre wash. 22.5 by 21.5. Photo. Gray. Between Ridolfo Ghirlandajo and Sogliani.

Benozzo Gozzoli (pp. 6-11)

529ᴮ (former 2387) [CAMBRIDGE, Fɪᴛᴢᴡɪʟʟɪᴀᴍ Mᴜsᴇᴜᴍ],¹ formerly G. T. Cʟᴏᴜɢʜ—Various studies for figures
Fig. 41 of the Baptist, Paul, Nicholas, female saints, etc. (pp. 11, note; 146). Bistre and wh. on pinkish ground. 19 by 23.5. Pl. ʟxxx of F. E. Verso: The Florentine lily and two studies for a Madonna [with a saint to each side]. Bistre on pinkish ground.

[It is hard to understand what made me, when I first saw this sheet of drawings some five and thirty years ago, ascribe it to Cosimo Rosselli. It seems to have all the peculiarities of type, technique, purpose, and quality that characterize B. in his middle years. The sketches on the obverse would seem to have been made for an altar-piece with standing and kneeling figures.]

529ᶜ (former 539) [CAMBRIDGE (Mass.), Fᴏɢɢ Mᴜsᴇᴜᴍ], Cʜᴀʀʟᴇs Lᴏᴇsᴇʀ Bᴇǫᴜᴇsᴛ, No. 123—St. Augustine sitting under tree, suffering from toothache. A man addresses him, and behind him appears a woman kneeling, and between them a woman standing. To r. a figure sketched so hastily as to be scarcely decipherable. In the background are town-wall and a running stream (pp. 11, 83). Pen on prep. paper. 10 by 15. Vasari Soc., I, iii, 5. Van Marle, XI, p. 191.

This drawing, as is sufficiently proved by an inscription [transcribed by Venturi in *L'Arte*, 1910, p. 288], was intended for the frescoes at S. Gimignano depicting the story of St. Augustine; but owing doubtless to the triviality of the episode, was slightly changed to represent St. Augustine moved by a voice from heaven, while reading St. Paul, in the presence of his friend Alipius. As the fresco comes between the window and the wall, the oblong composition of the drawing had to be narrowed. In quality it is not quite on a level with one or two of B.'s earlier drawings. The line, for instance, is not so delicate. The modelling, however, is excellent.

1. [See my 161ᴬ for one of B.'s earliest drawings, a St. Matthew, also at Cambridge.]

530 CHANTILLY, Musée Condé —Sheet containing Christ as Judge, and two angels, studies for a Last
Fig. 28 Judgement. Above, an angel in profile kneeling, and the palm of a hand (pp. 7-8). Bistre
wash height. with wh. on buff prep. paper. 25 by 15.5. Braun 65010. [Schottmüller,
p. xxxiii. *Dessins de M. A.*, No. 51. Van Marle, X, p. 137.] Verso: Head of monk (p. 8).
Fig. 29 Apparently a portrait of Fra Angelico [Van Marle, X, p. 128. It is worth noting that the
angel in the lower l.-hand corner of the recto occurs on folio 19 of the Koenigs sketch-
book (my 558ᴮ, Fig. 50), most of which drawings are after originals by B.]

531 Saint reading (p. 9). Bistre on wh. paper. 19 by 14. Braun 65009. Verso: Study for
Fig. 31 Evangelist looking straight before him with r. hand held out, and book on l. knee (p. 9).
Giraudon. J. W. Goodison, *Burl. Mag.*, LIX (1931), opp. p. 214. [In the ceiling of the
Madonna della Tosse at Castel Fiorentino painted by B. after 1484 this figure occurs with
slight variants (Alinari 19223).]

531ᴬ DARMSTADT, Landes Museum, No. A. E. 1297—Ambrose preaching from wooden pulpit to women
Fig. 43 squatting on the floor and men standing, or sitting on bench. Conspicuous among the
last is Augustine (p. 83). At the bottom in B.'s own hand: " come santo Aughustino stava
alla predica di santo Anbrosio." Pen on wh. paper. 8 by 9.5. *O. M. D.*, VII (1932/33),
pl. 22.
 Charming, almost lyrical sketch for the fresco in S. Agostino at S. Gimignano (Ali-
nari 9549). In the finished work this episode had to be combined into one composition
with another representing Augustine disputing and necessitated a rearrangement of the
figures. The painting is so damaged that it is not fair to compare its quality with that
of the well-preserved drawing—companion, by the way, to my 529ᶜ in the Loeser Col-
lection. I owe my first acquaintance with the Darmstadt drawing to Dr. Georg Gronau.

532 DRESDEN, Print Room—Full-length figure of St. Michael holding hilt of sword in r. hand, and globe
Fig. 30 in l. Above him a nude *putto* walking (pp. 9-10). Bistre wash, on wh. paper rubbed with
r. ch. 24.5 by 14. Pl. ᴠɪ of F. E. [Schottmüller, p. xxxii. Van Marle, X, p. 139.] Verso:
Lion and nude youth with mantle on his wrist. Sp. and wh., on brownish prep. paper.
[The nude *putto* occurs on folio 19 of the Koenigs sketch-book (my 558ᴮ, Fig. 50), most
of the drawings in which are copies after B.]

533 Monks under porch receiving girl saint. She is attended by her woman friends (p. 10).
Fig. 33 Pen, with slight touches of pink ch. on wh. paper. 16 by 10. [Vasari Soc., I, iii, 3.
Meder, *Handz.*, fig. 607.]

533ᴬ EDINBURGH, National Gallery, No. 1249—Heavily draped elderly saint kneeling in profile to r.
with hands clasped in prayer. Pen height. with wh. and gone over with reddish wash.
16 by 10.5. Photo. Museum. From B.'s ripest years.

534 FLORENCE, Uffizi, No. 12ᴱ—Gabriel, kneeling almost in profile to r., with r. hand held out from
elbow, and l., with olive branch in it, kept close to knee. Bistre wash height. with wh.
on pink prep. paper. 20 by 14.5. [Fototeca 2097.]
 In attitude and silhouette this figure is identical with the Angel of the Annunciation
in the *predella* of the Lateran picture painted in 1450. Nevertheless, the more robust
type, and the better understanding of the draperies, bespeak a considerably later date for
the drawing. If we examine the Gabriel in the fresco of the Camposanto at Pisa, painted
by B. towards the end of his career, we shall see that there also he has not changed in
outline, but grown still more robust, even heavy. The inference is that B. had small power
of reacting against, or advancing upon, his first well-learned lessons. He had learned to
draw certain silhouettes, and was, at need, ever ready to use them like so many punches.
What change was inevitable had to take place within the fixed outlines, because to alter
these required serious command over the figure in action, and that apparently cost him too
much trouble.

Verso: Powerful male nude walking along facing to l. He wears a cap and holds his hands as if with both he were carrying a club. He may have been studied for a Hercules. Pen. [Fototeca 2098.] Scarcely autograph.

534ᴬ (former 1844) FLORENCE, Uffizi, No. 62ᴱ—Study of slender youthful figure seated on ground which he touches with both hands. His r. leg is curled under him. The attitude suggests a shepherd roused by message of angel in a Nativity. Also three studies for drapery. Bistre on wh. paper. 13 by 18. Brogi 1661. [Seems by B. in a Pesellinesque moment. The sketches on verso are by later hand.]

534ᴮ (former 171) No. 101ᴱ—[Madonna seated visible nearly down to feet, holding Child on her l. knee (p. 6).
Fig. 36 Bistre and wh. Oval 14.5 by 11.5. Braun 76016. Alinari 1882. Brogi 1607. Schott-müller, p. xvii. Van Marle, X, p. 143.

As close as possible to Fra Angelico but I no longer (1935) hesitate to give it to B. himself. In the Koenigs sketch-book (my 558ᴮ: photo. Cooper 58958, *Riv. d'A.*, 1930, p. 89) there is a copy of this Madonna as she looked before this leaf was mutilated. Her draperies spread over her feet, which rest on a platform. The character seems singularly Benozzesque, as might be expected of one who had learned to draw under B. and not like B. himself under Fra Angelico.

Fig. 37 Verso: Bust of little boy. Sp. and wh. on brown prep. paper. Brogi 1829. It seems to me now (1935) done with an almost unexpected freshness, directness, and veracity. Somewhat later perhaps than the Madonna.]

534ᶜ No. 333ᴱ—Elaborate study for rectangular composition representing Totila's camp close
Fig. 35 to S. Ercolano, with the houses and towers of Perugia rising above it. The lower r. quarter of the drawing is in a poor state and leaves it doubtful if it was originally filled with figures. If there were any they represented the finding of S. Ercolano's body (pp. 329-330). Sp. and wh. on purple prep. ground. 32 by 42. Van Marle, XIV, p. 110. Brogi 1838ᴮ. Fototeca 12663. W. Bombe, *Geschichte der peruginer Malerei*, Berlin, Cassirer, 1912, p. 111. *L'Arte*, 1932, p. 90. This study, though catalogued as by Bonfigli, is clearly by B. in his first Umbrian period.

535 (see 1866ᶜ)

536 No. 20ꟳ—Head of a little girl seen full face, simple and severe. This would seem to have been done from life by B. at S. Gimignano, or soon afterwards at Pisa. Pen and wh. on pink prep. paper. 14 by 9. [Van Marle, XI, p. 218. Fototeca 7135.]

536ᴬ No. 21ꟳ—Matron seated looking down at something held between her two hands on her
Fig. 46 lap. She seems to be sewing. Pen wash and wh. on pearl prep. paper. 17.5 by 17. Fototeca 12548.

This might be a study for a woman in B.'s Camposanto frescoes, but she does not occur in any of them still preserved. And yet this sketch may have been done in connection with them and certainly was done at the same time. Some of the women there recall Cossa. This one recalls that master, and Piero della Francesca and even Cézanne. It is not a resemblance confined to type only. The lighting, the volumes, the space relation, are singularly suggestive of the two artists last named.

537 No. 1358ꟳ—Cardinal followed by acolyte. Inscribed in an oldish hand "Giulio da Forlì,"
Fig. 39 and therefore attributed to this otherwise unknown painter (p. 11). Pen. 12 by 6. Pl. viii of F. E. [C. Loeser, *Rass. d'A.*, 1903, p. 178. N. Ferri, *Boll. d'A.*, 1909, p. 374.]

How came this ascription of a genuine drawing by B. to an unheard-of name like this? I have no suggestion to offer, yet it may not be without interest to note that in 1447 a Pietro Iachomo da Furli was, along with B., assisting Fra Angelico in St. Peter's (see *Spogli Vaticani*, by Adamo Rossi, in *Giornale di Erudizione Artistica*, VI, p. 151).

537A (former 1891) FLORENCE, Uffizi, No. 14497F—Head and shoulders of child. Bistre and wash.
Fig. 44 9.5 by 7.

> [This was catalogued in the first edition as being by Pier Francesco Fiorentino, which would now mean Alunno di B. But it seems too spirited for that draughtsman at his best, and despite interrupted contours the attribution to B. himself is the more acceptable. The type and expression recall children in the Riccardi Chapel, and in the Camposanto frescoes.]

538 No. 26S—Study of architecture and landscape. In foreground a pavement tesselated with
Fig. 48 squares of pink, blue, buff and wh. marble. To r., standing upon this pavements, an arcade of three arches supporting a palace. To l. two palaces seen in profile. Beyond them the country, stretching upward to a hilly horizon. The buildings are pinkish brown, the openings in bistre, the landscape brown and grey, the sky white and grey. 30 by 27. [Fototeca 5324. Uffizi Publ., V, iv, 6. Degenhart, *Zeitschr. f. Kunstg.*, 1935, p. 123.] There is nothing in this design which as draughtsmanship is peculiarly B.'s; but the colouring is his, so that the attribution to him is probably correct. If his, then from his last years. [In 1931 this seems to me to be one of B.'s most convincing as well as most interesting drawings.]

539 (see 529C)

540 LONDON, British Museum, 1885-5-9-38—Madonna appearing to girl saint, who sits up in her bed.
Fig. 34 She is attended by male and female friends (p. 10). Pen on pinkish prep. paper. 18 by 15. Pl. VII of F. E. [Vasari Soc., I, iii, 4. Van Marle, XI, p. 189.]

540A Pp. I-2—Sketch for Deposition taking place in foreground with Calvary in middle distance
Fig. 51 and landscape beyond. The Saviour is held almost erect between two groups of disciples, while the Magdalen kisses His feet. Bistre and wh. 13.5 by 10.

> Pictorial and spirited, from end of B.'s middle period, when the artist painted the splendid Deposition now in the Horne Collection, Florence. It is not impossible that despite so many important differences the drawing was a first thought for that picture. On the other hand, the half circle at the bottom seems to contain the head and shoulders of a figure conceivably for a Dead Christ. This may mean that the sketch was for a fresco to go over another or over a stained glass window.

541 Pp. I-9—Roundel containing figure of St. Francis holding cross in r. hand, and pointing with his l. Bistre and wash, on buff ground. Diameter 11 cm. Braun 73010. Ascr. to Angelico, but clearly not his. The type, the pointing hand, the folds, all speak for B. It probably was intended for a St. Francis, to be painted on the frame of an altar-piece, or along with other roundels under some fresco. [Verso: Two drawings for a console and one for a volute. Bistre and wh. on greenish paper.]

542 British Museum, Malcolm, No. 8—Bare-headed young man, in cloak, pointing with r. hand
Fig. 32 as he walks. Following him a turbaned youth, in jerkin and hose, with sword dangling by his side, and l. hand held out. He doubtless served for a young king carrying a monstrance in his hand in an Adoration of the Magi (p. 11). Pen slightly washed with bistre, on pink prep. paper. 20 by 16.5. Pl. IX of F. E. [Van Marle, XI, p. 219.]

543 No. 9—Design for Presentation of the Virgin in the Temple. Pen outline, bistre wash, buff for halos and some of robes, and pale pink for roofs (pp. 11, 12, 329). 21 by 28. [*L'Arte*, 1932, p. 95.]

> This is ascribed to Neri di Bicci, but is a most intimately characteristic work of B.'s middle years. What could be more his than the types, the architecture, and the arrangement? To make comparisons with other drawings alone, note the likeness between the Virgin and the young female saint in the small design at Dresden, and the resemblance

between the figures on either side of the High Priest and one in the other small design at the B. M. Like those, this Presentation was probably a sketch intended for the employer's eye, but is freer and bolder, although at the same time much less delicate. [This "model" was made for the Chapel of the Visitation now attached to the Conservatorio di S. Chiara outside Castelfiorentino on the road to Castelnuovo, dating from about 1484, when B. frescoed the Cappella della Tosse at some distance farther on the same road. The lower part of the fresco (Alinari 19222) has disappeared, but it is clear from what remains that the sketch is superior to the painting. For the latter the composition had to be narrowed and made more vertical.]

544 LONDON, South Kensington Museum, Dyce Collection, No. 173—Madonna seated with angel on each side. To l. on larger scale than the other figures a saint adoring. To r. a youth seated, seen from behind, painting. Bistre wash and wh. (which has turned bl.) on brown paper (p. 11, note). 14.5 by 19.5. [Van Marle, XI, p. 220. H. Reitlinger, *Selection of Drawings in the V. and A. Museum*, London, 1921, pl. I. Verso: Seated figure in monastic robes wearing kerchief. Three youthful shepherds, one kneeling in worship, another playing bagpipes, the third dancing. These obviously for an Adoration of Shepherds. Photo. Museum. Front and back close to Alunno di B.]

544A Savile Gallery—Draped female figure, seen from behind. Pen on pink prep. paper. 18 by 8. Vasari Soc., I, viii, 2, and in Cat. of Savile Gallery, 1930, 13. From B.'s early middle years, and of his best quality, resembling a figure in my 540 (Fig. 34), as well as the woman with the child in the Miracle of Greccio at Montefalco (Van Marle, XI, p. 138).

544B Earl of Harewood—Virgin erect in Gothic tabernacle carried by angels. Study for a Transfer of the Holy House of Loreto. A subject not infrequently treated in Urbino. Pen height. with wh. on pink prep. ground. Verso: Two kneeling and two standing angels for frescoes in Riccardi Chapel, also studies for two hands. Vasari Soc., I, x, 1A and 1B. Verso in Van Marle, XI, p. 225; and Popham Cat., No. 24. Interestingly different calligraphy and technique, but probably done about same time. The Madonna is later, if anything, than the angels. Bl. ch. and bistre on pink prep. ground, the architecture almost entirely coloured.

544C MUNICH, Print Room, 345-20—Choir of church with flat roof, and early Renaissance forms but Gothic
Fig. 42 window at end. To l., against arches of low structure behind which rise sumptuous buildings, appear nine figures seemingly discussing. At their feet an oblong geometrical object in perspective (pp. 12, 329). The figures sketched lightly with the pen and here and there touches of colour. The buildings are in almost full colour. 18 by 24. *L'Arte*, 1932, p. 99. Verso: Capital of column in ink, horseman with steed galloping and two sketches of further horsemen. Originally in bl. ch. The first gone over with ink possibly by Alunno di B. *L'Arte*, 1932, p. 99. Note that this is apparently the only trace of bl. ch. found in B.'s drawings.

The obverse was a study for the fresco representing the Expulsion of Joachim from the Temple in the chapel for which my 543 was another study. The architecture in the drawing is almost identical with that in the painting except that there is more of it on our r. than in the painting. The figures correspond only in the bystanders on our l. This sketch thus represents an early stage in the search for the final composition, and that perhaps accounts not only for a certain scratchiness in the figures but a wobbliness in the perspective which naturally was corrected in the fresco.

544D PARIS, Louvre, Edmond de Rothschild Bequest—Head of youth almost in profile to r. with mouth wide open and wearing round cap. Bistre wash and wh. on washed brownish ground. 16 by 11.

545 (see 559G)

545^A ROTTERDAM, MUSEUM BOYMANS —Naked youth wearing hat with three plumes holding long cane
Fig. 38 in r. fist, his l. hand extended (p. 328). Sp. and wh. on r. prep. ground. 17 by 6.5.
Amsterdam Exh. Cat., No. 555-556. See Van Marle, XI, p. 227, where it was first published.
Fig. 40 Verso: Naked youth leaning on staff in r. hand, while his l. arm is akimbo. I owe my
acquaintance with this sketch to the photo. which Dr. Van Marle procured for me. From B.'s
earliest years and companion to my 545^B. The three plumes are a Medici device and may
indicate that the sketch was for a painting ordered by the family.

545^B (former 545^A) STOCKHOLM, PRINT ROOM, Nos. 57 and 58 —Nude young man standing with reed in r.
hand; behind him a lion. [Sp., pen and bistre height. with wh. on greenish prep. ground.
22.5 by 15.5. Pl. I of Stockholm Dr. Schönbrunner & Meder, 1086.] Verso: Cherub's head
seen against halo with eight wings decoratively arranged. Pen and bistre on ruddy ground.
[Sirén, *Dessins*, opp. p. 16, as Fra Angelico. Attr. to B. in his cat. of 1917.] The face of the
cherub, the features, the hair are clearly B.'s and to no other master can we attribute the
nude young man. We find him again clothed in that loveliest work [of B.'s youth], the
Rape of Helen in the N. G. (No. 591). This should also be compared with B.'s St. Se-
bastian at Montefalco, or better still with another St. Sebastian at S. Gimignano (Ali-
nari 9559).

545^C Inv., 34 —Study for Francis turning to r. with hands held out in surprise. Bistre and wh.
on brownish yellow ground. 20 by 15. Attr. by G. Gronau to Sassetta in *O. M. D.*, VII
(1932/33), pl. 2. By the young B. or possibly Bonfigli.

545^D VENICE, ACADEMY, No. 102 —Head of youth wearing cap, and back of head of small boy. Bistre
Fig. 47 and wh. on pink prep. ground. 22.5 by 8.5. Van Marle, XI, p. 140. Verso: St. Louis
Fig. 49 of France with rosary. Study for the fresco in the choir of S. Francesco at Montefalco
(Alinari 5439). Pen on wh. paper. First publ. by Charles Loeser (*Rass. d'A.*, 1903, p. 178).
Fogolari, pls. 71 and 72.

This fragment of drawings done for or in connection with the frescoes at Montefalco
is intrinsically delightful. The head is as vivacious and well drawn as any B. ever did,
and the pen-sketch of the saint offers a valuable piece of evidence toward the solution of
the question whether certain drawings are by him or his master Fra Angelico.

546 WINDSOR, ROYAL LIBRARY —Head of youth, smooth faced and curly haired, turned little to r. with
Fig. 45 frank, direct look. Sp. and wh. on brown prep. paper. 23.5 by 17. [Cooper 58508.
T. Borenius, *Pantheon*, 1930, p. 142. Popham Cat., No. 23.] The execution is not quite
on a level with the excellence of the conception, but the whole is not unworthy of B.
Verso: Four saints. Pen. Not unlike those on the verso of my 176, by a feeble follower
of Fra Angelico. B. thus would seem to have drawn his head on the back of some
sketches by a fellow pupil. It is probable therefore that this head dates from his early
years, before he had left Angelico's workshop.

School of Benozzo Gozzoli

546^A (former 164) BERLIN, PRINT ROOM, No. 1351 —Youthful Evangelist. Study for a Crucifixion. Bistre
and wh. on greenish paper. 14 by 4.5. [Close follower of young. B. Another copy of
same original by B. occurs on folio 7^B of Koenigs sketch-book (my 558^B: Cooper 58959).]

547 No. 5107 —Four heads [of angels], two full-face, and two in profile. Bl. ch. and wh. on
brown paper. 24 by 14. [Now correctly attributed to Niccolò da Foligno. Ede, pl. 16.
Van Marle, XIV, p. 61. Fischel, pl. II.]

547A CAMBRIDGE (Mass.), Fogg Museum, Paul J. Sachs Collection—Sketch for figure flying to r., and separately of each hand. Bistre and wh. on brown prep. paper. 21.5 by 17. No. 35 of Boerner Sale Cat., Leipzig, 1924, pl. II. Cat. of Savile Gallery, 1929, No. 40.

This charming sheet may be by B. in his Umbrian phase, but more likely by his gifted Perugian pupil B. Caporali. Another interesting version of the same subject is in the Loeser Collection (Fogg Museum, Loeser Bequest, No. 380), which may be by Albertinelli or Sogliani.

548 (see 1864A)

549 (see 1864B)

550 (see 1866B)

551 (see 1866D)

552 (see 1867A)

553 (see 1867B)

554 (see 1867C)

554A FLORENCE, Uffizi, No. 107E – Kneeling female figure. Bistre and wash height. with wh. on pinkish prep. paper. 12.5 by 9.5. Verso: Saddled but not bridled horse walking to r. Sp. and wh. on brown paper. Studio drawings from B.'s early Umbrian years.

555 (see 1868A)

556 (see 1872)

557 (see 1873)

558 (see 1874B)

558A GIJON, Istituto Jovellanos, No. 2—Sketch for composition representing story of the children of Korah. Pen and wash on grey paper. 24 by 40. Gijon Dr., pl. I.

Faithful although later, probably 17th century, copy of the fresco in the Camposanto at Pisa for which B. was paid in 1481. The painting has disappeared but this sketch gives us a fair idea of the arrangement and quality of the composition. One wishes more ruined and lost paintings were as well recorded.

558B HAARLEM, Franz Koenigs Collection —Sketch-book containing twenty leaves with various drawings of entire figures, heads, hands, feet, and details of architecture (pp. 9, note; 11, note; 330). Fully described by A. E. Popham in *O. M. D.*, IV (1929/30), pp. 53–58, pls. 54–56, and discussed by him as well as by Mario Salmi in *Riv. d'A.*, 1930, pp. 87–95. Between them they reproduce seven of the drawings, and Cooper of London photographed them all when they were shown as No. 429 at the Italian Exhibition of 1930.

They seem to have been produced in the studio of B. If found separated from the contaminating vicinity of inferior work, one might be tempted, but should resist the temptation, to give the three following to the master himself:

Fol. 5—Magdalen kneeling and to her l. John the Evangelist, study for a Crucifixion. Below on smaller scale Francis in prayer and just over lower margin small head of friar. Cooper 58955.

Fol. 6B—Four figures: Cardinal looking down to r., youthful nude, novice kneeling, and youtful friar approaching him. Perhaps in connection with works of the Montefalco period. Cooper 58961.

Fol. 8^B—Friar seen from back sitting on pedestal to our r. Perhaps for a composition representing a saint preaching or teaching. Cooper 58973.

None of the others come quite so close to B. The portrait head on fol. 3 has reminded Carlo Gamba as well as myself independently of Boccatis of Camerino, although the derivation from the portrait heads of B. at Montefalco, for instance, is patent. The feet on fol. 5^B and 6, drawn from the cast, are almost indentical with a sheet in the Uffizi that used to pass for Castagno's (No. 67^E, my 1866^A). The mourning John the Evangelist of fol. 7^B (Popham Cat., No. 26; Cooper 58959) is the copy of the same original as my 546^A. On fol. 10 is a nude seated with his r. hand on his knee and his l. caressing the sole of his r. foot. This is copied either from my 176 or from the original Fra Angelico of which the last itself was the copy. It is interesting to compare the two copies. The one in our sketch-book is hard and yet flickering, while the other is suave and plastic.

A number of the drawings in this book are done with the same technique, sp. height. with wh. on prep. grounds, and share the same qualities, e. g. 9^B, 11^B, 12. These and the elaborate floral scrolls e. g. 1^B, 2, 18^B may be by an Umbrian follower of B., say the youthful Antoniazzo as we know him at Rieti and Subiaco.

Folio 10 has beside the seated nude, one sprawling on the ground which Mr. Popham describes as a copy "from a figure in the fresco of the 'Destruction of Sodom' in the Camposanto at Pisa completed by Benozzo Gozzoli in 1474 (*sic*) or perhaps from a study for the fresco," and argues that the sketch-book must have been completed about that time. There is no reason for accepting either suggestion. The fact is that B. and his pupils, like all other artists of that time, laid in while young a stock of sketches which served them for a lifetime, and this would have been especially the case with the nude in difficult postures. Even for such stock subjects, and so easy to dash off as an Evangelist in a ceiling fresco, we find that B. used the same sketch (my 531 verso) for Montefalco in 1452 and, more than thirty years later, in the Madonna della Tosse at Castelfiorentino. There is no valid reason for dating any leaf of this sketch-book later than 1460.

Fol. 11 (Cooper 58958) is a Madonna copied from my 534^B (Fig. 36), in all likelihood by B. A comparison is instructive.

Fig. 52 Fol. 16^B—The youth in profile is closer to Fra Angelico and to a head probably by the Carrand Master among the recently recovered fragments of fresco ascribed to Uccello than to B. in the Riccardi Chapel.

Fig. 50 Finally, fol. 19, besides the charming study for a Madonna of Humility, has two other sketches, one copied from my 530 (Fig. 28) and the other from my 532 (Fig. 30). I venture to believe that this coincidence confirms the attribution of these two to B. A number of other drawings here catalogued as by apprentices of the young B. may have formed part of the same sketch-book, e. g. my 559^I and most of those at Stockholm.

558^C LEIPZIG, C. G. BOERNER SALE (May 9-10, 1930)—Female bust in profile to r. with plaits wound round head. Sp. height. with wh. on pink prep. paper. 20.5 by 14.5. Sale Cat. Verso: Male head in profile to l., floating angel and two smaller heads in profile to r.

Attractive and probably by one of the authors of the Koenigs sketch-book (my 558^B) but the reproduction of the recto permits no conclusion regarding authorship or even authenticity, and the original I have not succeeded in seeing, as it passed from hand to hand too rapidly. For the same reason I could not procure a photograph of the verso.

559 OXFORD, CHRIST CHURCH, A. 10—Four nudes in various attitudes. Ascr. to Cosimo Rosselli. Bistre and wh., on buff prep. paper. 18.5 by 27. [Bell, pl. 44.]

559^A (see 559^L)

559^B PARIS, LOUVRE, No. 54—Vincent Ferrer standing in an aureole on clouds looking to r. and pointing to l. Sp. and wh. on brown paper. 18.5 by 13. Arch. Ph. Verso: Stag, ascr. to Fra Angelico, but close to my 545^C, and if not by B. himself by an Umbrian follower, most likely Bonfigli.

559[C] PARIS, LOUVRE, R. F. 435—Bust of smooth-faced middle-aged man wearing turban. Bistre wash and wh. on green prep. paper. 22.5 by 16. Alinari 1415. Giraudon 673. Umbrian follower of B. who may have had his start under a pupil of Gentile da Fabriano.

559[D] ÉCOLE DES BEAUX-ARTS, 1181—Half-length youthful Evangelist in profile to l. with hands clasped in grief. Bistre and wh. on pale salmon ground. 17 by 15.5. Verso: Virgin seated on ground, with naked Child framed in by fold of her mantle, stretching from her r. shoulder to her lap. Sp. and wh. Arch. Ph. The youthful John, intended for a Crucifixion, is Umbrian, as the hands tend to prove. The parallel semicircular folds on the forehead make it probable that the author was Caporali. The Madonna is closer to B. but Umbrian nevertheless and possibly by Caporali.

559[E] MANZI COLLECTION (formerly)—On pp. 22 and 23, Fascicule 179 (1919) of *Les Arts*, André Pérate publishes the reproduction of a large drawing after the Camposanto fresco representing the Building of the Tower of Babel. He describes it as in r. ch. and bistre, which would be an unusual technique for B., and does not claim that it is an autograph. It is a sketch that deserves attention, which unhappily I cannot give, as I have not seen the original. Another copy of the same fresco exists in Rome in the collection of Ludwig Pollak. Count Umberto Gnoli has been good enough to send me a photograph of it. It shows slight differences from the Manzi one, is executed in ink, bistre, and wh. on paper fixed on canvas, and measures 51 by 14.5. Both are interesting for what they tell about the fresco when it was less ruined and less restored.

559[F] PISA, MUSEO CIVICO, Sala XIII—Copy of the Camposanto fresco representing Solomon and the Queen of Sheba and very interesting as the original is in bad condition. Bistre and water colour. 55 by 21.5. Brogi 19392/3.

According to Bellini Pietri's catalogue this copy was in the collection of the Canonico Zucchetti, left to the Opera del Duomo in 1796, and it is not unlikely that it was the Canonico himself who ordered the copy to be done sometime in the second half of the 18th century.

559[G] (former 545) ROME, CORSINI PRINT ROOM, No. 128283—Cardinal holding kneeling bishop by hand. Pen. 22.5 by 16. Verso: Head of youngish bishop drawn over youthful nude asleep. Photos. Calderisi. Sp. on purple prep. ground. [Anderson 30029. Van Marle, XI, pp. 221, 222. Probably leaf from Koenigs sketch-book (my 558[B]); studio copy, and not as I used to think by B. himself.]

559[H] STOCKHOLM, PRINT ROOM, Inv. 31—Friar sits on bench and throws up hands at sight of snake curling toward him. Bistre wash and wh. on red ground. 22.5 by 16. Early studio. May have formed part of Koenigs sketch-book (my 558[B]).

559[I] Inv. 33—Christ giving keys to Peter. Francis in ecstasy. Full-length Virgin for a Crucifixion. Bistre on prep. ground. 21.5 by 15.5 May be a leaf out of the Koenigs sketch-book (my 558[B]).

559[J] Inv. 35—Three male heads after antique. Bistre and wh. on pinkish ground. 20 by 15.5. Early studio. May have formed part of Koenigs sketch-book (my 558[B]).

559[K] Inv. 88-89—Roman eagle, garland of oak leaves, and ribbons copied from relief in vestibule of SS. Apostoli, Rome. Bistre and wash. 15.5 by 15.5. Verso: Half-effaced head of youth turned slightly to r. and below Francis kneeling to receive the stigmata. Studio work, like those of the Koenigs sketch-book (my 558[B]).

559[L] (former 559[A]) Inv. 93 and 94—Monk and nun holding book. Pen wash and wh., on brown ground. 16.5 by 14. Sirén's *Dessins*, opp. p. 18, as Fra Angelico [but attr. to B. in his catalogue

of 1917]. Verso: Cherub's head with wings. Pen and bistre on pale red ground. Schönbrunner & Meder, 947. By a follower of B. [perhaps one of those who did some of the drawings in the Koenigs sketch-book (my 558B)].

559M VENICE, ACADEMY, No. 104—Fragment of study for portrait of youth seen down to below his r., and his only visible, shoulder, looking to l. wearing round cap. Sp. and wh. on green paper. 22.5 by 9. Photo. Fiorentini. Carlo Loeser who first drew attention to this head (*Rass. d'A.*, 1903, p. 179) ascribed it to B. himself. It is too flat and too stiff for that artist, and is more likely by an Umbrian follower, B. Caporali for instance.

559N No. 10—Cow turning head sharply to l. while calf is sucking. Bistre and wh. on lilac-pink ground. 15 by 16.5. *O. M. D.*, VI (1931/32), p. 62 and pl. 57.

I owe my acquaintance with this sketch to Mr. J. Byam Shaw, who ascribes it to B., basing his attribution on the similarity amounting almost to identity with the cow in the Riccardi Palace fresco at Florence (Van Marle, XI, p. 167). The contours seem too stiff and lifeless and the modelling too rudimentary for the master, and it is safer to ascribe this effort to a fellow-pupil or follower. Needless to add that a cow suckling a calf must have been a stock subject for young artists.

559O VIENNA, ALBERTINA, S. R., 15—Nude youth with l. hand on hip and r. holding staff. Pen and brown wash on mauve prep. paper. 20.5 by 13. Studio version of my 545B. Verso: Peter looking sentimentally down to l. with keys in r. hand and book in l. This too may be a studio version of a B. The hand that did both sides may be the same that did most of the Koenigs drawings. The fact that the nude is a copy of a B., permits the inference that others of the Koenigs sketch-book and kindred drawings may be studio versions of lost or unknown originals by that master.

559P S. R., 23—Design for Mocking of Christ. The scene is laid against a massive arch decorated with rosettes. Vociferating Pharisees and soldiers surge around the Saviour seated blindfolded on a throne. Pen and bistre. 25 by 20. Schönbrunner & Meder, 840. Albertina Cat., III, No. 17.

Close to B., and not improbably by him. There are suggestions of Pesellino and of Cosimo Rosselli. It corresponds closely to a Florentine engraving (B. XIII, 265, 12) forming part of a series representing the Life of the Virgin and her Son, which reproduced compositions by various Florentine artists of the third quarter of the 15th century. There is no reason why B. should not have been one of them. But Hind in his catalogue of the B. M. engravings (text, p. 110) inclines to believe that the drawing is a 16th century copy of the engraving.

Bicci di Lorenzo (p. 13)

559Q FLORENCE, UFFIZI, No. 58E—Our Lord in the midst of cherubim blessing as He hands the keys to the kneeling Peter while the seated Paul, sword in hand, looks on. Pen, wash and wh. on green prep. vellum. 61 by 36. Braun 76123. Salmi, *Riv. d'A.*, 1935, p. 3. This highly finished *modello* tells us little about Bicci as a draughtsman. Except in technique it has the characteristics of his paintings.

560 OXFORD, ASHMOLEAN MUSEUM—Head of middle-aged, smooth-faced Florentine burgess in profile, to l.
Fig. 63 (p. 13). Five short lines of writing in Gothic script indicating the colours. Inscribed, in much later hand: "Paulo, vcciello, delin. 1425." Hence the attribution to Uccello. Pen on pinkish prep. paper. The face coloured pink, the hood blue, and the coat light brown. 11.5 by 11. [See *O. M. D.*, IX (1934/35), pl. 28 and pp. 23-25, where K. T. Parker mentions and reproduces another profile with similar headdress and done in the same technique at the Louvre, but already by a somewhat later, more sensitive, more personal artist.]

560[A] VIENNA, Albertina, S. R., 32-35—Four heads, two in profile r., the first inscribed as "frate Andrea da Servi" and the second as "il priore die San Michele Barteldi proprio," and two to l., one with shaven crown and the other a humanist with laurel wreath (p. 13, note). Pen and bistre wash. 11 by 9, 13.5 by 10, 11 by 9, and 13.5 by 10. Albertina Cat., III, Nos. 1-4. Seemingly by the same hand as my 560 (Fig. 63), and perhaps for the same work.

560[B] Sc. V. 2—Study for Church Father writing on scroll. Sp. and wh. on purple prep. paper. 14.5 by 13.5. Albertina Cat., III, No, 7.

Sandro Botticelli (pp. 93-100, 333-334)

561 BERLIN, Print Room—Drawings in pen and ink, sketched in with the stile, to illustrate Dante's *Divina Commedia* (pp. 95-98). See F. Lippmann's publication in facsimile, *Zeichnungen von Sandro Botticelli zu Dante's Goettlicher Komoedie*, Berlin, G. Grote, 1887. Another edition reduced to half the size of the originals, and including the sheets in the Vatican Library is *Drawings by Sandro Botticelli for Dante's Divina Commedia.... with an Introduction and Commentary by F. Lippmann*, London, Lawrence & Bullen, 1896. [Three leaves repr. in Berlin Publ., 5, 6, 7; one in Popham Cat., No. 42; various others in Bode (*Klass. der Kunst*) and in Van Marle, XII.

The silver-point with which these designs were first drawn has with the rarest exceptions disappeared under the ink which has gone over it. The superiority of the illustrations that have remained without inking, as, for instance, those for Inferno XXX, Purgatorio VIII, and Paradiso XIX, is so manifest that one is tempted to ask whether B. himself did all the repassing with the pen or whether he left some of it to assistants.

I believe that a detailed examination (for which there is no room here) would reveal the presence of more than one apprentice hand, but that the larger number were gone over by the master himself. Only one must not always expect it even of him that he will not slip occasionally into calligraphic ways of inking his silver-point and thereby lose something of the sparkle of the creative effort.]

561[A] CAMBRIDGE, Fitzwilliam Museum—Madonna bending to present on her r. knee the Child, Whose
Fig. 200 foot is being kissed by a prostrate king. Above to l. Joseph leaning with head in his arms against wall (p. 333). Umber tempera on fine linen. 30 by 23. H. Horne, *Burl. Mag.*, I (1903), p. 67. Fragment of design for Adoration of Magi of which bits are my 561[B] and 569[A] (Figs. 201, 202).

561[B] (former 580)—Group of draped figures for r. part of an Adoration of the Magi, one kneeling, one
Fig. 201 stooping and the others standing (p. 333). Umber tempera on fine linen. Greatest height and width 44 by 37. Ottley, opp. p. 14. See Horne, *Burl. Mag.*, XVI (1909/10), opp. p. 40. For same composition as my 561[A] and 569[A] (Figs. 201, 202).

562 FLORENCE, Uffizi, No. 187[E]—Lunette with three angels floating and singing (pp. 95, 99). Pen
Fig. 192 and wh. on pinkish prep. ground. 10 by 23.5. Ascr. by Morelli to a pupil (*Kunstch.*). Pl. XLIV of F. E. [Brogi 1724. Photo. Mannelli. Uffizi Publ., I, iii, 19. Popham Cat., No. 40. Ede, pl. 29. Yashiro, 269. Van Marle, XII, p. 194. Bode, *Klass. d. K.*, p. XIII. Scharf, fig. 142.]

563 No. 188[E]—Study for Baptist standing (p. 94). Pen and wh. on pinkish prep. ground.
Fig. 196 36 by 15.5. Pl. XLI of F. E. [Brogi 1728. Photo. Mannelli. Uffizi Publ., I, iii, 25. Van Marle, XII, p. 199. Yashiro, 264.]

564 No. 193[E]—Study for St. Jerome (p. 95). Sp. and wh. on greyish pink paper. 24.5 by 12.5. Pl. XLII of F. E. [Van Marle, XII, p. 192. Yashiro, 265.]

8

565 FLORENCE, UFFIZI, No. 202—Angel standing in profile to r., with r. arm held up. May be brought
Fig. 190 into relation with the angels pulling aside curtains in the St Barnaba altar-piece (Uffizi 8361
[Bode, *Klass. d. K.*, 61]) and in the Ambrosiana *tondo* [(*ibid.*, 82)]. Pen, bistre wash and
wh. 27 by 16. Braun 76132. [Photo. Mannelli. Popham Cat., No. 41. Yashiro, 263. Uffizi
Publ., I, iii, 21. Van Marle, XII, p. 195.]

566 No. 209E—Nativity (p. 95). Pen and wh. on pinkish paper. 26 by 16. It has been
Fig. 193 several times folded and considerably gone over. Morelli (*op. cit.*) described it as by a
pupil of Lorenzo di Credi and B. Pl. XLIII of F. E. [Photo. S. I. 4714. Uffizi Publ., I,
iii, 20. Bode, *Klass. d. K.*, p. xlii. Van Marle, XII, p. 201. Yashiro, 270.]

566A HAMBURG, KUNSTHALLE—Youth sitting lightly to l. with legs crossed over ankles and head buried
Fig. 198 in folded arms (p. 334). Sp. on pinkish prep. paper. 16 by 11. Prestel Publ., pl. 4.
L'Arte, 1922, p. 189, where Venturi first recognized that it is B.'s. Cooper 60781. Popham
Cat., No. 43.

567 LONDON, BRITISH MUSEUM, MALCOLM, No. 11—Study for allegorical figure of Abundance (p. 93).
Fig. 191 Fine pen on light reddish ground, in bistre, the shadows hatched, and the high lights
indicated with wh. The cornucopia and the *putti* to the l. are in bl. ch., and rougher.
31.5 by 25.5. Pl. XL of F. E. [Bode, *Klass. d. K.*, p. xxiii. Van Marle, XII, p. 196.
Yashiro, 261.]

567A (former 50) No. 14—Head of youth looking up in adoration almost in profile l. (pp. 334, 336). Pen
Fig. 197 and wh. on dark pink ground. Circular. Diameter 7.5.
[I used to ascribe this to "Amico di Sandro," and if there was anything to justify,
more than thirty-five years ago, when we knew even less than we do now, the demand
for an artistic personality like "Amico's," it is this drawing with its vivacity of expression
and daintiness of touch that might almost as well be Filippo's as B.'s. Indeed, it has
required frequent return to the problem before I could solve it in favour of B. Of course
it belongs to the earlier part of his career although scarcely the earliest.]

567B NATIONAL GALLERY—On back of early Adoration of Magi (No. 592). Draped female figure
holding up a shield with l. hand. Bl. ch. 33 high. Photo. Museum.
Mr. Kenneth Clark, the director of the National Gallery, who was good enough to
send me the photo., writes on May 12th, 1936: "It is done straight onto the wood without
any priming or preparation. The head is full face but only roughly indicated. As far as
I can see the r. arm was originally raised and the thing hanging down at the figure's
right side is part of the sleeve." Let me for my part add that in the reproduction I can
discover nothing that B. might not have done in the early years when he was groping his
way between Fra Filippo, Pollajuolo and Verrocchio toward his own style.

568 MILAN, AMBROSIANA LIBRARY—Study for a Pallas (p. 95). Pen. 19.5 by 9. Ascr. to Fra Filippo
Lippi. Braun 75258. [Yashiro, 267.]

569 Study for St. Thomas kneeling in profile r., with arms outstretched. Pen, bistre wash and
wh. on washed ground. 19 by 18. This and the above drawing are mounted on the same
sheet, and have been photographed together by Braun. See above. [Alinari. Yashiro,
266. Van Marle, XII, p. 200.] The figure has been taken over with scarcely a change by
the engraver who executed the thoroughly Botticellian print of an Assumption [(Van
Marle, XII, p. 282)]. Indeed, our drawing may have been made expressly for it. The
quality is scarcely better than in the Uffizi Nativity, and indicates that, like this, it belongs
to B.'s declining years, but is nevertheless somewhat earlier.

569A NEW YORK, MORGAN LIBRARY—Tumultuous crowd, horses and men pushing toward r., the foremost
Fig. 202 figure stooping forward with hands crossed over breast and an expression of ecstasy on

his face as if close at last to the object of his desire (p. 333). Umber tempera o linnen. 17.5 by 19.5. Morgan Dr., I, pl. 5. Fragment of the Adoration of the Magi. For same composition as my 561ᴬ and 561ᴮ (Figs. 200, 201). First mentioned by H. Ulmann, *Sandro Botticelli*, Munich, Bruckmann, 1893, p. 147, as a probably autograph drawing.

570 ROME, Vatican Library—A number of sheets for the illustrations, the bulk of which are at Berlin, for Dante's *Divina Commedia* (pp. 95-98). See Joseph Strzygowski, *Die acht Handzeichnungen von Sandro Botticelli zu Dantes Göttlicher Komödie im Vatikan*, Berlin, Grote, 1887. Also F. Lippmann's more popular edition of the entire work, cited under my 561 [and Bode, *Klass. d. K.*, 104, 105].

School of Botticelli (pp. 98-100, 333-334)

570ᴬ (former 584) BAYONNE, Bonnat Museum, No. 122—Large full-length Madonna, tenderly embracing
Fig. 203 Child. Pen on yellowish paper. 40 by 26.5. [Arch. Ph. Faithful contemporary copy of very fine design by the master dating from toward 1490.]

570ᴮ (former 43) BERLIN, Print Room, No. 5135—Five apostles listening to the supplication of a kneeling
Fig. 206 woman (p. 334). Bistre and wash on washed ground. 16.5 by 15. [Berlin Publ., 9. I used to ascribe this to "Amico di Sandro" but now see that it is very close to B. except in quality. It may be a studio copy of part of a composition by the master, dating from about 1490 and representing the Story of the Woman of Canaan (Matthew xv: 21-28).]

570ᶜ Wendland Sale (Ball & Graupe, 1931)—An elderly apostle cowering on the ground, asleep (p. 336). Pen wash and wh. 19 by 15. Pl. 30 of sale catalogue. Copy possibly by Carli of corresponding figure in the Agony in the Garden in Granada Cathedral, first recognized as B.'s by Gómez-Moreno (*Gaz. d. B. A.*, 1908, ii, p. 311) and repr. by Yashiro, 252.

570ᴰ, 570ᴱ CHANTILLY, Musée Condé, 11ᵇⁱˢ—Young woman with torch in l. hand dragging youthful nude. 11ᵗᵉʳ—Young woman whispering into king's ear. Bistre and wh. on buff grey paper. Each 28 by 20. Giraudon 888 and 889. A. Maurel, *Revue de l'A.*, 1922, i, p. 54, reproduces 11ᵇⁱˢ. Copies of episodes in B.'s Calumny probably after the painting.

571 (see 760 verso)

572 DARMSTADT, Print Room—Design, perhaps for an embroidery, representing lower part of Descent
Fig. 199 of the Holy Spirit (pp. 99, 333). Pen and bistre. Schönbrunner & Meder, 578. See Venturi, *L'Arte*, 1926, p. 4.

572ᴬ DIJON, Museum—Christ before Pilate. The Procurator of Judaea enthroned under a semicircular
Fig. 211 baldachin between two laymen and two rabbis dressed as monks, reaches forward to hold his hands over a basin held by a footman who pours water out of a pitcher. To the r. guards bring in Our Lord. The scene is placed in the pretorium with door opening on a river and a bridge. Bistre and wash. 21 by 19.

Dates from last years of Quattrocento and interesting as being at once intensely Botticellian and yet a drawing that few if any students would be tempted to assign to the master himself. But assistants who drew like this could easily have painted pictures like the Boston Madonna with the infant John (Van Marle, XII, p. 268) and similar confections.

573 FLORENCE, Biblioteca Riccardiana, Codex 1711—Fior di Virtù. Inside of first page. Sketch of winged female figure floating with r. foot over vase. In her extended r. hand she holds flowers, and in her l. an astrolabe. Pen and wash. 20 by 14.

There is an almost exact correspondence in action between this sketch and the

painting on the back of a lady's profile of Botticelli's School formerly Miss Cohen's, now in the London N. G., 2084. The drawing, however, is of superior quality to the painting, and closer to B. in feeling, although the technique is not quite that of a strict follower.

574 FLORENCE, Uffizi, No. 189 E—Sketch for lower part of male figure standing in landscape. Pen and bistre height. with wh. on pinkish prep. paper. 12 by 10. Brogi 1723. [Photo. Mannelli. Yashiro, 268.] Ascr. to B. but poor and too angular for him. It is by a follower of B.'s Pollajuolesque manner.

575 No. 201 E—Study for a Pallas (pp. 99, 333). Pen and bistre over almost effaced bl. ch.
Fig. 195 height. slightly with wh. on pinkish ground. Squared, pricked for enlarging. 22 by 14. Braun 76134. [Brogi 1725. Bode, *Klass. d. K.*, p. xvii. Uffizi Publ., I, iii, 22. Yashiro, 262. Van Marle, XII, p. 197. Meder, *Handz.*, fig. 18. Verso: Part of a frieze with diaperings and the heads of *putti*. Seems by another and inferior hand. Pen and bistre.]

576 (see 2787 A)

576 A (former 46) No. 1149 E—[St. John the Evangelist bringing the bridegroom to life, as recounted by
Fig. 205 Jacopo de Voragine in the *Legenda Aurea*] (pp. 334, 336). Pen wash and wh. on pinkish paper. 16 by 14.5. [Uffizi Publ., I, iii, 24. Probably a studio drawing from B.'s later but not last years, and intended for embroidery like those after his designs at Milan and Orvieto. Companion, no doubt, to the original of my 582 (Fig. 212).]

577 No. 1248 E—Two youths kneeling in midst of four other figures; above them the Holy
Fig. 204 Spirit (p. 99). Pen. 16 by 11. Pl. xlvi of F. E. Brogi. Ascr. to Piero di Cosimo, with whom it has but a remote although a certain affinity.

577 A No. 160 F—Elderly bearded nude in attitude of floating to l. with billowing draperies
Fig. 209 blown to r. away from his belly and loins, with r. arm almost horizontal and both hands to his mouth (p. 334). Pen and wash on wh. paper. 13.5 by 16. Fototeca 10279. N. Ferri, *Boll. d'A.*, 1909, p. 380.

Contemporary copy or possibly even an original outline in bl. ch. completely disguised by the ink of another hand, of a figure intended perhaps for one of the winds in the Birth of Venus. It is of course possible that it was meant for a demon in some such composition as my 586 (Fig. 210).

577 B GÖTTINGEN, University Museum—Study for upper part of Coronation of the Virgin (p. 334).
Fig. 208 Pen and wash height. with wh. over outlines in bl. ch. 22.5 by 38.5.

I know this sheet only from Van Marle's reproduction (XII, p. 275), and it remains possible that the outline was by the master himself. The sketch in its present aspect cannot, however, count as his although it would seem to represent an earlier idea for the upper part of the Uffizi Coronation, with the angels forming an arch over the principal figures and the cherubs below.

578 LONDON, British Museum, Malcolm, No. 12—An allegorical figure of Faith (pp. 99, 333). Pen
Fig. 194 and bistre height. with wh. over rapidly sketched bl. ch. on light brown paper. 25 by 17.5. Pl. xlv of F. E. [Van Marle, XII, p. 276.]

579 No. 13—Madonna and Child. Feeble and niggling, but pretty. Child's head and Virgin's shoulder almost effaced. Pen and bistre. 24.5 by 14.5. Poorer version of [same original as my 570 A (Fig. 203)].

580 (see 561 B)

581 OXFORD, Aꜱʜᴍᴏʟᴇᴀɴ Mᴜꜱᴇᴜᴍ—Female head (life-size) after the portrait (of B.'s School) in the Städel Institut at Frankfort. Bistre and much wh. on brown prep. paper. Verso: Elaborated version by inferior hand of the drawing in the Uffizi for a Pallas (my 575, Fig. 195). Close to Raff. dei Carli. Bistre and wh. on ground rubbed with pink. Colvin, V, pls. 5 and 6.

582 PARIS, Lᴏᴜᴠʀᴇ, No. 2686—King lifting shroud off two young men whom St. John the Evangelist
Fig. 212 has just brought to life. Pen on fine silk. 29.5 by 23. Arch. Ph. Probably a tracing from a Botticellian drawing made for an embroidery. The original must have been companion to my 576ᴀ (Fig. 205).

583 No. 679—Study for fragment of Pietà. The young Evangelist embraces the feet of the
Fig. 207 dead Christ (of whom no more is visible), while an angel stands by holding a candelabrum. Bistre and wash much height. with wh. on wh. paper. 21 by 16. Braun 63220. Crude [but not unlikely a contemporary copy of an original of about 1490].

584 (see 570ᴀ)

585 TURIN, Rᴏʏᴀʟ Lɪʙʀᴀʀʏ, No. 15594—St. Paul enthroned. Pen. 26 by 10.5. [Anderson 9867. Van Marle, XII, p. 277. Paul looks like a faithful copy of a B. design of about 1480-5. The throne, the *putti*, and something in the touch suggest the engraver.]

586 No. 15596—Funeral of St. Marina. Pen. 28 by 18.5. [Crude copy of intensely Botticellian
Fig. 210 composition of about 1490 done perhaps by an engraver.]

587 No. 15597—Pallas. Wash with slight touches of pink. 22 by 17.

Francesco Botticini (pp. 70-73)

587ᴀ BUDAPEST, Nᴀᴛɪᴏɴᴀʟ Gᴀʟʟᴇʀʏ, No. 16—Study for Jerome in the London N. G. altar-piece (No. 227) dedicated to that saint (p. 72). Pen, bistre and wh. on pink prep. paper. 20 by 13. Identified by Simon Meller. Publ. and repr. by B. Degenhart in *O. M. D.*, V (1930/31), pp. 49-51 and pl. 31. Verso: Draperies.

588 FLORENCE, Lᴀᴜʀᴇɴᴛɪᴀɴ Lɪʙʀᴀʀʏ, Pluteo 40, Codex 53—Medallion with pen portrait of Matteo Palmieri. On fol. 149 verso is the inscription: "Anno salutis humanae, Mcccclxxiij & ij° innij hoc celeberrimum opus consumatum est: Die autem mercurij hora vero xijᴬ" (p. 72).

589, 590, 591 LONDON, Bʀɪᴛɪꜱʜ Mᴜꜱᴇᴜᴍ, 1875-6-12-11, 12, 13—Three studies for Coronation. In one is
Fig. 136 Christ, in another the Virgin, and in the third two angels making music (p. 71). Bistre
Fig. 137 and wh. Christ and angels on pale buff washed lightly with greyish blue; Virgin on pearly buff ground. Each 31 by 21. Pls. xxvii and xxviii of F. E. [590 repr. Van Marle, XIII, p. 423.]

591ᴀ (former 53) PARIS, Lᴏᴜᴠʀᴇ, No. 458 R. F.—Head of young woman (pp. 72, 336). Bistre and wh. on
Fig. 133 pink prep. ground. 15 by 11. Pl. xʟɪx of F. E. Alinari 1401. Photo. Giraudon 32096. [Paris Exh. Cat., 1931, pl. II. Van Marle, XII, p. 265. *Gaz. d. B. A.*, 1932, ii, p. 277. Verso: Study for sleeve and arm.]

591ᴮ STOCKHOLM, Pʀɪɴᴛ Rᴏᴏᴍ, Inv. No. 102—Four figures, two of Christ blessing kneeling Virgin, and two of angels (p. 72). All for Palmieri Coronation in London N. G. Pen and bistre. 11 by 16. Schönbrunner & Meder, 1067.

591ᶜ Inv. No. 43—Sketch for Christ blessing in Palmieri Coronation in N. G. (p. 72). Pen and
Fig. 134 bistre. 18.5 by 11. *Gaz. d. B. A.*, 1932, ii, p. 275. Photo. Museum.

Raffaele Botticini (pp. 145-146, note)

592 STOCKHOLM, PRINT ROOM, Inv. 54—Sketch of kneeling Virgin for Nativity (p. 146, note). Ascr. to [the school of Lorenzo di Credi in Sirén's catalogue]. Sp. height. with wh. on pinkish ground. 23.5 by 13. Pl. LXXVIII of F. E. [Schönbrunner & Meder, 1000.]

Bronzino (p. 321)

593 (see 598A)

593A BERLIN, PRINT ROOM, 5156—Bust of man with close-fitting cap, short beard and mongoloid eyes,
Fig. 1000 and head of another bearded man wearing hat. Bl. ch. on greyish paper. 22.5 by 19. Photo. Museum.

593B BESANÇON, MUSEUM, D. 1933—Figure seated to l. reading book and study of l. arm supporting book. Bl. ch. and wh. 20.5 by 16.5. Squared for transfer. Photo. Festas. Attr. to Michelangelo. Might be by B. as Mr. A. E. Popham of the B. M. (to whom I owe acquaintance with this and the next number) has already suggested.

593C D. 3172—Elaborately draped headless female figure seated in *contrapposto* holding small amphora in r. hand. Bl. ch. 41.5 by 25. Photo. Festas. Attr. to B. in old hand-writing. Very likely by him or by Alessandro Allori.

593D CAMBRIDGE (Mass.), FOGG MUSEUM, CHARLES LOESER BEQUEST, 145—Full-length female nude seen from back with l. arm lifted to head (p. 321, note). Bl. ch. 38 by 22.5. Mc Comb, pl. 45.

594 (see 599A)

594A (former 1633) FLORENCE, UFFIZI, No. 609E—Fortune seated on her wheel. Bl. ch. 45.5 by 29. Brogi 1510. Braun 76200. [Uffizi Publ., V, i, 6. One must accept Gamba's attribution, for, academic though this figure seems, the torso is too marmorean to be by Allori, who, however, has other if less classical qualities (see text to Uffizi Publ.).]

595 No. 880E—Fantasia based upon Michelangelo's Last Judgement, more interesting to students of pathology than of art. Bl. ch. and wh. 1m. 71 by 1m. 6. Mc Comb (p. 148) may be right in attributing this sheet to Allori.

596 No. 4982F—Design for Fall of Lucifer. Highly finished, and almost worthless. Bl. ch. 74 by 45.

597 No. 570F—Number of *putti* flying to r. Dainty, and almost charming. Bl. ch. 26 by 18.5.

598 No. 571F—Male nude seated, drawing up his legs and holding r. arm over face. Bl. ch. 37 by 26.5. This is done with considerable freedom, and is much better than most of the other sketches by B.

598A (former 593) No. 572F—Portrait head of young man looking out, with face turned a little to r. Fairly good. Bl. ch. on greyish green ground. 26 by 18.

599 No. 576F—Bearded head looking up to l. Smooth and pretty. Bl. ch. 14 by 10.5.

599A (former 594) No. 577F—Head of young woman looking down in profile to l. (p. 321). Bl. ch. 22 by 18. Pl. CLXXVIII of F. E.

600 No. 6357F—Allegory of the Zodiac. Very pretty and feeble. Bl. ch. 19 by 31. [Uffizi
Fig. 1001 Publ., V, i, 7.]

601 FLORENCE, Uffizi, No. 6359^F—Two hands and a foot. Highly finished. Bl. ch. 20 by 25.

601^A (former 2063) No. 6562^F—Nude female figure seen from back with head in profile to l. Bl. ch. 40 by 15. [I agree with Clapp (*Dessins*, p. 156) and Mc Comb (p. 149) in thinking this sheet more likely by B. than by Pontormo.]

601^B No. 6621^F—Study for nude woman seen from back with l. foot resting on step and bit of drapery round neck. R. ch. 41 by 14. Clapp (*Dessins*, p. 191), and Mc Comb (p. 150) quote it as B. and Clapp points out its affinity to Uffizi 6704^F, my 601^D connected with the Palazzo Vecchio fresco of the Passage of the Red Sea.

601^C (former 2131) No. 6639—Study for the sleeping Child in the Holy Family at the Pitti Palace (No. 39; Mc Comb, pl. 6) and study for a hand (p. 321, note). Bl. ch. 26.5 by 19. Fototeca 867. Clapp (see *Dessins*, p. 199) has been the first to identify this drawing as by B. and for a definite purpose.
 Fig. 999

601^D (former 2187) No. 6704^F—Study for man seen from back [wading through water (p. 321, note), in the Palazzo Vecchio fresco of the Crossing of the Red Sea (Mc Comb, pl. 43)]. Bl. ch. 42 by 15.5. [Brogi 1312. Clapp (*Dessins*, p. 248) was the first to recognize the authorship and purpose of this sketch.]

602 No. 10894—Head of youth looking down to l. (p. 321). Bl. ch. 15 by 16.5. Charming, almost exquisite in its dainty precision.

603 No. 13847^F—Head of boy looking up sentimentally. Bl. ch. gone over with wh. 13.5 by 10. If B.'s, as is probable, then from his youth when he was closest to Pontormo.

604 No. 13848^F—Study for draped l. shoulder, arm and joined hands of male figure. Bl. ch. 17.5 by 15.5. Very neat.

604^A (former 2439) No. 17819^F—Nude, reclining in niche, with hands joined in prayer. R. ch. 21 by 36. Fototeca 8788. [Kusenberg in *O. M. D.*, IV (1929/30), p. 37 and pl. 42 proves it to be the sketch for the fresco at the Certosa which the young B. painted while his master Pontormo was working at his series of frescoes in the same convent.]

604^B HAARLEM, Koenigs Collection, Inv. 188—Study for Christ in a Pietà and in larger proportions of the head alone. Bl. ch. and wh. 28.5 by 23. Lees, fig. 99. *Burl. Mag.*, XLV (1924), p. 124. Verso: Rapid sketch for same figure and for the legs.
 Fig. 1002

604^C Inv. 379—Nude male leaning with l. arm held high on staff. R. ch. 39.5 by 23. The attribution to B. goes back to 17th century and is possible as an early work but the statuesque "academy" has more in common with Bandinelli and Rosso than with B.'s master Pontormo.

604^D LUZERN, Gilhofer and Ranschburg Sale (June 28, 1934)—Bust of young woman. Bl. ch. 26 by 19. Sale Cat., pl. III. Verso: Half-length sketch of same young woman.

604^E MUNICH, Print Room, 2147—Profile to r. of Dante Alighieri. Bl. ch. 29 by 22. Photo. Museum.

604^F LONDON, Victoria and Albert Museum, Dyce Bequest—Sketch for portrait of youth. Bl. ch. 27.5 by 21.5.

605 PARIS, Louvre, No. 19—Two female heads in pain or terror, each on a separate bit of paper. Very neat. Sp. Each, 13 by 10.

605^A No. 1026—Jumble of nudes for the Deluge at S. Lorenzo (p. 321, note). Bl. ch. 26 by 74. This and following first publ. and repr. by Valerio Mariani in *L'Arte*, 1926, pp. 58 and 59.

605^B PARIS, Louvre, No. 1027—Nude man lying on ground, study for the same fresco as my 605^A (p. 321, note).

605^C No. 9878—Profile of curly headed youth. Bl. ch. Arch. Ph. Cf. with my 599^A.

605^D École des Beaux-Arts, 10907—Nude male figure seated in Michelangelesque *contrapposto*,
Fig. 1003 lifting l. arm to r. shoulder as if to carry a weight. Verso: Nude male figure standing in profile to l. with curved back and bent head. R. ch. 42.5 by 18.5. Arch. Ph. Not satisfactory but perhaps B.'s.

School of Bronzino

605^E PARIS, Louvre, No. 953—Venus and three Graces. Bl. lead pencil and bistre wash. The contours gone over with pen. Squared for transfer. 40.5 by 30. Braun 62034. See Voss in *Jahrb. d. Pr. K. S.*, xxxiv (1913), pp. 208/9, 215, and 315. Probably a copy by Alessandro Allori after a lost picture by B. painted in occasion of Francesco I dei Medici and Joanna of Austria's wedding, in 1561.

Bugiardini (pp. 253-254)

606 FLORENCE, Uffizi, No. 228^F—Nude Baptist lightly seated, leaning on l. elbow, with r. hand held
Fig. 813 up (p: 254). Hard bl. ch. and wh. on brownish grey paper. 40 by 24. Fototeca 15935. Timid and precise, but pleasant.

607 Casa Buonarroti, No. 71—Cartoon for Madonna suckling the Child (pp. 253-254). Ascr.
Fig. 812 to Michelangelo. Bl. ch., but the Child's arm and torso highly modelled with colour. 54 by 39. Pl. cli of F. E.

608 CAMBRIDGE (Mass.), Fogg Museum, Loeser Bequest, No. 146—Head of young woman. Bl. ch. [Too intimately Raphaelesque for Bugiardini or any other Florentine.]

Raffaele dei Carli (pp. 111-119, 121-123)[1]

608^A (former 644) BAYONNE, Bonnat Museum, No. 1272—Study for figure prostrate with grief, perhaps for a Pietà. Bistre wash. 13 by 18. Arch. Ph.

608^B BERLIN, Print Room, No. 4085—Annunciation. Perhaps cartoon for embroidery. Pen and wh. on pink prep. ground. 33 by 21.5.

609 No. 5044—Design for a Baptism. Pen and bistre, height. with wh. pricked. 26.5 by 17.5.
Fig. 271 Still decidedly Botticellian.

609^A (see 609^D)

609^B No. 5603—Flight into Egypt. Bistre wash and wh. on buff ground. Oval, 12 by 10.

609^C CHELTENHAM, Fitzroy Fenwick Collection—Study for Virgin in a Visitation. Bistre and wh. over bl. ch. 15.5 by 14.5.

1. The following drawings, unless otherwise stated, are ascribed to Garbo.

609^D (former 609^A) DRESDEN, Print Room—St. Francis embracing the Cross. Bistre and wh. on pinkish ground. 21.5 by 14.5. Braun 67028.

610 FLORENCE, Uffizi, No. 52^E—St. Peter enthroned between the Evangelist and St. Sebastian. Pen and bistre height. with wh. on brownish ground. 24 by 21. [H. Bodmer, *O. M. D.*, IV (1929/30), pl. 40.] Ascr. to Verrocchio, and so obviously C.'s that some of my colleagues like Dr. Ullmann have attr. it to Garbo. The types and the draperies are unmistakably C.'s.

610^A No. 156^E—Female saint kneeling in profile with hands folded in prayer. Bistre and wh. on purplish paper. 20 by 12. Fototeca 10995. A. Scharf, *Jahrb. d. Pr. K. S.*, 1931, p. 208. Copy after the Virgin in Filippino's Crucifixion at Berlin (No. 96) but the technique and the folds point to C.

611 No. 196^E—Half-length figure of Baptist. Pretty and close to Garbo. Ascr. to Botticelli. Pen and bistre height. with wh. 15 by 11. Braun 76130.

612 (see 629^B)

613 (see 629^C)

614 (see 629^D)

615 (see 631^A)

616 (see 631^B)

617 No. 211^E—Christ in the midst of His disciples. Cartoon for embroidery on a cope. Bistre and wh. on tinted ground. Pricked. 30 by 19 Brogi 1612. [Alinari 146. Van Marle, XII, p. 446.]

618 No. 306^E—Study from life for head of Lawrence in C.'s altar-piece still at S. Spirito
Fig. 266 (pp. 113, 121). Sp. height. with wh. on pinkish ground. 19.5 by 23.5. Braun 76250. [Fototeca 4134. Frizzoni, *L'Arte*, 1910, p. 331. Van Marle, XIII, p. 231. Küppers, pl. VIII.] Ascr. to Ghirlandajo and close to him.

619 No. 340^E—St. Sigismund (p. 123). Pen and bistre height. with wh. on yellowish ground. Pricked. 28 by 13.5. Brogi 1627.

620 No. 341^E—St. Sigismund (p. 123). Pen and bistre height. with wh. on pinkish ground. Pricked. 25 by 11. Brogi 1628.

621 No. 345^E—Madonna with the Child blessing (p. 123). Pen and bistre on yellowish ground.
Fig. 268 Pricked. 13.5 by 12.5. Brogi 1634. [G. Francovich, *Boll. d'A.*, 1926/27, p. 77.]

622 No. 346^E—Busts of Peter and Paul enclosed within garland. Pen and bistre on wh.
Fig. 273 paper. Pricked. 15 by 14.5. Brogi 1633.

623 No. 347^E—St. Barbara. Pen and bistre on wh. paper. Pricked. 23 by 14. Brogi 1889.
Fig. 270

624 No. 348^E—St. Paul (pp. 123, 130). Pen and bistre height. with wh. on pink prep. paper. 28 by 12.5. Brogi 1732. [Alinari 202.]

625 No. 398^E—Youth almost nude leaning on highly conventionalized flower-shoot. Pen and wh. on pink prep. ground. 20.5 by 12. Pl. 288 of Schönbrunner & Meder. [Fototeca 4125. A. Pellegrini, *L'Arte*, 1926, p. 186, and Venturi, *Studi*, pp. 64, 65.] Ascr. to unknown master of Ferrarese School; yet this figure is an imitation, fairly close, of Garbo's

9

Resurrected Christ. The type, the forms, and the decorative stem - cf. support of table in C.'s Vision of St. Bernard, in the B. M.—make it more than probable that the imitator is no other than C.

626 FLORENCE, UFFIZI, No. 441ᴱ—Head of young woman looking down to r. Ascr. to Leonardo. Sp. and wh. on pink prep. paper. 11 by 10. Brogi 1625. Pl. 668 of Schönbrunner & Meder. [Küppers, *Monatsh. f. K. W.*, 1915, pl. 72.]

627 No. 1119ᴱ—Female saint with book and lance. Pen, wash and wh. on pink ground. Pricked. Restored. 28 by 19.

628 No. 1129ᴱ—Marriage of St. Catherine (p. 123). Pen and water-colour. Background dark
Fig. 272 greenish blue, curtain back of Madonna red, Catherine's dress red, all the rest clayey buff. 42 by 27. Alinari 139. Ascr. Domenico Ghirlandajo.

629 No. 1171ᴱ—Four nude figures. Pen, bistre wash, and much wh. on pink prep. ground. 23 by 20. [Fototeca 13136] A composition suggesting a plaquette and ascribed to Robetta, but the types, the forms, the draperies, and the technique point to C. [Was he copying a Francesco Francia? A niello in the B. M. which Mr. Hind kindly pointed out to me (No. 202 of his catalogue) would encourage one to answer in the affirmative.]

629ᴬ No. 2ꜰ—Study for St. Andrew seated embracing his cross with l. hand and holding book in r. Pen and bistre. 24 by 15. Fototeca 12546. Ascr. to Fra Angelico and very likely early Quattrocento. Yet it is possible that it is an archaizing imitation by C.

629ᴮ (former 612) No. 214ꜰ—Young female saint. Pen and bistre wash height. with wh. on pink prep. paper. Pricked for transfer. Circular, diameter 12.

629ᶜ (former 613) No. 216ꜰ—Annunciation. Pen, wash and wh. on pink ground. Pricked. 12 by 12.

629ᴰ (former 614) No. 218ꜰ—Incredulity of Thomas. Pen and wash on yellowish ground. Pricked. Circular, diameter 12.

630 No. 219ꜰ—Madonna for a Visitation. Pen, wash and wh. on yellowish paper. Pricked. 14 by 11. Possibly for the Visitation by C. at S. Proculo, Florence.

631 No. 220ꜰ—Head of female. Pretty. Bl. ch. rubbed with pink. Oval, diameter 15.

631ᴬ (former 615) No. 221ꜰ—Arched composition of Resurrection. Bl. ch., bistre and wh. Pricked for transfer. 34 by 25. The Christ was evidently inspired by Garbo's in his Academy picture. The rest is so Umbrian that one is almost tempted to doubt its being even by C.

631ᴮ (former 616) No. 222ꜰ—St. Jerome in cardinal's robes, reading. Ascr. to Botticelli. Pen and bistre height. with wh. 18.5 by 13.5.

632 No. 223ꜰ—Half-length figure of bishop in profile to l. Pen, wash and wh. on pink prep. paper. Circular, diameter 15.

632ᴬ HAARLEM, TYLER MUSEUM, A. 2—St. Peter seated on bench holding book and key. Sp. height. with wh. and a little colour. 17.5 by 12. Pricked through afterwards. Probably for an embroidery.

633, 634 LILLE, MUSÉE WICAR, Nos. 264, 265—St. Bartholomew. St. Nicholas. Bistre and wh. on tinted paper. Pricked. Each, 21.5 by 10.5. Braun 72023, 72024.

635, 636, 637, 638, Nos. 517, 518, 519, 520—A bishop. Monastic saint. St. Agnes. A female saint. All gone over. Bistre wash and wh. Pricked. In roundels, diameter of each, 13. All ascribed to Lo Spagna, but copies after Perugino by C.

639 LILLE, Musée Wicar, No. 253—St. Mark. Pen and bistre wash height. with wh. on tinted paper. Pricked. In roundel, diameter 16.

640 LONDON, British Museum, 1860-6-16-114—Vision of St. Bernard (p. 122). Pen and wash
Fig. 267 height. with wh. Pricked. 27.5 by 36.5. Pl. LXIII of F. E.

641 1860-6-16-45—Mater Dolorosa. Bust. Bistre and wh. on pink prep. paper. Pricked. 12.5 by 8.5.

641A 1923-4-17-6—Study for young martyr bishop, seated in niche. Bistre and wash height. with wh. and pricked. 16 by 9.5.

642 British Museum, Malcolm, No. 33—Circumcision. Pen and bistre wash height. with wh. on tinted ground. Pricked for transfer. 32.5 by 22. Cartoon for embroidery of a cope.

642A (see 642E)

642B Sotheby Sale (May 13, 1924), No. 77—The Virgin and the Evangelist, studies for Crucifixion. Pen and bistre wash, pricked for transfer. 18 by 14. Repr. in Sale Cat. opp. p. 15. Ascr. to Castagno but possibly an archaizing drawing by C.

642C (former 658) [New York, Mr. Robert Lehman] (former Oppenheimer Collection)—Sketch for Adoration of the Magi. Bistre and wh. Pricked for transfer. 24 by 33. Pembroke Dr., 32. A crude composition suggested by Botticelli, Ghirlandajo, and Filippino. Catalogued as Florentine School, but as the general character and folds of the draperies prove sufficiently, this is a feeble design by C.

642D OXFORD, Ashmolean Museum—Small Annunciation. Design for embroidery for back of a cope. Both figures kneeling with the dove descending. Pen and wash on brown prep. paper. Pricked for transfer. 12 by 12.

642E (former 642A) PARIS, Louvre, No. 520—St. Paul seated. Bistre, wh. and pinkish wash. Pricked.
Fig. 269 21 by 12. [Arch. Ph.]

643 No. 1225—Cardinal. Pen and wash. Pricked. 23 by 16.

644 (see 608A)

645 ROME, Corsini Print Room, No. 13054—St. Paul. Bistre wash and wh. [Pricked and framed for embroidery.] 23 by 11.5.

646 No. 13056—St. Christopher. Bistre wash and wh. Pricked [and framed for embroidery]. 23 by 11.5.

647 No. 130457—St. Benedict. Bistre and wh. on pink prep. paper. Pricked. 23.5 by 10.5.

648 No. 130458—Saint pointing to open book. Bistre and wash. Pricked. 19.5 by 13.

649 No. 130465—Sts. Bartholomew and Anthony Abbot in roundel. Bistre and wh. on pink prep. paper. Pricked. 13 by 14.

650 No. 130466—Christ and the Madonna. Studies for a Coronation. Bistre on pink prep. paper. Pricked. 11 by 14.5.

651 No. 130469—Madonna for Annunciation. Bistre, yellowish wash and wh. Pricked. 14.5 by 11.

652 No. 130470—Visitation, in a roundel. Charming. Pen. Pricked. Diameter 12.

653 ROME, Corsini, Print Room, No. 131754—St. Sigismund, in roundel. Pen, wash and wh. on yellowish paper. Pricked. Diameter 10.

654 No. 131755—Female head, full-face. Bistre. Pricked. 6 by 5.5.

655 No. 131756—Female head, profile.[1] Bistre. Pricked. 6 by 5.5.

656 (see 771A)

656A VENICE, Academy, No. 15—Study for John the Baptist kneeling towards r. Sp. and wh. on buff prep. paper. 22 by 14.

657 WEIMAR, Library—An angel. Bistre and wash. Pricked. 21 by 18. Braun 79573. Cf. the angel between the Madonna and St. Bernard in the Vision of St Bernard in the B. M.

658 (see 642C)

School of Castagno (pp. 15-17, 332)

658A CAMBRIDGE (Mass.), Fogg Museum, Charles Loeser Bequest—Bust of Virgin slightly to l. wringing her hands. No doubt study for Crucifixion. Pen on wh. paper. 16.5 by 9. Castagnesque in type and modelling, and yet curiously suggesting a 16th century Flemish Madonna.

658B DÜSSELDORF, Academy, Print Room—Kneeling apostle in profile to l. with hands uplifted in wonder. 14 by 8. Düsseldorf Cat., No. 5. See next.

658C Kneeling apostle as last but seen almost from behind. 13 by 8. This and last, brown and red wash height. with wh. on red prep. paper. Düsseldorf Cat., No. 4. Studies for an Assumption, by an artist close to C.

659 (see 1866A)

660 FLORENCE, Uffizi, No. 250F—Head of elderly man, by some follower of C., not devoid of merit
Fig. 71 and not altogether unworthy of C. himself (pp. 16, note; 332). Pen, bistre and wh. on yellowish paper. 19.5 by 17.5. Brogi 1747. [Van Marle, X, p. 373.]

660A No. 252E—The Eternal supporting dead Saviour under the arms. Below, seated in attitudes of mourning, Virgin and John the Evangelist (p. 332). Bistre on wh. paper. 22 by 16. Fototeca 4718. Feeble copy or imitation of C. dating from end of Quattrocento and perhaps by Raffaele dei Carli.

The following (661-669) are all by the same hand.

661 No. 329E—Saint standing in profile to l. with book in l. hand (pp. 16, 332). Pen on pinkish prep. paper. 23.5 by 10.5. [Fototeca 12662.]

662 No. 330E—Various draped females, several with children in their arms, and a horseman (pp. 16, 332). Pen on pink prep. paper. 27 by 19.5. Verso: Similar figures. [Fototeca 12875 and 12876.]

663 No. 331E—Two male saints (pp. 16, 332). Pen on pink prep. paper. 27.5 by 19. [Fototeca 12630.]
Fig. 69

664 No. 332E—Several draped female figures. Pen on prep. pink ground (pp. 16, 332). 25.5 by 18. [Verso: Study for drapery and flying angels. Fototeca 12631 and 12632.]

1. All these Corsini drawings were probably intended as cartoons for embroideries.

665 FLORENCE, Uffizi, No. 14495—Headless draped female, seen from behind (pp. 16, 332). Pen. 10 by 6. [Fototeca 12664.]

666 No. 14496ᶠ—Franciscan and three other draped figures in profile to r. (pp. 16, 332). Pen. 8 by 5.5. [Fototeca 12665.]

667 No. 14498ᶠ—Spirited sketch of draped figure in profile to l., suggested by Donatello's apostles on the sacristy doors of S. Lorenzo (pp. 16, 332). Pen on pink prep. paper. 17.5 by 10. Verso: Bold sketch of head. [Fototeca 12666 and 12667.]

668 No. 14499ᶠ—Two apostles conversing. Of same kind as recto of last (pp. 16, 332). Bistre on pink prep. paper. 21 by 11. Verso: Draped male figure. Almost Japanese. [Fototeca 12668 and 12669.]

669 No. 14501ᶠ—Two draped male figures holding up open book between them (pp. 16, 332). Pen on pink prep. paper. 13.5 by 13.

669ᴬ No. 14509ᶠ—Female figure with streaming hair and fluttering skirts turned slightly to l. holding bow as if she meant to break it (p. 16). Pen. 29 by 17.5. Fototeca 11887. Publ. by Byam Shaw as Liberale in *O. M. D.*, VI (1931/32), pl. 21. Close to C., but something in the pen-stroke, in the hands, in the feet, and in the way the figure stands, in the way the legs are displayed, suggests Montagna, Giovanni Bellini and Zoppo.

669ᴮ NEW YORK, Mr. Robert Lehman (former Oppenheimer Collection)—An elderly saint seated
 Fig. 70 reading (p. 16, note). Pen, bistre wash and wh. 26.5 by 17. Pricked for transfer. Popham Cat., No. 35. K. Clark (*Burl. Mag.*, LVI, 1930, opp. p. 176) ascribes it to C. and but for quality it might be by him. Perhaps it is the pricking that suggests drawings for embroideries and inclines me to wonder whether it is not rather a copy and a faithful one, after C. by Raffaele dei Carli.

Lorenzo di Credi (pp. 55-68, 73-76)

669ᶜ (former 727) BAYONNE, Bonnat Museum, No. 727—Head of youth [with protruding mouth] looking up to l. Sp. and wh. 15 by 17. [Arch. Ph.]

669ᴰ No. 1236—Child in lap of His mother (who is not represented), blessing. Below, l. arm and torso of infant Baptist. Sp. and ink. Some of this ink by later hand. Corresponds with C.'s tondo in Borghese Gallery (Venturi, VII, i, p. 802), and as that is early, the drawing, although seemingly still earlier, may have been for that picture.

669ᴱ BERLIN, Print Room, No. 467—Portrait bust of youth looking straight out. He wears a cap over long hair. Sp. and wh. 18.5 by 16. About 1500, almost Raphaelesque.

669ᶠ No. 5040—Bust of spare humorous middle-aged man looking through half-closed eyes. Sp. and wh. Oval, 10 by 7.

669ᴳ No. 5041—Head of young man looking up to l. Sp. and wh. on buff ground. 21 by 19.5.

670 No. 5048—Study for God the Father seated on rocks reading in book; in the distance a
 Fig. 135 church tower (pp. 76, note; 89-90). Bistre and wh. on pinkish prep. paper. 26.5 by 19. Pl. xxxix of F. E. [Berlin Publ., pl. 8. *L'Arte*, 1932, p. 359.] Ascr. Botticelli.

670ᴬ (former 702) BOSTON, Museum of fine Arts—Portrait head of youth slightly to l. with lank hair and cap with turned-up brim. Toward 1500. Sp. and wh. on buff ground. 23 by 15. [Photo. Museum.]

670^B (former 700) CAMBRIDGE, Fitzwilliam Museum, G. T. Clough Bequest—Head of youth with stiff hair and jaunty cap. Sp. and wh. on brownish paper. 18 by 13.

670^C Head of child turned somewhat to our r. and looking up vaguely and dreamily (p. 67). Sp. ant bl. ch. height. with wh. 23 by 16. Vasari Soc., I, ii, 1. Popham Cat., No. 56. *Boll. d'A.*, 1933/34, p. 262.

This sensitively modelled head can only be an early work by C. It is so Leonardesque, however, that Leonardo himself could scarcely have disclaimed it. If it is C.'s it offers a good instance of what a mediocre artist can achieve with the example of a great but kindred genius before him, if he has the luck to encounter it when this technical training is complete but custom and customers have not yet shaped him into a mould for producing the same article to the end of his days.

670^D Ricketts and Shannon Collection—Head of young man looking up to l. Sp. and wh. on buff ground. 20 by 15. Vasari Soc., I, iv, 1.

671 (see 1274^B)

671^A DARMSTADT, Landes Museum, No. 106 —Study for Madonna adoring Child and for infant Baptist with lamb. In l.-hand corner a Dantesque face. Attr. to Piero di Cosimo. Pen and bistre height. with wh. on pink prep. paper. 14.5 by 10.5. *Stift und Feder*, 1929, 10.

Made over and the hatching certainly by another hand. Originally it was by the young C. working under the direct inspiration of Leonardo, but whether this is a copy or the original itself entirely made over is hard to determine.

671^B No. 131—Study for Madonna and Child. Sp. and wh. on reddish prep. paper. 14.5 by 10. *Stift und Feder*, 1929, 35. From C.'s early middle years and of better than average quality.

672 DRESDEN, Print Room—More than half-length figure of woman looking down to l., and beside
Fig. 139 her, study for child with the head in two different positions (pp. 66, 73). Sp. on wh. paper. 18 by 16 at base. Arched top. Braun 67049. [*Boll. d'A.*, 1933/34, p. 258. Degenhart, *Riv. d'A.*, 1932, p. 267.]

672^A DUBLIN, National Gallery, No. 2069—Bust of young woman slightly bent to l. and looking down. Sp. on cream-coloured ground. Diameter 23. J. Byam Shaw, *O. M. D.*, III (1928/29), pl. 8. Popham Cat., No. 59.

672^B DÜSSELDORF, Academy, Print Room, No. 11—Head of youth with flowing locks wearing flat cap. Sp. and wh. on yellowish ground. 19 by 14. Düsseldorf Cat., pl. 5. One of C.'s most vivid and attractive portraits.

673 FLORENCE, Biblioteca Marucelliana—"Disegni di diversi Autori," III, No. 137. Study for Madonna and Saints. Virgin holding Child; to r. a saint, and to l. an angel holding up the infant Baptist. The angel has lovely curls, and the folds of his sleeve are almost Leonardo's. This is one of C.'s few best drawings. Pen on pinkish prep. paper. 10.5 by 15.5. [*Boll. d'A.*, 1909, p. 316.]

673^A (former 735) UFFIZI, No. 513^E —Study for Holy Child sitting in profile towards l. Sp. and wh. on pinkish prep. paper. 28 by 19. Alinari 190. [Van Marle, XIII, p. 324.]

674 No. 111^E —Head of young man with straight hair to his shoulders. On smaller scale, erect figure of young man wrapping mantle about him (pp. 76, 143). Bistre and wh. on brownish prep. paper. 26.5 by 20. Brogi 1659.

674ᴬ (former 2788) FLORENCE, Uᴏᴏᴏᴏ, No. 212ᴱ —Venus reclining and Cupid. Ascr. to Verrocchio
 Fig. 141 (p. 68). Pen and sp. 15 by 26.5. Torn off diagonally to r. Brogi 1615. [Popham Cat.,
 No. 54. Uffizi Publ., I, iii, 18. Comm. Vinc., I, l. *Boll. d'A.*, 1933/34, p. 263.]

675 No. 216ᴱ —Two studies, one nude, the other draped, for pennon-bearer with shield by his
 side (p. 76). Bistre on wh. paper. 24 by 13. Brogi 1660. [Fototeca 9103. H. Bodmer,
 O. M. D., IV (1929/30), pl. 59.]

 Labelled "Maniera di Verrocchio," but the short stroke and the touch in general, not
 to speak of the types, seem C.'s. At all events, there exists an unquestionable painting
 by Lorenzo for which both these sketches may have served as studies. It is the figure of
 a pennon-bearer, usually described as a St. George, belonging to Lord Rosebery [(*O. M. D.*, IV,
 1929/30, p. 63)].

676 (number omitted in first edition)

677 No. 236ᴱ —Head of smooth-faced man. Sp. and wh. on greyish prep. paper. 16 by 15.
 Brogi 1805. [Van Marle, XIII, p. 330.]

678 No. 237ᴱ —Head of man in cap, possibly a portrait of Perugino (p. 76). Sp. and. wh. on
 greyish prep. paper. 16 by 15. Brogi 1806. [Uffizi Publ., IV, iv, 8. Van Marle, XIII, p. 329.]

679 No. 390ᴱ —Head of large-eyed youth with long hair, wearing cap. Simple and fine. Bl. ch.
 and wh. on brownish paper. 16 by 16. [Degenhart, *Pantheon*, 1931, p. 463.]

679ᴬ No. 430ᴱ —Verso: Fragment of head of youth slightly leaning to l. and looking to r. Sp.
 and wh. on pink prep. paper. 16 by 11. In every probability by C. On the recto is a
 copy after a lost Madonna from Leonardo's second Milanese period (Sirén, pl. 124ᴬ).

680 No. 476ᴱ —Cartoon for Madonna with the Child in her lap. Bl. ch. on wh. paper. 78 by 45.
 Brogi 1898. [Van Marle, XIII, p. 325.]

681 No. 493ᴱ —Female figure holding astrolabe (pp. 76, 89). Upper part in slight bl. ch., but
 Fig. 142 drapery in bistre height. with wh. 39 by 26. [Uffizi Publ., IV, iv, 9. *L'Arte*, 1932, p. 363.]

682 No. 506ᴱ —Study for drapery over knees of seated figure (p. 76). Pen on wh. paper. 13.5
 Fig. 148 by 16. Brogi 1899. [Degenhart, *Münch. Jahrb.*, 1932, p. 100.]

683 No. 507ᴱ —Study of drapery over knee of seated figure. Very good (p. 89). Sp. height.
 with wh. on pinkish prep. paper. 17.5 by 24. Brogi 1893. Braun 76363. [Van Marle, XIII,
 p. 326. Degenhart, *Riv. d'A.*, 1932, p. 293.]

684 No. 516ᴱ —Studies of drapery almost certainly for Madonna in the Louvre altar-piece
 Fig. 149 (No. 1263). More spirited than usual. Pen on yellowish paper. 16 by 22. Brogi 1471.

685 No. 1195ᴱ —Study for head of Madonna. Sp. wash and wh. on pinkish paper. 20.5 by 17.5.
 [Van Marle, XIII, p. 328.]

685ᴬ (former 737) No. 1197ᴱ —Copy after original study for Child in Munich Madonna [now accepted by
 most of us as Leonardo's earliest existing painting]. Sp. 18 by 13.5. Brogi 1896. [Fo-
 toteca 5934. Degenhart, *Riv. d'A.*, 1932, p. 269.

 An early drawing. The contours may have been retouched by later hand. With only
 the change of the fingers on one of the hands this sketch reversed may have served for
 C.'s early Madonna with the Infant Baptist at Dresden (Van Marle, XIII, p. 278).]

686 No. 1436ᴱ —Study for marble chapel with Annunciation over altar. [Eternal blessing in
 lunette above, Baptist and Francis in niches to l. and r. Medici arms in roundels under

arches of background (p. 74).] Pen on wh. paper. 37 by 26. Pl. xxxii of F. E. [A. Scharf, *Jahrb. Pr. K. S*, 1931, p. 205. Uffizi Publ., V, iv, 5. Meder, *Handz.*, fig. 127. Early. Architectural and ornamental parts reinforced probably by assistants.]

687 FLORENCE, Uffizi, No. 1772E—Cartoon for Madonna and Child blessing (p. 76). Bl. ch. on wh. paper, pricked for transfer. More than half life-size. Alinari 412.

688 No. 195F—Head of pretty maiden with charming eyes. Slight bl. ch. height. with wh. on pinkish tinted paper. 17.5 by 15.5. [Fototeca 12658. Degenhart, *Pantheon,* 1931, p. 465. Despite obvious faults too characteristic to be by anybody but C. himself.]

689 No. 196F—Head of heavy, sentimental youth. Bl. ch. and wh. on brown paper. 18 by 18. Retouched and tattered. [Degenhart, *Münch. Jahrb.,* 1932, p. 141.]

690 No. 199F—Two nudes seated with their arms tied behind them. Sp. and wh. on buff paper.
Fig. 153 26.5 by 18.5. [Degenhart, *Münch. Jahrb.,* 1932, p. 144.] Verso: Head of youth. [Fototeca 15218 and 12659. It may have served for a cassone picture. Mr. John Walker suggests that the nudes may have been imitated by Robetta in his engraving of the Allegory of Love.]

690A No. 789O—Head of sheep. Bistre and wh. on pink prep. paper. 10 by 9.5. Fototeca 14984.

690B No. 957P—Walled town on a lake. Lead on wh. paper. 20 by 29.5. Fototeca 14985. A typical middle distance for C.

690C HAARLEM, Koenigs Collection, 467—Head of youth almost in profile to r. with waving locks sweeping over ear to back of head. Sp. and wh. on pink prep. paper. 17 by 14. Almost Granacci.

690D 468—Profile of youth looking up slightly to l. His hair is smoothed over back of head. Sp. and wh. on pink prep. paper. 17 by 14. Becker, *Handz.,* pl. 33. Same kind and quality as last.

690E THE HAGUE, Fritz Lugt Collection—Study for drapery over lower part of seated figure (p. 64).
Fig. 143 Point of brush over sp. height. with wh. on cream-coloured paper. 22 by 17.5. J. Meder, *O. M. D.,* I (1926/27), pl. 7. Popham Cat., No. 57. *Boll. d'A.,* 1933/34, p. 253. Degenhart, *Riv. d'A.,* 1932, p. 295. Amsterdam Exh. Cat., No. 539.

691 LONDON, British Museum, 1860-6-16-29—Study for angel in the Forteguerri monument. Above, a
Fig. 140 figure striking the same attitude, and a cast of drapery (pp. 66, 73). Sp. and bistre height. with wh. on pale grape-purple ground. 24.5 by 18. Pl. xxix of F. E. [Van Marle, XIII, p. 321.]

692 1906-1-24-1—R. arm of child, very delicately modelled in C.'s best style. The hand lightly holding a piece of drapery (p. 90). Sp. hatched with wh. 12 by 17.5. Vasari Soc., I, i, 21. *L'Arte,* 1932, p. 365.

693 1900-7-17-29—Study for St. Julian in the Louvre altar-piece, No. 156. Possibly this sketch was originally C.'s, but it has been gone over in ink by a later hand. Originally sp. and wh. on greyish-green paper. 28 by 19.

693A 1875-6-12-6—Profile of youth to r. with prominent nose and hair falling down to sides, turbanlike cap. In reversed direction bunch of drapery. Sp. and wh. on brown paper. 14.5 by 20.5. Photo. B. M. Verso: Face with crown of head cut off looking down.

693[B] LONDON, BRITISH MUSEUM, PAYNE-KNIGHT, 1-14—Head of young man looking up to l. Sp. and wh. Oval, 17 by 15.5. Late. Like other heads looking up this one may have been a study for St. John in a Crucifixion.

694 BRITISH MUSEUM, MALCOLM, No. 22—Two studies for drapery of kneeling Virgin. Sp. height. with wh. on rose-pink prep. ground. 28.5 by 19.5. [Photo. Macbeth. Popham, *O. M. D.*, XI (1936/37), p. 19 and pl. XVI. Verso: Infant Christ reclining in mother's lap and infant John reaching up; to l. an angel about to kneel.] This sheet is late, and not impossibly an early work by C.'s pupil, Michele di Ridolfo.

695 (see 2763A)

696 No. 24—Head of boy with long hair, wearing cap. Sp. height. with wh. on yellowish prep.
Fig. 151 ground. 25.5 by 20. Braun 65050. Charming study of the same pretty youth as we have in the Louvre and Oxford drawings.

697 No. 25—Head, full-face, of old man (p. 76). Sp. height. with wh. on pale buff-coloured prep. ground. 25 by 19. Braun 65049.

698 No. 26—Head of youth, bending over but looking up to l. Sp. height. with wh. on brownish-buff prep. ground. 17.5 by 17. [Degenhart, *Pantheon,* VIII (1931), p. 463.] Nearly the same but inferior to my 696 (Fig. 151).

699 No. 161—Smooth-faced head of oldish man. Bistre and wh. on pink prep. ground. 13.5 by 13. [Van Marle, XIII, p. 331. K. T. Parker, *O. M. D.*, IV (1929/30), pl. 8.] Ascr. to Perugino. The confusion bears interesting witness to the affinity between the two masters.

699A (former 704) BRITISH MUSEUM, SALTING BEQUEST, 1910-2-12-30—Bust of pretty boy wearing cap over long hair. Sp. and wh. on yellowish-brown paper. 17 by 17.

699[B] VICTORIA AND ALBERT MUSEUM, No. 2314—Design for monument attributed to anonymous
Fig. 130 Florentine (pp. 68; 75, note). Black lead gone over later with ink by another hand. 27 by 19.5. Vasari Soc., II, x, 3. *Boll. d'A.*, 1933/34, p. 262. Another drawing for the same monument is my 720.

700 (see 670B)

701 [MRS. MICHAEL WRIGHT]—Head of youth, with locks curling down from under cap to his
Fig. 150 shoulders. Sp. and wh. on pink prep. paper. 27.5 by 20.5. [Photo. B. M. Vasari Soc., II, xvi, 2.]

702 (see 670A)

703 (number omitted in first edition)

704 (see 699A)

705 OXFORD, CHRIST CHURCH, B. 7—Bust of youth full-face, almost life-size. The same model perhaps as in the Malcolm (my 696, Fig. 151) and Louvre (my 711) drawings of a youth's head. Sp. height. with wh. on brown paper. 21.5 by 21. [Colvin, V, pl. 3. Bell, pl. 28.]

706 B. 8—Cast of drapery over knees (p. 76). Pen height. with wh. 17 by 17.5. [Poor enough but not Botticini's as B. Degenhart proposes in *O. M. D.*, V (1930), p. 51, and in *Riv. d'A.*, 1932, pp. 297 and 300.]

707 B. 9—Cast of drapery over leg. Sp. and wh. on brown paper. 12.5 by 18.5.

10

708 PARIS, Louvre, No. 1787—Head of woman, study for Madonna, perhaps for the one with two saints at Dresden. R. ch. 31 by 22. Braun 62081.

709 No. 1779—Head of oldish man, wearing cap (p. 76). Sp. and wh. on salmon-tinted paper.
Fig. 146 29.7 by 21.2. Pl. xxx of F. E. [Alinari 1372. Van Marle, XIII, p. 333.]

710 No. 1780—Head of old man, seen three-fourths face and bent to l., study for St. Joseph in the Adoration of the Shepherds at the Uffizi (No. 8399). Sp. height. with wh. on salmon-tinted paper. 30 by 21.5. [Arch. Ph.]

711 No. 1781—Head of youth looking up. Same model as at Oxford. Sp. (height. with wh. perhaps by more recent hand) on reddish-tinted paper. 24.5 by 19. Braun 62085. [Degenhart, *Pantheon*, 1931, p. 365. Verso: Head of angel. Pen on wh. paper. Not by C. but by an inferior older hand.]

712 No. 1782—Bust of youth, nearly the same model as in Malcolm head (p. 75). Sp. and wh. on pinkish tinted paper. 24.5 by 19. Braun 62082. [A. Pellegrini, *L'Arte*, 1926, p. 187.]

713 No. 1783—Bust of maiden. This served perhaps as study for head of the Venus in the
Fig. 145 Uffizi (pp. 75, 143). Sp. height. with wh. on pink tinted paper. 29.5 by 21. Braun 62083. [Alinari 1375. Degenhart, *Pantheon*, 1931, p. 366.]

713^A No. 1785—Bust of old man in flat cap looking up slightly to l. Bistre and wh. on pinkish ground. 30 by 21.5. Braun 62086. Alinari 1376. Degenhart, *Pantheon*, 1931, p. 364. Paris Exh. Cat., pl. v. More elaborated and slightly dramatized version of my 733 (Fig. 147).

713^B No. 1786—Bust of young woman with hair twisted under kerchief. Looking down to l. Sp. and wh. 19 by 13.5. Arch. Ph. Verso: Bl. ch. study of youthful profile l. and vague indication of a bust.

714 No. 1789—Study for Annunciation. Bl. ch. on wh. paper, pricked for transfer. 26 by 30. [Alinari 1373. Van Marle, XIII, p. 327.] Excellent [from C.'s mature years].

715 No. 1791—Study for St. Bartholomew (p. 76). In oils on paper. 39 by 27. Pl. xxxi of F. E. [Braun 62087.]

716 No. 2675—Head of youth looking down. Unmistakably C.'s but catalogued as "Inconnu, École Florentine, XV^e Siècle." Bl. ch. height. with wh. on pink prep. paper. 18 by 14. [Arch. Ph.]

717 No. 1784—Head of youth with curling hair, looking little to r. Bistre and wh. 13.5 by 10.5. Braun 62193.

718 No. 1784—Head of smooth-faced elderly man. Sp. and wh. 13.5 by 10. Braun 62194. [Degenhart, *Pantheon*, 1931, p. 466.]

719 No. 1784—Portrait bust of youngish man in cap, turned little to r. and looking down. Sp. Roundel, diameter 13. Braun 62194 bis.

719^A No. 1784—Dishevelled head of youngish man looking to r. Sp. and wh. Diameter 12. Braun 62194.

720 No. 1788—Study for monument. On vase under baldachin, Justice stands between Fortitude and Prudence (p. 75). Pen and bistre on wh. paper. 30 by 22. Braun 63007. [Alinari 1374. Degenhart, *Münch. Jahrb.*, 1932, p. 101. Timid and niggling. Variant of my 699^B (Fig. 130). Originally in lead or sp. Gone over later by C. himself or as likely by Vasari, by whom it was decked out before inclusion in his collection.]

721 PARIS, Louvre, No. 1793—Angel [kneeling and supporting infant Baptist, another with flowers in his lap, Madonna seated on ground with the two Children, and woman kneeling in adoration]. To begin with in sp. and wh. on brown paper, retouched later with bistre and lowest group disfigured. 20 by 21. [Arch. Ph. Degenhart, *Münch. Jahrb.*, 1932, p. 100. Originally one of Credi's best, and very Leonardesque.]

721A No. 2586—Head of stout man thrown back to r. Sp. on pink paper. 12.5 by 9.5. Degenhart, *Pantheon*, 1931, p. 463.

722 No. 2676—Same head as my 716, but bent lower. Ascr. to Pollajuolo. Bl. ch. height. with wh. on pink prep. paper. 14 by 13. [Arch. Ph.]

723 No. 1784—Study of sheep. Sp. and wh. on tinted ground. 9 by 11. [Braun 62194.]

724 No. 1784—Study of a sheep and a lamb. Sp. and wh. on tinted ground. 9 by 11. [Braun 62194.]

725 No. 455—Study for Baptist in C.'s early altar-piece in the Pistoia Cathedral (pp. 66; 74,
Fig. 138 note). Sp. and pen, washed with bistre and height. with wh. on pink tinted paper. 27 by 13. Braun 62986. Giraudon 640. [Alinari 1379. Van Marle, XIII, p. 323.]

726 No. 462—Bust of young man (p. 143). Sp. height. with wh. on grey prep. paper. 21 by 21. Alinari 1377. Braun 62985. Giraudon 639. [Degenhart, *Münch. Jahrb.*, 1932, p. 135.] Pretty.

727 (see 669 C)

728 M. Gustave Gruyer (formerly)—Laurel-wreathed curly head (p. 75). Catalogued as of Lombard School, and ascribed by Morelli (*Kunstchr.*) to Marco d'Oggiono. Bl. ch. on wh.
Fig. 144 paper. 20 by 18.5. Braun 65148. Although probably of earlier date, this head may yet have served for the shepherd on the extreme l. who holds a lamb in the Adoration of the Shepherds at the Florence Academy.

728A RENNES, Museum, Cadre 3, No. 5—Fine alert head of youngish man almost full-face. Bl. ch. and
Fig. 154 ink on pink prep. paper. 18 by 13.5. See K. T. Parker in *O. M. D.*, II (1927/28), p. 55, pl. 57. Attr. to Botticelli. C. at his best.

728B ROME, Corsini Print Room, 124144—Studies for three feet and some hair hanging down, probably for a Magdalen. Sp. height. with wh. on pale pink paper. 12 by 21.5. Degenhart, *Burl. Mag.*, LVII (1930) p. 14.

728C 130484—Study for Child blessing. Sp. and wh. on brown paper. Anderson 31340. B. Degenhart, *Burl. Mag.*, LVII (1930) p. 11. If an original, as is probable but not certain, this can only be a study for the Child in the Pistoia altar-piece (Van Marle, XI, p. 537).

728D STOCKHOLM, Print Room, Inv. 111—Portrait head of smooth-faced elderly man wearing hat, and below it head of boy. Sp. 16 by 9. Ascr. to School of Verrocchio but in every probability by C., who here is almost Umbrian.

729 (former 743) VENICE, Academy, No. 103—Nude with r. hand touching l. ankle. Head and torso of
Fig. 152 youth, and, on much larger scale, head of boy. [In opposite direction to last, upper part of youthful face bending down.] Sp., pen and wh. 34 by 22. [Photo. Fiorentini.]

730 VIENNA, Albertina, S. R., 90—Infant John, with arms folded over breast, running forward to r. (p. 76). Pen. 14.5 by 11.5. Braun 70109. [Albertina Cat., III, No. 30.]

731 VIENNA, Albertina, S. R., 105—Head of youth which may have served as study for Lord Rosebery's Pennon-bearer. Sp., wh., and pink, on yellow tinted paper. 19.5 by 16.5. Braun 70081. [Schönbrunner & Meder, 327. Albertina Cat., III, No. 29. Venturi has published this head more than once as Leonardo's (IX i, p. 67; *L'Arte*, 1922, p. 1). It is reminiscent of the Virgin in Leonardo's Uffizi Annunciation, which is not surprising in C.]

732 S. R., 106—Head of bearded saint. Sp. and wh. on flesh-coloured paper. 16 by 16.5. Schönbrunner & Meder, pl. 589. [Albertina Cat., III, No. 25.] I do not understand why the old attribution to C. should be disputed.

732A 24414—Portrait head of young man seen four-fifths to r. but looking out through half-shut eyes slightly to l. He wears a hat with curled-in brim. Sp. and wh. on buff paper. 23 by 15. Albertina N. F. II, pl. 39. Albertina Cat., III, No. 28. Almost as smooth as a Sogliani.

733 WINDSOR, Royal Library—Bust of old man, turned slightly to l., wearing flat cap (p. 76). A more
Fig 147 elaborate version in the Louvre (my 713A). Sp. and wh. on mauve prep. paper. 19.5 by 17. Braun 99137.

734 Annunciation, taking place in front of two arches. The figures seem C.'s, but not the architecture. Pen and brownish-yellow ink. 18 by 14.

734A No. 12365—Cow, possibly for Nativity. Atttr. to Leonardo. Sp. gone over with bistre height. with wh. on dull light-brown paper. 19 by 27. De Toni, fig. 28. Clark, I, p. 44 and II, No. 12365. I owe acquaintance with this drawing to Mr. Kenneth Clark, who also proposed the attribution to C.

734B (former 2756) Head of ecstatic youth turned slightly to l. Ascr. to Ghirlandajo. Sp. height. with wh. on prep. pink paper. 16 by 12. Braun 79253.

School of Lorenzo di Credi

735 (see 673A)

735A DARMSTADT, Landes Museum, No. 130—Study for naked child reclining and twisting to l. Sp. and wh. on reddish prep. ground. 7.5 by 7. *Stift und Feder*, 1929, 34. Meant probably for one of the usual Leonardesque compositions.

735B No. 57—Contemporary copy of original drawing by C. for the Madonna and infant Baptist at the Borghese Gallery in Rome. Sp. gone over with ink on pink prep. paper. 10 by 9.5. *Stift und Feder*, 1928, 57.

736 FLORENCE, Uffizi, No. 1196E—Sketch for Annunciation and its frame. Pen and bistre. 14 by 15. Copy after early drawing by C., to whom it is attributed. [Possibly the completed picture is represented by the Annunciation in S. Spirito, Florence, now given to Pietro del Donzello. (Alinari 4729).]

737 (see 685A)

738 No. 188F—Head of child. Sp. 10.5 by 5. [Fototeca 14980.] Ascr. to C. [but more likely Sogliani (see my 2540). In any case, not for Pistoia altar-piece as published by Anna Trombetti in *Riv. d'A.*, 1929, pp. 205 *et seq.*]

738A No. 191F—Madonna kneeling in worship and behind her Joseph asleep with hand on staff. Fragment of *tondo* representing Nativity. Bistre and wh. on greyish-green. 16.5 by 12. Fototeca 18915. Degenhart, *Münch. Jahrb.*, 1932, p. 135. Studio copy. Verso: *Putto* blowing acanthus out of his mouth. Not by the same hand. Sp. on pink ground.

739 FLORENCE, Uffizi, No. 198F— Drapery for seated figure. Ascr. to C., but too feeble and formless. Bistre wash. 22.5 by 17.

740 (see 974)

741 No. 1918F—The Magdalen, in foreground of rocky landscape. Bistre wash, bl. ch., and wh., retouched later with bl. ch. 37.5 by 25.5. Fototeca. Ascr. to Cesare da Sesto, but so close to C. that it must be an old copy after a design of his.

742 MUNICH, Print Room—Sketch for kneeling shepherd in Nativity. Feeble, and by a late follower. Sp. and wh. on pink prep. ground. 21 by 14. Bruckmann 166.

742A PARIS, Louvre, No. 1792—Three studies in same frame: Madonna and Child in usual Leonardesque attitude and two studies for the Child alone in ovals. All in sp. on red paper. Madonna 11.5 by 8, ovals 9 by 7. Arch. Ph.

743 (see 729)

743A VENICE, Academy, No. 107—Young saint standing in attitude of prayer. Pen and wh. 25 by 10.5. [Photo. S. I. Verso: Youthful saint reading. His pose as well as drapery suggest Perugino.]

Fra Diamante (pp. 85-86)

744 FLORENCE, Uffizi, No. 152E—Head for Madonna in profile to r. (p. 85). Bl. ch. (considerably gone
Fig. 173 over) and wh. on pale buff prep. paper. 17.5 by 14.5. [Fototeca 12621.] Ascr. to Filippino Lippi. [Verso: Nude in profile to l. in ink, probably by later hand.]

744A (former 1388) No. 184E—Simplified copy after the Uffizi Madonna with angels holding the Christ Child [(Van Marle, X, opp. p. 430)]. Sp. height. with wh. on pale buff prep. paper. 33 by 24. Brogi 1680. [Alinari 243.] Ascr. to Fra Filippo. Verso: Jerome kneeling in prayer with the lion looking at him; below, a floral scroll over a meander pattern. Brogi 1475. [The Jerome is probably by F. D., and there is no reason why the Madonna should not be by him.]

745 No. 673E—Two figures for Visitation (p. 85). Sp. and wh. on bluish grey prep. paper. 29.5 by 17.5. [Fototeca 12881.] Ascr. to Filippino. Verso: Draped figure (p. 85, note).
Fig. 175 Sp. and wh. retouched in r. ch. on buff ground. [Fototeca 12638. Study for the major-domo in the fresco at Prato representing the Feast of Herod. Of the Visitation there is a copy by a later hand in the B. M. (1859-9-15-455, Photo. Macbeth).]

746 No. 674E—Saint, perhaps Jerome, seated in profile to l., reading a book which he holds
Fig. 176 on his desk (p. 85). Sp. and wh. on bluish grey prep. ground. 27.5 by 19.5. [Fototeca
Fig. 177 12639.] Verso: Jerome kneeling in profile to l. Sp. on buff ground. [Fototeca 12640. Possibly inspired by or reminiscent of Piero della Francesca's Jerome now in Berlin (No. 1904) dated 145....]

747 LONDON, British Museum, Malcolm, No. 6—Verso: Study of draped male figure (p. 85). Sp. height.
Fig. 174 with wh. 30.5 by 16.5. [See my 1387 (Fig. 169) for recto.]

Filippino (see Lippi)

Fra Filippo (see Lippi)

Franciabigio (pp. 294-295)

747A (former 71) FLORENCE, Uffizi, No. 312F—Male nude in profile to l. with both hands lifted in attitude
Fig. 924 of supplication (p. 295, note). R. ch. 3.9 by 17.5. [Uffizi Publ., IV, 4, 12. Alinari 379.
Di Pietro (figs. 2 and 3) identified this sketch as for the Job in F.'s Uffizi altar-piece
of 1516. It is feebler and softer than Andrea, to whom all of us used to ascribe it, but
inferior as it is to that master in quality of line it is by no means so in the treatment
of light and shade, for which reason perhaps one let it pass as the work of a greater
than F.]

748 No. 346F—Slight sketch of draped kneeling figure. R. ch. 12 by 9.

749 No. 638E—Study for Holy Family in a roundel (p. 295). Ascr. to Andrea. Bl. ch. Dia-
Fig. 922 meter 25. Pl. CLXVI of F. E. [Braun 76390.]

750 No. 6366F—Bust of *Salvator Mundi*. R. ch. 11 by 10. [Fototeca 11194.]

750A No. 14065F—Study of Bathsheba bathing for the Dresden cassone front No. 75, dating
Fig. 925 from 1523 (p. 295). Bl. ch. Fototeca 4499. Looser in handling but no less firm in mod-
elling than his earlier drawings.

751 UFFIZI, SANTARELLI, No. 446—Two draped figures asleep, probably for apostles in an
Agony in the Garden. R. ch. 13 by 19. Ascr. to Rosso.

752 No. 641—Slender draped figure kneeling, in profile to r., with hands joined in prayer. R.
ch. 23 by 16. Ascr. to Andrea.

753 LILLE, MUSÉE WICAR, No. 429—Sketch for portrait of smooth-faced man (p. 295). Sp. 13.5 by 10.
Braun 72091. Ascr. to Raphael.

753A LONDON, MR. ARNETT STIBBERT—Study for St. James in the Last Supper of the Convento della
Fig. 920 Calza. Underneath study for shoulder, sleeve and hand of same figure. In r. upper
corner much later inscription: " Dicono Del Pordenone dipinse a Piacenza in Chiesi de' Pri
Zoccolanti." In lower l. corner "Franciabigio" in even later handwriting. R. ch. 30.5
by 22.5. First publ. by Popham, *O. M. D.*, X (1935/36), p. 44 and pl. 42.

753B MONTECASSINO, LIBRARY—Sketch for portrait of young man. Bl. ch. 22 by 18. Ascr. to Raphael.

754 MUNICH, PRINT ROOM, Inv. 2449—Study, perhaps from model, of gentleman in short cloak, looking
up in profile to r. R. ch. 26 by 11. Bruckmann 162. May possibly have been intended
for one of figures in the Temple of Hercules at the Uffizi. The drawing is so feeble and
so much in the manner of Andrea that I have been tempted to ascribe it to Puligo. It is,
however, much more likely by F.

755 PARIS, LOUVRE, No. 1204—Cartoon for portrait of young man (p. 295). Bl. ch. 31 by 25. Pl. CLXV
Fig. 919 of F. E. Braun 62093. Alinari 1413.

756 No. 1671—Design for altar-piece in frame, representing the Madonna and two male saints
Fig. 923 (p. 295). Bistre and wash. 28 by 20. Braun 63524. [Venturi, IX, i, fig. 433.] Ascr. to
Andrea.

757 VIENNA, ALBERTINA, S. R., 267—Copy, with variations, after Pythagoras group in Raphael's
Fig. 921 School of Athens, or not improbably after original sketch for same (p. 295). Sp. and
wh. on light grey prep. paper. 29.5 by 40. Braun 70172. Schönbrunner & Meder, pl. 50.
[Albertina Cat., III, No. 68.] Ascr. to Raphael.

Taddeo Gaddi (pp. 2-3)

758 PARIS, LOUVRE, No. 222—Virgin going up steps of temple (pp. 2-3, 324, 325). Greenish wash and
Fig. 1 wh., halos brownish pink, background dark blue. 36 by 28.5. Pl. I of F. E. [Alinari 1414.
Popham Cat., No. 2.] Study for the fresco in the Baroncelli Chapel, S. Croce, Florence.

Raffaellino del Garbo (pp. 107-111, 119-121)

758A ASCHAFFENBURG, Z. III, 73—Copy of original study for G.'s Munich Pietà (H. G. 801; Van Marle,
XII, p. 436). The minuteness and fineness of the hatching is certainly not G.'s and the
touch is too slack for him. Probably a faithful copy by a follower of Fra Bartolommeo.
Pen and ink. 28.5 by 36.5. O. Weigmann in *Münch. Jahrb.*, 1932, p. 85.

 The deviations from the painting are interesting, and nearly all tend toward a less
Filippinesque and more Peruginesque phase of Garbo than we discover in the finished
picture. Based upon Perugino's Pietà now in the Uffizi (8365; Van Marle, XIV, p. 347),
our drawing partakes not only of its greater calm but of its relatively greater compactness.
Even the folds are more Peruginesque than in the painting. The date of this last can, by
the way, be no earlier than 1490, the earliest date that may be assigned to Perugino's
above-mentioned masterpiece.

759 BERLIN, PRINT ROOM, 5026—Head of woman looking down to l. (p. 120). Pen and bistre on wh.
Fig. 263 paper. 22.5 by 16.5. [Berlin Publ., 15. A. v. Beckerath, *Burl. Mag.*, VI (1904/05), opp.
p. 234.]

760 CHATSWORTH, DUKE OF DEVONSHIRE—Head of curly haired youth with sweet looking mouth and
characteristic expression. Also an arm with stone in hand. Sp. and wh. on purplish
ground. 29 by 20. [Chatsworth Dr., pl. 14. Vasari Soc., II, vi, 6. Popham Cat., No. 50.]
Verso (former 571): St. Roch between St. Catherine and Anthony Abbot. Highly coloured.
St. Roch in a separate panel. All within a frame drawn in bistre. Probably done in
preparation for the triptych in S. Felice at Florence painted in [Botticelli's studio.
So close to G. in his Botticellian manner as to make it probable that it is by him. For
other drawings framed in with these by Vasari on both recto and verso see my 1275,
1276, 1276A, and 1276B.]

760A CHETENHAM, FITZROY FENWICK COLLECTION—Two studies of hands. (1) Sp. on grey prep. paper
height. with wh. 5.5 by 6.5. (2) Sp. on salmon-pink prep. paper. 7 by 8.

761 FLORENCE, UFFIZI, No. 167E—Angel of Annunciation (p. 120). Pen on wh. paper. 18 by 9.5.
Fig. 261 Braun 76277. [Brogi 1677. Uffizi Publ., IV, i, 15. Ede, pl. 39. Scharf, fig. 163. Verso:
St. Justine holding the point of the sword in her draped hand. Possibly by G. copying
earlier master, Piero della Francesca perhaps. Ink and wash over r. ch. Fototeca 14936.]

762 No. 207E—Angel holding up the Christ Child to play with infant Baptist (p. 121). Sp. and
Fig. 262 pen height. with wh. and rubbed with red on pink prep. paper. 21.5 by 20.5. Brogi 1611.
[Ede, pl. 43. Van Marle, XII, p. 448.]

763 No. 1252E—Study of nude for young martyr (p. 121). Sp. height. with wh. on pinkish
Fig. 265 ground. 26.5 by 11. [Fototeca 11013. Uffizi Publ, IV, i, 16. Verso: Sketch for seated
child. Pen on wh. paper. Fototeca 12644.]

764 LONDON, BRITISH MUSEUM, Pp. 1-32—Resurrected Christ (p. 119). Sp. height with wh. on greyish
Fig. 260 blue prep. paper. 35 by 23.5. Pl. LX of F. E.

765, 766 LONDON, British Museum, Pp. 1-14—Two sheets with studies of hands. Sp. height. with wh. on lilac ground. 14.5 by 21. [Alinari 1694, 1695. Vasari Soc., II, viii, 3.] Ascr. to Botticelli, but the forms, the contours, and the technique alone would induce me to believe that they are by G. in his Botticellian phase. [Actually two of them are the hands of the Madonna in G.'s Pietà at Munich.]

766A NEW YORK, Metropolitan Museum—Roundel with sketch of Announcing Angel in profile r. seen to above knees. Pen and bistre pricked for transfer. Diameter 9. Photo. Museum. Close to Filippino.

767 [Mr. Robert Lehman] (former Oppenheimer Collection)—In a roundel, the head of young person in profile to l. Sp. and wh. on pinkish ground. Diameter 15.

768 OXFORD, Christ Church, B. 5—Study for Madonna with St. Catherine and Magdalen (pp. 110, note; Fig. 259 111, 120). Bistre and wh. on brownish ground. Circular, diameter 27. Pl. LXI of F. E. [Colvin, V, 8. Bell, pl. 36.]

769 PARIS, Louvre, No. 1224—Martyrdom of St. Lucy (p. 121). Bistre, wash and wh. on wh. paper. 21.5 by 35. Pl. LXII of F. E.

770 ROME, Corsini, Print Room, No. 130455—Profile of boy's head to l. Sp. and wh. on tinted ground. Fig. 264 20.5 by 15. Anderson 2814. [Scharf, fig. 182.] Ascr. to Filippino.

770A STOCKHOLM, Print Room, Inv. 52—Head of young woman with hair streaming down her shoulders, and looking down to l. Above to r. a larger head of young woman, but torn so that only tip of nose and mouth and neck appear. Close to Filippino. Pen and bistre. 15.5 by 13.5.

771 VIENNA, Albertina—Studies of hands (p. 120). Sp. height. with wh. on greyish ground. 32.5 by 24.5. Pl. 51 of Schönbrunner & Meder. [Albertina Cat., III, No. 36. The lowest hands are for the Madonna in Dresden (No. 22).]

771A (former 656) S. R., 512—Head of curly-haired angel looking down in profile to r. Sp. and wh. on yellow ground. 17.5 by 19. Schönbrunner & Meder, 404. [Albertina Cat., III, No. 35. *Pantheon*, 1932, opp. p. 273. Ascr. by me formerly to Carli, but too fine for him.]

David Ghirlandajo (pp. 136-141, 343-345)

771B BAYONNE, Bonnat Museum, No. 703—Studies for legs in armour and for a head turned up with closed eyes. Sp. and wh. on pink prep. paper. 30 by 21.5. Arch. Ph. Attr. to Florentine School.

772 BERLIN, Print Room, No. 457—Bust of man and boy (pp. 137; 141, note). Sp. and wh. on buff Fig. 329 prep. paper. 28 by 21.5. Very naïve. Verso: Three young men (pp. 137, 138). [Berlin Fig. 330 Publ., 10A and 10B.]

772A No. 496—Heavily draped figure seated on ground in profile to l. Sp. and wh. on buff prep. ground. 17.5 by 15.5. Photo. Museum. Attr. to Domenico.

772B No. 5046—Bust of nude man in profile to r. Sp. and wh. on purple prep. ground. 7.5 in diameter. Photo. Museum. Attr. to Domenico.

772C No. 5092—Three youths, one draped and two nude; the nude to l. looks like the study for a Baptist. Sp. and wh. 20 by 27.5. Photo. Museum.

772^D BERLIN, Print Room, No. 5189—Heavily draped man walking towards l. Sp. and wh. on bluish grey prep. ground. 19.5 by 14. Photo. Museum. Attr. to Filippino.

772^E No. 5222—Hermit saint in profile to l. in Renaissance frame. Sp. and wh. on grey paper. 22 by 12. Photo. Museum.

772^F (former 850) [CAMBRIDGE, Fitzwilliam Museum]—Draped figure, in all probability a study for the fresco at the Buonomini di S. Martino at Florence representing the Visiting of Prisoners (p. 136). Pen, bistre touched with the brush on prep. grey paper. 20 by 12. Photo. Museum.

772^G CHATSWORTH, Duke of Devonshire—Two studies for nude male figures, one pointing with r. hand, the other stepping forward with l. leg and stretching out l. arm. Verso: Nude male figure seated on ground, supporting itself on l. arm. Sp. and wh. on purple prep. paper. 19 by 27.5. Chatsworth Dr., pl. 12 as Signorelli.

772^H CHELTENHAM, Fenwick Collection—Man heavily draped looking pathetically to l. with r. hand touching his thigh. Study probably for a St. Roch; cf. my 818 for a Sebastian. Verso: Head of boy. Sp. and wh. on grey ground. 26.5 by 16.5. Close to Filippino, ascr. Garbo in Fenwick Cat.

772^I DRESDEN, Print Room—Heavily draped figure in profile to l. Sp. and wh. on greenish grey prep. ground. 20 by 12. Photo. Museum.

772^J DÜSSELDORF, Kunstakademie—Studies for torsoes with outstretched arms and for arms alone. Sp. wash and wh. 25 by 19. Verso: Filippinesque head bending down to l. Düsseldorf Cat., pl. IV.

772^K EDINBURGH, Print Room, R. N. 1558—Two male nudes, one kneeling in profile to r., the other seated on the ground and looking up. Sp. and bistre. 12.5 by 14.

773 FLORENCE, Uffizi, No. 13^E—Young man leaning over to l. and pointing to r., to a youth asleep (cf. my 802). Sp. and wh. on yellowish-brown prep. paper. 18.5 by 21.5. Same style as my 811 and 825. Ascr. to Filippino.

774 No. 39^E—Draped figure. Sp. and wh. on buff prep. paper. 19 by 9.5. Ascr. to Pesellino.

775 No. 40^E—Three draped figures. Sp. and wh. on buff prep. ground. 19.5 by 27. Ascr. to Pesellino, but cf. my 837.

776 No. 41^E—Draped figure with r. hand on hip. Sp. and wh. on prep. buff paper. 19.5 by 9.5. Ascr. to Pesellino, but of same character as my 774.

777 No. 54^E—Two draped figures, one standing erect and the other seated reading. Sp. and wh. on grape-purple prep. paper. 19.5 by 28. Braun 76294. [Van Marle, XIII, p. 167.] One of the best of D.'s drawings, and ascribed to Masolino, but see my 814, which it exactly resembles. Verso: Three draped figures of the same character. The middle one would seem to have served as a study for an *Ecce Homo*.

778 No. 65^E—Youth in full armour but bare headed, seated holding a sword across his knees.
Fig. 348 The same as the youth in armour on D.'s B. M. sheet ascribed to Masaccio (my 843 verso), but suaver, and turned to l. Sp. and wh. on deep buff prep. ground. 21 by 14.5. Characteristic zigzag hatching. Ascr. to Filippino. [In bl. ch. alone, and done before the seated figure, scrawls of a crouching quadruped below and of a goose above. Fototeca 12616. Verso: A foot and shin, and part of an impost on green ground.]

779 FLORENCE, Uffizi, No. 69E—Two draped figures. Catalogued as "unknown." Bistre and wash on buff ground. 19.5 by 14.5.

780 No. 72E—Seated man, study from life for a portrait. Sp. and wh. on brownish buff ground. 19.5 by 12. Brogi 1683. The technique and the character are unmistakably D.'s. The type recalls more than one head in the Ognissanti Deposition. A closely similar sketch is in the Louvre (my 859). Ascr. formerly to Masaccio, and now to Filippino.

781 No. 112E—Study after reliefs and medallions on the Arch of Constantine (p. 141). Pen. 24 by 21.5. Ascr. to Domenico. [Egger, *Codex Escurialensis*, I, p. 29. Verso: Study of the Arch of Trajan at Ancona. Fototeca 12674.]

782 (former 1375) No. 132E—Draped seated figure. Sp. and wh. on pale grape-purple ground. 18.5 by 9.5. [Fototeca 10993.] Ascr. to Filippino.

783 No. 150E—Male nude. Sp. and wh. on grey ground. 25 by 16. Of same type as next, and like that ascr. to Filippino. [Verso: Hastily sketched girl's head. Brush and bistre.]

784 No. 158E—Two nudes in same model and attitude as the nude in D.'s B. M. sheet ascr. to Castagno (my 844, Fig. 342). Also the same meditating figure as in that sheet, but leaning instead of sitting (pp. 139; 141, note). Sp. and wh. on grey ground. 21 by 27. Catalogued as Filippino's.

785 No. 159E—Two nudes, one of them to serve as a Christ on the Cross. Sp. and wh. on grey ground. 21 by 26. [Fototeca 10996.] Drawing of legs and hatching D.'s, but ascr. to Filippino. [The legs of Christ curiously like those in the Crucifixion at S. Apollonia (Van Marle, XIII, p. 143).]

786 No. 160E—Youth in profile to r.—same model as youth on my 772 (Fig. 329). Sp. and wh. on buff ground. 19 by 7. Brogi 1690. Ascr. to Pesellino. [Verso: Two sketches in same technique of lower part of profile.]

787 No. 161E—Draped youth. Sp. and wh. on bluish ground. 17 by 9. [Fototeca 10997.] Brogi 1690. Folds and hatching D.'s, but ascr. to Pesellino. [Verso: Part of a woman's head, looking up to r. on greenish ground.]

788 No. 162E—Youth lightly seated in profile to l., looking at a staff which he holds before him with both hands. Sp. and wh. on buff ground. 9.5 by 18.5. Brogi 1690. Ascr. to Pesellino but the type, the folds, the l. hand are characteristic of D.

789 No. 163E—Rough-featured but sentimental-looking youth, standing with his r. hand on a staff. Sp. and wh. on buff ground. 8 by 20. Brogi 1692. Again ascr. to Pesellino, but his draperies and his type stamp him as D.'s. He should be compared with the youth seen coming forward in the fresco of the Visitation at S. Maria Novella.

790 No. 164E—Draped man seated, turned to l. and pointing with his l. hand to l., in his r. a fire-shovel. Sp. and wh. on buff ground. 14 by 24. Brogi 1692. Also ascr. to Pesellino.

791 No. 165E—Draped youth standing. Sp. and wh., on buff ground. 8 by 19. Brogi 1692. Same character as in my 786 and 787, and even more like the youth in the Visitation mentioned under my 789.

792 No. 197E—Nude, in half-seated posture, with his arms tied behind him. Sp. and wh. on buff ground. 19 by 8. Clipped. Brogi 1617. [Photo. Mannelli.]

793 FLORENCE, Uffizi, No. 213E—Angel in profile to r., kneeling in adoration; also two children
Fig. 343 (p. 141). Pen. 20 by 12.5. Verso: Draped figure seen from the back (p. 141). Sp. and
wh. on buff ground.

This sheet is ascribed to Verrocchio, but the draped figure is certainly D.'s. The
pen-sketches have the Ghirlandajesque stroke and hatching, and the angel's hand has
the two middle fingers bent down in a way that characterizes D. (cf. my 788). The angel
thus offers us a starting-point for the study of other drawings with the pen by D.

793A No. 221E—Two studies for Evangelist in a Crucifixion. Sp. and wh. gone over with ink,
on mauve prep. ground. 20 by 26.5. Verso: One standing and one seated figure. Probably
for same composition. Sp. and wh.

794 No. 225E—Head of young woman [of Flemish type] and two nudes of the character of
those in my 784. Sp. and wh. on reddish pink ground. 20 by 28. [Fototeca 13125.]
Ascr. to Filippino.

794A No. 228E—Youthful nude lying on his back asleep. Sp. and wh. on buff paper. 8 by 19.5.

794B No. 229E—Stately heavily draped young man with a hand held up. Sp. and wh. on
grey-purple ground. 23 by 10.5. Filippinesque.

794C (former 1379) No. 232E—Half draped figure running to l. but looking back with bow in hand.
Sp. and wh. on buff ground. 25 by 16. [I used to assign this sketch to the school of
Filippino while now it seems to me in every respect characteristic for D. Same hand
as my 782.]

795 No. 245E—Young woman leaning over, in profile to l. Sp. and wh. on purplish ground.
22.5 by 11. Drapery and hands characteristic of D., but ascr. to Filippino. [Verso: Study
of draperies for standing figure.]

796 No. 255E—Three draped figures, of whom the middle one asleep, with his head resting
on a table (p. 141, note). Sp. and wh. on pinkish ground. 20.5 by 27. [Van Marle, XIII,
p. 166.] Verso: Two draped figures. Of a type occurring frequently in D.'s paintings.
The folds and hatching point to him also, but the attribution is to P. Pollajuolo.

797 No. 283E—Three draped figures (pp. 138; 141, note). Sp. and wh. on pinkish ground.
Fig. 333 20.5 by 27. Brogi 1761. [Küppers, pl. XVII.] Pl. LXXII of F. E. Ascr. to Domenico.
Fig. 334 Verso: Three further draped figures (p. 138). Brogi 1762.

798 No. 292E—Verso: Fifer (p. 141). Pen. 20 by 26. Ascr. to Domenico. See my 872
(Fig. 299) for recto by Domenico.

799 No. 304E—Three nudes, of the character of my 784; the one on the r. being even the
same model. Sp. and wh. on reddish pink ground. 19.5 by 27. Ascr. to Filippino.

800 No. 308E—Youth seated, in profile to l., bending over a tablet writing or drawing. Also
Fig. 336 two legs, and another youth kneeling in profile to r. (p. 138). Sp. and wh. on greyish
blue ground. 19.5 by 26. Ascr. to Domenico, and almost worthy of him, but nothing
could be more characteristic of D. Brogi 1654. Verso: Three draped figures standing
(p. 138). Pink prep. paper. They differ very slightly from those on the front of my 826.
Brogi 1450.

801 No. 309E—Two draped figures, one kneeling, and the other seated (p. 137). Sp. and wh.
Fig. 331 on bluish grey ground. 19.5 by 25.5. Ascr. to Domenico, but drapery and hatching
are D.'s. Brogi 1653. Verso: Two figures, one seated half-draped, and the other standing
Fig. 332 with a book in his hand (p. 137). Pink prep. paper. Brogi 1449.

802 FLORENCE, Uffizi, No. 319 E—Draped figure sitting pensively, in exact attitude of a figure on D.'s B. M. sheet ascribed to Castagno (my 844, Fig. 342). Also a horse. Sp. and wh. on yellowish brown ground. 17 by 25.5. Ascr. to Verrocchio. Verso: Hindquarters of horse.

803 No. 321 E—Three draped figures. Sp. and wh. on buff ground. 19 by 28.5. [Fototeca 12625. Verso: Head of youth and draped young man leaning forward in profile to r.] Ascr. to P. Pollajuolo.

804 No. 322 E—Two men, one with a book under his arm, and the other bending down. Sp. and wh. on buff ground. 16 by 19.5. Ascr. to P. Pollajuolo.

805 No. 323 E—Friar. Sp. and wh. on brown ground. 21 by 8. Photo. Mannelli. Ascr. to Botticelli, but the folds, the hatching, and the technique are D.'s. The hand is exactly like that of the youth reading on the back of my 813. [Verso: Heavily draped youth reading.]

806 No. 324 E—Head of a youth. Sp. and wh. on purplish grey ground. 16 by 17. Pl. 658 of Schönbrunner & Meder. It certainly is not Domenico's as ascribed, and is probably D.'s in the phase that we find him in at the Buonomini di S. Martino. On the other hand, it is just possible that it is by his assistant in that work. [Verso: Study of a r. arm.]

807 No. 326 E—Sketch, after Roman portrait statue. Sp. and wh. on buff ground. 20 by 11. Ascr. to Botticelli. [Verso: Landscape with walls of town and church in middle distance on wh. paper. Filippinesque.]

808 No. 328 E—Draped youth standing. Sp. and wh. on buff ground. 20 by 11.5. Ascr. to Botticelli, and goes with last. [Verso: Study for a Nativity and two dogs. Wh. ground.
Fig. 346 Fototeca 12629.]

809 (see 1311 B)

810 No. 354 E—Draped figure standing, and a sleeping nude reclining. Sp. and wh. on pink ground. 18 by 22. Fototeca 12732.

811 No. 355 E—Two nudes, one seated, and the other seen from the back, standing. Compare with my 825. Sp. and wh. on yellow-brown ground. 20.5 by 26. Verso: Three nudes standing in various attitudes.

812 No. 358 E—Portrait bust of smooth-faced man, wearing *lucco* of Pollajuolesque folds. Sp. and wh. on buff ground. 16 by 11.5. Alinari 120. [Van Marle, XI, p. 413.] Ascr. to Pollajuolo [probably because of the *lucco*]. But it is clearly Ghirlandajesque, and the technique makes it probable that its author was D.

813 No. 360 E—Two draped figures, one sitting and the other standing. Sp. and wh. on grape-purple ground. 20 by 24. Ascr. to Masolino, but the hatching, the drawing of the feet, and the general character leave no doubt that this sheet is of our series. Verso: Two draped youthful figures seated, the one on the l. reading, and the one on the r. reclining in the exact attitude of a figure on D.'s B. M. sheet ascr. to Castagno (my 844, Fig. 342).

814 No. 361 E—Two draped figures. Sp. and wh. on pinkish ground (retouched with bistre). 20 by 26. The one in profile almost identical with one on D.'s B. M. sheet ascr. to Masaccio (my 843, Fig. 338), while this is catalogued as Masolino's. Pl. LXXIII of F. E. Verso: Three draped figures facing.

815 No. 362 E—Draped figure. Sp. and wh. on purplish ground. 20.5 by 8. Goes with my 813, and like that is ascr. to Masolino.

816 FLORENCE, Uffizi, No. 382^E—Draped youth, seated reading. Sp. and wh. on pink ground. 17.5 by 10.5. Ascr. to Pesellino.

817 No. 383^E—Youth, with arm akimbo, lance in r. hand, and legs wide apart. Sp. and wh. on purplish pink ground. 20.5 by 11. Ascr. to Filippino, but the hatching and the folds are D.'s.

818 No. 384^E—Draped figure with arrow in hand; above to r. slight sketch for seated Madonna. Sp. and wh. on buff ground. 28.5 by 12.5. [Fototeca 9630.] Ascr. to Domenico. A most characteristic sketch going with my 780. [Intended no doubt for a St. Sebastian like my 772^H for a St. Roch. Both perhaps for the same altar-piece.]

819 No. 385^E—Draped youth in profile to l. Sp. and wh. on purplish ground. 20 by 10.5. Ascr. to Filippino.

820 No. 386^E—Draped youthful figure kneeling to r. Sp. and wh. on dark purple ground. 19.5 by 13. Ascr. to Filippino and very Filippinesque.

821 No. 391^E—Draped figure, and a nude facing him. Sp. and wh. on buff ground. 20.5 by 26.5. Almost like Alunno. Ascr. to P. Pollajuolo. Verso: Nude with r. hand on hip and l. arm lifted up.

822 No. 392^E—Draped youthful figure. Sp. and wh. on buff ground. 20 by 10. Ascr. to Domenico.

823 No. 393^E—Young man, and dog. Sp. and wh. on buff ground. 17.5 by 19. Catalogued as unknown, but clearly D.'s.

824 No. 394^E—Two nudes, one standing with his feet wide apart, the other picking a thorn out of his foot. Sp. and wh. on buff ground. 19 by 18. Same character and attribution as last. [Seated youth Filippinesque.]

825 No. 1111^E—Draped figure of the type of my 780, and a young soldier with drawn sword and a feather in his cap; also head of a boy. Sp. and wh. on brownish buff ground 19.5 by 26. Ascr. to P. Pollajuolo, but certainly D.'s. See my 811.

826 No. 1113^E—Three draped figures, almost identical with those on the back of my 800 (pp. 138, 345). Sp. and wh. on purplish ground. 21 by 25. [Fototeca 15133.] In the lower r.-hand corner we read, in no very ancient hand, the word "David." It would thus seem that the attribution to D. of one at least of this series of drawings had already occurred to some one before. Catalogued as Masolino's. Verso: Draped youth and the
Fig. 341 inside of an open hand. Deep purple ground. This hand is most characteristic of D. [Fototeca 15134.]

827 (see 834^C)

828 No. 1142^E—Nude seated, and two draped figures standing. Sp. and wh. on buff ground. 21 by 29. The nude resembles the one on D.'s B. M. sheet ascribed to Masaccio (my 843, Fig. 338). Catalogued as Masolino's. Verso: Draped seated figure, and two nudes.

829 No. 1143^E—Three nudes, of the style and character of my 784. Sp. and wh. on pink prep. paper. 21.5 by 35. Ascr. to Filippino.

830 No. 1146^E—Man, wearing peaked cap and heavily draped, sits looking down in adoration. Sp. and wh. on purplish brown ground. 25 by 16.5. Ascr. to Filippino.

831 No. 32^F—Nude. Sp. and wh. on buff ground. 24 by 9. [Cut out and pasted onto brown paper.] Ascr. to Uccello.

832 (see 969^D)

833 FLORENCE, UFFIZI, No. 165^F—Youth walking forward with little dog on a plate. Sp. and wh. on
Fig. 347　pinkish ground. 22 by 12. [Fototeca 12654.] Ascr. to Filippino [and very close to that master].

834　. . . .　No. 170^F—Study chiefly of drapery for a Madonna with the Child in her lap. Sp. and wh. on reddish ground. 24 by 13.5. Ascr. to Filippino. Verso: Draped figure bending as if to shake hands. Pen on reddish ground.

834^A (former 894) No. 171^F—Girl in fluttering draperies with hands held out, runs forward to l. Study for
Fig. 351　angel supporting a mandorla. Pen. 19 by 15. [Fototeca 12741. Verso: Memory sketch
Fig. 352　after Vatican torso, buttocks and legs of another nude and naked child seated in an attitude of frequent occurrence among Verrocchio's followers. In this particular case it is close to the Infant Christ in an altar-piece at Villamagna representing the Madonna and four saints which for other reasons I ascribe to the earlier years of D. Fototeca 12742.]

834^B (former 896) No. 176^F—Girl steps forward carrying with both hands a covered dish. Also two heads of horses. Pen. 20 by 14. [Fototeca 12743.] Verso: Nude male bends over to r. holding small stringless bow with both hands. [Fototeca 12744.] This leaflet is certainly by the hand that did my 834^A (Figs. 351, 352).

834^C (former 827) UFFIZI, SANTARELLI, No. 5—Draped figure in profile to r., pointing. Sp. and wh. on buff ground. 18.5 by 10.5. Very Filippinesque. Ascr. to Pesellino.

835　. . . .　No. 69—Cartoon for head of seated soldier on l. in D.'s Resurrection at Berlin (p. 141). Bl. ch. and wh. 31 by 26. Ascr. to Domenico, and slightly retouched.

835^A FRANKFURT a/MAIN, STÄDEL MUSEUM, No. 416—Three heavily draped youths, one standing, and one seated, both of these facing us, and a third in profile to l. walking toward them. Sp. and wh. on purple prep. ground.

835^B HAARLEM, KOENIGS COLLECTION, No. 10—Draped youth holding a staff in r. hand. Sp., bistre and
Fig. 356　wh. on blue paper. 20 by 15. Verso: Draped bearded man in profile l.

835^C　Inv. 193—Two draped youths, one seated holding a book, the other standing in the attitude of an orator. Pen and wh. on grey paper. 19 by 19.5.

835^D　No. 493—Heavily draped man with shaggy hair seated in profile to r. Sp. and wh. on blue greyish paper. 22.5 by 11.5. Verso: Sketch for Madonna seated frontally and
Fig. 344　holding Child with l. arm.

835^E HAMBURG, KUNSTHALLE, No. 21044—Two draped and one naked youth. Sp. and wh. on purple prep. paper. 19.5 by 28. Pl. 5 of Prestel Publ. Verso: Two draped figures.

835^F LEIPZIG, BOERNER'S SALE (May 12, 1930)—Head of youth with pointed cap and curly hair. Bistre
Fig. 350　and wh. on red ground. 28.5 by 21.5. Repr. in Sale Cat. as by Domenico.

836 LILLE, MUSÉE WICAR, 304 [1]—Young man, almost nude, asleep, and another seated (p. 138). With
Fig. 337　the latter's hand compare that of the Christ in D.'s Berlin Resurrection. Sp. and wh. on pinkish paper. 14 by 21. Braun 72003. [Van Marle, XIII, p. 164.] Ascr. to Masaccio.

1. As is well known to students, only a small part of the Lille drawings are exposed. The rest have remained inaccessible, although I have made repeated visits in the hope of seeing them. My acquaintance with these is confined, therefore, to those only that have been photographed by Braun. I infer, from the descriptions in the official catalogue, that the following numbers also may be by David: 266, 286, 287, 290.

GHIRLANDAJO (DAVID)

837 LILLE, Musée Wicar, Nos. 288 and 289—Three draped figures, the one on the l. seated in insolent attitude, the middle one facing the one on the r., a youth who bends towards him (pp. 138; 141, note). Sp. and wh. on pinkish ground. 21 by 25. A most characteristic sheet. Ascr. to Filippino. Braun 72004. Verso: Three draped figures, the one on the l. a rough-featured man, pensively seated, the middle one with his arm akimbo, the third imitated after the figure on the extreme r. in Leonardo's Adoration of the Magi (pp. 138; 141, note). Cf. my 797 verso (Fig. 334). Braun 72008. [Van Marle, XIII, p. 165.]

Fig. 335

838 No. 77—Two young men. Sp. and wh. on grape-purple ground. 16.5 by 10. Braun 72022. Freely copied after the two figures in Botticelli's Adoration of the Magi (Uffizi, No. 1286), for which reason this is ascribed to Sandro. But the technique and the folds are certainly D.'s.

839 No. 80—Draped figure. Sp. and wh. on grape-purple ground. 20 by 8. Braun 72021. Freely copied after Botticelli's own portrait in the same Adoration. Companion to last sketch, and like that ascr. to Sandro.

840 No. 81—Three youthful nudes (pp. 138-139). Sp. and wh. on pinkish ground. 19 by 28. The one on the l. is Pollajuolesque, and resembles a nude in a sketch by Finiguerra at Dresden (Braun 25). Braun 72007. Ascr. to Botticelli. Verso: Three similar figures (pp. 138-139). Braun 72006.

840A No. 231—Study for draped headless figure. Pen height. with wh. 25 by 12.5 (p. 141).

841 No. 233—Man heavily draped looking up in profile to l. Sp. and wh. on pink ground. 20 by 10.5. Braun 72136. Ascr. to Finiguerra.

842 No. 232—Almost the same figure seated. Sp. and wh. on salmon-pink ground. 17 by 13. Braun 72135. Also ascr. to Finiguerra.

842A No. 371—Half-length draped figure of man seated sideways in profile to l. Sp. and wh. on yellow paper. 14 by 14.5. Braun 72013. Attr. to Pollajuolo.

843 LONDON, British Museum, Pp. 1-13—Draped figure standing almost in profile to l., and seen sideways; nude seated (p. 138). Sp. and wh. on pale pink ground. 19.5 by 22. Braun 73030. Ascr. to Masaccio. Verso: Young man in full armour, but bareheaded, sitting, and a draped figure erect, reading (p. 138). Braun 73031.

Fig. 338

844 Pp. 1-16—Draped figure sitting in irate meditation, and a nude, probably for a Sebastian tied to a tree (pp. 139; 141, note). Sp. and wh. on greyish blue ground. 21 by 29. Braun 73035. Ascr. to Castagno. Verso: Two draped figures erect, in profile reading, and another turning away (p. 139). Braun 73036.

Fig. 342

845 1860-6-16-46—Nude looking down to l., but raising his r. arm (pp. 343-344). Sp. and wh. on buff. 21 by 9.5. [K. T. Parker, O. M. D., III (1928/29), pl. 50.] Ascr. to [Filippino] but by a hand not quite his. The quality, the handling, and the rapid zigzag hatching, in particular, point to D. [On back in later and perhaps already 17th century writing " Agno di Donin...."]

846 Pp. 1-4—Nude in attitude of shooting with a bow. Sp. and wh. on pinkish buff ground. 27 by 19. [Van Marle, XI, p. 443.] Catalogued as Florentine. The type and handling are D.'s, but it was evidently drawn under the inspiration of Pollajuolo.

847 1875-6-12-2—Three draped figures. The one on the r. stands with legs wide apart, his hands on the pommel of a sword with its point planted in the ground. The other figures face one another and suggest one of the couples of apostles on Donatello's bronze doors

87

in the Sacristy of S. Lorenzo. Sp. and wh., on pink ground. 20.5 by 27. Ascr. to Castagno. Verso: Two sprightly youths, draped, and standing with legs wide apart, l. arms akimbo; heads tossed to r. A most characteristic sheet, almost every bit of which is identical with corresponding bits in the various drawings by D. discussed in the text.

848 LONDON, British Museum, Pp. 1-12—Youth in costume of about 1500, walking with a halberd
Fig. 353 in his hand. Sp. and wh. on greyish prep. paper. 20 by 9. Braun 73060. Ascr. to Baldovinetti.

849 (former 40) Pp. 1-24—Two draped figures, one standing, and the other, apparently St. Jerome, seated
(p. 139). Sp. and wh. on pinkish ground. 20 by 22. Braun 73064. Ascr. to School of Filippino and formerly to Botticelli.

850 (see 772ᴱ)

850ᴬ Oppenheimer Collection (formerly)—In roundel bust of apostle or prophet speaking, with r. hand held out. Sp. and wh. on tinted ground. Diameter 7.5.

851 (see 40ᴬ)

852 (see 1271ᴳ)

852ᴬ MILAN, Ambrosiana, Cassetta 21—Studies for legs in various positions. Bistre wash and wh. on grey prep. paper.

852ᴮ NEW YORK, Morgan Library—Two striding nudes, one playing on viol and the other singing. Sp. and wh. on grey prep. paper. 19 by 21.5. Morgan Dr., IV, pl. 2. Ascr. to Castagno.

853 OXFORD, Christ Church, No. 844—Standing draped figure, looking slightly to r. Sp. and wh. on bluish-grey ground. 21 by 13. [Attr. to Botticelli by an old Greek inscription.]

854 PARIS, Louvre, No. 2348—Heavily draped seated figure pointing to l. with r. hand, and with l. on
Fig. 357 breast. Sp. and wh. on grey tinted ground. `27.5 by 13.5. Braun 62197. [Alinari 1378.] Ascr. to Fra Filippo.

855 No. 678—Head of youngish man, of truculent expression, and draped figure of youth bending
Fig. 349 over to shake hands. The latter is a repetition of a figure by D. on the back of my 834. Sp. and wh. on dark pink ground. 26 by 34.5. Giraudon 77. [Alinari 1400. Arch. Ph. Otto Kurz, *O. M. D.*, XI (1937), p. 14 and pl. 5.] Ascr. to Botticelli. Verso: Two erect draped figures.

855ᴬ No. 2680—Heavily draped man in *lucco* seated frontally. Sp. and wh. on buff ground.
Fig. 354 26 by 16.5. Arch. Ph. Attr. "École Florentine XIVᵉ."

855ᴮ No. 9844—Study of archer in profile to r. Bistre and wash modelled in wh. 27 by 19.5. Arch. Ph. Attr. "Ecole d'Italie XVᵉ."

855ᶜ No. 9846—Heavily draped young man kneeling in profile to l. Sp. and wh. 18.5 by 11.5. Arch. Ph. Verso: Angel kneeling in profile to r. and dog; vertical to this group a heavily
Fig. 345 draped female figure striding to l. Pen. Arch. Ph. Typical example of a pen-drawing reminiscent of both Filippino and Domenico. Cf. my 793 (Fig. 343).

855ᴰ No. 9862—Sketch for youthful nude with drapery over loins sprawling on a couch with l. leg and l. arm dangling (p. 339). Sp. and wh. on brown paper. 12.5 by 17.5. Arch. Ph. *O. M. D.*, VIII (1933/34), pl. 37. Attr. to "École Italienne XVᵉ." Faithful copy after the principal figure in Filippino's sketch for the dying Meleager in the Fenwick Collection, Cheltenham. Cf. my 1277ᶜ (Fig. 242).

856 PARIS, Louvre, No. 2693—Nude standing turned to r., and with hands tied behind him. Sp. and wh. on brownish ground. 18 by 9. Braun 62094. Of the same kind as my 784. On same mount: Draped youth standing in profile. 18 by 8.

857 No. 417—Young man, draped, walks to the l. reading. Bl. ch. and wh. on yellowish ground. 22 by 11.5. Braun 62050. [Arch. Ph.]

858 No. 429—Heavily draped man, seated. Sp. and wh. on pinkish ground. 21 by 14. Braun
Fig. 358 62506. [Arch. Ph.]

859 No. 9845—Young man, seated sideways but facing front, with his r. hand held out. Sp. and wh. on buff ground. 26 by 16.5. Verso: In reverse direction another young man seated. Braun 62511. [Arch. Ph.]

859ᴬ (see 1356)

859ᴮ (see 1357)

859ᶜ (see 1358)

859ᴰ (former 998) No. 415—Heavily draped young man seated, looking down on a tablet which he holds in both hands. Sp. and wh. (modern) on yellowish green paper. 19.5 by 13. Braun 62504. [Arch. Ph.]

859ᴱ No. 434ᵇⁱˢ—Youthful nude pointing with r. hand, holding a staff—study for a Baptist. Sp. and wh. on pinkish ground. 23.5 by 15. [Arch. Ph.] Labelled "École Florentine."

859ᶠ Louvre, His de la Salle, No. 126—Portrait figure seated, wearing mantle and cap of earliest Cinquecento fashion. Sp. and wh. on pink ground. 22 by 14. [Arch. Ph.] Close to Filippino.

859ᴳ (see 859ᴾ)

859ᴴ (see 859ᵠ)

859ᴵ École des Beaux-Arts, No. 1180—Heavily draped youth seated towards r. leaning on what may be frame of harp and intended perhaps for King David. Sp. and wh. on pale salmon ground. 19.5 by 14. J. Byam Shaw, *O. M. D.*, IX (1934/35), pl. 63. The folds of mantle suggest Credi as early Ghirlandajesque draperies often do. Verso: Pasted onto the paper, sketches of legs almost effaced, partly in sp., partly in bl. ch. Both sides attr. to Botticelli. Arch. Ph. It is no doubt the Verrocchiesque folds that have tempted Byam Shaw (*op. cit.*, p. 60) to ascribe this sketch to Credi. If my attribution did not satisfy me, I would think rather of Alunno di Domenico.

859ᴶ Profile of man in close fitting cap and two casts of drapery for lower part of seated figure. Sp. and wh. on pink prep. paper. 24 by 31. Delacre, pl. iii.

859ᴷ (former 1364) École des Beaux-Arts, Armand Valton Collection—Three draped male figures [one pointing to his thigh, probably study for a St. Roch] one leaning on a staff and one with a Dantesque profile to l. Sp. and wh. on paper tinted greyish green. 19.5 by 23. [Delacre, pl. i as Filippino Lippi, to whom I used to attribute this sheet, but the draperies are too angular and the touch too rough for that delicate and nimble draughtsman. See also E. D. B. A. Exh. Cat., opp. p. 16.]

859ᴸ Mr. Walter Gay—Heavily draped young man standing proudly looking to l. Sp. and wh.
Fig. 355 on buff ground. 20 by 10. No. 59 of *Dessins de Maîtres*, III, 1911.

859^M PARIS, Baron Edmond de Rothschild—Head of man turned slightly to l. (p. 345). Sp. and wh. On back in 18th century hand "David Ghirl."

859^N RENNES, Museum, Case 60, 4—Draped figure of youth with curly hair and cap looking out to l. Bl. ch. and wh. 26 by 11.

859^O ROME, Corsini, Print Room, Inv. 130487—Heavily draped youth seated reading. Sp. and wh. on pale grey paper. 21 by 20.

859^P (former 859^G) STOCKHOLM, Print Room, No. 42—Three draped figures. Verso: Two draped figures. Sp. and wh. on buff ground. 21 by 24. [Schönbrunner & Meder, No. 1034.]

859^Q (former 859^H) No. 44—Four draped men standing. Two of the figures are reproduced in Sirén's *Dessins,* opp. p. 33. Verso: Three draped men. Sp. and wh. on buff ground. 23 by 33.

860 VIENNA, Albertina, S. R., 25—Two draped figures standing. Sp. and wh. on bluish ground. 20 by 28. Pl. 697 of Schönbrunner & Meder. Ascr. to school of Filippino. Verso: One figure kneeling to l., and another seated, pointing to him—study perhaps for verso of my 864 (Fig. 340). [Albertina Cat., III, Nos. 23 and 23^R.]

861 S. R., 26—Two draped figures turning away from each other (p. 139). Sp. and wh. on
Fig. 339 greyish blue ground. 20.5 by 28. Ascr. to school of Filippino. Verso: Kneeling figure,
Fig. 340 and St. Jerome seated in profile to l. (p. 139). Pls. 477 and 411 of Schönbrunner & Meder. Albertina Cat., III, Nos. 24 and 24^R.

861^A S. R., 36—Studies for St. Anthony Abbot, St. Peter without head and an announcing angel running in profile to r. Pen. 14.5 by 20. Photo. Frankenstein. Attr. by Wickhoff (Albertina Cat., I, ii, p. IX) to Domenico.

862 (former 42) S. R., 44—Draped figure pointing down. Sp. and wh. on buff ground. 21.5 by 14. Pl. 623 of Schönbrunner & Meder. [Albertina Cat., III, No. 34.] Slightly varied study of the central figure on my 797 recto (Fig. 333), and like so many of David's drawings, formerly ascr. to Masaccio. Now given to Garbo.

862^A WINDSOR, Royal Library—Boy seated on stool drawing and a dog curled up asleep. Sp. and wh. on buff ground. 23.5 by 16. Braun 79145. Attr. to Masaccio.

Domenico Ghirlandajo (pp. 63, 132-136, 340-342)

862^B (former 888) BAYONNE, Bonnat Museum, No. 136—Study for a Coronation, with saints and angels. Pen and bistre on pink prep. paper. 35 by 21. [Bonnat Publ., 1926, pl. 5. See my 877 and 889, very close to last.] In poor state.

863 BERLIN, Print Room, No. 458—Horseman turning round. Pen, on wh. paper. 20 by 13.5. Verso: Drapery for kneeling figure (p. 132). [Berlin Publ., 11^A and 11^B.]

864 No. 2368—In the presence of three bystanders, two males and a female, an almost nude
Fig. 317 kneeling man presents to another man as little draped, a tiny crib and within it a babe. Pen, on wh. paper. 16 by 13. [A. von Beckerath, *Burl. Mag.,* VI (1904/5), p. 238.] This most spirited sketch, suggested perhaps by some antique cameo, I found going under some other name, but a more characteristic sketch by D. G. will not easily be seen. Verso: Various scrawls of horses' heads, etc.

864^A No. 4519—Sketch for the fresco at S. Trinita representing St. Francis received by Pope
Fig. 319 Honorius (pp. 340-341). Pen and bistre. 25 by 37. Photo. Museum. *L'Arte,* 1933, p. 169.

865 CHANTILLY, Musée Condé, No. 12—Head of an elderly woman. At r. angles to it, on smaller
Fig. 310 scale, a mask (p. 135). Sp. and wh. on tinted ground. 26.5 by 19. Braun 65048. Ascr.
to Credi.

866 CHATSWORTH, Duke of Devonshire—Head of middle-aged woman. Study for the lady on extreme l.
Fig. 305 in the fresco at S. Maria Novella representing the Birth of the Virgin (p. 134). Bl. ch.
and wh. on yellowish paper. 36.5 by 22. [Popham Cat., No. 37. Vasari Soc., II, vi, 5.]
Verso: Study for youngish woman in same group (p. 134). [Chatsworth Dr., pls. 22 and 23.]

866 A COPENHAGEN, Print Room, Case I, No. 1—Study for a Mary Magdalen holding ointment box in r.
hand (p. 340). Pen and bistre. Cut out and pasted on. Pricked for transfer. 15 by 12.
Attr. to Garbo. *L'Arte*, 1933, p. 164. Probably for embroidery. A good bit spoiled by
meticulous pricking but still recognizable as an early sketch by D. G.

866 B DARMSTADT, Landes Museum, No. 33—Study for Judith in Berlin dated 1489, and executed by
Fig. 321 David (Van Marle, XIII, p. 147). Inscribed in 17th century hand "di man di Fra Filippo
Carmelitano nella Pieve di Prato," and still attr. to that master (p. 341). Sp. and wh.
24.5 by 15.5. *L'Arte*, 1933, p. 173. Verso: Copy from Fra Filippo's fresco in Prato of
Fig. 322 the two women talking together. *Stift und Feder*, 1928, 33. (For another copy of same
subject see my 970 D.)

866 C DRESDEN, Print Room—Study for head of angel looking up (p. 340). Sp. and wh. on pale blue
Fig. 311 prep. paper. 17 by 13.5. *L'Arte*, 1933, p. 164. Attr. to Florentine School, 15th century.
Early and so close to Verrocchio as to be all but a copy of my 2780 E (Fig. 126).

867 (see 221 B)

868 No. 287 E—Study for an Annunciation. Pen on yellowish paper. 21 by 13.5. Brogi 1656.
Fig. 318 [Van Marle, XIII, p. 113.] The connection between this sketch and Leonardo's Annunciation
at the Uffizi (No. 1618), bears witness to the influence that Leonardo exerted over D. G.

869 FLORENCE, Uffizi, No. 289 E—Study for female figure pouring out water, in fresco of Birth of
Virgin (p. 134). Pen on wh. paper. 22 by 17. Braun 76240. [Alinari 45.]

870 (see 221 C)

871 No. 291 E—Study for the fresco of the Visitation (p. 133). Pen on wh. paper. 26 by 39.
Fig. 298 Braun 76238. [Brogi 1766. Ede, pl. 36.]

872 No. 292E—Study for the fresco representing the Marriage of the Virgin (pp. 133, 141).
Fig. 299 Pen. 26 by 17. Braun 76239. [Alinari 313. For verso see my 798.]

873 No. 294 E—Study for the two female figures standing by themselves to the r. in the fresco
Fig. 303 of Zacharias naming the infant John (p. 134). Pen on wh. paper. 26 by 17. Braun 76242.
[Alinari 258. Pl. 144 of Schönbrunner & Meder. Giglioli, *Boll. d'A.*, 1935/36, p. 490.]

874 No. 296 E—Study for a St. Michael, summary but spirited. Pen on wh. paper. 23 by 11.
Fig. 320 [Fototeca 12769.]

875 No. 298 E—Bust of woman approaching middle age (p. 135). Sp. and wh. on purplish
grey prep. paper. 33 by 25. Alinari 105. [Popham Cat., No. 39. Van Marle, XIII,
p. 107. G. Gronau, *Zeitschr. f. B. K.*, 1918, p. 170.]

876 No. 315 E—Study for drapery of Virgin in Louvre Visitation (p. 135). Wash and wh. on
Fig. 313 pinkish prep. paper. 29 by 13. Pl. LXIX of F. E. [Brogi 1763. Alinari 54. Van Marle, XIII,
p. 109. Meder, *Handz.*, fig. 192. Küppers, pl. X.]

877 FLORENCE, Uffizi, No. 179F—Design for a Coronation. Pen, faded. 28 by 18. [S. I. 4253. N. Ferri, *Boll. d'A.,* 1909, opp. p. 380.]

 The upper part differs from the painting at Narni in having fewer figures. This design may have been intended to serve for that work. [So may have my 862B and 889 although less likely. All three are interesting variants on the theme, and much happier than the crowded altar-piece.]

878 LONDON, British Museum, 1866-7-14-9—Rapid sketch for the fresco representing the Birth of the
Fig. 302 Virgin (p. 134). Pen on wh. paper. 21 by 28. Pl. LXVI of F. E. [Ede, pl. 34.]

879 Pp. 1-27—Bust of young woman, seen full-face (p. 135). Bistre and fine brush and wh.
Fig. 308 on pearl grey paper. 32 by 21. Braun 73145. [Probably the study for a portrait of which a contemporary copy now belongs to Mrs. Payson of New York (Van Marle, XIII, p. 158).]

880 Pp. 1-26—Bust of young woman in close-fitting cap and long straggling hair. Sp. on pearly grey ground. 37.5 by 24. [Anderson 18759. Vasari Soc., I, ii, 2. Schönbrunner & Meder, 1130. Van Marle, XIII, p. 97. Fischel, fig. 115.

 I was never happy over the attribution of this head to D. G. When Fischel some twenty years later (see p. 112) gave it to Perugino I accepted it without hesitation. The fact that most of us could confuse Ghirlandajo with Perugino in such an obvious case as this proves how close they stood to each other in maturity and points to a common influence to which they were submitted in earlier years. That influence must have been exerted by Verrocchio and more still by the young Leonardo.]

881 Pp. 1-3—Bust of oldish man, in profile to r. (p. 135). Sp. and wh. on pink prep. paper
Fig. 307 17 by 13. Pl. LXVIII of F. E. [Van Marle, XIII, p. 108.]

882 1860-6-16-44—Saint writing in a book, and to l. smaller and more spirited figure of a
Fig. 323 bishop, also writing, both erect (p. 138). Pen on wh. paper. 23.5 by 15. Ascr. to Garbo, but the stroke, the hatching and the forms are unmistakably D. G.'s. An important drawing from his earlier years.

883 British Museum, Malcolm, No. 15—Study for figure of a great lady in the fresco of the
Fig. 304 Birth of the Baptist at S. Maria Novella (p. 135, note). Pen and bistre on wh. paper. 24 by 16.5. [Ede, pl. 37.]

884 No. 16—Study for the fresco representing Zacharias naming the infant John (p. 134).
Fig. 301 Pen and bistre on wh. paper. 19 by 26. [Van Marle, XIII, p. 106.]

885 MUNICH, Print Room, No. 2151—Bishop baptizing a person of ripe years (p. 136). [Inscribed on
Fig. 316 step, in almost contemporary hand, with the words "Domenico del Grillandaio".] Pen and bistre on wh. paper. 28.5 by 24. Pl. LXX of F. E. [Van Marle, XIII, p. 115. The choir is probably a memory picture of old St. Peter's.]

886 PARIS, Louvre, No. 2678—Head of man, seen full-face (p. 135). Pen, bistre, wash and wh., the face worked up with pink, on grey prep. paper. 27.5 by 20. Braun 62509. [Alinari 1552. Fischel, fig. 16. Venturi, *L'Arte,* 1925, p. 161.] Ascr. "Ecole Florentine, XVe Siècle," but attributed to D. G. by Morelli (*Kunstchr.,* 1891-92, p. 376). [Fischel (p. 92) ascribes this head to Perugino. It is one that might be by that follower of Verrocchio's, as well as by Credi. I still believe that it was most probably done by D. G.]

886A No. 1870, 517—Heavily draped headless figure in profile to l. (p. 63). Bl. ch. and wash.
Fig. 315 31.5 by 17.5. Attr. to Fra Filippo. Arch. Ph. *Boll. d'A.,* 1933/34, p. 252.

887 PARIS, Louvre, No. 513—Head of a young man, turning slightly to l., with curling hair under a
Fig. 312 cap. Sp., bistre wash and wh. on tinted paper. 18 by 13. Braun 62513. [Alinari 1553.]
Not classified, but correctly ascribed by Morelli (*ibid.*).

[It is not quite of D. G.'s best quality, although probably belonging to the period of
his best activity—the frescoes at S. Trinita, etc.—the period in which he comes closest
to Botticelli. There is in this head a something of the last-named master which may
tempt students to ascribe it to the painter who stands, as it were, between D. G. and
Botticelli, I mean Alunno di Domenico, others may think of Filippino.]

888 (see 862 B)

888 A RENNES, Museum, Case 53, No. 5—Draped figure seen from the back (p. 340). Bl. ch. and wh.
Fig. 314 on pink prep. paper. 27 by 12. *L'Arte*, 1933, p. 167. Attr. to Florentine School but
inscribed "Domen. Grillan...." in somewhat later hand.

889 ROME, Corsini, Print Room, No. 127617—Study for a Coronation. Pen and bistre on wh. paper.
26.5 by 17. Anderson 2769. [Rusconi, *Emporium*, 1907, p. 265. *Gallerie Nazionali
Italiane*, II (1896), pl. VII.] Scarcely to be regarded as a sketch for the painting at
Narni, with which it has in common nothing but the subject. The drawing, however, is
of about the same date as the picture. The quality, on the whole, is excellent. [See my 877,
and 862 B.]

890 No. 130495—Saint (Francis?) appearing in a Chapter Hall, where a monk is delivering a
lecture. Pen on wh. paper. 19 by 22. Anderson 3175. [Rusconi, *Emporium*, 1907, p. 264.
Van Marle, XIII, p. 110.] Verso: More summary outlining of the same subject.

[Probably for a fresco representing Francis appearing to the Brethren at Arles, in
which case we may assume that D. G. painted or at least was invited to paint the
Franciscan legend in some cloister of the order.] One of Domenico's most admirable
pen-drawings, spirited, firm, and clear.

890 A STOCKHOLM, Print Room, Inv. 109—Two young women in fluttering draperies. Excellent and
no doubt after the antique. Pen and bistre wash. 17.5 by 17. Sirén, *Dessins*, opp. p. 29.
[Schönbrunner & Meder, 951.]

890 B (Listed in *Additions* to F. E.) Inv. 1—Head of old man (p. 341). [Sp. and wh. on pink
Fig. 309 prep. paper. 34 by 29.5. Pl. 886 of Schönbrunner & Meder. *L'Arte*, 1933, p. 171. Cut
down to oval and framed with decorative Michelangelesque nudes by Vàsari.]
Study for the Louvre picture [(Van Marle, XIII, p. 101)] of an old man and his little
grandson. It must have been sketched while the subject was asleep or more likely just
expired. [In either case it must have been done in one sitting, and that not a long one.
This gives a measure of the rapidity with which the Renaissance masters drew, and makes
one wonder what has become of the thousands of sketches every one of them must have
made in the course of his career. Michelangelo burned sackfuls periodically.]

891 VIENNA, Albertina, S. R., 102—Study for the fresco representing Zacharias in the Temple (pp. 133;
Fig. 300 187, note). Pen on wh. paper. 26 by 38. Braun 70050. Schönbrunner & Meder, pl. 216.
[Abertina Cat., III, No. 26. Meder, *Handz.*, fig. 300.]

892 S. R., 102 A—Study for the Volterra altar-piece. Pen and bistre wash on wh. paper.
26 by 28. Braun 70051. Schönbrunner & Meder, pl. 309. [Albertina Cat., III, No. 27.]

893 WINDSOR, Royal Library—Bust of elderly female. Study for the one next to the last in the
Fig. 306 group to the l. in the fresco of the Birth of the Virgin (p. 134). Sp. and wh. on prep.
orange paper. 23.5 by 18.5. Pl. LXVII of F. E. [Popham Cat., No. 38.]

School of Domenico Ghirlandajo

893^A CAMBRIDGE (Mass.), FOGG MUSEUM, PAUL J. SACHS COLLECTION, No. 699, 1933—Capture of a Princess. Pen. 8 by 20.

893^B No. 700, 1933—Martyrdom of female saint. Pen. 7.5 by 13. This and last by a close follower like the one who did the sketches in the Codex Escurialensis (see my 893^C).

893^C ESCORIAL, Codex Escurialensis. Reproduced and commented in an exemplary fashion by Hermann Egger with the assistance of Christian Hülsen and Adolf Michaelis, Vienna, 1906 (p. 342).

894 (see 834^A)

895 FLORENCE, UFFIZI, No. 1172^E—Copy after an original sketch, for the Brutus, perhaps, in the Palazzo Vecchio. Catalogued as "Maniera di Filippino." Pen and wh. on greyish green prep. ground. 30.5 by 19.

896 (see 834^B)

896^A THE HAGUE, LUGT COLLECTION—Head of little boy with longish hair in profile to l. Sp. and wh. on pink ground. 19 by 15. Inscribed in lower l.-hand corner in a hand of about 1800 with the words "di Leonardo da Vinci." This is tribute, no doubt, to the resemblance with Milanese profiles that used to be attributed indiscriminately to the great Florentine. It is, on the contrary, quite close to D. G. but perhaps closer still to his brother Benedetto as we find him at Aigueperse (photo. Bulloz).

897 LILLE, MUSÉE WICAR, No. 268—Bishop saint between two angels. R. ch. 17.5 by 31.5. By an
Fig. 325 unknown assistant of D. G. Braun 72026. Verso: Anatomical studies.

898 Monk kneeling to r., and two sketches of a man lifting up his r. hand and turning to l. Pen. 25 by 16.5. Braun 72191. Seems to be of D. G.'s following, although not indisputably Florentine.

898^A MUNICH, PRINT ROOM, No. 2938—Two studies for *putti*, one facing us and one seen from behind (p. 342). Sp. and wh., the hair touched up with pen on grey-purple ground. 21 by 11. Attr. to unknown Italian 18th century. *L'Arte*, 1933, p. 167.

898^B PARIS, LOUVRE, No. 1235—Copy by close follower of D. G. and David of the fresco in S. Maria Novella representing the Dance of Herodias (p. 342). Bl. and r. ch. 23.5 by 34. Arch. Ph. *L'Arte*, 1933, p. 179. Verso by later hand.

898^C No. 1439—Profile of youth with lank streaming hair. Sp., bistre and wh. wash. 24 by 18. Arch. Ph. Verso: Bust of old man with short beard and high cap. Arch. Ph. Attr. anonymous Florentine 15th century. The profile reminds one of Mainardi and Benedetto Ghirlandajo, the old man of Piero di Cosimo. It may conceivably be not Florentine at all, but by Juan de Borgoña, who must have worked under the Ghirlandajo in Florence and very likely been influenced by Piero di Cosimo.

898^D STOCKHOLM, PRINT ROOM, Inv. 6—Studies for floating angels perhaps for a Crucifixion. Inscribed in 17th century hand with the word "Giotto" (p. 342). Pen and bistre. 19.5 by 13. *L'Arte*, 1933, p. 181. Attr. to D. G. himself.

Ridolfo Ghirlandajo (p. 142)

899 FLORENCE, Uffizi, No. 73F—Saint blessing a sick man (p. 142). Pen. 12 by 12.

899A HAARLEM, Koenigs Collection, Inv. 469—Head of elderly man done probably from death mask.
 Fig. 362 Sp., bl. ch. and water colour. 20 by 13. Ascr. to Perugino.

900 LILLE, Musée Wicar, No. 470—Head of bearded man. Bl. ch. on wh. paper. 22 by 19.5. Ascr.
 to Raphael.

901 LONDON, British Museum, Malcolm, No. 181—Study of male head (p. 142). Bl. ch., on wh. paper.
 25.5 by 19. Ascr. to Raphael. [Alinari 1699. I no longer hold to this attribution. Despite
 many faults, due perhaps in part to retouching, the head now seems much more like an
 early Raphael (Dec., 1932).]

901A Heseltine Sale (Sotheby, May 27-29, 1935)—Head of Florentine gentleman in early middle
 Fig. 361 years looking keenly and even dramatically to r. (p. 142). Bl. ch. 47 by 32.5. Sale Cat.,
 opp. p. 54. Pl. 14 of Heseltine Cat., 1917, as Franciabigio. It seems far too sentitive for
 him, and the folds of drapery bring it much nearer to R. Its date is scarcely later
 than 1515, which makes it possible that it is, as Mr. Heseltine believed, a portrait of An-
 gelo Doni.

901B Russell Sale (Sotheby, May 9, 1929), lot 17—Study for portrait of middle-aged lady seated
 Fig. 359 low in profile l. Bl. ch. 31 by 23. Repr. in Sale Cat. Mature and interesting work.

902 ROME, Corsini, Print Room, No. 130493—Study for the Uffizi picture representing the transfer of
 Fig. 360 S. Zanobi's body (p. 142). Pen and bistre, on wh. paper. 15.5 by 18.5. Pl. lxxiv of F. E.
 Venturi, IX, i, fig. 373.

School of Ridolfo Ghirlandajo

903 FLORENCE, Uffizi, No. 172F—Study for altar-piece. Pen. 20 by 18.
 The author of this drawing would seem to have been a follower of R.'s, who fell
 completely under Raphael's influence. I suspect him to have been Leonardo da Pistoia.
 A comparison with the latter's altar-piece at Volterra tends to confirm this attribution.

904 No. 116F—St. Catherine standing between Sts. Stephen and Lawrence. Pen. 13 by 19.
 This also betrays the dominant influence of R., and it is not impossible that it again
 is by Leonardo da Pistoia, but in an earlier, more strenuous phase. At all events, this
 sketch is by the author of a drawing at Munich ascribed to Fra Angelico. The drawing
 in question is a copy after Fra Angelico's Vatican fresco representing the Stoning of Stephen
 (see my 177).

904A Uffizi, Santarelli, No. 76—Study for S. Bernardino in profile to l. with monstrance in
 r. hand and staff in l. Pen. 25 by 13. Close to R. and possibly by him.

904B No. 78—Study for altar-piece. Virgin surrounded by five male saints, one of whom, Ste-
 phen, hands the Child to Anne. Below kneel Sebastian and another saint, perhaps Roch.
 Bistre and wash. 33 by 23. Fototeca 10039. Follower of the mature R., possibly Michele
 di R., to whom it is attributed.

905 FLORENCE, Uffizi, Santarelli, No. 707—Fine design for Annunciation, with two angels looking on. R. ch. 27 by 39.5.

 Charming, and close to R. If memory does not fail me, there is a connection between this drawing and a painting of the same subject in S. Maria at Panzano. In that case the sketch also would be by Michele di Ridolfo.

905^A WASHINGTON CROSSING (Pa.), Prof. F. J. Mather—Sketch for Madonna enthroned against niche with two male saints on each side and two female saints kneeling below. Recognizable are Nicholas, Stephen, and the Magdalen. Pen and bistre. 17 by 14. Close to R. By an early follower if not by himself.

Giovanni da Milano (p. 324)

905^B BERLIN, Print Room, 4290—Highly finished study for Crucifixion. Bistre height. with wh. on brown ground (p. 324). 28 by 22. Repr. opp. p. 208 of *Jahrb. Pr. K. S.*, 1906, by Sirén who first identified it as by Giovanni. Sirén quite rightly says that this design might pass for a monochrome illumination as easily as for a drawing. It illustrates every peculiarity of modelling as well as all else that characterizes Giovanni in his frescoes and panels.

Giusto d'Andrea (pp. 92-93)

905^C BERLIN, Print Room, No. 12889—Two large angels carrying candelabra facing each other in profile against background of embroidered stuff. Designs for embroidery. Watercolour. 80 by 40. Hind in *History of Woodcut*, I, pp. 164, 166, has come to almost the same conclusion, as he attributes them to the School of Fra Filippo.

905^D LONDON, British Museum, 1935-10-12-122—Two large angels carrying candelabra. Similar to my 905^C. *B. M. Quarterly*, X (1936), opp. p. 85.

906 British Museum, Malcolm, No. 34—Pope on horseback carrying falcon on his wrist (p. 93).
 Fig. 189 Pen and bistre. 16 by 15. Ascr. to Raffaellino del Garbo. For further description, see Malcolm catalogue.

906^A PARIS, Louvre, 1968—Bust of child with crossed hands looking up to l. Bl. ch. and bistre wash. 25 by 18. Arch. Ph.

 Attr. to Uccello, this painstaking but stiff and wooden drawing is from the close following of Benozzo. Kenneth Clark's plausible suggestion is that it may be by Giusto d'Andrea in the years when he was assisting that master at S. Gimignano.

Francesco Granacci (pp. 143-145)

906^B BERLIN, Print Room, No. 4265—Bust of man full-face with powerful features, looking up as if startled towards l. Bl. ch. and wh. on purple washed ground. 6.5 by 6.5. Photo. Treue. Attr. to Pollajuolo.

906^C CHATSWORTH, Duke of Devonshire—Two heavily draped figures, one standing with r. arm akimbo, the other seated with head resting on r. hand. Sp. and wh. on buff prep. ground. 21 by 29.5. Chatsworth Dr., pl. 11. Attr. to Filippino.

907 FLORENCE, Uffizi, No. 55^E—Two draped young men, one seated and the other standing. Sp. and wh. on yellowish ground. 20 by 26. Braun 76295. Ascr. to Masolino, but the spirit, the technique, and the touch prove this to be by G. when close to David.

907A FLORENCE, UFFIZI, No. 75E—Draped figure. Sp. and wh. on yellow paper. 19.5 by 11.5.

907B No. 77E –Draped figure, companion to last. Sp. and wh. on yellow paper. 19.5 by 11.5. Verso: Kneeling female figure, for Annunciation or Nativity, almost Umbrian in feeling. Fototeca 12728.

908 No. 80E —A head (p. 144). Sp. and wh. on greyish ground. Diameter 11. Catalogued as
Fig. 371 " Maniera di Ghirlandajo."

909 No. 82E —Study for a Madonna kneeling in adoration (p. 144, note). Sp. and wh. on buff ground. 20.5 by 15. The type and the hatching point to G.; otherwise this drawing might pass as David's. It is by no means improbable that this sketch was made in preparation for a Madonna in a Nativity [formerly] belonging to M. Emile Richtenberger of Paris—G.'s earliest work among those known to me [(*Riv. d'A.*, 1930, p. 197)].

910 No. 108E—Youthful nude reclining in an attitude which recalls the reclining figure in the foreground of Signorelli's Pan, now in Berlin. Sp. on grey ground. 7.5 by 19. Ascr. to Pesellino, but the type and the Credi-like touch are G.'s.

911 No. 109E—Draped elderly man seated in profile to l. Sp. and wh. grey ground. 19 by 11.5. Ascr. to Filippino.

912 No. 112E—Two youthful nudes, one seated and the other standing (p. 144). Sp. and wh. on buff ground. 18.5 by 14.5. Differs from David only in greater refinement, in the closer hatching, and in the way the white is applied.

913 No. 123E —Head of man with open mouth, looking to r. Sp. and white on pinkish buff ground. 12 by 8.5. Ascr. to Botticelli, but the type, the hatching, and the white are Granacci's.

914 (see 970A)

915 (see 970B)

916 (see 970C)

917 No. 140E —Head of the Virgin in profile nearly to r. Copy, with very slight variations, of
Fig. 377 the head in Fra Filippo's Uffizi Madonna. Below to l., in vague outline, mask of a female head. Also a l. foot in profile and toes of another foot. Sp. and wh. on grape-purple ground. 25 by 18. [Fototeca 13124.] Verso: Study of the same nude model as in my 954, seated in the same position, save that he is looking to r. and holds out his l. arm.

The profile on the front of this sheet is one of the daintiest and sweetest bits of drawing of the entire school. Its strict Filippesque type and its prettiness were responsible, apparently, for its attribution to Filippino. But this artist neither imitated his father's types nor had a touch so delicate. Obliged to look further for its author, the critic will think of many names before G.'s. Yet I believe that the last is the right one. I came to this conclusion after examination of the touch, and quite independently of the nude figure on the verso. This nude, as it happens, is beyond question by G., but that has not greatly influenced my decision; for instances are not infrequent of a front and back of the same leaf being by different draughtsmen. It is rarer perhaps to find masters of this date copying so faithfully older painters; but even this occurs, and G. seems to have been addicted to it. Flagrant cases are his copies after Pesellino [and Fra Angelico], my 956 recto and verso (Figs. 392, 393).

918 No. 173E —Head of nun. Sp. and wh. on red ground. Diameter 9. [Fototeca 13032.] Ascr. to Ghirlandajo. Early.

13

GRANACCI

919 FLORENCE, Uffizi, No. 174E—Portrait of young woman. Sp. and wh. on red ground. 12 by 10.
Fig. 372 [Fototeca 13033.] Same character and attribution as last.

920 No. 175E—Head of nun. Sp. and wh. on red ground. Diameter 9. [Fototeca 13034.]
Same character and attribution as last two.

921 (see 971A)

922 No. 190E—Young woman, nude but for a gauzelike drapery which she holds over her l.
Fig. 382 leg, with her r. arm over her head. On much larger scale, study of the inside of a hand
with bent fingers. On smaller scale again, a r. foot and foreshortened head of a young
person. Sp. and wh. on orange-buff ground. 27 by 19. Braun 76140. Brogi 1727.
 This leaf is catalogued as Botticelli's, because it is assumed that the nude was destined
for the Truth in Sandro's Calumny. But the conception of the nude is different in the two
figures. The sketch is at once more realistic and more advanced than Sandro's figure, nor
is the type, nor the proportions, nor the technique in any way Botticellian. In all these
respects the drawing is Ghirlandajesque. At least as clearly characteristic of the same
school is the study of a hand. Regarding this sheet closer, we cannot fail to observe that
the hatching and the application of white are G.'s. Finally, almost by way of "Granacci
his mark," we have the woman's long, boneless, curved thumb, peculiar to him, as, for
instance, in the St. Jerome in the St. Petersburg Nativity. But although certainly not
Botticelli's, it is by no means improbable that while drawing this nude G. had in mind
Botticelli's Truth.

923 No. 198E—Study for a Lucretia (p. 144). Bl. ch. on wh. paper. 26 by 15.5. [Photo. Man-
Fig. 376 nelli.] Pl. LXXVII of F. E. Ascr. to Botticelli.

924 No. 199E—Draped female, in profile to l. Sp. on wh. paper. 27 by 16. Originally a pendant
to last, and like that ascr. to Botticelli, but entirely made over with bistre and wash by
a later hand. [Verso: Two large winged cupids in profile playing on pipes and a small
faun and sphinx.]

925 No. 220E—Draped figure. Sp. and wh. on buff ground. 28.5 by 15.5. Ascr. to Ghilan-
dajo, but exact type and character of my 957.

926 No. 222E—Three youthful nudes. Sp. and wh. on buff ground. 19 by 24.5. Fototeca
13188. Ascr. to P. Pollajuolo, but except for greater gentleness and finer hatching this
might be David's.

927 No. 230E—Nude youth seated [his body square on to the spectator with his l. leg in violent
foreshortening, and his head in profile to l.] The hatching like Credi's. Sp. and wh. on
buff ground. 25 by 18. Ascr. to P. Pollajuolo.

928 No. 231E—Powerful male nude standing, in profile to l., with his r. hand on a staff and
his l. falling at his side. Sp. and wh. on pinkish buff ground. 36 by 18. Ascr. to P. Pol-
lajuolo, but the type of head and the ear are distinctly G.'s, while the body recalls the
Baptist in the Berlin altar-piece [(Venturi, IX, i, p. 479)]. Finally, the drawing of the arms
and the use of white confirm our attribution.

928A No. 238E—Head of clean-shaven man with open mouth and suffering expression very likely
copied after a Scopasian bust. Sp. and wh. 24 by 14. Fototeca 13128. Suggests Raphael
and Ridolfo Ghirlandajo.

929 No. 239E—Study for the lower part of erect male figure. Sp. and wh. on grey paper. 27
by 15. Ascr. to Credi, but the folds and the hatching are most characteristic of G. (cf.
my 937, 943 and 947).

98

929A FLORENCE, Uffizi, No. 243E —Two draped figures, one seated facing us, the other in profile to l. Sp. and wh. on pink prep. paper. 21 by 26. Fototeca 13189. Verso: Pen sketch for a loggia and a statue in armour holding shield and sword. Fototeca 12730.

930 No. 247E —Infant seated, stretching out its little arms to the l. Sp. and wh. on pink ground.
Fig. 380 10.5 by 13. Brogi 1662. Ascr. to Credi, by whom it is not. A comparison with the Child in G.'s Berlin altar-piece [(Venturi, IX, i, p. 479)], but even more the technique and touch, secure the attribution to G.

931 No. 248E —Elderly nude, holding out his arms, with a stone in r. hand. Sp. and wh. on pinkish buff ground. 28 by 18. Ascr. to Pollajuolo. An attribution to Credi would have been more reasonable, for both as type and as technique this is the most like Credi's of all G.'s drawings. Verso: Draped figure holding book and staff.

932 No. 254E —Two nudes seated, one facing us, and the other turning away with a movement recalling Michelangelo's decorative nudes on the Sixtine Ceiling. Nevertheless, these two figures are ascr. to P. Pollajuolo. Sp. and wh. on pinkish buff ground. 24 by 24.5. Here everything is G.'s, and almost of his better known maturer phase. Comparison with Credi's sheet (my 690, Fig. 153) is instructive. Verso: Head of a bearded man, and in bistre a girl's head [also in hand of about 1600: "Puligo o Ridolfo del Ghirlandaio"].

933 No. 257E —Draped figure of young man looking down to his l. Sp. and wh. on pinkish
Fig. 385 buff ground. 29 by 15. [Fototeca 13129.] Ascr. to P. Pollajuolo, but of the precise style of my 938 and 939 (Fig. 373). Verso: Similar draped figure, but with folds more as in my 937. Also a woman's head, in type recalling both Credi and Perugino, but in technique Credi alone. [Fototeca 13130.] This sheet thus furnishes points of contact between those of G.'s drawings in which he is nearer David, and those in which he approaches Credi.

934 No. 258E —Nude standing with legs apart and firmly planted, his r. arm held up and his l. stretched out. Sp. and wh., on pinkish buff ground. 32 by 22. The head, in profile to l., and the ear are visibly G.'s. So is the Credi-like character of the technique (cf. my 931). Ascr., like that, to Pollajuolo.

935 No. 259E —Nude figure standing in striding posture to l., with the l. arm held out. Sp. and wh. on pinkish buff ground. 30 by 16. Ascr. to Pollajuolo. The type, the proportions, the drawing of the arms, the touch, all are G.'s.

936 No. 268E —Male nude seated by a table, with his head sharply turned to r. resting in his
Fig. 379 hand, and his legs crossed. Sp. and wh. on pinkish buff ground. 26 by 13. [Photo. S. I.] Ascr. to Pollajuolo. Here the type of head and the ear are unmistakably G.'s. The touch is also clearly his. In the cross-hatching, however, we are reminded somewhat of Filippino.

937 No. 270E —Study of drapery for figure standing in profile to l. Sp. and wh. on grape-purple ground. 28.5 by 16.5. [Fototeca 12624.]
Why this should have been ascribed to Credi, except for something in the touch, it is hard to understand. The folds are not of his system but rather Ghirlandajesque, somewhat as in a study for drapery over knees on my 939 (Fig. 373), or in the two standing figures on the same sheet. The nearest parallel to them are the draperies of the Virgin in a Coronation at Città di Castello [(Van Marle, XIII, p. 125)], the execution of the whole of which Cavalcaselle would take to be G.'s. Perhaps other assistants as well have worked on this picture [designed by Domenico] but the Virgin is clearly G.'s. To return to our drawing, it should further be compared with my 978, which, although so much later and more obviously G.'s, yet resembles it in the folds.

938 FLORENCE, Uffizi, No. 293ᴱ—Draped youth seated, drapery for standing figure, and two studies of a girl in brisk movement. Sp. and wh. on greenish grey ground. 25 by 32. Verso: Elegantly draped youth, in attitude of the figure on the extreme r. in Leonardo's Adoration of the Magi. Also a smaller figure in profile.

This sheet is ascribed to Ghirlandajo, but the quality of touch is not his, nor are the draperies of his system. The relation to David is much closer, and it is obvious that their author must have been on intimate terms with the latter. That this author was G. is clear from the Credi-like hatching and touch, and from the squarish folds. It is obviously by the hand which drew the next (Fig. 373).

939 Fig. 373 No. 295ᴱ—Two draped figures, drapery for lower part of seated figure, and sketch for a Madonna adoring the Child (p. 144, note). Sp. and wh. on pinkish buff ground. 33 by 26.5. Brogi 1765. Ascr. to Ghirlandajo. [Verso: Two studies of drapery in same technique.]

The figures on the recto are Ghirlandajesque, but in David's rather than Domenico's fashion. For David, however, these sketches are too refined. The system of folds recalls G.'s earliest painting and such a study as my 937. The hatching and white, moreover, connect this sheet with the school of Credi, in the way that all G.'s earlier studies attach themselves to that school. Finally, the sketch for a Madonna recurs with no change on a sheet certainly by G. in the Santarelli Collection (my 981, Fig. 374) of the Uffizi. These sketches for a Madonna, as well as the one on my 909, may have served as studies for a Nativity [formerly] belonging to M. Richtenberger, of Paris [(*Riv. d'A.*, 1930, p. 197)].

940 Fig. 387 No. 297ᴱ—Virgin kneeling, turned to r., and the Child reaching up to her. This with the pen and wh. Also study, with sp. and wh., for a hand. 18 by 24. Brogi 297. Ascr. to Domenico. The hand should be compared with the one on my 922 (Fig. 382). Both the Virgin's face and the Child's are clearly G.'s.

941 No. 305ᴱ—Draped figure seen from behind. Sp. and wh. on grey ground. 18 by 8. [Brogi 1424ᴮ.] Ascr. to Masaccio, but folds and touch are G.'s.

942 Fig. 370 No. 307ᴱ—Draped figure, and two children's heads (p. 143, note). Sp. and wh. on buff ground. 25.5 by 33. Brogi 1764. Ascr. to Domenico and close to him.

943 No. 310ᴱ—Study after the cast of a foot. Drapery for legs of figure sitting on the ground stretched out. The rest of this figure is indicated in outline, and has a face of distinctly Granacciesque type. The folds and the technique also are his. Sp. and wh. on buff ground. 14 by 25. Ascr. to Credi.

944 Fig. 384 No. 311ᴱ—Almost nude male standing in martial attitude, with r. arm held out, and facing to r. Nearly identical with my 935. Sp. and wh. on deep grape-purple ground. 21.5 by 11. [Fototeca 13132.] Ascr. to Pesellino [but rather Peruginesque].

945 No. 312ᴱ—Nude holding sword with both hands. Sp. and wh. on purplish buff ground. 23 by 13.5. Ascr. to P. Pollajuolo, but in the character of my 927.

946 No. 313ᴱ—Two draped young men. Between them study of a foot. Also a child's head, and an angel running to l. Sp. and wh. on pinkish ground. 22 by 29.5. [Fototeca 13090.] Ascr. to Domenico, but in every way characteristic of G., and one of his best Ghirlandajesque drawings. [Verso: Study from same antique relief as verso of my 948: nude youth on horseback, seated Victory with cornucopia. Sp. inked over later. The nude on horseback far too Leonardesque for Domenico or David. Fototeca 13091.]

947 No. 314ᴱ—Draped young man seated on the ground. His folds as in my 943. Also a child exactly like the one in my 930 (Fig. 380). Sp. and wh. on pink ground. 14.5 by 20. [Fototeca 15094.] Ascr. to Credi.

948 FLORENCE, Uffizi, No. 317^E—Young woman seated, reaching down with both arms to the ground—study perhaps for a figure in a Birth of the Virgin. Sp. and wh. on pink ground. 18 by 16.5. Brogi 1754. Ascr. to Domenico, but the touch and the technique are G.'s. Both thumbs are highly characteristic of him (see my 922, Fig. 382). Verso: Nude on horseback, and two other figures after the antique.

949 No. 325^E—Youthful nude seated, holding his l. foot with both hands on his r. knee. Sp.
Fig. 397 and wh. on grey ground. 20 by 13. [Photo. S. I. 4722.] Ascr. to Credi.

950 (see 974^A)

951 (see 974^B)

952 (see 974^C)

953 (see 974^D)

954 No. 359^E—Male nude seated on ground with legs crossed, and leaning on his r. arm. Head in profile to l. Sp. and wh. on pinkish buff paper. 18 by 13. Ascr. to P. Pollajuolo. The type, the proportions, the technique, all are G.'s. The foreshortened r. arm suggests Michelangelo. The l. hand is of a character found only in the Cinquecento.

955 No. 373^E—Virgin seated on ground with the Child on her l. knee; He reaches out towards
Fig. 383 the infant John, who faces Him, while above the latter Joseph throws up his hands in delight; below, torso of a child. Pen, on yellowish paper. 17 by 11. [Photo. S. I. Thiis, p. 127.] Study for a picture not unlike G.'s Holy Family at the Pitti Gallery (Alinari 2946), and resembling also two drawings ascr. to Fra Paolino, but also by G., my 979. [See also my 1059 for the Leonardesque quality of the motive.] The spirit, the types, and the pen-stroke are distinctly G.'s. With the Child compare those on my 930 (Fig. 380) and 947.

956 No. 380^E—Draped young woman seated on ground, turning to r., but seen from behind;
Fig. 392 also vague sketch of Apollo. Sp. and wh. on pink ground. 19 by 28. Braun 76310.
Fig. 393 Brogi 1691. Verso: Young man, with curling long locks heavily draped, sits on the ground facing to l., with hands held out towards a landscape; also lower part of excessively slender nude like my 982^C. Brogi 1541.

This sheet is ascribed to Pesellino, for the good reason that the female figure on the recto is copied after one in Pesellino's predella at the Uffizi representing St. Anthony causing the miser's heart to be sought for [(Van Marle, X, p. 487)]. It is, however, done in a technique that recalls not the earlier middle years of the fifteenth, but the earliest years of the sixteenth century. Turning to the Apollo, we note a search for *contrapposto* which suggests Michelangelo, but not Pesellino. This figure has, moreover, the exact proportions and build of G.'s nude on my 922 (Fig. 382). His hand is identical with the r. hand on my 948. The stroke and the technique are exactly as in the two last-mentioned drawings. Reversing the sheet we see, obviously drawn by the same person, a nude of proportions as undreamt of in Pesellino's time as they were frequent in an epoch closer to Cellini's. The seated figure on the verso [is copied from the St. John in the Pietà of the predella to Fra Angelico's Coronation at the Louvre (Schottmüller, 51)]. The profile and hands are decidedly G.'s, and the folds approach those on my 947 by the same artist.

957 . . . No. 381^E—Draped seated figure in profile to r. Sp. and wh. on buff ground. 17 by 13.5. Brogi 1693. Ascr. to Pesellino. Exact type and character of the figures on my 933 (Fig. 385) and 938, but of a technique nearer David's, as, for instance in my 786, which I ascribe to the latter.

958 FLORENCE, Uffizi, No. 508^E—Two kneeling figures, one in profile to l., the other seen frontally. Studies chiefly of drapery. Sp. and wh. on grey ground. 20 by 26. Ascr. to Credi, but the type and the hand are certainly G.'s. [According to Jakobsen studies for the St. Jerome in the Berlin Assumption and for the St. Michael in the Uffizi altar-piece (No. 1596). See *Jahrb. Pr. K. S.*, 1904, p. 189.]

959 No. 1144^E—Heavy nude, seated with his hands tied behind him. Sp. and wh. on pink ground. 23 by 12. Ascr. to P. Pollajuolo. In character of my 928. Verso: Torso a nude. Most characteristic of G.

960 No. 1148^E—Nude seen from behind. Sp. and wh. on grey ground. 23 by 12.5. Ascr. to of Pollajuolo. Same character as last.

961 No. 1150^E—Masklike bearded head. Sp. and wh. on pink ground. 12 by 10. [Fototeca 12643. Photo. Mannelli.] Ascr. to Botticelli, but probably G.'s. Almost same as head of bishop in Florence Academy (No. 3247) but much earlier.

962 No. 1152^E—Youthful nude facing l. and holding stick in both hands, at arm's length. Sp. and wh. on pinkish buff. 23.5 by 12. [Photo. Mannelli.] Ascr. to Botticelli. Same character and probably the same model as on my 949 (Fig. 397).

963 No. 1154^E—Male nude in profile to l. Sp. and wh. on pink ground. 29 by 11. [Foto-
Fig. 386 teca 13135.] One of G.'s most typical drawings, despite its attribution to Botticelli.

964 No. 1155^E—Nude seen from behind. Exact character of last. Sp. and wh. on pink ground. 26 by 9.5. Brogi 1831. [Van Marle, XII, p. 368.] Ascr. to Botticelli.

965 No. 1199^E—Drapery of figure seated turning to r.; torso and head barely indicated. Sp.
Fig. 390 and wh. on grey ground. 27 by 18.5. [Fototeca 13137.] Ascr. to Credi.

966 No. 1247^E—Study for young Mage (p. 145). Bl. ch. and wh. on purplish ground. 28 by 15.
Fig. 375 Pl. 139 of Schönbrunner & Meder. Catalogued as "Maniera del Ghirlandajo." [Verso: Head of smooth-shaven oldish man.]

967 No. 1249—Young woman striding rapidly forward to l., but looking back to r., her draperies tossed by the breeze. Bl. ch. on wh. paper. 21 by 15.5. Ascr. to Filippino, but G.'s in the character of my 923 and 966 (Figs. 375, 376).

968 No. 1399^E—Profile of girl looking up to r. with drapery twined in her hair. Sp. and wh. on pinkish ground. 16 by 12.5. Braun 76258. Close to Garbo.

969 No. 1400^E—Magdalen kneeling at foot of Cross. Sp. and wh. on pinkish ground. 26.5 by 18. Braun 76259.

969^A No. 13^F—Heavily draped figure seen from behind and in reversed direction head of child looking up. Sp. and wh. on pink paper. 27 by 16. Fototeca 13138.

969^B No. 17^F—Study from model for Christ on the Cross. Torso, head and l. arm finished in r. ch. and wh., legs in sp. alone on pink paper. 27.5 by 19.

969^C No. 36^F—Profile to l. of youth with hat worn soon after 1500. In later writing attributed to Agnolo di Donnino (p. 344). Sp. and wh. on pale mauve ground. 10.5 by 9.5. Fototeca 13192.

969^D (former 832) No. 107^F—Two nudes, one sitting and the other seen from the back. Head of bearded [Leonardesque] man in profile. Sp. and wh. on buff ground. 20 by 25.5. Verso: Portrait head of smooth-faced old man [which suggests the antique and may have been done after a bust like the one published by Professor Fred. Poulsen in *Revue Archéologique* for July-Oct., 1932, and reproduced on page 66. Fototeca 12647.]

969[E] FLORENCE, Uffizi, No. 124[F]—Figure seated with head in hand as if for an apostle in Gethsemane. Sp. and wh. on pink prep. paper. 12.5 by 10.5.

970 No. 126[F]—Deposition from the Cross. [Bl. ch. used in Michelangelesque way.] 22 by 18.
Fig. 391 [Fototeca 13142.] Late.

970[A] (former 914) No. 127[F]—Bearded male head, slightly turned to l. Sp and wh. on buff ground. Diameter 21. [Fototeca 15096. Imitated from such of Perugino's drawings as reproduced in Fischel, figs. 112 and 114, particularly the last, of which it is almost a reversed copy. Observe, however, how much more plastic G. is than his original.]

970[B] (former 915) No. 128[F]—Study for head of Jerome in the Berlin altar-piece (No. 88) (p. 144). Sp. and wh. on greyish ground. 27 by 18. [E. Jakobsen, *Jahrb. Pr. K. S.*, 1904, p. 187. Verso:
Fig. 388 Various pen-sketches for a standing Leda, inspired by Leonardo, but probably of considerably later date than the head on the other side. Foteteca 15098.]

970[C] (former 916) No. 135[F]—Nude young man seen from the back. Sp. and wh. on buff ground. 27 by 14. Attr. to Baldovinetti.

970[D] No. 158[F]—Copy after the two women talking excitedly at r. of Filippo Lippi's Prato fresco representing Feast of Herod (Van Marle, X, p. 439). Bl. ch., bistre wash and wh. on brown tinted paper. 34 by 19. Fototeca 13579. Verso: Head of young man seen three-fourths to l. Bl. ch. and wh. on grey ground. Fototeca 13580. The head on the verso is almost certainly by G. and the copies on the recto may be his as well. See for other copy of same subject my 866[B] verso (Fig. 322).

971 (see 37[B])

971[A] (former 921) No. 187[F]—Study for child. Sp. and wh. on buff ground. 15 by 7. Ascr. to Credi. Of same kind as the large number of sketches of children in the Corsini Collection in Rome. Verso: Companion study.

971[B] No. 189[F]—Head of badly shaved man in profile r. Sp. and wh. on blue paper. 11.5 by 12.5.

972 No. 193[F]—Child seated. Sp. and wh. on pinkish ground. 16 by 7.5. Ascr. to Credi. Of the same kind as the sketches in the Corsini Gallery in Rome.

973 No. 197[F]—Head of child in profile, and two studies of feet. Sp. and wh. on pinkish ground. 16 by 16.

974 (former 740) No. 200[F]—Male figure in short tunic, starting back with hands held up in fright. Sp. and wh. on buff ground. 22 by 14. [Fototeca 14983.] Verso: Seated figure, a repetition of my 949 (Fig. 397). [Fototeca 15219. Listed by mistake as both 974 and 740 in F. E.
Dr. B. Degenhart in *Riv. d'Arte*, 1930, pp. 417-419, points out the connection between this sketch and a figure in the Botticellian panel formerly in the Spiridon Collection and now the property of Señor Cambo of Barcelona, and concludes that the drawing is a study for the painting, the usual fallacy that when a sketch and painting correspond one must have been done for the other. In this case it is probable that G., who so often imitates and follows Botticelli, has copied this figure from a study by that master, for that the Cambo panel was designed by Botticelli in every part should be beyond dispute. On the verso the eclectic G. is at his nearest to David Ghirlandajo, while in the other version of the same subject—the classical one of the youth pulling out a thorn from his foot (my 949, Fig. 397)—he is nearer to Credi.]

974[A] (former 950) No. 345[F]—Study for the head of guard on extreme l. in panel representing Joseph led to prison [(Venturi, IX, i, p. 486)] (p. 144). Sp. and wh. on purplish grey ground. Diameter 7.

974^B (former 951) FLORENCE, UFFIZI, No. 347 F—Head in profile of an old man, a young man in profile,
Fig. 381 and various hands (p. 144). Sp. and wh. on purplish grey ground. 20.5 by 23. Studies,
like last, for the Uffizi panels representing the Story of Joseph.

974^C (former 952) No. 348 F—Bust of the Saviour (p. 144). R. ch. on wh. paper. 27 by 29. Pl. LXXVI
Fig. 378 of F. E. Ascr. to Franciabigio.

974^D (former 953) No. 349 F—Five busts (p. 144). Sp. and wh. on purplish grey ground. 20.5 by 23.
Pl. LXXV of F. E. Studies for same subject as my 974^A and 974^B (Fig. 381).

975 No. 435 F—Male head. Sp. on grey ground. Diameter 11. Ascr. to Sogliani, but the type
and the handling are G.'s.

976 No. 436 F—Profile to r. Goes with last. Diameter 8.5.

977 No. 6351 F—Madonna seated leaning a little to l., with the Child clinging to her r. knee.
Bl. ch. 33.5 by 22. Late.

978 No. 6352 F—Erect draped figure. Bl. ch. and wh. 39 by 15. [Fototeca 13193.] Late,
but folds still recall the much earlier study, my 937, ascr. to Credi.

979 No. 6807 F—Madonna, sitting on ground with legs curled under her, offers the Child to
the embrace of the infant John. Joseph and Francis adoring. Bl. ch. 34.5 by 27. Very
late, and almost as mannered as if by Michele di Ridolfo, but resembling my 955 (Fig. 383).
Ascr. to Fra Paolino. Verso: Virgin seated looking to r., with the Child on her r. knee,
looking up to her. On l. the infant John tries to get His attention. Above Him, behind
a wall, Joseph. This composition recalls G.'s Pitti picture (Alinari 2946).

980 No. 14764 F—Portrait head of smooth-shaven man, looking down in profile to l. Bl. ch.
26.5 by 20. Typical of G.'s maturer manner.

981 UFFIZI, SANTARELLI, No. 7—Study for Judith of fantastic height holding the drawn sword
Fig. 374 in her r. hand, and with l., high above her, head of Holofernes; another female figure of
more ordinary proportions in a similar attitude; also study for a Madonna kneeling in
profile to l. (p. 144, note). Pen. 26 by 18. [Brogi 1251.]

This sheet, given to Filippino, is highly interesting in connection with various other
drawings that we have ascribed to G. That it is not Filippino's we need not attempt to
prove. The pen-stroke and the folds of the draperies are enough to establish that it is G.'s,
for both partake, as his work only does, of Credi as well as of Ghirlandajo. Then, if you
reverse the figure, it turns out to be practically identical with the Lucretia (my 923,
Fig. 376). The fantastic proportions we have found matched in a figure on the back of
my 956 (Fig. 393). The head of the other figure resembles that of the Madonna on my 955
(Fig. 383). Finally, the kneeling Virgin is identical with a Virgin on my 939 (Fig. 373),
with which leaf, therefore, it must be contemporary.

982 No. 3 P—View taken near west front of S. Maria del Fiore, looking toward the Baptistery,
Bigallo, and present Via Calzaioli. The Baptistery is sketched as standing on four steps,
which, of course, it never did, although this change was suggested by Leonardo. Pen,
pricked for transfer. 16.5 by 26. [Fototeca 4818.] Topographically interesting, and in
other respects pleasant.

982^A HAARLEM, KOENIGS COLLECTION, Inv. 115—Bust of youth in profile to l. and bust of woman turned
slightly to r. with kerchief on her head and arms folded under apron. Also faint indication
of another youthful head. Bl. ch. on red prep. paper. 17.5 by 26.5. Attr. to Naldini but
if not G.'s, is it possibly by an Italianate Fleming? The youthful head must have been
inspired by an antique bronze.

982 B HAARLEM, KOENIGS COLLECTION, Inv. 255—Study for St. Jerome praying and drapery over shoulder
 Fig. 394 and arm. Sp. and wh. on blue paper. 25.5 by 11.5. Attr. to Ghirlandajo's studio. Studies for the Jerome in the Berlin picture (Venturi, IX, i, p. 479).

982 C HAMBURG, KUNSTHALLE, 21354—Study for nude male figure with l. arm raised and r. arm behind hip, probably for a St. Sebastian. Also some writing. Sp. and wh. on purple prep. paper. 28 by 11. Attr. to School of Filippino. The elongated proportions point to a relatively advanced period of G.'s career but contradict the rather meticulous contours and modelling. The writing has grown more cursive than in the letter of 1508 reproduced in Pini's *La Scrittura di artisti italiani*, II (Florence, 1876). But this could have been added later, and would seem to have been done so after the drawing, seeing that the scribbling tries to avoid the figure.

983 LILLE, MUSÉE WICAR, No. 230—Nude holding disc above his head. Sp. and wh. on tinted ground. 21.5 by 10. Braun 72137. Ascr. to Finiguerra, but goes with my 945.

984 No. 231—Study of drapery for figure standing, turned slightly to r. with the r. foot forward.
 Fig. 580 Pen and wh. on pinkish ground. 25 by 12.5. Braun 72134. Ascr. to Finiguerra. It corresponds with a figure on the extreme l. in the Assumption of the Virgin at S. Maria Novella. That it is G.'s the form of the hand suffices to prove (cf. my 963, Fig. 386). The hatching is remarkably close to that of the very young Michelangelo.

 [It now (1934) seems that the close pen-hatching must have been done by Michelangelo when he and G. were both helping the Ghirlandajos with the frescoes of S. Maria Novella. There is nothing like it in G.'s work and it is far too fine and plastic for Domenico Ghirlandajo himself. See my 1475 A (Fig. 580).]

985 No. 370—Nude, middle-aged man seated on the ground. Sp. and wh. on buff ground. 20 by 17. Braun 72010. Ascr. to A. Pollajuolo, but of the exact kind of my 927. Verso: Half-length draped figure.

985 A No. 286—Bushy-headed nude seen from behind with his r. arm held out. Sp. and wh. on pinkish ground. 23 by 15. Braun 72195. Ascr. to Filippino. Nearly of the character of my 928 and 959.

985 B No. 287—Male nude seated on stool with l. hand on lance. Sp. and wh. on pinkish ground. 28.5 by 13.5. Ascr. to Filippino. Braun 72196. [Listed as 985A verso in F. E.]

986 LONDON, BRITISH MUSEUM, Pp. 1-18—Study of one of the Dioscuri on Monte Cavallo. Sp. and wh. on blue ground. 36.5 by 24.5. Braun 73065. Ascr. to A. Pollajuolo, this rather fetching drawing has all the characteristics of my 928 and 933 (Fig. 385).

987 (see 2731)

988 1890-4-15-174—Profile of man to r., wearing moustache. Bl. ch. 24 by 17. [Popham, *O. M. D.*, XI (1936/37), p. 17 and pl. VI.] Ascr. to Ridolfo Ghirlandajo, and perhaps correctly, but the type, the modelling, and handling are closer to Ridolfo's master, G.

989 1875-6-12-3—Almost life-size portrait head of fat smooth-faced man looking out a little to l. Below, on a smaller scale, head of youth looking down. Sp. and wh. on brownish prep. paper. 30 by 21. Ascr. doubtfully to Credi, but the conception is too Ghirlandajesque for Credi, while the handling points to G. The youth, or a head almost identical with it, occurs on more than one Uffizi drawing attributed to Ghirlandajo or to Credi, but which, it seems to me, are G.'s.

990 LONDON, British Museum, Crackerode, F-f, 1-34—Head of bald man with short beard. He looks down a little to r. Bl. ch. 22.5 by 15. Ascr. to Lo Spagna. The only question is whether it is G. or Sogliani; but it is probably a late G. Verso: Pen sketch for St. Sebastian, by a hand close to Fra Bartolommeo's; and, considering how poor his nudes are, it may well be his, but considerably retouched.

991 British Museum, Malcolm, No. 21—Heavily draped pensive youth, seated, reclining on his elbow. Sp. and wh. on buff. 19 by 11. Ascr. to Credi, but if not G.'s, then David Ghirlandajo's, yet more likely the former's.

992 No. 125—Five nudes, two of them in the attitude of combattants and the others of
Fig. 395 onlookers; one of these reclines on the ground and the other two stand erect. Bl. ch. 27 by 36. Ascr. to Rosso, but too firm for that painter and not in his manner. The types betray G. in a phase between the panels at the Uffizi recounting the story of Joseph and the Assumption at the Academy [(Venturi, IX, i, pp. 486 and 480)]. The touch is his. Characteristic of him is the r. arm of the hand holding a dagger or some such object. Compare it with the arm in the drawing of a Dioscurus in the B. M. (my 986). A copy in pen and ink of the figure on the r. is ascribed in the Uffizi (No. 6496) to Rosso.

992A Dr. Bullingham Smith—Study for Raising of Lazarus. Pen. 20 by 28. Repr. in Sotheby's
Fig. 398 Sale Cat. of Nov. 26, 1929, as No. 67. A typical late design with types, proportions, and penmanship characteristic of that period.

992B MILAN, Ambrosiana, Libro Resta—Youthful male nude seen from behind turning to l. On pedestal decorated with vase, cornucopia, and segment of knobbed wheel a male statue with its arms tied behind resting on badly broken stumps. Sp. and wh. 17 by 13. Braun 15283.

993 OXFORD, Christ Church, B. 14—Head of young man in profile, turned down a little to l. and looking straight out; the ear well exposed. Sp. and wh. on prep. buff paper. 13.5 by 11. [Colvin, V, pl. 4.] Perhaps he is never again so close to Domenico Ghirlandajo, but the handling of the white betrays G.

994 B. 14—Mask of the same, without ear and looking through half-closed eyes. Sp. and wh. on prep. buff paper. 13.5 by 11. [Colvin, V, pl. 4.]

994A B. 10—Study for male nude with hands folded in prayer, probably study for a baptism. Sp. and wh. 27 by 14.5. Degenhart, *Münch. Jahrb.*, 1932, p. 106. Bell (pl. 29) gives it to the school of Credi and connects it with the St. Victor in the Louvre altar-piece (Van Marle, XIII, opp. p. 292).

995 B. 11—Nude, being a free copy of Verrocchio's David. Sp. and wh. on greyish ground. 27.5 by 12.5. [Bell, pl. 30. Colvin, VI, pl. 3.] The mingling of Ghirlandajo and Credi influences, as well as the touch, point clearly to G.

996 No. 192—Copy of antique bas-relief representing struggle of horses and fight of Amazons. Sp. and wh. on pinkish buff prep. paper. 21 by 29.5. [Colvin, VI, 2. Text to same has interesting information about the original relief.] Ascr. to Giulio Romano, but obviously earlier and Florentine. The influences of Ghirlandajo, Filippino, and even Botticelli are discernible in the types, and the handling is wholly G.'s.

996A PARIS, Louvre, No. 769—Three figures copied from Michelangelo's Brazen Serpent. R. ch. 27 by 25.
Fig. 396 Arch. Ph.

996B No. 2677—Study of male figure, nude except for loin cloth. Bistre and wh. on pinkish paper. 20 by 14.5. Arch. Ph. Ascr. to Pollajuolo. Meticulous and tight like Credi.

996^C PARIS, LOUVRE, No. 2683—Two drawings on same mount: male nude with hands tied behind back for a St. Sebastian and male nude seen from behind; with latter cf. my 985 A. Both in bl. ch. and wh. 27.5 by 10 and 27.5 by 11. Arch. Ph. Attr. to "École Italienne XVᵉ."

997 No. 2687—Two youthful draped figures. Sp. and wh. on pinkish ground. 19.5 by 22. Braun 62502. Arch. Ph. Verso: Study for drapery of standing figure. Of the exact kind as my 925 and 939 (Fig. 373), and almost identical with my 933 verso.

997^A No. 2696—Two studies of nude male figure in profile to l. holding pomegranate in r. hand. Pen, bistre and wh. on prep. yellowish paper. 20 by 17. Arch. Ph. Probably copied after Antonio Pollajuolo.

998 (see 859 D)

998^A No. 9860—Two women, one crouching on the floor, the other kneeling behind her. Probably
Fig. 389 for a Nativity of the Virgin. Sp. and wh. on pale grey paper. Squared for transfer. 11.5 by 9. Arch. Ph. It is quite possible that this was done for a finished drawing made in competition with Andrea del Sarto for the fresco that the latter painted in 1514 for the SS. Annunziata at Florence.

998^B ÉCOLE DES BEAUX-ARTS, No. 34901—Study of man in short tunic and bare legs in attitude of rhetorical orator. R. ch. 39 by 27.5. Verso: Youthful nude, seated in profile with head leaning on l. hand and looking round towards us. 21.3 by 17.3. Both Arch. Ph. Both distinctly Michelangelesque. Dating from perhaps 1520-1530.

998^C RENNES, MUSEUM, Case 3, No. 3—Two figures in heavy draperies, a monk and a woman. Between the two a female profile to l. Bl. ch. and wh. on buff ground. 16 by 17. Copies from Fra Filippo's Prato frescoes and attr. to Fra Filippo.

998^D Case 3, No. 4—Curly head of youth looking towards l. Bl. ch. and wh. 20 by 17. Attr. to Pollajuolo but Ghirlandajesque.

998^E Case 28, No. 2—Heavily draped male figure with head in profile to r. and hands folded. Bistre and wh. on pink paper. 20 by 10. Attr. to the Florentine School of the 15th century.

998^F ROME, CORSINI, PRINT ROOM, No. 127616—Sketch for nude leaning on staff with r. knee bent and looking up. Done from the model. Sp. and wh. on pink prep. paper. 33.5 by 15.

999 No. 130472—*Putto* seated, looking to l. (p. 144, note). Sp. and wh. 12 by 13. See my 1002.

1000 No. 130473—Child seated, pointing to himself (p. 144, note). Sp. and wh. on pink ground. 14 by 8.5. [Rusconi, *Emporium,* 1907, p. 272.] Almost a repetition of my 972. See my 1002.

1001 No. 130474—Child seated (p. 144, note). Sp. and wh. on brown ground. 14 by 8.5. See my 1002.

1002 No. 130476—*Putto* reclining to r., pointing to himself (p. 144, note). Bistre wash and wh. on grey paper. 14.5 by 12.

This and the other studies in this collection of naked children ascribed to P. di Cosimo, along with two or three in the Uffizi ascribed to Credi, are more likely by G. I base this opinion upon the technique and touch, which apparently are his; upon the different influences traceable in them; upon the fact that their modelling recalls such drawings as my 954; and finally, upon the probability that several of these *putti* may have been drawn for the Child in a Nativity which I have good reason for believing to be an early work by Granacci. For this Nativity [formerly] belonging to M. Richtenberger, of Paris [*Riv. d'Arte,* 1930, p. 197], we already have found more than one study in the Uffizi (my 909, 939, Fig. 373). All these *putti,* moreover, are of the type rapidly indicated on my 939 (Fig. 373).

1002A ROME, CORSINI, PRINT ROOM, No. 130477—Study for *putto* seated on a block. Sp. and wh. on grey ground. 11.5 by 18.

1002B No. 130479—Study for child. Sp. and wh. on pink prep. paper. 14 by 11.

1003 No. 130480—Two studies of child. Sp. and wh. on brown ground. 14 by 10.

1004 No. 130481—Child reclining, pointing to himself (p. 144, note). Sp. and wh. on pink ground. Verso: Inscribed, by much later hand, with the words "Pier de Cosimo." 11 by 10.5. [Rusconi, *Emporium*, 1907, p. 272. Anderson 2820. Van Marle, XIII, p. 389.] See my 1002.

1005 No. 130482—Study of seated child. Sp. and wh. on tinted ground. 13 by 11. See my 1002.

1006 No. 130483—Study for Child in Nativity lying in attitude close to that of the Child in the Nativity formerly belonging to M. Richtenberger. Bistre wash and wh. 12 by 12.5. Verso: Young woman draped, unmistakably G.'s. Sp. and wh. on tinted ground. Anderson 31345. [The verso is listed under my 19 in F. E.]

1007 No. 130450—Draped youth. Sp. and wh. on grey ground. 23.5. by 15. Anderson 2815. Verso: Nude. Ascr. to P. di Cosimo.

1008 No. 130489—Draped youth standing, facing to r. Sp. and wh. on grape-purple ground. 23 by 13. Anderson 2815. Ascr. to P. di Cosimo. Close to David Ghirlandajo.

1009 No. 130490—Draped youth, facing front. Sp. and wh. on grape-purple paper. 23 by 14. Anderson 2815. Ascr. to P. di Cosimo. Verso: Head and drapery. The above three leaflets are certainly G.'s, as is testified by the stroke, technique, and character of the heads. Compare with my 933 verso and 942 (Fig. 370).

1009A VENICE, ACCADEMIA, 168—Nude man sitting with legs crossed and r. arm leaning on table and holding small bowl in r. hand. Bl. ch. and wh. on pink prep. paper. 18 by 10.5.

1009B VIENNA, ALBERTINA, Sc. R., 332—Draped figure kneeling in profile to r. Bl. ch. and wh. 30 by 23.5. Ascr. to Franciabigio. Albertina Cat., III, No. 164.

School of Granacci

1009C OXFORD, CHRIST CHURCH, B. 16—Two pen-studies for a Trinity. The larger drawing 19.5 by 14.5, the other 7.5 by 15.5. Pricked for transfer.

The connection noted by C. Bell with the Trinity in S. Spirito (Van Marle, XII, p. 427) is certain. It is not so sure that these sketches were studies for, rather than after, the picture. The features of the Eternal in the lower study and the touch suggest Sogliani, of whom the painting gives no reminder. The inscriptions, by the way by later and different hands, name two of the painters whose style is most closely recalled by the S. Spirito altar-piece: Antonio *(sic)* Granacci (really Francesco) and R. del Garbo. A third is Ridolfo Ghirlandajo.

Leonardo da Vinci [1] (pp. 50-52, 55-68, 166-183)

1010 AMSTERDAM, Fodor Museum—Magnificent bust of old man, looking to r. and pointing in the same direction with his r. hand. Probably for an Adoration. Pen. 10 by 9.5. [Venturi, *Studi*, p. 60. Amsterdam Exh. Cat., No. 570.]

1010 A (former 1072) BAYONNE, Musée Bonnat, No. 659—Sketch for hanging figure of Bernardo di Bandini, who was executed December 28, 1479. The transliteration of the writing will be found in Richter, paragraph 664. Pen. 18 by 7. Pl. xcviii of F. E. [Bodmer, 116. Comm. Vinc., II, 37. Sirén, 57. Verso: Vague indication in bl. ch. of legs of a hanging figure.]

1010 B (former 1073) No. 658—Sketch for Nativity [that is at the same time an Adoration of the Shepherds
Fig. 482 (p. 171). Seems earlier than the studies for the Adoration of the Magi.] Pen. 21.5 by 15. Pl. cii of F. E. [Bodmer, 131. Suida, No. 22. Sirén, 53. Comm. Vinc., II, 45.]

1010 C (former 1074) No. 660—Sheet containing three figures below a stele—[the last might have come
Fig. 476 straight from the Keramaikos or from 4th century lecythe] while the figures are of the kind L. might have drawn while thinking of his Adoration—a mermaid, two children, and a youngish woman kneeling in profile to r. (p. 170). Pen. 24 by 17. Müntz, p. 248. [Bodmer, 142. Comm. Vinc., II, 39.]

1010 D (former 1075) No. 153—Studies for Madonna with the Child fondling kitten. Pen. 23 by 17. Müntz, p. 450. [Bodmer, 122. Bonnat Publ., 1926, pl. 18. Comm. Vinc., I, 26.]

1010 E (former 1076) No. 1211—Slight sketch for a St. Sebastian (p. 180). Bl. ch. 14.5 by 5.5. Müller-Walde,
Fig. 544 Beiträge II, p. 251. [Suida, No. 85. Comm. Vinc., II, 69 B.]

1010 F (former 1077) No. 1324—Profile of old man to l. R. ch. 6 by 4.5. [Arch. Ph. Popp, 32.]

1010 G (former 1078) No. 1325—Profile of old man to r. Pen. 6.5 by 4.5. [Arch. Ph.]

1010 H (former 1079) No. 656—Sketch for an allegory. Pen. 9.5 by 9. Pl. cxx of F. E. [Bodmer, 232. Comm. Vinc., III, 105. Interpreted by Popp, 28.]

1010 I No. 1326—Geometrized sketch for a horse with measurements. Bl. ch. on pink paper. 17.5. by 20.5. Bonnat Publ., 1926, pl. 19. Traditional type of drawing in the Florentine School as we see in the Pollajuolesque drawing from the Pembroke Collection now in the Metropolitan (my 1947 B). A similar study at Windsor (Bodmer, 192).

1. It is my intention to catalogue those only of Leonardo's drawings that reveal his activity as an artist. It is not always easy to distinguish between sketches which show him in this light and such as do not; and I have used my own discretion in the matter, being guided somewhat by convenience. The number which I shall record here will surely suffice all but the greediest, and these, praiseworthy in their craving, will, with their eyes trained on the examples here entered, find no difficulty in separating the wheat from the chaff. This is perhaps the appropriate place to mention my great indebtedness to Dr. Richter's *Literary Works of Leonardo da Vinci*. I am not a student of diplomatics, nor of the many sciences in which Leonardo was absorbed, and can not judge of Dr. Richter's supposed shortcomings as a transcriber of texts, and commentator upon them. This much I can say: that a better choice of drawings for illustrations than his work contains could scarcely have been made; and that, despite the many improvements which have taken place since the appearance of his book, better reproductions are as yet hardly attainable. In the selection of examples to illustrate the present work, I have taken it for granted that every one will have in his hands Dr. Richter's volumes, and I have tried to supplement rather than to repeat his materials. [1937. I have just learned that a new edition of Dr. Richter's book is being prepared and will be published by the Clarendon Press, Oxford. Fortunately, the plate numbers are not being changed.]

Correcting this proof, I receive the welcome news that the Italian Government has undertaken to publish in facsimile all of Leonardo's manuscripts and drawings.

[June, 1933. The last-named publication is well under way and for quality of reproduction surpasses anything ever done for Italian drawings. But as this and Richter are not always accessible we find an admirable substitute in Bodmer's volume on Leonardo in the *Klassiker der Kunst* series. It gives nearly the whole of the material, drawings and paintings, necessary for understanding the master and marshals the first in a chronological order which I have seldom found it necessary to disagree with. Before using this list students should read what is said in Chapter VIII as well as in Chapter III, pp. 50-52, 55-66.]

1010ᴶ BERN, Mʀ. Lᴜᴅᴡɪɢ Rᴏꜱᴇɴᴛʜᴀʟ—Study of a bear walking. Sp. on pinkish buff paper. 10.5 by 13.5. Kenneth Clark, *O. M. D.*, XI (1936-37) pp. 66-67, pl. 65.

1011 BUDAPEST, Mᴜꜱᴇᴜᴍ ᴏꜰ Fɪɴᴇ Aʀᴛꜱ, No. 343—Bald-headed man with open mouth turning suddenly
Fig. 538 to the r., and facing him the lower part of the profile of another man (p. 179). Bl. ch. 19 by 18.5. Pl. ᴄxᴠ of F. E. [Bodmer, 306. Popham Cat., No. 81. Popp, 58. Sirén, 177.] Studies for the two central figures in the cartoon for the Battle of the Standard.

1012 No. 344—Bust in profile of youth with mouth wide open, the face and neck highly finished,
Fig. 541 the rest barely outlined; study for the same (p. 179). R. ch. 22.5 by 18.5. Pl. ᴄxᴠɪ of F. E. [Bodmer, 307. Popham Cat., No. 82.] Verso: Bust of helmeted young warrior in profile to l., carrying a staff on his shoulder. Study for the same. [Bodmer, 297.] Pls. 794 and of Schönbrunner & Meder.

1013 Four studies for leg of horse. Sp. on tinted ground. Müller-Walde, Beiträge III, opp. p. 108. [Bodmer, 241. Seidlitz, II, pl. 54. Suida, No. 77.]

1013ᴬ CHATSWORTH, Dᴜᴋᴇ ᴏꜰ Dᴇᴠᴏɴꜱʜɪʀᴇ—Sketch for half-kneeling Leda, similar to the ex-Weimar one now at Haarlem (my 1020ᴬ, Fig. 546) (p. 180, note). Pen and bistre. 15.5 by 14. Chatsworth Dr., pl. 35 as Sodoma. Sirén, 195ᴮ. Looks as if it had suffered and been perhaps somewhat restored.

1013ᴮ CHELTENHAM, Fɪᴛᴢʀᴏʏ Fᴇɴᴡɪᴄᴋ Cᴏʟʟᴇᴄᴛɪᴏɴ—Two studies for Mary Magdalen. Pen on wh. paper. 13.5 by 8. Vasari Soc., II, xii, 3. Fenwick Cat., pl. xv.
In the larger sketch she looks with determination to l. while her torso swings to r. and her r. arm crosses her chest in the same direction, all with a *contrapposto* more twisted than in Michelangelo's Minerva Christ begun in 1518; for which reasons we must place this sheet well on in the first Milanese period. The hatching speaks for the same date.

1014 COLOGNE, Wᴀʟʟʀᴀꜰ Rɪᴄʜᴀʀᴛᴢ Mᴜꜱᴇᴜᴍ, No. 460—Sheet with figures, most of them nude, for the Adoration [a trifle weaker than the other studies for the same]. Pen. 27 by 17.5. [Bodmer, 133. Thiis, p. 189. Comm. Vinc., II, 62.
The two lower hindmost figures walk hesitatingly and humbly bent over, one with hands folded and the other with hands spread out, like figures in advanced Byzantine representations (as for instance at Serres, see Dalton, *Byzantine Art and Archaeology*, fig. 233) of Christ giving the Communion to the Disciples. It is by no means impossible that L. was acquainted with drawings after Byzantine originals, if not the originals themselves on ivory, or textiles.
Verso: Two crabs, almost nearer to Dürer than to L. in quality. De Toni, fig. 35. Comm. Vinc., II, 63.]

1014ᴬ (former 2790) FLORENCE, Uꜰꜰɪᴢɪ, No. 420ᴱ—Study for drapery of lower part of angel, kneeling
Fig. 523 in profile to r. (p. 61). Umber and wh. on greyish tinted linen. 16.5 by 17. Brogi 1877. [Müller-Walde, 19. *Boll. d'A.*, 1933/34, p. 242.] Ascr. to L.

1015 No. 421ᴱ—Madonna holding the Child Who fondles a kitten (pp. 169, 170). Pen and wash.
Fig. 474 12.5 by 10.5. Pl. xᴄɪx of F. E. [Bodmer, 120. Uffizi Publ., V, iii, 19. Comm. Vinc., I, 24. Sirén, 30ᴬ.] The finest with this motive. The Madonna here has considerable resemblance to the one in the Adoration. Verso: Nude child lying in mother's lap, almost in profile to l., playing with a kitten. She is not indicated save for the l. arm and hand, with which she holds Him under the legs. He has two heads and three shoulders, drawn one over the other. [Fototeca 12442. Comm. Vinc., I, 25.]

1015 A (former 2791) FLORENCE, UFFIZI, No. 428 E—Head of woman in profile to l. (pp. 55, 60). Pen,
Fig. 561 bistre and wh. 28 by 20. Braun 76429. Brogi 1868. Müntz, pl. III. [Comm. Vinc., I, 16.
Müller-Walde, 6. Sirén, 9 B. *Boll. d'A.*, 1933/34, p. 204.

I used to regard it as a copy after Verrocchio; Morelli *(Kunstchr.)* insisted that the
copy was Flemish. What remains of the ink looks too much like Leonardo to permit
any serious doubt that the head must have been by him. It has unhappily suffered from
retouching, particularly the whites on the forehead, nose, and chin, and also on the throat.
Marvellous are the single hairs straggling across and between the separate strands. They
are done in white with a point of a brush more tenuous than any style, and with an
elaborate and refined subtlety as if the artist had set himself the task of overcoming
every imaginable difficulty.]

1015 B (former 2792) No. 433 E—Study of drapery for lower part of erect female figure (p. 61). Umber
Fig. 517 wash and wh. on greyish tinted linen. 28 by 16. Brogi 1870. [*Boll. d'A.*, 1933/34, p. 245.
Degenhart, *Münch. Jahrb.*, 1934, p. 223.]

1015 C (former 2793) No. 437 E—Study of drapery for seated figure (pp. 61, 62). Variant of my 1071 C
Fig. 528 (Fig. 529). Umber wash and wh. on greyish tinted linen. 29 by 20. Brogi 1618. [Thiis,
p. 101. *Boll. d'A.*, 1933/34, p. 243.]

1016 No. 446 E—Old man and youth facing each other (pp. 168, 170, 178). Pen. 20 by 27.
Fig. 470 Anderson 18638. Braun 76439. Schönbrunner & Meder, pl. 148. [Bodmer, 115. Comm.
Vinc., II, 33. Sirén, 34 A. Uffizi Publ., V, iii, 17. Verso: Various sketches for machinery.
Pen. Fototeca 8710. Comm. Vinc., II, 34.]

As the recto is dated 1478 ("... bre 1478 inchominciai le 2 Vgine Marie ") it is of the
utmost importance for the student. He will not fail to be struck by the great resemblance
between the way the older man's face is modelled and the modelling of the heads in the
numerous sketches for the Adoration, nor can he fail to note the striking likeness between
the youth and more than one youthful face in the same work. Indeed, between this
upturned profile and one in the painting—one on the r. appearing with his head only above
the old man—there is almost identity.

[The suggestion first made by Müller-Walde (see figs. 43 and 44, also Bode, *Leonardo*,
pp. 86 and 87) of the youthful head being a sketch for the Leonhard in the Berlin Re-
surrection can scarcely be accepted but the resemblance in type does point to the fact
worth noting that the design for that painting, which by the way L. never touched, goes
back to his Florentine period.]

1017 No. 8 P—Landscape. Through an opening in the foreground a level plain enclosed by
Fig. 469 hills. On the l. a castle. Inscribed in the master's own hand: " di di Sta Maria della
Neve, addì 5 d'Aghosto 1473 " (pp. 168, 170). Pen. 19.5 by 28.5. Alinari 244. [Foto-
teca 4821. Bodmer, 111. Popham Cat., No. 60. Popp, 1. Comm. Vinc., I, 2. Sirén, 5.
Uffizi Publ., V, iii, 16. Verso: Pen scratches over others done in bl. ch. for landscape
and studies for a flying nude, a profile to l. and four words in a writing apparently not
L.'s. Comm. Vinc., I, 3. Fototeca 12445.]

1018 No. 449 E—Profile to r. of man. Little more than a scrawl, but good. [Same date as
Adoration.] Pen. 11.5 by 8. [Bodmer, 109. Suida, No. 95. Comm. Vinc., II, 35. Thiis,
p. 149. Anderson 18659.]

1019 No. 423 E—Old man and youth facing each other in profile. The youth almost Mantegnesque.
Exquisite finish. R. ch. 21 by 15. Braun 76450. [Bodmer, 224. Thiis, p. 137. Uffizi
Publ., V, iii, 20. End of first Milanese period.]

1020 No. 436 E—Study for architecture and figures in background of the Adoration (p. 172).
Fig. 485 Pen, bistre, and wh. 16.5 by 29. Pl. CIII of F. E. [Brogi 1621. Bodmer, 139. Popp, 13.
Sirén, 43. Uffizi Publ., V, iii, 18. Comm. Vinc., II, 47.]

1020A HAARLEM, KOENIGS COLLECTION, No. 466 —Sketch for half-kneeling Leda (p. 180, note). Bl. ch.
Fig. 546 and pen. 12.5 by 11. Formerly in the Granducal Collection at Weimar. Bodmer, 329.
Sirén, 195A. Amsterdam Exh. Cat., No. 571.

1020B HAMBURG, KUNSTHALLE, No. 21482—Grotesque head of old man in profile to l. R. ch. 10 by 8.
Prestel Publ., 10. End of first Milanese period. A copy of this head is to be seen in the
Ambrosiana (Anderson 12793).

1020C No. 21487—Aristotle and Phyllis or Campaspe. Pen on greyish blue prep. paper. 9.5
by 13.5. Bodmer, 110. Prestel Publ., 8. Verso: Several lines of writing. About same
date as the Christ Church and B. M. Allegories (my 1023 verso, 1051, and 1055; Figs. 551,
553, 554). Probably beginning of first Milanese period. Valentiner reproduces it as fig. 28
of his essay on *Leonardo as Verrocchio's Coworker* (*Art Bulletin*, XII, opp. p. 77) and
speaks of its relation to the Careggi Resurrection now in the Bargello, ascribed to Ver-
rocchio.

1020D No. 21486—Profile of curly-headed youth to r., of the same type as the Windsor profiles
on my 1161 (Fig. 539) and 1163. E. Möller, *Jahrb. K. H. Samml.*, 1928, p. 148, fig. 204.
Probably gone over later by another hand.

1021 No. 21488—Three male nudes, two young and one old, and three babes (p. 171). Pen over
Fig. 483 sp. on grey purple paper. [Bodmer, 130. Prestel Publ., 7. Comm. Vinc., II, 44. Study for
a Nativity and Adoration of the Shepherds, forming part of the same group as my 1010B,
1015, 1081, 1109, 1110 (Figs. 474, 479, 481, 482, 486). The motive of the old man, Joseph
probably, explaining to the shepherds what they are seeing, is, I suspect, new.]

1022 No. 21494—St. Sebastian tied to a tree, with three heads in different positions (p. 180).
Pen with traces of style underneath. Müller-Walde, Beiträge II, p. 250. [Bodmer, 178.
Suida, No. 87. Comm. Vinc., II, 69. Prestel Publ., 9.]

1023 LONDON, BRITISH MUSEUM, 1886-6-9-42—Various draped old men and a profile—this bearing the
Fig. 478 strongest resemblance to the one in the Uffizi dated 1478—studies for the Adoration (p. 170).
Pen. 16.5 by 25.5. [Bodmer, 138. Comm. Vinc., II, 60. Sirén, 42.] Verso: Allegory
representing Ingratitude and Envy. Pen and bistre, on pink prep. ground. On l. of sheet
figures for same allegory in sp. [Bodmer, 144. Popp, 31. Comm. Vinc., III, 98.

On the recto the two men in thoughtful attitudes are undoubtedly studies for the
Adoration but the figure on the extreme r. seems almost too oratorical for that composi-
tion. On the l. there is a group inspired probably by the antique of a woman seated in
the attitude of a muse attentively listening to a man who leans with his elbows on a
pedestal.]

1024 1860-6-16-98—Sheet of studies for Madonna with the Child fondling a kitten, and profile
Fig. 471 of a youth (pp. 169, 170). Thiis, p. 171. Obviously early. Pen and bistre. 27.5 by 19.
Verso: In a rectangle a maiden seated, and a unicorn nestling close to her: an allegory, not,
Fig. 550 as we should naturally take it, of Chastity, but of Incontinence (Richter, paragraph 1232)
(p. 181). [Bodmer, 121 and 127. Comm. Vinc., I, 18 and 32. Vasari Soc., I, i, 1 and 2.

The upper study on the recto already suggests some such composition as the one
executed by Boltraffio decades later (Poldi Pezzoli, No. 642), the idea of which may go
back to a sketch of this period. On the verso there is below the allegorical figure, a
faded drawing [not included in our reproduction] with the style of the same subject
only that the young woman turns with a twist of her body to l. and has two or three
heads. Sogliani may have painted his little picture now in the Lanckoronski Collection
at Vienna after this last or a similar sketch (cf. Suida, Nos. 44 and 45).]

1025 LONDON, Bʀɪᴛɪsʜ Musᴇuм, 1857-1-10-1—Several studies of the Child fondling kitten. Verso: The same. Pen and bistre. 21 by 15. [Bodmer, 123 and 124. Sirén, 25ᴬ and 25ᴮ. Comm. Vinc., I, 19 and 20.]

1026 1856-6-21-1—Madonna in arched frame with Child fondling a kitten. Pen, brush and bistre. 13.5 by 9.5. Verso: The same [but note that here, as not rarely in Verrocchio's following, the Virgin's head is indicated in two different positions. Bodmer, 161 and 162. Comm. Vinc., I, 22 and 23. Vasari Soc., II, iii, 3 and 4. Suida, Nos. 57 and 58.]

1027 1860-6-16-100—Sketch for Madonna and various profiles, and one or two figures. Sp. (the Madonna gone over in ink), on pink prep. paper. 20 by 15. [Bodmer, 117. Comm. Vinc., I, 28. The profiles are of the exact character of the early ones at Windsor, and of those in the figures of the various sketches for the Adoration. The Madonna is of the same kind. Verso: Three studies for Madonna nursing the Child, the two upper ones with the pen and the lower one in sp. Bodmer, 118. Comm. Vinc., I, 29. K. Clark, *Burl. Mag.*, LXII (1933), p. 137.

 The framed Madonna recalls the Benois picture (Bodmer, 8). The other pen-sketch anticipates Boltraffio's Poldi Pezzoli Madonna (*ibid.*, 76), which may, indeed, hark back to an early idea of L.'s. The same is certainly the case with the sp. jotting. It foreshadows the Madonna Litta (*ibid.*, 43). See my 1038, 1129ᶜ, 1129ᴰ, and 1261ᶜ.]

1028 1875-6-12-17—Sheet containing a Madonna with St. Anne, being a study for the Royal
Fig. 511 Academy cartoon (p. 175). Two small sketches of other Madonnas and some wheels. Sketched in with bl. ch. and gone over with pen and bistre. Bl. ch. 26 by 19.5. [Anderson 18784. Bodmer, 279. Popp, 44. Venturi, fig. 84. Sirén, 127.] Verso: Profile to r. of a smooth-faced old man close to my 1087 (Fig. 540) in r. ch. Also tracing of the group on the obverse. [Bodmer, 312. Alinari 1779.]

1029 1854-5-13-7—Pen-sketch of careering horsemen—for the Battle of the Standard. Bl. ch. 8.5 by 12. [Bodmer, 291. Popp, 51. Sirén, 170ᴮ.] Verso: Man striving forward. [Bodmer, 298.] The verso is former 1032.

1030 1860-6-16-99—Machine for mowing down enemy. Below other machines and implements. Pen and bistre. 17.5 by 25. [Sirén, 61. Comm. Vinc., III, 78. Alinari 1783.]

1031 1886-6-9-41—Profile of leg, pubis, and abdomen. R. ch. on pink prep. paper. 25 by 19.5. [Bodmer, 302. Anderson 18791. Bodmer suggests that it is for the nude in the Battle of the Standard like my 1204.]

1032 (see 1029 verso)

1033 1860-6-16-9—Classical nude leaning on staff. Retouched, and the shading of the background added. Pen. 11 by 5.5. [Malaguzzi Valeri, fig. 28. Müller-Walde, between figs. 47 and 48. Late.]

1034 1900-8-24-106—Head of old man in profile to r. R. ch. 10 by 8. [Bodmer, 221. Sirén, 107. Vasari Soc., I, i, 4. Alinari 1782. Anderson 18797.] Drawn, perhaps, in connection with the Last Supper, and at all events of that time.

1034ᴬ 1913-6-17-1—Study for kneeling angel and below, in outline only, a seated figure in violent *contrapposto*. Pen. 12.5 by 6. Bodmer, 150. Vasari Soc., I, ix, 1. Sirén, 55. The *contrapposto* of the angel as he kneels to r. and swings to l. and the hatching seem to point to the earlier Milanese period.

1034B LONDON, Brtish Museum, 1913-6-17-2—Girl in fluttering robes carrying child. Pen. 12.5 by 8.5. Bodmer, 143. Vasari Soc., I, ix, 2. Comm. Vinc., II, 38. Same date as sketches for the Adoration.

> One wonders whether first Fra Bartolommeo was acquainted with this drawing when he designed his Madonna with St. Bernard now in the Florence Academy, and then Hans Holbein, whose Child's action in the Bürgermeister Meyer altar-piece now at Darmstadt may have been suggested by the one here.

1035 British Museum, Malcolm, No. 38—Profile bust of a warrior in fanciful armour (p. 178).
Fig. 537 Sp., highly finished, on cream-coloured prep. ground. 29 by 21. Pl. cxiv of F. E. [Alinari 1778. Bodmer, 112. Sirén, 141. Vasari Soc., I, i, 3.] Suggested doubtless by a figure in Verrocchio's Decapitation of the Baptist finished in 1480 in the silver altar now in the Opera del Duomo at Florence.

1035A No. 39—Studies for two dogs and a cat. Sp. 14 by 10. Bodmer, 181. Sirén, 160A.

1036 No. 42—Sheet containing draped figure blowing trumpet into ear of a nude [perhaps
Fig. 491 reminiscent of popular Epiphany playfulness in the streets of Florence to the present day; below, two figures in conversation] (p. 172). Pen and bistre. 25.5 by 19. Braun 65040. [Bodmer, 136. Comm. Vinc., II, 59. Popp, 15. Sirén, 40. Thiis, p. 202.] Probably studies for the Adoration.

1037 No. 44—Studies for a Victory placing a shield on a trophy. [Under the head to r. are
Fig. 559 traces of the body in silver-point, now all but invisible] (p. 182). Pen and bistre. 25.5 by 20.5. Pl. cxxi of F. E. [Bodmer, 160. Sirén, 96. Thiis, p. 175. Comm. Vinc., III, 104.] The character of this sheet points to the time when L. was preparing his Adoration as the draperies go with his early works.

1037A (former 2799) No. 51—Study of drapery for kneeling figure (pp. 60; 62, note; 63; 132, note). Umber
Fig. 524 wash and wh., on greyish tinted linen. 28 by 19. Pl. xxvi of F. E. [Vasari Soc., I, ii, 3. Thiis, p. 70. *Boll. d'A.*, 1933/34, p. 241. Degenhart, *Münch. Jahrb.*, 1934, p. 225. The turn of the head and what appears of the hands make it seem as if it were intended for an Annunciation rather than for a Nativity.]

1037B British Museum, Arundel MS., 263, Folio 136 verso and 137 recto—Nude figure of adolescent striving forward with a spear in l. hand. Faint outlines of a profile to l. and twelve lines of writing. To r. larger profile of curly-headed youthful person and nineteen lines of writing. Sp. Comm. Vinc., C. A., II, opp. p. 219.

1037C No. 263, Folio 250 recto—Slight sketch of horse and rider looking back to l. and a tiny grotesque head in r. ch. With the pen drawn over the hindquarters of the horse, effaced design for a cameo or emblem and to the r. a peacock with extended tail under a light structure consisting of a rounded covering that rests on four arches. Comm. Vinc., C. A., III, opp. p. 401. Both sketches in midst of explanatory text scarcely less obscure in expressing definite meaning than are the drawings.

1038 No. 263[1], Sheet divided by the binding into two pages, Fol. 253 verso—Head of child sucking, turned to l., and under it slight indication of an infant's foot. Sp., on greyish blue ground. [Comm. Vinc., C. A., III, opp. p. 405.] Fol. 256 recto—Foot and hand of a child. Sp. and wh. on greyish blue ground. [Comm. Vinc., C. A., III, opp. p. 408.]

> I am indebted to [the late] H. P. Horne for my acquaintance with this sheet and the excellent suggestion that the sketches thereon must have been for a picture like the Madonna Litta. Indeed, it would seem that this famous picture was made in reversed order

1. On the first page of this is a long inscription by L. stating what he means to do in the volume he is just beginning. It will be found in Solmi's *Leonardo*, pp. 173 *et seq.* The date is March 22, 1508.

after a cartoon or even a finished painting in the preparation of which these studies had served. As the volume in which they occur is dated March, 1508, it is probable that these sketches were made at that time [although they look a bit earlier]. At the same time L. wrote to Chaumont, the French governor of Milan (Solmi, p. 175), that he had begun two Madonnas which he hoped to bring back with him. We can hardly avoid concluding that our sketches were for one of these pictures—the one of which the Madonna Litta is either a copy [or perhaps the only version that ever existed and with little of L.'s own hand in it]. See my 1261C.

1039 LONDON, ROYAL ACADEMY, DIPLOMA GALLERY—Cartoon for the Virgin with St. Anne (p. 175). Bl.
 Fig. 510 ch. and wh. 1 m. 39 by 1 m. 1. Pl. CIX of F. E. [Bodmer, 280. Popham Cat., No. 78. Vasari Soc., I, vi, 1-5.]

1040 VICTORIA AND ALBERT MUSEUM, FORSTER COLLECTION,[1] Codex II, Fol. 19 recto—Head of elderly ecclesiastic in profile to l. Apparently a portrait. R. ch. 9.5 by 7. [Comm. Vinc., C. F., p. 26 verso.

1040A Fol. 27 verso—Faint sketch in r. ch. for head turned to r. with powerful nose and downcast eyes. Comm. Vinc., C. F., p. 34 verso.

1041 Fol. 37 recto—Slight sketch of woman seated with child in her lap. She faces front, but the figure is turned to r. Note perhaps for a Madonna. R. ch. 9.5 by 7. [Comm. Vinc., C. F., p. 45 verso.]

1041A Fol. 52 verso—Youthful profile to l. and various lines of writing in r. ch.; with the pen, sketch for a roof. Comm. Vinc., C. F., p. 71.

1042 Codex III (in which occurs the date July 16, 1493), Fol. 8 verso, fol. 9 recto and verso, fol. 10 recto—Slight sketches of various articles of apparel, and one or two heads to show how certain hats were worn. Bl. ch. 9.5 by 6.5. [See letter by Eric Maclagan in *Times Literary Supplement*, March 8, 1933.]

1043 Fol. 23 recto—Hind legs of a camel. R. ch.

1044 Fol. 25 recto—Hind leg of a horse. R. ch.

1044A (former 1116) CAPTAIN COLVILLE—Sketch of horse dashing forward, while the rider, lightly seated, looks back. Sp. (retouched with the pen) on pale buff ground. 14.5 by 12. Pembroke Dr., pl. I. [Bodmer, 147. Vasari Soc., II, i, 2. Popham Cat., No. 66. Popp, 14. Comm. Vinc., II, 66. Oppenheimer Sale Cat., pl. 24.]
 Done perhaps in connection with the Sforza Monument [and in that case one of the earliest sketches for it. Bodmer relates it to the Adoration. As action, not as form and technique, it could almost as easily be related to the Battle of the Standard. The hatching with the pen seems to belong to his first Milanese period.]

1044B Studies on recto and verso for the paws of a bear. Metal-point. 13.5 by 10.5. Popham, *Burl. Mag.*, LXX (1937), p. 86.

1044C Head of a bear. Metal-point. 7 by 7. Popham, *Burl. Mag.*, LXX (1937), p. 86.

1044D HON. A. HOLLAND-HIBBERT (formerly)—Two horses seen almost frontally with nude riders on their backs. These face each other, one holding a *fiasco* to his mouth and the other looking defiantly skywards. To r. a half-effaced sketch for a female figure. Sp. gone over with ink. 13 by 14. Bodmer, 148. E. Möller, *Burl, Mag.*, XLVII (1925), opp. p. 275. Period of Adoration and perhaps for it.

1. I owe my first acquaintance with these sketches in the Forster Collection to [the late] H. P. Horne.

1045 LONDON, Mond Collection—Head of the Virgin for the Louvre version of the Madonna with
Fig. 514 St. Anne. Bl. ch. with touches of colour (p. 176). 20.5 by 16. Grosvenor Gallery, Cat.
Winter Exh., 1877-78. [De Rinaldis, fig. 69. Frizzoni, *Rass. d'A.*, 1911, p. 43.]

1045A Mrs. W. M. H. Pollen—Study for Madonna with kitten. Pen and bistre wash. 8.5 by 7.
Bodmer, 125. Vasari Soc., II, iii, 5. Venturi, *L'Arte*, 1922, p. 2.

1046 MILAN, Ambrosiana, Codex Atlanticus—Large number of small sketches, some of considerable
interest (p. 180). I shall not attempt to catalogue them. They are in course of publication
in facsimile, and will soon be accessible in this form (Milan, Hoepli). [Bodmer, 247.
Popp, 72. Sirén, 87A. Venturi, *L.*, fig. 128. Mc Curdy, *Burl. Mag.*, LVI (1930), p. 140.
Three particularly interesting leaflets are reproduced by the Commissione Vinciana. On
pl. 21 (Vol. I) two separate sketches, one for a child playing with a cat and one for a
putto crouching at the corner of a pediment over a cornice; on pl. 41 (Vol. II) a sheet
with machines for pressing or grinding and to the r. a kneeling figure of a slender graceful
woman, perhaps for a Nativity, with proportions recalling Filippino Lippi.]

1047 Head of old man almost in profile to r. Pen. Small and slight.

1048 Forepart of horse in profile. Pen. Richter, II, p. 4.

1048A Series of grotesque heads in profile, all in pen and ink. See Bodmer, 165, 166, 167; also
Anderson 12783, 12784 and 12786. First Milanese period.

1049 Brera, Codice Trivulziano—Small codex containing sketches, published by L. Beltrami,
Codice Trivulziano, Milan, Hoepli, 1891. The most interesting to us are the profile head
of an old man, pl. 68, another profile, pl. 54, and some caricatures, pl. 1.

1049A NEWPORT (R. I.), John Nicholas· Brown Collection—Sketch for horse and rider, both slightly
turning to l. and the rider's head in two different positions. Pen. 12 by 8. Comm. Vinc., II,
67. Borenius, *Pantheon*, I (1928), p. 166. Buffalo Exh. Cat., pl. 20. Almost identical
with the Holland-Hibbert sketch (my 1044D) but in much better state.

1049B NEW YORK, Metropolitan Museum, Nos. 37139 and 37133—Dainty sketch of a youthful figure
asleep under a tree with his head resting on his arms and close to his head a lizard
fighting with a snake. Several lines of writing explain it as an Allegory of Faithfulness.
Pen. 20 by 13.5. The sketch alone 7 cm. in diameter. Bodmer, 233. Popp, 27. Comm.
Vinc., III, 106. Verso: Niche with three figures in it, an architectural plan and some
writing. Apparently sketch for the setting of a stage (see Bryson Burroughs, *Metr. Mus.
Bull.*, 1918, p. 216). A similar type of niche appears in the Arundel MS., fol. 231 verso
(see Comm. Vinc., C. A., opp. p. 374). End of second Milanese period.

1049C No. 37134g—Four different studies for a Madonna kneeling with outspread hands wistfully
Fig. 484 adoring the Child (pp. 171; 172, note). Pen and bistre on pinkish paper. 19.5 by 17.
Bodmer, 149. Comm. Vinc., II, 40. Popp, 19. Sirén, 54. Bryson Burroughs, *Metr. Mus.
Bull.*, 1918, p. 215.
 For a Nativity either by itself or combined with an Adoration of the Shepherds,
which seems to have preoccupied L. just before getting absorbed in the creation of the
unfinished Epiphany. It is interesting that in the two sketches with a certain *contrap-
posto,* particularly the central one with the infant Baptist in it, there is an anticipation
of the Virgin of the Rocks. Florentine paintings of the 16th century inspired by this
central group are to be seen in the Uffizi depot (Bodmer, 78; Borenius, *Burl. Mag.*, LVI,
1930, p. 146) and in Mr. Henry Harris' Collection (*Burl. Mag.*, LVI, p. 143) while a
Milanese one exists in the Melzi d'Eril Collection in Milan (Bodmer, 79).

1049D NEW YORK, METROPOLITAN MUSEUM—Profile to l. of man with shaggy hair and powerful nose. Pen and bistre. 12 by 5. Vasari Soc., I, vii, 2, where it is compared to the famous profile of a warrior in the B. M. (my 1035, Fig. 537). It is, however, much later.

1050 OXFORD, CHRIST CHURCH, A. 28 — Portrait of a Gipsy in profile, turned up to r. (p. 178). Bl. ch.
Fig. 536 sadly retouched. 38 by 26.5. [Bodmer, 305. Bell, 54. Colvin, I, 5. Contemporary with the Battle of the Standard.] I strongly suspect that it was this head which Vasari had in mind when he was writing in his Life of Leonardo, of "Scaramuccia capitano de' Zingari, che poi ebbe Messer Donato Valdambrini lassatogli del Giambullari."

1051 A. 29—Allegory of Pleasure and Pain. The text, Richter, paragraph 676. Verso:
Fig. 553 Allegory of Envy—an exact illustration to the text on the same sheet, transliterated in
Fig. 554 paragraph 677 of Richter (p. 181). Pen. 21 by 29. Richter, pls. 59-61. [Bodmer, 158 and 159. Comm. Vinc., III, 99 and 100. Bell, 55 and 56. Fully discussed by Colvin in text accompanying pls. 6 and 7 of Pf. II of Oxford Drawings. The verso is listed under my 1053 in F. E.]

1052 A. 30—Horseman at full speed attacking fallen foe. Cogwheels, and a nude working a treadmill. Also several lines of writing in two columns. The horseman is probably for the Battle of the Standard. Pen. 21.5 by 14. [Colvin, V, 2B. Verso: Studies of crossbows. Comm. Vinc., III, 74, 75.]

1053 (see 1051)

1054 A. 31—Study for draped r. shoulder and arm of angel in Uffizi Annunciation. This is in pen. In r. ch. the line of a cheek with curling hair. 8.5 by 9.5. [Bodmer, 110. Colvin, V, 2A. Popp, 4. Sirén, 8A. Comm. Vinc., I, 11.]

1055 A. 32—Allegory representing, it is suggested, the political state of Milan at the end of
Fig. 551 the 15th century. Pen and brown ink. 21 by 28. Popham Cat., No. 76. Comm. Vinc., 102. Verso: Allegory of Fame and Prudence (p. 181). [Bodmer, 156 and 157. Bell, 57 and 58. Photo. Cooper. Fully discussed by Colvin in text accompanying pls. 4 and 5 of Pf. II of Oxford Drawings.]

1056 ASHMOLEAN MUSEUM—[Rider on rearing horse defending himself with long sword against attack of griphon.] Sp. on greenish paper. 9 by 14. [Colvin, I, 4C. Comm. Vinc., II, 65. Mentioned by Seidlitz, I, p. 292. The attitude of the horseman anticipates one of the well-known figures in the Battle of the Standard. The contours and the hatching seem earlier, although not as I used to think as early as the Adoration.]

1057 Young woman pointing to a unicorn at her feet. Even lovelier than the similar subject at the B. M. (my 1024 verso, Fig. 550). Pen and brown ink. 9.5 by 7.5. [Bodmer, 126. Popham Cat., No. 64. Colvin, I, 4A. Comm. Vinc., I, 5.

1058 Two men sitting and putting on or taking off their shoes. Also various machines and implements. Sp. on wh. paper. 20.5 by 18. [Bodmer, 140. Colvin, III, 2B. Thiis, p. 205.
 The technique and style of drawing would suit the epoch of the Adoration, but as we see in my 1065, where on the one side we find studies for an Adoration of the Shepherds and on the other for a Last Supper, so here we find him preoccupied with the motive of Christ washing the feet of two Disciples. People taking off or putting on their sandals and one at the same time putting his hand to his head, as Peter does traditionally when Christ kneels before him, suits this subject, and better than it does palefreniers and other menials in the background of the Adoration, and it would seem odd that L. would have used them for such a low purpose without becoming aware of parodying sacred writ, as it were.]

1059 OXFORD, Ashmolean Museum—[Light sketch of the Virgin seated on the ground holding the Child on her knee while to her r.the infant Baptist is presented to her by a female figure which might be taken either for a St. Elizabeth or for an angel. Sp. 14.5 by 18.5. Bodmer, 126. Colvin, III, pl. 2A. Sirén, 35B. Comm. Vinc., III, 85. Verso: Various studies of perspective.

Bodmer thinks the recto may have been a first idea for the Virgin of the Rocks, a suggestion that has little to support it beyond the fact that the two designs have the same number of figures, and possibly that the third figure in the drawing seems too youthful for a St. Elizabeth. In Fra Bartolommeo's imitations of this design (see for instance my 405, 406, 466) the accompanying figure is an angel. The motive goes back to Verrocchio and, further still, to Fra Filippo. The only difference is that the two principal figures are seated on the ground like the Madonna of Humility, which as a religious motive had gone out, but which L. took up again for purely compositional reasons and handed on to Raphael and Fra Bartolommeo and to Andrea del Sarto, who gave it its highest realization in the *Madonna del Sacco*. Other echoes of L.'s preoccupation with this composition exist: one in the Uffizi which I ascribed to Granacci (see my 955, Fig. 383; and Thiis, p. 127) and in which we have an intensely Leonardesque Joseph in the place of Elizabeth, and another also in the Uffizi (206F), a rough copy in bistre and wash of exactly the same motive. The value of this copy is that it allows us to see through the absurdities of the draperies that the folds belong most probably to the Florentine and not to a late period of L.'s career. The motive was not forgotten, either in Tuscany or in Milan. Suida reproduces as No. 65 a 19th century engraving after a lost *tondo* of the early 16th century, possibly Milanese and as No. 67 a painting in the Uffizi attributed to Alfani but probably by Soggi representing the Madonna, Elizabeth and the two Children. Both are reminiscent of the last-mentioned sketch.]

1059A Unicorn digging its horn into the ground. Pen. To the r. the hind-quarters of a horse, in sp. 9.5 by 8. Bodmer, 182. Comm. Vinc., II, 70. Popham Cat., No. 65. First Milanese period.

1060 PARIS, Louvre, No. 2249—Head of an old man. R. ch. 9.5 by 6. [Alinari 1605. Bodmer, 221. Popp, 81. Demonts, *L.*, 16. First Milanese period.]

1061 No. 2255—Cast of drapery over lower part of seated figure (pp. 62, 63, 64; 176, note).
Fig. 530 Bistre and wh. on fine linen. 26 by 22.5. Pl. cxii of F. E. [Alinari 1588. Braun 62180. [Comm. Vinc., I, 15. Müller-Walde, pl. 18. Demonts, *L.*, 1. *Boll. d'A.*, 1933/34, p. 247.]

1062 M. 1. 753—Bust of lady in profile to r.—cartoon for portrait of Isabella d'Este (pp. 168, 177).
Fig. 532 Bl. ch. and pastel. [In the hair and flesh there are touches of red, in the dress of yellow.] Pricked for transfer. 63 by 46. Braun 62162. [Alinari 1603. Bodmer, 275. Sirén, 148. Suida, No. 145. Popp, 43. Demonts, *L.*, 17. Verso: The pricking makes a complete design and has been helped out with ink over forehead and nose. The resulting profile, as simple and direct as the famous P. Pollajuolo in the Poldi Pezzoli, Milan (Van Marle, X, opp. p. 326), corresponds very likely to what L. did from the life and transferred to the panel before giving this cartoon the finish of an independent work of art.] The credit of first recognizing Isabella in this cartoon is due to the late Charles Yriarte (*Gaz. d. B. A.*, 1888, i, pp. 118-131. As is well known she sat to L. early in 1500.

1063 No. 2257—Study for the drapery of the Virgin in the Louvre version of the Madonna with
Fig. 518 St. Anne (p. 176). Bl. ch., bistre wash and wh.—slightly modernized, yet the original line is nearly untouched. 23 by 24.5. Pl. cxi of F. E. [Popp, 46. Sirén, 132. Demonts, *L.*, 19.]

1064 No. 2247—Allegory, possibly of an incantation (p. 181). [A little tight, and probably
Fig. 548 quite late.] Pen. 10.5 by 10.5. [Bodmer, 164. Popp, 21. Suida, No. 118. Demonts, *L.*, 9. Alinari 1614.] An exact copy of this passes at the B. M. for an original (Braun 73053;

[Müller-Walde, 23]). A comparison of the torso is instructive. A magnificent contemporary engraving in the B. M., probably by a Milanese hand, was taken from this study. But for the nude figure in the print L. must have furnished a separate sketch (Bartsch, vii, p. 515, No. 44; repr. by the Chalcographical Soc., 1891, fig. 28).

1065 PARIS, Louvre, No. 2258—Six figures, chiefly nudes, for the Adoration, of about the same quality as the sheet at Cologne. Pen. 28 by 21. Verso: Slight study for a Madonna in bl.
Fig. 499 ch. and nudes at a table, others in conversation, and still others by themselves in ink (p. 173). Giraudon 363. Braun 62185 and 62186. [Alinari 1602. Bodmer, 134 and 135. Thiis, pp. 197 and 203. Comm. Vinc., II, 56 and 57. Demonts, L., 7.]

These studies are variously designated as either for a Last Supper or for an Adoration. It seems to me that both designations are right. The style of the drawing points clearly to L.'s earlier years, and the figures in conversation can scarcely have been intended for any other purpose than the Epiphany. At the same time, the nudes at the table, and the single figure, surely representing Christ Himself, at another table, are plainly for a Last Supper. If all this be so, then this interesting result follows: that while L. was still engaged upon his Adoration, he was already planning a Last Supper—not, of course, necessarily with the immediate intention of painting one.

1065A No. 2260—Halberds, spears and various other weapons. Pen on grey-blue paper. 22 by 36. Comm. Vinc., III, 71. Bodmer, 197. First Milanese period.

1066 No. 2316—Small study for Madonna with Infant John. [Here too the Madonna appears seated on the ground as in the Oxford sheet, my 1059.] Pen. 10 by 8.5. [Bodmer, 125. Popp, 6. Sirén, 35A. Comm. Vinc., III, 84. Demonts, L, 6. Verso: Fragments of ornament.]

1067 No. 2250—Study for head of Baptist in the Virgin of the Rocks (p. 172, note). Re-
Fig. 487 touched [but still very fine.] Sp. and wh. on greenish paper. 17 by 14. Braun 62170. [Alinari 1607. Müller-Walde, 63. Suida, 129. Demonts, L., 13. Comm. Vinc., III, 87.]

1067A (former 2801) No. 2256. Study for the drapery of figure kneeling in profile to r., presumably an
Fig. 521 angel (p. 61). [In upper l. corner the Roman numeral I.] Umber wash and wh. on greyish tinted linen. 18 by 23.5. Braun 62182. [Suida, No. 7. Sirén, 19B. Demonts, L., 2. *Boll. d'A.*, 1933/34, p. 244. Degenhart, *Munch. Jahrb.*, 1934, p. 227.]

1067B No. 2282. Sketch of fortress with high tower, perhaps intended for a lighthouse. Pen. 14.5 by 22. Bodmer, 200. Richter, pl. 80. Demonts, L., 15. Bodmer considers it to be a sketch for the Castello of Milan.

1067C No. 2376 - Head of a young woman looking down almost in profile to l. (pp. 55, 60). Sp. and wh.
Fig. 562 on greenish prep. paper. 18 by 16.5. Braun 62168. Bodmer, 230. Sirén, 76. Suida, No. 56. Müller-Walde, 51. Thiis, p. 103. Comm. Vinc., III, 95. Demonts, L., 14. Below very rapid sketch of upper part of nude male figure almost in profile l. not by L. Verso: The woman's head traced by cruder hand in ink. The outlines of the face on the recto seem so stiff that they may have been gone over by another hand. Generally considered as a study for the Madonna Litta.

1068 No. 1978—Study for the entire composition of the Adoration, the most elaborated and
Fig. 477 delightful of the series (pp. 170, 171). Left to the Louvre by the late M. Galichon. Pen and bistre. 28 by 21. Pl. CI of F. E. [Bodmer, 132. Alinari 1604. Popp, 10. Sirén, 38. Comm. Vinc., II, 46. Demonts, L., 8.] Verso: Seated nude figure, leaning on r. hand, and with knee lifted up, for same composition. [The nudes composing the episodes in the middle distance in the stable yard are, it is most curious to note, reminiscent of Fra Angelico's Adoration of the Magi, finished by Fra Filippo, in the Cook Collection at Richmond (Van Marle, X, p. 401).]

1069 PARIS, LOUVRE, R. F. 486—Madonna, turned to r. holding in r. hand a vase, from which the Child
Fig. 475 takes fruit, while He caresses her cheek (pp. 169, 170). Sp. and ink. 35 by 25. Pl. c of F. E.
[Bodmer, 119. Comm. Vinc., I, 31. Popp, 16. Sirén, 31. Thiis, p. 164. Demonts, L., 5.]
Verso: Study of vaulting.

The drawing on the recto was still ascribed to Raphael [in 1900] despite the fact that
M. de Tauzia and M. Ephrussi had long since recognized its authorship. [It must have
been the sketch for a picture very close to the Benois Madonna but done a little later
and on the way to the Madonna in the unfinished Adoration.]

1070 R. F. 460—Small and ruined study for the Madonna with St. Anne. Interesting as indicating
a stage in the composition between the cartoon and the picture. Bl. ch. gone over with
the pen. 16 by 12. [Bodmer, 278. Sirén, 128A. Demonts, L., 18. Anderson 18604.]

1070A No. 1081—Draped figure of bearded man facing to r. with arms folded under his chest
Fig. 526 and hands hidden in ample sleeves; in upper l. corner the Roman numeral III (p. 62).
Bl. ch. on linen, below the waist elaborately finished with umber and wash. 31 by 17.
Arch. Ph. Demonts, L., 3. *Boll. d'A.*, 1933/34, p. 245.

1070B No. 1082—Study of drapery for figure facing r. (p. 62, note). Bistre wash and wh. on linen.
20 by 15. Demonts, L., 4. Degenhart, *Munch. Jahrb.*, 1934, p. 228. Seems to have been
shortened at top and bottom. Simpler and earlier than last.

1070C 18. 965—Head of young woman with elaborately arranged hair turned slightly to l.,
looking down. Brush over bl. ch. height. with wh. on orange pink prep. paper. 22.5 by 26.5.
Popp, *O. M. D.*, II (1927/28), pl. 37. *Boll. d'A.*, 1933/34, p. 203.

1071 INSTITUT DE FRANCE (Manuscripts)—Containing various sketches scattered through them
chiefly as illustrations to the text, some of them of great beauty. They have been published
in six volumes under the editorship of M. Ravaisson-Mollien (Paris, A. Quantin, 1881-91).
A number will be found reproduced in such accessible works as Richter's and Müller-Walde's
[and Seidlitz's. See also Bodmer, 201, 234, 235. Popp, 25. Sirén, 120, 121. Venturi,
L., 427. Comm. Vinc., III, 76.]

1071A COMTESSE DE BÉHAGUE—Variant of the Malcolm cast of drapery (my 1037A, Fig. 524),
Fig. 525 slightly less geometrical (p. 62, note). Bistre wash and wh. on linen. 26 by 15.5.

1071B Drapery of figure kneeling to r. with torso barely indicated (p. 62, note). Bistre wash
Fig. 522 and wh. on linen. 18.5 by 25.5. Would seem to have been done after my 1014A and 1067A
(Figs. 521, 523).

1071C Cast of drapery for seated figure, perhaps for Virgin Annunciate (p. 62, note). Variant of
Fig. 529 my 1015C (Fig. 528). Bistre wash and wh. on linen. 26 by 18.

1071D Variant of my 1070A (Fig. 526), done perhaps between 1070A and 1070B; in upper l.-hand
Fig. 527 corner the Roman numeral XII (p. 62, note). Bistre wash and wh. on linen. 25.5 by 15.5.

1071E Cast of drapery amply covering r. leg of seated figure and flowing out to our r. (pp. 62,
Fig. 531 note; 64). Almost the reverse of the famous somewhat later study in the Louvre,
my 1061 (Fig. 530). Bistre wash and wh. on linen. 22 by 17.5. Degenhart, *Munch.
Jahrb.*, 1934, p. 229.

1072 (see 1010A)

1073 (see 1010B)

1074 (see 1010C)

1075 (see 1010^D)

1076 (see 1010^E)

1077 (see 1010^F)

1078 (see 1010^G)

1079 (see 1010^H)

1080 PARIS, Baron Edmond de Rothschild—Two horsemen fighting a dragon. Below, a nude youth on a galloping horse, three other horses and a dog barking at one of them. Richter, I, p. 293. [A. Blum, *Gaz. d. B. A.*, 1932, ii, p. 99. After 1500.]

1080^A Nude rider on horse at full gallop, below another horse seen from the back and larger head of a horse in profile to r. Pen and bistre. A. Blum, *Gaz. d. B. A.*, 1932, ii, p. 98. In connection with Battle of the Standard and at all events of that period.

1081 École des Beaux-Arts, No. 34555^A—Various nudes [for an Adoration of the Shepherds]
Fig. 486 or for the unfinished Epiphany (p. 172). Pen. 18 by 26. [Bodmer, 137. Comm. Vinc., II, 61. Popp, 12. Siren, 41. Thiis, p. 190.]

1082 No. 34555^B—Men escaping from a bomb, and other studies for the Art of War. Pen and bistre. 20 by 27.5. [Bodmer, 194. Braun 65035. Sirén, 60. Comm. Vinc., III, 77. End of first Milanese period.]

1082^A RENNES, Museum, Case 57, No. 2—Study for drapery around lower part of nude figure (p. 61). Bl. ch. and wh. on linen. 28 by 21. Photo. Couturier. *Boll. d'A.*, 1933/34, p. 246.

1082^B ROME, Corsini, Print Room, No. 125770—Study for a heavily-draped kneeling figure with the head
Fig. 520 in three different positions (pp. 61, 62, 66). Sp., wash. and wh. on red prep. paper. 25.5 by 19.5. Anderson 27985. Comm. Vinc., I, 17. Venturi, *L.*, fig. 11.
 The action seems to be of a person who has just come to rest after moving rapidly. This would suit the Announcing Angel better than the Virgin Annunciate. Not necessarily for the Uffizi Annunciation and certainly not for the predella in the Louvre, which I now believe Credi's (pp. 58-59). In date probably earlier than Uffizi picture. The action might allow the possibility that the figure was intended for a Virgin in a Nativity.

1082^C No. 31645—Torso of old man with big hooked nose and grotesquely protruding chin. R. ch. 18 by 10.5. Verso: Caricatured profile to l. of bald man. Anderson 27992. Bodmer, 220. First Milanese period. The hand of the figure on recto is in essentials like enough to the one in the Cracow portrait (Bodmer, 44) to persuade us that both were done by the same artist.

1082^D STEYNING, WISTON PARK, Mr. Ch. Clarke—Allegory of the ermine as symbol of purity. Pen and bistre. Circular, 9 cm. in diameter. Bodmer, 232. Vasari, Soc., I, ix, 3. Comm. Vinc., III, 107. From end of second Milanese period.

1083 TURIN, Royal Library, No. 1557—Portrait of old man, in every probability L. himself. [Not free from retouches in nostrils and mouth.] R. ch. Richter, pl. 1. [Bodmer, 229. Popp, frontispiece. Popham Cat., No. 95. Cooper 9843.]
 It is true that the person represented looks older than L. should have looked, but that he seemed much older than his years is a well-known authenticated fact.

1084 No. 15572—Head of a young woman (pp. 172, 178). Sp. on brown toned paper. 18.5 by 16.
Fig. 489 Richter, pl. 42. [Bodmer, 151. Sirén, 70. Popham Cat., No. 72. Comm. Vinc., III, 86. Anderson 9846.] Study from the life. In every probability for the angel in the Virgin of the Rocks.

16

1085 TURIN, ROYAL LIBRARY, No. 15573 — Three views of male head, according to Richter of an Armenian. R. ch. 28 by 11. Richter, pl. 120. [Bodmer, 227. Anderson 9848. Seidlitz, I, p. 212. First Milanese period.]

1086 No. 15574—Study for proportions of face and eye. Pen. 20 by 16. Richter, pl. 12. [Bodmer, 212. Anderson 9837.]

1087 No. 15575—Bust of laurel-wreathed old man in profile to r. (p. 178). R. ch., outlined and
Fig. 540 shaded with ink. 17 by 12. [Anderson 9849. Polifilo 40ᴮ. Thiis, p. 151. Close to my 1028 verso.]

1088 No. 15576—Two studies of the eye and three lines of writing. Pen. 11 by 14. [Anderson 9844.]

1089 No. 15577—Fine study of the muscles of torso and legs. A male nude with sword. On smaller scale, other nudes; and smaller still, horses and riders. Pen. 25 by 20. Müller-Walde, Beiträge I, p. 140. [Sirén, 169. Bodmer (301) connectes it with Anghiari Battle.]

1090 No. 15578—Study of human legs. Pen. 16 by 14. [Anderson 9841. Contemporary with Anghiari Battle.]

1091 No. 15579 —Legs and breasts of horses. Sp. on greenish paper. 21.5 by 29. [Bodmer, 239. Anderson 9840.]

1092 No. 15580—Studies of horses' legs. Sp. and wh. on bluish paper. 15 by 20. [Bodmer, 240. Anderson 9847. Sirén, 82ᴮ. First Milanese period.]

1093 No. 15581—Study of two insects—exquisitely finished. Pen, on pink ground. 13 by 12. [Comm. Vinc., III, 108. First Milanese period.]

1094 No. 15583—Two machines pulled by horses for mowing the enemy's limbs. Pen and wash. 30 by 21. [Anderson 9838. Thiis, p. 134. Comm. Vinc., III, 80. First Milanese period.]

1095 VENICE, ACADEMY, No. 214—Three sketches [for a soldier poniarding a prostrate man for the Battle of the Standard.] Pen. 9 by 15.5. [Anderson 22533. Suida, No. 156.]

1096 No. 216—A cavalry skirmish, for the Battle. Pen. 10 by 13.5. Alinari 1083. [Bodmer, 295. Suida, No. 154. Popp, 54. Popham Cat., No. 83.]

1097 No. 215—Various cavalry skirmishes, for the Battle. Pen. 16 by 15.5. Anderson. Bodmer, 296. Popp, 53.

1098 No. 215ᴬ—Cavalry skirmishes, for the Battle. Pen. 14.5 by 15. [Alinari 484. Bodmer, 294. Popp, 52.]

1098ᴬ No. 217—Sketch for the naked body of a child turning to r. with the l. leg bent at the knee. R. ch. 13 by 9.5. Anderson 18619. Bodmer, 282.
 Period of Madonna with St. Anne, for the Child in which it may be a study. It is, however, almost identical with the Child in the Holy Family by Melzi in the former Nemes Collection and it would not overwhelm me with surprise if it turned out to be by the same hand—so trickily close to L.'s.

1099 No. 228—Man within a circle. Study for the proportions of the human figure. Pen. 34 by 24.5. Anderson 15105. [Bodmer, 171. Seidlitz, I, p. 294.]

1100 No. 232—Profile to r. of old man with open mouth and intense expression (p. 179, note). Bl. ch. 21.5 by 12. Anderson 15120. [Bodmer, 304.] Looks like a study for the head between two riders who brandish swords in the Battle of the Standard.

1101 VENICE, ACADEMY, No. 233—Two young women dancing together and another figure fluttering a
Fig. 565 shawl (p. 183). Pen. 10 by 15. Pl. CXXV of F. E. [Bodmer, 333. Popham Cat., No. 71.
Comm. Vinc., III, 89.

A late drawing, a conclusion at which I arrived independently, confirming both Seidlitz
and Bodmer. The latter's suggestion that Leonardo may have been inspired by Mantegna's
Parnassus is not at all improbable.]

1102 No. 230—Sketch for the Louvre version of the Madonna with St. Anne (p. 176). Pen.
Fig. 515 12 by 10. Pl. CX of F. E. [Bodmer, 277. Popham Cat., No. 80. Popp, 45. Siren, 128B.]

1103 No. 231—Head of the Saviour (perhaps for a Christ bearing the Cross). Sp. 11.5 by 9.
Alinari 1056. [Bodmer, 261. Suida, No. 97.]

1104 No. 235—Large sheet with cavalry charging at infantry; below a harvest of lances. Pen.
24.5 by 17.5. Anderson 22530. [Alinari 1177. Popp, 22. Upper part, Suida, No. 155.
First Milanese period. Verso: Machines for besieging a fortress. Comm. Vinc., III,
72 and 82.]

1105 No. 237—Studies of flowers. Pen. 18 by 20. [Sirén, 75. Comm. Vinc., 91.]

1106 No. 236—Sheet containing profiles to r. of bald-headed old man in bl. ch., gone over
with ink and squared (perhaps of earlier date), and in r. ch. a youth galloping and a nude
in attitude of riding. The youth galloping is nearly identical with one at Windsor (my 1224,
Fig. 495), almost certainly for the Battle of the Standard. 28 by 22. Alinari 1084. Ander-
son 11558. [Bodmer, 289. Popp, 26. Sirén, 173.] Verso: Profile to l., squared.

1107 No. 254—Large sheet containing a study for the Last Supper (p. 174). R. ch. 26 by 39.
Fig. 501 Anderson 15110. Richter, pl. 46. [Bodmer, 252. Sirén, 102.]

1108 No. 255—Horseman—a slight sketch. Pen. 6 by 7. [Fototeca 2881. Popham Cat., No. 85.
Comm. Vinc., II, 66. In Popham's Cat., p. 25, it is very plausibly suggested that this may
be a copy by Battista Franco.]

1109 No. 258—Sketch for a Nativity with angels in the air (p. 171). Pen over bl. ch. 11.5 by 13.5.
Fig. 479 [Foteteca 2881. Bodmer, 128. Comm. Vinc., II, 43A. Popham Cat., No. 68. Popp, 17.
Suida, No. 23.] Charming.

1109A (former 1264) No. 257—Studies for the Child and the Virgin's torso in the Madonna with St. Anne
Fig. 563 (p. 168). R. ch. 28 by 22. [Anderson. Fogolari, No. 20. As in my 1098A there is the
barest chance of it's being an imitation by Melzi. A dry copy of both 1098A and 1109A,
but leaving out the two torsos for the Madonna exists in the Musée Condé at Chantilly
(see Müntz, p. 12).]

1110 No. 259—Youth kneeling, four studies for *putti,* and an angel flying (p. 171). Perhaps for
Fig. 481 the same Nativity as my 1109 (Fig. 479). Pen. 10.5 by 12. Anderson 30189. [Bodmer, 129.
Popham Cat., No. 69. Popp, 18. Sirén, 55B. Comm. Vinc., II, 43B.]

1111 No. 213—Study for Battle of Standard. R. ch. 13 by 21.5. [Anderson 22532. Looks more
like a close imitation by Cesare da Sesto.]

1112 No. 264—Profile to r. of old man of rather antique style. Bl. ch. shaded with ink, and
somewhat retouched. Anderson 15120. [Polifilo 40A.]

1112A No. 234—Caricatured head of man with hooked nose, protruding lower lip, and deeply
sunk eyes. Pen and wh. 11.5 by 7.5. Anderson 22535. Bodmer, 222. End of first
Milanese period.

1112ᴮ VENICE, Academy, No. 266—Tiny sketch for kneeling *putto*. Pen. 5 by 6. Anderson 15119. For infant Baptist in a Nativity and probably of the first Milanese period. Perhaps not by Leonardo but by one of his most cringing followers, say Ambrogio de Predis.

1113 VIENNA, Albertina—Bust of apostle—[early idea] for Peter in the Last Supper (p. 174). Pen and
Fig. 502 wash, on greenish paper. 14.5 by 11.5. Pl. 590 of Schönbrunner & Meder. Braun 70094. [Bodmer, 257. Albertina Cat., III, No. 18. Popp, 33. Not far removed in style from the sketches for the Adoration, although the hatching is already distinctly Milanese.]

1114 Sheet mounted by Vasari, containing six heads, chiefly caricatures, slightly drawn, of no great quality, but genuine sketches, dating from L.'s earlier years. Pen and bistre. Braun 70103-9. Pl. 590 of Schönbrunner & Meder.

1115 S. R., 79—Head of a blackmoor in profile to l., a study in reversed direction for the Scaramuccia at the Christ Church, Oxford, and of the same date. [Small grotesque head to l.] Pen. 5.5 by 6. [Albertina Cat., I, ii, fig. 1. Cat., III, No. 19.]

1116 (see 1044ᴬ)

1116ᴬ WILTON, Pembroke Collection—Head of young woman. Study probably for the Virgin in the Royal Academy cartoon for a Madonna with St. Anne. R. ch. 23 by 16. Pl. 63 of Pembroke Dr.
 This head has been considerably retouched, so that a facile sceptic might easily mistake it for a copy. But with all its faults it is neither copy nor imitation, but, allowing for restoration, of the exact quality and kind of two other heads (my 1151 and 1152, Figs. 512, 513) for the same work.

1117 WINDSOR,¹ Royal Library, No. 12570—Neptune guiding his sea-horses (p. 180). Bl. ch. 25 by 39.
Fig. 542 Pl. cxviii of F. E. [Bodmer, 315. Popp, 48. Suida, No. 151. Thiis, p. 37.] In every probability a study for the cartoon which Vasari says was designed for Antonio Segni. [As a very early idea for this is found in my 1189 done after 1500 this design may be of the same date.]

1118 No. 12496—Wolf sitting in the stern of a boat steers it towards an eagle resting on a
Fig. 552 globe (pp. 181-182). R. ch. 17 by 28. Pl. cxxii of F. E. [Bodmer, 345. Popp, 82. Dated according to Bodmer (p. 419) 1516, which would make it refer to the Meeting in Bologna between Leo X and Francis I.]

1119 No. 12497—Allegory, the purpose of which I do not begin to understand (p. 182). Pen.
Fig. 549 15.5 by 21.5. Richter, pl. 58. [Müller-Walde, 81ᴬ. See Clark, I, pp. 72-73.]

1120 No. 12701—Very meticulously drawn devices. Pen, washed with colour. 27 by 19.5. Richter, pl. 62.

1121 No. 12700—On recto and verso various devices, diagrams of cameos containing emblems and single figures; also a good deal of writing. Pen. 28.5 by 20. Recto in Richter, pl. 63. [Two at least of the cameos directly inspired by the antique.]

1122 No. 12585—Boar-headed man on horseback, playing on a horn [probably for a masquerade and possibly the one of Galeazzo da San Severino in January, 1491] (Richter, paragraph 1458).

1. [Luckily Kenneth Clark's *Catalogue of the Drawings of Leonardo da Vinci in the Collection of His Majesty the King at Windsor Castle* (Cambridge, University Press, 1935) has appeared in time for my final revision. I have compared it carefully with my own catalogue of the Windsor drawings and adopted not a few of his conclusions, generally with regard to dating. The introduction is informing and delightful and the catalogue all that a catalogue should be. Every item is not only adequately reproduced but described and discussed. The student is told all the author knows and can legitimately infer and not a word more.]

Bl. ch. 20 by 28. [Bodmer, 203. Comm. Vinc., III, 103. Verso: Geometrical and architectural drawings in ink. Clark (I, p. 99) disputes the date because the writing on the verso seems to him later. But recto and verso need not be contemporary.]

1123 WINDSOR, Royal Library, No. 12337—Each in a rectangle, two studies for a nude woman kneeling
Fig. 547 with an infant, probably for a Leda (p. 180). In upper l.-hand corner a galloping horse [which Clark (I, pp. 27-28) connects with Battle of Anghiari.] Below, rougher sketch of nude female. Bl. ch. The Leda is gone over with pen. 28.5 by 40.5. Pl. cxix of F. E. [Bodmer, 328. Sirén, 194.] The outline and the strokes point to L.'s last years. The full-face Leda is already as soft and feminine as is Correggio in the Convent of S. Paolo at Parma. [Verso: Mortars firing into a town.]

1124 No. 12572—Nude St. John with staff in l. hand, pointing with r. Sp. and wh. on greenish ground. 18 by 12. Braun 79203. [Bodmer, 177. Thiis, p. 35.]
 A rather timid and perhaps early sketch. If early it is possible that the model for this youthful figure was Jacopo Salterello, in which case the date would be 1476 (N. Smiraglia Scognamiglio, *Archivio Storico dell'Arte*, 1896, pp. 313 *et seq.*). [The hatching, as Bodmer remarks, points to a later period.]

1125 No. 12575—Youth in short coat and fluttering sleeves, spear in hand and arm akimbo
Fig. 556 (p. 182). Pen, and wash over bl. ch. 27.5 by 18.5. Pl. cxxiii of F. E. [Bodmer, 205. Popp, 80. Thiis, p. 31. Müller-Walde, 36. Second Milanese period.]

1126 No. 12577—Young woman in cuirass, l. arm akimbo, r. hand spread out. Bl. ch. 21.5 by 10.5. [Sirén, 62.] Companion to the next [and same date as my 1125 (Fig. 556)].

1127 No. 12576—Young woman in coat of mail and long skirt, standing with feet wide apart,
Fig. 558 with l. arm akimbo and palm in her r. hand (p. 182). Bl. ch. 21.5 by 11. [Bodmer, 206. Müller-Walde, pl. 37. Same date as my 1125 (Fig. 556).]

1128 No. 12581—Young woman in fluttering robes pointing—a vision of youthful health and action. Bl. ch. 21 by 13.5. Richter, pl. 26. [Popham Cat., No. 94. Müller-Walde, 39. Popp, 89. Suida, No. 127. Comm. Vinc., III, 90. End of second Milanese period.]

1128A No. 12586—Lion's head facing front and another in profile to r. with jaw stretched open. Bl. ch. 15 by 11.5. Sirén, 160B. Comm. Vinc., II, 52A. Verso: Geometrical sketches, five lines of writing, a foot and the profile of an old man facing r. Comm. Vinc., II, 52B. End of first Milanese period. Clark (I, p. 99) connects the recto with Battle of Anghiari.

1129 No. 12539—Slight sketch of child. Connected with the Virgin and St. Anne. Bl. ch. 8 by 7. [Bodmer, 276. Sirén, 131.]

1129A No. 12561—Headless nude body of baby in profile to l. supported by an arm and two clasped hands. Pen and wash on wh. paper. 13.5 by 13. Sirén, 30B. Suida, No. 138. Braun 79205. Free, supple, and mature—almost like a Rubens—yet probably done before L. left Florence for Milan. The motive is so much one that Raphael should have used that one is surprised not to find it in his works.

1129B No. 12562—Studies for nude babies. Bl. ch. and pen. 20.5 by 15. 13 by 10. Anderson 18619. Sirén, 29A. On extreme l. the child—a torso only—may have been for a composition recorded in the Madonna reproduced by Suida as No. 226. On extreme r. the child twists to r. against the lap of a seated figure looking down on him. This in bl. ch. singularly like Michelangelo's. Another child elaborately finished in ink, twisting to l. and looking to r. Under its feet a child's head looking down. to r. Early in second Milanese period. Clark (I, pp. 91-92) connects these sketches with the Virgin and St. Anne.

1129^C WINDSOR, ROYAL LIBRARY, No. 12567—Studies of a baby's chest and back. R. ch. 16.5 by 13.5. Comm Vinc., III, 97. Same date as my 1129^B. Clark, I, p. 93.

1129^D No. 12568—Studies for three or four children in different attitudes, one only with a head, two in profile l. reclining as if at the mother's breast, and of the two others we see one in profile to r., and above, a child's hand, and of the other the belly and l. leg bent at the knee with a hand supporting the groin. R. ch. gone over with ink. 19.5 by 14. Bodmer, 155. Sirén, 27^A. Comm. Vinc., I, 9. See next.

1129^E No. 12569—Studies for naked children in various attitudes, only one with head visible, some as if at the breast or lying in a lap, others as if walking, and separate legs and arms and hands. Sp. in part gone over with ink. 17 by 22. Bodmer, 154. Sirén, 27^B. Comm. Vinc., I, 10.

This and the last sheet dating from the end of the Florentine years contain, among others, studies for a Madonna which years later, in fact during the master's second Milanese period, was painted in his studio and is now known as the Madonna Litta of the Hermitage (Clark, I, p. 94, and *Burl. Mag.*, LXII, 1933, pp. 136 *et seq.*). Having no acquaintance with the orignal I cannot even speculate as to how much of this work is from L.'s own hand. For a mere copy, no matter how accomplished, it seems too good.

1130 No. 12574—Youth, lance in hand, riding. Pen. 24 by 15. Braun 79193. [Bodmer, 204. Müller-Walde, 38. Thiis, p. 30. Same date as my 1125 (Fig. 556).]

1130^A No. 12578—Bearded old man bending forward, towards another barely indicated figure. Pen. 3.5 by 4. Clark (I, p. 96) dates it soon after 1490.

1131 No. 12579—Old man wrapped in gown, seated meditating, in profile to r. Also studies for swirls [more likely of water than] of hair. Pen. 15 by 21.5. Richter, pl. 25. [Bodmer, 228. Suida, No. 162. Thiis, p. 160. Verso: Studies of architecture in r. ch.] First Milanese period. [Clark (I, p. 97) dates it toward 1510.]

1132 No. 12573—Prisoner in chains begging. Bl. ch. 18.5 by 13. Braun 79191. [Bodmer, 207. Same date as my 1125 (Fig. 556). Clark (I, p. 95) draws attention to faint outlines of nude on verso.]

1133 No. 12540—Nude youth seated in profile, resting on his r. hand. Below, a child fondling a lamb. Bl. ch. 17.5 by 14. [Bodmer, 288. Venturi, *L.*, fig. 92. Perhaps both studies for the Baptist at different ages. The nude youth not impossibly a first idea for the unfinished so-called Bacchus in the Louvre (Bodmer, 48) which was really meant to be a Baptist.]

1134 No. 12580—Actor in tragic attitude. R. ch., with slight touches of bl. on red ground. 20 by 14. Braun 79195. [Sirén, 63. Same date as my 1125 (Fig. 556).]

1135 No. 12502—Shaggy-haired old man. Below, sketch for lion's head. R. ch., highly finished, on pink ground. 18.5 by 13.5. The man's face retouched. [Bodmer, 308. Sirén, 98^B. Thiis, p. 136. Clark (I, p. 74) would date it c. 1501.]

1136 No. 12583^A—St. Sebastian, with his arms twisted around the column to which he is bound (p. 180). Pen and r. ch., on buff prep. parer. 11 by 7. [Bodmer, 178. Late like the other drawings of this subject. Cf. my 1010^E, Fig. 544, and 1022. Must have inspired his Milanese followers.]

1137 No. 12582—Caricature of old man, with hair erect, in long coat, standing in profile to r. Bl. ch. 21 by 15.5. [Bodmer, 208. Second Milanese period.]

1137ᴬ WINDSOR, Rᴏʏᴀʟ Lɪʙʀᴀʀʏ, Nos. 12588, 12590—Profile to r. wearing lifted helmet. Pen. 4 by 4.5. Two larger profiles to r. both wearing lifted helmets. Pen and ink. 6 by 14. Bodmer, 168.

1137ᴮ No. 12704—Group of tiny figures belonging (see Clark, I, p. 149) to L.'s first Milanese period. Pen. 3 by 4.5.

1138 No. 12705—Small draped figure seen from behind [and study for a r. sleeve of a draped figure.] Pen. 5 by 4.5. Richter, pl. 28, fig. 7. [Seidlitz, I, p. 335. Clark (I, p. 150) dates it c. 1498.]

1138ᴬ No. 12706—Various pen scribbles: a nymph, a wolf, two machines, etc. etc. Some writing according to Clark not by L. 7.5 by 13. Same date as my 1138.

1138ᴮ No. 12707—Three tiny figures, two standing, one kneeling. Pen. 9 by 6.5. Some lines of writing on the verso. Clark (I, p. 150) dates them c. 1505.

1138ᶜ Nos. 12712-12725—Series of pen-sketches, all autograph and discussed and dated by Clark (I, pp. 151-153).

1139 No. 12519—Plaquette-like bust of child in profile to l.—study, perhaps, for the Infant in
Fig. 488 the Virgin of the Rocks, but turned the other way (p. 172). R. ch. 10 by 10. Richter, pl. 44. Braun 79215.

1140 No. 12548—Study for head, perhaps of Matthew, in the Last Supper (pp. 174, 178). R. ch.
Fig. 504 19.5 by 15. Richter, pl. 47. [Bodmer, 254. Regarded now generally as a sketch for Bartholomew.]

1141 No. 12551—Study for head of Philip in same (pp. 174, 178). Bl. ch. 19 by 15. Pl. cvɪɪɪ
Fig. 506 of F. E. [Bodmer, 253. Sirén, 103.]

1142 No. 12547—Study for Judas in same (pp. 175, 178). Slightly retouched. Bl. ch. on red
Fig. 508 paper. 18 by 15. Richter, pl. 50. Braun 79179. [Bodmer, 256. Sirén, 104.]

1143 No. 12555—[Powerful head in profile to r.] indicated by Dr. Richter, and I believe correctly, as a study for the Judas, probably from the very earliest phase of L.'s studies for the fresco (pp. 174, 178). R. ch. 17 by 12.5. Richter, pl. 51. [Thiis, p. 227. Verso:
Fig. 509 The same head traced through and given a short beard; on the l. half a small grotesque head (p. 174). Pen and ink. Anderson 18624.]

1144 No. 12553—Study from antique for Matthew in the Last Supper [perhaps inspired by the
Fig. 503 busts of Lucius Verus] (pp. 174, 178). R. ch. 18 by 13. Braun 79219. [Bodmer, 259. Sirén, 107ᴬ.]

1145 No. 12554—Another study from antique, probably for last figure on l. in same composition
Fig. 505 (pp. 174, 178). R. ch. 21.5 by 15.5. Pl. cvɪɪ of F. E. [E. Möller, *Jahrb. K. H. Samml.*, 1928, p. 147, fig. 201.]

1146 No. 12598—Nude torso of elderly man in profile to l. (p. 178). R. ch., on pink ground. 20 by 14.5. [Sirén, 98ᴬ. Clark (I, p. 102) dates it about 1511. Perhaps from the same model as my 1142 (Fig. 508).]

1147 No. 12556—Bust of oldish man in profile to r., with massive hair (p. 178). R. and bl. ch. 22 by 17. [Bodmer, 309.] Vigorous. [Late.]

1148 No. 12599—Head and shoulders of bald man in profile to r. (p. 178). Bl. ch. 13 by 10. [Bodmer, 313. Inspired by the antique and in turn the inspiration of all of L.'s Milanese followers so that they seem more often than not carrying out posthypnotic suggestions of the Great Magician.]

LEONARDO

1149 WINDSOR, ROYAL LIBRARY, No. 12557—Profile to l. of curly-headed youth (p. 178). Bl. ch. 19.5 by 15. [Bodmer, 260. E. Möller, *Jahrb. K. H. Samml.*, 1928, p. 147, fig. 203. Thiis, p. 136.] Same type as my 1145 (Fig. 505).

1150 No. 12433—Head of youth in profile to l.—a caricatured profile—and in obverse direction a nude, seen from behind, looking up (p. 178). Looks like bl. ch. but may be sp. 14.5 by 7. [E. Möller, *Jahrb. K. H. Samml.*, 1928, p. 147, fig. 200. Verso: Sketch of machinery.]

1151
Fig. 513 No. 12534—Head of matron, looking through half-closed eyes, wearing a kerchief, which falls down to her neck (p. 175). R. ch., but kerchief bl. ch. and wh. Somewhat damaged by damp. 24.5 by 18.5. Braun 79222. See my 1152 (Fig. 512).

1152
Fig. 512 No. 12533—Head of woman with kerchief wound about her, looking down to the r. (p. 176). Bl. ch. 19 by 13. Braun 79223. [Bodmer, 281. Siren, 133. Thiis, p. 60.]

This and the last sketch, both of which had passed almost unnoticed [when this was first published] merit attention. They are authentic, as the modelling, the outlines, the folds, and the quality prove; and both are studies for the heads in the Madonna with St. Anne. The one in red chalk is obviously for St. Anne herself, not, however, as we see her in the Louvre picture, but as in the cartoon at the Royal Academy. But even with the last the identity is not absolute. L. seems to have found the expression too calm, and in the cartoon the head has more movement, and the face is lit up with more visible delight. This sketch, then, takes us a stage further back in L.'s conception. The drawing in bl. ch. is of a younger and livelier person. Placing it alongside of the one in red chalk, their relative positions are nearly the same as that of the two heads in the cartoon. It is therefore possible that the sketch in bl. ch. is a study for the Virgin. But there is no facial resemblance with the Virgin in either the cartoon or the painting. On the other hand, there is more than considerable likeness to the head of St. Anne in the picture, and in all probability our sketch was a study for this, so to speak, definitive edition of the masterpiece. But L. seems this time to have found the action and the expression lacking just a trifle in subtlety and calm; wherefore he changed it to a head more sedate, as we find it in the picture. (At Wilton House there is another head (my 1116A) that deserves notice in this connection.)

1153 No. 12552—Bust of youngish man nearly in profile, with open mouth and expression of great effort. R. ch. 25 by 17. Below, in ink, a castle. Pl. CXVII of F. E. [Bodmer, 255. Sirén, 105. Popham Cat., No. 75. Popp, 36.

I used to regard this as a study for the standard bearer but the position of the l. hand which somehow had escaped my notice proves that it was instead, as indeed is now universally believed, a study for the St. James in the Last Supper.]

1154
Fig. 535 No. 12505—Bust of lady with head in profile (p. 178). Sp. on pale pinkish ground. 32 by 20. Pl. CXIII of F. E. [Bodmer, 231. Popham Cat., No. 73. Sirén, 146. Vasari Soc., II, v, 3. Comm. Vinc., III, 96.] Study for a portrait. [Beginning of first Milanese period.]

1155
Fig. 545 No. 12516—Four studies of heads with hair fancifully arranged, doubtless for Leda (p. 180). Pen over bl. ch. 20 by 16. [Bodmer, 330. Sirén, 186. De Rinaldis, 60.] Morelli, as is well known, believed this sheet to be Sodoma's, but I cannot even guess his reason.

1156 No. 12518—Another head for the same, almost identical with the largest one on the last sheet (p. 180). Pen and wh. 17.5 by 14.5. [Bodmer, 331. De Rinaldis, 59. Popp, 60. Sirén, 185 B.]

1157
Fig. 543 No. 12515—Another head for the same but of more bizarre expression, and several words of L.'s writing (p. 180). Pen. 9 by 11. [Bodmer, 332. De Rinaldis, 62. Sirén, 185 A.]

128

1158 WINDSOR, ROYAL LIBRARY, No. 12517—Another head for the same, with hair tied in knots almost as complicated as in his famous "Academy" (p. 180). Pen over bl. ch. 9.5 by 10.5. [Venturi, *L.*, fig. 120 bis. De Rinaldis, 61.]

1159 No. 12499—Head of elderly man in profile to r. He wears a flowing beard, and has his hair braided on the back. Bl. ch. 21.5 by 15.5. Braun 79216. [Bodmer, 311.] The features have considerable resemblance to L.'s own. [Looks like a slight idealization of the head on my 1166, which bears every trace of having been done directly from the life.]

1160 No. 12508—More than half-length profile of youngish woman (p. 178). Bl. ch. touched
Fig. 534 with red. 17 by 14.5. Braun 79232. [Second Milanese period.]

1161 No. 12441—Bust of old man in profile to l., resembling L. himself, in a costume singularly
Fig. 539 prophetic of the Anglo-Indian of today (p. 178). Pen. 13 by 7. [Bodmer, 169.]

1161A No. 12440—Half-draped male nude in profile to r. and various geometrical diagrams. Pen. 10 by 4. Müller-Walde, 13. Perhaps early in first Milanese period.

1161B No. 12442—Bust of young man in profile to r. wearing *lucco*. Pen. 4.5 by 7. Comm. Vinc., I, 4. Müller-Walde, 13. Same style and date as the profiles on my 1170 verso (Fig. 473). Possibly after Domenico Veneziano or Castagno.

1161C No. 12432—Bust of curly-headed youth in profile to r. Pen. 13.5 by 8. Müller-Walde, 11. Comm. Vinc., II, 50B. Same style and date as the profiles on my 1170 verso (Fig. 473).

1161D No. 12438—Profile of curly-headed youth to r. Pen. 7 by 6. Seidlitz, I, p. 78. Thiis, p. 153. Comm. Vinc., II, 50A. Verso: Study for a baby's hand. Same style and date as my 1170 verso (Fig. 473).

1161E No. 12439—Profile of curly-headed youth to r. Profile of youth to l., the ear and back of head cut away. Pen. 6 by 5. Comm. Vinc., II, 50A. Same style and date as the profiles of my 1170 verso (Fig. 473). Verso: Slight sketch for machinery.

1161F No. 12437—Two youthful profiles, facing each other, the one towards r. with curly hair, the one towards l. barely indicated. Pen on blue-greenish paper. 4.5 by 5.5. Comm. Vinc., II, 50A. Looks much later than the preceding Nos. and may have been done during the second Milanese period.

1162 No. 12283—Man in profile to r., visible to below waist, standing on a miniature hill on which grows a miniature tree. Below at l. a careering horseman, and a nude with shield at his side. [The rest of the sheet taken up by geometrical figures, also very carefully drawn flowers.] Pen. 32 by 44.5. Richter, pl. 30. [Müller-Walde, 13.]

1163 No. 19093—[In MS. on the Anatomy of the heart (C. II. 23).] Profile to r. of a curly-headed youth, on a sheet containing notes on physiology. Pen. 25 by 19. [E. Möller, *Jahrb. K. H. Samml.*, 1928, p. 148, fig. 206.]

1163A Nos. 12447-12486, 12489, 12490—Series of pen-sketches for male heads, a few female, almost all in profile and most of them grotesque. Rouveyre in his *Têtes Grotesques* reproduced many of them. See also Bodmer, 217, 218, 219, 223, 225. Popp, 34. Müller-Walde, 13. See also Clark, I, pp. 63-70, and appendix B. Although some of them are of poorer quality or may have been gone over by pupils, Melzi in particular, there is no reason for discarding them altogether.

1164 No. 12495—Profile of old man wearing oak wreath, in midst of four caricatured heads. Pen. 26 by 20.5. Richter, pl. 122. [Bodmer, 226. Müller-Walde, 16. Suida, No. 121. Sirén, 97. End of first Milanese period.]

1164A WINDSOR, Royal Library, No. 12498 – Profile to l. of smooth-faced, middle-aged man wearing low felt hat. Gold-point on grey prep. paper. 13 by 10.5. Bodmer, 170. Suida, No. 105.

 The features recall Lodovico il Moro but seem older, thinner, and sadder. The stroke and the straggling hair might easily pass for L.'s, but the lines of the profile and the eye are hard and along with the modelling of the face must have been entirely made over, perhaps by Melzi.

1165 No. 12604—Profile to l. of a bald-headed old man [with indications for the lighting of the face. Some manuscript notes on painting.] Pen. 20.5 by 14.5. [Verso: Window in a mount.]

1166 No. 12500—Profile to l. of old man with hooked nose and long beard. Bl. ch. 25.5 by 18. [Bodmer, 310. Anderson 18617.]

1166A No. 12488—Torso of male nude seen from back, and profile to r. of very old man leaning on stick. Pen. 8 by 12. Popp, 75. The features suggest a possibility that this may be an ironical and half-pitying record of the way the great master saw himself in his last days.

1167 No. 12503—Head of man, seen full face. R. ch. on red prep. paper. 18 by 13.5. [Clark (I, p. 74) dates it c. 1511.]

1167A No. 12513—Rapid sketches for busts of women in various attitudes. Sp. 23 by 19. Bodmer, 153. Sirén, 122. Comm. Vinc., II, 36.

 After Adoration. Nowhere else is L. so specifically, locally Florentine, so much like Botticelli in his most prosaic moods, as for instance in the Bella Simonetta, so much like Ghirlandajo at S. Trinita and S. Maria Novella. Indeed, one may ask whether the last-named artist was not influenced by drawings of this nature.

1168 No. 12514—Bust of woman, the head barely indicated, but the throat elaborately modelled. R. ch. and sp. on red ground. 22 by 16. [Popham Cat., No. 79. Sirén, 123.

 Although the drawing seems close to my 1167A, the *contrapposto* and the features point to a later date and remind us of the Cecilia Gallerani at Cracow. It may be even later and would seem like the sketch that inspired Raphael for his Madonna del Prato. Andrea del Sarto in his fresco for the Birth of the Virgin at the Annunziata dated 1514 may have had it in mind when he was designing the seated woman looking straight out at us.]

1169 No. 12371—Female monster, winged, horned, and tusked with two goitres like pendant udders. R. ch. and bl. on red ground. 21.5 by 15. [De Toni, fig. 25. Probably an original. The contours in particular of the face meticulously retouched.]

1169A Nos. 12366, 12367—Four heads of grotesque animals. Pen. 10.5 by 15.5 and 11 by 7. Bodmer, 180. Müller-Walde, 24. De Toni, figs. 37, 38. Not quite satisfactory but, like a certain number of the grotesque human heads, cannot be dismissed lightly. They may turn out to be imitations or copies by Melzi.

1169B No. 12369—Sketch for a dragon-like creature. Bl. ch. in part gone over with ink. 19 by 27. Bodmer, 179. De Toni, fig. 26. Done perhaps in connection with design of which there is a careful copy in the Uffizi (my 1261A).

1169C No. 12370—Three studies for dragons, two of them ready to strike, and the third less combative. Above the last, faint traces of a fourth. Style, the first two finished with ink. 16 by 24.4. Comm. Vinc., II, 64. K. Clark, *Burl. Mag.*, LXII (1933) p. 23, Popp, 3. De Toni, fig. 24. Sirén, 162. Although almost certainly done before Leonardo left Florence it may have served for the design of which my 1261A is the copy.

1170 WINDSOR, ROYAL LIBRARY, No. 12276—Madonna nursing the Child, with infant John; profiles of
 Fig. 472 heads; nude male figure (pp. 169, 170). Pen and bistre on wh. paper. 40.5 by 29. Verso:
 Fig. 473 Eleven profiles, male and female, in the exact style of the pen-drawing in the Uffizi dated
 1478, and of about the same date (pp. 169, 170). Müller-Walde, 49. [Bodmer, 113 and
 114. Comm. Vinc., II, 48 and 49. Sirén, 32 and 33. Thiis, pp. 155 and 162.]

 The fixing of the date is a matter of some importance, for the recto of this sheet
contains besides a further number of profiles, the study for a Virgin seated with the
Child at her breast, and the infant John nestling up to her. (If Raphael, by the way,
when doing his *Belle Jardinière* or his *Madonna del Prato*, knew nothing of this design
it would greatly surprise me. Brescianino in his Naples Madonna with the Infant John
was doubtless acquainted with this composition. See Suida, Nos. 38 and 39). If this sketch
is of about 1478, then the Madonna in the His de la Salle Collection at the Louvre need
not be any later; and that fine Madonna cannot have left L.'s hand much earlier than
the one in the Adoration of the Magi. It would thus follow that the last-named work
was early, relatively much earlier at all events than L.'s departure from Florence.

1171 No. 12560—Madonna kneeling in landscape adoring Infant (p. 171). Slight but important
 Fig. 480 sketch. [To l. profile of bald man and another study for the Child. The rest of the
 sheet is taken up by various sketches for machinery, windows, etc.] Sp. on bluish tinted
 paper. 18.5 by 13.5. Richter, pl. 40, fig. 3. [Bodmer, 150. Comm. Vinc., II, 42.
 Thiis, p. 178.]

1172 No. 12605—Three [studies for proportions of man's head, one in profile and two frontal.]
 R. ch. 3.5 by 9.5. Richter, pl. 40, fig. 1. [Verso: Perspective studies of blocks and stairs.
 Clark (I, p. 105) believes these sketches are copies. They do L. no credit, certainly.]

1173 No. 12558—Hand laid on a wrist, another hand (p. 182). Sp. and wh. on yellowish tinted
 Fig. 557 paper. 21 by 14.5. Pl. cxxiv of F. E. [Popham Cat., No. 63. Sirén, 147.]
 Very careful studies, not for the Monna Lisa. [Usually now connected with the
Liechtenstein portrait, which it is assumed had hands in this position. It seems unlikely
that L. could have drawn hands like this at the same time that he was doing the Uffizi
Annunciation. The period of the Virgin of the Rocks would suit better as a date.]

1174 No. 12616—[Hands for Adoration of Magi. Sp. 28 by 18.5. See Clark, I, p. 108.]

1175 No. 12521—Drapery for figure kneeling towards l. (pp. 172, 176). Brush and bistre height.
 Fig. 490 with wh., on greenish prep. paper. 21.5 by 16. Braun 79196. Richter, pl. 43. [Bodmer, 152.
 Popham Cat., No. 61. Sirén, 72. Comm. Vinc., I, 14. This drapery is conventionally
accepted as being for the kneeling angel in the Virgin of the Rocks, as the crinkliness
of the folds tends to witness. It is for the Milanese version of it now in the N. G., executed
a number of years after the autograph one in the Louvre.]

1176 No. 12546—Study for Peter's r. arm in the Last Supper (p. 176). Bl. ch. and wh. 16.5 by 15.5.
 Fig. 507 Richter, pl. 49. [Bodmer, 258. Comm. Vinc., I, 30. Sirén, 106.]

1177 No. 12526—Study for drapery over knees, probably for the Madonna with St. Anne (p. 176).
 Bl. ch. and wh., on dark grey paper. 17.5 by 14.

1178 No. 12527—Variation of same (p. 176). Bl. ch., on buff paper. 17 by 14.5. [Bodmer, 286.]

1179 No. 12530—Study for drapery over r. knee, for the same (p. 176). Bl. ch. and much wh.
 Fig. 519 16 by 14.5. [Bodmer, 284. De Rinaldis, 72. Sirén, 131ᴮ.]

1180 No. 12529—Study for drapery about the waist, for the same (p. 176). Bl. ch. 12 by 14.
 [Sirén, 130ᴮ.]

1181 WINDSOR, Royal Library, No. 12531—Study for drapery over r. leg, for the same (p. 176). Bl. ch. on brick-red paper. 8 by 9, but irregularly cut off.

1182 No. 12532—Study for drapery of r. arm. Bl. and r. ch. and wh., on reddish ground. 8.5 by 17. [Venturi, *L.*, fig. 90. De Rinaldis, 74. Clark (I, p. 82) identifies it as for Virgin in Louvre Virgin and St. Anne.]

1183 No. 12524—Study for sleeve. Dark r. ch., on pink prep. paper. 14 by 22. [Bodmer, 285.]

1184 No. 12525—Study for drapery over shoulder and around wrist. Dark r. ch. on pink prep. paper. 16 by 16. [Bodmer, 287.]

1185 No. 12538—Study for the [Child] with arms stretched out, in the [Louvre] Madonna with
Fig. 516 St. Anne (p. 176). Dark r. ch., on pink prep. paper. 12 by 14.5. [Bodmer, 283. Popp, 47. Sirén, 130A.]

1186 No. 12583—Small nude with bit of drapery fluttering behind. R. ch. on reddish-buff prep. paper. 11.5 by 5.

1187 No. 12702—Lightly seated nudes conversing, a group probably for the Adoration of the Magi. Sp. on reddish toned paper. Richter, pl. 52, fig. 1. [Bodmer, 141B. Comm. Vinc., II, 58A. Sirén, 100B. Thiis, p. 204.]

1187A No. 12703—Two figures in conversation, one seated towards l. and turned towards r., the other kneeling or crouching with head resting on l. hand. R. ch. Bodmer, 141A. Sirén, pl. 100A. Comm. Vinc., II, 58B. Clark (I, p. 149) dates it after 1490.

1188 No. 12542—Two studies for the Last Supper (p. 174). [Important for the slight indication
Fig. 500 of the architecture.] Pen and bistre. 26 by 21. Richter, pl. 45. [Bodmer, 251. Popp, 35. Sirén, 101 (but reversed). Clark (I, pp. 84-85) dates it c. 1495.]

1189 No. 12591—Study for a David, bearing the strongest resemblance to Michelangelo's study for same. Below, a less finished study for same. [Sketches for architecture. At the feet of the more finished David a rapid notation for the Neptune, my 1117.] Bl. ch., pen and bistre. 27 by 20. Richter, pl. 83. [Bodmer, 314. Müller-Walde, between figs. 47 and 48. Done perhaps in competition for the David ordered in 1501. It is not to be off hand assumed that the older was copying the younger master.]

1190 No. 12648—[Two small naked figures seated in Michelangelesque attitude with one leg drawn up, the one on the l. holding out a rod as if fishing. Below, a female figure mounting steps and leaning over as if to wash in a tub. R. ch. 14.5 by 9.5. Bodmer, 234. Seidlitz, I, 290.] Verso: Nudes working a mortar. Bl. ch. [Jottings like those on the recto make one wonder just what were the relations of Michelangelo to L. Was the younger in youth acquainted with sketches by the elder? His dislike of the older may have been an offensive-defensive on the part of one who hated to take anything from the other but could not help himself.]

1191 No. 12643—Oxen ploughing and groups of sowers (p. 182). R. ch. 9.5 by 27. [Popp, 29.
Fig. 555 Sirén, 159. About 1500.]

1191A Nos. 12644, 12645, 12646—Three sheets of the same quality having on both sides numerous small figures in action, apparently studies of agricultural occupations. Bl. ch. and some ink. 20 by 13, 18 by 12.5, 19 by 13. See Clark, I, pp. 117-118.

1191B No. 12651. Sketches for various weapons. Pen and ink. 20.5 by 15.5. Bodmer, 198. Comm. Vinc., III, 73. Early in first Milanese period.

1191^C WINDSOR, ROYAL LIBRARY, No. 12652—Mine layer steered by a man, another similar machine and various models of guns or canons. Pen. 28 by 20.5. Bodmer, 196. Comm. Vinc., III, 81. Verso: Town on a hill being blown up into the air. Early in first Milanese period.

1191^D No. 12655—Nude figures in combat and various geometrical sketches. R. ch. 13.5 by 14.5. Bodmer, 293. Probably for Battle of Anghiari.

1192 No. 19149—Verso: Small nude figures swinging axes; notes and diagrams on the theory of light and shade. Pen. 43.7 by 31.4. [Vertically to them in r. ch. a nude seated figure bending down, not by L. as Clark (I, p. 191) correctly affirms.] Richter, pl. 5.

1193 Nos. 12606-12628—Various studies for human proportions, some of them exquisite in quality and of great beauty. The best are reproduced in Richter, pls. 7, 8 (fig. 2), 10, 11, 13, 14, 15, 16, 17 (fig. 2), 19 and 20. [See also Bodmer, 213, 214, 215, 216, 299. Seidlitz, I, 283, 292 and Clark, I, pp. 105-111.]

1193^A No. 12637—Two nude male figures, one in profile to l. the other seen from the back. Sp. to some extent height. with wh. on blue paper. 17.5 by 14. Bodmer, 174. Well on in first Milanese period.

1194 No. 12640—Two male figures in profile, and on larger scale a leg, in r. ch. Tiny figures, with the pen, of a horseman and two combatants. 16 by 15. Richter, pl. 21. Braun 79204. [Bodmer, 300. Popham Cat., No. 86. Sirén, 172. Studies for the Battle as Bodmer suggests.]

1195 No. 12639—[Studies for a leg écorché; for a nude male figure in profile to r., for an eye and for tiny figures of men walking uphill and downhill.] Pen. 12 by 15. Richter, pl. 23, fig. 4. Verso: [Female head not by L. R. ch.]

1196 No. 12641—[Nude male and female about to embrace, lower part of male nude with legs crossed, two sketches for a mountain landscape, other slight sketches. None of these by L. A good deal of writing. Pen. 23 by 16.5. Sirén, 183.] Verso: Studies of the nude in action and some writing. Richter, pl. 24, fig. 1.

1197 No. 12708—Two tiny figures chasing one another, in a battlefield. Pen. 3.5 by 5.5. Richter, pl. 38 (fig. 3).

1198 Nos. 12690, 12691—Designs for a fountain. Pen. over r. ch., on bluish paper. 15 by 6, and 17 by 6. Richter, pl. 101, fig. 3. [Clark (I, p. 145) dates them c. 1513.]

1199 No. 12632—Profile of lower half of male figure. A fine anatomical study. Sp. on tinted ground. 23 by 18.

1200 No. 12596—Nude male with arms held out, seen from behind. A beautifully finished anatomy. R. ch. 27 by 16. [Bodmer, 209. Clark (I, p. 102) dates it 1503-7.]

1201 No. 12595—Nude male in same attitude as last, but facing front and of same quality. R. ch. 26 by 15.5. Braun 79197. [Clark (I, p. 102) takes this for a copy of my 1202. The shading from l. to r. favours his opinion and yet I find it hard to agree.]

1202 No. 12594—Nude male in same attitude as last, but smaller and less finished. In the drawing of the feet and legs there is a certain reminder of Pollajuolo. R. ch. 23 by 13.5. [Bodmer, 210.]

1202ᴬ WINDSOR, Royal Library, No. 12601—Nude man seen to below waist in profile to l., the head squared for proportion and a note on the proportions of the head. To the r. full-length figure of nude man in profile to l. Sp. on blue prep. paper. The measurements in ink. 13 by 10. Richter, pl. 10. Bodmer, 172. Clark (I, p. 103) connects it with the early anatomies in MS. B. and with some of those mentioned in my 1193.

1203 No. 12629—Nude male seen from waist down with legs wide apart. R. ch. The r. hip and leg gone over with ink, the l. leg barely indicated. 21 by 14.5. Bodmer 211. Similar in quality to my 1200 and 1202. Clark (I, p. 111) dates it 1504-6.

1204 No. 12630—Powerful nude seen from waist down with torso bent back, legs wide apart, the r. more highly finished. Bl. ch. 22. 5 by 14. Bodmer, 303. Popham Cat., No. 93. K. Clark, *Burl. Mag.*, LVI (1930), p. 180.

Bodmer suggests that this like my 1031 may have been intended for a combatant in the Battle of the Standard.

1204ᴬ No. 12638—Nude male facing front with l. arm akimbo and the other resting on staff. Sp., the l. arm gone over with ink. 19 by 14.5. Bodmer, 173. First Milanese period, and singularly like Perugino's heroes in the Cambio at Perugia. Coupled together by Giov. Santi as Verrocchio's best pupils it is not only likely that L. and Perugino knew each other in Verrocchio's studio but met repeatedly in later life.

1205 No. 12631—Legs with abdomen, highly finished, in modelling perhaps better than any kindred effort of Michelangelo's. The drawing of the knees and the feet is singularly like Pollajuolo's. R. ch., washed, and slight touches of black. 19 by 14. Braun 79201. [Verso: Two slight sketches of nude men seen back and front in same position.]

1206 (see 1209)

1207 (see 1209)

1208 C. III (19095-19103)—Small book of size and aspect of the one published by M. Sabachnikoff on *The Flight of Birds* (Paris, E. Rouveyre, 1893) on generation and gestation, with dainty sketches. [J. P. McMurrich, *Leonardo da V. the Anatomist*, London, 1930, figs. 84 and 85. Popp, 71.]

1209 (including also former 1206 and 1207). Anatomical MSS. A and B. (19000-19059)—A series of anatomies in pen and ink, of the highest beauty both as drawing and modelling. I will not attempt to enumerate them, as they have been reproduced in almost perfect facsimile by M. Sabachnikoff in his *Dell'Anatomia, Fogli A* (Paris, E. Rouveyre), and *Fogli B* (Turin, Roux and Viarengo). [See also Bodmer, 175, 176, 341, 342, 343, 344, and Clark, I, pp. 154-169.]

1210 No. 12353—Various small sketches for [the Trivulzio, not as I used to think] the Sforza monument, with an elaborate architectural base. Pen. 28 by 19.5. Richter, pl. 65, fig. 1. [Bodmer, 325. Popp, 38. Sirén, 89. See Clark, I, pp. 36-37.]

1211 No. 12357—Sforza on a careering horse. Sp. on greenish ground. 11.5 by 19.5. Richter, pl. 65, fig. 2. [Sirén, 78ᴬ.]

1212 No. 12355—Sketches for an equestrian statue standing on a triumphal arch (p. 173). Pen.
Fig. 492 28 by 20. Braun 79181. Richter, pl. 66. [Bodmer, 324. Popp, 37. Sirén, 88. Suida, No. 72. Now accepted as being for the Trivulzio monument.]

1213 No. 12325—Two horses in profile, one standing and the other walking. Sp. gone over with ink. In sp. alone a rider on a galloping horse and studies of horses' legs, probably for the Adoration. 11.5 by 19.5. Bodmer, 146. Sirén, 85ᴮ. K. Clark, *Burl. Mag.*, LXII (1933), p. 20ᶜ. Verso: Slight sketch of a human head in bl. ch.

1214 WINDSOR, ROYAL LIBRARY, No. 12358—Nude on horseback trampling a prostrate foe (p. 173). Sp.
Fig. 496 on greenish ground. 15 by 18.5. Pl. CIV of F. E. [Bodmer, 185. Malaguzzi Valeri, fig. 70 (but reversed). Popp, 30. Sirén, 79. Hevesy, *Gaz. d. B. A.*, 1931, i, p. 106.] Study for the Sforza monument.

[This drawing seems to go with my 1044ᴬ and indeed it would be easy enough to bring both in relation with the two horsemen tilting against each other in the background of the Adoration who so prophetically anticipate the group of the Battle of the Standard, if the hatching in both would not seem of later date. I am inclined to agree with Malaguzzi Valeri, who calls it "un motivo classico caro all'artista;" he certainly was partial to this motive throughout his whole career. Clark (I, pp. 40-41) thinks, as I used to do and still do, that this particular study was intended for the Sforza monument.]

1215 No. 12354—Over a triumphal arch a nude on horseback trampling a prostrate foe (p. 173).
Fig. 493 Bl. ch. on pale pink ground. 20 by 12. Pl. CV of F. E. [Popham Cat., No. 89. Popp, 67. Sirén, 83. Very likely one of the later drawings for the Trivulzio monument.]

1216 No. 12360—Sheet of studies for a monument. Two sketches are of nudes on horseback trampling on a prostrate figure; the other three are of horses walking quietly. One in pen, the rest in bl. ch. 22.5 by 16. Pl. CVI of F. E. [Bodmer, 243. Popp, 68. Sirén, 84. Suida, No. 71. Late enough to be connected with the Trivulzio monument.]

1217 No. 12359—Two horses walking, on third a rider. Looks like bl. ch., but may be lead. 26.5 by 16. Richter, pl. 70. [Bodmer, 244. Inspired by the antique. Same date as my 1216.]

1218 (see 1222)

1219 No. 12343—Man on horseback with staff held out. Pen. 15 by 14.5. Richter, pl. 72, fig. 3. [Bodmer, 323. Popp, 41. Sirén, 87ᴮ. Same date as my 1216.]

1220 No. 12342—Sketches of horses walking, and riders. Bl. ch. 28 by 18.5. Richter, pl. 73. [Bodmer, 246. Malaguzzi Valeri, fig. 49. According to Clark (I, p. 30-31) for Trivulzio monument.]

1220ᴬ Nos. 12347-12352—Sketches and instructions for the casting of the horse. See Bodmer, 249, 250. Malaguzzi Valeri, 53, 54 (but reversed).

1221 No. 12356—Study for monument of equestrian group, with recumbent figure, on top of high pedestal—perhaps for the Trivulzio monument. R. ch., the equestrian group gone over with ink. 22 by 17.5. Richter, pl. 74. [Bodmer, 322. Popp, 39. Sirén, 90. Verso: Tracing of horse and rider in bl. ch.; the horse gone over with ink. Popp, 40.]

1222 (including former 1218) No. 12344—Horses walking, for equestrian monument. Bl. ch., gone over with pen and bistre. 20 by 14. Braun 79184. [Popp, 66. Sirén, 86. Verso: Two sketches, one of a horse, another of horse and rider. Bl. ch. gone over with pen and bistre. Bodmer, 245. Richter, pl. 71. Malaguzzi Valeri, fig. 50 (but reversed). Probably late.]

1223 No. 12321—Horse walking, and two studies for chest and foreleg of horse, seen full face
Fig. 494 (p. 173). Sp. 21 by 16. Braun 79185. [Bodmer, 191. Sirén, 82ᴬ. First Milanese period.]

1223ᴬ No. 12322-24—Three pen-studies for horses mounted together but of different dates. Bodmer, 183. Malaguzzi Valeri, fig. 43ᴮ.

1224 No. 12340—Nudes on rapidly galloping horses, and others pursuing, most probably for
Fig. 495 the Battle of the Standard (p. 173). R. ch. 17 by 24. Braun 79194. [Bodmer, 290. Sirén, 171.]

1224A WINDSOR, ROYAL LIBRARY, No. 12341—Horse walking in profile to r. and head of another horse facing front. Bl. ch. 12 by 17.5. Bodmer, 326. Sirén, 85 A. According to Clark (I, p. 30) for Trivulzio monument.

1225 No. 12326—Highly spirited horse prancing, and heads of others snorting. [Also head of
Fig. 497 roaring lion and, below, profile of an open-mouthed "Pollajuolo-Verrocchiesque" warrior] (p. 173). Pen. 19.5 by 31. [Müller-Walde, pl. 25. Bodmer, 316. Sirén, 164. Comm. Vinc., II, 53. Thiis, p. 206.] Verso: Manuscript notes and head of horse. [Generally connected with the Battle and yet how close to the unfinished background of the Adoration and the drawings related to it!]

1225A No. 12327—Mounted together with 1225. Head of horse. Pen. 10.5 by 6. Bodmer, 318. Comm. Vinc., II, 54. Seidlitz, I, p. 181. Malaguzzi Valeri, fig. 24. Probably connected with Battle. Carried out with a vigour and plasticity more than ordinary in L. even. Note how the mane seen by itself may be read off as a generous growth of reeds and rushes. See Clark, I, p. 22.

1226 No. 12285—Heads of horses. [A prancing horse in profile to r. Faint sketch of a standing horse seen from the back and a child's hand. Sp. on buff prep. paper. 21.5 by 15. Bodmer, 186. Malaguzzi Valeri, fig. 41.

In every probability first Milanese period, although the horse in profile seems almost later. The decision of the question may come from a closer study of the hand and forearm of the child. Bodmer connects it with the Madonna of the Rocks. To me it seems held out as in an Adoration, although not at all necessarily for that particular picture. Clark (I, p. 7) connects it with an Adoration of the Shepherds.]

1227 No. 12328—Sheet with various tiny pen-sketches of nudes, horses, and horsemen. In bl. ch., on a much larger scale, an angel pointing upward, with the action of the half-length St. John of the Louvre—a work of L.'s latest years. Pen and sepia on greenish paper. 21 by 28.5. [Bodmer, 319. Sirén, 202.] Verso: Horses, and a small medallion-like profile. [See Clark, I, pp. 22-23.]

1227A No. 12330—Man on prancing horse bearing down on riderless horse, and two groups of fighting horses. Nudes, probably studies for foot soldiers. Pen over sp. 17 by 14. Bodmer, 292. Sirén, 170A. For Battle of Anghiari (verso by another hand).

1228 No. 12331—Large sheet with sketches for careering and gambolling horses [for a kitten,
Fig. 498 and five studies, as Clark suggests (I, pp. 24-25, and *Burl. Mag.*, LXII (1933), pp. 21-26), for a St. George fighting the Dragon (p. 173). Pen and bistre. 30 by 21. Braun 79246. Bodmer, 320. Popp, 76. Sirén, 161. Probably later than the studies for the Battle, which would make it almost contemporary with Raphael's St. George painted for Urbino, formerly in the Hermitage, and now in the Mellon Collection, Washington, D. C.]

1228A Nos. 12334-12336—Three studies, two in bl. and one in r. ch. for horses rearing. Bodmer, 317 and 318. Comm. Vinc., II, 55A and 55B. Popp, 56. Sirén, 165A and 165B. Probably for the Battle. The one in r. ch. modelled like a bronze.

1229 No. 12338—Horsemen in a circle, probably drawn in connection with the Battle of the Standard. Verso: The same. Bl. ch. 21.5 by 38.5 Richter, pl. 56. [Sirén, 176.]

1230 No. 12332—[Fantastically gigantic quadrupeds charging over a battlefield, one of them carrying a platform with fighting men on the back.] R. and bl. ch. on prep. pink paper. 15 by 20.5. [Popp, 70. Sirén, 166. Late.]

1231 No. 12653—Batteries and horseman, and archer charging at them. Pen and bistre. 20 by 28. [Bodmer, 195. First Milanese period.]

1232 WINDSOR, ROYAL LIBRARY, Nos. 12286, 12289-12320—Series of studies, most of them in sp., for the anatomy, proportions and movement of the horse. [Their date and purpose, whether for the Adoration or the Battle or one of the monuments, are so exhaustively discussed by Clark (I, pp. 8-18) that I dispense therefore with a more detailed description of each number here. See also Bodmer, 182, 184, 187, 188, 189, 190, 192, 193, 236, 237, 238, 242, 248, 327. Malaguzzi Valeri, figs. 18, 20, 21, 42, 43, 44, 45. Sirén, 80, 81 A.]

1232 A No. 12362—Studies for domestic animals, a cow, a donkey lying down, and two donkeys grazing. Above, a human figure being helped down from a donkey by a man. Sp. partly gone over with ink. 16.5 by 17.5. Bodmer, 145. K. Clark, *Burl. Mag.*, LXII (1933), p. 20 D. Sirén, 56. Popp, 11. Probably for an Adoration of the Shepherds as Clark (I, p. 43) suggests.

1233 No. 12363—Studies for kittens and dogs [and dragons and panthers]. Pen and touches of wash over bl. ch. 27 by 21. [Bodmer, 321. Müller-Walde, fig. 20. Probably as late as my 1228 (Fig. 498). May have been gone over by a pupil.]

1234 No. 12402—Small study of two old trees. Pen. 7 by 7.5. [Bodmer, 334. Late.]

1235 (see 1236)

1236 (including former 1235) Nos. 12418-12430—Fourteen botanical studies, seven in r. ch., the rest with the pen (p. 182). [Bodmer, 266-274. De Toni, figs. 7-21. Popham Cat., Nos. 90 and 91. Popp, 2, 65, 74.]

1237 No. 12417—A tree. The slight indication in bl. ch. was probably by Leonardo. It was then elaborately finished with the pen by a pupil (p. 182). Pen on greyish-green paper. 39 by 26.5. Braun 79248. [Bodmer, 265. Popp, 49. Sirén, 163. G. Frizzoni in *Burl. Mag.*, XXVI (1914/15), p. 194, ascribed this sheet to Cesare da Sesto, because that master when he did draw trees, drew them in this fashion. On the same principle this great critic ascribed to various pupils works of Bellini himself because they were of the kind which these same pupils repeated continually. To my eye the foliage has the airy lightness of the best Sung masters.]

1238 No. 12431—Study in miniature of a wood. Verso: A tree, some notes (p. 182). R. ch. 19 by 15. [Bodmer, 346 and 347. De Toni, fig. 2. Venturi, fig. 69. Comm. Vinc., III, 92 and 93. Clark (I, p. 60) dates it c. 1498.]

1239 No. 12400—Landscape in miniature with ferry (p. 182). Pen. 10 by 13. [Bodmer, 334. Popp, 73. Clark (I, p. 52) dates it between 1503 and 1505.]

1240-1245 . . Nos. 12376-12380—Five sheets with studies of rocks and storms (p. 182). Bl. ch. Richter, pls. 34, 37. [See Bodmer, 340, 349. Popham Cat., No. 92. Popp, 78, 83, 84, 88. Clark (I, pp. 46-48) dates them 1512-16.]

1246-1250 B . . Nos. 12382-12388—Seven other studies of storm and deluge effects (p. 182). One with the pen, the others in bl. ch. One of them containing small figures which may represent the Vison of Ezekiel [12388, Popp, 77]. Richter, pl. 39 (but reversed). [See Bodmer, 339, 348. Popp, 63, 77, 85, 86, 87. Sirén, 168. Clark (I, pp. 48-50) dates them 1511-12.]

1251 No. 12409—Storm over town lying in deep valley (p. 182). R. ch. 29 by 15. Richter, pl. 29. [Bodmer, 262. Popp, 42. Clark (I, p. 54) dates it between 1499 and 1501.]

1251 A No. 12401—Castle by sea half swept over by waves (p. 182). Pen over ch. 16 by 20.5. Bodmer, 336. Sirén, 152. Clark (I, pp. 52-53) dates it between 1512 and 13.

18

1252 WINDSOR, Royal Library, Nos. 12405-12408 — [Four studies of mountainous landscapes and cloud effects (p. 182). Bodmer, 264. Popp. 50, 59. Sirén, 136. Clark (I, pp. 53-54) dates them c. 1499-1506.]

1253-1259 . . Nos. 12410-16 — Seven studies of mountain chains (p. 182). R. ch. on pink ground. [Sirén, 135. Clark (I, pp. 54-56) dates them c. 1511.]

1260 Nos. 12394-97 — Four studies of rock strata, precipices, and defiles (p. 182). [See Popp, 20, 62, 64. Sirén, 153, 184. Comm. Vinc., III, 94. Clark (I, p. 51) dates 12395 toward 1475, the others c. 1510.]

1260A Nos. 12398, 12399 — Two river landscapes (p. 182). Bodmer, 263. Popp, 69. Clark (I, pp. 51-52) dates them c. 1503.

1261 No. 12647 — The courtyard of an arsenal (p. 182). Pen. 25 by 18.5. [Bodmer, 199.
Fig. 560 Popham Cat., No. 74. Popp, 24. Sirén, 59. Comm. Vinc., III, 83. Clark (I, p. 118) dates it about 1487.]

Imitations of Leonardo

1261A FLORENCE, Uffizi, No. 475E — Dragon fighting lion. Pen and bistre wash highly finished. In the corners, with pen alone, two outline copies of sketches for Madonna with cat (cf. my 1015, Fig. 474), a third for a Madonna crouching on ground and of children's heads. Brogi 1620. Müller-Walde, 22. Thiis, opp. p. 207. Suida, No. 117.

 The original must have been a work that gave the artist full scope for his gifts of conveying form and movement combined in a way that art has seldom rivalled. The composition is as compact as if intended for an intaglio, and it is not easy to conceive of action more vehement, more violent, and yet so concentrated, so undispersed. The modelling, as this indifferent copy cannot help showing, must have been of gemlike firmness and delicacy. The accompanying outline copies of early Madonnas must not prejudice us too greatly about the date of the design. Plastically it seems to belong to L.'s advanced Milanese style, although scarcely so late as its last phase.

 Dragons and combats with them were among the score or more of subjects that kept turning up in the course of L.'s career. We have a Florentine sheet at Windsor with three dragons tamer by far than ours. A later sheet there (my 1169B) of a creature half lion, half dragon may possibly have been sketched in connection with ours. One need scarcely refer to the drawings much later still of dragons fighting horsemen (e. g. my 1228, Fig. 498). As for the date of our copy, if by the same hand that did the outline Madonnas then it is of the 16th century made by Sogliani or an equally archaizing eclectic.

1261B No. 206F — Half-finished sketch in pen and bistre for a Madonna seated on the ground with the infant Baptist and another barely visible figure behind him, either a St. Elizabeth or an angel. See my 1059, which deals with this composition. Fototeca 7833.

1261C THE HAGUE, Fritz Lugt Collection — Study for head and shoulder of child almost in profile to r. sucking. Sp. and wh. on blue ground.

 The correspondence with the Child in the Madonna Litta (Bodmer, 43) is very close and yet not quite identical. One may suspect that it was done by Melzi or possibly Salai as either an extra copy of an original L. or as a perfect imitation. The question is raised whether the one or the other of these two painters may not have assisted L. in execution of the painting. See my 1027 verso, and 1038.

1261D LONDON, British Museum, Malcolm, No. 47 — Faithful copy of a lost sketch for drapery of Christ in the Berlin Resurrection. Sp. and wh. 18 by 15.5. Bode, fig. 47. E. Hildebrandt, *Leonardo da Vinci*, Berlin, 1927, p. 279. Milanese, by Salai or Melzi, although the original can have been no later than the period between the Adoration and the Virgin of the Rocks.

1262 TURIN, Royal Library, No. 15584—Profile to r. of old man seated and pointing (p. 168). R. ch.
Fig. 566 13 by 18. Very careful copy.

1262A No. 15630—Study for Hercules seen from back with legs wide apart holding club in r.
hand, lion at his feet. Bl. ch. 28 by 19. Anderson 17239. Looks like copy of the man
with sword in my 1089, but done in an almost Michelangelesque way.

1263 VENICE, Academy, No. 227—Five caricatured heads (p. 168). Pen. [Anderson 15115. Very close
Fig. 567 imitation.]

1263A No. 229—Seven grotesque heads. Anderson 15114. Dry, conceivably an imitation by Melzi.

1264 (see 1109A)

1264A No. 270—Head of woman with plaited hair and eyes cast down. From an original sketch
for the Virgin and St. Anne or for the Leda. R. ch. on pink paper. 20 by 14. Fogolari,
No. 19. Suida, no. 300. Anderson 15116. Possibly by Melzi or perhaps Salai.

1265 WINDSOR, Royal Library, No. 12564—Imitation of studies for a *Madonna del Gatto* (p. 168), with
Fig. 564 the difference that here the Virgin reclines on the ground. Morelli also noted this as an
imitation (Galleries Borghese and Doria, p. 227). Pen. 20 by 15. Braun 79186. [Müller-
Walde, fig. 58. Suida, no. 40. Thiis, p. 174.]

1266 No. 12584. Profile to r. of old man (p. 168). R. ch. 18 by 13.

Filippino Lippi (pp. 103-107)

1266A BAYONNE, Bonnat Museum, No. 1245—Youth seated on balustrade, leaning on r. arm, pointing
downward with l. Sp. and wh. on grey prep. paper. 17 by 9.5. Bonnat Publ., 1924, pl. 3
Verso: Seated figure seen from behind in attitude of sketching.

1266B No. 1246—Figure of draped young man seated in profile to l. Sp. and wh. on pearl-
greyish paper. 17 by 6. Arch. Ph.

1267 BERLIN, Print Room, No. 474—Young man seated. Sp. and wh. on pale grape-purple ground.
25 by 18. [Berlin Publ., 19.] Verso: Young martyr. [Variant of my 1266B.]

1268 No. 475—Youngish female standing to l. but facing front, holding up her draperies with
l. hand. Cf. my 1329B. Pen and bistre on pinkish prep. ground. 22 by 9. [Berlin
Publ., 20.]

1269 No. 2367—Allegory of Music (p. 106). Pen and bistre on paper rubbed slightly with pink.
Fig. 227 18 by 13. [Berlin Publ., 21. Scharf, fig. 188.]

1269A No. 616—Head of man in profile r. as if for kneeling figure in an Adoration. Bistre and
wh. on blue-black ground. 9 by 12. Scharf, fig. 168, and *Berliner Museen*, 1930, p. 146.
It does not occur in the Uffizi Adoration but is of the same years and may possibly have
been instead the study for a donor in an altar-piece.

1270 No. 5150— Young man holding l. hand to his mantle, and in his r. a pen (pp. 106, 108).
Sp. height. with wh. on pale grape-purple ground. 25.5 by 11.5. An early drawing, as
is testified by the form of the hands. A kindred sketch must have served for the Sebastian
in the altar-piece of F.'s school at Berlin (No. 98), which has been discussed at length in
the text. Verso: Nude lightly seated (p. 106). [Berlin Publ., 17A and 17B.]

1271 BERLIN, Print Room, No. 5043 — Young man receiving an older person, his inferior in rank. Sp. height. with wh. on greyish ground. 21 by 24.5. [Berlin Publ., 16. Popham Cat., No. 48. Scharf, fig. 147.] An early drawing, charming in feeling, and delicately done.

1271ᴬ (see 1271ᴱ)

1271ᴮ (former 44) No. 5174 — Head of youth (p. 337). Sp. height. with wh. on paper rubbed with red. 19 by 12.5. Pl. LII of F. E. [Berlin Publ., 18. A. v. Beckerath, *Burl. Mag.*, VI (1904/05), p. 238. Note likeness of hair with the head of Tobias in former Benson Tobias and Angel and better still in the Turin Tobias and the Archangels (Van Marle, XII, p. 260).]

1271ᶜ No. 5169 — Madonna in roundel with Child on her l. knee. Of exact kind and quality as my 1333ᴬ recto and verso. Bistre and wh. on slightly rubbed pink paper. Diameter 7.

1271ᴰ No. 5509 — Head of youngish woman in medallion. Ascr. to Franciabigio but certainly F.'s.
Fig. 236 Cf. my 1326ᶠ, 1326ᴳ, and 1330. Sp. on brown prep. paper. Diameter 7.

1271ᴱ (former 1271ᴬ) BOSTON, Isabella Gardner Museum — Boy Christ and youthful Baptist meeting and embracing. Pen and bistre. 9 by 9. [Scharf, fig. 160.]

1271ᶠ BUDAPEST, Print Room, No. 421 — Two angels in profile r. making music while kneeling at feet of Madonna, of whom only the skirts and one leg of the Child appear. Pen and bistre. Pl. 1106 of Schönbrunner & Meder. Probably by F.

1271ᴳ (former 852) CAMBRIDGE (Mass.), Fogg Museum, Paul J. Sachs Collection — Draped male kneeling to r. and behind him female also in profile bending over with arms extended. Sp. and wh. on grey tinted paper. 22 by 19. [Buffalo Exh. Cat., pl. 16. Almost as early as Esther panels, and of same kind and quality.]

1271ᴴ Fogg Museum, Charles Loeser Bequest, No. 129 — Two studies, front and back, for altarpiece representing Madonna sitting high with the Dead Christ in her lap. She is assisted by two angels. The difference is that on one side Paul Hermit and Anthony Abbot kneel in adoration and the entire group appears against architectural setting, something like a palatial staircase, and in the other the saints lean on their staffs in contemplation and two angels with crowns float on high. Pen and bistre on wh. paper. 25 by 18. Vasari Soc., I, iv, 2, 3. Scharf, figs. 172, 173, and *Jahrb. Pr. K. S.*, 1931, pp. 210, 211. Van Marle, XII, pp. 362, 363. Meder, *Handz.*, fig. 11. For the same work as indicated in my 1360. Note how the action of the Virgin and the Dead Christ in two of these three designs anticipates Michelangiolo's Pietà of St. Peter's done four years later.

1272 (see 1353ᶜ)

1272ᴬ CASSEL, Former Habich Collection (sold in 1899) — Moses striking Rock. Pen. Repr. and publ. by Guido Cagnola in *Rass. d'A.*, 1906, p. 41. Study for cassone panel done for Matthias Corvinus and now in Collection of Sir Henry Bernhard Samuelson, Bart., London (publ. and repr. by Claude Phillips in *Art Journal* for Jan., 1906). Apparently done in 1488. (See also my 1382ᴬ, Fig. 258.) Verso: Trial of Moses. Sketch for another cassone panel of same series as last, but, unfortunately, its present whereabouts is unknown. Pen. Scharf, fig. 187. Repr. and publ., *ibid.*, p. 42.

1273 CHANTILLY, Musée Condé, No. 23 — Head of boy nearly in profile to r., wearing cap over his long thin hair (p. 107). Sp. height. with wh. on grey ground. 18.5 by 13. Braun 65047. Ascr. to Credi, but obviously by F., as is proved by every feature and the technique. This or a similar head may have served F. as a model for the angel peeping out under the Madonna's r. hand in the Vision of St. Bernard.

1274 CHANTILLY, Musée Condé, No. 7—Head of smooth-faced man looking down slightly to l., his hair straggling out from under cap (p. 107). Sp. height. with wh. on greyish paper. 22 by 18.5. Braun 65012. A characteristic sketch, which F. may have done for a portrait either in the Minerva or in the Strozzi Chapel frescoes.

1274ᴬ No. 8—Draped figure of bearded man. Sp. and wh. on purple greyish paper. 27 by 10. Giraudon 933. Of Carmine period but reminiscent of both Filippo and Botticelli.

1274ᴮ (former 671) CHATSWORTH, Duke of Devonshire—Head of old man in an oval. Sp. height. with
 Fig. 238 wh. on bluish-grey paper. 19 by 14. Braun 74030. [Popham Cat., No. 58. Chatsworth Dr., 29.]

 Morelli, who thought he discerned Credi's hand in this drawing, ascribed to Daniele da Volterra, believed it to be a portrait of Mino da Fiesole. This is far from improbable, and assuming it to be true, Credi could have made it no later than 1484, the date of Mino's death. As the person represented looks fifty years old at least, a date much earlier than 1484 is not to be thought of, for Mino was born in 1431. [But the author of this sketch cannot be Credi as I too used to think. The system of planes is not his, the concept is not his, nor is the light and shade or the stroke. Not even the ear is his. All are characteristic of F., to whom we now must attribute this study.]

1275 Female saint praying. Sp. and wh. on grey ground. [On the same side of the sheet framed in by Vasari are four more sketches by F., three in pen representing a running *putto* and two angels or Victories and one in sp. and wh. representing a muse leaning against a herme and another draped female figure seen from behind. All are of the Strozzi Chapel period. For another drawing on this side of the sheet see my 760 verso; for the other side see my 760 recto, 1276, 1276ᴬ, and 1276ᴮ.]

1276 Young king with parts of nude figures behind him, and one with whirling drapery. Sp. height. with wh. on brown ground. 22 by 33. [Popham Cat., No. 50. Framed in by Vasari together with my 760, 1276ᴬ, and 1276ᴮ. For verso see my 760 verso and 1275.]

1276ᴬ Study for half-nude beggar leaning on staff. Sp. height. with wh. on tinted ground. 20 by 10. Chatsworth Dr., 34. [Popham Cat., No. 50. In same frame as my 760, 1276, and 1276ᴮ.]

1276ᴮ Youthful nude with head turned to r., r. hand held out and l. touching thigh as for a St. Roch. Sp. and wh. on tinted ground. 20 by 10. Chatsworth Dr., 34. [Popham Cat., No. 50. In same frame as my 760, 1276, and 1276ᴬ.]

1277 Head of smooth-faced elderly man in Florentine costume. He turns somewhat to l. Nose aquiline and sensitive, mouth firm, look direct. Sp. height. with wh. 21.5 by 18.5. [Vasari Soc., II, vi, 4. Popham Cat., No. 44. Chatsworth Dr., 2.]

 This spirited, vigorous sketch can be by no other than F., but of his prime while he was painting works of such relative excellence as the frescoes at the Brancacci Chapel. I would beg the student to compare this drawing with the portraits in those frescoes. That the conception is either too realistic or too powerful for F. will scarcely be said by any one who has in mind the donors in the Badia or the S. Spirito altar-pieces. The ear is certainly F.'s and not Ghirlandajo's. No less characteristic of F. is the rapid delicate technique. Let the sceptic compare the stroke, the hatching, and the way the white is applied with what he will find in typical drawings by F. like those at Dresden, or my 1286, 1295, 1296 (Fig. 245).

1277ᴬ CHELTENHAM, Fitzroy Fenwick Collection—Saint seated on ground; probably for John the Evangelist in ceiling of S. Maria sopra Minerva period. Sp. height. with wh. on cream-coloured prep. surface. 19 by 14.5.

1277B CHELTENHAM, FITZROY FENWICK COLLECTION—Studies of drapery. Vague indications of a torso, a hand resting on a book, etc. Sp. height. with wh. on grey-green surface. 20.5 by 14. Much damaged and faded but nevertheless characteristic of the phase in which Raffaellino del Garbo branches off from him.

1277C Sketch for Death of Meleager (pp. 105, note; 338-339). Pen and brown ink and brown
Fig. 242 wash with wh. 30 by 28.5. Possibly the wh. has been retouched, and here and there the ink as well. *O. M. D.*, VIII (1933/34), pl. 35. Fenwick Cat., pl. VIII. Scharf, fig. 197.

Elaborate composition from F.'s last years. The scene takes place in a tent decorated with panoplies. The youthful hero lies on a couch with head hanging down and l. arm falling limp. Three women behind him bend over and wail. To l. two others try to put out the torch. Under the limp arm and leg of Meleager crouches his dog, and on the r. appears the boar. The design may have been executed. A variant for the woman with the torch is my 1300. My 855D is more likely a faithful copy by David Ghirlandajo after an original by F. rather than by F. himself.

1277D Study for Cumaean Sibyl in S. Maria Sopra Minerva (Scharf, fig. 67). Sp. height. with wh. on grey prep. paper. 13 by 11. Fenwick Cat., pl. IX. Scharf, fig. 161.

1277E Sketch for one of the decorative female figures in the Strozzi Chapel at S. Maria Novella just above the Fides to r. Pen and brown ink and brown wash. 16.5 by 9.5. I owe my acquaintance with this drawing to Mr. Popham, who also pointed out to me that it was used by Robetta for an engraving (see Hind, D. II, 16). In the fresco (Scharf, fig. 120) the figure looks less slender and bends gracefully to converse with her companion.

1277F CLEVELAND, MUSEUM OF ART—Study for St. Jerome seated at desk. Pen. 24 by 25. Pricked for transfer, damaged and restored. Photo. Museum. Ascribed to Ghirlandajo in nineteenth century handwriting. Dating from the time when F. was painting in the Carafa Chapel, S. Maria Sopra Minerva. (Used by contemporary engraver. See Hind, D. III, 6.)

1278 DRESDEN, PRINT ROOM—St. Andrew standing and reading, and another saint seated facing him (pp. 106, 108). Sp. height. with wh. on grey paper. 27.5 by 20. Braun 67032. [Scharf, *Jahrb. Pr. K. S.,* 1931, p. 217.]

This sketch, so singularly characteristic of F., and of F.'s youth, in the types, in the forms, and in the draperies, not to speak of the technique, of the stroke, of the hatching, and of the quality, was some time ago taken away from F., to whom it was correctly attributed by Morelli (*Kunstchr.*), and ascribed on the authority of Dr. Ullman to Raffaellino del Garbo (*Rep. f. K. W.*, XVII, 1894, p. 111). This writer, starting from the unsound basis that the Madonna with Sts. Andrew and Sebastian (Van Marle, XII, p. 426) was by Raffaellino, jumped to the conclusion that this drawing, because of the resemblance of the Andrew in both, must be by the same hand, and that hand Raffaellino's. But the Andrew in the painting is no more than a caricature of the drawing. How grand and spirited is the one, how monkish and uncouth the other! In the sketch the draperies have a swing and a cast which are to some purpose, while in the painting we have but a spiritless copy.

Verso: Two male saints, one of them with mace and turban. [Scharf, fig. 150.]

1279 Youth pensive, seated. Sp. height. with wh. on greyish paper. 27.5 by 8.5. Pl. LVII of F. E. Verso: Nude with staff, walking (p. 106). [Van Marle, XII, p. 369.] These also have been ascribed to Garbo. But they are highly characteristic and most unmistakable products of F.'s hand. The head of the nude, it should be noted, is still somewhat Verrocchiesque, a type which in F.'s paintings never occurs after the Corsini tondo—a work dating from a time before Raffaellino had perhaps as much as begun to paint.

1280 DRESDEN, Print Room—Youth walking away with r. hand held out, and l. down balancing it (p. 106). Pen and slight touches of bistre wash. 22 by 11. Braun 67013.

Ascr. by Morelli *(Kunstchr.)* to Ghirlandajo, with whom it shows superficial relations, particularly in the pen-stroke; but even this is really F.'s; the type is his, the folds are his, and, above all, the form of the hands is his. Cf. l. hand here with, for instance, hand of Madonna in Lady Ludlow's picture, and the action with that of the figure carrying a stool in my 1286. Verso: Back view of draped figure bending over, seated on high parapet.

1281 FLORENCE, Uffizi, No. 128ᴱ—Old man, elaborately draped, kneeling in profile l., blessing with r. hand and holding an incense box with l. Sp. and touches of pen height. with wh. on prep. ground. 16 by 12. Brogi 1670. Scharf, fig. 171. [Verso: Sketch for St. Thomas in the fresco at S. Maria sopra Minerva (Van Marle, XII, p. 323) (p. 104, note). Fototeca 12013. See Giglioli in *Dedalo*, VII (1926/27), pp. 779, and 781.

Although the folds are still so Botticellian and the head as well as the action of the r. hand different, it is probable that the kneeling figure was an idea for the one in the foreground of the Uffizi Adoration. The presence on the back, of a sketch for the Thomas at S. Maria sopra Minerva, Rome, renders this probability more likely as both these works must have absorbed the mind if not the hand of F. at about the same time.]

1282 No. 129ᴱ—Sketch for St. Bernard in the Badia altar-piece (p. 104, note). Sp. and wh. on
Fig. 223 buff ground. 21 by 13. Braun 77064. [Brogi 1671. Scharf, fig. 145.]

1283 No. 133ᴱ—Draped figure sitting on stool. Sp. height. with wh. on greyish ground. 18 by 12. Braun 76260.

1284 No. 134ᴱ—Three draped figures squatting on ground. Sp. height. with wh. on pale brown paper. 25 by 36. Early, probably for evangelists in a ceiling.

1285 No. 139ᴱ—Study for head of the Madonna in the Vision of St. Bernard (p. 104). Pen and
Fig. 222 bistre wash height. with wh. on yellowish tinted ground. 25 by 19. Pl. LIV of F. E. [Uffizi Publ., IV, i, 24. Ede, pl. 41.]

1286 No. 141ᴱ—Three figures. The one in the middle turned away with r. foot awkwardly resting on stool, the one to the r. carrying a stool, the other looking on as if surprised (p. 106). Sp. and wh. on pale buff ground. 20 by 28. Brogi 1774. [Uffizi Publ., IV, i, 19.]

A drawing of F.'s best quality, and most typical. With the r. hand of the man to l. cf. the identical hand in the Berlin sketch of a young man (my 1270). The stroke and technique are most characteristic, and it should be noted how close they are to Ghirlandajo's, but how much more spirited.

Verso: Youth seated holding a reed, and a somewhat older man asleep with his head on table. Brogi 1775. Same qualities as last, and same technique. [Both possibly done with reference to S. Maria Novella frescoes.]

1287 No. 142ᴱ—Sketch for altar-piece representing Madonna enthroned between Sts. Nicholas
Fig. 231 and Peter Martyr, and two female saints (p. 107). Pen and bistre wash on wh. paper. 18 by 16.5. Pl. LVIII of F. E. [Uffizi Publ., IV, i, 22. Ede, pl. 42. Scharf, fig. 176.]

With the women compare the drawing for the Raising of Drusiana (my 1298). With the Madonna and Child, those in the S. Spirito picture (Van Marle, XII, p. 325). The action of the Child is identical with that of the one in the S. Angelo tondo.[1] We may safely place this sketch in the nineties.

1287ᴬ No. 143ᴱ—Two studies for angel in an Annunciation. Sp. and wh. on buff ground. 10 by 9.

1. [Now at Cleveland.] Reproduced in the second series of my *Study and Criticism of Italian Art,* London, 1902, opp. p. 92, and in Van Marle, XII, p. 326.

1288 FLORENCE, Uffizi, No. 144E—Study for Christ among the Doctors; affixed to r. two tiny sketches
Fig. 230 of same quality and technique (p. 107). Pen and bistre wash on wh. paper. 12 by 26.
Braun 76279. [Uffizi Publ., IV, i, 18. Scharf, fig. 186. Rapid, late. Figure extreme r.
almost Pontormesque.]

1288A No. 145E—Kneeling draped figure to r. with hands crossed on breast, in every probability
for Uffizi Adoration of Magi. Sp. and wh. on pink prep. paper. 18 by 15. Fototeca 12620.

1289 No. 146E—Slight and hasty sketch after Botticelli's fresco in the Sixtine Chapel, represent-
Fig. 249 ing the Destruction of the Children of Korah. Pen on wh. paper. 12 by 20. Braun 76278.
[Fototeca 4705. Brogi 146. Steinmann, I, p. 262. Scharf, fig. 162.]
 Ascr. to Botticelli, but correctly attributed by Morelli *(Kunstchr.)* to F. We need
not, however, go further and conjure up from the nether regions of nonsense the inference
that because this sketch is by F., he therefore must have had the chief part in painting
Botticelli's fresco. When that was painted F. must certainly have been well established
as an independent master, with better to do than to follow Sandro to Rome in the capacity
of assistant. The sketch doubtless was done by F. in haste during a visit to the Sixtine
Chapel in the years while he was painting in the Minerva.

1290 No. 147E—The Virgin seated on a stool looks up from her sewing to the Child, Who is
held erect on the ground by the kneeling St. Anne. On the l. the young Baptist looks
on, kneeling by a chair on which stands an open book in which he has been reading. Pen.
6 by 12.5. Braun 76280. [Uffizi Publ., IV, i, 12.] A charming bit of genre, but of unequal,
in places mincing, touch, although of his later period.

1290A (former 1376) No. 148E—[Youthful dead Christ sustained by two angels while two others with arms
crossed on breast mourn and worship.] Bl. ch. on wh. paper. 11 by 23. [Fototeca 12770.
Photo. Mannelli. By F. himself and for a predella—not, however, for the former Benson one.]

1290B No. 149E—Study for kneeling Madonna in a Nativity. Sp. and wh. on mauve prep. paper.
14.5 by 12.5.

1291 No. 154E—Figure with torch and basket. Slight and rather late. Sp. height. with wh. on
pinkish paper. 13 by 18. [Fototeca 10994. Scharf, fig. 191. Verso: Skulls of deer and
skeleton of a hand. Pen, bistre and wash on wh. paper.]

1292 (see 1326F)

1293 (see 1326G)

1294 (see 1329A)

1295 No. 171E—Saint kneeling, with a crozier, and a man standing close to him. Sp. and wh.
on greyish ground. 24 by 25. Braun 76261. [Van Marle, XII, p. 365.] Verso: Two men
seated. Brogi 1779. Earlyish and typical drawings.

1296 No. 172E—One man kneeling before another, and a third looking away. Sp. and wh. on
Fig. 245 greyish ground. 25 by 31. Braun 76262. Brogi 1780. Verso: Three men in conversation.
Brogi 1781. Same character as last, but perhaps a trifle earlier. The types are [still
early.] The hands are most typical.

1297 No. 185E—Two litter-bearers, study for the fresco of Raising of Drusiana (p. 106). Sp.
Fig. 226 height. with wh. on pinkish tinted paper. 19.5 by 24. Braun 76271. [Uffizi Publ., IV, i, 20.
Scharf, fig. 183. Ede, pl. 38. Popham Cat., No. 47.]

1298 FLORENCE, Uffizi, No. 186^E—Study for Raising of Drusiana (p. 105). Pen on wh. paper. 26 by
37.5. Pl. LVI of F. E. [Fototeca 11885. Uffizi Publ., IV, i, 21. Scharf, fig. 184. Verso:
Fig. 225 Bl. ch. study for the Drusiana, and a column of Arabic numerals in ink (p. 105, note).
Fototeca 11003.]

1299 No. 195^E—Nude pushing with staff (pp. 105, 106). Sp. and wh. on pale tinted paper. 21
by 13. Braun 76129. [Scharf, fig. 177.]
Ascr. to Botticelli, but recognized by Morelli *(Kunstchr.)* as F.'s, and, as has been
said in the text, it is a study for a figure in the Martyrdom of St. John the Evangelist in
the Strozzi Chapel at S. Maria Novella.

1300 No. 202^E—Two witches stirring the magic cauldron (p. 339). Bistre, brownish wash and
much wh. 25.5 by 15.5. Braun 76131 (but a hundred shades too dark). [Uffizi Publ.,
IV, i, 23.]
Ascr. to Botticelli, but, as Morelli *(Kunstchr.)* recognized, indisputably by F. It is of
his Strozzi Chapel period. The figure to the r. here should be compared for the action
with the two muses to the r. of the window in that chapel. [Turns out to be for a Death
of Meleager in the Fenwick Collection, Cheltenham. See my 1277^C (Fig. 242) and *O. M. D.*
VIII (1933/34), pls. 35 and 36.]

1301 No. 204^E—Draped male figure seated, with sword erect in l. hand. Rough. Sp. and wh.
on greyish prep. paper. 19.5 by 11.

1302 No. 205^E—Three draped male figures, of inferior quality and poor condition, but probably
F.'s. Sp. and wh. on purplish grey prep. ground. 19.5 by 20.

1303 No. 206^E—Hasty sketch of draped male figure seated on a stool. Sp. on greyish prep.
paper. 19.5 by 10.5.

1303^A (former 45) No. 210^E—Study for oblong Epiphany (p. 336). Pen and wash height. with wh. on
Fig. 239 yellowish paper. 10.5 by 35.5. Pl. LI of F. E. Brogi 1613. [Van Marle, XII, p. 262.
Scharf, fig. 143.]

1304 No. 226^E—Charming study for Nativity. The Madonna kneels in the foreground, almost
Fig. 243 facing us, adoring the Child. To r. St. Joseph asleep, and to l. two angels. Background,
a ruin and a shed. Sp. on greyish tinted paper. 22.5 by 17. Braun 76281. [Scharf, fig. 164.]
Handling free, but delicate. Delightful feeling. From F.'s later years. Verso: Portrait
Fig. 234 bust of a somewhat timid, large-eyed youth. [Fototeca 11004.]

1305 No. 227^E—Mystical representation of Christ on the cross, wearing His seamless coat and
triple tiara. The cross is upheld by two angels, and at its foot stands a chalice. The
Baptist and another saint kneeling (p. 120). Pen and wash on wh. paper. 20 by 23.
Braun 76213. [Scharf, fig. 198.]
Ascr. to Piero di Cosimo, this charming drawing has been correctly attributed by
Morelli *(Kunstchr.)* to F. The angels should be compared with those in monochrome over
the tomb in the Strozzi Chapel. The study is enclosed in a frame by F. also, and the
whole may have served for an altar-piece to be painted for Lucca, where the Saviour was
frequently represented as He is here [and known as the "Sacro Volto," the "Saint Voult"
of King William Rufus' favourite oath.]

1306 No. 249^E—King David as Psalmist: rough and effaced, but masterly. Sp. and wh. on pale
brownish paper. [Fototeca 11005. Verso: St. Dominic blessing and a study of drapery.
Same medium on blue ground.]

145

19

1307 FLORENCE, Uffizi, No. 299ᴱ—Draped male figure seated in profile to r. Sp. and wh. on orange-brown prep. paper. 18.5 by 11. [Fototeca 11006.] Same model as seated person in the Malcolm sketch (my 1347) of two draped figures. Early. This and the three following are ascribed to David Ghirlandajo.

1308 No. 300ᴱ—Draped figure seated, asleep. 16 by 10.5. [Fototeca 11007.] Same quality of technique and materials as last.

1309 No. 301ᴱ—Youngish man seated in profile to l., leaning forward with chin in r. hand. Same as last. 16 by 10.5. [Fototeca 11008.]

1310 No. 302ᴱ—Youth heavily draped, leans forward in profile to l., and looks up sentimentally, while supporting his chin on r. hand. Same as last. 18 by 11. [Fototeca 11009. Nothing could be more characteristically F.'s.

1311 No. 303ᴱ—Youthful figure with staff in hand, in attitude of falling out for fencing, but possibly for Strozzi Chapel. Sp. height. with wh. on pinkish tinted paper. 18 by 12. [Fototeca 11010.] Excellent in action, vigorous touch, altogether one of F.'s best.

1311ᴬ No. 327ᴱ—Figure in cloak and hood seated looking to r. with hand on book. Bistre and wh. on grey-green prep. paper. Cut out and pasted onto blue ground. 20 by 10.5. Fototeca 12628.

1311ᴮ (former 809) No. 353ᴱ—Six or seven horsemen—perhaps in connection with an Adoration of Magi. Pen. 29 by 14. [Uffizi Publ., IV, i, 10. Fototeca 12633. I used to ascribe this spirited sketch to David Ghirlandajo for reasons which now escape me.]

1312 No. 501ᴼ—Winged lion with paw resting on helmet. [To his r. appears part of circular window with winged *putto* clinging to its side.] Sp. height. with wh. on wh. paper. 18.5 by 14.5. [Fototeca 11016.]

1313 No. 1151ᴱ—Study [for head of apostle in F.'s fresco of the Assumption at S. Maria sopra Minerva Rome, or, but less likely] of the king kneeling with vase in hand in the Uffizi Epiphany (pp. 104, note; 105). Sp. and wh. on purplish-grey prep. ground. Circular, diameter 11. [Fototeca 11011. Scharf, fig. 169, and *Jahrb. Pr. K. S.*, 1931, p. 206.] Ascr. to Botticelli.

1313ᴬ (former 47) No. 1153ᴱ—Head of woman. Study perhaps for Madonna in a Nativity (p. 336). Sp. and
Fig. 232 wh. on pink paper. 24.5 by 18. Alinari 223. [Photo. Mannelli.] Pl. 254 of Schönbrunner & Meder. [A fairly early work.]

1313ᴮ (former 48) No. 1156ᴱ—Head of young woman (p. 336). Sp. and wh. on pinkish paper. 21 by 17.
Fig. 233 Alinari 231. Brogi 1830. Pl. 248 of Schönbrunner & Meder. [Rather early, and companion to my 1313ᴬ (Fig. 232).]

1314 No. 1164ᴱ—Seated female figure to l. with arms extended and the bust of a young person. Sp. and wh. on greyish paper. 16.5 by 14. [Fototeca 11012. Scharf, fig. 192.]

1315 No. 1168ᴱ—Europa. Bl. ch. height. with wh. on wh. paper. 14 by 15.5. Pl. LIX of F. E. [Popham Cat., No. 49.] More interesting than excellent. Cf. much earlier reclining figure in Abrosiana. Late.

1316 No. 1169ᴱ—In a niche St. Martin on horseback divides his cloak with a naked beggar. Under the niche, two squatting tritons hold up the arms of Tanai di Nerli. Pen and wash, on wh. paper. 39 by 8. [Uffizi Publ., IV, i, 13. Scharf, fig. 165.]
 The shape of the composition and the Nerli arms make it, to say the least, highly

probable that the study in question was intended for stained glass to fill the window in Tanai's Chapel, above F.'s picture, in S. Spirito. The forms are most characteristic, and the pen-stroke is certainly F.'s. Nevertheless, Morelli was at great pains to tell us that this is a typical drawing by Raffaellino del Garbo (*Galerie zu Berlin,* p. 16, note). Yet the tritons are almost identical with those in my 1322 which Morelli *(Kunstchr.)* accepts as F.'s. Years after writing the above I came across the following passage in " Antonio Billi," which must put an end to controversy on this point. Speaking of F. he says: "Fecie una tauola a Tanai de Nerli in Santo Spirito et il disegnio della finestra di uetro di Santo Martino." (*Il Libro di Antonio Billi,* ed. Frey, Berlin, 1892, p. 50.)

1317 FLORENCE, UFFIZI, No. 1170E—Chariot of Phaeton. Sp. and wh. on pinkish prep. paper. 16.5 by 16. [Uffizi Publ., IV, i, 14. Scharf, fig. 189.] Dainty and charming drawing.

1318 No. 1253E—One man standing and another kneeling beside him (p. 106). Sp. height.
Fig. 228 with wh. on purplish-grey prep. paper. 29 by 24. Brogi 1477. [Ede, pl. 40. Scharf, fig. 153.] Fine early drawing of the period of the Corsini tondo, and the Lucca altar-piece.

1319 No. 1255E—Bust of Minerva holding shield in hand (p. 120). Sp. and wh. on paper tinted
Fig. 250 greyish green. 25 by 20. [Fototeca 11014.] A masterly sketch and the white used with great pictorial effect and the pen-stroke having almost Leonardo's freedom. Dates from F.'s Roman period, and is the type on which Raffaellino formed his style. [See, for instance, the St. Catherine in my 768 (Fig. 259).]
Verso: Outline sketch after antique bas-relief, and of a harpy.

1320 No. 1256E—Woman sewing. Sp. on greyish tinted paper. 13 by 18. Brogi 1500. [Scharf, fig. 194.] Latish but pleasant and authentic.

1320A (former 1380) No. 1257E—Delightful design representing Cupid playing with the arms of sleeping warrior, and the same knight uncovering a sleeping nymph. Pen and bistre. 16 by 37. Brogi 1473. [Scharf, fig. 185. Uffizi Publ., IV, i, 1, as Piero di Cosimo. No doubt it was done under Piero di Cosimo's influence, for if F. was the stronger he nevertheless was affected by the other.]

1321 No. 1258E—Draped figure, staff in hand. Sp. height. with wh. on pinkish prep. paper.
Fig. 247 17 by 8.5. [Fototeca 11015. Scharf, fig. 193. Spirited and masterly.]

1321A (former 49) No. 1259E—Sketch for a Coronation (p. 337). Of later date than the lunette in the
Fig. 241 Marquess of Lothian's Collection repr. in my *Study and Criticism...,* I, opp. p. 52. Pen. 16 by 23. Alinari 57. Brogi 1474. [Fototeca 4769. Uffizi Publ., I, iii, 23. Van Marle, XII, p. 263.]

1322 No. 1630E—Two Tritons (p. 107). Pen and wash on wh. paper. Circular, 8 cm.
Fig. 237 Braun 76287. [Scharf, fig. 158.]

1323 No. 1631E—Two Mermen (p. 107). Exact companion to above. Braun 76286.

1324 No. 1632E—Sheet of arabesques, a child clinging to female nude, etc. (p. 107). Pen on wh. paper. 26 by 19.5. Braun 76290. [Scharf, fig. 157.]

1325 No. 1633E—Marine creatures, an arabesque (p. 107). Pen and wash. 17 by 10.5. Braun 76288. [Scharf, fig. 155.]

1326 No. 1634E—Arabesque (p. 107). Pen and wash. 18 by 12. Braun 76289. [Scharf, fig. 156.]

1326A (former 1331) No. 1635E—Arabesque (p. 107). Charming. Pen on wh. paper. 18.5 by 13.5. Braun 76292.

1326^B (former 1332) FLORENCE, Uffizi, No. 1636^E—Winged *putto* feeding swan; arabesque (p. 107). Pen on wh. paper. 20 by 10. Braun 76291. [Cf. Berlin allegory of Music (Scharf, fig. 109).]

1326^C (former 1333) No. 1637^E—Arabesque (p. 107). Braun 76293. Verso: Arabesque. Pen on wh. paper. 23.5 by 18.

1326^D No. 35^F—Male nude with round shoulders and arms folded over breast walking to r. (p. 344). Bistre and wh. on pink prep. paper. 20.5 by 7.5. Fototeca 13139. Inscribed in later hand on verso with the words "Agnolo di Donnino" but despite clumsy retouching still recognizable as F.'s. Robetta seems to have used this figure in his Baptism (John Walker in *Bulletin of the Fogg Art Museum,* March, 1933, where it is repr. p. 36).

1326^E No. 106^F—Two horsemen brandishing swords violently careering away from each other, and four footmen, one running and the others standing. Pen on brown paper. 16.5 by 29. Fototeca 4240. G. Bernardini, *Boll. d'A.,* 1910, p. 156.

 Catalogued as "in the manner of Pollajuolo," but a F. of 1480-1485. The horses are inspired by Leonardo, for which reason, no doubt, some connoisseur of centuries ago labelled this sheet "Leonardo." The three standing footmen are as clearly inspired by Perugino. It is not surprising that F. should have been influenced by both these elder and greater contemporaries.

1326^F (former 1292) No. 159^F—Head of young woman looking.to r. Sp. and wh. on pinkish prep. paper. Oval. 10 by 8. [Fototeca 13145.] A characteristic study by F. although ascr. to Botticelli.

1326^G (former 1293) No. 161^F—Head of youngish woman. Sp. on pinkish prep. ground. 8 by 8. [Fototeca 13146.] Like last, ascr. to Botticelli, but, like that, by F., although neither so characteristic nor so good.

1326^H No. 162^F—Stately draped male figure standing to l. Bistre wash and wh. on wh. paper. 22 by 7.5. Fototeca 12879. Cut out from a larger composition and poor but possibly for an Adoration. In kind and quality like my 1366^E.

1327 No. 166^F—Two female saints kneeling in profile to l. Sp. and wh. on purplish ground. 15 by 13. [Fototeca 10998.] Swift and pleasant.

1328 No. 167^F—Study for the Virgin supported by another woman, doubtless for Crucifixion. Sp. and wh. on grey ground. 20.5 by 14. [Fototeca 11000. Scharf, fig. 192. Verso: A reclining female torso, almost Pontormesque. Sp. and wh. Fototeca 12653.]

1329 No. 168^F—Young woman in attitude suggesting Virgin in an Annunciation. Sp. and wh. on buff ground. 20 by 14. Fototeca 11001.

1329^A (former 1294) No. 169^F—Laocoön while sacrificing seized by the serpents (p. 339, note). Pen and bistre wash on brownish paper. Pricked for transfer. Torn, and partly effaced. 32 by 25. [Fototeca 19517. Scharf, fig. 195.]

 The treatment here is highly interesting. The type and the architecture leave no doubt that F. drew this sketch while he was at work upon the Strozzi Chapel frescoes. The famous marble group was not yet discovered, so that we here have that rare and fascinating thing, antiquity as genuinely mirrored in the mind of a Quattrocentist, and revealed to us by the transfer of his visual conception to paper. Hence the singular resemblance in arrangement, and to some degree in spirit, between this and the Pompeian painting (now in the Naples Museum) of the same subject (discovered, of course, centuries afterwards) is all the more suggestive. [P. Halm in *Mitt. des K. H. Inst. Florenz,* III, 1919/32, pp. 393 *et seq.,* reproduces this drawing and proves that it was for a fresco in the porch of the Medicean villa at Poggio a Cajano. Another study for the same, in the Koenigs Collection, Haarlem (my 1341^F), reproduced by A. Scharf, *ibid,* p. 531.]

148

1329B (former 1857A) FLORENCE, Uffizi, No. 173F—[Youthful female looking out somewhat archly with billowing draperies, standing to l. with kerchief fluttering from extended r. hand, and l. holding up skirt.] Bistre and wh. on washed ground. 22 by 10. [Uffizi Publ., IV, i, 17.

 A drawing in Berlin (my 1268) has nearly the same pattern but is tamer both in touch and in spirit. In my first edition, I, p. 129, note, I ascribed this one to Piero di Cosimo and called it a "most vivacious drawing done with mastery and joy."]

1329C No. 177F—Sketch for angel of Annunciation kneeling to r. Pen. 9 by 7. Fototeca 13147. F.'s despite superficial resemblances to any of the three or four Ghirlandajos.

1330 No. 178F—Head of youngish woman. Sp. and wh. on greyish ground. In oval, 9 by 7.5. [Fototeca 11002.] Like my 1326G only better.

1331 (see 1326A)

1332 (see 1326B)

1333 (see 1326C)

1333A (former 1381) No. 617O—Symbolical representations of Force and Temperance. Pen and bistre wash. 18 by 23. Verso: Symbols of four evangelists [arranged in one almost Cellinesque design, and crowned seated figure holding circle framing an open book in her hands, and her feet on prostrate figure labelled *Serdanapallo*. Fototeca 13150 and 13151. F.'s brain and hand and not a follower's.]

1333B Uffizi, Santarelli, No. 183—Four agitated male figures heavily draped. In background a figure kneeling close to a sarcophagus and to r. vague indications of curving many-storied building, the Coliseum, no doubt (p. 104, note). Pen on wh. paper. 16.5 by 14.5. Fototeca 13148. Idea perhaps for apostles on l. in Assumption of Virgin at S. Maria sopra Minerva, Rome, cf. my 1382, 1383A.

1334-1341 (see 1322-1326C)

1341A (former 38) FRANKFURT A/MAIN, Städel Museum, No. 418—Young man seated [and above his extended r. arm the palm of an open hand (p. 337). Evidently fragment of a sheet of drawing.] Sp. height. with wh. on grey prep. paper. 17 by 10.5. [Städel Dr., XV, 5. It used to be ascribed to Ghirlandajo, which fact may have influenced me to the extent of attributing this sketch to Alunno di Domenico.]

1341B (former 51) Bust of young man. 18 by 16.5. Braun 65052. [Städel Dr., V, 3.]
 Fig. 248

1341C HAARLEM, Teyler Museum, No. 47—Heavily draped youth with staff in l. hand standing and looking down almost in profile to r., with a gesture of surprise. Bl. ch. and wh. on grey paper. 24 by 12. Photo. Museum.

1341D (former 1384) Koenigs Collection, No. 11—Two men, one seated somewhat to l., the other leaning over to l. with r. foot on stool and with chin in r. hand. Verso: Two heavily draped men in lively conversation. Sp. and wh. on grey paper. 24 by 20.

1341E No. 12—Various sketches for architecture and tiny figures in various groups, the most important for a Christ kneeling. Pen. 17 by 27. It is hazardous to attribute thumb-nail sketches like these. There is something almost Venetian about them, as if Bonifazio's or Paul Veronese's, but the architecture and the touch are F.'s.

1341F No. 13—Study for Laocoön. Compare my 1329A. Pen height. with wh. 29.5 by 24.5. Scharf, fig. 196 and *Mitt. des K. H. Inst. Florenz*, III, 1919/1932, pp. 530-533.

1341^G HAARLEM, KOENIGS COLLECTION, No. 489—Rapid sketch for Anthony Abbot turning slightly to r. Pen. 12.5 by 6. Late.

1341^H THE HAGUE, F. LUGT COLLECTION—Study for monk standing to r. with arms folded holding book. Sp. height. with wh. on red prep. paper, cut out and pasted on. 19.5 by 7. Boerner, Sale Cat., 9/10 May, 1930, No. 5.

1341^I Female figure in billowing draperies, in profile to l., carrying a branch or flower in r. hand. The attitude could be interpreted as that of an announcing angel, but otherwise she looks more like a muse, reminding one of the allegorical female figures in the Strozzi Chapel. Pen. 18 by 10.5. Verso: Draped female figure facing front, in the attitude of a Virgin Annunciate.

1341^J HAMBURG, KUNSTHALLE. Inv. 21275—Study for draped man striding towards l. Sp. and wh. on grape-purple ground. 20 by 13.5. Prestel Publ. H., pl. VI. Scharf, fig. 146.

1341^K LEIPZIG, MUSEUM—Head of clean-shaven elderly man looking down to r. Sp. and wh. on pink
Fig. 235 ground. 15 by 11.5. H. Voss, *Zeitschr. f. B. K.*, 1913, p. 229.

1342 LILLE, MUSÉE WICAR, No. 18—Study for a Madonna sitting stiffly, holding the Child with her l.
Fig. 244 hand and a small book in her r. Sp. and wh. on pink ground. 17 by 9. Braun 72020. Ascr. to Botticelli, but a characteristic sketch of F.'s last years.

1343 No. 290—Four crouching nudes, one of them holding a book from which he looks away (p. 106 and note). Sp. and wh. on grey tinted ground. 20 by 28. [Van Marle, XII, p. 367.] Evidently intended for such ceiling figures as the Patriarchs in the vaulting of the Strozzi Chapel.

1344 LONDON, BRITISH MUSEUM, 1860-6-16-75—Study for Triumph of Thomas Aquinas, fresco in the
Fig. 224 Minerva at Rome (p. 104). Pen and wash on wh. paper. 29 by 24. Pl. LV of F. E. [Anderson 18798. Scharf, fig. 159.]

1345 1858-7-24-4—Two nudes, one seated reading, the other standing; both in profile to l. Sp. height. with wh. on purplish-grey ground. 26 by 18.5.

1346 1860-6-16-64—Man in profile to l. in the act of striking. Sp. height. with wh. on purplish-grey ground. 24 by 17.5.

1347 BRITISH MUSEUM, MALCOLM, No. 18—Two draped figures, one bareheaded seated, the other standing turned away. Sp. height. with wh. on grey tinted ground. 28 by 21. Braun 65046. Verso: Slender youth with F.'s own face, and a man holding a book. [Photo. Macbeth.] With hands cf. those of Madonna in the Badia picture, as well as those in the Lucca altar-piece [(Van Marle, XII, opp. p. 302 and p. 299).]

1347^A BRITISH MUSEUM, FAWKENER (anonymous unmounted)—Female head in roundel. Sp. and wh. on mauve prep. ground. Diameter 7. Companion to my 1326^F, 1326^G, and 1330, all in the Uffizi.

1348 (see 1353^A)

1348^A MR. C. R. RUDOLF—Study for Christ in the Garden. The Magdalen prostrates herself in profile to r. at Our Lord's feet, He quite youthful. Sp. and wh. on coloured ground. 27 by 20. Scharf, fig. 154. Verso: Heavily draped young man with hands on long sword and youth
Fig. 253 stooping toward him with l. knee on a rectangular wooden object and in his r. hand a staff. Both repr. in Boerner's Sale Cat., May 12, 1930, pls. 28 and 29. Most characteristic of F.'s best years. Earlier and not connected with the Seminario picture.

1349 (see 1353^B)

1349^A (former 1367) LONDON, MR. C. R. RUDOLF—Christ supported on the tomb in arms of turbaned old man. To r. and to l. an angel. In the background rectangular rocks. Pen and bistre wash, pricked for transfer. 18 by 26.5. Pembroke Dr., 18. [Scharf, fig. 62. Oppenheimer Sale Cat., pl. 26.]

Sloppy and poor, but genuine. It is the cartoon for a pleasantly coloured little picture [that used to be] in the collection of the late Robert Benson [and now belongs to Mr. Frederic Houseman of New York (Scharf, fig. 63)]. Its next-of-kin among F.'s drawings is the so-called Circe at the Uffizi (my 1300), a late sketch by F. still ascribed to Botticelli. The technique of both is similar, they are equally slovenly as draughtsmanship, and share equally in a certain pictorial quality. The bl. ch. study for a Pietà (my 1290^A) has no connection with this one.

1350 (see 1366^I)

1350^A COLNAGHI & Co.—Triumphal car drawn by two men preceded by group of "Oriental horsemen," while others keep coming on in background. Pen and brown ink. 19 by 28. Pl. 8 of *Drawings by Old Masters*, Saville Gallery, London, 1930. Ascr. to Carpaccio no doubt because of the "Oriental horsemen" and the turbaned person, and certainly for no more compelling reason. In Colnaghi's *Cat. of an Exh. of Old Master Drawings*, Dec., 1935, it is repr. as No. 65 and ascr. to Lorenzo Costa.

1351 MILAN, AMBROSIANA—Study for head of old man in the Florence Adoration of the Magi (p. 105). Bistre and wash on dark tinted ground. 21 by 15. Braun 75101. [Scharf, fig. 170.]

1352 In Libro Resta—Reclining female figure. Pen height. with wh. on greenish-grey ground.
Fig. 246 14 by 19. Braun 75265.

Inscribed with Garbo's name, but certainly by F., and from his early middle period. [The pose alone (not the action or the expression) recalls a bas-relief of Europa in the Lanckoronski Colletion at Vienna.]

1353 SIG. GUSTAVO FRIZZONI (formerly)—Bust of old man, half nude. Sp. and wh. on buff ground. Small, circular.

1353^A (former 1348) NEWBURY, DONNINGTON PRIORY, GEOFFREY E. GATHORNE-HARDY—Study for Baroque
Fig. 229 top to a composition. I suspect a first thought, modified in the execution, for the top of the altar in the fresco of the Strozzi Chapel, representing St. Philip exorcizing (p. 106, note). Pen and bistre on wh. paper. 17 by 26.

1353^B (former 1349) NEW YORK, METROPOLITAN MUSEUM—St. Sebastian standing and a seated man reading. Excellent and characteristic, in style of the Malcolm and kindred sketches. Sp. height. with wh. on pinkish prep. paper. 24.5 by 21.5. [Popham Cat., No. 46. Oppenheimer Sale Cat., pl. 25. *Metr. Mus Bull.*, 1937, p. 7.]

1353^C (former 1272) MORGAN LIBRARY—Tondo with representation in foreground of king reclining half-naked by ruined hut, with two women and a man coming to address him. Pen. Diameter 10.5. [Morgan Dr., IV, 3. Scharf, fig. 178.] It would seem like Job and his consolers (cf. my 1355^A,5). In the background the Visitation. A charming dainty sketch in F.'s best manner.

1353^D Man in heavy mantle seated with face almost in profile looking down with hands clasped as if in mourning. Study perhaps for Pietà. Sp. and wh. on grey ground. 18 by 12.5. Morgan Dr., II, 72. Buffalo Exh. Cat., pl. 17. Verso: Youthful bishop (?) leaning back with staff in his l. hand. Morgan Dr., II, 73.

LIPPI (FILIPPINO)

1353^E NEW YORK, MORGAN LIBRARY—Study for heavily draped youthful martyr with palm in r. hand and book in l. looking to l. Angular draperies, but spirited. Sp. and wh. on grape-purple ground. 27 by 14. Morgan Dr., II, 74.

1354 OXFORD, CHRIST CHURCH, A. 12—Youth bending forward in profile to r. (p. 106, note). Sp. and wh. on pink prep. paper. 18 by 13. [Bell, pl. 60.] Study for one of litter-bearers in original sketch for the Raising of Drusiana, companion to my 1297 (Fig. 226).

1355 A. 13—Heavily draped, full-length youth, leaning over slightly to l. Early and excellent. Sp. and wh. on prep. grape-purple paper. 29 by 17. [Bell, pl. 61.]

1355^A Five drawings framed in by Vasari: (1) Tritons holding up trophies. Pen and brown wash. 8.5 by 10.5. Popham Cat., No. 45. Scharf, fig. 175. (2) One man fighting with a centauress and another carrying off a door. Same medium. 13.5 by 12. Popham Cat., No. 45. Scharf, fig. 175. (3) Battle between centaur, satyr, man, and woman. Same medium. 13.5 by 15.5. Popham Cat., No. 45. Scharf, fig. 175. (4) Virgin and Child with saints. Same medium. 28.5 by 19.5. Popham Cat., No. 45. Colvin, III, 3. Bell, pl. 63. Van Marle, XII, p. 364. Scharf, fig. 175. (5) Afflictions of Job. Pen and brown ink with corrections in body colour. 29.5 by 20.5. Popham Cat., No. 45. Colvin, III, 4. Bell, pl. 62. Van Marle, XII, p. 364. Scharf, fig. 175. All latish, the two sacred compositions being of the period of the S. Maria Novella frescoes. All of recto repr. by O. Kurz, *O. M. D.*, XLV (1937), pl. 7. The verso, which Kurz (*ibid.*, pl. 8) publishes as by F., is not Florentine.

1355^B Large Portfolio—Two sheets of sketches on one mount: (1) Four draped figures. (2) Two nude and two draped male figures. O. Kurz, *O. M. D.*, XLV (1937), pl. 6. Each sheet has been pieced together from two fragments. For the verso, which is by David Ghirlandajo, see under *Additions and Corrections*, my 853^A.

1356 (former 859^A) PARIS, LOUVRE, No. 1257—Two children's heads. Of excellent quality, and in type
Fig. 252 resembling those of the angels in the Corsini *tondo*. [Arch. Ph.] Sp. height. with wh. on pearly-grey ground. 19 by 26. Verso: Male nude holding staff.

1356^A No. 1253—Seated heavily draped young man. Ascr. Filippo. Very good. Sp. and wh. on grey ground. 18.5 by 13. [Alinari 1440. Van Marle, XII, p. 366.] Verso: Study of angel for an Annunciation.

1357 (former 859^B) No. 1254—Young man, sprawling on ground and hastier sketch for same. Sp. height. with wh. on grey ground. 20.5 by 17. [Arch. Ph.] Verso: Study of two horses.

1358 (former 859^C) No. 1255—Two young men seated, one playing the mandolin. Most typical. Sp. height. with wh. on grey ground. 19.5 by 18. [Arch. Ph.] Verso: Man seated at work.

1359 No. 2609—Study for more than half-length figure of St. Francis. Sp. and wh. on yellowish tinted ground. 20 by 13.5. Relatively early. Cf. the drawing of St. Francis in the Corsini Palace at Rome.

1359^A (former 52)—No. 2665—Head of youth looking down to l. (p. 337). Sp. and wh. on yellowish paper. 12 by 10. Verso: Draped female figure from waist down, walking to l. Pen. [Arch. Ph. Degenhart, *Münch. Jahrb.*, 1932, p. 144. Ascr. to Credi and superficially like him but essentially F.'s as indeed is sufficiently proved by the ear of the youth and the hand of the woman on the verso. Proportions and draperies are, by the way, decidedly Peruginesque.]

1359^B No. 2690—Man's head in profile to r. looking down slightly. Attr. to Florentine School, 15th century. Sp. and wh. on pinkish ground. 13.5 by 10.5. Arch. Ph.
Delicate and sensitive and probably a study from the life of Tanai de Nerli in the

S. Spirito altar-piece, perhaps the greatest work of F.'s mature years. The difference in the tilt of the head looking down rather than up may imply that the original idea for this altar-piece was that it should be a Nativity.

1360 PARIS, LOUVRE, No. 2697—Study for altar-piece representing Dead Christ in lap of His mother, with Anthony Abbot and Paul the Hermit (p. 107). Pen. 14 by 17. Scharf, fig. 174 and *Jahrb. Pr. K. S.*, 1931, p. 212.

This can scarcely be aught else than a sketch for an altar-piece which, on March 7, 1495, F. undertook to paint for the Certosa di Pavia, but never finished, leaving it at his death a mere sketch. See Vasari, III, p. 475, note 3, and IV, pp. 226, 227 notes. (Cf. my 1349ᴬ.)

1361 No. 9876—Mermaid gambolling with two *putti*. In the style of the Uffizi arabesques. Pen on wh. paper. 14 by 13. [Arch. Ph.]

1362 No. 432—Draped figure seated. Sp. height. with wh. on grape-purple paper. 20 by 11. [Arch. Ph.] Verso: Young man bending over to l. with head in hand. Both in style of Dresden and Malcolm studies.

1362ᴬ (former 54) No. 457 RF—Tobias and the angels (p. 336). Pen and wh. on pinkish ground. 17 by 22.
Fig. 240 Tattered and on l. incomplete. Pl. L of F. E. Braun 63017. [Van Marle, XII, p. 264. It is interesting to note the resemblances and the differences between the angel to r. and the one in the same position in Botticini's study for the Coronation at Stockholm (my 591ᴮ).]

1362ᴮ Nos. 63451 and 63452—Two studies each for an angel kneeling on a pedestal and holding a candelabra. Pen. Each 13 by 7. Arch. Ph. Rather feeble but autograph.[1]

1363 ÉCOLE DES BEAUX-ARTS, *His de la Salle Gift*—Two students in conversation. Same style my as 1362. Sp. and wh. on tinted ground. 25.5 by 21. Müntz, *Les Primitifs*, opp. p. 206. [Scharf, fig. 151.] Verso: Two figures of the same type as on recto.

1364 (see 859ᴷ)

1364ᴬ (former 1383) ROME, CORSINI, PRINT ROOM. Inv. 128403. [Study of youthful nude with l. hand on hip.] Sp. and wh. on pink prep. paper. 20.5 by 18. Anderson 21026. Verso: Venus
Fig. 254 draped, sailing on a swan. Pen. [Anderson 31343. [Early, close to Botticelli, contemporary with the Esther panels and both somewhat Peruginesque.]

1365 No. 130452—St. Francis hands his regulations to the tertiary order as represented by a kneeling king and a widow. Sp. and wh. on brownish tinted paper. 26 by 18.5. Anderson 2813. [Rusconi, *Emporium*, 1907, p. 273. Scharf, fig. 166.] Verso: Pen study of charming female head in style of the heads in the S. Angelo *tondo*, now at Cleveland. [Also in bl. ch. summary sketch of head and torso probably for a St. Sebastian.]

1366 No. 130485—Nude man bending down. Sp. height. with wh. on pinkish tinted paper. 14 by 11.5. Verso: Baptist pointing. Sp. on pink ground.

1366ᴬ STOCKHOLM, PRINT ROOM, Inv. 67 and 68—Nude looking down in profile to r. with his hands and entire action expressive of pity and surprise. Sp. and wh. on greyish-blue ground. 27 by 15. [Schönbrunner & Meder, 877 and 1171.] Verso: A bare-legged youth bending a pole.

Dr. Sirén, to whom I am indebted for my acquaintance with this and the following sheet, published them both in his *Déssins* as Garbo's [but has given them back to F. in

1. [Dr. Oskar Fischel in his *Raphaels Zeichnungen* (Berlin, 1924), V, pp. 227, 228, reproduces two hair-line drawings done after two of the patriarchs at S. Maria Novella. The touch seems Raphaelesque, and the sketches after the frescoes rather than after original drawings.]

20

his catalogue of 1917 (see p. 15).] They are beyond question drawings by F. The figures now before us might seem to have been done in connection with the Strozzi frescoes but their exact silhouettes are not to be found there and besides they must be of earlier date. The nude may have been intended for a spectator at the Fainting of the King's Son, and the youth with the pole for one of the attendants in the Martyrdom of the Evangelist.

1366ᴮ STOCKHOLM, Print Room, Inv. 76—Youthful Baptist, a delicately sentimental stripling, sits under
Fig. 256 a tree with his head in his hand, lost in reverie; in one of the branches of the tree an axe—a Byzantine motive. Sp. on greyish-blue ground. 26 by 18. [Pl. 868 of Schönbrunner & Meder.] This is one of F.'s most romantic early creations, and as draughtsmanship characteristic in every touch. Verso: Two powerful nudes, one of whom holds a cow by the tail [*ibid.*, pl. 1188].

1366ᶜ Inv. 2—Hercules and Nessus, and, inset below, centaur downing male nude, in presence of Herm with extended hand. Pen and wash. 28 by 28. Framed by Vasari. Scharf, fig. 190. The Hercules and Nessus reminiscent of Antonio Pollajuolo's painting of that subject now in the Jarves Collection, New Haven (Van Marle, XI, p. 363).

1366ᴰ Inv. 50—Youthful figure seated sewing, probably sketch of a tailor's apprentice. Sp. and wh. on buff ground. 18 by 14. Charming and autograph.

1366ᴱ Inv. 69—Two heavily draped figures, one seated, the other standing, both looking to l. Pen, bistre, and wh. on buff ground. 27 by 24. Ascr. to Verrocchio in Sirén's catalogue (p. 17) but F.'s and in kind and quality like my 1326ᴴ. Hatching of seated figure may have been added later.

1366ᶠ Inv. 83—Young monk in profile l. with hands folded in prayer. Sp. and wh. on pink
Fig. 251 prep. paper. 21 by 12.5. Decided and effective in its verticality. Rather early.

1366ᴳ Inv. 96—Two slender women walking, the one to r. turning toward the other, who appears in profile r. Pen. 11.5 by 6.5. Pl. 893 of Schönbrunner & Meder. Scharf, fig. 180. Fairly late, although still Botticellian in feeling and movement.

1366ᴴ TURIN, Royal Library, No. 15611—Athletic youth with legs wide apart, with arms stretched up
Fig. 255 and hands grasping and struggling with the shaft of a hoe that reaches down to the ground and moves the earth. Perhaps for an Adam. Below to r. a r. leg, fragment, no doubt, of another nude. Pen. 17.5 by 10. Anderson 9834. Probably a late work, and of the kind that might seem by Piero di Cosimo, like the impudent young woman in the Uffizi, my 1329ᴮ.

1366ᴵ (former 1350) [VIENNA, Albertina, Inv. 24413]—Draped young man seated to l. and back of l. hand on hip. Sp., pen and bistre height. with wh. on grey prep. paper. 19 by 12.5. [Albertina, N. F., II, pl. 38; Cat., III, No. 21. Verso: Vague indications for a head.]

1367 (see 1349ᴬ)

1368 WINDSOR, Royal Library—Madonna holding the Child to her knee; at one side a kneeling angel,
Fig. 257 and opposite, another with a lute. Pen on wh. paper. 14.5 by 18.5. Ascr. to Credi, but F.'s in the style of his various pen-sketches in the Uffizi. The structure, the types, the hands, and the hatching are clearly F.'s. It is inscribed "Filippo" in an almost contemporary hand.

1369 Shaggy head of smooth-faced man (p. 106, note). Braun 79251. Sp. and wh. on bluish-grey ground. 24.5 by 18.5. [Scharf, fig. 152.] Late. Verso: Folded hands.

School of Filippino Lippi

(Here I shall subjoin a few of the more interesting drawings which may be considered as either copies of lost originals or imitations.)

1369A BOSTON, Museum of Fine Arts—Youth seated on a stool in profile to r. pointing out with r. hand. Bistre, sp. and wh. on yellowish brown prep. paper. 22 by 17. Sotheby Sale, July 4, 1923, Cat., No. 9. Bull. of the Museum, 1936, p. 95. So close to Granacci that one would be tempted to attribute it to him, but for the fact of the typically Filippinesque thumb of the l. hand. Too smooth for F. himself and probably by a close follower.

1370 BRUNSWICK, Museum—Young man in profile to l. Sp. and wh. on buff tinted paper.

1371 CHANTILLY, Musée Condé—Venus, a female figure holding a lyre, and three other figures. Pen. 19.5 by 19.5. Braun 65020. Ascr. to Botticelli, but by a follower of F.'s later manner. [A. Warburg, *Botticellis Geburt der Venus und Frühling* (Hamburg, 1893), p. 14.]

1372 DRESDEN, Print Room—Sheet with a study of the Baptist on either side. Pen on brownish tinted paper.

1373 Copy after the figures to r. in F.'s Prato Tabernacle. Braun 67045. Attr. to Credi.

1374 FLORENCE, Uffizi,[1] No. 127E—Virgin adoring the Holy Child. Sp. and wh. on tinted ground. [Inked by later hand.] 17 by 19. Braun 76267. [Fototeca 10991.] Rather charming. By an imitator active early in the sixteenth century.

1375 (see 782)

1376 (see 1290A)

1377 No. 176O—Study of arabesques. Copy. Bistre on wh. paper. 23 by 13.5.

1378 No. 200E—Angel of Annunciation. Sp. height. with wh. on pinkish ground. 23.5 by 14. Braun 76133. [Van Marle, XII, p. 193.] Ascr. to Botticelli, but obviously by a close follower of F. Cf. the angel on the l. in the Vision of St. Bernard, the angels in the Uffizi altar-piece, and particularly the Gabriel in the Minerva Annunciation.

1379 (see 794C)

1380 (see 1320A)

1381 (see 1333A)

1382 No. 174F—Faithful studio copy after the finished study for the l. part of the Assumption at the Minerva, Rome, for which my 1333B is perhaps an earlier idea (p. 104, note). Pen on paper washed with wh. 28.5 by 19. Hatching by later hand. As the painting is made over, this copy has value as a transcript of the original. Note that all the apostles here have their names in the haloes and that the sarcophagus is adorned with bas reliefs.

1382A OXFORD, Christ Church, A. 14—Elaborate study for Moses striking the Rock. Bistre and pen Fig. 258 touched up with wh. on stone-coloured paper. 27.5 by 40.5. Exact contemporary copy of more advanced although not quite final scheme for central group in the Samuelson *cassone* front. See my 1272A, where an earlier stage of same composition is mentioned.

1. All attributed, unless otherwise stated, to F. himself.

1382[B] PARIS, Louvre, No. 1256—Study for dog catching a hare. Sp. gone over with ink. 7 by 17.5. Arch. Ph. (See my 2779[E] for other drawing on same mount.)

1382[C] No. 9877—Study of nude from the Apollo Belvedere. Sp. and wh. on grey prep. paper. 18 by 10. Suggests David Ghirlandajo but the hatching is like F.

1382[D] Mr. Walter Gay—Man in hooded cloak seated in profile to l. Bistre and wh. 26 by 16.

1383 (see 1364[A])

1383[A] SIENA, Pinacoteca, No. 138—Contemporary copy of advanced but not final study for the Assumption in the Minerva, Rome (Scharf, pls. 48, 49). Bistre and wash. 25 by 43. Publ. and repr. by C. Brandi in *Burl. Mag.*, LXVII (1935), p. 31. May be by same hand but in rougher phase, nearer to Antonio and Giuliano da San Gallo, and perhaps from same sketch-book as my 1382[A] (Fig. 258). An earlier idea for the Assumption is possibly contained in F.'s original drawing, my 1333[B].

1384 (see 1341[D])

Fra Filippo Lippi (pp. 80-84)

1384[A] CAMBRIDGE, Fogg Museum, 1936, 118—Youngish woman looking down a little to l. with r. hand
Fig. 170 held up and l. on hip, with mantle slipped under waist but leaving feet and lower legs bare. On our l. a sarcophagus (p. 84). Pen, height. with wh. on bluish green paper. 25 by 11. Popham Cat., No. 27. Oppenheimer Sale Cat., pl. 28. A characteristic work of about 1440, still Gothic in action like the Virgin in the S. Lorenzo Annunciation (Van Marle, X, p. 411) but more like the Corneto and Louvre Madonnas in type (*ibid.*, pp. 409, 417). There is no clue to the purpose of this sketch.

1385 FLORENCE, Archives, Mediceo innanzi il principato, filza VI., c. 258—Letter of F. L. dated
Fig. 166 July 20, 1457, and addressed to Giovanni di Cosimo de' Medici. At the bottom, sketch for a triptych (pp. 81, 82, 84). Pen. 23.5 by 21, being size of entire sheet. Pl. xxxiii of F. E. [Fototeca 13510. *O. M. D.*, VII (1932/33), pl. 23.]

1385[A] Pitti, No. 343—On back of *tondo* painting of Madonna (Van Marle, X, p. 429): Shield with griphon in profile l. holding staff in claws (p. 83). Bl. lead, perhaps, on fresco ground. 1.31 is diameter of roundel. Repr. in *Rass. d'A.*, 1908, p. 44, by Giovanni Poggi, who first published it. Fototeca 5219.

1385[B] Uffizi, No. 1598—On back of painting of Madonna and Angels (Van Marle, X, opp. p. 430):
Fig. 172 Head and bust of woman in early middle years, nearly in profile. Perhaps the indication of a niche and an oval opening in a wall (p. 83). Probably bl. lead on gesso ground. Head and bust only measure 42 cm. in height. Fototeca 14106.

1385[C] Museo Mediceo, Palazzo Riccardi—On back of Madonna from Castel Pulci painted about 1442 (*Boll. d'A.*, 1932/33, p. 55): Colossal head of saint looking slightly to r. wistfully, almost tearfully (p. 83). With brush and perhaps some bistre preparation. Head alone 52 by 37. Alinari 20466. Poggi, who first published and reproduced it (*Rass. d'A.*, 1908, p. 44), takes it for a Jerome in penitence. The colossal size would speak for its having been a study for a fresco to be seen at a considerable height.

1386 HAMBURG, Kunsthalle, No. 21239—Sketch for the fresco at Prato representing Stephen exorcising
Fig. 168 a demon (p. 82). Pen and bistre wash height. with wh. on purplish prep. ground. 33 by 22.5. Pl. xxxiv of F. E. [Prestel Publ., pl. 3.]

1387 LONDON, British Museum, Malcolm, No. 6—Study for Virgin in Crucifixion (pp. 82, 85). Sp. height.
Fig. 169 with wh., on light minium red prep. ground. Pl. xxxv of F. E. Braun 65013. [Vasari
Soc., II, v, 2; Van Marle, X, p. 458.] Morelli (*Kunstchr.*) regarded this masterpiece as a
forgery. This judgement can be accounted for when we bear in mind that it was based not
on the original but on a hasty glance at the poor reproduction of Braun. Among F. L.'s
paintings now existing there is no figure which may be brought into connection with
this drawing.
Verso: [See my 747 (Fig. 174).]

1387A OPPENHEIMER COLLECTION (formerly)—Sketch for Crucifixion (p. 83). The cross is planted
Fig. 167 in a small mound on which the Magdalen stoops to kiss the feet of the Saviour. Below,
His mother lies fainting on the ground in the midst of her women friends while Jerome
kneels to one side and Francis to the other. Just above them stand two male figures.
Pen on pink prep. paper. 13.5 by 12. Sale catalogue of Wm. Bateson Coll., Sotheby,
April 23, 1929, No. 44. *O. M. D.,* VII (1932/33), pl. 21. Oppenheimer Sale Cat., pl. 27.
This may have been a study for a circular composition worthy of F. L. and so close to him
that one may venture to ascribe it to him.

1387B OXFORD, Ashmolean Museum—Study for drapery of figure seen from back turning slightly to l.
Sp. and bistre wash height. with. wh. on pinkish ground. 18 by 10. Vasari Soc., II, xi, 2,
where it was first published by W. K.
It corresponds to the drapery on the back of a woman, seen second to our l. in the
Berlin panel representing the Infancy of Ambrose which formed part of the predella to
F. L.'s S. Ambrogio Coronation now in the Uffizi (*Jahrb. Pr. K. S.,* 1907, opp. p. 34).
I am not convinced that it is by the master himself. It is perhaps too fluid, too elegant,
more like the achievement of a highly accomplished copyist. But when in doubt it is
always safer and more furthering to accept than to reject. Other sketches related to the
same panel are my 1387D and 1390A.

1387C RENNES, Museum, Case 3, No. 1—Kneeling figure in profile r. with arm held out as if to make an
offering (p. 84). Bl. ch. height. with wh. on buff ground. The back and arm highly finished.
16 by 15. *O. M. D.,* VII (1932/33), pl. 26. Early. Probably for a king in an Epiphany.

School of Fra Filippo Lippi (p. 84)

1387D BERLIN, Print Room, No. 5081—Woman kneeling in profile to l. with r. arm extended. Sp. and
wh. on greenish grey prep. paper cut down to dimension of figure. 17 by 14.5. Repr.
opp. p. 36 of *Jahrb. Pr. K. S.,* 1907, where it was published by Frida Schottmüller. She
identifies the woman with the one on the r. in the Berlin S. Ambrose panel (repr. *ibid.,*
opp. p. 34), for which Dr. Schottmüller believes this to be the original study. I cannot
follow her. The head is not Filippesque, the figure lacks bulk, the drapery over l. arm
looks concave where it should be convex. It is more likely a copy, but seems inferior
to the Oxford (my 1387B) and even the Windsor (my 1390A, Fig. 171) sketches connected
with this predella.

1387E NEBEHAY COLLECTION (formerly)—Kneeling deacon in profile to l. with hands folded over
stomach. Pen and ink. 20 by 13. Verso: The same figure seen from behind but standing,
with head in less than profile and slightly bent to l. Repr. as 143 and 144 in pt. IV of *Die
Zeichnung,* Kunsthandlung Nebehay. Attributed to Pesellino but in the reproduction—I
am not acquainted with the original—these two figures look like later copies after F. L.'s
originals dating about 1445.

1387^F DÜSSELDORF, ACADEMY, PRINT ROOM, No. 2—Head corresponding to that of Magdalen in S. Ambrogio Coronation (Van Marle, X, p. 425). Brown wash and wh. on purplish ground. 10 by 11. Düsseldorf Cat., pl. 1. I used to think this was an autograph by F. L., but it now seems at once too uncertain in line and too hard in modelling. Probably copy after the painting by a slightly later hand.

1387^G No. 3—Announcing angel kneeling on l. knee in profile to r. with r. hand held close to breast, and l. holding a stem (p. 84). Bistre height. with wh. on brown prep. paper. 23.5 by 19.5. *O. M. D.*, VII (1932/33), pl. 25.

1388 (see 744^A)

1389 FLORENCE, UFFIZI, No. 191^E—Pretty copy after head of F. L.'s Pitti Madonna [Van Marle, X, pp. 429, 431]. Sp., bistre and wh. 30.5 by 20.5. Alinari 103. Ascr. to F. L. himself.

1390 (former 1391) No. 180^F—Study for Annunciation, by some follower of F. L.'s earlier manner (p. 86). Pen. 11 by 17.5. [Fototeca 12657. *O. M. D.*, VII (1932/33), pl. 24.] Verso: Cupid flying with arrow in hand.

1390^A WINDSOR, ROYAL LIBRARY, No. 12753—Study for cast of drapery to cover belly and thighs, and a
Fig. 171 l. hand and arm going with them. Woman seated in profile to r. leaning with folded arms on a parapet (p. 84). Sp. and bistre height. with wh. on pinkish ground. 20 by 20. *O. M. D.*, VII (1932/22), pl. 27. See *Amtl. Ber.*, 1911/12, p. 174, where it was first published by Oskar Fischel.

This scholar rightly identified the woman with the one leaning over the bed in the Berlin Infancy of Ambrose, which he reproduces; and the cast of drapery is for the Baptist in the S. Ambrogio Coronation, to which the Berlin panel formed part of the predella. Fischel's conclusion that the presence of these two studies on the same drawing speaks for their being connected with the same work, and that the Berlin panel must therefore have formed part of the predella to the Coronation is final whatever one may think of the authorship of the sketch. Fischel ascribes it to F. L. himself, and it is not sure that one could dispute him along the line of quality alone. The quality is admirable but does not seem quite F. L.'s. There is too much precision as well as elaboration in the folds. The head of the woman is too long for F. L., and her volume less massive than one expects from him. The way the hand of the Baptist is jotted down does not answer either. And besides, why should the creator of an altar-piece with scores of figures in the central panel and as many more at least in the predella have studied in the same drawing the drapery of just these two figures, one from the main work and the other from the predella? It is more likely that another artist—and the author of this sketch was an artist—took a fancy to these draperies and noted them down in his own more elegant, more fluent, and at the same time more miniaturelike style. It does not seem to be by the hand that did the Oxford sketch, my 1387^B, but were I convinced that it was, I for one would rather reject than accept both as F. L.'s.

1391 (see 1390)

Lorenzo Monaco (p. 324)

1391^A FLORENCE, UFFIZI, No. 11^E—Six saints in every probability, as pointed out by Dr. Sirén (see his *L. M.*), for the dexter wing of an altar-piece, like the one now in the London N. G. (No. 215, Van Marle, IX, p. 171). Pen on pinkish paper. 24.5 by 17.5. Van Marle, IX, p. 169. Ali-
Fig. 3 nari 325. Verso: Study for St. Benedict enthroned—a free and masterly sketch.

1391^B No. 179—Study for Madonna in Epiphany. Pen on wh. paper. 10.5 by 6.5.

1391^C No. 180—Study for Madonna in Epiphany. Pen on wh. paper. 10.5 by 6.5. This and 1391^B first ascribed by Sirén to Lorenzo (see his *L. M.*).

School of Lorenzo Monaco

1391^D CAMBRIDGE (Mass.), FOGG MUSEUM, 1936, 116—Incidents of pilgrimage. Dated 1417 but drawn perhaps a little later. Pen and water-colour on vellum. 25.5 by 13.5. Popham Cat., No. 11. Oppenheimer Sale Cat., pl. 1. Close to Rossello di Jacopo Franchi, yet probably not Florentine but rather Bolognese.

1391^E FLORENCE, UFFIZI, No. 19^E—Two studies for St. Jerome before his desk. Pen, bistre and touches of wh. on pink prep. paper. 19.5 by 11.5. Braun 76230.

1391^F LONDON, OPPENHEIMER COLLECTION (formerly), No. 420—Two scenes from legend of sainted hermit. Pen and water-colour on vellum. 24 by 13.5. Popham Cat., No. 12. K. Clark, *Burl. Mag.*, LVI (1930), p. 177. This, 1391^{F-1}, and 1391^{F-2} are not necessarily by the same hand as 1391^D, but of the same school and date and therefore quite likely parts of the same scroll.

3191^{F-1} . . . A friar approaching the shore in a vessel, a friar kneeling before a sarcophagus, and view of a walled town. Pen and water-colour on vellum. 12 by 12. Probably incidents of pilgrimage forming part of the same scroll and by the same hand as my 1391^D and 1391^{F-2}.

1391^{F-2} . . . MUNICH, JACQUES ROSENTHAL COLLECTION (formerly)—Various incidents of pilgrimage: the reception of a friar by the Sultan of Jerusalem inside the walls of the city, underneath the capture of a friar on the seashore and still lower down a stormy sea, and an angel saving a vessel and three drowning pilgrims from the devil. Pen and water-colour on vellum. Probably part of the same scroll as 1391^D and 1391^{F-1}, and by the same hand.

Maestro del Bambino Vispo (p. 327)

1391^G BERLIN, PRINT ROOM, No. 5149—Fragment of study for Flagellation (p. 327). Pen on wh. paper.
Fig. 12 20.5 by 12. Van Marle, IX, p. 27, as Bicci di Lorenzo, to whom it was given by Sirén. See his *L. M.*, p. 176, note.

1391^H DÜSSELDORF, ACADEMY, No. 1—Leaf with four seated figures on each side (p. 327). Recto: Prophet pointing to r. Girl playing on harp. Below, two personages in ample draperies like doctors of law. Bistre wash, height. with wh. on blue-grey paper. 28.5 by 20. Düsseldorf Cat., pl. I. Verso: Madonna of Humility, and three apostles or prophets.

1391^I PARIS, LOUVRE, No. 9834—Evangelist seated on clouds writing in book (p. 327). Bistre and wh.
Fig. 13 on brown paper. 25.5 by 17.5. Arch. Ph. Verso: Traces of writing and attribution to Raphael.

1391^J STOCKHOLM, PRINT ROOM—Thick-set young man seated low at desk reading. Bistre and wh. on
Fig. 15 purple ground. 15 by 14. Photo. Museum. Attributed to Spinello but far more likely by the M. D. B. V. as we find him in the younger shepherd of a Nativity in the Von Zur Mühlen Collection.

1391^K VIENNA, ALBERTINA, Inv. 9—Madonna with donor and female figure (p. 327). Pen on parchment. 17.5 by 23.5. Repr. *Jahrb. Pr. K. S.*, 1906, p. 221, by Dr. Sirén, who at that time identified this painter with Pietro di Domenico da Montepulciano.

Maestro di San Miniato (pp. 101-102)

1391^L FLORENCE, UFFIZI, No. 42^F—On the same sheet four stories from the legends of female saints
Fig. 221 (p. 102; our reproduction shows only one of the scenes). Sp. and wh. on pink prep. paper. 20.5 by 28. Photo. S. I. Uffizi Publ., IV, iv, 1.

Bastiano Mainardi (p. 136)

1391M (former 1395) BAYONNE, Bonnat Museum—Study for Abundance: female figures carrying a horn of plenty, in profile to l., walking. Sp. and wh. on pinkish paper. 20 by 13. Braun 65022. [Photo. Bulloz. Bonnat Publ., 1925, 5. Venturi, *Studi*, p. 72.] Ascr. to Ghirlandajo, but the feebleness of the execution, the niggling draperies, and the carriage, point clearly to M.

1392 FLORENCE, Uffizi, No. 288E—Two children's heads for the *tondo* in the Louvre (p. 136). Sp. and
Fig. 326 wh. on orange-red prep. paper. 17 by 25.5. Pl. LXXI of F. E. [Brogi 1758. Van Marle, XIII, p. 229, but reversed.] Verso: Head of *Ecce Homo*. Fototeca 13036 and 13037. Brogi 1759. Both ascr. to Ghirlandajo.

1393 No. 316E—Study for drapery of kneeling figure. Sp. and wh. on pinkish prep. paper.
Fig. 328 25 by 18.5. Brogi 1756. [Fototeca 12627.] Ascr. to Ghirlandajo, for whom it is too feeble. A comparison with M.'s draperies, particularly with the fresco of the Assumption in the Baroncelli Chapel at S. Croce, leads to the conclusion that this sketch is by him. [Hatching same here as in my 1392 (Fig. 326).]

1393A 18F—Study for head of child turned slightly to r. Sp. and wh. on pink prep. paper. 13.5 by 10.5.

1394 PARIS, Louvre, No. 9864—Study for head of child looking to r. Sp. and wh. on tinted ground.
Fig. 327 13.5 by 9.5. Braun 62509. Arch. Ph. More probably by Mainardi than any other of Domenico's followers.

1395 (see 1391M)

Preface to Michelangelo Catalogue

[In the study of Michelangelo's drawings, every difficulty mentioned in the general preface is accentuated and magnified. With Michelangelo draughtsmanship became an instrument which until not long ago satisfied every European artist who took an interest in the nude. In the beginning and for some decades and even generations, he was imitated consciously. Then he was followed unconsciously in the way, for instance, that until about 1850 all architects of the Western world followed Bramante, Vignola, and Palladio.

If, therefore, we wished to ascertain whether a given sketch attributed to Michelangelo is or is not an autograph, we should have to know the drawings of hundreds upon hundreds of conscious imitators in all countries, and then of the thousands of unconscious followers, down to Delacroix and J. F. Millet and Degas, not to speak of artists of the nineteenth century who deliberately went back to Michelangelo, like the English Stevens, for instance. It is a task beyond anyone's individual strength.

Until this is achieved, it is inevitable that few drawings so widely and admirably imitated as those here catalogued as autographs by Michelangelo should pass unquestioned. Allowing that some of the questionings are due to insufficient preparation on the part of the questioner and others to his self-assertiveness, it does remain distressingly difficult to distinguish between an autograph, a good copy, or an even better imitation. Considerations of quality come into play as nowhere else. Not the line alone counts, but the modelling and both with differing techniques, and with varying purposes as, for instance, the kind of pen, the kind of chalk, whether a thoughtless jotting, an anxious note, a thought-out sketch, or an elaborated drawing. There is even less to help one's feeling than in the mature paintings of a Velasquez. For in those glorious masterpieces we have brushwork, we have colour, we have the possibility of helpful photographs. No reproductions of Michelangelo's drawings are good enough to allow of an opinion about the quality of their originals.[1] The difficulties regarding the attribution of Michelangelo's drawings are equalled, if not surpassed, by the difficulties of dating them, for as is told in the general preface, and retold again and

1. Among the less trustworthy are the reproductions in Frey's indispensable work on Michelangelo. Unfortunately, most German writers since the appearance of that publication have, to an extent that they are themselves unaware of, based their judgements on his plates. While I am about it, let me add that I must warn them that Frey in his text seldom quotes me correctly and often misquotes me.

again in the Catalogue, the differences in type of nude, in pose and movement, in technique and habits and tricks of notation vary so little in the first fifty years of his long career that one is at a loss where to place the drawings and there is no little disagreement amongst students. To give but a few flagrant examples: the Triton in the Villa Michelangelo at Settignano is put by some at the very beginning of Michelangelo's activity, while to others it seems twenty-five years later at least. It is hard to decide whether a pen-sketch like my 1398 is for the Bathers, the Last Judgement, or the Expulsion from the Temple; whether my 1402-3, 1414-15, and 1573 (Fig. 718) are for the last-named composition or for the Brazen Serpent, or possibly even for the Bathers; whether my 1556 and 1558 (Figs. 591, 592) are for the Bathers or for the Medici Chapel; whether my 1572B is for the Bathers again or for the Last Judgement; whether my 1399B is for the Bathers or for a decorative nude on the Ceiling. If for the latter it is singularly like in everything except technique to my 1513, which is almost certainly for the Last Judgement. And yet, rough as 1513 is, far rougher still is the first jotting down of the entire foreground of the Bathers (my 1397C, Fig. 585). It was this roughness, indeed, which led me, when preparing the first edition of this book into doubting that it could be a relatively early work, and to supposing that it must be a copy by an imitator of Michelangelo's last manner.

One could go on multiplying instances of the kind I have been citing. Enough has been presented to give a fair sense of how far we still are from being able to date Michelangelo's drawings.

Happily, our plight is not unique. There is no branch of research which is not beset by similar doubt and temporary helplessness. We need not despair. If we are patient, severely critical of our own ingenuity and happy guesses, as well as of those proposed by others, if we try hard enough to become aware of our own egoism, conceit, and self-assertiveness and overcome them we shall learn little by little to see more clearly and more conclusively.]

Michelangelo [1] (pp. 184-237, 346-354)

1395A BAYONNE, BONNAT MUSEUM, No. 681—Study for group of elect to l. of Virgin in the Last Judgement. Also several profiles of cornices (p. 230, note). Bl. ch. 16.5 by 22.5. Buloz and Arch. Ph. Steimann, II, p. 668.

1395B No. 1217—Early study for Christ and groups to His r. and l. in the Last Judgement (p. 229, note). Worked over later. Soft bl. ch. and wh. 34.5 by 29. Braun 65692. Bonnat Publ., 1925, pl. 3. Venturi, *M.*, 235. Steinmann, II, p. 665. Gentler in types, the foremost nude r., in attitude of contemplation, is almost Raphaelesque.
Fig. 706

1396 BERLIN, PRINT ROOM—Sheet of studies (pp. 195, 196, note). On the r. a bust of the Virgin in profile, and the Child on a cushion tossing Himself towards her, with arms held out and a look of almost Botticellian pathos. Over His l. arm appears a male head, full face. The upper left-hand corner is taken up with three *putti*, in whom one feels reminiscences of earlier masters—of Desiderio, perhaps, and Verrocchio. In the space between them and the Christ Child we see the upper part of a noble masculine profile, of a type recalling both the St. Matthew and the Creator of Adam in the Sixtine Ceiling. Pen. 28.5 by 21. Pl. CXXVIII of F. E. [Frey, 12. Berlin Publ., 32. Brinckmann, 19, Popham Cat., No. 212.]
Fig. 602

It is not easy to determine the exact date of this wonderful sheet. The Madonna's profile recurs with slight change in a drawing at the Louvre (my 1588 verso, Fig. 642)

1. The student who fails to find under this rubric a drawing usually ascribed to M. should look further under " School of Michelangelo " or under " Sebastiano del Piombo " or even—in one instance only—under Bugiardini. Should he not discover it then, he may conclude that the drawing either was not seen by the author or, as is more probable, that it did not offer sufficient interest.

[The student is invited before using this part of the Catalogue to master the introduction preceding it, as well as Appendix X. He is warned not to fail to look up references to the Text and Appendixes. There he will find information which to avoid repetition has been omitted here. Considering that most students, particularly in Germany, will base their studies on Frey's reproductions they must be seriously warned that they seldom do justice to the originals, and that conclusions regarding the originals should not be derived from them. A flagrant instance is the Oppenheimer study for the Minerva Christ (my 1543), Frey 36, to be compared with the Vasari Soc. reproduction (II, ii, 6). Frey's reproduction would lead me to question whether the hatching had not been added later. No such doubt troubles me while looking at the Vasari plate. The student should rely rather on the Alinari, Braun, Anderson, and Brogi photographs. For the Louvre and B. M. Alinari's prints are particularly to be recommended.]

of the Sixtine Ceiling period and is close to the one of the female helping to carry the dead Saviour in the N. G. Entombment. Her dress suggests the Doni Madonna, painted certainly just before the Ceiling.[1] The other profile, as we have seen, recalls the Matthew as well as the God the Father in the Creation of Adam. The technique yields no clue, although it points decidedly to the year preceding the Ceiling. My own impression is that this design must be contemporary with the two marble *tondi,* and thus date from just before 1508.

1396^A (former 1539) [CAMBRIDGE, FITZWILLIAM MUSEUM, PRINT ROOM]—Study for draped figure of Christ drawing back His l. foot, with His face nearly in profile to r., His r. arm stretched out vehemently and in attitude of command, l. hand held close to side, but open and eloquent, with a fold of His garment cast over the wrist. Also a separate study for this hand, and another of the same hand and arm, but in different position (p. 228). Bl. ch. 27 by 16. [Frey, 77. Vasari Soc., II, xii, 7.] Verso: Nude starting forward on his l. foot, with r. arm stretched out, and l. hand over the chest, [another smaller and more sketchy nude], and two studies of a l. hand with the forefinger slightly bent. Frey, 78.

Vasari (VI, p. 277) tells us that on a cartoon of M.'s, Pontormo painted a *Noli me tangere* destined for Alfonso Davalos, and that this was so successful that he had to paint a replica thereof for Alessandro Vitelli. From a letter addressed about the end of October, 1531, by Figiovanni, we learn that Pontormo was then painting this picture in M.'s workshop (Frey, *Briefe...,* p. 310). The cartoon must have been finished in the autumn of the same year. Neither of this nor of the two paintings is any trace known to me. But it seems probable that in the draped Christ that we are now examining we have one of the original studies for this work. The stern haughtiness and almost brutal aloofness of the conception well suits the time when the master was girding himself for the Last Judgement. The style of drawing does nor preclude this precise period, although it might point to a somewhat later date. The type of face and the fact that the figure is draped leave no doubt that the sketch is of a Christ. Being of a Christ, and of about this time, I cannot conceive what other purpose it could have served than that of a study for the *Noli me tangere.*[2] The hand at arm's length sketched on the same side of the sheet would point to an attitude not less stern, but more argumentative. The nude and the hands on the back of the same sheet are probably a slightly earlier sketch for the same idea, but feebler, and, as proved by the event, less satisfactory to the artist himself. If, as we have good ground for assuming, these studies were for the *Noli me tangere,* then that work is no longer wholly lost to us. I do not believe that in the finished cartoon the Christ underwent further change of action or conception. It remains to ask how the Magdalen came into the composition. To the r. of course, but just how? Perhaps a shadow of an answer may flit by us if we turn to Bronzino's exaggeratedly Michelangelesque painting of this subject at the Louvre [(Venturi, IX, vi, p. 57).[3] Thode (*Kr. U.,* III, No. 367) makes the interesting suggestion that these sketches may have been for a Christ taking leave of His Mother.]

1397 CHANTILLY, MUSÉE CONDÉ, No. 29—Sheet of studies (p. 186). Nude in profile to r. with cloak
Fig. 575 hanging from l. shoulder—a copy from the antique of the faun or satyr type. Nude female, seen behind, with cloak hanging from l. shoulder—also a copy from the antique. Draped

1. Compare the nudes in the background of this roundel with those in the boat and on the platform of the ark in the Deluge, one of the earliest bits of the Ceiling.

2. I am aware that M. designed a Christ at the Well for Vittoria Colonna (Campori, *Lettere artistiche inedite,* p. 14). But I cannot reconcile with that subject the menacing Christ of our sketch. By the way, Beatrizet's engraving (fig. 119 of Pittaluga's *Incisione Italiana nel cinquecento,* Hoepli, Milan, preface dated 1928) may reproduce a version by Battista Franco of this lost composition. Curiously enough the hand of the Saviour therein has the character and action of the lower hand on the recto of the present sheet.

3. Gamba in the *Boll. d'Arte,* 1909, p. 148 (Venturi, IX, vi, p. 275) published a version by Battista Franco made in 1536 or 1537 after the same cartoon. If it offers a fairly close reproduction of M.'s design, this must have undergone more change from the Cambridge drawing than I expected.

lady in profile to l.—a copy, judging by the folds of drapery, after Masaccio. Nude female in profile to l.—a copy after an antique of a type approaching the Medici Venus. Cast of antique drapery over a l. shoulder. Pen. 25 by 37. Braun 65070. [Frey, 2. Knapp., *Klass. d. K.*, p. XII.]

One would naturally be inclined to assume that this drawing was made by the youthful M. after the antiques and cartoons in the Medici gardens. But the exquisite cross-hatching has more freedom than in the very earliest sketches, and one may conclude that the date of this sheet could scarcely be earlier than 1495. The Ghirlandajesque way of sketching the head of the draped lady should be noted: first a line for the contour of the face, and then nibs for the features. If memory do not betray me, there is a striking likeness between the female nude seen from behind and one of the goddesses in Rubens's Judgement of Paris. I need scarcely add that this is perhaps the most important of M.'s earliest drawings.

[Verso: Draped male figure seated in *contrapposto* almost frontally with head in sharp profile and l. arm extended horizontally to r. Below in smaller proportion a crouching draped figure, and to r. a study of drapery. These two small sketches seem genuine, the large figure, on the contrary, so weak as to suggest the possibility that it is a copy. The original may have been for the Bathers. Tolnay (*Münch. Jahrb.*, 1928, pp. 450-458) rightly connects the crouching figure with the Bargello tondo, and the study of drapery with the Bruges Madonna.]

1397A CHELTENHAM, FITZROY FENWICK COLLECTION—Sheet 43 by 26 cut out at top to the extent of 16.5 by 17.4. Below in brown ink elevation of building and sketch of small structure consisting of three openings led up to by three steps. Over the central opening a lunette, over the side ones square panels, over them a cornice and above it a dome like my 1566 (Oxford) and like Popp, pl. 69B (Casa Buonarroti) in connection with works at S. Lorenzo. To l. above in M.'s writing "Sessantum / la vena Ceto is / Lorzo 37" (in S. Lorenzo?) Verso: Diagram in bl. ch.

1397B (former 1600A) [CHESTERFIELD, BARLBUROUGH HALL], LOCKER-LAMPSON COLLECTION—Bit of r. shoulder and arm in bl. ch., and, in ink, first draft of a sonnet beginning with the line: "ne debbo a cor tãto dispiace addio." 28.5 by 21.

CLEVELAND, MUSEUM— See my 1599A, which has recently been acquired by the Cleveland Museum of Art.

1397C (former 1636) FLORENCE, UFFIZI, No. 613E—[Sketch for foreground figures on the cartoon for
Fig. 585 the Bathers (pp. 191, 346, 347). Soft bl. ch. 23.5 by 35.5. Fototeca 2944. Brogi 1792. Brinckmann, 12. Venturi, *M.*, 24. W. Köhler, p. 140, pl. XI.

Done so freely and therefore with such anticipation of the master's draughtsmanship of forty years later that in my first edition I catalogued it as a copy by Allori. Happily this error counted for little in the effort I made to arrive at an idea of how this famous design was composed. In opposite direction in lower l. corner scrawls for two or three nudes struggling up the bank, and towards the middle a group hard to interpret. I cannot take it for either a Madonna and Child or for a Leda and the Swan, as some students have supposed. Could it represent two nudes also for the cartoon of the Bathers, one of whom is preparing to pull a shirt over his head? Verso: Nude with l. arm held up, another even more sketchy one drawn over (p. 347). The first for one of the groups in the Bathers where two nudes hold up a third as in my 1479 (Fig. 596) and 1598, and the other for one of the foreground figures, the fourth from l. In the upper r. corner a nude kneeling lightly on one knee as if about to rise and pointing upward as he does so. On the edge in a beautiful hand the words: "di Michelagnolo" written perhaps by the first possessor, who may have been a friend or even follower of the artist. Fototeca 847.]

1398 FLORENCE, Uffizi, No. 618ᶠ—Two small figures stealthily walking. Perhaps for the Expulsion of the Money Changers, and certainly of that late period. Pen. 9 by 6.5. Braun 76198. [Jakobsen and Ferri, Text, fig. 1.]

1398ᴬ (former 1641) No. 621ᴱ—Child making water and to l. from it a nude [kneeling. Underneath, a grotesque nude carrying another pick-a-back. All these in profile and done with bare outlines.] Two lines and a half in M.'s hand [for which see Frey, Text, p. 30], and lower down another line in a later hand. Pen and bl. ch. 26. 5 by 21.5. Braun 76194. Brogi 1785. [Frey, 54. The principal motive corresponds with one in the Children's Bacchanal at Windsor (my 1618, Fig. 691). Frey is right in pointing out that the one here is not copied, as I used to think, from the great design at Windsor but that it is an antique subject that M. could have done much earlier. From the style one would be disposed to date it no later than 1510. Verso: Five *putti* dancing, the l.-most in bl. ch. the others in ink and wash. Truly Etruscan in spirit but in no relation to M.]

1399 No. 620ᴱ—Full-length figure of man covered with antique mantle leaving r. shoulder bare
Fig. 581 (p. 189). He looks to l., and at arm's length holds a staff or sword with l. hand, while his r. holds up his draperies. Another study for same r. hand. R. ch. 43 by 28. Braun 76199. Alinari 245. [Jakobsen and Ferri, Text, fig. 2.]

This noble figure, even more antique than Donatellesque, certainly belongs to M.'s earlier years. The date at which, for morphological reasons, it must be placed, agrees so well with the time when M. was commissioned to carve the Twelve Apostles for S. Maria del Fiore, that we can safely assume that this was a sketch for one of them. Which, precisely, may not so readily be determined. As the artist never began another than the Matthew, it was perhaps for that grand work. If so, the conception underwent radical changes, although a likeness remained. Be this as it may, of the quality of the drawing there can be no question. Among the master's sketches in r. ch. it would be difficult to name its superior. One of the suavest works of Renaissance sculpture, a St. Peter, probably by Montorsoli, in front of the church at S. Piero a Sieve, seems to have been inspired by this design even more than by the unfinished marble Matthew. [It is instructive to compare with this sheet Uffizi No. 17370ᶠ, a faithful copy of it by Gabbiani.]

1399ᴬ No. 14412ᶠ—Head in r. ch. of man looking somewhat pensively down to r., resting on shoulders rapidly sketched in bl. ch. The remainder of the page is taken up with the plan of a fortification, and two sketches of heads of halberds, all in ink. Various words and phrases for which see Frey, Text, p. 48. R. ch. 28 by 27.5. Verso: Horseman seen from back dashing away. The date of this sheet is perhaps about 1530. [Frey, 98 and 99. Brinckmann, 6. Fototeca 4503 and 4504. Jakobsen and Ferri, pls. I and II.

It now (1934) seems not improbable that the r.-ch. head so incisive and so Leonardesque is of the Sixtine Ceiling period, like my 1545ᴬ, 1598ᴬ and 1599ᴬ (Fig. 616); while the rest may be considerably later. Artists at that time would use up any empty space on paper (then so much more expensive than now) no matter what they had put there years or even decades earlier. A drawing like this head had no value for M., he was not a collector of his own sketches; on the contrary, he burnt sackfuls of them. A confirmation for the early dating of the head may be the fact that it is copied on the sheet of hands (my 1706) at Oxford, all after earlyish originals.]

1399ᴬ⁻¹ Nos. 17379ᶠ and 17380ᶠ—Two studies (p. 197, note) for figures holding up the Books of
Fig. 611 Genealogy in the lunette which M. destroyed when he painted the Last Judgement over the high altar in the Sistine Chapel. Pen. 11 by 6 and 10.5 by 6. Steinmann, II, pp. 452-6 and 657. Jakobsen and Ferri, pl. XVI.

1399ᴬ⁻² No. 17381ᶠ—Rapid sketches for some of the figures trying to save themselves in a boat in the Sixtine fresco representing the Flood. Pen. 10 by 25. Frey, 249ᴮ. Jakobsen and Ferri, pl. XVI. Steinmann, II, p. 589.

1399^B FLORENCE, UFFIZI, No. 18718^F—In bl. ch. profile to r. of marked and vigorous head of old man. The features certainly recall Pope Julius, and this sketch may be a memory-portrait, but with much of the quality of the great grotesques as we find it in the Lille sheet. [It could not have been done earlier than the beginning of 1511 as Julius was beardless till then (Steinmann, II, p. 116, note 2).] In sp. [on recto and verso studies of] legs for the decorative nudes [in monochrome] on the Sixtine Ceiling. 43.5 by 28. [Fototeca 4529, 4530, 4531. Jakobsen and Ferri, pls. III and IV. Steinmann, II, p. 35. Toesca, *E. I.*, pl. **xx**.]

1399^C No. 18719^F—Study for the Night (New Sacristy of S. Lorenzo), the hip and shoulders fairly finished, but as if after the *ecorché*; the rest in mere outline. Two sketches of hip and torso of same figure, but in slightly different position (p. 221, note). Bl. ch. 34.5 by 28. Verso: Two sketches for leg of same figure. [Jakobsen and Ferri, pls. v and VI. Fototeca 4532 and 4533. Brinckmann, 39.]

1399^D No. 18720^F—Splendid study of torso and legs, with head and arms slightly indicated
Fig. 617 (p. 198, note). The figure seems seated, looking to l., but pointing to r. Sp. 42 by 28. Verso: Three studies for legs. Certainly of the date of the Ceiling. [Fototeca 4534 and 4535. Jakobsen and Ferri, pls. VII and VIII. Steinmann, II, pp. 610 and 611.

Steinmann (II, p. 594) connects these studies with the nude to the l. over Isaiah (Venturi, *M.*, 78). The early technique and a comparison with the legs on the verso prove that he is right, and not Jakobsen and Ferri, who interpret them as preparatory to the Christ in the Last Judgement. No doubt there is a certain identity of action for even M. has a small repertory of movements, and similarities of pose and gesture occur between figures in every part of his long activity. As a matter of fact, the nude on the recto is reversed from the nude (Venturi, *M.*, 78) as it appears in the fresco with differences only in the action of the arms. This is confirmed by the drawings on the verso in which the legs are already as in the fresco and the foot seen in the opposite direction like the l. foot of the same. The recto would thus have been done before M. had decided whether the figure was to look to r. or to l. In my 1598^B verso we have a sketch for the figure as it was finally painted. Interesting is the statement made by Jakobsen and Ferri (see Text, p. 16) that paper with the same watermark (a siren with a forked tail) has been used by M. for a letter dated March 8, 1510, and for the next drawing mentioned in this Catalogue (my 1399^E, Fig. 629), most certainly connected with the Ceiling. We may therefore assume that the sheet we are dealing with is of about the same date. The corresponding fresco would naturally be no earlier.]

1399^E No. 18722^F—Sheet of studies. In r. ch., torso and legs of reclining nude, for the Eternal
Fig. 629 in Creation of Adam. In sp. crossed knees perhaps for one of angels in same fresco, or possibly for the decorative nude [to r. above Daniel and just under the Eternal in same composition]. In pen, rapid sketch of a lunette the inner arch of which supports a staircase, upon which stands a nude pointing to a reclining figure on top (p. 349). 35 by 25.5. Verso: In sp., study for nude who holds his arm bent over his head [to r. over the Isaiah (Venturi, *M.*, 80) and study in bl. ch. for the nude to l. above Joel.] Fototeca 4538 and 4539. Jakobsen and Ferri, pls. IX and X. Steinmann, II, pp. 617, 618.

The vicinity of these several sketches on the same sheet is a matter of some importance. It goes to prove how M. was working on neighbouring compositions a bit here and a bit there as mood or occasion impelled. If we were sure that the pen-sketch was done at the same time we should know that while still working at the central narrative frescoes of the Ceiling he already was thinking of the lunettes with the ancestors of Christ, for the sketch could have served no other purpose.

1399^F No. 18723^F—Over statuesque draped female, seated in profile to l., with two heads sketched in, the more accented one looking up. The spirit of this is [far from convincingly] M.'s, but if his nevertheless, it may have served for one of the Ancestors of Christ in the

lunettes of the Ceiling. Rapid small sketch of nude running with lifted arm. Bl. ch. 25 by 27.5. [Fototeca 4540. Jakobsen and Ferri, pl. xi. Jakobsen and Ferri suggest that the seated figure may have served for the Virgin in an Annunciation and the nude for the angel flying down from the l. It now (1934) looks to me as if this nude was embracing and kissing another but so faintly indicated that one hesitates to believe one's eyes.]

1399G FLORENCE, Uffizi, No. 18729F —Rapid jotting of rather shapeless male nude, seated uneasily on a block with his l. hand on a book in his lap, at which he looks vehemently, while his r. hand is lifted as if to strike (pp. 205, note; 349). The action suggests the Moses of S. Pietro in Vincoli, and the Ezekiel on the Ceiling, but sketched perhaps for one of the Ancestors of Christ. Bl. ch. 22.5 by 9. [S. I. 4543. Jakobsen and Ferri, pl. xii. Jakobsen and Ferri (Text, p. 22 and fig. 10) point to the resemblance in action and we may add in shape as well, to one of the Slaves for the Tomb of Julius now in the Florence Academy.]

1399G-1 No. 18730--Male torso with legs faintly indicated, study for a l. foot and outline of foot turned to r. (p. 205, note). R. ch. 18.5 by 14. Frey, 97. Jakobsen and Ferri, pl. xxi. S. I. 4544. Probably, as Frey concludes, the torso was for a Slave in the earliest projects for the Tomb of Julius. Not necessarily autograph. Perhaps by same hand as my 1654A.

1399G-2 No. 18733F —Faint architectural outlines and a tiny figure, according to Jakobsen and Ferri (Text, p. 36) reminiscent of my 1571 (Fig. 683). Bl. ch. 20 by 25.5.

1399G-3 No. 18734F —Study for male torso and bent r. arm (p. 205, note). Bl. ch. 20.5 by 16. Verso: Study for a l. arm. S. I. 4546 and 4547. Jakobsen and Ferri (pls. xxii and xxiii) consider the arm on the recto to be a study for the arm of Moses, the one on the verso for the arm of David. The style would suit the date of these masterpieces.

1399H No. 18735F —Hasty sketch of torso and hips turning to r., in attitude recalling the Virgin in the Last Judgement (p. 230, note). Bl. ch. 33 by 20. [Jakobsen and Ferri, pl. xiii.]

1399I No. 18736F —Slight jotting for the Tityus (Windsor). Bl. ch. 19 by 11. [Fototeca 4548. Frey, 74. Jakobsen and Ferri, pl. xiv.]

1399J No. 18737F —Rapid sketches for four or five figures in violent action and study for a Leda
Fig. 686 in the embrace of the Swan, and of another youthful nude, perhaps for a Leda again (p. 225, note). Sp. The Leda touched up with pen. 24 by 21. Fototeca 2945. Jakobsen and Ferri, pl. xv.

The nudes in violent action were done for the Bathers and correspond to figures on the large sketch here (my 1397C, Fig. 585), for which figures they may have been a preparation. The voluptuous Leda must be of the same date and therefore the earliest of M.'s ideas for that subject that has come down to us. How rapturous, how Correggiesque, how different from the hard sensuality of the famous version of later years preserved for us in Rosso's copy now in the N. G.

1399K (former 1654) Uffizi, Santarelli, No. 170—Sketch for upper part of Last Judgement, including
Fig. 705 Christ and figures to our r. (p. 229, note). Bl. ch. 19.5 by 28.5. [Fototeca 4593. Frey, 100. Steinmann, II, p. 667. Jakobsen and Ferri, pl. xxiv. Brinckmann, 63.]

The figures do not correspond in general arrangement and action so well with the saints that we now see in the fresco as they do with the nudes above them struggling with the columns. It is clear then that this sketch, along with the one for the entire composition in the Casa Buonarroti, was drawn before M. had yet made up his mind to destroy his own two lunettes belonging to the Ceiling, and use their space for the upper part of the Last Judgement. When he finally did take this determination he pushed up into the lunettes the figures originally intended—as we see from the Santarelli sketch—to

be on Christ's l., taking away from them their symbols, as the gridiron of Lawrence and the cross of Philip.

[As is obvious from the implications of the above paragraph, I must have taken this sketch for an autograph by M. as I certainly do now (1934). It slipped into the school category by one of those errors for which there is no accounting.]

1400 FLORENCE, CASA BUONARROTI[1] No. 1—Head of woman looking up almost in profile to l. Most probably
Fig. 603 a study for the Madonna in the Doni *tondo* of the Tribuna (p. 195). R. ch. 22.5 by 18. Alinari 1024. Brogi 1240. [Frey, 52. Knapp, *M.*, p. 24. F. Baumgart, *Boll. d'A.*, 1934/35, p. 351.

Tolnay says that this head was meant for the Jonah (see *Rep. f. K. W.*, 1927, p. 192, note, and fig. 24). I should not exclude the possibility, but in spirit it seems different, in treatment sculptural, which is far from being the case with the Jonah, and in handling more severe and therefore earlier. I venture to believe that it was sketched at the time that the artist was doing more sculpture than painting, which would suit the Madonna Doni better than the Jonah. When M. painted that gigantic figure he had perhaps not touched a chisel for three years. The resemblance goes to show how limited was the number of types and attitudes even of a Michelangelo, the greatest of Italian inventors *of types and attitudes.*]

1401 No. 7F—Head of youth in profile to l. bending down; beside it, study for eye and nose
Fig. 604 of similar but older face in same position (p. 196). R. ch. 35.5 by 27. Pl. CXXIX of F. E. Brogi 1239. [Frey, 16. Brinckmann, 31. Venturi, *M.*, 137. Toesca, *E. I.*, pl. XX.

Of the Sixtine Ceiling period but not to be identified with any existing head there. Except for arrangement of hair and shape of cranium very close to profile of Libyan Sibyl. Steinmann (II, pp. 602 and 653), followed by Venturi, believes it may have been intended for the sleeping woman in the Ozias group (Venturi, *M.*, 136); not impossible providing one allows for change of sex, character and expression.]

1401A No. 4F—Slight sketch in r. ch. for figure bearing down with r. arm on something he is holding with his l. 11.5 by 7. Frey (pl. 155B, Text, p. 75) suggests that it might have been for a Samson slaying the Philistines or for Christ and the Money Changers. He may be right, but the contours and stroke seem earlier.

1401B No. 11F—R. and l. leg of reclining figure bent at knee. Pen. 20 by 17. Frey, 263A. Same technique and quality and possibly for same purpose as my 1409A (Fig. 687).

1402 No. 17F—Three nudes in staggering attitudes. Pen. 9 by 9. [Frey, 126A. F. Baumgart, *Boll. d'A.*, 1934/35, p. 349.]

1403 No. 18F—Three nudes in attitudes similar to last, and for same purpose (p. 232). Pen. 9.5 by 10.5. [Frey, 126B. Baumgart, *Boll. d'A.*, 1934/35, p. 349.]

These two sketches, like my 1414 and 1415 here and my 1573 (Fig. 718) at Oxford, are for some composition akin to the Christ chasing the Money Changers out of the Temple, or the Conversion of St. Paul, and are interesting as being among M.'s very last pen-sketches. [Further study of this group convinces me that the forms despite a certain sprawling looseness in touch are much earlier and may be connected with the fresco of the Brazen Serpent on the Sixtine Ceiling.]

1403A (former 1660) No. 19F—[Two nudes, one more finished than the other, for one of the blessed who
in the lower l. of the Last Judgement is seen pulling up two others with the help of a

1. Following my principle of excluding the discussion in this book of architectural drawings, I have only indicated them, and only those that seem of unquestionable authenticity, excepting, however, mere ground plans. The student of M. as an architect, may not be unwilling to know which of the drawings he would be tempted to base his researches upon have the approval of an eye that has devoted years to the mere study of this master's touch as a draughtsman.

rosary (p. 230, note), as in my 1572 (Fig. 734). A double staircase divided by a rectangular niche, one part going to r. along a wall and the other to l. Study for a tomb, three of sarcophagi and two of niches for same. Bl. ch. 20 by 19. Brogi 1354. Frey, 236. Steinmann, II, p. 670. Verso: A nude for same figure as on the recto and another more sketchy perhaps for the floating nude next seen on our l. in the fresco. Further sketches for a tomb and its volutes and for a staircase. Brogi 1349. Tolnay, *Munch. Jahrb.*, 1928, p. 397.

Steinmann in *Monatsh. f. K. W.*, 1908 (pp. 963-974) gave the first satisfactory account of this drawing. The staircase is for the Senator's palace on the Capitol and the sketches of a tomb for the monument to Cecchino Bracci (d. Jan., 1544) still to be seen at the Aracoeli, and repr. in Steinmann's *M. um Spiegel seiner Zeit*. Note the discrepancies between the sketches and the finished work. See also Frey, Text, pp. 111-112. The nudes for the Last Judgement were of course done earlier.]

1404 FLORENCE, Casa Buonarroti, No. 29F—Sketch of a r. leg, of two nudes, one of them probably for a slave in the Tomb of Julius, and profile of a conventionalized face. Slight and early. Pen. 17 by 17.5. [S. I. 10890. Frey, 231.]

1405 No. 30F—Sketch of upper part of youthful nude with face turned away to r. Below it several lines of writing. Pen. 11 by 7.5. [Frey (244C) connects it with the Haman fresco. See his text (p. 116) for the interpretation of the writing.]

1406 No. 32F—Rapid sketch for nude figure awaking from death, doubtless intended for lower part of the Last Judgement, although not to be found there (p. 230, note). R. ch. 13.5 by 19.5 [Frey, 179.]

1407 No. 35F—Nude turning head sharply to r. towards more summary figure of a startled supplicating person. R. ch. 16 by 15. [Brogi 1353. E. Panofsky, *Zeitschr. f. B. K.*, 1927/28, p. 237. I failed in the first edition to see that this is a sketch for a Resurrection like my 1580 (Fig. 696).]

1408 No. 37F—Number of nudes rushing forward seizing hold of one another, two or three lines of writing, and rapid scrawls of feet. Perhaps this study is to be connected with the Ceiling fresco of the Fiery Serpents, and is at all events of that date. R. ch. 19 by 25. [Brogi 1352. E. Panofsky, *Zeitschr. f. B. K.*, 1927/28, p. 239. The writing, as already seen by Prof. Panofsky *(loc. cit.)* is almost certainly Mini's. The cublike nudes may be his as well. They are not M.'s. If for the Fiery Serpents they would tend to strengthen Popp's conclusion (see *M. K.*, p. 159) that M. had the idea of painting that subject in the Medici Chapel.]

1409 No. 38—Three nudes, in pen, four or five fainter ones in lapis (p. 347). Frey, 291. [F. Baumgart, *Boll. d'A.*, 1934/35, p. 348. Dainty, almost too dainty, and perhaps for Bathers in attitudes of surprise and terror.]

1409A No. 44F—Study for lower part of reclining figure resting on it's buttock with l. leg bent
Fig. 687 high at knee and tucked under thigh with the foot showing sole (p. 225). Pen. 15 by 19. Frey, 114. Popp, *M. K.*, 43.

The universal technique prevented my recognizing this drawing as an autograph. Frey connects it with the Eve in the Temptation of the Sixtine Ceiling and Popp with the Danae. Popp is certainly nearer to the truth. It is, however, far from safe to make sure of the purpose of an attitude like this one occurring so frequently in M.'s works, particularly in the period of the Medici Tombs.

1409B No. 45F—Study for Adam in Expulsion. Lapis (?) 27 by 20. Steinmann, II, p. 639. Frey, 115. Probably M.'s and certainly by the hand that did my 1409. Done for the action only. Slight differences in r. hand and l. arm were made in the fresco. Interesting to compare with my 1664A, which I take to be a copy after a similar original.

1409^C FLORENCE, CASA BUONARROTI, No. 46^F —Rough sketch for upper part of muscular male nude looking down. Bl. ch. 15 by 10.5. Frey, 280^C. Of the period of the Last Judgement and perhaps for it. To be compared with sketches like my 1525 verso (Venturi, *M.*, 241).

1409^D No. 47^F —Mask of middle-aged man looking down to r. R. ch. 14 by 12. Alinari 1038. Steinmann, II, p. 442. Frey, 172^A. Probably done in connection with the Ceiling and perhaps for it's early stages, but does not occur there. It is all but a variant reversed of a head on my 1416 verso.

1409^E No. 48^F —Torso and r. leg bent high at knee of figure reclining nearly flat on it's back (p. 225). Pen. 12.5 by 19.5. Frey, 263^B. Same technique and purpose as my 1401^B and 1409^A (Fig. 687). Only here neither the heroic proportions nor attitude lend themselves quite so well to a Danae.

1409^F No. 49^F —Slight sketch in bl. ch. for nude seated figure with l. leg drawn up and r. arm raised above head. Bl. ch. 10.5 by 6. Frey (232^B) connects it with one of the nudes on the Ceiling. Might pass for Degas.

1409^G No. 54—Kneeling male nude with hands lifted as if in supplication, seen from back
Fig. 710 (p. 239, note). Bl. ch. 25.5 by 15.5. Alinari 854. Brogi 1233. Frey, 276. Steinmann (II, pp. 606 and 674) considers it a study for one of the figures in the group of the damned in the Last Judgement. I cannot find its exact counterpart in the fresco, but it may have been done for one of the nudes struggling to rise but beaten back.

1410 No. 57^F —Profile of female head. Above it some writing. Pen. 6 by 6. [Frey, 244^A. Probably for Sixtine Ceiling and perhaps for a Sibyl as Frey (Text, p. 116) suggests.]

1411 No. 58^F —Three rapidly jotted figures of dancing nymph and two fauns. Pen. 7.5 by 7.5. [Frey, 244^B. To Frey (Text, p. 116), on the contrary, this looks like a sketch for the Transfiguration and the horns that seem to belong to an old faun he transfers to the forehead of Moses. Scarcely later than 1515.] It is interesting that the same sketch should lend itself to such very different intrepretations.

1411^A No. 59^F —Tiny profile of youth with helmet of fur and feathers. Pen. 6.5 by 5. Very early. Cf. with other sketches of same type in Oxford and Paris. See my 1560 and 1597 verso.

1411^B No. 60^F —Study for r. arm stretched out with hand dropping from wrist. Pen. Alinari 853. Conceivably for the Adam but in that case reversed.

1412 No. 63^F —Crouching nude seen from back in attitude all but like one of Degas' pastels of women tubbing [and another erect nude about to strike a prostrate one.] Pen. 14 by 9. [S. I. 10891. Frey, 244^D.

The writing on the verso does not seem M.'s. Thode (*Krit. U.*, III, No. 55) assumes that this is for a Hercules and Cacus and may be right, but the attitude of the arm does not exclude that it may have been for a Samson knocking down a Philistine with the jawbone of an ass.]

1413 No. 65—Earliest known study for entire composition of the Last Judgement (p. 229).
Fig. 703 Bl. ch. [The outlines of two of the figures on the l. strengthened with ink probably by a later hand.] 42 by 30. Alinari 1014. [Frey, 20. Brinckmann, 60. Jakobsen and Ferri, Text, fig. 16. Venturi, *M.*, 236. Knapp, *M.*, pl. 90. Toesca, *E. I.*, pl. XXII.] Although M.'s conception underwent considerable change in detail before the fresco was ready for painting, its main masses and movement are here fixed once for all. It is clear that when this was drawn the artist as yet had no idea of the groups of angels with the symbols of the Passion that now top the composition, necessitating the destruction of

169

two lunettes which he himself had painted in connection with the Ceiling frescoes. [J. Wilde (*Die Graphischen Künste*, N. F. I, 1936, pp. 7-11) suggests that the lacuna in the lower part of this sketch indicates that at this stage it was M.'s intention to preserve Perugino's frescoed altar-piece of the Assumption of the Virgin, composing the Last Judgement around it. Verso: Male nude with chest and r. shoulder violently twisted round and r. arm lifted. Bl. ch. Brogi 1355. See *Münch. Jahrb.*, 1928, pp. 446, 447, where Tolnay considers it a copy after the original sketch in the archivio for the Resurrection. It is not a copy, but a more tentative and feebler variant.]

1414 FLORENCE, Casa Buonarroti, No. 67—Three nudes in staggering attitudes. Pen. 11 by 11. [Frey, 126C. F. Baumgart, *Boll. d'A.*, 1934/35, p. 349.] See my 1403.

1415 No. 68—Three further nudes in staggering attitudes. Pen. 11 by 11. [Frey, 126D.] See my 1403.

1416 No. 69F—Study for torso and arm of reclining nude, and of r. arm stretched out with
Fig. 730 balled fist (p. 234). Both are drawn in M.'s most powerful early style. The torso served as preparatory study for the much more highly finished design for a Dead Christ in the Louvre (my 1586, Fig. 729). Bl. ch. 40 by 28. Alinari 1013. [Frey, 15. Venturi, *M.*, 47. Verso: Large bald head close, except for being turned in the other direction, to the one on the recto of my 1399A and in similar proportions torso of a nude, another nude seen from the back crawling up a bank as if for the Bathers, three studies of legs and one of an arm, all probably done in connection with the story of the flood and, in any case, of that date. In type and in technique similar to my 1544B (Fig. 631), the Metr. Mus. study for the Libyan Sibyl. Brogi 1347. See also *Festschrift für Julius Schlosser*, pp. 159-160, where Prof. Panofsky published these sketches as made for the Last Judgement and as being possibly mere copies; but Michelangelo's types of that late period are athletic, morose and tragic as on my 1468 (Fig. 709), the *chiaroscuro* is more elaborated, with modelling nevertheless more generalized as if done, so to speak, in porphyry instead of marble. A comparison between the nude on the recto here and the one on the verso of my 1484 (Fig. 731) would also serve to confirm the dating of both sides as of the Sixtine Chapel period. As for their being copies I for one miss no quality here that I expect of an original.]

1417 No. 70F—Design for a Sacrifice of Isaac (p. 232). Bl. ch. 41.5 by 29. Alinari 1012.
Fig. 721 [Frey, 292. Knapp, *M.*, pl. 61. Toesca, *E. I.*, pl. xix. Steinmann (II. pp. 595 and 625) connects this with one of the medallions in the Sixtine Ceiling. Undoubtedly later but not as late as I implied in my Text. Perhaps towards 1535.]

1418 No. 73—Study of nude seen from back for one of figures that must have occurred in the
Fig. 586 cartoon for the composition of the Bathers (p. 191). Pen. 40.5 by 28. Alinari 1011. [Frey, 26. Knapp, *M.*, p. 29.]

1419 No. 49A—Sketch for sarcophagus standing on platform against a background. On top of
Fig. 660 the sarcophagus in the broken arch rests a round slab. The structure rising behind and above this is taller and narrower, and consists of three divisions—the middle one about twice the breadth of those at the sides. The whole is topped by a tall cornice (pp. 217, 221, 353). Bl. ch. 10 by 16. [Frey, 125A. Tolnay, *L'Arte*, 1934, p. 13, fig. 9.] Most probably this is a sketch for the early project of the Medici Tombs, which was to consist of a cube with [a sarcophagus] on each side. [My 1434 may have been done in this connection. It is on the back of a letter dated 1520.]

1420 No. 50A—Architectural sketch for an interior of a dome and its supporting arch, in every probability for the New Sacristy. Pen. 24 by 20. Frey, 173A and 174C. Verso: Architectural scrawls and some writing for which see Frey, Text, p. 84.

1421 FLORENCE, Casa Buonarroti, No. 51^A—The profile edge of a building in three stories. Pen. 53 by 24. [Frey, 264. An architect's studio drawing. The writing looks very early.]

1422 No. 6^A—Slight architectural decorations, and rapid sketch of eagle with outspread wings. Pen. 30 by 20. Alinari 1050^C. [Below, a rectangular piece of tapestrylike decoration of acanthus leaves, certainly not by the master, and the other studies, including the eagle, now seem perhaps by Antonio da San Gallo the Elder.] Verso: Some verses transcribed in Frey's *Dichtungen*, LXVII.

1423 No. 48^A—Various architectural sketches as of a pediment and the interior of a façade, perhaps for the inside entrance wall of the S. Lorenzo Library. This consists of three openings separated by half columns, and above it a shorter storey with three square openings separated by circles. Pen. 26.5 by 20. [Frey, 234. Wittkower, *Art Bulletin*, 1934, p. 134 and fig. 11.]

1424 No. 46^A—Architectural study, consisting of a projecting mass containing an opening flanked by two broad pilasters, and in the background two narrow openings (p. 221). Pen. 14 by 14. [Frey, 125^B. Popp, *Münch. Jahrb.*, 1927, p. 399.
 I see no reason (1934) for not connecting this with the Medici Tombs and it may be an early idea for the wall in the New Sacristy with the Madonna, Cosmas and Damian. Popp would see here a sketch for the Medici Tombs to be erected in the Choir of S. Lorenzo.]

1425 No. 44^A—Various architectural scribbles, including a long terminal pilaster crowned with a head upholding a cornice, and a very simple sketch for a façade of S. Lorenzo. Also a number of words and phrases (p. 213). The whole sheet seems to have been a cast-off letter, as is indicated by one line of writing at the top as follows: "Messere Domenicho a questi dì e stato Iachopo Salviati a pietra santa pare." Pen. 20 by 27. The façade reproduced in *Rass. d'A.*, I, p. 70, sketch A. [See Frey's excellent account for the historical connections of this sheet (Text, pp. 18 and 19, and pl. 29). Tolnay, *Gaz. d. B. A.*, 1934, I, p. 26.]

1426 No. 47^A—Sketch for façade of S. Lorenzo, showing three doors and four windows below, one great and two small pediments above (p. 213). R. ch. 14 by 18.5 Supino, *L'Arte*, 1901, p. 252. [Frey, 96^B. *Gaz. d. B. A.*, 1934, i, p. 27.]

1427 No. 36^A—Slight plans and sketch for portal. Bl. ch. 14.5 by 17.5. [Frey, 223^A.]

1428 No. 37^A—Rough sketches of windows. Bl. ch. 37 by 28.

1429 No 39^A—Rough sketch for window or opening. Bl. ch. 39.5 by 23. [Verso: Similar drawing of different proportions. Both very likely, as Frey (209, 210) proposes, for the Ricetto of the Library of S. Lorenzo (see also Wittkower in *Art Bulletin*, 1934, p. 140, and fig. 16).]

1430 No. 40^A—Study perhaps for an altar. Bl. ch. 39.5 by 24.5. [Frey, 285.]

1431 No. 55^A—Two Ionic capitals. Bl. ch. 8.5 by 16.5. [Frey, 107^E.]

1432 No. 56^A—An Ionic capital. Bl. ch. 8.5 by 16. [Frey, 107^D.]

1433 No. 58^A—Study for a rectangular window, with a mullion in the middle. Bl. ch. 13.5 by 12. [Frey, 282^C.]

1434 No. 66^A—Architectural study, perhaps for a monument. [According to Frey (123 and 124) an early idea for the cupola of the New Sacristy of S. Lorenzo but a comparison with the structure behind the sarcophagus in my 1419 (Fig. 660) leads one to suspect that it

may have been done in connection with that scheme for one of the Medici Tombs.] R. ch. 28.5 by 21. [Verso: Unshaded repetition of lower part of recto and writing dated 1520 for which see Frey, Text, p. 57.]

1435 FLORENCE, Casa Buonarroti, No. 71A—Various slight architectural sketches and study for receptacle rather than a sarcophagus or perhaps the butt end of a sarcophagus placed between two heavy squat pillars (p. 353). Bl. ch. 14 by 12. [Frey, 267B. Tolnay, L'Arte, 1934, p. 13, fig. 11. Frey suggests that this was for the monument to stand free in the Medici Chapel and Tolnay confirms him. See Appendix XIII.]

1436 No. 72A—Plan and sketches for a monument. R. ch. 17 by 13. [Frey, 266A. Popp, M. K., 64.

The one on the l. would seem to be a study for the entablature resting above the pilasters of either of the two tombs in the Medici Chapel with the projecting part of the attic crowning the same 'monument, dating from a moment when perhaps M. vaguely thought of placing a figure over each of the salients of the attic as in the Sixtine Ceiling above the Prophets and Sibyls. To the r. of this a sketch to me undecipherable. It looks as if it were meant for a low rectangular receptacle which was to be occupied by one or more squatting figures, as for instance in my 1438.]

1437 No. 73A—Two or three sketches for vases and basins. Pen. 12 by 17. [Frey. 137B.]

1438 No. 107A—Slight sketch for a tomb, bearing some resemblance to one or two of the B. M. studies for the Medici tombs. Bl. ch. 15 by 15. [Frey, 214B.]

1439 No. 105A—Sketch for a window either in the New Sacristy or the Library of S. Lorenzo. R. ch. 19 by 15. [Frey, 177B.]

1440 No. 88A—Various slight architectural sketches, including one for a tomb, unmistakably
Fig. 659 for S. Lorenzo. The reclining figures are already visible on the top of the high sarcophagus [as well as the erect figure in the niche above] (pp. 217, 353). Pen. 19 by 24. [Frey, 70. Popp, M. K., 72. Tolnay, L'Arte, 1934, pp. 13 and 19, figs. 12 and 16. Verso: Some verses transcribed in Frey's Dichtungen, XXIV.]

1441 No. 89A—Architectural sketches, doors and windows. Doubtless connected with S. Lorenzo projects. Pen. 24 by 23. [S. I. 5144. Frey, 71. Wittkower, Art Bulletin, 1934, p. 156 and fig. 23.]

1442 No. 90A—Study for a bit of cornice. R. ch. 9.5 by 10.5. [Frey, 282B.]

1443 No. 91A—Rough sketch for façade of S. Lorenzo (p. 213). Slight and simple. R. ch. 9 by 9. [Frey, 96A. Tolnay, Gaz. d. B. A., 1934, i, p. 27.]

1444 No. 92A—On a sheet already containing sketches in r. ch., such as a male head in profile and
Fig. 804 the lower part of a large nude, both possibly by Antonio Mini, studies in pen and ink for a small altar, and [various sketches for the staircase in the Library of S. Lorenzo] (pp. 365, 366). Verso: Three heads in r. ch. [by the same hand as the nude on the recto] and in bl. lower part of nude. In pen various sketches for the staircase and Library of S. Lorenzo. 39 by 28. [Frey, 164 and 165. L'Arte, 1935, p. 277. Wittkower, Art Bulletin, 1934, pp. 156 et seq., and figs. 24 and 25.]

1445 No. 93A—Sketch for a structure consisting of three openings below, and two above, with statues in the lower side openings. Pen. 18 by 20. [S. I. 5147. Frey, 125C. Popp, Münch. Jahrb., 1927, p. 392.

In the first edition it was suggested that this might be an idea for the altar of the New Sacristy in S. Lorenzo. That no longer seems possible. Equally improbable is

Popp's inference that it may have been intended for the tombs of Leo X and Clement VII to be erected in a tiny room off the old Sacristy in S. Lorenzo. But it looks as if meant to have three or even four sides and as if the central arch was to be hollow. Is it conceivable that this was the first notion that passed through M.'s head on reading Cardinal Giulio's request for the design of a four-sided structure for the New Sacristy consisting of arches? See extract from Buoninsegni's letter of Dec. 28, 1520, in Tolnay, *L'Arte*, 1934, p. 38.]

1446 FLORENCE, CASA BUONARROTI, No. 94A—Profile sketch for one of the reading stands and benches in the Library of S. Lorenzo. Pen. [Also scrawls of two hands and arms in r. ch.] 16 by 20. [Frey, 269.]

1447 No. 82A—Slight bl. ch. sketch of [Ionic] composite capital. 8.5 by 6. [Frey, 107A.]

1448 No. 83A—Bl. ch. sketch of more ornate composite Ionic capital. 10 by 8. [Frey, 107B.]

1449 No. 84A—Study for ornate doorway. Bl. ch. 11 by 8. [Frey, 211C. Of his later years.]

1450 No. 85A—Slight bl. ch. sketch of window. 12.5 by 7. [Frey, 211D.]

1451 No. 86A—Rapid bl. ch. sketch for Ionic capital. 16.5 by 8.5. [Frey, 107F.]

1452 No. 87A—Bl. ch. sketch for ornate Ionic composite capital. 8 by 6.5. [Frey, 107G.]

1453 No. 101A—Study for palace window. Pen. 27 by 19. [Frey, 286. Hatching and shading not convincingly the master's.]

1454 No. 110A—Study for a tabernacle-like erection, perhaps for font. [More likely, as Frey suggests, for the reliquary at S. Lorenzo (see his Text, pp. 39-40).] Bl. ch. 26 by 19. [Frey, 73.] Verso: Important memorandum in M.'s hand regarding the façade of S. Lorenzo, transcribed in Gotti's appendix, p. 185, and Milanesi's *Lettere*, p. 567.

1455 No. 112A—Study for niche framed in with Ionic columns and broken pediment. [Unusually precise.] R. ch. 19.5 by 12.5. [Frey, 177A. See Gotti for writing on verso.]

1455A No. 126A—Sketches, as Frey has rightly seen (Text, p. 125), for the ceiling of the Library of S. Lorenzo. R. ch. 21 by 37. Frey, 266B and 266C. Wittkower, *Art Bulletin*, 1934, p. 196, and fig. 57.

1456 No. 43A—Pen scrawl representing mitred nude supported on a sarcophagus by another
Fig. 643 nude holding him under the arms (p. 204). Doubtless a sketch for the Tomb of Julius. Pen. 15 by 11. Verso: Sketch for a façade of S. Lorenzo (p. 213). R. ch. and pen. Supino, *L'Arte*, 1901, p. 251. [Frey 211A and 211B. Tolnay, *Gaz. d. B. A.*, 1934, i, p. 27.]

1457 No. 8A—Various architectural sketches, including a magnificent one for a triumphal arch or town gate. R. ch. 29 by 43. [Frey, 161.
 Thomas Ashby in *Papers of the British School at Rome* (II, 1904, pp. 6-8) suggests that this sketch as well as my 1505 and 1506 are either copies by Coner himself, or copied by some one else from Coner's sketchbook, but certainly not by M. Frey, on the contrary, defends them as being early works by the great master. As for me I am not sufficiently acquainted with the contingencies of architectural drawing to be as positive as Frey. The difference in quality between one drawing and the other, even on the same sheet, as for instance on my 1505 or 1505 verso, suggests the possibility that they were done under M.'s eyes with his assistance after slighter sketches by himself or for that matter by Coner, if dates permit the latter supposition.]

1458 No. 9A—Study for bases of capital. R. ch. 28 by 21. [Frey, 163.]

1459 FLORENCE, Casa Buonarroti, No. 10ᴬ—Studies for bases of capitals, with five lines in writing (pen and ink). R. oh. 28 by 21. [Frey 162, and Text, p. 79.]

1460 Codice delle Rime, p. 145—Various sketches, the most important being the bust in profile to r. of a woman of about thirty, the profile of a man wearing a boar's head for a helmet, and three other profiles. Scarcely later than 1540, or earlier than 1530. Pen. 29 by 21.5. See Frey's *Dichtungen*, p. 385 [and Tolnay in *Münch. Jahrb.*, 1928, p. 474 and fig. 79.]

1461 Codice delle Rime, p. 148—Slight sketch of male nude kneeling on l. leg with head almost in profile to r., l. hand held out [and r. pointing at himself.] Bl. ch. 27 by 19. [Early, gone over by other hand and for uncertain purpose. See Frey, *Dichtungen*, 61, and Tolnay, *Münch. Jahrb.*, 1928, p. 475 and fig. 80.]

1462 Codice delle Rime, p. 169—Verso: Rapid sketch of large hand with thumb and index finger extended, and the others curled in. Pen. 29 by 18.

[Almost certainly done from model, but nevertheless seen in the terms of the master's canon. It is curiously enough the exact type of hand found in Jacopino del Conte's portraits, see my 1600ᴮ. For poem on recto see Frey, *Dichtungen*, 99. See also Tolnay in *Münch. Jahrb.*, 1928, p. 429 and fig. 38.]

1462ᴬ FLORENCE (Settignano), Villa Michelangelo, First floor on a wall—Sketch of almost life-size male nude of advanced years, seen from waist upwards, turned to l., with billowing draperies to r. and l. and r. arm raised holding what might be a drinking horn. Bl. ch. Proportions and action belong to the period between the Sixtine Chapel and the Last Judgement. The action suggests the Resurrection and the famous drawing of a demon (my 1619, Fig. 712). The neck has the length and the head the detachment of the Giuliano in the Medici Chapel and later figures. The neck in his earlier creations is shorter. The torso recalls the Cavalieri drawings. The r. arm is unintelligible, the l. arm much better. Tolnay reproduces it in *Jahrb. Pr. K. S.*, 1933, p. 97, and believes this bravura sketch to be the earliest surviving drawing by M., dating it toward 1489. This is another instance of what differences of opinion are still possible in judging of M.'s drawings.

1463 HAARLEM,[1] Teyler Museum, No. 1—Study for the figure in the Bathers helping to buckle up the armour of his friend, a bit of whose abdomen is roughly sketched in. Also the shoulder and profile to l. of a man looking away, perhaps for the [discarded motive represented by several sketches (see my 1479, 1481, 1598; Figs. 596, 597) of two soldiers holding up a third] (p. 192, note). Bl. ch. 40.5 by 26. Marcuard, pl. ɪ. [Frey, 305. Brinckmann, 85. Popham Cat., No. 211. Steinmann, II, p. 627. Knapp, *M.*, pl. 15.] Verso: Rapid, large jotting, with softer chalk than used on the front, of a subject not readily determined. In a door lies a dead figure in an uneasy posture. To l., two figures, one of whom places something on the head of the other. To r., two men look on. Marcuard, pl. ɪɪɪ. [Frey, 306. Brinckmann, 86. Steinmann, II, p. 628.]

A clear, grand arrangement, but for what? Possibly for a fresco representing Judith walking off with the head of Holofernes. The fact that the reclining figure still has his head on is scarcely ground for doubting this suggestion, for in a sketch so rapid as this the artist might not have thought of first decapitating him. This is among the most rudimentary of M.'s studies, and its bold, masterly qualities are particularly recommended to those who would believe in the authenticity of the Uffizi and Berlin designs for the Tomb of Julius, on the ground of their being hasty jottings. The nearest parallel to this study is a rough sketch in the B. M. for an almost shapeless reclining figure of no de-

1. These drawings have been published in remarkable facsimile by Bruckmann (Munich), with slight notes—excellent so far as they go—by Herr F. von Marcuard. For greater convenience of reference I catalogue them here, not as I found them in the portfolios, but in the order they have in the publication.

terminable purpose (my 1480). Close to it is also the torso for a Dead Christ on the back of the B. M. pen-notes for the Sixtine decorative nudes (my 1484; Figs. 613, 731).

[Professor Brinckmann maintains that this and following drawings are copies after the corresponding frescoes and uses exquisitely ingenious and highly elaborate but irrelevant arguments to prove his point. In my opinion they are not copies but autographs by M. I know of no one contemporary with that master or later who drew in a way so indistinguishable from him. Opinions apart, one thing is that if they are not originals they are perfect copies not after the frescoes, but of autograph sketches by M. and therefore can count in the study of the artist's mind as if they were originals (see my 1544B, Fig. 631). The reproductions of these drawings in the supplement to Frey give no idea of their quality, and arguments based upon them are worthless.]

1464 HAARLEM, TEYLER MUSEUM, No. 2—Study for the nude lancer in the Bathers, who reaches forward with a lance in his r. and drapery in his l. hand. The r. hand and the inside of the r. knee are repeated. Also another hand and foot (p. 192, note). Bl. ch. 40.5 by 26.5. Marcuard, pl. II. [Frey, 303. Brinckmann, 84. Knapp, *M.*, pl. 16.] Verso: A torso in reclining position, the profile head and the l. arm vaguely indicated, the r. leg and arm scarcely at all. Also three rougher sketches of a knee. Perhaps for a Pietà or Dead Christ, and not unconnected with such other early studies for this subject as the one just mentioned in the B. M., the one belonging to the Hon. A. E. Gathorne-Hardy, and the two replicas in the Casa Buonarroti, and at the Louvre. Marcuard, pl. IV. [Frey, 304. See last paragraph of my 1463.]

1465 No. 5—Study for the decorative nude in the Ceiling above the Persica, and next to the
Fig. 615 Creation of the Sun and Moon (p. 198, note). [Compare the quality of this sheet with my 1476 (Fig. 587).] The head less elaborated. As Marcuard observed there is no space on the leaf to draw the arm in connection with the shoulder, for which reason it is sketched separately. R. ch. 28 by 21. Marcuard, pl. V. [Frey, 308. Brinckmann, 94. Steinmann, II, p. 613. Knapp, *M.*, pl. 56.] Verso: Studies of detail from the model for
Fig. 622 the group of the God the Father and attendant spirits in the Creation of Adam (p. 199). Each figure or limb is to be identified with the greatest facility, and indeed an inventory of the whole has been made by Marcuard. Marcuard, pl. VI. [Frey, 309. Steinmann, II, p. 614. Two of the decorative attending figures in bl. ch. and on smaller scale were drawn earlier than the larger ones in bl. ch. See last paragraph of my 1463 and what is said under my 1544B (Fig. 717).]

1466 No. 7—Study from the model for the head of the nude sketched on the last leaflet, one for the l. leg, and two for the r. leg of the Creator in the Creation of Adam (p. 198, note). R. ch. 26.5 by 19.5. Marcuard, pl. VII. [Frey, 310. Steinmann, II, p. 615. Amsterdam Exh. Cat., No. 590.] Verso: More rapid sketches for two of the *putti* clinging one over the other close to the Creator's r. side in the same composition. Also the study of a torso seen from the back, and of a knee, the purpose of which cannot be conjectured. [In bl. ch. the outlines of sketches for decorative seated figures and some undecipherable scrawls.] Marcuard, pl. VII. [Frey, 311.]

Perhaps the point of greatest interest in these two leaflets is the finding, intertwined, as it were, upon them, detailed studies for two separate if neighbouring compositions. The verso of my 1465 (Fig. 622), where we see the legs for the Creator of Adam, and the head for the decorative nude on the other side of the next composition, all done, most probably, at the same sitting and with the same model, implies even more than the other studies on these two leaflets that at this time the complete design for the Separation of Earth from Water, no less than for the Creation of Adam, must already have existed. It follows, therefore, that M. in this instance got two, at least, of the compositions ready for execution before he began to paint either. The idea then occurs to one that this may not have been a solitary instance.

1467 HAARLEM, TEYLER MUSEUM, No. 11—Two leaves pasted together, containing studies for the knees
Fig. 672 of Giuliano, the l. knee and thigh of Night, and the r. thigh and leg of Day (p. 221,
note). 41 by 21.5. Marcuard, pl. XI. [Frey, 314.] Verso: Plans and sketch for a façade,
of indeterminate character, intended probably for the Library of S. Lorenzo, and not nec-
essarily contemporary with the studies on the front, it having been M.'s habit to take
up for sketching the first bit of paper that came to hand. Pen. Marcuard, pl. XII. [Frey,
315. Wittkower, *Art Bulletin*, 1934, p. 146, fig. 19.]

1468 No. 13—Study for St. Lawrence in the Last Judgement, in the exact attitude that he has
Fig. 709 in the fresco (p. 230). The quality is altogether admirable, the soft bl. ch. used with
the utmost effectiveness in the contours. Also, on much larger scale, the head of the
same figure. Bl. ch. 24 by 18. Marcuard, pl. XIII. [Frey, 322. Brinckmann, 83. Stein-
mann, II, p. 671. Knapp, *M.*, pl. 92.] Verso: Torso and legs of male figure seen from
behind, standing firm, with legs far apart, the body bending to r. [In silhouette having
a certain likeness, as Prof. Panofsky points out (see *Rep. f. K. W.*, 1927, p. 43 and fig. 12)
with a figure in the Crucifixion of Peter, but too different in action and spirit to have been
drawn for it, and more likely for the Last Judgement again, perhaps for the figure to l.
and above the Isaiah. The hatching and modelling in spite of the lapse of time as in
my 1479 (Fig. 596), for the Bathers. Marcuard, pl. XIV. [Frey, 323. Popham Cat., No. 225.
Steinmann, II, p. 672.]

1469 No. 16—Two cross-sections for cupola and its lantern, with two separate sketches for
the latter. One or more nearly effaced nudes. Pasted on, a small sketch for a town gate.
Bl. ch. 40 by 23.5. Marcuard, pl. XVI. [Frey, 326.] Verso: Segment of plan for cupola.
Four or five several studies for prophets or apostles, each in his rectangular niche. One
gets up to speak. Another is seated like Botticelli's little St. Augustine (Uffizi) lost in
contemplation. Marcuard, pl. XVII. [Frey, 327.] The cupola must surely be St. Peter's.
The gate may be the Porta Pia. The destination of the sketches for prophets is unknown.

1470 No. 18—Sketch for prophet of same kind and date—about 1550—as the last, but of greater
interest. He is very aged and has been reading. He gets up while shutting his book,
and glares with deep-set dimmed eyes but awe-inspiring look. It is the Ezekiel of the
Ceiling, or better still, the marble Moses, with the difference that here he is done by an
old man and there by a youth, here with a more spiritual and there with a more physical
conception. Also the upper part of a similar figure, and an architectural plan. Bl. ch.
13.5 by 18. Marcuard, pl. XVIII^A. [Frey, 328. Knapp, *M.*, p. 58.] Verso: Vigorous nude
Fig. 772 looking up to r., with his l. arm reaching across to something that a boy is holding in
his arms (p. 356). Also one or two other scrawls of figures [that in connection with
what follows result as being Dido on her couch.] Marcuard, pl. XVIII^B. [Frey, 329.
Knapp, *M.*, p. 59.

 Professor Wilde has published this as study for a picture by Daniele da Volterra
mentioned by Vasari (now in an unnamed Swedish Collection) which represents Mercury
bidding Aeneas to depart from the couch of Dido (see *Belvedere*, 1927, pp. 142-143,
figs. 1 and 2). Undoubtedly the drawing served for the picture but it is not by the hand
of the painter, as it has all the dynamic ponderousness of the aged M., as well as his
tricks and mannerisms of notation at that period. Daniele reduced it to something sleek,
half elegant, half brutal. Why should he draw so differently from the way he paints?
He does not even quite transfer the drawing to his cartoon. Not only is the rest of his
composition totally unlike the drawing, but the two principal figures are much more vertical,
more "classical" in the bad sense, than M. ever is. I know no drawing plausibly ascribed
to Daniele that offers a justification for this attribution. What we have here is a note
made by M. for one of his parasites, in this case Daniele da Volterra. This, by the way,
is a flagrant instance of the attribution of a drawing because it corresponds to shapes in
a painting.]

1471 HAARLEM, TEYLER MUSEUM, No. 21ᴬ—An almost effaced and originally hasty sketch perhaps for
a Fall of Phaeton. R. ch. 11 by 19. Marcuard, pl. xxiᴬ. [Frey, 319. Baumgart, *Boll.
d'A.*, 1934/35, p. 348. Verso: Rapid linear indication of figure running to r., probably
for the same purpose. Prof. Panofsky (*Rep. f. K. W.*, 1927, pp. 38-40, figs. 10 and 11)
is positive that this drawing is by Daniele da Volterra and for a Resurrection or Con-
version of Paul or better still for a Moses breaking the Tablets of the Law, connecting it
with a picture at Dresden ascribed by Voss (p. 132, fig. 34) to Daniele da Volterra.]

1472 No. 21ᴮ—Small sketch for a Hercules and Antaeus. Hercules is seen in profile to r.,
Fig. 681 holding the giant, who struggles with his legs and arms to get away (p. 224). Bl. ch.
11.5 by 10. Marcuard, pl. xxiᶜ. [Frey, 320. Verso: Tracing of outlines of same com-
position probably by a later hand, with Antaeus turned into a female. Marcuard, pl. xxiᴮ.
Frey, 321.]

1473 No. 24—Satyr seated in profile to l., with l. arm akimbo and r. elbow resting on knee.
Also a nude female bending to ground hoeing. A delightful early sketch, no later than
the Bathers, the satyr laid in with bl. ch. and finished elaborately with the pen, the female
in little more than outline with the pen. 21 by 23. Marcuard, pl. xxiv. [Frey, 307.
Verso: Two feet one in bl. ch. and a larger and inferior one in ink. Certainly not by M.
Frey, 307ᴬ. A warning to students who make too much of mere pen-work which here
as calligraphy is close to the master. As for the figures on the recto they may be by M.
but I am no longer sure of it. The satyr and small pen-drawings may be by "Andrea
di M." On the other hand, the proportions of the female are those in Battista Franco's
Noli me tangere (Venturi, IX, vi, p. 275). This figure was used by the author of the
drawing at Chantilly for the fresco representing Ceres at Fontainebleau that Dimier in
his book on Primaticcio ascribes to that decorator. The connection was pointed out by
Delacre in *Burl. Mag.*, 1935, p. 284. See also A. E. Popham in *Burl. Mag.*, 1935, p. 45.]

1474 No. 25—Female, of classical aspect and erect carriage, turns with hands folded in prayer
Fig. 573 to saint, perhaps Peter; beside her kneels a young man in adoration; also more rapid
indications of figure in similar attitude (pp. 186, 362). Pen. 27 by 19.5. Marcuard, pl. xxv.
[Frey, 301. Knapp, *M.*, pl. 78.] Verso: Draped youth in profile to r., stooping as he
Fig. 574 walks (pp. 186, 362). [Suggests some such figure as the Masaccio-Pesellinesque verso of
my 1602 (Fig. 570) behind outlines of older person in same attitude. Frey, 302.] Looks
like copy after an earlier master. The two males on the recto would suggest Masaccio,
yet neither the slenderness nor the drapery of the female recalls [him but rather Fra Fi-
lippo and Pesellino. Recto and verso may reproduce r. and l. of some oblong composition.]

1474ᴬ (former 1676) Portfolio B. 46—Nude youth, of almost Egyptian proportions, staggering forward with
Fig. 600 head thrown back (p. 347). Pen. 19 by 10. Ascr. to Giulio Romano, but near enough
to such early drawings by M.—as, for instance, the Louvre sketch for the bronze David
(my 1585, Fig. 577)—to demand mention [and possibly connected with the cartoon for the
Bathers. Verso: Scrawls for several figures, one of them female, in various attitudes.
Too unintelligible to be attributed to any one. Four lines of script close to M.'s early
writing but stiffer. Above them appear the lower ends of letters showing that the leaf
has been cut.]

1475 LILLE, MUSÉE WICAR, No 95—Seven grotesque heads (p. 223). This is a drawing of somewhat earlier
Fig. 677 date, I should judge, but of the same kind as the one in the B. M. Morelli consistently
ascribed this one also to Bacchiacca (*Kunstchr*). R. ch. 20.5 by 31. Braun 72035.
[Panofsky, *Zeitschr. f. B. K.* 1927/28, p. 229.]

1475ᴬ No. 231—Draped figure (p. 187, note), already catalogued as by Granacci under my 984,
Fig. 580 and the hatching is there described as: "remarkably close to that of the very young M."
Looking at this hatching again in Oct., 1911, I concluded that it was M.'s own and I
confirmed this conclusion in Feb., 1929. In 1934, while rereading Vasari's Life of M.,

I came across a passage that I had forgotten (VII, p. 139) which may be paraphrased as follows: "As it happened that one of the young men who were learning with Domenico (Ghirlandajo) had with the pen drawn certain draped female figures after originals by the master, M. snatched the sheet and with a coarser pen redrew one of these figures with outlines of his own and in the way it should stand if it was to stand properly. It is a wonder to see the difference between the two ways of drawing, and the quality and sense of a youth so spirited and sure of himself that he felt he could improve the work of his master. This sheet is now in my possession, treasured as a relic, for it was given me by Granacci to place it in my book of drawings along with others that M. had given him. In 1550 Giorgio (Vasari) being then in Rome showed it to M. who recognized it and was glad to see it again and added in all humility that he was a better draughtsman as a boy than he was now as an old man." It would be rash to conclude that the drawing before us is the same that Vasari had in mind in the passage just quoted. For one thing he speaks of a female figure and this one is rather masculine. On the other hand Ghirlandajo's youths (of one of which this is a copy) and particularly when, as in this case, the head is missing, can almost as well pass for one sex as for the other. Add the probability that the drawing was first done by Granacci, who thus would be the young apprentice of the above narrative, that it was he who gave it later to Vasari, the possibility that this is the image described is by no means to be excluded, particularly as Vasari's descriptions seldom sin through precision. Even if this is not the identical sheet, it must be of the same kind and date, and if we admit that the hatching is by M. on a drawing after Ghirlandajo by an apprentice of the latter it furnishes diagrammatic, indeed almost geometrical, proof that the same Ghirlandajo and no other was the master who taught the youthful M. how to draw and formed his style as a draughtsman. Needless to say that this pen-hatching may be the earliest trace of M.'s work that has come down to us.

1476 LONDON, British Museum, 1887-5-2-116—Study for a figure in the famous cartoon of the Bathers
Fig. 587 (p. 191). Showing us the back of his head, he turns to the r. to climb onto the bank, one leg already touching it, the other hanging over. In Agostino Veneziano's engraving after part of the cartoon this figure occurs in the exact position he has here. Pen, touched with wh. 41.5 by 28. Repr. in Symonds, I, opp. p. 168. [Frey, 103. Vasari Soc., II, ix, 1. Alinari 1680. Brinckmann, 11. Venturi, *M.*, 29. Toesca, *E. I.*, pl. xviii.] Verso: Various rough sketches of legs and two male nudes seated, all for the Bathers, the nudes being just possibly a first idea for the man putting on his hose. The legs were perhaps for the group of two soldiers one of whom is helping the other fasten on his armour. [Frey, 104.]

 The sketch on the recto has been worked over more than a little, which fact doubtless accounts for much in it that is unsatisfactory; but, restorations apart, it could never have had that decision, that freedom, that complete mastery which we should expect to find in a drawing by M. for his greatest archievement in draughtsmanship. Yet we must swallow our disappointment. Relatively tame and anxious as is the execution of this nude, it would yet be rash to jump to the conclusion that it is not M.'s. The fine close hatching is most characteristic of him, and while it is true that from him we should have expected more, who else working in this style is there from whom we expect so much? The sketches on the back [are still less satisfactory. I hesitate to say they are not by M. although I should prefer to believe they were by a pupil drawn over faint and no longer visible indications by the master.]

1476^A 1859-5-14-820—Study for l. leg and for foot pushing against knee of same leg (p. 221, note). R. ch. 21.5 by 16. Braun 73006. Kind and quality of my 1399^C. Apparently for the Day in the Medici Tombs.

1477 1859-5-14-821—Leg of figure seated in profile to r. Of the figure the torso only is indicated, and that but vaguely. Under the leg is written *in fuora*. Pen. 28 by 25. [Frey, 192.]

Verso: Torso of erect figure with shoulder and beginning of arms suggesting the possibility of it's being connected with the Haman. Bl. ch. [Frey, 191.] This is a leaf of fairly early date.

1478 LONDON, BRITISH MUSEUM, 1859-6-25-563—Torso of figure standing and facing nearly to r., and the
Fig. 590 same in scrawled outline (p. 192, note). Bl. ch. 22.5 by 16.5. [Frey, 183.] This may be a study for the soldier in the Bathers who helps his friend to buckle his armour, or indeed for the Adam in the Sixtine fresco of the Temptation of Eve, and, at all events, is of that early period (much more probably the soldier).

1479 1859-6-25-564—Two nude acrobats holding erect in their hands a third, also nude; at one
Fig. 596 side of the sheet an almost colossal nude with a child between his knees—a study for the Bruges Madonna (pp. 188, 194, 346, 350). 31 by 28.5. Braun 73016. [Frey, 45. Alinari 1682. Brinckmann, 9. Venturi, *M.*, 32. Popp, *M. K.*, 62.] Verso: A repetition of the acrobat on the r., two *putti* exactly like those on the back of the drawing to be catalogued next, and in inverse direction a splendid study from the *écorché* of a l. leg, and above it four lines of an interesting sonnet (p. 347). These reprinted in Frey's *Dichtungen*, XXII. [Frey, 46.] The acrobats and the nudes on the back are in bl. ch., the remainder in ink.

The sketch of the acrobats represents perhaps an earlier stage of a drawing in the Louvre, than which, however, it is much more spirited and prompt. A kindred motive occurs in the Oxford drawing (my 1564, Fig. 630) for the Sixtine fresco of the Brazen Serpent. [The proportions of the Madonna have already the heroic athletic character of the Last Judgement period and should serve as a warning against considering only one factor in the problem of dating drawings. But for the Child many students might have been tempted to assign this nude to the fourth rather than the first decade of the 16th century. As for the acrobats it now seems that they represent an earlier idea for the Bathers where two soldiers were to have held up a third who was to find out from which side the enemy was coming. Adolfo Venturi (*M.*, pl. 45 and pl. 32) has before me reached this conclusion. Cf. also my 1481 (Fig. 597) and 1598 as for same composition. In that case the study of a l. leg which occurs on the recto of this sheet and on my 1598 would be for the r. leg of the soldier who is being held up, only that it is reversed.]

1480 1859-6-25-558—Reclining almost shapeless nude female (p. 349). Bl. ch. 28 by 22. [Frey, 221.] A blurred scrawl [interesting chiefly as notation done perhaps in connection with lunettes of the Ceiling.] To be compared with my 1463 verso, and probably of that date.

1481 1887-5-2-117—Slender nude with straggling curly hair turning sharply to r. with l. arm held
Fig. 597 out while he walks in opposite direction (pp. 194, 347). The chest and abdomen are elaborately hatched: the legs are barely sketched, the r. arm not even indicated. The other arm is thin and long, like the one for the David in the Louvre drawing (my 1585, Fig. 577). Also a l. leg of *putto* slightly indicated in bl. ch., and the first lines of a sonnet written in sprawling chalk. Pen. 37 by 21.5. [Frey, 92. Vasari Soc., I, viii, 5. Alinari 1683. Brinckmann, 10. Venturi, *M.*, 28.] Verso: Eight separate *putti* in different attitudes
Fig. 578 and in various degrees of finish (p. 188). Near one of the *putti* are the words in M.'s hand: "Lessandro manecti." The inscription in another but contemporary hand, "chostì di brugis," is repeated twice, once beside a *putto* in profile to r., and again close to one who is seen nearly full face. [Frey, 91. Alinari 1688. Brinckmann, 18.] There is nothing in either peculiarly close to the *putto* in the Bruges Madonna. [One of them is close to the infant Baptist in the Royal Academy *tondo*.]

It is interesting to note that there is a strong resemblance between these *putti* and Desiderio's famous marble one at S. Lorenzo. [The nude on the recto seems (1934) connected with the group of three figures in my 1479 (Fig. 596) and 1598, which must have been meant for the Bathers. And as on the verso of my 1479 there are drawings for *putti*

and on the recto a full sketch for the Bruges Madonna, the almost contemporary writing referring to Bruges on this sheet would indicate that the *putti* here as well, although never used, were drawn while M. was thinking about the composition of the Bruges Madonna.]

1482 LONDON, British Museum, 1895-6-25-547—Haughty sibyl-like young woman, seated and visible
Fig. 609 down to below the knees (pp. 197, 250, 252; 317, note; 361, 362). A nude, in much smaller proportions bending forward to r., seems to stand like a Liliputian in her lap, but was doubtless drawn first. Sketched in with r. ch. and then freely with the pen. 32 by 25.5. Pl. cxxxiii of F. E. [Frey, 184. Braun 65021. Alinari 1674. Brinckmann, 29. *L'Arte*, 1935, p. 257.]

This is perhaps as near an approach to portraiture as we shall ever find M. making. Very striking is the height of the cranium, a characteristic also of the Madonna in the Pietà at St. Peter's. The features and the look, however, bring this drawing nearer to the time of the Sixtine Ceiling. The stroke points to a date somewhat earlier than these frescoes, and recalls such a drawing as the one at Oxford of soldiers conversing (my 1545, Fig. 790). In his exemplary study on the early career of M., Wölfflin (*Die Jugendwerke des Michelangiolo*, Munich, Ackermann, pp. 61 and 63) dates this head 1505. It certainly is no earlier, and perhaps somewhat later. Verso: Young woman seen to below waist. She
Fig. 777 turns somewhat to l., has refined features, and a much gentler expression than her sister on the obverse (pp. 250, 252, 360, 361). Bl. ch. [Frey, 185. *L'Arte*, 1935, p. 257. I leave this as it was written thirty-five years ago and but for the dating, which is certainly later, it may still stand. What I now feel and think may be read in Appendix XV.]

1483 1859-6-25-567—Study for scheme of decoration (pp. 197, 349). In a spandrel a throne
Fig. 612 where sits a male figure. To r. and to l. are circles framed in squares, and above the throne a diamond tipped with smaller circles. Part of the sheet is taken up by two sketches of hands, one of a whole arm, and another of part of an arm. The decoration is in ink with the pen; the remainder in bl. ch. 27.7 by 39.5. Repr. (the decoration only) in Symonds, I, opp. p. 385. Wölfflin, *Jahrb. Pr. K. S.*, XIII (1892), p. 179. [Frey, 43. Brinckmann, 21. Knapp, *M.*, p. 30. Toesca, *E. I.*, pl. xviii. Frey (see Text, p. 26) suggests that the hands and arms may be studies for the l. arm of Adam in his Creation. In that case they would have been added later, which is not improbable.] Verso: Cast of drapery, and a youthful slightly draped figure done perhaps from the model, and probably intended for one on the Ceiling. Pen. [Frey, 44.]

Steinmann (II, pp. 202 and 594) thinks it is a study for the nude to r. over the Delfica. Although the intention of this study for decoration would seem obvious, it has only recently been recognized. It is a sketch for the first scheme of decoration for the Sixtine Ceiling, which M. perhaps actually began, and then gave up as being "too slight and mean." Wölfflin was the first—and for some time the only one—to realise its purpose and importance. I refer the student to his brief but pithy article in the *Jahrb. Pr. K. S.* (XIII, 1892, pp. 178-182), where he makes also a most interesting attempt to reconstruct the chapel as it would have looked if this scheme of decoration had been carried out.

1484 1859-6-25-568—Three separate studies of beautiful nude youths sitting, of whom two are
Fig. 613 pulling at ribbons; at one side a kneeling figure with his bent arm held up (pp. 198, 200, 267). Pen. The kneeling figure in bl. ch. gone over with ink. 24.5 by 19. Verso: Male torso
Fig. 731 (p. 234). Bl. ch. [Frey, 121 and 122. Brinckmann, 34. Venturi, *M.*, 39. Steinmann, II, pp. 609 and 610.]

Manifestly studies for the various single figures of nudes in the Sixtine Ceiling, none of these three is to be found there exactly as it appears here. The nearest resemblance is between the uppermost one in the sketch and the youths in the monochrome space above the painted arch over Rehoboam. The kneeling figure should be compared with the Cupid at S. Kensington. It has a *pentimento*. At first the nude was kneeling on

both his knees, then on the r. only. In going over with ink the kneeling on both knees was emphasized. Certainly this sketch is as close to the Cupid as any of the other figures on this sheet are to the Sixtine nudes. Yet I would not vouch for it that M., while drawing it, had in mind the Cupid rather than one of the crouching or kneeling nudes in the Ceiling. One fact, at all events, is established by this leaf: that the Cupid belongs to the period and style of the Sixtine nudes. The male torso on the back of this leaf is unexpected. It is of a lifeless seated figure, the head, arms and legs slightly indicated—probably for a Dead Christ. If I had encountered this study by itself, it would scarcely have occurred to me to question that it belonged to no earlier period than the Last Judgement. There is something of the late *bravura* in the forms and spirit, and there is also the loose, careless touch of later years. But at the same time it should be observed that in rapid and large chalk sketches M. differs little from epoch to epoch—too little, at all events, for ready distinction—so that it is probable that this almost Baroque sketch was done at the same time as the exquisite flowers of Quattrocento art on the other side. A careful comparison with the study for a Dead Christ in the Casa Buonarroti will change this probability into certainty. The advanced aspect may further be accounted for, in part at least, by the softness of the chalk and the rapidity of the stroke. It is by no means uncommon for an artist thus to anticipate some later phase of his own style. [Steinmann (II, p. 594) goes so far as to say that the torso was done for the Slave over the Sibylla Delphica. While not excluding the possibility, there yet is a definite pathos here which, to my feeling, would only suit a Dead Christ. Why shouldn't M. in a moment of listlessness or fatigue or mere leisure during his work on the Ceiling have planned to do a Dead Christ, a subject, be it remembered, that preoccupied him through the whole length of his career? In the Ca' d'Oro there is a Dead Christ upheld by two angels in which the Saviour corresponds so well with this torso that one cannot but suppose that the artist, Pordenone as it happens, must have been acquainted with a picture done after this drawing; for he is not so likely to have known the drawing itself.]

1485 LONDON, British Museum, 1887-5-2-118—Sketch for a prophet on the Ceiling, but for an early phase of that work, and not executed. He sits with his knees crossed in profile to r. in an attitude recalling the Erythraean Sibyl. Badly worked over with the pen and bistre wash, this figure at first seems like a pupil's copy. Careful study convinces me, however, that the outlines in bl. ch. and some of the pen hatching are M.'s. Bl. ch. and pen. 38 by 25. Repr. in the "Lawrence Gallery." [Frey, 94. Steinmann, II, p. 647.] Verso: Rapid sketch for a decorative nude in profile to r., also for the Ceiling, and smaller and vaguer sketch for another of these nudes. Also a hand recalling the l. hand of the Erythraea. Bl. ch. [Frey, 93].

1486 1887-5-2-115—Study for the Isaiah (p. 198). He sits slightly reclining, with his r. elbow
Fig. 614 and l. hand resting on a pedestal on the l. His face is in profile to r. A nude *putto* stands beside him. This is one of M.'s most interesting pen-drawings. Pen and bistre. 42 by 28. Magnificently repr. by Ottley, opp. p. 32. [Frey, 242. Vasari Soc., I, ix, 4. Steinmann, II, p. 644.] Verso: Sketch for an ecclesiastic ceremonial by some Raphaelesque Florentine. Slight bl. ch. [Frey, 243.

 Steinmann (II, p. 600) was the first to protest against the accepted designation of the figure on the recto as sketch for the Isaiah. His arguments why it should have been intended for a Sibyl are not conclusive, although the arm lightly outlined on the r. seems to belong to a female rather than to a male. Perhaps the solution to propose is something like this: the arm just mentioned may have belonged to a figure with a certain attitude and expression that M. had not yet decided to give to any person in particular. It may even have been of indeterminate sex. Then it occurred to him that it best suited his idea of the Prophet Isaiah; it underwent further modifications before it was painted.]

1487 1859-6-25-555—First sketch for the Haman in the Sixtine Ceiling (pp. 199, 206). Pen.
Fig. 624 25 by 16. Pl. cxxxvi of F. E. [Frey, 281. Brinckmann, 28. Steinmann, II, p. 630].

Perhaps the most rapid and spirited of all M.'s drawings, surpassing even the earlier sketch (my 1585, Fig. 577) for the bronze David, with which, by the way, it should be compared by any one inclined to doubt its authenticity. He might also look at the sheet (my 1481; Figs. 578, 597) with the nude youth on the obverse, and the *putti* on the reverse. An admirable bit of shorthand is the corkscrew scrawl which renders with the same stroke both the roundness and roughness of the tree-trunk. The action of the upper figure anticipates the Bound Captive (now in the Louvre), upon which M. was working two or three years later, in 1513. It also should be noticed how perfected already in this figure is M.'s favourite attitude as it occurs so frequently later, one leg stretched out and the other bent at the knee [as in the Tityus.]

1488 LONDON, BRITISH MUSEUM, 1859-6-25-554—Torso and legs only of small nude figure seated; vertically to the torso the bust of a youth as if in rough cast [and opposite to last an urn]. Also, in every direction, writing, most of it scratched out, and the rest of no interest. I have no idea of the purpose of these sketches. The nude might conceivably be connected with the angels in the Creation of Adam, but this is not probable. It is of the exact kind of a nude for a Crucifixion at Christ Church (my 1574, Fig. 727). Pen and bl. ch. 12 by 12. [Frey, 137A.]

1489 . . . 1854-5-13-1—Athletic nude with arms tied behind struggling to get free, but bent nearly
Fig. 641 double with the effort, the l. leg pressed hard under the thigh (p. 203). Hard r. ch. 24.5 by 20. [Frey, 215.]

This rapid but masterly sketch, which has all the essential qualities of M.'s feeling and touch, must have been meant for the figure of a slave—perhaps for the one we now see in the Victory at the Palazzo Vecchio—intended for the Tomb of Julius. The attitude suggests certain of the decorative nudes in the Sixtine Ceiling. This, among other considerations, leads us to place it between the completion of the frescoes and the commencement of the plans for the façade of S. Lorenzo. But the way of indicating the contours with curving lines which cross one another is singular, and exactly paralleled in only one other drawing, and that of the period of the Last Judgement, namely a leaf in the B. M. (my 1508, Fig. 707), with a study among others perhaps for a scene in Dante's Purgatorio. This consideration need, however, not disturb us in assigning the sketch to an earlier date. [M.'s technique and stroke change little in the course of his lifetime. The only "fool-proof" indication of date that I venture to name is that in no drawing earlier than the Cavalieri series does M. attempt to model with an effect of rubbing.]

1490 . . . 1859-6-25-557—Three faces of satyrs (pp. 223, 224). Studies doubtless for grotesque
Fig. 678 heads, such as we now see in the marbles at S. Lorenzo, but dating perhaps a few years earlier, and intended perhaps for the Tomb of Julius. Also a rapid sketch for a Hercules and Antaeus. On the l. of the sheet is a vaguer indication of a head, probably also M.'s. R. ch. 25 by 34. Pl. cxxxvii of F. E. [Frey, 31. Alinari 1677. Brinckmann, 43. Steinmann, II, p. 680. Popp, *M. K.*, 65. Toesca, *E. I.*, pl. xix.]

As grotesques, these heads vie with any others, ancient—which inspired them—or modern. The way of mapping out the features should be compared with the stroke in the sketch for the slave, last catalogued. The shading is characteristic. The touch throughout is free and firm. Nevertheless, Morelli would ascribe this sheet to Bacchiacca! (*Kunstchr.*, 1891-92, p. 212).

Verso: Two athletic nudes looking up, [to our l. vague indication of a figure in similar action], and in bl. ch. two other grotesque heads. [Frey, 32.]

The nudes are among M.'s noblest achievements, both as draughtsmanship and as design. They nearly face one another, starting forward with staves in their hands, each holding up an arm, and looking up as if to ward off an assault threatening them from above. The actual drawing is not infallibly correct, but is of scarcely surpassable swiftness and vigour.

1491 LONDON, BRITISH MUSEUM, 1859-6-25-544—Mere outlines, rapidly jotted down, of two aspects of a
Fig. 644 figure kneeling in the attitude of the Doni Madonna, but with the arms in the position held
by the Eternal in the separation of Light from Darkness in Sixtine Ceiling (pp. 203, 205, 206).
The heads are barely indicated. Measurements in braccia are noted down at various points.
Pen. 13.5 by 21. [Frey, 60. Brinckmann, 42. Popp, *M. K.*, 46. Meder (*Handz.*, p. 364,
fig. 139) and Popp (*M. K.*, p. 146) have noticed that these sketches are not, as I thought, for
two different statues but for one seen in two different ways, once frontally and once in
profile.]

 This scrawl gains value from its obvious intention. Evidently it was one of the many
sketches sent to the stonecutters at Carrara or Seravezza to guide them in blocking out
the figures quarried at M.'s orders. Of such drawings there is frequent mention in the
contracts and correspondence between the artist and the workmen. It would be of high
interest to discover which statue was to be fashioned out of the marble to be thus rough
hewn. I have looked through the contracts and letters between M. and the stonecutters
in the hope of finding a correspondence between the measurements in the drawing and
any of those given there; but in this again I have had no success. [Popp (*M. K.*,
pp. 145-46) fancies that it may have been for the river gods and of later date.] My impres-
sion is that this sketch should be dated about 1520.

 Before leaving it, just a word more. Here we have a drawing which was done with
as much unconsciousness of aesthetic intention as is the writing itself. Yet its quality
as touch, even as expression of function, is of the highest. I would have this brought
to the attention of writers who attribute to M. such idiot-drawings as the one in the
Uffizi for the Tomb of Julius, on the ground that in work of this nature there was no
aesthetic intention, and that therefore its puerility does not exclude its being from M.'s
own hand. Now *correct* draughtsmanship may doubtless have much to do with the
artist's intention; but the quality of touch, the life, the sparkle, the vibration have just
as much to do with his intention as the shape of his head or the colour of his eyes. The
age of discretion once attained, and dotage not yet reached, the great draughtsman cannot,
if he would, draw lifelessly.

1492 1859-6-25-549—Sketch for the capital of a column. R. ch. 13 by 21. [Frey, 131.]

1493 Pp. 1-58—Nude, matronly female seated turning a little to her l., but her face almost in
Fig. 676 profile to r., with the Child firmly straddling her knee, and sucking vigorously at her
breast; on the r. roughly sketched the head of Joseph, and below it in mere outline the
infant Baptist nude (pp. 222, 248, 302). Bl. ch. 31.5 by 19. [Frey, 270. Knapp, *M.*, pl. 83.
Brinckmann, 17. Venturi, *M.*, 30.]

 This beautiful drawing, which is obviously for a Holy Family, commonly passes as a
study for the marble Madonna in the New Sacristy at S. Lorenzo. In a certain sense
that opinion is well founded, but I question whether, when M. was sketching this design,
he already had in mind the sculptures of S. Lorenzo. With a view to these he went, as
we know, on April 9, 1521, to Carrara, occupying the twenty days or so that he spent
there in making sketches and models for this undertaking. A drawing for the Madonna
as she actually was to be carved out of marble must have been ready on April 23, for
on that day M. contracted for the necessary marble, and for the blocking out of this group.
That drawing could not have been the one now before us. For one thing, it probably
was a mere scrawl with measurements, like the one we have just examined in this
collection. Then the divergence both in the movement and the action of the Virgin is
too great, and the Joseph and infant John are composed pictorially, not sculpturally.
In point of style and manner this sketch [1] is not far removed from a sheet in the Louvre
drawn on both sides (my 1584; Figs. 626, 733), which contains on the front nudes

1. The Madonna's hand still has the early form that we know in the Bargello *tondo*, and meet again in the fine sketch at Oxford
for the child beside the Libyan Sibyl (my 1562, Fig. 632).

carrying a corpse, and on the back a woman and children. Now that sheet is certainly related to the period of the Sixtine Ceiling, if indeed it was not to some extent intended for that work. Our Madonna, it should however be granted, can be placed three or four years later. Again, there are two other studies in which the same motive recurs with slight modifications. One is in the Louvre (my 1589 verso, Fig. 640), the other in the Albertina (my 1603, Fig. 675). But for many reasons these may not be dated as late as 1521, and should indeed be put back a number of years. The conclusion we must reach is that all these drawings, of which the one we are now examining probably was the latest, were executed [without specific destination] as studies for the Madonna suckling the Child, and that when M. came to work upon the sculptures for S. Lorenzo he made the agreeable discovery that these studies had advanced him on the road to the completion of the Madonna for that monument. [I note (1934) sufficient likeness between this nude and the nude on my 1598^B (Fig. 618), which certainly is for the Sixtine Ceiling, to justify us in dating it from the end of that period or soon after.]

1494 LONDON, BRITISH MUSEUM, 1859-6-25-545—Plans, elevations, and studies for the Medici Tombs in the
Fig. 661 New Sacristy at S. Lorenzo (pp. 218, 353). The most important features here are the following:
Fig. 662 on the upper right-hand a sarcophagus with a cover consisting of a circular slab resting on volutes, standing against a wall under a small square opening flanked by two tall niches. Then, on the l. but lower down, the front and sides of a monument, each façade of which contains, as sculptural decoration, two nudes in full relief, clinging to a large slab which rests on a sarcophagus. (Our reproductions, Figs. 661, 662, show two of the drawings on this sheet). Bl. ch. 21 by 22.5. [Frey, 39. Geymüller, VIII, fig. 15. Popp, *M. K.*, 73. Tolnay, *L'Arte*, 1934, pp. 13 and 19, figs. 10, 13, 17.]

The attitudes of these nudes vividly recall certain decorative figures in the Sixtine Ceiling. Of all the studies for the Medici Tombs with which I happen to be acquainted this is the earliest. It may indeed be earlier than the one—which surely must have been more elaborated, more of a show drawing—dispatched by M. to Cardinal de' Medici on November 23, 1520. At all events this sheet gives us some notion of how the monument, intended at first to have four sides, and to stand in the middle of the chapel, would have looked. Verso: Profile to r. of a face like a death mask. [Frey, 38.] Slight but fine. Its purpose is unknown to me. Of course it suggests the Dying Slave (in the Louvre).

1495 1859-5-14-822—Study for the Medici Tombs. Certainly from M.'s own hand, as the touch,
Fig. 665 the stroke, and the peculiar "shorthand" clearly prove. Two sarcophagi stand alongside. The cover of each, consisting of two shallow concave curves, supports a reclining figure. Under the sarcophagus on the l. lies a river god. Between the sarcophagi on a pedestal a colossal figure stands erect against the wall. To r. and l. are windows [or rather rectangular niches] resting on supports. The one to the r. is more elaborated. In the niche itself is the indication of a herma, and against its supports lean two nudes in smaller proportions than the other figure. That the wall forming this background was meant to have a certain thickness, and the monument a certain depth, may be inferred from the indication of figures at the sides. At the top of the sheet, but turned round, is a slight but clear sketch for the Twilight nearly as it was afterwards completed (pp. 209, 218, 219, 353.) Bl. ch. 26.5 by 19. Rep. Symonds, I, opp. p. 384. [Frey, 47. Brinckmann, 35. Venturi, *M.*, 187. Geymüller, VIII, fig. 17. Popp, *M. K.*, 24. Tolnay, *L'Arte*, 1934, p. 19, fig. 14.] Verso: Sketch containing a sarcopagus, and above it a large pedestal with two
Fig. 664 figures leaning against it, and over it a window [or rather niche.] This, although it may be simply a study for one half of the monument on the other side, seems more probably a sketch for the four-square monument. Also ground-plan of a square with a sarcophagus on one of its sides (pp. 218, 353). [Frey, 48. Geymüller, VIII, fig. 16. Popp, *M. K.*, 23, Tolnay, *L'Arte*, 1934, p. 13, fig. 8.]

Not only the plan, but, as well, the sketch going with it on the back, suggests a monument to stand free with four sides. But the more elaborated study on the front

must have been made after that idea was given up, for the notion of two sarcophagi side by side was obviously not to be entertained in connection with a monument to stand in the middle of the sacristy. On the other hand, we are not forced to assume that the sketch for the Twilight necessarily implies that this sheet belongs to an advanced period of M.'s labour over this monument. He may well have had the single figures clearly in mind from the very beginning. It was probably not these which gave him trouble, but the architectural and decorative design. Here the arrangement is still far from what finally was adopted. The likeness of the figures to those which probably existed in the scheme for the Tomb of Julius should be noted. It is interesting also to see how M. first intended to place the river gods.

1496 LONDON, BRITISH MUSEUM, 1859-6-25-543—Study for the Medici Tombs (pp. 206, note; 209, 219).
Fig. 667 Two sarcophagi on a platform against a high background, consisting of a base in three divisions, and above it a high windowlike opening flanked by a niche on each side. In this opening appears a tall seated figure, and in each niche the indication of a standing one. At the bottom of the sheet is an inscription, not divided into lines, which I copy out of Prof. Frey's invaluable edition of Michelangelo's verse:

> "La fame tiene gli epitafi a giacere,
> Non va nè inanzi nè indietro,
> Perchè son morti, e e' loro operare fermo."

Pen. 21.5 by 16.5. Repr. Symonds, I, opp. p. 380. [Frey, 9ᴬ. Geymüller, VIII, fig. 22. Popp, *M. K.*, 27ᴬ.] Verso: Two sarcophagi of the simplest possible kind, standing on
Fig. 668 a high platform against a wall in six divisions, the three below shorter, and forming a kind of base (p. 219). In the upper middle division a scrawl to indicate the figure. Just above each sarcophagus a seated figure, and, if I mistake not, the one at the r. is Lorenzo, and the other Giuliano, in something like the attitudes that they now have. [Frey, 9ᴮ. Geymüller, VIII, fig. 21. Popp, *M. K.*, 27ᴮ.]

This sheet, from M.'s own hand, is a further study for the arrangement of the Tombs in pairs along the walls of the Sacristy. The sketch on the back is clearly for the monument of the two dukes. The destination of the other is less certain. I state as a mere possibility that it was for the monument to Lorenzo the Magnificent and his brother Giuliano, in which case the seated figure would represent the Madonna which is now placed over their tombs.

1497 1859-5-14-823—Study, blurred and blotted, but perhaps the most interesting of all [the
Fig. 663 sketches] for the Medici Tombs, and certainly from M.'s own hand. On a pedestal rests a sarcophagus with two figures, recalling the Dawn and Twilight, reclining upon it. The heads of these figures are on a level with the top of the base of the background, which here is elaborately drawn, consisting of three openings above the base, the one in the middle being a square, and the others flanking it as windows. Between each two divisions are two columns or pilasters projecting considerably. Above this order are three further divisions, decorated in high relief, the one in the middle with trophies, the one on the l. with [crouching] figures. The top was to have been highly ornate. Below, on the platform, clear of the sarcophagus, lie two river gods. Against the l.-hand division of the base we see the seated figure of Duke Giuliano (pp. 208, 219, 220, 353). Bl. ch. 29 by 21. [Frey, 55. Geymüller, VIII, fig. 23. Popp, *M. K.*, 25. Tolnay, *L'Arte*, 1934, p. 19, fig. 15.]

The resemblance of this sketch to the monument as finally left is so striking that one feels tempted to believe that this is one of the last drawings that M. made for the Tombs. But there are difficulties in the way of this idea. The greatest of these is the indication, to one side, of Giuliano. Lorenzo is not drawn, but we scarcely can conceive of Giuliano thus subordinately placed to one side, unless Lorenzo was to balance him on the other. Then if this was a monument to both the dukes, how is it that there is but one sar-

24

cophagus? There is, moreover, no trace in contemporary records of a deliberate intention to break with the plan established toward the end of 1523 of having the sarcophagi in pairs. If it could, however, be assumed that this drawing was later, as one is certainly tempted to assume, then it would clearly witness to M.'s final decision to have the arrangement pretty much what it is now. What alternative to suggest I scarcely know. Surely not that it is a sketch for the four-sided monument as first planned.

Verso: Two urns, and outlines for a nude doubling his r. arm up to his chin. [Frey, 56.]

The nude may have had some connection with the Victory of the Palazzo Vecchio. Should that have been the case, then M. must have been working on this group while the plans for the Tombs were being settled. Also a number of lines of a madrigal published in Frey's *Dichtungen*, p. 15. [A drawing clearly resembling the recto may have been known to the sculptor of the beautiful monument to a Duke of Montmorency (died 1652) at Moulins, translated of course in the severe forms of the most noble 17th century in France.]

1498 LONDON, British Museum, 1859-6-25-569—Male figure, seen from behind, walking away to r. The outlines have been gone over with a stilus, and the rest is somewhat rubbed. Bl. ch. 28.5 by 16.5. [Frey, 147.] Verso: Study for torso and l. thigh of the Night in the Sacristy
Fig. 671 of S. Lorenzo (p. 224, note). [Frey, 146.] This is of the exact quality of my 1548 and 1549 (Figs. 669, 670). [The attitude recalls as well the model for a river god, now in the Academy, discovered since the first publication of this book (see Thode, *Kr. U.*, I, p. 495).]

1499 1859-6-25-559—Several studies for structures like triumphal arches, conceivably, although not probably, for the altar in the New Sacristy of S. Lorenzo. Bl. ch. and pen. 21.5 by 27.7. [Frey, 106. Geymüller, VIII, fig. 18. Popp, *M. K.*, 70.] Verso: Cast of drapery for seated figure and a head in profile to r. vaguely indicated. [Popp (*M. K.*, pp. 169-70) makes the interesting suggestion that the drawings on recto may have served for the Tomb of Leo X in S. Maria Sopra Minerva.]

1500 1859-6-25-550—Study for window or door, with Medici arms. Verso: Same, with papal blazon. Pen. 27.5 by 20.5. [Vasari Soc., I, ii, 6 and 7. Frey, 117A and 117B. Wittkower, *Art Bulletin*, 1934, p. 186 and figs. 40 and 41.] Doubtless for the Laurentian Library.

1501 1859-5-14-824—Design for podium of Tomb of Julius, made probably in 1526 (p. 203). Pen.
Fig. 645 14.5 by 23. [Frey, 10A and 10B.] Under the design is the following in the artist's own hand: "Questo schizo è una parte della faccia dinanzi della sepultura el quale e tucto finito di quadro e dintagli la qual parte è alta dalla terra alla prima cornice braccia sei e dall' un canto all'altro di largeza braccia undici ed è di pez.... sessanta secte chon que pezi segniati che ve su il numero ed è messo insieme in una stanza che èin casa in sul cortile nella quale stanza è dua ruote dun carra (*sic*) che io feci fare e lasso el resto e in un'altra stanza terrena in casa in Roma."

Verso: Rough sketches, with verbal annotations and measurements of separate pieces of this podium.

1502 1859-5-14-818—Two studies, in reversed order, for the Madonna and Child. In the one she
Fig. 806 is seen full face, while the Child looks away to the l.; in the other, almost the whole figure is given, seated, looking in profile to r. at the Child. Both, particularly the one in profile, are curiously Donatellesque. These are simple drawings in pen and ink, done by M. to serve as models for Antonio Mini. Beside them we see the latter's attempts to copy them in r. ch. (pp. 255-256). As he took service in December, 1523, and the date October 4, 1524, occurs on the back, it cannot be said that in the course of a year he had made great progress. His copies resemble certain primitive types of draughtsmanship—Aztec,

let us say. M. seems to have found his apprentice dawdling, and under his more wretched copy has written: "Disegnia Antonio, disegnia Antonio, disegnia, e non perder tempo." 41 by 27. Braun 73024. [Frey, 251. Popp, *M. K.*, 52. *L'Arte*, 1935, p. 273.] Verso: Two records of payment written in M.'s hand. Published in Milanesi, *Lettere*, p. 595, under dates October 4 and 5, 1524.

1503 LONDON, Bᴙɪᴛɪsʜ Musᴇᴜᴍ, 1859-6-25-546—Plan and elevation of a one-storeyed octagonal structure. Fine penmanship. Pen. 14.5 by 18. [Frey, 186.]

1504 1859-6-25-553—Outline sketch for a giant reclining, and a smaller figure approaching him,
Fig. 684 doubtless a study for a Samson and Delilah (p. 224). This rapid jotting dates, to judge by the style, from about 1530. The same subject is treated by a pupil in a large r. ch. drawing at Oxford (my 1718, Fig. 685), but there the arrangement is somewhat different. Pen. 8.5 by 12. [Frey, 212ᶜ. Popp, *M. K.*, 48ᴬ.]

It has not escaped me that the larger figure corresponds to a surprising degree with the Venus designed in 1531 by M., and coloured by Pontormo, now in the Uffizi. It might be said that rather than for a Samson this was a sketch for that Venus. I should answer that in the sketch the figure is male, and, what is more important, that the smaller figure is stealthily approaching the larger, whereas the subject of Pontormo's picture being Venus embraced by Cupid, M. would not have failed, even in the earliest jotting down of the motive, to indicate this action.

[As a matter of fact the two motives have much in common. For M. every subject became a problem in pose and action. Poses and actions are as limited as the letters of the alphabet and like them suffice for all the needs of any one artist even if he is a M. In this case the figures lend themselves almost as well to one interpretation as to the other. Cf. my 1718 (Fig. 685). A design, by the way, independent of the cartoon for the Pontormo painting and representing Venus breaking Cupid's bow may have existed and antedated the cartoon. This design is represented in several slightly differing versions of a picture by Allori. One at Montpellier (photo. Bulloz), one at the Uffizi (photo. Brogi 2050) and another at Hampton Court. It must have been known to Lotto when he did his Rospigliosi Triumph of Chastity no later than 1528 (Berenson, *Lorenzo Lotto*, 2nd ed., opp. p. 180)).]

1505 1859-6-25-560-2—Section of a cornice and capitals. Verso: Columns and entablatures. R. ch. 28 by 21.5. [Frey, 181 and 182. See my 1457.]

1506 1859-6-25-560-1—Section of a cornice. Verso: Bases and capitals. R. ch. 28 by 21.5. [Frey, 85 and 86. See my 1457.]

1507 1860-6-16-133—Study for a composition of Christ's Resurrection (pp. 228, 353). Bl. ch.
Fig. 698 32 by 28.5. Pl. ᴄxʟɪɪ of F. E. [Frey, 59. Alinari 1687. Brinckmann, 46. Popp, *M. K.*, 58. Venturi, *M.*, 224.]

The most carefully thought-out and noblest of the designs for this subject. Here Christ floats away as in a dream, like a rising mist, and even the soldiers have less agitated attitudes. The greatest merit of this composition is, perhaps, its spaciousness; and the pictorial intention is, for M., singularly clear. If Sebastiano had but painted it, we should have had a picture of a solemnity and grandeur rivalling, if not surpassing, his matchless Pietà. The forms and the technique have all the characteristics of the Cavalieri and kindred drawings, and the date is therefore about 1533.

1507ᴬ 1887-5-2-119—Christ rising out of the tomb (p. 228, note). He pushes the lid aside with
Fig. 699 His l. foot, and looks down to r. upon the amazed or still sleeping guards, while He points upward with His r. hand, and holds the banner in His l. His figure is fairly elaborated, but the others are in outline. The quality is excellent. The Christ, by the way, is but a more highly finished version of the one traced on the back of the Tityus at Windsor (my 1615). Bl. ch. 40.5 by 27. [Frey, 110. Alinari 1686. Brinckmann, 51. Venturi, *M.*, 225.]

1508 LONDON, British Museum, 1859-6-25-565—Sheet with various studies (pp. 230, 264). A rapid sketch
Fig. 707 for a Madonna, in profile, with the Child lying in her lap. [She turns the pages of a prayer
book with her r. hand. Below, a group of nudes reclining and brooding. It is not impossible—
for M. wasa lifelong student of Dante, and is said even to have illustrated him—that these
refer to the following lines in *Purgatorio* (canto iv, 103–108):

<div align="center">

"ed ivi eran persone
Che si stavano all'ombra dietro al sasso,
Com'uom per negligenza a star si pone.
Ed un di lor che mi sembrava lasso,
Sedeva ed abbracciava le ginocchia,
Tenendo il viso giù tra esse basso."

</div>

Still lower on the sheet is a nude, or rather an *écorché*, standing on one leg. There are several
less interesting scrawls here and there. Hard bl. ch. 39 by 27. [Frey, 227. Alinari 1685.]
Fig. 708 Verso: Athletic female nude standing, another reclining as if in troubled sleep, and several
heads, one or two of them approaching the grotesque (pp. 230, 264). [Frey, 228.]
 This side is, as draughtsmanship, more interesting than the other, although both
doubtless were done at the same time. The date should be about 1535, as in the firm
outlines in hard chalk there is considerable resemblance to the Malcolm drawing for the
Last Judgement (my 1536, Fig. 704). The feeling for form is the same as in that famous
fresco, with this striking difference, that here it is colossal but firm and alive, and there
colossal but frequently lacking the breath of life. The verso, at all events, of this sheet
seems for power and touch, to be among M.'s masterpieces, and perhaps the last wherein
his hand retains all its pristine vigour. [A drawing of exactly the same type and spirit
as the one on the recto, but done a little earlier, must have inspired Pontormo when
he sketched the Madonna on the verso of the Hamburg drawing (my 2252A, Fig. 992),
an allegorical figure made for Castello, the date of which we know to have been
between 1528 and 1532.]

1509 . . . 1859-6-25-551—Slight jotting of a nude. Bl. ch. 9 by 4. [Frey, 212B.]

1510 . . . 1885-5-9-1893—Sketch of nude with arms thrown up, coming forward to l., no doubt for
the Last Judgement (p. 230, note). This figure, with slight change, occurs in the upper
l.-hand corner of the Malcolm sketch, for the great composition. Bl. ch. on pink prep.
paper. 10 by 6. [Frey, 279B.]

1511 . . . 1885-5-9-1894—Two nudes crouching or tumbling head downwards, also for the Judgement
(p. 230, note). Bl. ch. on prep. paper. 10 by 7. [Frey, 279A.]

1512 . . . 1856-5-10-1173—Study for r. arm held up and the shoulder (p. 230, note). Bl. ch. 11 by 15.5.
[Frey, 200B.] A rough sketch, perhaps for a figure in the Last Judgement, just above
Peter's shoulder to r. At all events of that period.

1513 . . . 1859-6-25-556—Rough large study, in little more than outline, of seated male figure, without
head or feet. His r. hand is held out as if in protection or blessing, his l. touches a wound
in his side (p. 230, note). Bl. ch. 33 by 25.5. [Frey, 229.] Verso: Scrawl for torso of
figure in action, with head thrown back between extended arms. [Below a balled-up hand.
Frey, 230.]
 The purpose of this uncouth sketch, is not clear. One feels that it must have been
made with reference to the Last Judgement. But if for the Christ, as one is tempted to
believe, [it must have been for a softer conception than in the fresco and corresponding
to the Bonnat drawing for the upper part of the composition (my 1395C, Fig. 706).] I cannot
get over the feeling that the man who made this sketch was well acquainted with the
famous Vatican torso.

1514 LONDON, Bᴀɪᴛɪsʜ Mᴜsᴇᴜᴍ, 1860-6-16-4—Study for the Holy Women at the foot of the Cross—for the lower left-hand part of a Crucifixion. Bl. ch. 21 by 14. Braun 73015. [Frey, 258. Brinckmann, 71. Venturi, M., 292. Baumgart, Boll. d'A., 1934/35, p. 347.]

The action is rendered admirably, but in the touch there is a certain hesitation—not so much in the outlines as in the shading. The date should be about 1535. This sketch, be it noted, has no connection with the series of studies for a Crucifixion done for Vittoria Colonna and later.

1515 1860-6-16-2/2—Christ expelling the Money-Changers from the Temple. Bl. ch. 14 by 27. [Frey, 253.] Verso: Sketch for the r. side of the same, with indication of architectural background, and, separately at other end of sheet, jotting for the l. side. [Frey, 254.]

1516 1860-6-16-2/1—The same. Verso: Single figures, and one group for the same. Bl. ch. 13 by 16. Repr. in the "Lawrence Gallery." [Frey, 252ᴬ and 252ᴮ.]

1517 1860-6-16-2/3—The same. Repr. in the "Lawrence Gallery." Alinari 1675. Verso: Single figures for the same. Bl. ch. 17 by 36.5. [Frey, 255, 256.]

These sketches of nude figures, loosely handled, and drawn, I should think, about 1545, were used by Marcello Venusti, who polished them up and waxed them down into a small picture, which the curious may admire at the N. G.

1518 1859-6-25-562—Study—it is hard to be sure whether of a nude or draped figure—for
Fig. 720 a Madonna bending slightly at knees, with the Child most fondly embracing her (p. 232). Bl. ch. 26.5 by 12. [Frey, 257. Brinckmann, 81.]

This figure, as action no less than as draughtsmanship, bears considerable resemblance to the Mary in the Crucifixion (my 1530, Fig. 728). Being even looser in manner, it may be dated about 1550.

1519 1900-6-11-1—Study for the Virgin in an Annunciation (p. 237). One of the finest recent
Fig. 738 acquisitions of the B. M. Bl. ch. 22.5 by 35. [Frey, 190. Vasari Soc., I, ii, 5. Brinckmann, 78.]

There scarcely can be a doubt that this figure was made in connection with the picture painted under M.'s direction by Marcello Venusti for the Lateran [Venturi, IX, vi, p. 489]. Only in the action of the torso does it differ from the finished work.

1519ᴬ (former 1746ᴬ) 1926-10-9-1—Study of Adam in the Creation of Adam in the Sixtine Ceiling (p. 199,
Fig. 623 note). The hands are repeated. Bl. ch. 19.3 by 25.9. Verso: Head of boy in cap, looking to r.—after one of the decorative nudes in the Ceiling. R. ch. Both reproduced in Ottley. [Vasari Soc., II, vii, 8. Photos. Museum. Steinmann, II, pp. 621, 622.

In my first edition, while speaking of this drawing in highest terms, I did not assign it to M. himself and said that neither the planes nor the light and shade are such as my eyes are accustomed to discover in the master's genuine drawings. There are few sketches that we attribute to M. about which I now could say with absolute conviction that they are from the hand of the master and there are many more which in my heart of hearts I am equally disinclined to take away from him. This is the kind of drawing regarding which I find it impossible to decide. If not M. himself its author was all but as great a draughtsman and being such, and having nothing to do but copy what was before him, why should he fumble for the hands as he does here on the r. of the sheet when all he had to do was to copy M.'s hand as he did so admirably in the lower l.-hand corner? Fumbling on the part of an artist is natural enough when he is trying to think things out but hardly so when he is copying another draughtsman. So as lifelong experience has taught me to accept when in doubt rather than reject, I transfer this sheet from the school of M. to the body of his autograph drawings. It is not without significance that the two other versions of this study for the Adam, that we know, agree so exactly that each might pass for an accurate version of the other. One is in the Ingres Museum at Montauban and apparently unpublished. The other has been reproduced in the Burl. Mag. for June, 1935 (opp.

p. 278), by Maurice Delacre, who claims that it is the original and the B. M. version a copy, perhaps a forgery. To my eye this version, belonging, by the way, to Mr. Walter Gay of Paris, looks in the reproduction harder and more accentuated, and therefore the copy. Be that as it may be, the three versions in such perfect agreement go to prove that even if none of them is an autograph they accurately reproduce an original study by M. for the Adam.]

The head on the reverse of the Adam may be a copy of a discarded study by the master for the nude just under the r. leg of the Adam, or possibly for the one with the cornucopia above the Adam and Eve in the Expulsion. On the Oxford sheet of heads made toward 1560-70 after drawings then believed M.'s (my 1706) this head occurs but more elaborated, one cannot say whether after the sketch before us or after another, the autograph perhaps.

1520 LONDON, BRITISH MUSEUM, MALCOLM, No. 58—Bust of man with alert, wild look, in profile to l.
Fig. 610 (p. 197). But for drapery over the r. shoulder he is nude. Pen and bistre. 13 by 13. [Popp, *Zeitsch. f. B. K.*, 1925/26, p. 174.]

A superb example of M.'s early style, no less splendid in conception than concise and masterful in execution. Note the modelling of the cheek-bone, the neck, the shoulder. Bronze itself could scarcely give greater firmness. The hatching is characteristic of the years just preceding the cartoon for the Bathers, and the date may be 1502 or 1503.

1521 No. 59—Sheet of studies (pp. 187, note; 188, 192, 193). On the r. a draped figure, but
Fig. 579 with shoulder and arm bare, stands more than in profile to r., his r. foot resting on a pedestal, his r. elbow resting on a book, which the l. hand supports on the knee. To the l. is a figure in almost identical pose, but nude and in outline only, whereas the first is hatched. Across the sheet, between the two figures, runs a sketch for a skirmish of horse and foot—the work of an instant—with no shading, vividly recalling Ghirlandajo's best and most rapid sketches, as for instance the bas-reliefs in the Albertina drawing representing Zacharias in the Temple (pl. LXX of F. E.). There can be no doubt that the two figures are first thoughts for the St. Matthew, and it is highly probable that the skirmish was for the background of the cartoon for the Bathers. This sheet may therefore safely be assigned to 1504, the figures to the very beginning and the skirmish to the end of the year, for it need not be assumed that the whole was drawn at the same moment. The few written words are not devoid of interest, scribbled down most likely in a moment of listlessness. They show the drift of the artist's mind at the time. They are: "Dio devotamente," and perpendicular to these, "Deus in nomine salvum me fac," and perpendicular to this again, "stanza nell'inferno." Pen and bistre. 18 by 17.5. Pl. CXXVII of F. E. [Frey, 13A. Brinckmann, 5. Verso: Grotesques and arabesques not by M. but by the hand that did the pen-sketches on my 1645A (Fig. 601). By M. himself, in outline only, the Matthew again and, as pointed out by Frey, a note for the figure in the Bathers of which my 1476 (Fig. 587) is an elaborate version. On opposite edge of sheet even slighter indications of a figure with an arm over its head and shoulders and of another head and shoulders. The one with the arm over the head suggests the Slave for the Tomb of Julius but more probably was meant for the Bathers. Also six lines of verse for which see Frey, Text, p. 9. Anderson 8796. Frey, 13B. The leaf has been cut down at the edge.]

1522 No. 61—Draped figure of a sage (p. 186). In profile to r. holding out a sphere. He wears
Fig. 576 a pilgrim's hat. Pen and bistre. 38 by 20.5. Pl. CXXVI of F. E. [Frey, 41. Alinari 1676. Knapp., *M.*, p. 11.]

M.'s chief interest here is the drapery, which, as in several other studies, he derived from Giotto and Masaccio, if indeed he did not actually copy them from those masters. In the face there is a curious suggestion of M.'s own cast of features, but of himself as an elderly man. The technique of the drawing rigidly compels us to date it about 1500,

and thus not even a professional iconographer will feel obliged to prove that this sage was actually intended by M. for a presentment of himself. In the good old times it passed for this.

Fig. 621 Verso: Head in profile l., and below it a hand (p. 199). Bl. ch. touched up with pen and bistre. [Frey, 42. Alinari 1681. Brinckmann, 26. Venturi, *M.*, 70.]

Perhaps in the whole range of Italian art there will not be found a head approaching nearer to the Greek type. It has the aloofness and pathos of the works we are accustomed to connect with the name of Scopas. But whether all this is convincingly Michelangelesque is another question, and the execution does not help us to a decision. On the whole, I think the probabilities are greatly in favour of its being by M., in which case it would have been drawn later than the figure on the other side, and we should have to agree with Mr. Colvin (*Guide*, p. 30) that the head as well as the hand were done as studies for the Adam in the Sixtine Ceiling. It is, at all events, rash to take away from M. work of this order, in conception matchless, in execution if really inferior then inferior to his own best only, without being as the same time able to assign it with certainty to some other artist. Some day I may be ashamed of having had any doubts on this matter, meanwhile let me be frank and add that there is here a *non so che*, which makes me think of Sebastiano del Piombo's Lazarus. May it not be a copy by the latter, corrected by M.—for that these pen-strokes are M.'s I cannot doubt?

1523 LONDON, BRITISH MUSEUM, MALCOLM, No. 64—Resurrected Christ (p. 228). He soars over the
Fig. 700 sepulchre with a banner (scarcely perceptible) in His hand. Bl. ch. 40.5 by 26.5. [Frey, 288. Alinari 1679. Brinckmann, 50. Venturi, *M.*, 222.] Verso: Grotesque animal, and a nude walking forward holding out a dish, and faint chalk outline of large nude torso stretched backwards.

If the study on the recto was intended for the same work as were the other sketches for a Resurrection, then this one, later certainly than the rest, would indicate a change and even an enfeebling of the idea. The proportions, the attitudes, the execution, witness clearly to the date of this drawing. It belongs to the period of the Last Judgement. [As a matter of fact, the attitude and action are almost of the Christ in that fresco but reversed.] We shall not be straying far if we assign it to about 1536, scarcely earlier.

1524 (number omitted in first edition)

1525 No. 65—Study of a mantlepiece, written on it, "8 ruli e 7 baiocchi." Bl. ch. and 8 lines of writing in pen. 14 by 18. [Frey, 159A.] Verso: Rapid sketch of nude [squatting in profile r. perhaps as Frey suggests (see Text, p. 77) for a figure in lower l. of Last Judgement (p. 230, note). Frey, 159B. Venturi, *M.*, 241. Steinmann, II, p. 669.]

1526 No. 66—Sketches for the upper part of a reclining figure, and two wrestlers (p. 224). Pen
Fig. 680 and bistre. 16 by 14. [Frey, 297B.] Repr. in Ottley. Verso: Fragment of a letter with M.'s signature and the date Oct. 18, 1524—the whole transcribed in the Malcom. Cat. [and by Frey, Text, p. 135].

The above sketches are in outline and done with a trembling hand; yet so splendid, so clearly realized is the action of the wrestlers, that one scarcely notices the faltering line. These wrestlers must have been intended for a Hercules and Antaeus. As we have seen, the small study in r. ch. at the B. M. (my 1490, Fig. 678) for the same subject is from about the same time. According to a record quoted by Gaye (*Carteggio*, II, p. 464), M. was expected to carve out of the block ultimately allotted to Bandinelli, a Hercules and Antaeus. [Frey considers the group not as a study for Hercules and Antaeus but as an erotic symplegma.]

1527 No. 70—Architectural studies for the Library of S. Lorenzo. Pen and bistre. 17 by 17. [Frey, 120A.] Verso: Outlines of a head in profile to l. looking down, noble and fine, yet, in its present state at least, of dubious authenticity. Bl. ch. [Frey, 120B.]

1528 LONDON, British Museum, Malcolm, No. 71—Sheet of studies in pen and ink for bases of columns and other architectural features said to be for the vestibule of the Library of S. Lorenzo (see Wittkower, *Art Bulletin*, 1934, p. 154 and fig. 21). Those on the back were drawn

Fig. 801 over two heads in bl. ch., one in profile and the other full face, not by M., and possibly by his pupil Antonio Mini (p. 366). 27.5 by 25.5. [Frey, 118 and 119.]

1529 No. 72—Study for Crucifixion (p. 233). Christ is nailed to the cross, the top of which is

Fig. 725 shaped like an inverted triangle. The Saviour's head rests at its apex. To r. and l. stand John and the Virgin. These two figures show interesting *pentimenti*. The torso on the cross is a most exquisite bit of modelling. Bl. and wh. ch.; the white retouched. 41.5 by 28.5. [Frey, 127.]

 This is one of a series of studies for a Crucifixion which occupied M. toward the end of his acquaintance with Vittoria Colonna (see my 1547). [Frey (Text, p. 59) makes the observation that this series of drawings may have been done during that great lady's sojourn in Rome which ended in 1542.]

1530 No. 73—Study for Crucifixion (p. 234). Christ nailed to the cross, with His head drooping

Fig. 728 to l. Mary leans up against His side, and John, standing close, looks up. This belongs to the same series as the last, although not for the same composition. In date it may be [somewhat] later, but [nearly as well] of the same time. [The Virgin resembles the one in my 1518 (Fig. 720).] Bl. and wh. ch. 41.5 by 28. [Frey, 128. Brinckmann, 75. Venturi, *M.*, 295].

1531 No. 75—Nude seen from behind. Slight and latish. Hard bl. ch. 12 by 7. [Frey, 280D.]

1532 No. 76—Nude carrying something under r. arm. Slight, and from the period of the Last Judgement. Bl. ch. 17 by 6. [Frey, 291A.]

1533 On same mount, sketch of animal not unlike one of those Scythian bronze plaques [which since the first publication of this have become so very popular]. Bl. ch. 9 by 12.5. [Frey, 297A.]

1534 No. 78—Study for Annunciation (p. 237). Bl. ch. 28 by 19. [Alinari 1684. Frey, 259.

Fig. 739 Brinckmann, 77. Baumgart, *Boll. d'A.*, 1934/35, p. 346.]

 The Virgin leans with her r. arm on a table, over which the angel comes flying, close enough to touch her. This certainly served for some such picture as the Annunciation we now see in the Corsini Gallery in Rome, executed by Marcello Venusti. M. could scarcely have drawn in this style before 1550, nor many years afterwards.

 Verso: A reclining figure of a Dead Christ on the lap of His Mother, only the legs finished. Of somewhat earlier date, and drawn partly over it the Announcing Angel. [Frey, 260.]

1535 No. 79—Fall of Phaeton. Bl. ch. 31 by 21.5. Braun 65071. [Frey, 57. Brinckmann, 55. Venturi, *M.*, 227. Popp, *M. K.*, 45. Toesca, *E. I.*, pl. XXII.] A less elaborated and much more delightful version than the over-finished one at Windsor. Drawn for Tommaso Cavalieri in 1533. At the bottom is a note from M. to Tommaso as follows: "Co. Tommaso se questo schizzo non vi piace ditelo a Urbino che io abbi tempo d'averne fatto un altro domani dissera, vi promessi, o se vi piace e vogliate che io lo finisca."

 I doubt that Cavalieri had the audacity to tell his friend that the design did not please him, and it scarcely will be assumed that the Windsor version was done in the twenty-four hours. But this Malcolm sketch is surely the earlier, and as it was executed in Rome, its date much precedes M.'s departure thence, in June, 1533. When the more finished version was finally received on September 5, Cavalieri speaks of it as something long promised (see Frey's *Dichtungen*, p. 522).

1536 LONDON, BRITISH MUSEUM, MALCOLM, No. 80—Studies for Last Judgement (p. 230). Bl. ch. 38.5
Fig. 704 by 24.5. Pl. CXLIV of F. E. [Frey, 79. Brinckmann, 64. Venturi, *M.*, 242. Steinmann, II, p. 675.]

 At first the sheet had on it at the top a superb sketch of a torso and arms in M.'s grandest manner, and, lower down, a seated nude. Just what purpose they were meant to serve I cannot tell, unless indeed they were the lower one for the Christ, and the upper one for angels hurling down the damned. Then M. added a sketch for the groups that comprise St. Sebastian and the figures below of repelling angels. The great difference between the sketch and the corresponding parts of the fresco shows that we are in the first stages of the work. The date therefore is 1535, and this is important, for it enables us to place many other drawings in more accurate chronological order.

 Verso: Various small single figures for the same, and on large scale two heads almost in profile to r. [Frey, 80. Steinmann, II, p. 676.]

1537 No. 81—Cartoon for Holy Family (p. 231). The Madonna, lightly seated, listens to the
Fig. 719 eloquent discourse of a young saint, probably the Evangelist, while with her l. hand she puts off Joseph, as if fearing his interruption. Between her feet the Child plays on a cushion, and the infant John looks at Him, as if eager to join Him. The heads of several other saints appear vaguely at the top. Charcoal on brown paper. 232 by 185. [Vasari Soc., I, x, 4.]

 It requires much patient study, and some faith, to discern in this sadly ruined and restored cartoon the hand of M., but it is discernible, and unmistakable, especially in the relatively untouched Evangelist, and in the Children. In type and spirit the connection with the frescoes of the Cappella Paolina is obvious, and I think the completion of these works, 1550, the latest date that may reasonably be assigned to the cartoon. As is well known, a painting executed from it exists in the Casa Buonarroti. (See Mr. Colvin's admirable note in his *Guide,* p. 32.) It is not at all improbable that this cartoon is the one thus referred to in the inventory made on M.'s death of the contents of his house: "Un altro cartone grando dove sono designate et schizzate tre figure grande et duì putti," Gotti, II, 151. [See also Steinmann, *Boll. d'A.,* 1925/26, pp. 3-6, pl. I.] My 1725A (Fig. 702) should be studied in this connection.

1538 BRITISH MUSEUM, Manuscripts, No. 21,907—A madrigal published in Frey's *Dichtungen,* p. 402. To the r. a slight sketch of a nude seated facing to r., with his arm held out. Bl. ch. (the sketch only). 15 by 18.5. Verso: Head of man nearly in profile to r. of questionable authenticity, and study for the anatomy of a leg in the position of the l. leg of the Day in the Medici Tombs (p. 221, note).

1539 (see 1396A)

1540 (see 1544B)

1541 (see 1544C)

1542 SIR CHARLES ROBINSON (formerly) [Sold at Christies May, 1902, No. 212]—Two small nudes floating upward, probably intended for the Last Judgement. Bl. ch. 14.5 by 5.

1543 MR. BRINSLEY FORD [former OPPENHEIMER COLLECTION]—Study for the Christ in the
Fig. 657 Minerva (pp. 213, 357, 363). From the breast down elaborately and minutely hatched; the rest in outline. Also a slight sketch of leg and foot in r. ch. only. Pen over r. ch. 21.5 by 24. [Frey, 36. Vasari Soc., II, ii, 6. Popham Cat., No. 217. Oppenheimer Sale Cat., pl. 31.]

 The contract for this work was made on June 14, 1514, and the drawing must be of about the same date. Excellent is Dr. Frey's suggestion that this may represent the first version of the statue, which version, because of a flaw in the marble, M. threw aside (*Briefe,* p. 186). Verso: Sketch of nude for same Christ, and various limbs. R. ch. [Frey, 37.]

25

1543A LONDON, Sir Robert Witt—Verso of sheet. (See my 1696A, Fig. 791, for recto.) Various sketches in r. ch. for a leg, two torsos, a head in profile (not by M.) and with the pen a geometrized profile, a nude in suspended attitude, and to one side of the sheet two lines of a sonnet and below it to r. four other lines, while between and vertical to both appear a torso and legs of a figure seated to r. (p. 349). 20 by 28. Publ., repr., and sonnet fragments transliterated by Tolnay in *Münch. Jahrb.*, 1928, pp. 70-84. The seated nude may have served for a decorative figure on the Sixtine Ceiling and the one that seems suspended may possibly have had something to do with the Haman there or possibly, as Tolnay suggests, with a slave on the Tomb of Julius, although it seems as a whole too scattered for sculpture and the legs are not flexed as they are in all the figures for the monument.

1544 MUNICH, Print Room—Copy of Peter in Masaccio's Tribute Money (p. 186). Pen. 13 by 19.
Fig. 571 [Frey, 11. Knapp, *M.*, p. 10. Popp, *Zeitschr. f. B. K.*, 1925/26, p. 140.] A very early work, exactly contemporary with the Louvre drawing (my 1587, Fig. 572) after the two figures on the extreme l. in Giotto's Assumption of the Evangelist, and of its precise technique and quality. [Also arms in r. ch. probably by M. despite appearances to the contrary.]

1544A NAPLES, Pinacoteca, Print Room—Fragment of cartoon for the group in lower l. corner of the Cappella Paolina fresco representing the Crucifixion of Peter (p. 231, note). Bl. ch. and wh. Pricked for transfer. 263 by 156. Anderson 26567. Neumeyer, *Zeitschr. f. B. K.*, 1929/30, pp. 176 and 182.
According to Steinmann (*Boll. d'A.*, 1925/26, pp. 11-14, pls. 2 and 3) this is a fragment of M.'s original cartoon, done on the same kind of paper that the master used for the cartoon of the Battle and altogether of better quality and less retouched than the cartoon at the B. M. (my 1537, Fig. 719). To my eyes there is a disturbing sleekness about these figures. It may be accounted for by their having been worked over by another hand, perhaps Daniele da Volterra's. Of the uppermost figure l. there is a version possibly by Allori in the Collection of Professor F. J. Mather, Washington Crossing, Pa.

1544B (former 1540) NEWBURY, Donnington Priory, Geoffrey E. Gathorne-Hardy—Study of nude
Fig. 717 (p. 231). In exact attitude of those in Oxford (my 1569, 1 and 3; Fig. 716), which Robinson describes as of a figure going downstairs. All three are for the same purpose, but what that may be I cannot discover. The nearest approach is the nude in the upper corner r. of the Conversion of Paul. It is at all events a late drawing [but hardly as late as] 1550. Bl. ch. 23 by 10. [Photo. Wallace Heaton 2397.]

1544C (former 1541) Study for torso with head just indicated bent to r. [Below separate sketches of
Fig. 732 lowered r. and raised l. shoulder.] An interesting drawing of early date. To be compared with similar studies in the B. M., at Casa Buonarroti, and in the Louvre (my 1416 and 1484 verso; Figs. 730, 731). Probably it also was intended for a Dead Christ. Bl. ch. 24 by 17.5. Verso: Scribbles looking like *écorché* of r. leg. Photos. Wallace Heaton 2399 and 2410.]

1544D NEW YORK, Metropolitan Museum—Studies on front and back for the Libyan Sibyl (p. 349).
Fig. 631 Recto in r. and verso in bl. ch. 29 by 21.5. Frey, 4 and 5. Venturi, *M.*, 40. Toesca, *E. I.*, p. 177. A copy of the recto, minus the large head, exists in the Uffizi under No. 2318F. See Steinmann, II, pp. 601 and 652. The best account of this important sheet is Bryson Burrough's in *Metr. Mus. Bulletin*, 1925, pp. 6-14.
In the thirty years that I have known this drawing it has never occurred to me to question that it was an autograph. Nor to my knowledge has anybody else doubted it. But were I to apply to it the kind of criticism that has been made of the Haarlem drawings for the Ceiling how should we justify our confidence? The first sketch on the recto would seem to have been the young Goethelike profile below on our l. Taken by

itself its authenticity would scarcely pass unchallenged. Even more seriously should we hesitate over the rapid sketch of torso, head and l. arm drawn over and above it. While the arm and the hand are almost of the shape and action that we find in the finished fresco of the Libica, the torso and head are stiffly erect with nothing of the inclination and movement of the finished figure. But what could have been its purpose seeing that the mask which was drawn first has already the exact tilt of the same sibyl? And the less said about the drawing of the hand the less sceptical we shall be. After this the artist sketched in the seated nude with head and arms and swing of the body almost as in the completed work, only that the legs are missing. Instead we have under the hip a sketch of the l. foot. Then he repeats the toes twice, in the empty space to the r. Finally, in the empty triangle to l. he tries to improve on the l. hand and succeeds. On the verso in swift supple contours the back, belly and legs of the same figure and r. thigh and knee, and on top a huddled apelike figure in small dimensions. Returning to the recto, we may ask why, if an autograph, there is no logical sequence to the order in which these various studies were sketched and we may wonder at the absurdity of placing a foot under a thigh and the improbability that a supreme draughtsman would need to repeat the toes thrice, and we may quarrel with the breadth of the ear, with the inferiority of the hands (particularly of the more elaborate separate one if compared with the r. hand for the same sibyl on the famous Oxford sheet, my 1562, Fig. 632), with the overdone shading and with the overmonotonous hatching. It could be argued that the author of these studies was one of those contemporary copyists or rather forgers who, picking up a sheet of M.'s with an empty side, took advantage of it to fill it with brilliant imitations that would sell as originals.

But when I hold this leaf at a certain distance from the eye I get a feeling that it is all by M. because it has his tactile values, his line, his touch. And against this feeling no argument of the kind brought to bear can prevail. Quality is the ultimate test and feeling is the only judge of quality, a poor vacillating one, and at times an unjust judge, but the best there is.

1544[E] NEW YORK, MORGAN LIBRARY—Four rapid sketches in bl. ch. for a small nude bending over and beating a prostrate giant. 11 by 7, 8.5 by 7, 6.5 by 5, 8.5 by 5. Frey, 76. Morgan Dr., I, pl. 32.

These sketches cannot, like my 1571 (Fig. 683) represent Samson slaying a Philistine, for in that case the Hebrew and not his adversary was the giant. They would seem rather to have been done at the request of Daniele da Volterra for his Louvre picture (Venturi, IX, vi, p. 257) representing David slaying Goliath.

1545 OXFORD, ASHMOLEAN MUSEUM,[1] No. 1—Three soldiers standing engaged in animated conversation
Fig. 790 (pp. 268, 361, 362-363). Pen. 38 by 25. Braun 73460. [Frey, 197. *L'Arte*, 1935, p. 259.]

This is one of the most brilliant, and, in some respects, one of the most troublesome of M.'s drawings. I should be ashamed to confess how many scores of hours I have devoted to its study. I will first state some of the objections that may be made against its authenticity. The figures do not stand firmly nor are they constructed so well as they might be. The torso of the speaker seems almost disjointed from his hips, and the build of the listener's shoulder is not intelligible. Singular also are the straight lines for the same figure's side, and his chest, which is literally rectangular. Then the almost total absence of cross-hatching rouses suspicion. Moreover, the clear spaces meant for the lights, as on the arm and chest of the speaker, are drily and somewhat mechanically mapped out. There is also a certain carelessness, a touch almost of *bravura*, in the shading of certain parts, as, for instance, the legs.[2] Against this indictment there is much

1. For more complete descriptions I still refer the student to Sir Chas. Robinson's catalogue. Despite its frequent errors of attribution, it remains one of the best works on any one great collection of drawings, and considering when it was written—at the darkest moment before the dawn of systematic and accurate criticism—its excellence can never be too much admired.
2. Some of these reasons doubtless led Morelli so to overshoot the mark as to ascribe this drawing to Cambiaso (*Kunstchr.*, 1892).

to be said in defence. The sketch is obviously rapid, whence its unusual freedom, and also carelessness. Classical canons of pose, and perfect intelligibility of structure are not to be expected in a hasty drawing even by M. In general appearance it is like the superb sketch in the B. M. of a sibylline young woman (my 1482, Fig. 609). The touch, the penmanship, so to speak, is almost certainly his, and his are the many mannerisms. The pointing hand, for instance, is his most intimately, and we find it in the Bargello Madonna (the tondo) and the Oxford drawing (my 1562, Fig. 632) for the boy accompanying the Libyan Sibyl. The clawlike index of the listener's hand is almost as good as a signature, and for a parallel I refer to the B. M. sketch for the Isaiah (my 1486, Fig. 614). The r. leg and foot are also peculiar to M., as we see in my 1590 verso (Fig. 625). The profile of the same figure closely resembles one in the Albertina sketch after an original by Masaccio. The correction of the speaker's chin is made exactly as in the Louvre sketch for the bronze David.

Finally, let me say that this design has magnificent dramatic qualities, and that certain things in it can be the handiwork of the highest artist only, as, for instance, the arm of the figure behind the speaker. Let me add also that no case can be made out against it because of anything unusual in the "technique." In M.'s unquestionable drawings I have found nearly every possible kind of stroke and shading. Besides, the technique of my 1546, which is of indubitable authenticity, has nearly the same system of hatching.

It may be further objected that the vehemence of the listener is unexplained, that the action is unnecessarily expressive. If these in a sketch, obviously episodical, be faults, they are faults we shall find again and again in the Sixtine Ceiling. It is indeed to the period when that work was in hand that I would assign this drawing. It is too free to be earlier, and there are obvious reasons for its not being later. I strongly suspect that it may have been a first idea for one of the medallions which the decorative nudes hold suspended between them, for some such one as that between Noah's Sacrifice and the Erythraean Sibyl, representing, perhaps, Caesar's address to his army at Rimini.

A copy of this drawing ascribed to Battista Franco was famous in the eighteenth century, and is reproduced in Rogers's *Century of Prints*, I, opp. p. 71. To judge by the reproduction, this copy certainly was by Franco, and if by Franco then a strong proof from without that the original was by M.[1]

To clench the argument, on the back of the drawing are several words in M.'s own hand, written at the time when the sketch was drawn [for which see Frey, Text, p. 94]. [Much further study of this deservedly famous drawing leads me to suggestions rather than conclusions that will be found in Appendix XV. I may add that in the study of the drawings attributed to M. and his apprentices conclusions are nearly always out of place.]

1546 OXFORD, ASHMOLEAN MUSEUM, No. 2—Two figures, one of a soldier barelegged with r. arm akimbo, the other heavily draped and cowled, with his head bent over his breast, walking as in a dream. In kind like my 1545 (Fig. 790), and probably of the same date. Pen. 27 by 18. Ottley, opp. p. 26. Verso: Head in profile wearing the Tuscan fashion of Phrygian cap. Powerful and masterly. Braun 73461.

1547 No. 5—Study of chest with l. arm bent upward, somewhat as in the David. Also a thigh and knee. Bl. ch. 26 by 16. [Frey, 203.] Verso: Several anatomical studies, two of them probably for a Crucified Christ. [Frey, 201B.] It may be doubted whether any of these can be brought into connection with the David. The torso with the flexed arm resembles in action the nude in the Louvre (my 1589 verso, Fig. 640). On the recto the words " dì undici d'agosto."

1. [It may be the one used in this artist's Battle of Montemurlo, now at the Pitti, painted in 1537 (Venturi, IX, vi, p. 278) and so full of borrowings from the great master.]

1548 OXFORD, Ashmolean Museum, No. 6—Study for a reclining figure (p. 221, note). Clearly for the
Fig. 669 Night in the Sacristy of S. Lorenzo, similar in pose, quality, and style to the one next to
be described. Bl. ch. 34 by 26. [Frey, 216. Vasari Soc., II, iv, 3. Popham Cat., No. 221.]
 It is noteworthy how halting are the outlines in most of these chalk drawings, as if
the instrument were not quite under the master's control. His way of handling it would
suggest that he forgot that he was not holding a pen in his hand. Verso: Several studies
of shoulder, flexed arm and hand not by M. R. ch. [Frey, 217. My present feeling (1934)
is that these may be by M. himself although feeble enough.]

1549 No. 7—Torso and thighs of recumbent male nude (p. 221, note). Bl. ch. 17 by 27.
Fig. 670 [Frey, 218.] This is a study for the Day in the New Sacristy at S. Lorenzo and but for
the parts missing it differs slightly from the statue as we now see it, which has the thigh
tilted up a little more and the leg bent a little less.

1550 No. 8—Study of a r. leg, the thigh beautifully modelled. In inverse direction study to il-
lustrate action of lifted r. arm (p. 199). Verso: Slight sketch of a torso. R. ch. 22 by 17.
[Frey, 193 and 194.]
 This is contemporary with the Sixtine Ceiling. The torso and arm have the touch
of one or two drawings for that work here at Oxford. Indeed it is possible that the leg
is a study for the man supporting an expiring youth in the Deluge, and the torso for the
figure clinging to the tree in the same composition.

1551 No. 9—Study of man's head in profile to r. (p. 197). R. ch. 28 by 20. Pl. cxxx of F. E.
Fig. 607 [Popham Cat., No. 216.]
 He has a vehement, almost fierce, look, exaggerated by the protruding lip and
projecting nose. The columnar neck is magnificent. It is a masterpiece of design,
exquisitely precise in the rendering of the surfaces, yet with a splendid largeness of
handling. The type recalls the three soldiers (my 1545, Fig. 790) and the profile head
also at Oxford (my 1546 verso), which we already have catalogued, and more than one head—
the Josiah for instance—in the Ceiling. The treatment of the hair is also paralleled there,
particularly in the figures dating presumably from the earlier part of that enterprise. We
may place it toward 1509.
 Verso: Man carrying a hog. The action of the torso thrown back is superb. [It seems
to me now (1935) that the head on the recto of this sheet is late, as late as the Medici
Tombs and thrown off by M. while he was thinking over the head of Duke Giuliano. The
length of neck, the dramatic look, the plastic stroke and the somewhat emphatic lighting
suit the later date better. If it could be regarded as a study for the man riding on the
shoulders of two others for the Brazen Serpent (my 1564, Fig. 630) it would countenance
Dr. Popp's contention that this design was made not for the Sixtine Ceiling but for the
Medici Chapel (*M. K.*, pp. 159-60).]

1552 No. 10—Bust of youngish woman, the shoulder turned away, but the head in profile to r.
Fig. 608 (p. 197). R. ch. 21 by 16. Braun 73465. Pl. cxxxi of F. E. [Frey, 172. Vasasi Soc., II,
iv, 2. Brinckmann, 30. Colvin, II, pl. 10. Popham Cat., No. 214. Venturi, *M.*, 160. Popp
in *Belvedere*, VIII (1925), p. 21.]
 She wears earrings and a turbanlike hat with turned-up brim. She has the beauty,
the refinement, and the charm of the earlier decorative figures in the Ceiling. The work-
manship differs slightly from my 1551 (Fig. 607), I [used to] think we might date it 1508
[but I now (1935) believe it may be ten or more years later]. Robinson, No. 53, is an
excellent copy of this head [probably done by Salviati]. In the Uffizi there is another of
no interest, except that it passes for an original.

1553 No. 11—Bust profile to l. of bearded oldish man shouting. R. ch. 16 by 13. Pl. cxxxii
of F. E. [Popp, *Belvedere*, VIII (1925), opp. p. 10. I used to date the profile as con-
temporary with the Ceiling, but it may be as late as the Medici Tombs. With the hand
cf. my 1584 verso (Fig. 626).]

1554 OXFORD, ASHMOLEAN MUSEUM, No. 12—Two studies mounted on same sheet, the upper one a slight sketch of seated nude, the lower one a man's head in profile to l. The nude is a rapid note, probably from the model, for a Dead Christ, and would seem to belong to the epoch of the Sixtine Ceiling (p. 234, note). The head is an amusing caricature, nearly contemporary with my 1551, 1552 and 1553 (Figs. 607, 608). R. ch. Figure, 7.5 by 5. Head, 12 by 9. Braun 73467. [Frey, 155A.]

1555 No. 13—Study of a dragon huddled together, its tail curled between its legs and under
Fig. 794 its wing, its long neck in a knot, and the head with its yawning maw on the ground (pp. 250, 363). One of M.'s greatest and most artistic creations. As pen-work we find here the highest and last stage of the earlier manner, while M. was still using the pen as an instrument for elaborated drawing. This sketch should be compared with my 1545 (Fig. 790), which it even surpasses. In date it should be somewhat later, but not much, and a year or two before the Ceiling. A good copy of this is in the Louvre, No. 693 (Fig. 795). Also the profile of a man in r. ch. Below it, in inverse direction, the profile of a youth, [two profiles in outlines and some other undecipherable strokes all in r. ch.] and by a pupil's hand. Braun 73468. [Frey, 133. Colvin, III, pl. 6. Popham Cat., No. 218.]

Fig. 774 Verso: On the r., three heads, in profile, of a young man, resembling many other profiles by the same hand in the B. M., the Uffizi, and elsewhere, and to the l., sketches for eyes and locks of hair. These sketches served as a drawing lesson to a pupil whom M. addresses thus:

> "Andrea, abbi patientia
> Ame me consolatione assai."

Bl. ch. 25 by 33.5. [Frey, 134. Colvin, III, pl. 7. *L'Arte*, 1935, p. 245.]

By this Andrea are the various scrawls on this side, as well as the head of a youth and other profiles on the front (pp. 250, 251, 357, 360). As the dragon is drawn over this head, we may infer that the lesson sketches came somewhat earlier. "Andrea" must have been a pupil of M.'s at this date—1507 or thereabouts. Nothing further is, I believe, heard of him. Other such drawing lessons are known. One is of about the same date, and, in every probability, by the same pupil, my 1689 (Fig. 786). Another is the one in the B. M. for Antonio Mini (my 1502, Fig. 806). [If we should be obliged to recognize that this drawing was done towards 1530 it would be a warning to pay almost no attention to technique, stroke and touch in dating the drawings of the master, for it may be doubted whether on grounds of style alone it would occur to any one to date it later than the beginning of the Sixtine Ceiling. As for this Andrea being a myth (apart from the question of designation which I prefer to make, when possible, with a Christian name) he is as much an artistic personality as scores upon scores of masters of this and masters of that reconstructed by German art history. And he might as well, for all I care, be called the master of the dragon sheet profiles. (See also Appendix XV.) Note that the arabesque that renders the eye and eyebrow of the profile almost touching the dragon's snout is nearly like the one used by Sebastiano in drawing the face of the tall nude on the back of his Viterbo altar-piece—quite natural that pupils of the same master should learn the same notation. Finally, it should be noted that this dragon was probably done in connection with the candelabra of the Medici Chapel (Brogi 10621).]

1556 No. 16—Horseman opposed by lancers, attempting to gallop over a group of prostrate and
Fig. 591 struggling nudes (p. 193). Pen and bistre. 18.5 by 25. [Frey, 132. Popp, *M. K.*, 61.]

This sketch, no less vigorous and bold in touch than in action, has, since Ottley, been connected with the Bathers, for the background of which it may indeed have been intended.[1] It is in M.'s swiftest style, a few of the figures in vague outline, but the rest shaded with sabre strokes of the pen. The action, by the way, of the figure on the r. is

1. It is, however, not impossible that it is a study for one of the medallions in the Sixtine Ceiling, the one for instance beside the Creation of Eve.

MICHELANGELO

singularly like that of the so-called Apollo in the Bargello, and this resemblance is one of the many reasons for questioning whether that work can be identical with the one executed so late as 1532 for Baccio Valori.

1557 OXFORD, Ashmolean Museum, No. 17—Back of a torso; a horseman charging at full gallop (p. 194).
Fig. 599 Highly spirited sketch, probably for the background of the Bathers [and how much like the "Tartar Rider" dear to Sung painters!] The horse and the other scrawls in bl. ch. do not seem to be M.'s, and are at all events of no importance. Pen. 19 by 26. [Frey, 142.]

1558 No. 18—Horse in profile to r.; below, two studies of the hind quarters of a horse, and
Fig. 592 between them a rapid sketch of horse and foot fighting (p. 193). [Similar in spirit to my 1556 (Fig. 591).] Pen and bistre. 40 by 26. [Frey, 141. Colvin, IV, pl. 6. Popp, M. K., 60. Popham Cat., 209.]

M. paid as little attention to the horse as he did to everything else in the visible universe that was not the human figure. In his existing works the noble beast occurs but seldom, and then drawn in a conventional and perfunctory fashion. These sketches, however, must have been done direct from nature, and with a result most surprising; for I question whether in the whole range of Italian art, not excepting even Leonardo, we shall find another horse so like the real animal, and so close to the horse as contemporary art since Géricault has presented him. Evidently M., when he chose, could observe, and render, as no other of his contemporaries. There scarcely can be a doubt that all these sketches were intended for the background of the Bathers.

Verso: Verses, reprinted more than once, but best in Frey's *Dichtungen*, II, III, IV, V, VI. Repr. in the "Lawrence Gallery."

1559 No. 19—One nude mounting a horse, and another holding the stirrup (p. 193). Bl. ch.
Fig. 594 27 by 18.5. [Frey, 201. Colvin, V, pl. 9A. Brinckmann, 7. Popham Cat., No. 210.]
Fig. 595 Verso: Study probably for the torso of the latter figure (p. 194). Pen. [Frey, 202. Colvin, V, pl. 9B.]

The group is hasty and rough, but spirited. The torso is one of M.'s best pen-sketches. Both are certainly of the kind and quality of my 1558 (Fig. 592), and like that, intended for the background of the Bathers. [A copy of the torso is to be found in Casa Buonarroti, see my 1656.]

1560 No. 21—Various studies from nature. The back of a torso; a l. shoulder and outstretched arm from behind; the thigh of a r. leg. Pen. 19.5 by 24. [Colvin, III, pl. 5A.] Verso: Torso of seated man wearing winged Mercury cap, his arms and legs terminating in scrolls. Two bearded heads of men, one of them bald, and yet another head. [Colvin, III, pl. 5B.]

It is barely possible that the studies of the outstretched and uplifted arm are for the figure in the Bathers holding up his arm while a friend is buckling on his armour. The technique and quality—which is of the best—are, at all events, of the date of that great composition, 1505 or so.

1561 No. 22—Study for a group of the Virgin seated in the lap of St. Anne (p. 222). Pen.
Fig. 673 18 by 25.5. [Colvin, II, pl. 9A.] St. Anne sits almost in profile to l., and the Virgin turning towards her sits on her r. knee. The Child is supported on the Virgin's r. hip. The Child already suggests the Infant in the various studies which may be connected with the Madonna for the New Sacristy at S. Lorenzo. Verso: Torso with head and arms of youth seen from behind. Several heads more or less elaborated. Head and torso of seated youth in profile to l. He is the model or the type which Granacci, Franciabigio, Bacchiacca, and even Andrea and Pontormo used, or rather imitated. [Colvin, II, pl. 9B.]

The verso is of the precise date of my 1560. Not only is the touch the same, but one of the heads, that of the bald old man, occurs in both. But it may be questioned whether the recto be as late. The extreme length and gracility of the figures, the oval

of the Virgin's face, and the sort of sash she wears diagonally from the shoulder to the waist all recall the early Roman Pietà. And there can be no doubt that the motive is Leonardo's. It is not necessary to suppose that M. had already seen Leonardo's cartoon; but on hearing it talked about it may have occurred to him to jot down his own idea of how this motive should be treated. If all this is true, we may assign this sketch to the earlier months of 1501.

1562 OXFORD, ASHMOLEAN MUSEUM, No. 23—Study from nature for the boy holding a scroll under his l.
Fig. 632 arm, and pointing with his r. hand to the Libyan Sibyl—in the Sixtine Ceiling, of course (pp. 198, 200, 201, 202, 207). A little below and on the same scale, study for the sibyl's r. hand. On much smaller scale, rapid outline sketches of six slaves, three of them tied to columns, and one of them differing but little from the Louvre slave struggling to get free. Also the study for a cornice. R. ch. 28.5 by 19.5. Pl. cxxxiv of F. E. [Frey, 3. Colvin, I, pl. 6. Brinckmann, 33. Venturi, M., 164. Toesca, E. I., p. 177. Popham Cat., No. 213. Steinmann, II, p. 650.] Verso: "Two careful studies of a bent l. leg, and another of a thigh and knee" [as Frey suggests, for one of the slaves]. Pen. [Frey, 156.]

This sheet is not only one of the most beautiful that M. has left us, but, for many reasons, one of the most interesting as well. On the clean paper came first the two studies tor the group of the sibyl. That a working drawing already existed, we infer from the fact that only so much of the boy is sketched as actually appears in the fresco; but the hand goes to prove that the cartoon was not yet begun, for in the finished work it is changed enough to indicate some alteration in the action of the sibyl. It would seem that at this point M., suspending work on the Ceiling, rebounded instinctively to the great task of his life, the Tomb of Julius, jotting down six sketches for a captive slave, among them conspicuous the one now in the Louvre, on which he is known to have been working in 1513. That the part of the Ceiling in which the Libyan Sibyl occurs belongs to the end of that enterprise has been established beyond question by the acute, genuinely admirable criticism of Dr. Wölfflin (Rep. f. K. W., 1890, pp. 264 et seq.). Even in the finished frescoes signs are not wanting that, feeling the approach of the end of this undertaking, M.'s mind was wandering off toward the Monument. At all events, it is just above this sibyl that we find in one of the two exquisite nudes that motive of the hand touching the back of the head which gives such pathos to one of the slaves in the Louvre. I am thus led to wonder whether the drawing before us does not bear witness to a suspension of work on the Ceiling at the moment that the Libyan Sibyl was to be painted. Such an interruption occurred, as we know, in the autumn of 1510, when the Ceiling was not yet quite finished. If my conjecture be right, it was with this sibyl that M. began again in the spring or summer of 1511. In the intervening months he must have spent some of such time as he had to spare from dunning and mere worry, on the Tomb of Julius.

But we have not yet extracted from this sheet all that it has to teach us. Three of the slaves are tied to columns, and these three sketches throw a flood of light on what, to me at least, has been one of the darkest spots in that dark subject—the architecture and general arrangement of the Tomb of Julius as originally planned by M. All contemporary accounts speak of the slaves as standing against pilasters crowned with hermae. The vision called up at the mere mention of this is baroque enough; but far worse is the presentation we find in the two or three wretched drawings (Florence and Berlin) which were still widely accepted as M.'s own [when this book appeared for the first time]. In these feeble scrawls the hermae are elaborate, full-bosomed busts, whose chins just touch the tops of the slaves' heads. And now look at the columns in the Oxford drawing. In the first place, they are higher than the slaves, so that the hermae are well out of the way. And then—and this is important—the hermae are much smaller than the diameter of the columns, mere fair-sized knobs carved into decorative heads, perhaps even grotesques. But even thus, great difficulties remain. These knob-heads are a possible ornament on columns standing free. To introduce them on pilasters is an ingenuity of bad taste, of which I should be willing to accuse M. only on convincing proof. True the Ceiling

itself has instances enough of triviality and vulgarity in architectural arrangement, but nothing approaching this. I am led therefore to suggest the query whether M. actually would have put even these knobs on the pilasters of his finished work, whether he would not rather have left them out. In that case the tradition about the hermae might have been kept alive by the existence of a drawing like this, and as well of course by their presence in the blighted, stunted, finished work, where however the slaves were *deliberately* omitted. The purpose of the cornice is unknown to me.

1563 OXFORD, ASHMOLEAN MUSEUM, No. 27—Study for the figure seated in profile to l. for the Jehoram in a
Fig. 620 lunette of the Sixtine Chapel (p. 199). R. ch. 20.5 by 21. Braun 73471. [Steinmann, II, p. 659.]

In the fresco [perhaps not entirely] by M. himself, the figure has lost much of its dignity and refinement, and the action has undergone the very slight change from reading to actual writing. The date of the drawing may be early in 1512. [I can not get over the feeling that it is curiously like Andrea del Sarto in touch. A bl. ch. drawing of same figure repr. in Ottley looks more like a copy after the fresco.]

1564 No. 29—Studies, one under the other, for the entire composition in the Ceiling representing
Fig. 630 the plague of fiery serpents and the cure of the stricken by gazing on the brazen serpent (pp. 199, 347, 349, 353). R. ch. 24.5 by 33.5. Braun 73472. Pl. cxxxv of F. E. [Frey, 51. Colvin, VI, pl. 4. Brinckmann, 45. Steinmann, II, p. 635. Popp, *M. K.*, 59.]

For an excellently worded appreciation of this sheet I must refer to Robinson's catalogue. Suffice it to say that it is an unsurpassed masterpiece of draughtsmanship. But for the small scale, I doubt whether even the Bathers could have presented finer action than we have here. It is almost an epitome of M., for, while we are, on the one hand, reminded of the juvenile Centaurs and Lapiths we are, on the other hand, shot forward as far as the Last Judgement. Of parts of this late work there are suggestions here, not only in the grouping and action of the plague, but in the very touch of the more loosely drawn figures. Indeed, had I but these figures alone, I should scarcely have suspected their having been done at so early a date. As is well known, M. made no use whatever of this study. Doubtless he did not feel it to be suitable to the space at command. We are all the richer for these two versions; and while the fresco is not to be compared for action with the sketch, it has greatly improved upon it in one respect. Instead of the mad struggle to catch sight of the brazen serpent, we have, in the painting, the deeply touching motive of the gazing figures, motionless, awestruck, saved. It is of course a great improvement also to have the two groups really forming one whole, with the plague still raging among some, while the others are already convalescent; but then it is by no means to be assumed that the position of the two sketches on the sheet necessarily proves that that was the relative order in which M. ever intended to transfer them to the spandrel. A clever pen-copy of a group in the [lower] part exists in the Uffizi (No. 606ᴱ; Braun 76179) and is rightly ascribed to Aristotile da San Gallo. There also is the partial copy of the upper part ascribed to Gabbiani (1737ᶠ). [In the lower part is conspicuous a group of two nudes upholding a third as in my 1479 (Fig. 596) and 1598 where, however, the one supported is held by the foot and the knee while here he rides on the shoulders of the two others. The close likeness of the motive cannot surprise us for M. recurs to the same theme repeatedly in the course of years.]

1565 No. 39—Head of young laughing faun. R. (dark brown) ch. 21 by 15. [Frey, 222.]

Carefully and elaborately modelled in a way which suggests that it may have been done for execution in bronze. Both the red-chalk technique and the quality recall the Windsor Bacchanal (my 1618, Fig. 691). For this and other reasons, the treatment of the hair, for instance, this head must be placed alongside of the drawings for Tommaso Cavalieri. The most probable date is about 1534.

Verso: Study of drapery not by M. [Frey, 223ᴮ.] A memorandum in M.'s hand, for which see Robinson [and Frey, Text, p. 107].

1566 OXFORD, Ashmolean Museum, No. 40—Architectural studies for the New Sacristy and its tombs at S. Lorenzo. "They represent both elevations and plans, and show the ground lines of the inner face of the wall of the chapel." Two tombs with plain sloping or roof-shaped lids are here seen placed side by side. Pen and bistre. 39 by 26.5. [Frey, 143.]

This, of course, recalls one or two of the sketches in the B. M. for this same task. The one with a large statue in the middle niche, and a smaller one lower down at the side, may possibly have been for the Tomb of Lorenzo the Magnificent, the larger statue representing the Madonna.

1567 No. 48—Three studies on the same mount. (1) The Dead Christ supported on the knees of a disciple. Almost certainly to be dated 1524. See Robinson, p. 60. 8.5 by 7.5. (2) Architectural study, and slight sketch of a nude figure, not unlike the Ceiling decorative youths [but as the writing on the verso seems to indicate (see Frey, Text, p. 65) possibly later]. 17 by 15. (3) Nude standing figure looking to l. with arms stretched out and slightly upward. 9.5 by 9.5. All pen and bistre. [Frey, 138A, 138B, 138C.]

1568 No. 53—Study of a couchant dragon or salamander [and of a nude stumbling forward to l.]. This is probably by M., and, as Robinson states, of about 1530. Bl. ch. 13 by 21. [Frey, 178. Colvin, VI, pl. 5A. May have been done in connection with the Medici Chapel.]

1568A (former 1721) No. 58—Study for foreshortened nude getting out of tomb and looking back to l.;
Fig. 713 below, the r. hand separately (p. 230, note). For a figure that occurs in the lower l. corner of the Last Judgement. Bl. ch. 22 by 26.5. [Frey, 148.] Verso: R. leg with its foot hidden under the calf of a l. leg. [Probably for the nude helped by a woman in the group of the floating figures to l. in the Last Judgement. Frey, 149. Popp, *M. K.*, 44.

In the first edition I published this sheet as by the same hand that did a number of drawings at the B. M., at Lille, Windsor and elsewhere. It now seems in so far as one can judge of matters where "a hair divides the false from true" more intimate, more supple, more alive, in short, then the drawings just referred to. Good enough to be M.'s own. The verso certainly so.]

1568B No. 59—Head of uncertain sex, more likely male (p. 230, note). Mouth open, looking up
Fig. 711 to r., the r. arm visible nearly to elbow, the l. much less, with a kerchief wrapped tight around the skull, with bare shoulder and chest. Bl. ch. and wh. 63.5 by 57. Photo. Museum.

The attitude suggests a figure resting on the elbow as if to prepare to rise. The type, action, technique and quality of this fragment would tempt one to believe that it was part of M.'s cartoon for the Last Judgement. A head and shoulders close to it does occur in the lower l. of the composition (Venturi, *M.*, 268) but not really like it. If this is by M. why did he discard it? On the whole, it is harder to reject than to accept it and its present state makes a decision hazardous.

1569 No. 60 (1, 2, 3)—(1) Standing draped figure pointing to something to his l. Verso: Female figure leaning to r. 20.5 by 12.5. (2) Nude male in attitude of pulling or supporting.
Fig. 716 Very slight. 18.5 by 8.5. (3) One draped figure in attitude of last, and a smaller nude in attitude of first (p. 231). 21 by 13. Bl. ch. all of them.

These three small sketches are for the same purpose. (The nude belonging to Mr. Gathorne-Hardy, my 1540, Fig. 717, is another.) What it may have been is not clear. No. 2 would suggest an Entombment, but they possibly may have been jotted down with reference to the Pauline frescoes [or even for a Christ with the Money-Changers]. The date, at all events, is scarcely much before 1550. [They all suggest the action of the Evangelist in the Malcolm cartoon (my 1537, Fig. 719).]

1569A No. 60 (4)—Small study of head of skeleton enveloped in shroud as if rising from tomb in lower l.-hand side of the Last Judgement (p. 230, note). Bl. ch. 7 by 5.5. Steinmann, II, p. 604.

1570 OXFORD, Ashmolean Museum, No. 67—Study of arm and shoulder, and two bent legs. Bl. ch. 25 by 15. [Frey, 195. Brinckmann, 27.] Of small importance, but may be M.'s. The arm would do him no discredit. If his, then of about 1535.[1] [See my 1724 for verso.]

1571 No. 69—Six several studies for Samson slaying a Philistine (p. 224; our reproduction
Fig. 683 gives only one group). Two in outline, two more shaded, and the lower two carefully elaborated. [The uppermost one to l. resembles a group in my 1748B (Fig. 693), copy of a lost design by M. known as the Vanity of Human Wishes.] Rubbed pencil. 24 by 20.5. Braun 73283. [Frey, 157. Colvin, IV, pl. 7. Brinckmann, 44.]

 The action is good. The modelling, forms, and technique differ but slightly from the Cavalieri drawings, from the various later studies for the Resurrection, and those for the Last Judgement, especially the one in the Malcolm Collection (my 1536, Fig. 704). Robinson suggests that it may have been intended as a design for a medal. It will be remembered that in the passage of the Autobiography where Cellini recounts how he told Duke Cosimo what he thought of Bandinelli's Hercules and Cacus, he says that out of the original block M. had intended carving a *Samson with four figures*. But the great artist's various schemes for using that marble came to a head in 1528, and the sketches before us can scarcely be of so early a date. On the other hand, this may possibly be the leaf referred to by Vasari in his life of Pierino da Vinci (VI, p. 128): "Vinci, having once upon a time seen certain sketches by M. for a Samson slaying a Philistine with the jawbone of an ass...." On the r. of the recto another small square leaf has been pasted. It contains three or four roughly sketched figures for Christ Chasing the Money-Changers from the Temple.

 [Verso: Study of l. leg for seated figure and some writing not by M. Frey, 158.]

1572 No. 70—Two separate sheets of studies on the same mount. Sketches for Pietà and
Fig. 734 for two disciples carrying body of Christ (p. 235). Bl. ch. 11 by 28.5. [Frey, 239. Vasari Soc., II, iv, 4. Brinckmann, 80.]

 I must refer the student to Robinson's admirable note on this leaflet. He is of course right in seeing in the Pietà a sketch for the Rondanini group, and right in dating the drawing as of about 1542. It should be noted how in the action of the legs this as well as every other Christ for a Pietà that we have from M.'s hand, harks back to the picture in the N. G. The slight sketch on the extreme r. anticipates the motive of the Florentine Pietà.

1572A No. 70 (2)—Various slight studies of single reclining or sleeping figures, and of a group
Fig. 735 of three, which leave no doubt but that this is a preliminary sketch for the famous cartoon of Christ in the Garden (p. 236), mentioned by Vasari as belonging to Duke Cosimo. Bl. ch. 11 by 33. [Frey, 240. Vasari Soc., II, iv, 5. Tolnay, *Rep. f. K. W.*, 1927, p. 177.]

 This cartoon is now represented by a copy in the Uffizi, and by a number of paintings, the best of which to my knowledge is in the Balbi Piovera Collection at Genoa. The date of the studies before us is about 1545.

1572B No. 70 (3)—Two small studies of nude figures, reaching down as if to get water in a stream (p. 230, note). Date about 1540. Bl. ch. 12 by 11. [Frey, 280B. This sketch should be connected with the Last Judgement, for one of the blessed pulling up others. See my 1403A.]

1573 No. 71—Three figures slightly and hastily done (p. 232). Pen outline. 11 by 11. [Frey 279C.]
Fig. 718 In all probability for that late composition, Christ Chasing the Money-Changers from the Temple. Interesting as an example of the master's use of the pen in his last years.

1. More than a year after writing the above, looking at the figure again, it occurred to me that the arm and possibly the bent legs as well may have been studies for a Resurrected Christ in the attitude that we see Him, for instance, in the Windsor design, where He is seen, a single figure, rising out of the tomb, with both His arms tossed up (my 1616, Fig. 697). [In 1934 I cannot understand how I could find fault with so admirable a drawing.]

How little it has changed in sixty years! A number of other such sketches may be seen in the Casa Buonarroti at Florence (my 1402, 1403, 1414, 1415). [All these sketches seem now (1934) much earlier and, as already suggested by Frey, done perhaps in connection with the fresco of the Brazen Serpent on the Ceiling.]

1574 OXFORD, Ashmolean Museum, No. 72—Study for a Crucifixion (p. 234). Christ is nailed to the
Fig. 727 cross, His head sunk into His shoulders, the arms and torso relaxed in death. To r. His mother with her hands to her head; to l. the Evangelist looking up with a certain resentment. The types are those we encounter in the Cappella Paolina. The pathos suggests the great Pietà at Florence. Bl. and wh. ch. 28 by 23. Braun 73288. [Frey, 180.]

1575 No. 74—Annunciation (p. 237). A robust masculine figure seated with the face in profile
Fig. 740 to r. serves for the Virgin. The angel, a more gentle being, floats in from the same direction, his r. hand held out, his l. to his heart. Bl. ch. 21.5 by 20. [Frey, 140. Colvin, VI, pl. 5ᴮ. Brinckmann, 79. Popham Cat., No. 227.]
 This sketch has all the characteristics of M.'s latest draughtsmanship, and should follow rather then precede the sketch for the same subject in the Malcolm Collection (my 1534, Fig. 739). Above the Virgin's head are a few words in writing, not less loose and sprawling than the drawing, bearing pathetic witness to the cry M. so commonly uttered in his last years that writing was a burden to him. One of these words is "Casteldurante," another is "Pasquino," and although the rest are scarcely intelligible these two words may help to fix the exact date of this sketch. Casteldurante was the home of Cornelia, the wife of M.'s beloved servant Urbino. The latter died December 3, 1555, and thereupon his widow retired to her home with her children, M.'s wards. A correspondence ensued, and the carrier of the letters was a muleteer named Pasquino.[1] The earliest date for our drawing is therefore 1556—and I doubt whether it can be much, although it may be a year or two, later.

1576 No. 75—Head looking down, somewhat to r. The loose touch and the whole treatment are very late. Bl. ch. 24 by 20.5. Verso: Moulding, and a capital with a grotesque. [Frey, 225 and 226.]

1577 No. 77[2]—Four nudes (p. 231). Bl. ch. 15.5 by 11. Braun 73485. [Frey, 200ᴬ.]
Fig. 715 They bear a strong resemblance to some figures in the foreground on the l. in the Crucifixion of Peter. But the workmanship is at the least ten years earlier than the date of that fresco. The use of this sketch is thus unknown, unless indeed we assume—what need not be considered improbable—that it was done without reference to the fresco, but found later by M. among his papers, and thereupon introduced, with considerable changes of course, into the composition. [Has affinities with certain nudes on my 1600 (Fig. 701), the sketch for a Martyrdom of St. Catherine, made for Bugiardini.]

1578 Christ Church, C 13—Study for Christ on the Cross. The head of Christ is turned up as if still alive. The date is scarcely later than 1515. Lines of writing up and down across the page [some according to Frey (Text, p. 66) M.'s own and some not]. Bl. and bistre. 16.5 by 10.5. [Bell, pl. 73. Frey, 139ᴬ. Verso: Undecipherable scrawls, one of a bust. Frey, 139ᴮ.]

1578ᴬ B 21—Verso: Fine highly finished study of a l. leg and outline indication of the other. R. ch. 20 by 27. Colvin, II, pl. 11. Bell, pl. 72. For recto see my 2493 (Fig. 757).

1. See Frey, *Briefe*, pp. 351 *et seq.*
2. Nos. 80, 81, 82 are architectural studies and genuine [(see Frey, 271, 272, 273, 168, 169). On 81 recto (Frey, 273) there is, besides, the study of a r. arm.]

1579 PARIS, LOUVRE, No. 110—Two women seated beside each other on the ground, the elder one in
Fig. 628 profile to r., the younger one looking to l. with a movement and gesture of exquisite grace,
while holding her hand to her breast as she gives suck to the child in her lap (pp. 199-
200, 222). Another part of the leaf has a vigorous male nude in outline; also a head in
profile. As if foreseeing Morelli's doubts regarding the autenticity of this drawing, M. has
written by the group of two women, " chi dire mai chella fosse di mie mani." Pen. 32.5 by 26.
Braun 62053. Giraudon 84. [Frey, 27. Alinari 1340. Demonts, *M.*, 7. Brinckmann, 3.
Steinmann, II, p. 655. Toesca, *E. I.*, pl. XVIII. Popp, *Zeitschr. f. B. K.*, 1925/26, p. 135.]
Verso: Young woman kneeling to r., but her head turned sharp to l., holding on a charger
a human head. An eagle's head and a lamp (pp. 196, note; 199). At the top are six or
seven lines of writing in a more archaic but contemporary hand, from which it appears
that this leaf came out of an account book by Donato di Bertino and Buonarroto di Simone,
money-changers in Mercato Nuovo. This Buonarroto, is, of course, M.'s brother. Braun
62054. [Frey, 28. Steinmann, II, p. 656.]

If we had more knowledge regarding the business connection between Donato and
Buonarroto, we should know the earliest date which this sheet could possibly have; but
I have not come across any reference to this affair. We are thus left to judge by the
internal evidence. The hatching is no longer M.'s earliest manner, is much less laboured,
and altogether more free. The woman with the child already suggests the Madonna in
the Medici Tombs; the action and pose of the arm, for instance, are nearly the same. In
the Louvre catalogue the two women are described as the Madonna with St. Anne. That
is no impossible designation; but they sit on the ground in attitudes which remind one
vividly of the groups in the triangles between the sibyls and prophets in the Sixtine Ceiling.
The one between Ezekiel and Erythraea is most to the point; the types also are of this
period. It seems to me more probable, therefore, that the two women were intended for
one of the Sixtine family groups. As for the nude and the figure on the other side, I have
a suggestion to make which is most unlikely, yet worth the mere making. It is that the
nude is for a David and the figure on the other side, not for a Salome, but for a servant
receiving from Judith the head of Holofernes. These two subjects, it will be remembered,
occupy two neighbouring corners of the Ceiling. If this suggestion should happen to be
well founded, then these sketches would have to be regarded as first thoughts, before
M. had settled on the final treatment of these two themes. At all events, I would not place
them much later than 1509. The l. leg of the nude, for instance, is too much like the
study for the anatomy of the leg on the back of the B. M. drawing (my 1479, Fig. 596)—
containing, among other studies, one for the Bruges Madonna—to have been done many
years later than that marble.

[Frey's contention (Text, p. 18) that this can be no earlier than 1513 is groundless,
as we do not know the exact date of Donato di Bertino's and Buonarroto di Simone's
coming together. It may have been as early as 1511, which would allow the sketches to
have been done in connection with the Sixtine Ceiling.]

1580 No. 691bis—Small sketch for Resurrection (pp. 227, 353). Corresponds closely to the
Fig. 696 larger study at Windsor (my 1612). Date about 1530. R. ch. 15.5 by 17. Braun 62051.
Giraudon 86. [Frey, 40. Alinari 1348. Demonts, *M.*, 10, Brinckmann, 48. Venturi,
M., 221. Popp (*M. K.*, 57 and p. 162) would have this as well as my 1612 for a fresco over
one of the Medici Tombs.]

1581 No. 697—Faun dancing, striking a tambourine, while a young satyr dances beside him.
R. ch. 27.5 by 17. Giraudon 91. [Alinari 1345. Demonts, 12. Brinckmann, 82.]

A characteristic and beautiful drawing of the period following the completion of the
Sixtine Ceiling [cf. my 1584 verso, Fig. 626.] The dancing faun at Windsor (my 1749) is
a copy made by a brilliant pupil in the manner of his master at about 1535.

1582 No. 698—St. John, for a Crucifixion. One of the series of studies for a Crucifixion made
about 1544. Bl. ch. 25.5 by 8.5. Braun 62047. Giraudon 92. Arch. Ph.

1583 PARIS, LOUVRE, No. 700—Study for Crucifixion (p. 234). One of the series done soon after 1545.
Fig. 726 Here, as in the Crucifixions in the Malcolm Collection, Christ is represented expiring on the cross, the top of which is shaped like an inverted triangle. There is a *pentimento* in one of the arms. Mary and John stand in tragic attitudes. Bl. ch. and wh., on greyish paper. 43.5 by 29. Braun 62045. Giraudon 94. [Alinari 1343. Brinckmann, 74. Venturi, *M.*, 296.]

1584 No. 704—Three men carrying corpse on their shoulders (pp. 234; 235, note; 242, 347.) R. ch.
Fig. 733 29 by 18. Braun 62048. [Alinari 1344. Brinckmann, 65. Venturi, *M.*, 240. Steinmann, II, p. 646.]

Executed freely and largely, yet adequately rendering a motive unrivalled as action. The figures are on almost colossal scale, the most colossal being the corpse, whose shoulders are supported on the shoulders of the two men behind, while its legs swing over the shoulders of the foremost figure enclosing his head. The weight of the corpse, the strain on the bearers, the swing of their march, are all conveyed with a complete realization of the force employed.

Fig. 626 Verso: Youngish woman seated somewhat to r. but looking to l. while her hands hold a book spread open on a desk at a level with her shoulders; one child, nestling up to her, tries to get her attention, while another in profile to r. seems to wish to look over her shoulder into the book (pp. 200, 209, 245, 246, 249). Giraudon 13390. [Steinmann, II, p. 645.]

This may be a study for a Madonna with the two Holy Children, yet the resemblance in motive, action and pose to the sibyls and prophets on the Sixtine Ceiling is so great that one may be justified in considering it a discarded idea for one of the sibyls with the accompanying genii. The Isaiah, the Libyan and the Erythraean sibyls are the next of kin to this figure, but the original drawing for the Isaiah (my 1486, Fig. 614) still more than the fresco. Whatever its purpose, its connection with the Ceiling is too close to permit us to date it much later than 1512. The resemblance of the lower child to the faun (my 1581) fixes the date of that drawing also.

[Steinmann (II, p. 600) connects the recto with the flood and it occurs to me now (1935) that it may be even earlier and intended for a group in the background of the Bathers. As for the verso I now see in it too much resemblance to the Madonna with the two Children on my 1599 (Fig. 627), the Children being all but identical in both, to assign to it a date much earlier than 1520. It may even be questioned whether this group, like the one in my 1599 (Fig. 627), is not by "Andrea di M."]

1585 No. 714—Rapid sketch for the bronze David ordered by the Signoria on August 12, 1502,
Fig. 577 for the Maréchal de Gié, and on his disgrace, given to the royal treasurer Florimond Robertet (p. 187). David nude, very young, stands in profile to l., with r. foot on head of Goliath. On the same side, but to r., we read: "Davicte cholla fromba e io chollarco." Just below: "Michelagniolo." Much lower down: "Rocté lalta cholonna...." Between the David and these words, but in reversed direction, is a sketch of a r. arm and shoulder for the marble David, drawn probably a number of months earlier than the rest. Pen. 26.5 by 18.5. Braun 62049. [Frey, 24. Alinari 1351. Demonts, *M.*, 3. Brinckmann, 4. Knapp, *M.*, p. 23. Toesca, *E. I.*, pl. XVII.] Verso: Nude with the action of person digging,[1] two busts seen from behind [and studies for a shoulder and beginning of arm and one for a r. arm. Frey, 25. Steinmann, II, p. 637.] At top of sheet three lines of verse, published in Frey's *Dichtungen*, CLXVI.

This is a leaf the study of which cannot be too highly recommended to those who would seriously acquaint themselves with M.'s quality no less than with his shorthand and draughtsman's tricks, for here we have sketches of unquestionable autenticity. The drawing

1. Compare the man digging in the Drunkenness of Noah [as well as the one on our exreme l. holding onto the sheep in the Sacrifice of Noah, both among] the earliest in the Sixtine Ceiling.

of David's nose betrays the influence of Ghirlandajo, who also used to make a nib serve for a nose. The best accessible account, by the way, of the bronze David is Anatole de Montaiglon's in *Gaz. d. B. A.*, N. S., 1876, i, pp. 242-246.

1586 PARIS, Louvre, No. 716—Study for Dead Christ, reclining with head falling on r. shoulder (p. 234).
Fig. 729 Bl. ch. 25.5 by 32. Pl. cxlv of F. E. [Frey, 21. Alinari 1337. Demonts, *M.*, 8. Brinck-mann, 23. Venturi, *M.*, pl. 48. D'Achiardi, fig. 63. Knapp, *M.*, p. 35.]

The torso is exquisitely modelled, the legs are slightly indicated. It is a more finished version of a drawing in the Casa Buonarroti (my 1416, Fig. 730). Intended doubtless for some Pietà, and dating from a time just preceding the beginning of the Sixtine Ceiling. There, in the Deluge, is an expiring nude carried on another's shoulder, which resembles this study closely. The r. hand recalls the one in the Oxford drawing (my 1562, Fig. 632) for the child in the Libyan Sibyl. The other hand is almost more like Sebastiano del Piombo's exaggeration of M.'s forms than M.'s own; but it was the Ceiling and kindred works upon which Sebastiano formed his Roman manner. Also two sketches for the r. arm.

[Obviously used by Sebastiano in his Pietà at Ubeda and published as Sebastiano by Prof. Panofsky in *Festschrift für Schlosser*, pp. 150-161. Since this was published, I have reconsidered this study again and again. At times it seemed as if it should be given to Sebastiano. In the end my doubts have cleared up and given place to the conviction that it must be M.'s. Not only the modelling but the contours seem beyond Sebastiano's highest reach, particularly when drawing on a scale approaching this one.

It may however be later than I used to think it, ten or even fifteen years later than my 1416 (Fig. 730), which it repeats and elaborates. It may be asked whether it is likely that M. would go back to a sketch of years before when he wanted to draw a more elaborate version of the same figure. In answer I refer to what I have been obliged to say again and again, namely that even a genius like M. has a surprisingly limited repertory of types, poses and movements and that they vary surprisingly little from one period to another of his long career, least of all in the years between 1505 and 1535. While I can make no surmise as to what led him to repeat this motive later we must never loose sight of the fact that even of a life regarding which we are so abundantly informed as M.'s we know but fragments, although in his case happily the most important ones. Everybody who had access to him asked him for drawings for this and drawings for that. He may have done this Louvre sketch for some such occasion and preserved it as indeed he must have preserved its much earlier model (my 1416, Fig. 730). When years later Sebastiano dunned him for a dead Christ that he could use for the Ubeda picture, M. sent him this one.

That this procedure is by no means improbable we may infer from the following chance fact that has come down to us. A few years earlier than the beginning of the Ubeda picture Sebastiano on July 15, 1532, returns the drawing of a Christ to M. because it is "quasi simile a quello de Sancto Pietro Montorio"—almost identical with the one for S. P. in M. (Milanesi, *S. d. P.*, p. 98).

I trust that the student can be left to draw his own conclusions with regard to the attribution as well as the dating of this sheet. There remains just one more consideration. It is that Sebastiano was an accomplished painter and an indifferent draughtsman. If he was able to achieve such a masterpiece of drawing he would have done at least as well in the painting. The painted figure, however, is as wooden and stiff as the sketched one is rhythmic and supple. And finally, whatever Sebastiano may have been able to do in 1517, when youngish and utterly abandoned to the tempering glow of M.'s genius, twenty years later, lazy and indifferent, he could not have risen to this quality.]

1587 No. 706—One man standing and another bending over (p. 186). Copies made by the
Fig. 572 youthful M. after the two figures on the l. in Giotto's fresco in the Peruzzi Chapel at S. Croce, representing the Evangelist mounting to heaven. Pen. 32 by 20.5. Braun 62059. Giraudon 102. [Frey, 1. Alinari 1347. Popham Cat., No. 207. Toesca, *E. I.*, pl. XVII.

Popp, *Zeitschr. f. B. K.*, 1925/26, p. 141.] Made as early, perhaps, as 1492, hatched closely and precisely as in the kindred drawings at Vienna, Munich, Chantilly and elsewhere. Morelli condemned this as he did the bulk of M.'s drawings (*Kunstchr.*, 1891-92, p. 291). Verso: Shoulder and flexed arm. R. ch.

1588 PARIS, Louvre, No. 688—Study for a Mercury (or an Orpheus or Apollo). Pen on parchment. 40 by 20. [Frey, 87. Alinari 1341. Demonts, 5.] Braun 62063.

He is as beautiful as a god should be, and is nude but for a shadowy drapery falling behind the shoulder, and hanging down from the l. arm. The r. arm falls along the side, while with the l. hand he holds a viol to his shoulder. On his head, a winged cap. Lower down, is a rougher study for a nude boy struggling with a burden on his l. shoulder. His action recalls more than one nude in the Sixtine Ceiling, those for instance near the Creation of Eve, or near the Separation of Light from Darkness. He suggests as well the reclining figure beside the Madonna kissing the Child in M. Bonnat's famous sheet (my 1599, Fig. 627). The Mercury is perhaps M.'s most antique inspiration.

Fig. 642 Verso: A number of sketches in various directions (pp. 202, 252). A head of a man wearing a plumed cap. A l. leg. A male mask in profile recalling the Madonna in the Berlin drawing (my 1396, Fig. 602). Lower part of a male figure. A child, a cherub, and—most important of all—a study for the slave (now in the Louvre) with his hand touching the back of his head. [A tracing in bl. ch. of the figure on recto, scarcely by M.] and the following four lines from Petrarch's third sonnet on the death of Laura:

> "L'ardente nodo ond'io fui d'ora in ora
> Cantando anni ventuno ardendo preso
> Morte disciolse nè già mai tal peso
> Provai ne credo. "

[Frey, 63.] Giraudon 1393.

There is a freedom of touch in the hatching on this sheet which we shall not find in M.'s earliest drawings. The presence of the sketch for the slave is not decisive evidence of the exact date, for it might have been jotted down late in 1505, when the Tomb of Julius was begun, or, on the other hand, after the completion of the Sixtine Ceiling, when this monument was taken up again. The presence of the *putto*, so distinctly in the style of those in the Ceiling, if not actually for one of them—the nearest are the one beside Joel, and another on the pilaster beside Jonah—would point to the later date; and this view would be strengthened by the quality of the draughtsmanship.

1589 No. 689—Two nude women seated (p. 222). Both looking to l. and with r. arm stretched
Fig. 674 out. The one on the r. holds astraddle on her l. knee a child sucking at her breast. [Alinari 1346. Brinckmann, 15.] Giraudon 103.

The technique of this sketch is relatively rare in M., consisting of [little] more than outlines with [almost no] shading, and that not done by cross-hatching, but with more or less parallel curves. It is, in short, almost the manner of Raphael in his mature years. Its purpose is enigmatical. The woman with the child differs only in the pose of the head and in the absence of clothing from the study at the Albertina suggesting the Madonna of the Sacristy of S. Lorenzo (my 1603, Fig. 675). It is of earlier date than the beginning of the Sacristy of S. Lorenzo, and I believe nearer to the completion of the Sixtine Ceiling, but not later than 1514.

Fig. 640 Verso: Elaborate study of a nude in a somewhat contorted attitude looking at his doubled-up r. arm (p. 203). Pen. 37.5 by 19.5. Braun 62064. [Popp, *Belvedere*, VIII, (1925), p. 22.]

The action suggests the Victory in the Palazzo Vecchio, and although it could scarcely have been drawn for that figure, it yet helps to fix the date as being between the completion of the Sixtine Ceiling and the beginning of the façade of S. Lorenzo. Unfortunately,

this drawing has been retouched, but it retains great power notwithstanding. Its purpose is not clear. The quality of the work is like that of the Mercury. Perhaps it had some connection with the Tomb of Julius.

[It occurs to me now (1934) that the figures on the recto may have been done in connection with one of the lunettes over the popes on the Sixtine Ceiling and the verso for a figure in the Tomb of Julius as conceived after the death of that pope.]

1590 PARIS, Louvre, No. 1068—Nude youth standing lightly on his r. leg, the r. arm not given, the l. in outline
Fig. 639 is bent at the elbow (p. 202). Elaborately shaded with cross-hatching. Pen. 32.5 by 17. Braun 65073. Giraudon 104. [Frey, 88. Alinari 1336. Steinmann, II, p. 631.] A slightly varied copy of this figure exists at Windsor (see my 1749A). Verso: Study for the Haman
Fig. 625 in the Sixtine Ceiling (p. 199). In almost the same position that we find him in the fresco, with the difference that the movement instead of going from l. to r. goes from r. to l. [Frey, 64. Demonts, *M.*, 4. Steinmann, II, 632.] Also, but in inverse direction, a r. arm, and inverse to this again a very slight sketch of the bust of an old man with a beard as long as the one of M.'s Moses. A few words, seemingly the beginnings of poems, are scattered over the page.

The date of this leaf is happily determined by the presence of the sketch for the Haman. As this bit of the Ceiling was painted scarcely earlier than 1511, the drawing will be of the same [time]. And this date is a valuable acquisition, for it furnishes proof that several kindred drawings—my 1588 and 1589 (Fig. 674), for instance—need not be earlier as, but for this, one might be inclined to hold.

1590A No. 705—Nude Jerome kneeling on both knees in profile to l. with a stone in his l. hand and r. arm stretched out. Pen. 28.5 by 21. Arch. Ph.

It may be questioned whether an unspoiled touch of M.'s hand remains here. The drapery and rocks are certainly not M.'s but added by the hand which scrawled the word or two at the top of the leaf. The rest may, however, have been M.'s originally and of the period of the Bathers.

1591 No. 707—Study for a faunlike male nude in profile to r., leaping on his l. leg, the other held up and bent at the knee, the r. arm held out. Bl. ch. 29 by 20. Giraudon 13399.

The action and spirit of this nude bear considerable resemblance to the only figure with a bow in the Gods Shooting at a Mark (Windsor, my 1613, Fig. 688), and if not a study for that, is at all events of about the same date—perhaps 1530.

1592 (former 2498) No. 708—Female of ripe years seated, and but for a drapery over her knees, nude. She is in profile to l., her r. arm falls to her side, while her l. leans against something (p. 349). R. ch. 25.5 by 13. Braun 62057.

[Probably done in connection with the Sixtine Chapel and may be an early idea for one of the sibyls or possibly for one of the figures in the lunettes. So close to Sebastiano that in the first edition I catalogued it as his also under my 2498.]

1593 No. 709—Two nudes wrestling (p. 224). Study possibly for a Hercules and Antaeus.
Fig. 679 R. ch. 23 by 19. Braun 62060. [Frey, 33. Demonts, 9. Toesca, *E. I.*, pl. XIX.]

The action is of the best, the mannerisms are certainly M.'s. Morelli showed haste in condemning it (*Kunstchr.*). To the r., where the sheet must have been cut away, the fore part of a nude in outline, in an attitude recalling *the studies for the Matthew*. The date is not easy to fix, but most likely not long after the Sixtine Ceiling.

Verso: Lines of writing for which see Frey, 35A, and his Text, pp. 21-22. He affirms that the names mentioned would date it about 1524, the same therefore as on the verso of my 1526 (Fig. 680), with which I have paralleled this.

27

1594 PARIS, Louvre, No. 712—Nude youth with his head in profile to r., standing on l. leg, the r. slightly
Fig. 588 lifted; the r. arm is bent upward at the elbow, and the l. drawn across the chest toward
 it (p. 192). Pen. Braun 63518. A study from the model.

The pen-work is closer to that in the two nude women (my 1589, Fig. 674), but, as
the touch is much less prompt, it is probably earlier. I am inclined to put it as early as
the end of 1504, and it can be nothing less than a first study for that figure in the cartoon
for the Bathers whom a companion is helping to fasten his armour. In the Holkham
grisaille (Fig. 584) he is the topmost figure on the r. Be it noted, by the way, that this
drawing furnishes at least one good proof for the substantial faithfulness of that copy.
My 1730 verso (Fig. 634) is the copy of a slightly varied original.

1595 No. 720—Woman facing to r. and looking up. Study for a Crucifixion, and late. Verso:
Male nude in same attitude. Bl. ch. 23 by 10.

1596 No. 722—Male nude seated somewhat to r. but facing to l., legs crossed, the r. arm falling
Fig. 619 at the side, the l. hand held out from the elbow (p. 198). Pen. 21 by 12.

This seems to be a study from life done at first rapidly with bl. ch., then, while the
model was still keeping his pose, gone over and corrected with ink. The style and
manner is the same as in my 1588 and 1589 (Fig. 674), although inferior. This is the sort
of sketch which I fancy escaped by accident from M.'s periodic bonfires. It is probable
that it was intended for some figure in the lunettes of the Sixtine Chapel. These, executed
last of all were begun in August, 1511, and finished in October, 1512. The particular
figure for which the sketch may have served is the one over Pope Voius. But the dif-
ferences are considerable, for besides having a child between his legs, this figure sits a
little more sideways, and is older.

1597 No. 727—Sheet of studies (pp. 192, 347). Nude seen from behind [probably intended
Fig. 593 like my 1479, 1481 (Figs. 596, 597), 1598, etc. for the episode in the Bathers of two nudes
holding up a third.] A leg from above the knee with the foot stretched to the utmost.
A head in profile to r. wearing a fanciful helmet. Two helmets, one with a combat worked
in relief, and the other topped by an eagle. Pen. 27.5 by 21.

This fine early drawing, with its careful hatching, may have served for part of the
cartoon of the Bathers (see my 1479, Fig. 596; 1598, 1625). The warrior's head would
point to that, and the eagle helmet differs but slightly from the one in the Holkham
grisaille.

Verso: Seven heads, six of them in profile, with fantastic headdresses [no doubt for
the same purpose. Arch. Ph. (See my 1624C for copy of this leaf.)]

1598 No. 718—Two nudes holding up a third (pp. 194, 346, 350). A more elaborated version
of the sketch in the B. M. (my 1479, Fig. 596) [and like that connected with the cartoon
for the Bathers]. Although more finished, it does not seem of so good a quality [perhaps
because the shading has been reinforced by a later hand]. Bl. ch. 34 by 18. Braun 62062.
Verso: Two sketches of back of a torso and sketch of a contorted nude, in a free, rapid
Raphaelesque manner, in ink. Three small rough sketches of nudes [in various attitudes
also for Bathers (p. 347)] in bl. ch. [Arch. Ph. The Raphaelesque sketch, so much like
the Haman in the Ceiling, is perhaps for the middle figure in the group on the recto.]

1598A No. 842—Study for Crucifixion. Bl. ch. 25.5 by 13.5. Arch. Ph. Verso: Perspective
study of vaulting.

If by M., as is probable, it must be earlier than any other done for or in connection
with those made for Vittoria Colonna, e. g. my 1530 (Fig. 728). Curious is the head tainted
with a touch of that poverty of feeling which overcame M. when he designed the head
of the Minerva Christ.

1598[B] PARIS, LOUVRE, No. 860—Youthful smiling head looking out to r., and below fingers and thumb of r.
Fig. 618 hand (p. 198, note). Along the lower l. edge of the sheet several words of writing to me
unintelligible, but seemingly in M.'s hand. Bl. ch. and wh. 30.5 by 21. Verso: Youthful
nude leaning forward towards l. and head in same attitude as on recto (p. 198, note).
Arch. Ph.

Steinmann (II, pp. 595 and 623) recognizes the verso as a study for the nude to the
l. of Isaiah on the Sixtine Ceiling, a reversal of my 1399[D] (Fig. 617), corresponding more
closely with the figure in the fresco (Venturi, *M.*, pls. 78 and 79) but feels doubtful about
its being an autograph. The head on the recto would be a study for the same figure.
The difficulties of accepting these drawings are slight compared with the attempt to reject
them. There is a look in the head which is a trifle unexpected and the shape of the ears
is not convincingly M.'s. The hand is feeble, but so it is in the fresco. The nude is more
satisfactory although hypercriticism might find faults enough. And yet I can discover no
solecism here that M. himself could not have committed. And if not M.'s sketches for
this nude shouldering a cornucopia what are they? Not copies after the fresco, for the
head on the recto is older, more faunlike and the r. arm of the nude is not covered by
the cornucopia as it is in the painting. A copyist making variations after the finished
figure is scarcely to be thought of unless indeed, what seems unlikely in this case, he
was a deliberate forger. We fairly are reduced to the alternative of accepting this sheet
either as an autograph or as a copy of an autograph, copy so faithful and of such a
quality that an eye like mine can not distinguish it from an original. For which reason
it seems wiser to accept it as M.'s autograph. The nude is, by the way, both in modelling
and contours close to the study in the B. M. for a Madonna (my 1493, Fig. 676) and it
has further affinities with my 1399[A], 1416 verso, and 1596[A] (Fig. 616).

1598[C] No. 2491—Profile of man wearing a helmet mounted by a dragon as in the Verrocchiesque
tradition. Pen. 7.5 by 6.5. Cf. my 1560 verso and 1597 (Fig. 593). Early.

1598[D] No. 2715—Life-size head of bearded man wearing turban. Closely hatched with pen.
Fig. 568 36.5 by 25. Arch. Ph. Steinmann, *M. P.*, pp. 17-18 and pl. II.

I see no reason for not accepting this head of M. as an autograph portrait of himself.
It is in a bad state, but where not defaced or retouched the folds and the hatching are as
much his as any other early pen-drawings rightly attributed to him. In the Louvre there
exists a bust seen above a parapet (Louvre No. 1649, Steinmann, *M. P.*, pl. III) correspond-
ing so exactly to the drawing that it must have been done after it. The painting looks
like Daniele da Volterra's. The age given on the parapet cannot be trusted. M. could
not have been 47 years old when he drew his own portrait. Perhaps the 4 is a misunder-
standing for 2 and the reading should be 27. That is the utmost age one could give to
the face in the drawing, seeing that it is of an Italian of about 1500, when people in
general, and Italians in particular, aged earlier than they do now. The style of the
draughtsmanship would in no way oppose our dating the sketch 1502. Needless to insist
on its interest and importance. Here we have M. as he saw himself in earlier years, the
self-aware genius who a few years later bearded the fierce Pope Julius and some twenty
years later still terrorized Clement VII. There is a look in the eye as of one who does
not suffer fools gladly. The mask recalls portraits of the school of Pergamon—a school
of which the mature M. often reminds us.

1599 No. 4112—Sheet of studies (pp. 200, 361, 362). The Virgin lightly seated to l., with the
Fig. 627 Child between her knees, snuggling up against her breast; to the r. the infant John
restless with the cross in his l. hand. The Virgin is distinguished, even elegant. The
Children are peculiarly large. As a complete pyramidal group this sketch has few rivals.
Whether intended—if with any definite purpose—for painting or sculpture is not clear.
To my feeling the arrangement is more adapted to marble or bronze. In opposite di-
rection to this is another study for the Madonna seated, leaning back a little, the better

to support the weight of the Child, Who embraces and kisses her. To r., a nude asleep with the r. arm thrown over the head—perhaps St..Joseph, and at all events an integral part of the group. The tenderness and pathos of the Madonna and Child are matchless. Pen, torn in places. 37 by 26. [Demonts, *M.*, 6. Popp, *Zeitschr. f. B. K.*, 1925/26, p. 145. *L'Arte*, 1935, p. 259.] Verso: Tall woman looking down upon a seated child who is busy reading. Her face is almost in profile, and with her r. hand she holds up the drapery on which the child is sitting. Below, another study of the child (pp. 200, 361). Also three octave stanzas of verse, and three spare lines, all of which are published in Frey's *Dichtungen*, XXXVII. [Demonts, *M.*, 6B.] E. Müntz, *Gaz. d. B. A.*, 1896, i, opp. p. 324.

The purpose of this drawing would seem to have been a marble group representing the Madonna looking down on the Christ Child reading. The motive is of course unprecedented. The arrangement would lend itself perfectly to execution in marble, and the platform on which the Child sits is a clear enough indication of the material that was in M.'s mind when he made this sketch. Prof. Frey suggests that the shading in the background is for a niche, and he must be right. The Child is but little changed from the one in the Doni *tondo*.

It seems to me not impossible that the group of the Madonna with the infant John on the recto was drawn two or three years later than the rest of this leaf. Let us look first at the other two sketches. The cross-hatching is still close, although freer than in M.'s earliest work. The child on the verso has too much resemblance to the one in the Doni Madonna—which picture, I take it, was painted just before the beginning of the Sixtine Ceiling—and to the *putti* on the early sheet at the B. M. (my 1481 verso, Fig. 578), to be of a date much later than, say, 1510. In the group of the Madonna kissing the Child, His arm has the precise form that we find repeatedly in the Ceiling, and never much ealier or later. The arm of the sleeping figure thrown over the head is also a common motive in the Ceiling. But in the group with the infant John there is a greater freedom of touch, a looser hatching, which makes me suspect that it is of somewhat later date. This impression is confirmed by the size of the infants, which certainly indicates an advance in M.'s conception of the child's form—an advance accelerated, no doubt, by his having designed for the Ceiling so many *putti* necessarily on a larger scale than was called for by smaller and more intimate compositions. The Madonna, again, seems to me to descend from and not to precede the younger sibyls in the Sixtine Ceiling. As for the infant John, he should be compared with the *putto* in the Ceiling who supports Daniel's book, and also with the infant John in the beautiful r. ch. drawing for a Madonna in the Louvre (my 1584 verso, Fig. 626), which certainly stands close to the work in the Ceiling. The internal evidence would thus go to prove that the earlier sketches on the leaf might be contemporary with the Ceiling, and that the later one cannot have been done long afterwards. But it is obvious that a drawing like this later one must have been known to Raphael, and inspired his Madonna of Francis I, a work finished in 1518. Considering that the relations between M. and Raphael were not intimate, nor even direct, we must allow some time for this motive to have reached Raphael, and can date its production scarcely earlier than 1516. Then it should be noted that this same sketch is of the kind which had a great influence on Sebastiano del Piombo. One should look at the hand of the Madonna and compare it with, for instance, the Magdalen's in Sebastiano's Raising of Lazarus. Now, as we have seen (*cf.* section on Sebastiano), Piombo seems to have begun to study M. in good earnest when the Ceiling was approaching completion and to have forme his dmanner on that and on drawings furnished him by M. directly afterwards.

We may safely conclude, therefore, that these sketches are of no earlier date than 1510 and no later than 1516—I should think no later than 1514. Certainly no part of it has any connection with the work at S. Lorenzo. The writing on the [recto], of no intelligible significance, is by Prof. Frey said to be Antonio Mini's. If true, which seems to me improbable, it would prove only that this leaf was still in M.'s possession in 1524 or later—no cause of surprise, considering how many drawings he kept locked up in chests.

[I let this remain because it proves how difficult, if not impossible, it is to date the drawings of M. and his apprentices on internal evidence only. My present feelings about the Madonna and infant John on the recto will be found in Appendix XV.]

1599ᴬ PARIS, DE FREY SALE (June 13, 14, 1933) No. 7 (This drawing has recently been acquired by the
Fig 616 Cleveland Museum of Art, but the information came too late for our Catalogue entry
number to be changed)—Study for the nude over Daniel (Venturi, *M.*, 91) and in opposite
direction turbaned head, perhaps a first idea for one of the sibyls, the Delphica, for in-
stance (Venturi, *M.*, 113), who in the fresco finished by being much younger (p. 198, note).
R. ch. 33.5 by 23.5. Verso: Various studies for l. foot of same figure, heel and ankle
Fig. 606 of a l. foot walking, head and shoulders of middle-aged man looking up to r., lower half
of head and shoulders and upper part of arms of a man turning to r. and pulling hard
to lift some heavy object (p. 196, note).

The sheet has been cut down as the lower part of the turbaned face on recto and
the upper part of the man pulling on verso are missing. I cannot find the head or the
nude on verso in the Ceiling and yet one feels that if not made in connection with this,
they at least date from the same period. The nude alone suggests the one on our l. in
the Sacrifice of Noah, while it corresponds well enough with the man helping to carry
the Dead Christ in M.'s N. G. Pietà (Venturi, *M.*, 38) to authorize the conclusion that it
may have been sketched for that work. And should that turn out to be true it would
not only go toward proving that the great failure in the N. G. is M.'s but to dating it.

The style and quality of this sheet bring it close to the study for the Libyan Sibyl
in the Metr. Mus. (my 1544ᴮ, Fig. 631) and to the head in the Uffizi (my 1399ᴬ; Brinck-
mann, 6) as well as to a head on a sheet in the Casa Buonarroti (my 1416 verso), where
the ear is identical with the one of the man pulling on the verso of our sheet. The date
of the last two has been much discussed of late but is established beyond dispute by
their close relation to our sheet and its companion in the Metr. Mus., both of which as
we have seen were done for, or contemporary with, the Sixtine Ceiling.

1600 ROME, CORSINI, PRINT ROOM, No. 125514—Study for a Martyrdom of St. Catherine (p. 228). The
Fig. 701 scene takes place on the terraced steps of a palatial vestibule. The virgin martyr, with
an expression of ecstatic resignation, appears in the foreground tied to a stake between
two wheels. Her nude executioners are hurled over the wheel supports, and the bystanders
press, in frightened haste, to r. and l. In the background another group crowds to r. to
get away, while from the l. enter a princess and attendants with gestures of holy joy.
Bl. ch. 26.5 by 22. Anderson 3176. [Rusconi, *Emporium*, 1907, p. 269. Baumgart,
Boll. d'Arte, 1934/35, p. 345.

As was first published by Adolfo Venturi (*L'Arte*, 1899, pp. 259-261), this sketch is
the one] made by the master for his life-long friend, the self-satisfied, painstaking, amiable
simpleton, Bugiardini. A long article might be written and read with profit wherein
Vasari's methods and credibility would be discussed, and the differences between M.'s
sovereign genius and the hopeless, irremediable mediocrity of a Bugiardini made brilliantly
clear; but the intelligent student may have the pleasure of following it out for himself.
The materials are this noble, intellectual design—where for once outside of Trecento art,
the theme is treated as it should be—Bugiardini's purile labour, still at S. Maria Novella,
and Vasari's delightful pages on that painter in general, and on this work in particular.
[Here is what Vasari says about this altar-piece: "il quale finalmente diede finita l'opera
in modo che non si conosce che Michelagnolo lo guardasse mai" (VI, p. 208). In short,
nobody would have known that M. had ever had anything to do with it.]

The precise date of the drawing is not easily fixed. The style and the workmanship
recall the sketchier parts of the Cavalieri and kindred designs, as well as some of the
studies for the Last Judgement and others of that period. The saint herself, in action,
in expression, and even type, recalls the "Vita Contemplativa" in the Tomb of Julius.
The reclining figure in the foreground already suggests the Paul in the fresco of the

Pauline Chapel. Nothing in either style or workmanship would exclude the possibility that M. made this sketch during his last visit to Florence in the summer of 1533. [The architecture may not be altogether without interest in connection with the genesis of the Laurentian Library.]

1600^A (see 1397^B)

1600^B ROME, Vatican Library, Codex Vaticanus, Fol. 74 recto—R. hand turned up half closed holding a book. Pen. Tolnay, *Rep., f. K. W.*, 1927, p. 204. A good deal like my 1462 and a bit later.

1601 VENICE, Academy, No. 177—Fall of Phaeton (p. 227). Bl. ch. 39 by 26. [Frey, 75. Brinckmann, 57.
Fig. 694 Fogolari, 77. Venturi, *M.*, 228. Popp, *M. K.*, 47.]

 Another version of the finished Windsor drawing (my 1617, Fig. 695), and even earlier than the Malcolm one (my 1535), although later probably than the Haarlem sketch (my 1471). Consult these drawings in Catalogue.

 In the upper part this version differs from the others in that Phaeton falls between the horses instead of to the side. [This instinctive stretching of his arms toward the ground recalls the nude Joram falling out of a chariot in the medallion to the l. of the Drunkenness of Noah in the Ceiling.] Below, Eridanus is no indifferent river god, but stretches his arms upward, and the Heliades are even more convulsed than in the Malcolm sketch. Yet this is much more like the final version than the study for this part only at Haarlem. There Eridanus lies in the posture of the drunken Noah on the Sixtine vault and the Heliades, sexless, suggest Signorelli's "Fulminati" at Orvieto. [Eridanus reminds us of Titian's Lawrence in that saint's martyrdom at the Gesuiti, Venice.]

1602 VIENNA, Albertina, S. R., 150—In foreground an elderly man in profile to l. in long mantle, elabo-
Fig. 569 rately hatched; behind him to r. another man, also in profile, slightly bending over, wearing large keys at his girdle, and to l. another, younger man, whose head and shoulders only are visible (pp. 186, 365). Pen. 29 by 20. [Frey, 23.] Schönbrunner & Meder, 195. [Albertina Cat., III, No. 129. Popp, *Zeitschr. f. B. K.*, 1925/26, p. 142.] Verso: Youngish
Fig. 570 man kneeling to l., but seen from behind, wearing a flat cap (p. 186). [Frey, 22. Albertina Cat., III, No. 129^R. Popham Cat., No. 208.]

 These are perhaps the finest of M.'s earliest drawings, and they are obviously copies after older masters. Whose the originals may have been cannot—at least, for the figures on the recto—be open to doubt. These massively dignified people, with their majestic draperies, this profile in the foreground, could not have been a creation of any one but Masaccio. Perhaps one may venture to be more precise, and to suggest that these worthies were taken from the fresco of the Dedication of the Carmine described at length by Vasari. The man with the keys may well be the porter of the monastery whom Vasari mentions. Messer Giorgio, it is true, speaks of him as holding the keys in his hand (Vasari, II, p. 296), but we know he was not wont to sin on the side of over-exactness. The keys are so prominent that they must be considered as a badge of office, and Masaccio is not likely to have painted two porters. As for the kneeling figure, here also the sense for form, the structure, and the draperies are Masaccio's.

 [In the Casa Buonarroti there is on the verso of No. 36^F (my 1663 verso; Brogi 1648^C; Tolnay, *Jahrb. Pr. K. S.*, 1933, p. 99) a similar group with the addition of two other figures. Certainly not by M. himself but copied (perhaps by Antonio Mini?) from an original by the master done after the same fresco as the recto of the sheet we have just catalogued.]

1603 S. R., 152—Youngish woman seated, with her head bent down a little to r., looking at the
Fig. 675 naked child on her knee sucking at her breast (p. 222). Pen. 39 by 19.5. Braun 70034. Schönbrunner & Meder, 360. [Albertina Cat., III, 132^R. Brinckmann, 16. Venturi, *M.*, 211.

Popp, *M. K.*, 53.] This is the most beautiful of several studies treating the same motive, the action and expression being unsurpassable and the handling free and to the purpose. Verso: Nude man without arms, of rather Signorellesque proportions, seen from behind with the face in less than profile to l. (p. 347). Braun 70033. Schönbrunner & Meder, 419. [Albertina Cat., III, 132.]

The date of this leaf is hard to determine. If we had no other guidance than is given us by the figure on the back, we might date it along with the beautiful Chantilly sheet (my 1397, Fig. 575), as of 1504, or earlier. Nor does the Madonna give any decisive clue—unless indeed it be her head, which is drawn peculiarly with coarse lines, and altogether in a way which I find paralleled but once, and that in the drawing for the Christ at the Minerva (my 1543, Fig. 657) [formerly] in the Oppenheimer Collection [and now belonging to Mr. Brinsley Ford]. That sketch dates from early in 1514, and I would place the Albertina leaf no later, at all events. Be it noted that, although the motive of the Madonna closely resembles the one executed for S. Lorenzo, it yet could scarcely have been drawn with a view to that work. Evidently it was an idea that haunted M. for many years, but which he seems to have realized only in more than mid-career with the group at S. Lorenzo. Morelli condemned this leaf altogether (*Kunstchr.*).

[The nude on the verso seems now (1934) to have been done, like my 1479, 1597, 1598, and 1645A (Figs. 593, 596, 601), for the group of two soldiers holding up a third in the background of the Bathers. The Madonna need not have been done at the same date but possibly soon after.]

1604 VIENNA, ALBERTINA, S. R., 157—Studies (it would seem from the model) for the figure helping his
Fig. 589 friend with his armour, and for the fat man rushing forward (p. 192). Both in the famous composition of the Bathers, and dating probably from late in 1504. Pen. 27 by 20. Braun 70037. [Frey, 61. Brinckmann, 14. Knapp, *M.*, pl. 13. Albertina Cat., III, 130.]

Morelli's condemnation of these figures was more intelligible, if no more defensible, than many other of his pronouncements about M.'s drawings. That this leaf is the master's admits of no doubt, but it certainly is disappointing—as are nearly all the other remaining studies for the Bathers.

Verso: Study—more highly modelled than the recto, and perhaps gone over with white—for the nude carrying a lance in the back row of the same composition. Bl. ch. and wh. Frey, 62. Brinckmann, 13. Albertina Cat., III, 130R. See also W. Köhler, pp. 153-155. A drawing like this one may have had considerable influence on Raphael's draughtsmanship.

1605 S. R., 167—Studies of arm in various positions, with ciphered indication of the muscles. This is identical in quality with the last leaf for the Bathers, and must have been done with a view to that work, although its exact purpose is not to be determined. Four of the arms finished in pen, the rest more sketchily in bl. ch. 31.5 by 23. Braun 70041.

1606 S. R., 169—Studies in various stages of finish, from vague outline to the highest elaboration, of a nude seated woman leaning with her knees and arms against a drapery. Her head, in profile to l., is framed in by her arms and hands, and she shows her back and her l. breast. Sp. 17 by 19. Braun 70043. Brinckmann, 67. Albertina Cat., III, No. 133.

The motive is by itself an invention of genius, for one may scarcely conceive of another so calculated to bring out all the plastic qualities of the human figure. Indeed it is one that with variants has been treated again and again by the draughtsmen of our own time, by Degas in particular, in his many studies of women coming out of the bath. The execution of the most finished study (of the others it is not easy to speak) is indeed exquisite, yet not without a touch of senile mannerism. Nevertheless, this drawing cannot possibly belong to the date vouched for by the inscription. This, in ink, runs as follows: "Micaelis Angeli manu Anno aetatis suae lxxxvii. Romae 1560, xxvii. Martii." Below this some person, certainly not M., has added in pencil: "ali 17 di febbraio a hore 23 a uso

fiorentino 1563 alla Roma el Anno 1562." What all this nonsense may mean I cannot tell, but I venture to say that no competent person who has made a serious study of M.'s whole career as a draughtsman will place this drawing later than 1540. Indeed, the works it goes with best are the Cavalieri drawings, particularly the Ganymede and the Windsor Phaeton (my 1614, 1617; Figs. 690, 695). It even occurs to me that this leaf may possibly have been done in the course of a drawing-lesson given by the elder to the younger friend. This would explain the various stages of finish, and, indeed, the roughest version (on the l.) is scarcely M.'s own, and may be the pupil's—whoever he was.

1607 WINDSOR, ROYAL LIBRARY—Nude standing with head in profile to r., his body turned somewhat
Fig. 638 in same direction, the torso thrown back a little, the r. arm extended across the back, with the fingers resting on the l. arm (p. 202). All over the figure are indications of measurement for proportion. Also two very slight other sketches. R. ch. 29 by 18. Braun 79116.

The movement and proportions of the nude recall the David, although there is no obvious resemblance between them. The torso and the thighs are carefully and beautifully worked, the head and the legs carelessly. An almost contemporary copy of this figure on a larger scale once belonged to Sir Edward Poynter.

Fig. 637 Verso: Nude standing turned a little to r., but his face in complete profile, his arms folded (p. 202).

This is a rapid study from the model, which model recalls the drawing in the Louvre (my 1594, Fig. 588) for the man having his armour put on (in the Bathers), and cannot be of later date. A patient comparison with the figure on the recto, and with many of the pen-drawings of this period, must remove all question as to this sketch being by M. himself.[1] The intention of both these nudes is pretty clear. They almost certainly are sketches for the slaves, which seemed to have formed part of even the earliest design for the Tomb of Julius. The one on the verso is almost identical with the uppermost one in the Oxford sheet containing slaves (my 1562, Fig. 632).

1608 No. 12764—Head of youngish person wearing a cap with lappets covering the ears, looking
Fig. 785 down a little to r. haughtily (pp. 200, 359; 365, note). Bl. ch. 20.7 by 14.3. Braun 79113. [Vasari Soc., II, v, 5. Popham Cat., No. 215. *L'Arte*, 1935, p. 245. Steinmann, II, p. 661.]

The style of this head is of the end of the Ceiling. It [must have been] a study for a head in one of the lunettes, among the last bits designed by M. for the Sixtine Ceiling and [recalls] the Joseph [over Pope Eutychius]. Verso: Mask of nearly the same head, [done by some such artist as Sogliani.

Dr. Popp (*Belvedere, Forum*, VIII, 1925, p. 75) is right in dating the superb head on the recto much later and it follows, of course, that it could not have been done for the Sixtine Ceiling. It occurs on a Madonna in a sheet formerly in the Oppenheimer Collection which looks like a copy by "Andrea di M." See my 1694 (Fig. 797), and Popp, *loc. cit.*, opp. p. 71.]

1609 (see 1750A)

1610 No. 12762—Study for grotesque head with hair and beard decoratively arranged. Bl. and r. ch. 24.5 by 12. [Frey, 212A. Popp, *M. K.*, 67.] This, the most beautiful of M.'s grotesques, belongs almost certainly to the period of the Medici Tombs. Verso: Lower part of a figure rapidly sketched in the attitude of the Samson at Oxford (my 1718, Fig. 685). This one is closer to M., but scarcely his own. R. ch. [Frey, 213B.]

1611 Three feats of Hercules represented as one design (p. 227). R. ch. 27 by 41.7. Pl. CXXXVIII
Fig. 689 of F. E. [Frey, 7. Brinckmann, 53. Popham Cat., No. 224. Popp, *Zeitschr. f. B. K.*,

1. An exact copy of this figure in the Uffizi (No 6550F) passes as Pontormo's.

1927/28, p. 13.] To r. and l. are Hercules with the Hydra and Hercules with the Lion. Between them is Hercules and Antaeus.

(1) The Hydra is a dragon of huge bulk with a long tail, and many serpent heads which career over the hero, hiss venomously in his face, or bite his body and limbs, as he leans upon its already supine carcass, toiling to master it. This design has great decorative beauty, the figure of the hero furnishing, as it were, a framework for the pattern formed by the hydra and its many heads, while the contrast between the high finish of the man and the lighter sketching of the monster—a contrast surely deliberate—serves the double purpose of bringing the action into clear relief and of accentuating the differences between those elements in the legend which, from a plastic point of view, are more and those which are less real.

(2) Hercules holds Antaeus between his arm and his chest, pressing the life out of the giant as he struggles, with his head buried under his own inverted torso, and against the loins of Hercules, his l. foot stemmed against the hero's l. knee, his l. hand pressing against his slayer's r. thigh. From Hercules' r. shoulder hangs a shadowy drapery.

(3) Hercules, nude, with the lion skin swinging behind him, straddles over the lion, and stooping a little to r. wrenches the jaws apart. This, again, is most decorative, the lion and the lion's skin forming at once a frame and a background for the most beautiful, most exquisitely finished nude that M. ever drew. Above this group we read in the artist's hand: "Questo è il secondo leone che Ercole ammazzò."

This sheet shows us M. at the very beginning of his later manner, I mean the manner in which we find great dignity, matchless feeling for form, and wonderful finish, tinctured, if not tainted, with a certain relaxation of vigour in mere touch, as well as a certain carelessness in the drawing of extremities. In date it would seem somewhat earlier than the Cavalieri drawings, although it is tempting to fancy that it must have formed one of that series.

1612 WINDSOR, ROYAL LIBRARY—Study for Resurrection (p. 353). Bl. and r. ch. 23.7 by 34.5. Braun 79104. [Frey, 19. Popp, *M. K.*, 56. Popham Cat., No. 219. Tolnay, *Münch. Jahrb.*, 1928, p. 440. Brinckmann, 47. Venturi, *M.*, 220. Toesca, *E. I.*, p. 165.] Christ, nude, with a shadowy drapery tossed from His shoulder, bursts out of the tomb, touches the ground with one foot, and already soars up, with the action and look of an unconscious, somnambulant being. Of the guards, some are still asleep, others take flight in consternation, while the rest grope about, not yet aware of what is happening.

This is an enlarged and elaborated version of the small sketch in the Louvre (my 1580, Fig. 696). Both in the forms and in the treatment it has too many resemblances to the Three Deeds of Hercules to need special indication. They are doubtless of the same date. This also is a "show drawing"—it is indeed a marvel of dramatic force—and may well have been made for Cavalieri, although internal evidence alone would incline me to believe it of slightly earlier date.

Verso: An arm and other slight sketches. [Frey, 224.]

1613 The gods shooting at a herma with a target affixed to it (p. 227). They whirl up, some
Fig. 688 touching the ground with the toes of one foot only, one floating, and others sprawling or kneeling, all in attitudes of shooting. Yet but one bow appears in the composition, and that is carried by a Silenus-like creature who is not aiming. The foremost kneeling figure is singularly like one of the Aeginetan marbles at Munich, and should serve as a warning to those who would suppose M. had acquaintance with the Parthenon sculptures. In the foreground lies a sleeping Cupid, in which Professor Lange finds a resemblance to M.'s youthful work. Under the hindmost figure two *putti* are blowing at lighted faggots to make them flare up. R. ch. 21.5 by 32. Pl. CXXXIX of F. E. [Frey, 298. Popham Cat., No. 223. Brinckmann, 52. Venturi, *M.*, 161. Thode, III, p. 521.] Verso: Memorandum with the date April 12, 1530.

This may be the exact date of the drawing on the recto, but it need not be, and here

again one is tempted to believe that it must have been ·made for Cavalieri, in which case it would be two or three years later. The *putti* are exactly like those in the Bacchanal which we know was done for Cavalieri. No drawing by M. is more famous, and it deserves most of its renown. The theme itself has the alluring fascination of young and graceful nudes in splendid action, while, but for slight signs of carelessness in the extremities, the modelling is to the last degree exquisite, conveying a sense of a substance firmer than flesh, and yet more plastic than marble, or ivory, or even bronze. The subject, according to respectable German authorities, seems taken from Lucian's Nigrinus. This sketch was engraved by Béatrizet and, as is well known, served a follower of Raphael's for a fresco now in the Villa Borghese.

1614 WINDSOR, Royal Library—Rape of Ganymede (pp. 226, 227). Jove's puissant eagle soars calmly
Fig. 690　upward, bearing the beautiful youth, who lets himself go voluptuously as he nestles between the eagle's wings and claws. Bl. ch. 19 by 25.5. Braun 79117. [Frey, 18. Brinckmann, 88. Thode, III, p. 513. Quite likely this leaf is only half its original size, which must have been that of the other finished Cavalieri designs. The missing lower part may have had a landscape, a barking dog, etc. as in all the copies after this composition.]

　　There is a splendid contrast between action and relaxation, and as a pattern the design is delightful, Ganymede's fluttering mantle completing it to perfection.[1] This is perhaps the earliest of the drawings which we know that M. did for Tommaso Cavalieri. On January 1, 1533 (according to Frey, *Dichtungen*, p. 513), Cavalieri thanks M. for two drawings, and it is probable that the Ganymede was one of these. On September 5 (*ibid.*, p. 522), Cavalieri speaks of this drawing as being for some time in his possession. Then it must be with this drawing that we should connect the facetious suggestion of the jovial and frivolous S. del Piombo in a letter dated July 17, 1533 (Milanesi, *S. d. P.*, p. 104), that *the* Ganymede with the addition of a halo would do excellently well for a St. John the Evangelist rapt up to heaven, to be painted by Giovanni da Udine in the cupola of the New Sacristy at S. Lorenzo. We may thus date it early in 1533. [(See Frey's Text, p. 11). The version there mentioned as in the collection of the late Newton Robinson is by Marcello Venusti.]

1615 · · · ·　Tityus chained to a rock, on which he lies stretched, looks at the eagle, who is rending open his side (p. 227). The eagle is the bird that we have seen in the Ganymede. Highly characteristic is the rock, and a sort of stump which takes the vague shape of an eagle screaming. Bl. ch. 19 by 33. Pl. CXLIII of F. E. Engraved by Béatrizet, Bartsch, XV, p. 259, No. 233. [Frey, 6. Popham Cat., No. 222. Thode, III, p. 515. Brinckmann, 54. Venturi, *M.*, 230.] Verso: The same figure rapidly sketched on the outlines by M. himself, and arranged without much actual change of limb for a Resurrected Christ holding up the banner (p. 228). [Frey, 219. Venturi, *M.*, 219.] Beside it an equally rapid sketch of a figure looking up [intended, no doubt, for one of the soldiers.]

　　What could bear stronger witness to M.'s indifference to mere invention, and to his preference for a few fixed attitudes than this change of a supine victim subjected to torture into the victorious Christ. He knew, as the greatest artists always have known, that it is not in inventiveness that the spirit of the hightest art resides. The date is scarcely months, if even weeks, later than the Ganymede. In the letter of September 5, already cited, Cavalieri speaks of this Tityus also as being since some little time in his possession. It is indeed not improbable that, as Professor Frey suggests, this was the other drawing for which Cavalieri thanked M. on January 1, 1533. On September 5, as he writes, Ippolito de' Medici saw this design, and made Cavalieri lend it to him to be carved in crystal by Giovanni (delle Corniole).

1. If this were of an earlier date, one would not hesitate to pronounce it a faithful copy, rather than M.'s original. But this Cavalieri series is so constantly characterized by feebleness of touch and smoothness of execution that I do not in this instance regard these defects as militating against its authenticity. So far as I know, no better version of this drawing exists, although Allori's, in the Uffizi, comes close to it.

1616 WINDSOR, ROYAL LIBRARY—Study for Resurrected Christ (pp. 227, 228). He is a most beautiful
Fig. 697 youth, nude, with but a shadowy drapery tossed behind Him. He soars up with His arms
spread out, His r. foot pressing the tomb as if about to take flight. Bl. ch. 36.7 by 22.
Pl. CXLI of F. E. [Frey, 8. Popham Cat., No. 220. Brinckmann, 49. Venturi, *M.*, 223.]

Not free from certain mannerisms, it yet is one of the masterpieces not only of M.'s but
of all draughtsmanship. In point of date it seems to fit in between the last drawings and
the next—1533, therefore.

1617 Study for Fall of Phaeton (pp. 227, 262). At top of sheet Zeus is seen riding his eagle
Fig. 695 and hurling the thunderbolt. In the centre are the chariot, the four horses, and Phaeton
crashing headlong. Below, Eridanus indifferent, the three Heliades in attitudes of despair,
Cycnus and a watercarrier in a reedy meadow. Bl. ch. 41 by 23. Pl. CXL of F. E.
Braun 79112. Engraved by Béatrizet, Bartsch, XV, p. 258, No. 38. [Frey, 58. Brinckmann, 56.
Venturi, *M.*, 226. Popp, *M. K.*, 49. Thode, III, p. 517.]

This is a more highly elaborated, and more decoratively arranged version of the sketches
in the Malcolm Collection (my 1535), and at Venice (my 1601, Fig. 694), but scarcely a
more spirited one. Altogether admirable in the Windsor sheet is the group of Father
Eridanus and the Heliades. In a letter of September 5, 1533 (Frey, *Dictungen*, p. 522),
Cavalieri acknowledges having received this drawing three days before. [Verso: Female
Fig. 788 bust by "Andrea di M." (pp. 359, 362, 364). The hair, the folds, the stroke should be
compared with my 1630 (Fig. 783). R. ch. Brinckmann, 58. *L'Arte*, 1935, p. 255.]

1618 Bacchanal of children (pp. 227, 258, 262). R. ch. 27 by 38.5. [Frey, 187. Thode, III,
Fig. 691 p. 519.] In the foreground we see to l. a female satyr suckling one child while sheltering
under her mantle another asleep, and to the r. a man asleep, with *putti*, pulling a cloak
away from behind him. In the centre a number of children are toiling to carry an ass
with its feet in the air. Above on the r. other children play around a butt, some lapping
wine from the butt itself, one drawing it into a dish, and others drinking. On the l. we
see more children busy around a cauldron, some attending to the fire, others to the pot,
and one bringing in a suckling pig. Engraved by Béatrizet (Bartsch, XV, p. 260, No. 40),
by Aenea Vico (Bartsch, XV, p. 305, No. 48) in 1546, and again in 1553 by an anonymous
engraver giving the address of Antonio Lafrerii.

That this strangely charming composition was made for Cavalieri we know from
Vasari; but even without him we should conclude from internal evidence that it belonged
to the series. The children are exactly those we have seen in the Gods Shooting, the
sleeping nude is like the Eridanus in the Phaeton, and the treatment is exactly the same
as in the other Cavalieri drawings. The date may be 1533, and certainly not later than 1534,
for with the Last Judgement M.'s drawing undergoes a further change. A pen-drawing at
Oxford (my 1716, Fig. 818) is a hasty copy after this composition. The sketch in the
Uffizi (my 1398A), for the Tenieresque naughty child in the uppermost group on the r.,
is taken from the antique and may have been done twenty or more years earlier.

1619 Head of a lost soul roaring with rage or pain (pp. 230, 360). The few straggling hairs
Fig. 712 erect, shadowy draperies fluttering out like sails from his shoulders. Bl. ch. 26 by 21.
Braun 79114. [Steinmann, II, p. 678.]

There is a gruesome reality here that makes one smile at the harmless Gorgon-like head,
invented apparently by Pollajuolo, occurring so frequently in Tuscany and Umbria in the
last decade of the fifteenth and early in the sixteenth century. Both the idea and the
manner belong to the period of the Last Judgement, but the exact likeness of this demon
occurs nowhere in that work. The nearest approach to it is the head next to Minos. In
the Uffizi there is a copy of this head, more highly finished, completed, turned the other
way, and shorn of all its terror. A comparison of the two is instructive (my 1628, Braun 76182).
Verso: Study for the kneeling demon on shore who pulls a rope (in the Last Judgement).

1620 WINDSOR, ROYAL LIBRARY, No. 12776—Studies of nudes and of limbs. Bl. ch. 42.5 by 28. [Frey, 189. Steinmann, II, p. 681.] Verso : Sketches for the lower part of the Last Judgement. [Frey, 188. Steinmann, II, p. 682.

These sketches seem to me now (1934) to have been done at a fairly early moment in the gestation of the whole design, when the artist jotted down groups or single figures for every part of the composition as they occurred to him, without close reference to their ultimate place in the composition.]

1621 No. 12761—Christ on V-shaped cross, with His head falling on His l. shoulder; below,
Fig. 724 two figures, one looking up, and the other bent with grief (p. 233). Bl. and wh. ch. 40.3 by 21.7. Braun 79103. [Frey, 129. Brinckmann, 72. Venturi, *M.*, 293. Popham Cat., No. 226.] Christ is highly finished, but the other figures are slightly sketched. As in most of the series to which this belongs, there are numerous *pentimenti*. The series I refer to is of the studies for a Crucifixion made in 1546 for Vittoria Colonna, some however doubtless done later, after her death. Verso: Study of a leg. [Frey, 220.]

1622 No. 12775—Study for Crucifixion (p. 233). Here Christ is on an ordinary cross. He has
Fig. 722 been much changed and worked over. To r. St. John looking up, and to l. the Virgin with folded arms, her face in her hands. Bl. and wh. ch. 38.5. by 21. Braun 79102. [Frey, 130. Brinckmann, 73. Venturi, *M.*, 294. Far less interesting and, as it seems to me now (1934), either altogether later or the last of the series done for Vittoria Colonna.]

School of Michelangelo [1] (pp. 238-268)

1622A AMSTERDAM, FRED MÜLLER SALE (June 15-16, 1926) No. 122—Studies for a l. foot, a l. arm and shoulder and the bust of a man looking down. R. ch. 26.5 by 18. Frey, 250. Lees, fig. 32 and pp. 23-24. By a vulgar imitator, perhaps a forger.

1622B No. 119—Various pen-sketches for nudes in attitudes reminding one of the slaves for the Tomb of Julius (p. 205, note). 22 by 16.5. Frey, 249A. Lees, fig. 37. Verso: Autograph letter by M. which Frey (Text, pp. 119-120) interprets as being directed to a devoted apprentice in Rome or Carrara (possibly Silvio Falconi) and in which four blocks for the slaves are mentioned. Lees, fig. 38. The date might be either 1514 or 1516. The sketches on the recto Frey rightly considers to be copies after originals by M. but I cannot accept the attribution to Silvio Falconi. They seem later.

1622C BAYONNE, BONNAT MUSEUM, No. 1218—Nude female figure in profile to r. and in larger proportions head and shoulders of kerchiefed woman turned to l. Bl. ch. 20 by 18.5. Bonnat Publ., 1925, pl. 2, where the head is regarded as study for one of the sibyls. Certainly not M.'s and scarcely Italian.

1622D No. 1222—Copy after sketch for lower part of Monument of Julius II as carried out, with the difference, however, that the outer hermae do not rest on volutes but on pilasters narrowing down to their bases. Pen. See my 1501 (Fig. 645). Arch. Ph.

1623 BERLIN, PRINT ROOM, No. 15305—Two sheets drawn on front and back in exact imitation of one
Fig. 647 another: on front we see a design presumably for the Tomb of Julius, and on the back, studies of limbs. Pen. 52.5 by 34. [Venturi, *M.*, 163.] A discussion of these sheets will be found in the Text (pp. 205-210, 351-352), but see also my 1697A, 1735, 1736, 1747 (Figs. 653, 649, 650, 651).

1. [The student before using this part of the Catalogue is invited to read the introduction preceding the Michelangelo section, as well as Appendix XV and is warned not to fail to look up references to Text and Appendices. There he will find information which to avoid repetitions has been omitted here.]

1623A BERLIN, Print Room, No. 5132—Nude seen from back, turned slightly to l. but with head in profile to r. Pen. 29 by 21.5.

The stringiness of the lines, and the formation of limbs, as well as the general character, and the fact that whatever shading there is goes from l. to r., leave little doubt that this poor sketch is R. da Montelupo's. The few words on the verso, said to be in M.'s own hand, do not establish his authorship here any more than in the sketches at Oxford, where we find his writing and Montelupo's drawing.

1623B BESANÇON, Museum, in an album—Nose and mouth of youngish face, one eye full face and another in profile l., a foot in profile l. with theriomorphic buskin and ear of a curly head. Bl. ch. Arch. Ph. By "Andrea di M." in his last, most highly finished phase.

1623C BOSTON, Isabella Gardner Museum—Copy by close follower, possibly Marcello Venusti, of the
Fig. 736 Pietà designed for Vittoria Colonna, with the difference that the shaft only of the cross is visible (p. 235). Hard Bl. lead. 29 by 19. Photo. Museum.

In quality this is the best record of the lost design, reproducing admirably the flesh touching flesh, as of the arms and hands, the way the armpits of the dead body rest on His mother's knees and how His torso nestles between them. All this better than in the Vatican relief (Steinmann, II, p. 501) or in the engravings of Bonasone and Béatrizet. The first of these engravings, by the way, is dated 1546 and the second 1547. It is not likely that M.'s design was made much earlier. It would have been reproduced earlier.

1623D CAMBRIDGE (Mass.), Fogg Museum, Loeser Bequest, No. 152—Two sketches highly finished and
Fig. 796 several others in little more than outline (pp. 363, 364). Bl. ch. on buff ground. 16 by 16.
L'Arte, 1935, p. 267. Of the first the more important is a profile to l., half human, half bestial, of the kind that we have on the helmet and armour of the Malcolm warrior (my 1688, Fig. 780). The other is of a crouching faun in profile l. with his head between the arms of an incense burner shaped like a child's sledge. He is supporting it with his hands and blowing to revive the flame. Of the sketches in outline one is a deep-bosomed woman stretching up her arms like the Heliades in M.'s studies for the fall of Phaeton or the Resurrected in the Last Judgement. Below we see a crouching figure full face with his head between the horns of a lyre, a nude seated in profile l. apparently in the attitude of someone hammering away with his r. hand, and a l. eye as in my 1555 verso (Fig. 774).

There is no reason why these sketches should not be ascribed to "Andrea di M.," unless it be that the crayon used is somewhat softer. We must, however, recall that all M.'s drawings after 1530 are done with softer chalks than prior ones. The little chains hanging down from the helmet of the monster and from the faun's headdress make one think of goldsmith's work and indeed the sketches may have been for a metalworker—no unusual practice in those days.

1623E No. 148—Elegant and spirited profile to l. of young man. Below to r. part of a face, possibly a satyr's, seen frontally. R. ch. 14.5 by 10. By "Andrea di M." at his best.

1624 CHANTILLY, Musée Condé, No. 28—[Version of same Prudence that we have in my 1637 (Fig. 835), only that here she has alternative profiles one in front of the other. Pen and bistre. 26 by 20.5. Braun 65065 and A. Maurel, *Revue de l'Art*, 1922, i, p. 154. Verso: The two children from the same composition. Giraudon 1028. Interesting as being possibly not dependent on my 1637 (Fig. 835), but a direct transcript, as indeed my 1637 itself, of a design by M.]

1624A CHELTENHAM, Fitzroy Fenwick Collection—Sketch in outlines corresponding, on the whole,
Fig. 598 with the Holkham *grisaille*, after the Bathers, with the addition on the l. of groups of drummers, fifers and horsemen (p. 346). Pen, and bl. ch. 18 by 35.5.

1624^B DETROIT, Institute of Arts—Studies for male torso and for l. arm and hand in bl. ch. and ink. Plan for the decoration of a ceiling (p. 349). 36 by 25. Verso: Studies for a r. arm and shoulder and a r. hand in bl. ch. and in ink for a cast of drapery over a l. shoulder, two scrawls of niches and a small sketch inspired, perhaps, by the Delphic Sibyl. Frey, 247 and 248. Detroit Bulletin, VIII (1926/27), pp. 32-36. Lees, figs. 14, 30, and 40. Amsterdam, F. Müller Sale, June, 15-16, 1926, No. 118.

None of these sketches is by M., but least of all the pen-study for the coffering of the Ceiling. The volutes decorating the oblong are at least a decade later than 1508, when M. planned out the Ceiling for the first time. The seated nude and the *putto* are soft and round in the manner of certain Florentines who in Rome were as much influenced by Raphael as by Michelangelo. I am not acquainted with the original, but in the reproductions this sheet rouses suspicion.

1624^C DUBLIN, National Gallery—Sheet with various studies: male nude seen from back, bust and torso of youthful nude, two legs in profile, a leg seen frontally and a series of heads wearing fantastic helmets. Pen. Probably copies by Battista Franco after early design of M. for the Bathers. The helmeted heads after my 1597 verso, the nude seen from back, the frontal l. leg and the helmet at its foot after 1597 recto (Fig. 593).

1625 (see 1645^A)

1626 FLORENCE, Uffizi, No, 598^E—Half-length profile of youngish woman (pp. 251, 252). On the back
Fig. 781 of her head is a curling helmet, and she wears a dress which leaves the breasts bare (pp. 359, 360). Also a looser sketch of an elderly man's head, and another of a child's bust. Attributed to M., and by Morelli to Bacchiacca (*Kunstchr.*). Bl. ch. 36 by 25. Braun 76189. [Brinckmann, 87. Popp, *Belvedere*, 1925, opp. p. 11. Thode, III, p. 503. *L'Arte*, 1935, p. 253.] Verso: Two heads of same oldish man in profile to l., with curling
Fig. 782 protruding beard, and ear shaped exactly like that of the B. M. spinner (my 1680, Fig. 776), an anatomical study of head in profile to l., of skull for same, of testicles and of straggling locks of hair (p. 251). S. I. For reasons given in the Text I believe the sketches on this leaf to be by "Andrea di M."

1627 No. 599^E—Three profile heads of women (pp. 251, 359, 360, 363). Bl. ch. 34 by 23.
Fig. 778 [Braun 76188. Alinari 274. Popp, *Belvedere*, VIII (1925), opp. p. 11. *L'Arte*, 1935, p. 253.] At bottom, in a hand close to M.'s, but certainly not his, are the words: "Gherardo io non ho potuto oggi."

Even if his, they do not, of course, determine the authorship of the drawings, although they would go to support my theory that they were done in M.'s studio. It seems to have been the wont of both master and assistants to use the first handy bit of paper that had clear space upon it.

Fig. 779 Verso: Two female profiles sketched rapidly, and one half-length figure, more carefully worked, of a charming youngish woman with head slightly bent, wearing a sort of turban puffed out over either temple (pp. 251, 360, 361). [*L'Arte*, 1935, p. 255. Fototeca 846.]

The original sketch by M., after which I assume this was copied, must have been a figure in appearance and style between the one on the back of the B. M. drawing for a sibyl-like young woman (my 1482, Fig. 609) and the beautiful r.-ch. head (my 1552, Fig. 608) and, like these, must have been of date just preceding the Sixtine Ceiling. Attributed to M. and by Morelli (*Kunstchr.*) to Bacchiacca. This also, as I have tried in the Text to demonstrate, is by "Andrea di M."

1628 No. 601^E—Head known as the demon or lost soul. Feeble and elaborated copy of the original at Windsor (my 1619, Fig. 712). Bl. ch. 29.5 by 20.5. Braun 76182. [Knapp, *M.*, pl. 21. Another and still inferior copy of this is Uffizi No. 18738^F.]

1629 No. 602^E—Female head. Poor copy of my 1552 (Fig. 608). R. ch. 16 by 12.

1630 FLORENCE, Uffizi, No. 603ᴱ—Bust of youngish woman seen full face, and rougher sketch of
Fig. 783 man's head (pp. 252, 360). By "Andrea di M." Bl. ch. 20 by 16. Pl. cl of F. E. [Stein-
mann, II, p. 654. *L'Arte*, 1935, p. 255.]

1631 No. 607ᴱ—Study for tomb (pp. 210; 218, note). Pen. 20 by 14. Braun 76180. Brogi 1782.
Fig. 654 [Popp, *M. K.*, 30ᴬ.] Verso: Detail studies of reliefs for above. Brogi 1783.

 [Shaded and more precise version of a sketch in the Uffizi repr. by Geymüller, fig. 19.
Two sarcophagi with concave covers stand against a wall the middle rectangular niche
whereof is filled with a Madonna, while to r. and l. are bas reliefs. The whole structure
is crowned with candelabra and *putti* struggling as in Desiderio's Tomb of Marsuppini,
but with the draperies of a curtain instead of heavy garlands.] No longer ascribed to M.,
but correctly to Aristotile da San Gallo. Formerly, however, it figured largely in
literature. [Nothing can be less Michelangelesque than the *putti*, and as for the reliefs,
not only are they not in M.'s spirit but it is hard to imagine what they had to do with
the Medici dukes.]

1632 No. 608ᴱ—Supposed study for the Tomb of Julius (pp. 206, 210, 351). Pen. 36 by 29.
Fig. 646 [Venturi, *M.*, 162. Knapp, *M.*, p. 45.] Braun 76181. Brogi 1483. Verso: Hands feebly
copied from the Slaves now in the Louvre. R. ch.

1633 (see 594ᴬ)

1634 . . . No. 611ᴱ—Rape of Ganymede (pp. 226; 227, note). R. ch. 31 by 23. Brogi 1791.
Fig. 692 Certainly not by M.; yet the design may have much of him; for both the proportions
of the figure and the eagle remind us of the Cavalieri and kindred drawings (my 1614,
Fig. 690). [May be the copy of an earlier idea as Thode, *Kr. U.*, III, No. 216, suggests
for this drawing.]

 Verso: Male torso [which in the touch betrays the following of Andrea del Sarto].

1635 No. 612ᴱ—A rectangular composition with many nude figures representing the Resurrection
of Lazarus. Bl. ch. 43 by 26. Brogi 1484. [See also W. Köhler, p. 141, pl. xiii.]

 The drawing before us certainly is not M.'s, and seems to have been done by
Alessandro Allori, but the conception is by no means contemptible, and may have in it
something of the master's. One is reminded of his Pauline frescoes, and of a sheet at
the B. M. (my 1508, Figs. 707, 708) containing on both sides various sketches as of a
Madonna, a female nude, and figures for a scene in Dante's Purgatory. [Could we be
sure that in essentials the composition goes back to M., and assuming at the same time
that the central part at least of Sebastiano's masterpiece representing the same subject
is also essentially Michelangelo's, it would enable us to measure the distance travelled
by the great master towards a more athletic, more melodramatic, even more brutal attitude
towards persons and events.]

1636 (see 1397ᶜ)

1637 No. 614ᴱ—Prudence, study for an allegorical composition by Battista Franco (p. 265).
Fig. 835 Pen. 36.5 by 27. Braun 76186. Brogi 1793. [Thode, III, p. 505. Knapp, *M.*, p. 43.
See also my 1624.]

1638 No. 615ᴱ—Supposed studies for decorative nudes on the Ceiling and under them in faint
outline a nude on much larger scale kneeling on one leg and trying to get up with the
other. In opposite direction a figure on a cross which suffices to prove that this could
not have been done in 1510 (as would be the case if it were an original by M.), but as
late at least as the Pauline Chapel, and in my opinion even later, perhaps by Passerotti.
One should compare this with No. 6145ᶠ, a drawing ascribed to Passerotti in this collection
(p. 267, note). Pen. 27 by 20. Braun 76187. Brogi 1789.

1639 FLORENCE, UFFIZI, No. 617E —Catalogued as sketches by M. for the Last Judgement, but really by Passerotti, as the legs and the hatching fully prove. Pen. 15 by 21. Braun 76197. Brogi 1512.

As for the group of figures, they are either a faithful copy of some discarded sketch by M. for part of the Ceiling fresco of the Flood, or a free version after the fresco. The large mask is copied from a face in the same composition, to be seen on the l. of a woman who carries all her belongings on a reversed stool poised on her head. A kindred drawing exists in Casa Buonarroti (my 1661).

1640 No. 619E —Children playing at hot cockles, and two nudes, one seated, and the other
Fig. 819 reclining (pp. 258, 259, 260). Pen. 27.5 by 37. Pl. CLIII of F. E. [*Boll. d'A.*, 1935/36, p. 108.] Verso: Two similar nudes. Brogi 1798. By Raffaello da Montelupo.

1641 (see 1398A)

1642 No. 622E —Studies of four legs, by R. da Montelupo (p. 259). Pen. 21.5 by 26.5. Braun 76195. Brogi 1786. [Fototeca 10883. *Boll. d'A.*, 1935/36, p. 112.]

1643 No. 794O —Three studies of an eagle. Pen. 19 by 23. Verso: Study of an eagle and r. arm (p. 259). By R. da Montelupo.

1644 No. 229F —Elaborate but lifeless study for Marcello Venusti's Annunciation at the Lateran
Fig. 737 done after a sketch and under the auspices of M. (pp. 236, 237, 265). Bl. ch. 40.5 by 54.5. Alinari 173.

The differences between the design before us and Venusti's finished work are slight, and confined to the desk, which in the sketch is open and has upon it a statue of Moses breaking the Tablets of the Law. The flaccid, limp, cottony quality of the drawing does not permit [of its being by M.], and I see no reason why it should not be by Venusti.

1645 No. 230F —Study of same quality and character as the last for Christ in the Garden,
Fig. 836 after which various paintings exist (p. 265). Bl. ch. 36 by 60. Fototeca 4261.

Happily some of M.'s own jottings for this composition still remain (my 1572A, Fig. 735) and will doubtless aid in convincing us that this helpless piece of draughtsmanship is not by the great master. It should be assigned to Marcello Venusti.

1645A (former 1625) No. 233F —Various copies after known or unknown sketches by M. (pp. 195, 347).
Fig. 601 Pen. 28 by 26. [Anderson. Fototeca 3858. Brinckmann, 8.] Verso: Lower part of slender nude with legs wide apart. Bl. ch. and wh. on rubbed ground. Fototeca 3857.

The statuesque figure in profile to r. is copied from the sketch for the Matthew on the Malcolm sheet (my 1521, Fig. 579). The slight sketches for Madonnas may be copies of studies for the Bruges marble, or of a drawing like the Madonna at Vienna (my 1603, Fig. 675). The nude in the lower l.-hand corner, leaning against a kind of reading-desk, occurs with slight changes in the background of the Doni *tondo* as well as in the fresco of the Flood—without the reading-desk. As for the large nude in bl. ch., he is copied [from a nude for the Bathers] on the back of a sheet at the B. M. (my 1479, Fig. 596), the recto of which contains among other things, a sketch for the Bruges Madonna. In short, these drawings are copies of various figures done by M. in his earlier years. Their author was doubtless [a close and able follower. The bl. ch. nude (now, 1934) seems more likely by M. himself.

The interest of the five slight sketches for a woman and child lies in the fact that it is by no means easy to decide whether the originals were meant for the Bruges Madonna, on the one hand, or for the Medici Madonna, on the other, as we might be tempted to assume with regard to the central sketch between the two large figures. Again, we might think of figures in the lunettes of the Sixtine Chapel. It is a warning not to be too positive about the exact purpose of any drawing, as the number of types and attitudes of even such a genius as M. is strictly limited.]

1645^B (former 1645^A) FLORENCE, UFFIZI, No. 236^F—Five of the figures on the r. in the Bathers, copied by Daniele da Volterra (p. 192, note). R. ch. 57 by 43.5. [Köhler, p. 157.]

1646 No. 242^F—Hands in prayer, by Passerotti (p. 267). Pen. 21 by 23.

1647 No. 246^F—Study of a hand, by Passerotti (p. 267). Pen. 8.5 by 18.

1648 No. 247^F—Study for a Pietà, a large *putto*, and a running nude, by Passerotti (p. 267). Pen. 27 by 19.5.

1648^A No. 258^F—Sketch for Medici Tombs (pp. 207, note; 210; 218, note). Quite likely by
Fig. 655 Aristotile da San Gallo. See also my 1697^A, 1734^A, 1735, 1736 and 1747^A (Figs. 648, 649, 650, 653, 666). Pen and slight washing with bistre. 40 by 26. Fototeca 861.

1649 No. 14750^F—Study for some of the figures in the so-called sketch for the Tomb of Julius. [Four lines of hastily cursive writing scarcely Aristotile's and not necessarily by hand that did the drawing.] Pen and wash. 20 by 10.5. Philpot 2592 is a photograph of another similar study which has disappeared from the Uffizi.

In the first number of the *Miscellanea d'Arte* (1903, p. 13), Signor Nerino Ferri, to whom I had the pleasure of pointing out the connection of this drawing with my 1632 (Fig. 646), on the one hand, and on the other hand with the lost drawing mentioned in the note on p. 198 [of Vol. I of my first edition]—Signor Ferri, supported by the authority of Baron Henri de Geymüller, publishes them all as by Aristotile da San Gallo. Now the affinity of these sketches to Aristotile did not escape my attention when I wrote three years ago the first paragraph of p. 198 [of my first edition]; but I am startled to find them ascribed to him in person. I know him: he is a more dainty, more precise draughtsman; but my acquaintance with Aristotile is slight, while Geymüller has re-discovered him, and is a better judge of what may be ascribed to him. If Geymüller were right, my few pages on these sketches would need slight revision, and these sketches would become a trifle more interesting. But although Aristotile certainly could have known more about the Tomb than a later person, he clearly was fond of playing fanciful and even fantastic variations upon the great master's themes, so that even as his they would gain little as documents. Still, these Florence studies and sketches must be somewhat nearer, and the Berlin ones much nearer still, to Aristotile than I used to think. See also my 1735 and 1747 (Figs. 649, 651). [The lost drawing above referred to has the San Gallesque shadings and yet is by the same hand that did my 1649 and 1632 (Fig. 646), the design for the Tomb.]

1650 No. 14754^F—Study for prophet supporting his book on a *putto's* head (p. 267). Pen. 41.5 by 27. Verso: Different study for same prophet with two *putti*. Both [probably] Passerotti.

1651 No. 14769^F—Study of prophet probably by Passerotti (p. 267). Pen. 39 by 27. See my 1649.

1652 No. 17369^F—Copy probably by Passerotti after one of the groups in the lunettes of the Sixtine Chapel (p. 267). Pen. 27.5 by 20.

1653 No. 17391^F—Study inspired perhaps by the famous Vatican torso. By Daniele da Volterra, or possibly Allori. Cf. my 1723. Bl. ch. 35 by 21.

1653^A No. 18724^F—Sketches in r. ch. for a niche between two columns and for a colonnade. In pen, profile of a faun and tiny figure in profile to r. carrying a dish with both hands. 28 by 20.5. Verso: Three profiles in r. ch., one in bl. ch., and the ground plan for a central building in ink.

According to Jacobsen and Ferri (pls. XIX and XX, and text, p. 34) the architectural sketches on the recto might be connected with the Papal Chapel of Castel Sant'Angelo and with the courtyard of the Palazzo Farnese. The head of the faun and the nude are fairly close to M. but the profiles on the verso are no better than Mini's and perhaps his.

1654 (see 1399K)

1654A FLORENCE, UFFIZI, No. 18721F—Study for a male torso and, in a roundel, sketch for the Brazen
Serpent (pp. 205, note; 350). R. ch. 26 by 20.5. Frey 65. Jacobsen and Ferri, pl. XVII. Stein-
mann, II, p. 636. Verso: Study for an arm. S. I. 4537. Frey, 66.

 The sketch for the Brazen Serpent seems almost too dainty in touch and too elaborate
in composition for M. himself, and the torso which, by the way, might do for a slave in
the Tomb of Julius, and the arm are not necessarily by the master. The author may
have been a mannerist of the first generation, working not earlier than 1530, for the
composition of the roundel seems to betray acquaintance with M.'s studies of about that
date, for a Resurrection.

1654B UFFIZI, SANTARELLI, No. 169—*Écorché* of r. arm held out with hand turned up, in bl. ch.
On top the Spanish words *Dos Reales*. 16 by 26.5. Brogi 1254. Verso: Ten or more
lines of writing in loose hand. Over it profile of l. leg done with the pen, and over it
again a stumpy figure in r. ch. turning to r. with hand on what may be a sword. In bl. ch.
écorché of l. leg, a nude running to l., and under the last two, also in bl. ch., rapid sketch
of torso and thighs. Brogi 1253. By an unknown follower of M.'s from c. 1530-40, whom
it would be worth while to identify.

1655 CASA BUONARROTI,[1] No. 2F—Bust of Cleopatra, by "Andrea di M."[2] (pp. 359, 363). Bl.
Fig. 787 ch. 22.5 by 17. Alinari 1027. [Thode, III, p. 501. *L'Arte*, 1935, p. 253.]

1655A No. 3F—Profile l. of old woman looking down. Bl. ch. 15 by 11. Brogi 1243. Panofsky,
Zeitschr. f. B. K., 1927/28, p. 231. By "Andrea di M."

1656 No. 9F—Copy in ink of my 1559 verso (Fig. 595), and in bl. ch. of my 1547 verso.
[Brogi 1245. Alinari 1044.]

1657 No. 12F—Bust of youth reading book, which he holds with both hands, and study of an arm
with pointing hand and of a hand. R. ch. 16 by 22. [Alinari 864. Steinmann, II, p. 629.]

 This is a copy after an original study (unknown to me) for one of the readers by the
bedside of Ahasuerus, in the Fall of Haman in the Sixtine Chapel. [The arm may have
been for the extended arm of the monarch.] The original must have been identical in
quality with the Haarlem studies for the same great undertaking.

1657A No. 14A—Plan for fortifications. R. and bl. ink and wash. 54 by 38. Verso: To l. below,
two lines of M.'s writing ending with the date July 25, 1528. Opposite, in outline, a nude
with arms stretched up and the hand so foreshortened that one can scarcely interpret its
outlines. Below, a r. arm bent up and to r. two arms joined over breast as in my 1684
(Fig. 833). These must have been done in the studio while M. was working on the Last
Judgement. Even feebler, to r. of sheet a small profile to l. Bl. ch. S. I. 21934.

1658 No. 21F—Nude [with curious headdress seated and looking down] in profile to r. Pen.
[By a later imitator.]

1659 No. 22F—Studies of horses. Copies [probably by Montelupo] after originals (unknown
to me), which, like those at Oxford, must have been for the Bathers. Bl. ch. 40 by 27.5.
Brogi 1344. [Tolnay, *O. M. D.*, X (1935/36), pl. 41.]

1660 (see 1403A)

 1. In the Casa Buonarroti I take note of those drawings only which attract attention, and about which I have a word or two to
say. The rest I omit.

 2. The only Cleopatra mentioned as having been drawn by M. is the one which Vasari tells us in the "Life of Properzia de' Rossi,"
was given by Tommaso Cavalieri to Duke Cosimo. This Cleopatra, which in every probability was in the style of the other designs
for Cavalieri [may have been the model for the present sketch.]

1660A FLORENCE, CASA BUONARROTI, No. 27F—Studies for two nudes in Last Judgement, one in attitude of helping to pull up another, the second for the figure holding his hand to his head in Charon's boat. Bl. ch. 17.5 by 21.5. Steinmann, II, p. 669.

1660B No. 27A—First there came on this sheet to our l. a male nude seen almost frontally, and to l. at top the mask of a middle-aged man looking down to r. Below to l. a r. leg and to r. a leg bent at knee and vague traces of other limbs and perhaps torsos. Later at r. angles to above, a number of nudes of smaller size, sprawling, squatting, sitting and getting up, while one kneels in supplication before another who turns away (this recalls Genga's composition at Lille, Braun 72133, where also a nude kneels before another, in the midst of a number of figures). Finally, plan of a bastion with the word *terra* in M.'s hand repeated. Large figures in bl. ch., the small in r. ch., and the bastion with pen. 54.5 by 38.5. Brogi 1209. Verso: Male nude in profile l. and crossing it obliquely from torso to hip a leg, added afterwards. And last, a number of plans for bastions with indications in M.'s hand. Figures in bl. ch., the plans in r. and bl. ink. S. I. 21946. The bastions are by M. for the fortifications of S. Miniato. The hasty small figures on verso are probably Mini's and the over-finished large nudes, on both sides may be by the same hand.

1661 No. 28F—Several studies after female statue (p. 349), such as occurs in M.'s early Chantilly sheet, and the head out of the fresco of the Deluge that we have found already in a drawing in the Uffizi (my 1639). The latter and our sheet are obviously by the same hand—probably Passerotti's. Pen. 29 by 27. [Alinari 1047. Verso: Study for a l. hip and leg and for a female head. Bl. ch. on pink washed ground.]

1661A No. 31F—Head of middle-aged man almost full face, looking out. Bl. ch. 11 by 9. Alinari 1038. Steinmann, II, p. 608. This portrait-like head does not seem in the spirit of M. but more like "Andrea di M.," for whom, however, it is too good.

1661B No. 32F—Verso: Head of young man seen three quarters to l. (p. 366). Bl. ch. 21 by 22.5.
Fig. 803 Frey, 109, and his Text, p. 52-3. *L'Arte*, 1935, p. 281. Very likely, as Frey suggests, by author of heads on both sides of my 1444 and 2480 verso: see pp. 365, 366; Figs. 804, 809).

1661C No. 33F—Rough sketch for one of the nudes on the Ceiling, according to Steinmann (II, p. 595) for the one over the Daniel, and below in merest outline for another. Bl. ch. 24.5 by 15.5. Steinmann, II, p. 624. Brogi 1191.

 I do not feel competent to decide whether this kind of scrawl could have been done by M. The figure in outline suggests the Turin studies that I am tempted to give to Silvio Falconi, my 1746B verso (Fig. 811).

1662 No. 34F—Nude of disproportionate length, in attitude not unlike M.'s so-called Apollo in the Bargello. As draughtsmanship it is [inferior.] R. ch. 36 by 13. Brogi 1192. [Verso: Youthful nude of larger proprortions and more fleshy, looking down slightly to l. Cut off above the eyes and on r. side. Alinari 863.] I venture to suggest that the author of both sketches may have been Mini (p. 358).

1663 No. 36F—Figure in tragic attitude leaning with both elbows on a parapet. R. ch. 33 by 22. [Brogi 1351.] Much in this recalls Sebastiano del Piombo, but it is too slovenly for even him. May it also be by Mini (p. 358)? [Verso: Copy after one of M.'s early sketches inspired by Masaccio (p. 365). Brogi 1648C. Tolnay, *Jahrb. P. K. S.*, 1933, p. 99. See my 1602 (Fig. 569) and p. 365.]

1663A No. 52F—R. leg and l. leg from the two nudes above the Isaiah. Bl. ch. 27 by 20.5. Alinari 1046. Steinmann, II, p. 609. Frey, 171. Delicate copies by contemporary after the fresco in the Ceiling.

1663ᴮ FLORENCE, Casa Buonarroti, No. 52ᴬ—More elaborated variant of central niche as in my 1709 (Fig. 658) with sketch of same figure. Perhaps by same hand. Pencil and bistre. Thode, *Kr. U.*, III, No. 80. Brogi 1226.

1664 No. 53ᶠ—Sketch of tall female figure with r. hand held up and, on a much smaller scale, of a Hercules and Antaeus. [To l. a nude walking to l. and carrying a dish at arms' length. To r. a nude female turning on couch with l. hand extended over sleeping figure represents, no doubt, Psyche looking at Cupid while he is asleep. Vertical lines cross the sheet in a curious way and two horizontal ones and some diagonal ones cross the body of the principal figure in what we might take for the outline of a sheet, making the intention of the figure fascinatingly enigmatic. The Psyche and Cupid was used in the pavement of the Laurenziana, Florence (see A. E. Popp in *Zeitschr. f. B. K.*, 1927/28, pp. 8 and 10.] R. ch. 35.5 by 24. [Frey, 176.] Very poor but genuine work of M.'s following. The tall figure resembles Montelupo's at Oxford (my 1713 verso, Fig. 817). The group is taken from another sheet in the same collection (my 1712 verso, Fig. 682), which I attribute now to "Andrea di M."

1665 No. 55ᶠ—Two nudes. Not improbably by Antonio Mini. R. ch. 33 by 19.5.

1665ᴬ No. 61ᶠ—Scrawled variation upon the Christ in the Last Judgement (p. 230, note). Bl. ch. 36.5 by 24. Brogi 1231. Brinckmann, 61. Venturi, *M.*, 243. Verso: Another variation on same theme but facing r. Brogi 1350. Same quality and hand as my 1667 (Fig. 714).

1666 No. 62ᶠ—Nude starting back surprised. Perhaps by Mini. R. ch. 23 by 8.5. [Frey, 155ᶜ. Dr. Tolnay considers this sketch to be a copy after an original in the Archivio Buonarroti, which he dates 1531, for one of the soldiers starting backward in a Resurrection. See *Münch. Jahrb.*, 1928, pp. 442-3 and figs. 50 and 51.]

1666ᴬ No. 64ᶠ—Various studies for action of arms and hands of Adam in the Expulsion of the Sixtine Ceiling. Lapis. 38 by 24.5. Brogi 1222. Steinmann, II, p. 640. Frey, 105.

 This looks too tight and hard for M. and may conceivably be a meticulous copy by Bugiardini after a lost or to me unknown original. See my 1409ᴮ.

1667 No. 66ᶠ—Scrawled variation upon the Christ in the Last Judgement [and considered by
 Fig. 714 many critics as first thought for that figure (p. 230, note). I find it hard to admit that this and my 1665ᴬ are the master's.] Bl. ch. 32.5 by 19. [Brinckmann, 62. Venturi, *M.*, 244. Brogi 1232.]

1668 No. 74ᶠ—Nudes at various angles to one another, and two profiles. Here also there is a suggestion of Montelupo, but the drawing may be Mini's. R. ch. 42 by 27.

1668ᴬ No. 75ᶠ—Small nudes in various attitudes recalling the Jonah and the decorative figures on the Ceiling, a larger nude of same kind and part of a cornice. Lapis; the larger nude, the cornice and one of the small nudes gone over with ink. 40.5 by 26.5. Brogi 1229. Frey, 116. Two feeble for M. but faithful copies of originals.

1669 FRANKFURT a/M., Städel Museum, No. 392—Head of woman, nearly full-face, in fancy headdress,
 Fig. 784 the head of a puffy-cheeked boy; and sketches of an ear, an eye, and a leg (pp. 252, 358). The leg is a copy of one by M. on a sheet in the Louvre (my 1588 verso, Fig. 642). R. ch. Schönbrunner & Meder, 219. These various sketches seem to be by "Andrea di M." [Verso: Three heads of fauns and other grotesque heads and profiles published by A. E. Popp in *Belvedere*, VIII (1925), pp. 17-18 (figs. 12 and 14) as by Antonio Mini.]

1669ᴬ No. 393—Graceful slender nude asleep reclining with his head resting between his arms. To his side a boy in tunic looking down. Above them lines of writing torn away to r. Bl. ch. Thode, *Kr. U.*, III, No. 248.

Excellent but not M.'s, for whom it is too precise and hard in touch and too slender in proportions. Nor is the handwriting M.'s. Inspired, no doubt, by M.'s design for the Dream of Human Life. See my 1748B (Fig. 693).

1670 HAARLEM, TEYLER MUSEUM, No. 9—Study after upper part of Haman in the Ceiling, for both his hands, his ear, and the r. hand of Ahasuerus. Ascr. to M. but not of his quality. R. ch. 25 by 20. Marcuard, pl. IX. [Frey, 312. Brinckmann, 95. Knapp, *M.*, pl. 60. Steinmann, II, p. 633.]

These are faithful copies after the finished painting, made by some clever and painstaking pupil who was thoroughly acquainted with the master's draughtsmanship. The separate sketch for the ear tells its own tale. The copyist, in his eagerness to get it right, departs from M.'s form, and makes the lobe too fleshy.

[Verso: Scrawls for lower part of figure occupying whole length of sheet, and in opposite direction for a torso turning to r., also a figure, perhaps female, seated on the ground to l. Bl. ch. Frey, 313.]

1671 No. 10A—Elaborate study of the back of a torso and l. arm, in position singularly like the Day of the Medici Tombs. Also two repetitions of the arm (p. 264, note). Bl. ch. 19 by 25.5. Marcuard, pl. XA. [Frey, 316.] Verso: Rapid scrawl of torso and arm. [Frey, 317.]

It seems much safer, on the whole, not to accept these studies as M.'s own. Neither the quality nor the manner is precisely his, although very close. Perhaps they are copies after the Day. See next.

1672 No. 10B—Part of torso in profile to r. with r. arm. Slighter repetition of the same, and of the arm (p. 264, note). Bl. ch. 26.5 by 16. Marcuard, pl. XB. [Frey, 318.] This seems to be by the same hand as the last sheet, and, on the other hand, is so like a leaf in the B. M. (my 1683) that one can scarcely avoid concluding that all are by the same draughtsman [in slightly different phases]. Now the B. M. leaflet contains on both sides copies after figures in the lower part of the Last Judgement.

1673 No. 15A—Sketch for figure in the Last Judgement. Bl. ch. 16.5 by 18.5. Marcuard, pl. XV. [Frey, 324. Steinmann, II, p. 677.]

A figure in this precise attitude does not occur, and to certain minds this would be proof that the sketch was made by M. And they may be right. But at the B. M., at Windsor, at Oxford, and at Lille, there are similar sketches, most of them as dissimilar to anything found in the finished work, yet clearly not by M. This Haarlem study is certainly of better quality than those, but scarcely good enough to be the master's. It was done perhaps by some follower who need have been no cleverer than Cungi, either after some slight indication by M., or varied with a deliberate fraudulent intention.

Verso: See my 1674.

1674 No. 15B—Study apparently for the l. arm in the last leaflet, and pasted on, sketch of a l. shoulder and arm. By the hand that did the last. Bl. ch. 13.5 by 11. Marcuard, pl. XVB. [Frey, 325. Steinmann, II, p. 677.

The verso of this sheet and of my 1673 have been published by Knapp in the text to Frey's *Anhang* as sketches for a Pietà by M., and Panofsky reproduces them in *Rep., f. K. W.*, 1927, p. 42. The touch is too wooly to be M.'s own and a vision at once too crude and too soft. The head of the Saviour is not brutal in M.'s way and the other heads are too gentle for the late date and kind of draughtsmanship. How late may be inferred from the fact that the figure on the extreme r. is the imitation of the angel on my 1534 verso, which could have been done no earlier than 1550.]

1675 No. 22—Study for figure of Christ on the Cross, in attitude nearest to the one at Windsor. Also of a torso in profile. Surely too stringy and fumbling for M. Bl. ch. 32 by 21. Marcuard, pl. XXII. [Frey, 332.] Verso: The same figure traced through, and one or

two small sketches in bl. ch., and studies of architectural mouldings in r. ch. Marcuard, pl. XXIII. [Frey, 333.]

1676 (see 1474A)

1676A HAARLEM, KOENIGS COLLECTION, Inv. 20—Nude floating up as in a dream from his open tomb, with a drapery tossed behind him, the staff of a banner in his r. hand, his l. stretched up. Bl. ch. 35 by 17. School copy of study for the Resurrection made probably before the composition in the B. M. (my 1507, Fig. 698).

1676B Inv. 185—Profile to l. of youth wearing elaborate plumed helmet. To r. another less finished profile in same direction. Pen. 14 by 12. Lees, fig. 33. Copy or imitation perhaps by Bandinelli after studies by M. like my 1597 and my 1598B (Figs. 593, 618).

1676C Inv. 513—Horse with two nude riders, the hinder one in kneeling position clings to back of other. Parallel with the group, outline of the two figures and in opposite direction profile to l. and breast of youth. Bl. ch. 25.5 by 16. Verso: Study for arm stretched out. I cannot make out authorship, purpose or date of these sketches. They may be as late as 1535. On the other hand, they may be fifteen or even twenty years earlier.

1677 LILLE, MUSEE WICAR, No. 97—Brilliant contemporary drawing by Bandinelli after demon in the
Fig. 808 Last Judgement who carries by the legs a figure thrown over his shoulders. [Also a r. shoulder and arm in profile] (p. 255). Pen. 14 by 18. Braun 72033. The wriggling lines, the shading, the stroke are certainly Bandinelli's. One should compare the demon's r. foot with that of a man in a group on the r. in Bandinelli's *Ecce Homo* at the Uffizi (Braun 72035). [Cf. the same figure copied by Cungi (my 1745, Fig. 834).]

1678 No. 99—Study for nude in attitude of floating toward us, doubtless for one of angels in Last Judgement driving back the wicked. Also three studies of arms (pp. 230, note; 264, note). Bl. ch. 41 by 27. Braun 72037. [Steinmann, II, p. 679.]

Both these are by the hand we recognize in a number of other sketches for the same work, and, like some of these, seem to have been enlarged after slight jottings by M. himself. Morelli ascribed this sheet to M. (*Kunstchr.*).

1679 No. 101—Adonis starting for the chase. Said to be a free version of an ancient fresco found in the Baths of Titus. Pen. 26 by 39. Braun 72038. Verso: Nude seizing horse by bridle. Braun 72034. This leaf is certainly by Baccio Bandinelli, here at his very best.

1680 LONDON, BRITISH MUSEUM, 1859-6-25-561—Young woman in profile to l., seated, with her eye fixed
Fig. 776 on distaff which she holds in r. hand (pp. 250, 359, 361, 362). Bl. ch. 28.5 by 18. [Popp, *Belvedere*, VIII (1925), opp. p. 10. *L'Arte*, 1935, p. 245.] The motive is excellent, and doubtless M.'s, but the execution is by the hand that we know in the interesting sheet at Oxford (my 1555 verso, Fig. 774) whereon we find one or two sketches by the master himself and the others by the so-called "Andrea di M."

1680A 1859-6-25-566—Muscular back and l. shoulder, slighter study for a l. shoulder and arm, a l. arm bent and another study for back of neck and r. shoulder. Bl. ch. 25 by 33.5. Photo. Macbeth. Too timid for M.

1681 1854-6-28-1—Rhapsodical variation on the decorative nudes above Joel to r. in the Sixtine
Fig. 807 Ceiling (p. 255). Pen and bistre wash. (M., to my knowledge, scarcely ever used wash.) 40 by 21. Braun 73010. [Steinmann, II, p. 619.]

This is a most characteristic sketch by Bandinelli, with all his dash and emptiness. I should not have taken the trouble to include it here but for the fact that Morelli (*Kunstchr.*) accepted it as M.'s.

1682 LONDON, British Museum, Pp. 2-123—Variations on Jonah. Crude and lifeless. The head and hand betray a follower of Andrea del Sarto. This also was accepted by Morelli (*Kunstchr.*) as M.'s. Bl. ch. 36.5 by 27.5. Braun 73011. [Alinari 1753.]

1683 1886-5-13-5—Contemporary copy, by close follower of M., after the figure in lowest l.-hand group of the Last Judgement, who is raising himself from behind on his hands (p. 230, note). Bl. ch. 29 by 22.5. [Frey, 299. Steinmann, II, p. 683.] Repr. in the "Lawrence Gallery." Verso: Copy by the same hand of the seated figure seen over the shoulder in the lowest l.-hand bit of the same fresco, and of the hands of the man standing over this one. [Frey, 300. Steinmann, II, p. 684.]

The head of this man in the fresco is perhaps M.'s own [(Alinari 26913)] and the only extant [painted] portrait of himself by his own hand. [No other attempt at identifying him in his own paintings deserves as much attention. Even of this I now (1934) entertain serious doubts. It is, however, interesting in this connection that Marcello Venusti in his copy of the Last Judgement made at the end of 1548, now at Naples (Alinari 34014) has introduced to our l. of the copy of this head another portrait head, a younger one, perhaps his own. Venusti when he made this was probably in his 37th year and of course he would have done all he could to make himself look like the worshipped artist. See also (but badly reproduced) Steinmann, II, p. 584, better in same author's *M. P.*, p. 43 Hard and stiff, these sketches do not seem by M., but I am not so sure of that as I was in the first edition.]

1684 1860-6-16-5—Floating figure with arms held out, another foreshortened, with arms folded,
Fig. 833 arms, hands, and rapid outline sketch of a torso (pp. 230, note; 264, note). Bl. ch. 40 by 27. [Frey, 278. Brinckmann, 68. Steinmann, II, p. 663. Venturi, *M.*, 238.] Braun 73018.

I am able to identify none of these in the Last Judgement. They may therefore be either copies of original sketches not used, or enlargements of slight indications by the master. To this last supposition some weight is given by the fact that while, as I have said, I can find nothing like these figures in the fresco, in the Malcolm sketch for this work one or two figures not unlike these floating ones are to be discerned. Verso: Various other floating figures for same composition (p. 264, note). [Frey, 277. Steinmann, II, p. 664. The central figure on the recto repeated twice on the verso corresponds in a general way with one of the angels carrying the column as Frey (Text, pp. 128-129) and Steinmann (II, p. 605) have already noted.]

1685 1859-5-14-819—L. shoulder and arm seen from r. This sketch [which I used to give to] Bandinelli [but which now (1935) seems more like "Andrea di M."] must have passed for M.'s no later than 1600. A copy of it occurs on a sheet at Munich, dating from that time (Bruckmann 177). Pen over bl. ch. 16 by 13.5. Braun 73022.

1686, 1686ᴬ. . 1859-6-25-570 and 571—Two studies of an antique torso of Venus. Possibly by B. Ammannati. Bl. ch. 20.5 by 11. 25.5 by 18.

1687 British Museum, Malcolm, No. 54—Study of arm, and of its skeleton. A most characteristic drawing by Bandinelli. Pen. 27.5 by 16.

1688 No. 55—Ideal bust of warrior in armour [on which are embossed a mask in full relief
Fig. 780 and group of Hercules and Cacus in low relief, reminiscent of Verrocchio and ⸮Leonardo] (pp. 251, 360, 363, 366). Bl. ch. 41 by 26. Repr. in the "Lawrence Gallery." [Alinari 1754. Thode, III, p. 507. *L'Arte*, 1935, p. 255.] By "Andrea di M."

1689 No. 56—Profile of youngish woman to l., her hair dressed elaborately, with a jewel carved
Fig. 786 into the shape of a cherub's head (pp. 250, 251, 359, 360, 361, 366). Bl. ch. 28 by 23. Repr. in the "Lawrence Gallery." [Frey, 289. Alinari 1752. Thode, III, p. 509. *L'Arte*, 1935,

p. 253.] Of same character and by same hand as my 1688 (Fig. 780). Verso: Four rough profiles, one more highly finished of satyr with mouth wide open, a crouching figure and two studies, one a bust and the other the head only, of a youth wearing a cap with a plume in it (p. 250). These sketches also are by the hand that we found in the B. M. study for a young woman spinning (my 1680, Fig. 776) and in the sketches on the verso of my 1555 (Fig 774), drawn by "Andrea di M." R. ch. [Frey, 290. A weaker repetition of the female profile under B. M., No. 1895-9-15-494. 29.5 by 23.5.]

1690 LONDON, BRITISH MUSEUM, No. 60—Study after the Haman in the Sixtine Ceiling, with two sketches of the bent l. leg, and one of the r. foot. Bl. ch. 40 by 20. Braun 65068. [Frey, 261. Steinmann, II, p. 634.] Verso: Less elaborated sketches for upper part of the same figure, one in r., the other in bl. ch. [Frey, 262.]

I judge these sketches to be copies by some close follower of M. after the fresco and not after drawings. [There is nothing in them that might not be M. except the quality. The M. I have studied for so many years could not have done the arms and ribs of the nude on the verso.] At Windsor there is a copy of the recto (Braun 79130) [which like the one at Haarlem (my 1670) looks as if it was made by a draughtsman who had formed his style while copying the M. of the Cavalieri and Last Judgement periods].

1691 No. 68—Study for figure trying to soar upward on extreme r. in lower r.-hand corner of the Last Judgement (p. 230, note; 264, note). Bl. ch. 26 by 20. This is too stringy and dull to be M.'s own work, but it betrays an intimate acquaintance with his manner of drawing at this period.

1692 No. 74—Study for head in the Last Judgement, not of St. Bartholomew as stated in the Malcolm Cat. (p. 230, note). Bl. and r. ch. 39.5 by 25. [Frey, 274. Alinari 1755. Brinckmann, 66. Steinmann, II, p. 673.] Verso: Number of scrawls, studies of legs and outlines of various figures doubtless imitated from slight sketches by M., never used and since lost, for the awaking but still dazed dead. [Frey, 275. I no longer feel as sure as I did thirty-five years ago that the big head and the scrawls on the verso are not M.'s own.]

1693 (see 1697ᴮ)

1694 [OPPENHEIMER COLLECTION (formerly), No. 244]—Madonna and Child. The head imitated
Fig. 797 from my 1608 (Fig. 785). [A female profile in outline only, rump and hip in profile to l. and below it an elderly nude looking up with his hands to his ears] (pp. 364-365). Bl. ch. 21 by 25.5. Photo. Gray. [Popp, *Belvedere, Forum*, VIII (1925), opp. p. 71. *L'Arte*, 1935, p. 267.

Not, as I guessed in the first edition, by Mini but more probably by "Andrea di M.," and one of the latest works of this draughtsman. The handling and quality are what we should expect to have been reached by the author of the other drawings here ascribed to him. The elderly man may be reminiscent of M.'s Phaeton studies and anticipates those for the Last Judgement. It is likely, therefore, that when this sketch was done, Mini had already left for France.]

1695 SIR ROBERT MOND—Youthful profile to l. with long tresses. Bl. ch. 29 by 19. By "Andrea di M." See T. Borenius, *Catalogue of Drawings by Old Masters in the Collection of Sir Robert Mond*, London, 1937, p. 37 and pl. XXII.

1696 SIR CHARLES ROBINSON (formerly)—Highly elaborated study for Annunciation, doubtless for the one painted on M.'s design for the Pace by Marcello Venusti (p. 237, note). Certainly not by M. himself, and most probably by Venusti. Bl. ch. Repr. in "Lawrence Gallery."

1696A LONDON, SIR ROBERT WITT—Composition consisting of 12 figures representing probably the Saviour
Fig. 791 being conducted as prisoner before Pilate. Above and at r. angles to these figures, outlines of
a l. leg (p. 362). Pen. 20 by 28. First publ. and repr. by Tolnay in *Münch. Jahrb.*, 1928,
p. 71. Venturi, *L'Arte*, 1928, p. 155. *L'Arte*, 1935, p. 265. For verso see my 1543A.

The story is well told, too well for M., who does not set out to be a narrator. Very
skilful but rather superficial draugtsmanship with calligraphic tendencies. The stroke and
touch and mannerisms of notation point to "Andrea di M." Tolnay rightly recognizes the
same hand as in my 1704 and 1705 (Figs. 792, 789), which, following Wickhoff, I used to
give to Passerotti (pp. 266-267).

1697 MUNICH, PRINT Room—Seated male figure, draped in cloak, with hand extended, and a nude
Fig. 832 walking away carrying something on his l. shoulder. Pen. 23.5 by 18.5. The types, ankle,
and l.-handed shading make it clear that not M., to whom this drawing is attributed, but
Montelupo was its author.

1697A Sketch for Medici Tombs (pp. 207, note; 210; 218, note). Replica of my 1648A (Fig. 655)
Fig. 653 and almost certainly by Aristotile da San Gallo. Pen and bistre. 38 by 25. Photo. Graph.
Samml. Geymüller (VIII, fig. 20) placed it very near to Aristotile. Its affinity with, if
not derivation from, Louvre No. 686 (my 1729) is clearer even than in the copies. At the
same time it helps to bring the Bekerath design for the Tomb of Julius (my 1623, Fig. 647)
nearer to Aristotile da San Gallo.

1697B (former 1693) NEWBURY, DONNINGTON PRIORY, GEOFFREY E. GATHORNE-HARDY—Study for Pietà.
In the background against the cross in vague outline the Virgin with arms spread out.
Under the shadow of her arms four men struggling with the lifeless body of the Saviour.
All the figures are nude (pp. 235, 236). Bl. ch. 32 by 22.5. Verso: Various architectural
plans and three nudes.

As design the Pietà forms a beautiful group of exquisitely compact mass, and splendid
action. The execution is, however, not possibly M.'s own, but by some appreciative
follower who could adopt the master's ideas, although he could not hope to attain to the
vigour of even the faltering touches of the same master. The date is certainly toward 1550,[1]
so that this design may be an offspring of an early idea by M. for the unfinished Pietà
now at Florence.

1698 OXFORD, ASHMOLEAN MUSEUM, No. 3—Three studies after a nude Venus (p. 267). Pen. 21 by 24.
Braun 73462. Certainly not M.'s and judging by the wiry lines, and the strong preference
for zigzag hatching, probably Passerotti's. Verso: Nude youth, by same hand, here even
more obviously Bolognese. R. ch. [After originals by M., like the nudes on my 1661.
The figure on extreme r. is copied from one on my 1397 (Fig. 575).]

1699 No. 4—Sheet of studies of hands [and of back of male figure (p. 267).] Pen. 41 by 26.
Braun 73463. Verso: Four more hands and several seated nudes (p. 267). Pl. CLIV of F. E.
Fig. 838 This sheet of fetching brilliant studies deserves no small attention, being of the kind
which generally passes unquestioned as M.'s. His it clearly is not, but it took the enviable
knowledge of the later Italian draughtsmen which Prof. Wickhoff alone possessed to unearth
its real author in the clever Bolognese, Bartolommeo Passerotti (cf. Albertina Cat. I, i, fig. 7).

1700 (see 2490A)

1701 No. 20—Sketch for horse after bronze original, of two others plunging away from their
Fig. 814 driver, of a trophy, and of profile of youth (pp. 257-258, 259, 260, 261, 262). Pen and
r. ch. 28.5 by 19.5. [*Boll. d'A.*, 1935/36, p. 105.] Verso: Various architectural mouldings
Fig. 816 and large figure of a nude with head bent slightly l. (pp. 258, 263). [*Boll. d'A.*, 1935/36, p. 106.]

1. Cf. the Pietà engraved by Julius Bonasone (Bartch 64) and dated 1546.

80

The author of this sheet, so obviously not M.'s, has done a number of other drawings, and I suspect that he was Raffaello da Montelupo. My suspicions find confirmation in the fact that the few words in cursive script on the front are almost certainly in Montelupo's hand. Looking at the specimen reproduced in Pini's *Scrittura di artisti italiani*, we find the last is there identical with the one here, the same way of forming the letter *p*, and the same v-shaped *r*. This peculiarity returns even in the more formal hand in the words "Vico mio caro," etc., on our sheet.

It is curious that the more finished plunging horse occurs with but slight change in two versions of the Conversion of St. Paul, both ascribed to Pordenone and both by [Bonifazio], one in the Uffizi and the other now (1900) in the market but formerly in the Nardi Collection at Mira Dolo. Both pictures show in other respects as well the influence of Michelangelo. I should add that it is not improbable that this motive of the charioteer and his mad horses is a hasty copy after a sketch by M. for a Phaeton, of earlier date than any of the three that we still possess from the master's own hand.

1702 OXFORD, ASHMOLEAN MUSEUM, No. 24—Four leaves from a small sketch-book now joined together as a single sheet, containing on front and back sketches for the Ceiling of the Sixtine Chapel (pp. 197, note; 252). Pen and bistre, and bl. ch. The sheet as a whole, 27.5 by 27. Each leaf 13.5 square. [Frey, 151, 152. Knapp, *M.*, p. 33.] The leaf with God the Father dividing light from darkness, and the inscription, of which more presently, repr. in Ottley, p. 30. For a complete description of these leaflets I refer the reader to Robinson's catalogue [and to Frey's Text, pp. 71-74.]

These sketches positively are not by M., but by some pupil who naturally took up all his master's mannerisms and tricks of shorthand. It is conceivable that some of these scrawls were made after M.'s own sketches, which would of course have been accessible to the pupil. But there is no need of this hypothesis. The author may have entered M.'s service just when the Ceiling was finished, and, after attaining to a certain mastery, have been put for practice in rapid drawing to make these hasty notes after the frescoes. The sketch-book from which these leaflets come must have been given to his apprentice by M. himself, for on one leaf we find written in his hand "quindici di settembre," and on another (one of the leaflets under my 1703, Fig. 810, "dagli bere." It would be of some interest to know who was this apprentice, and I venture to say that a clue to his identity is offered in the two lines of writing [for which see Frey, Text, p. 72] on the leaflet with God the Father. [In them the words Silvio and Magliano occur.] The character of the hand [does not seem to me] M.'s, but betrays his influence, and as for the phrases, they seem to me just the kind that a person would write listlessly and almost unconsciously in that unimaginative mood when nothing occurs to one but one's own name. Now, as it happens, Silvio Falconi da Magliano is not only a real name, but the name of a pupil of M.'s. Prof. Frey (*Briefe*, pp. 21, 84) has published two of his letters to his master, wherein it appears that in August, 1514, he was left in Rome as foreman of the atelier, and that in 1517 he was already painting on his own account, not in Rome, however, where he could find no employment, but at Magliano. It thus would seem that in him no more than in his direct successor Urbano, or in Mini, Urbino or any other of his men-of-all-work, did M. happen upon a man of talent. I would assume, then, that these sketches are by the hand which listlessly scrawled down the name, and that the name was the person's own, and thus Silvio Falconi's. Until disproved I will hold that this is a good working hypothesis.

1703 No. 25—Four more leaves from same sketch-book containing studies after the Sixtine
Fig. 810 Ceiling (pp. 197, note; 252).[1] For a full description I again refer to Robinson [and to Frey,

1. [One of them calls for particular mention. I have hitherto failed to observe that the leaflet reproduced by Frey on the upper r. of his pl. 153 representing an old pilgrim hobbling along bent double over his staff with his dog ambling just in front of him corresponds with the reverse of the portrait medal of M. made by Leone Leoni in 1561 (Steinmann, *M. P.*, pl. 50) not in detail but in design. It is not likely that Leoni was acquainted with this jotting. He probably followed a drawing from M.'s own hand. Indeed Vasari says as much. The odd thing is that the pilgrim in our scrawl looks much more like M. aged 85 than he does in the medal, where of course Leoni translated him into his own forms. What are we to infer? That this sketch is the copy of a drawing from his earlier years that M. had kept for 40 years and then gave to Leoni?]

Text, pp. 71-74]. These sketches, if my hypothesis be correct, are also by Silvio Falconi. Pen. Same size as my 1702. [Frey, 153 and 154.]

1704
Fig. 792
OXFORD, Ashmolean Museum, No. 30—Draped seated female in manner of sibyls of the Sixtine Ceiling (pp. 266-267, 362). Pen and bistre. 26 by 20. Braun 73473. [Colvin, III, pl. 9. Steinmann, II, p. 651. *L'Arte*, 1935, p. 257.]

This is a forgery so brilliant and of so ancient a date that until the other day it had never aroused the slightest suspicion. Something theatrical in the face, the mouth awry, the sweeping lines, the vigorous *bravura* stroke, may have made this or that student uneasy; but I venture to say that, without having another artist to whom to ascribe it, scarcely any one would have dared to take this sketch away from M. We owe it to a connoisseur who understands how difficult, nay how impossible, it is to know the great masters perfectly without an intimate acquaintance with all the small fry who surround them or succeed them—we owe it to Prof. Wickhoff (Albertina Cat., I, i, p. iv) that we now can tell the author of such a clever performance. It was the Bolognese Passerotti, famous already in M.'s lifetime as a brilliant penman. There can scarcely be a doubt but that Passerotti made this and similar drawings with the intention of passing them off as M.'s. Here he may have had the Delphic Sibyl in mind, and such of the master's genuine sketches for the Sixtine Ceiling as the one now in the B. M. for the Isaiah (my 1486, Fig. 614).

[The above paragraph remains to commemorate the first serious attempt made to distinguish between the different imitators of M.'s drawings. In the decades that have passed since writing it, we who have been standing on the shoulders of our predecessors have learnt to look further and see clearer. In most respects the problems confronting us seem more insoluble than ever, but in some few we can perhaps reach more satisfactory, if only temporary, conclusions. Thus I have been led to wonder whether this drawing is not rather by "Andrea di M."]

1705
Fig. 789
. . . . No. 31—Standing figure of old woman, draped in voluminous cloak, a crook or staff in her hand, a boy standing beside her (pp. 266-267, 362). Reed pen and bistre. 33 by 20. Braun 73474. [Colvin, III, pl. 8. *L'Arte*, 1935, p. 257.]

This magnificent drawing is certainly by the same hand as the last, Passerotti's, and made, doubtless, with the same laudable object—to be passed off as a genuine study by the master, presumably for a sibyl in the Sixtine Ceiling. Whether for the mere love of excelling in forgery—a passion of certain minds—or at the orders of some such dealer as the Pomponio who got Calvart[1] to make copies with slight changes after the Last Judgement to be sold as original sketches, must remain an open question. But although even more brilliant than the seated sibyl, this "sempiternous crone" is more easily recognized as not M.'s, for the simple reason that Passerotti has here overreached himself. Obviously meant for a sibyl, and not for one of the so-called "ancestors of Christ," this hag puts us at once on our guard, for she is not at all in the spirit and intention of the figures executed— for I do not hesitate to assume that the intention and spirit of these figures underwent no change in M.'s mind. Moreover, this creature has obviously been pieced together out of two perfectly distinct figures in the Ceiling. The pose and the majestic sweep of the draperies are taken from the Eternal in the Creation of Eve, while the staff and the hand upon it are copied from the so-called Boaz. As for the boy, he is not even Michelangelesque. Here also it is evident that Passerotti had before him early drawings by the master, supplied, perhaps, by the dealer who ordered such a forgery; for the draperies, the early copies chiefly after Masaccio and kindred original studies, and for the rest, such a sketch as my 1545 (Fig. 790)—nay, I venture to believe that very one. Be it noted how carefully in the l. hand Passerotti has copied the l. hand of the speaker there, and in the foot the foot of the same figure. Her profile even may have been suggested by the listener's on that sheet. Passerotti's hand betrays itself throughout, where he does not

1. Malvasia, *Felsina Pittrice*, Bologna, 1841, Vol. I, p. 197.

painfully imitate M.'s cross-hatching. For this attribution also all praise to Professor Wickhoff. [A poor copy of this is to be found at Lille (Braun 72036).

I let the above paragraph stand for the same reason that I retain the text of the first edition for my 1704, but like the drawing there discussed this one now seems by "Andrea di M." The design before us, whether in this or other versions, must have been known to Bacchiacca, who used it in a birth plate formerly in the collection of the late Mr. F. A. White, and now in the S. H. Kress Collection, New York. See McComb in the *Art Bulletin*, 1926, pp. 144 and 158.]

1706 OXFORD, Ashmolean Museum, No. 32—Twelve heads [copies possibly by Heemskerck after earlyish] drawings by the master. Thus the middle one on the extreme l. was done after the same original that inspired the head on the verso of the study for the Adam [formerly] belonging to Mrs. F. Locker-Lampson [and now in the B. M. (my 1519A, Fig. 623)]. R. ch. 37.5 by 27.5. Braun 73475. [The mask just below of an elderly man is after the head in my 1399A.]

1707 No. 33—Draped figure of old woman walking in profile to l. Clearly by Battista Franco, and so catalogued by Robinson. Pen. 30 by 13. Braun 73476. Verso: Sketch of child. [A version of the sketch on the recto in bl. ch. is to be found at Chatsworth (*Kusenberg*, pl. 67).]

1708 No. 38—Study for Crucifixion. A copy almost certainly of an original (unknown to me) by Sebastiano del Piombo [and possibly done by Daniele da Volterra]. It is too neat and careful to be by Sebastiano himself. R. ch. 26 by 18. Photo. Museum.

1708A No. 41—Replica of part above sarcophagi in Louvre sketch (my 1735, Fig. 649) for
Fig. 656 Medici Tombs (pp. 207, note; 218, note). Pen and bistre wash. 24 by 25. Frey, 265.

1709 No. 42—Two slight sketches in r. ch. of male busts, and study in bl. for architectural
Fig. 658 arrangement of one of Medici Tombs (pp. 216-217). 14.5 by 22.5. [Frey, 214A.] Verso: Study in r. ch. of standing undraped female figure. [Frey, 213A. Brinckmann, 38.

The busts recall my 1497 verso.] While of relatively fine quality, and approaching M. closely, the leaflet for the tomb is perhaps not his. In kind it is like the Louvre sketch, my 1729 verso, but it is by a different hand [one closer to M.'s] again; whose I do not know, unless indeed, for a reason that will appear presently, it be by Stefano di Tommaso, M.'s foreman at the time. The date of the drawing is given at the top of the leaflet in an inscription, probably in M.'s hand, which by Robinson is transliterated thus: "A' dì 16 di giugno porto monagniola ventuno soldi al fornaio e chomincio taglie.... nel 1524." Of course the sketches may be of later date than this, but it is not likely. Their object may be explained by a passage in a letter of Fattucci's to M. (Frey's *Briefe*), dated Jan. 30, 1524, of the following tenor: "The pope told me with his own lips that he is anxious to hear of all that you are doing, and would like drawings; but not to waste your own time, he begs you will have them made by Stefano, or whom you please." Stefano may thus be the actual author of this sketch, which, at all events, has the interest of showing how far at this date the master had advanced, his own studies being undated. The arrangement is much as it is now; three niches, with a duke in the middle one, and below, only *one* sarcophagus. The duke here is evidently Giuliano. Under the same museum number (42) is catalogued a sketch of an amorino, too soft and pretty, it seems to me, to be by M.; nor does it quite seem by Sebastiano del Piombo, although much closer to him. Bl. ch. 16.5 by 13.

1710 No. 43—Sheet with studies, some of them after the figures in the Medici Chapel at
Fig. 821 S. Lorenzo (pp. 259, 260, 262, 365). Pen. [In bl. ch. profile of young woman in fanciful headdress, not unlike other Michelangelesque fancy heads.] 42 by 27.5. Repr. "Lawrence Gallery." [Verso: Skeleton and studies of legs, two of them in bl. ch.] All these sketches are Montelupo's (pp. 259; 263, note).

1711 OXFORD, Ashmolean Museum—Four anatomical studies of a r. leg (p. 259). Bl. ch. 20 by 29.5.
Fig. 822 Verso: Anatomical study in bl. ch. of a r. leg [in opposite direction of athletic r. arm held up high], and in bistre a number of prostrate figures (pp. 259, 350). [*Boll. d'A.*, 1935/36, p. 111.]

The prostrate figures are certainly by Montelupo, as a careful comparison with the other drawings that I ascribe to him will establish. [Besides, in all the bl. ch. studies the shading goes from l. to r. as is natural for a left-handed draughtsman.] The anatomical studies we can safely assume are by the same hand [and except that they are in ch. are all but identical with those on my 1642. The prostrate figures may be copied from a sketch for the Brazen Serpent by M.]

1712 No. 45—Sketches of all sorts, drawn apparently with no other object than to kill time
Fig. 798 (pp. 224, note; 365). The most noticeable are a horseman, two profiles, the head of a Mercury, etc. The whole l.-hand side was written over subsequently with verses in M.'s
Fig. 682 own hand. These are published in Frey's *Dichtungen*, XLIX. R. ch. 28 by 42. [Frey, 144.] Verso: Two studies of a group for Hercules and Antaeus (p. 224). Variations upon the themes treated by M. in drawings at Haarlem and in the B. M. Also the anatomical study of a l. leg [as in my 1669 (Fig. 784), and the same in outline only], two caricatures of an old woman [and an old man], an owl copied from the one in the Medici Tombs, and certain studies of an optical nature. [Frey, 145.]

Neither the handling nor the quality of these sketches is M.'s own, while the presence of his verses, written after the sheet was drawn upon, makes it certain that they were made in his studio. [I used to ascribe this sheet to Montelupo but it is obviously by "Andrea di M." The wrestlers were drawn over other studies, but not necessarily at another sitting and far from necessarily by M. himself.]

1713 No. 49—Ground plan by M. of a small relic chamber at S. Lorenzo. Bl. ch. 27 by 15.5.
[Frey, 135.] See Robinson's catalogue, p. 335, where it also appears that the date is 1532.
Fig. 817 Verso: Male figure [of disproportionate length with r. leg bent at knee and l. hand held up (pp. 258, 263). Frey, 136. *Boll. d'A.*, 1935/36, p. 106.]

This sketch, as comparison with, for instance, my 1701 verso (Fig. 816) will prove, is by Montelupo, and the date 1532 fits in with the time that he was working for M. [Tolnay suggests (*Münch. Jahrb.*, 1928, p. 445) that the verso may be the original sketch for a Resurrection with the contours gone over later, wherefore it makes a poor impression in the reproduction. I cannot see M.'s hand in it and it would not be at all improbable that Montelupo made a variant in his own long-drawn-out type of nude after one of the Cavalieri compositions which the master was working upon at that time.]

1714 No. 50—Two men engaged in dissecting a corpse (p. 268). Pen. 25 by 17. Braun 73480.
Fig. 840 [Steinmann, *M. P.*, p. 77.] This ghastly sketch, so characteristic of the melodramatic "Tenebristi," is surely, as Prof. Wickhoff was the first to see (Albertina Cat., I, i, p. IV), by Bartolommeo Manfredi.

1715 No. 51—Various sketches as, for instance, of a leg, the bust of an elderly man, various
Fig. 827 caricatures, etc. (p. 263). Pen and bistre. 28 by 21.5. Braun 73486. [*Boll. d'A.*, 1935/36, p. 115.] Verso: Two other studies of a r. leg, and one of an eye. Pen and r. ch. Certainly not M.'s, and I believe by Montelupo. The few words of writing, in a peculiar cursive, are in the latter's hand.

1716 No. 52—Free copy after M.'s famous design for a Bacchanal of Children, made in 1533
Fig. 818 for Tommaso Cavalieri, and now at Windsor (my 1618, Fig. 691) (pp. 258, 262). Pen. 41.5 by 27. [*Boll. d'A.*, 1935/36, p. 107.]

That this is a copy and not an original sketch admits of no doubt. It is equally certain that it is by Montelupo. As the original was done in 1533, and presumably sent

soon after it was finished, we are safe in assigning this copy to the same date. At this time Montelupo was working with M. This copy should be compared with a somewhat similar subject in the Uffizi (my 1640, Fig. 819; pl. CLIII of F. E.), also ascribed to M.

Fig. 815 Verso: Nude male figure, with r. arm held up over head and l. pointing. Also studies for legs of same figure—all by same hand as recto (pp. 258, 259, 260, 263). [*Boll. d'A.*, 1935/36, p. 107.]

1717 OXFORD, ASHMOLEAN MUSEUM, No. 54—Various studies for chimney-pieces, and the upper part of
Fig. 823 a nude female figure (pp. 259, 261, 262). Pen. 22.5 by 28. [*Boll. d'A.*, 1935/36, p. 112.]

This is, again, by the hand which I take to be Montelupo's. Here, however, the attribution to him is almost a certainty. The head has all the characteristics of the drawings in the Uffizi which are there ascribed to him. In this case, the studies of chimney-pieces may have been for those in the Castle St. Angelo, of which Vasari makes special mention.

1718 No. 55—Giant Samson reclining and, in much smaller proportions, Delilah (pp. 224-225, 256).
Fig. 685 The moment chosen is when, having cut his hair, she, while still dallying with him, turns around, no doubt to call the Philistines lying in wait. R. ch. 27 by 39.5.

One should look at the same subject in the Poldi Pezzoli Museum at Milan, there ascribed to Carpaccio, but really by Francesco Morone, to grasp the difference between the idyllic and heroic, the romantic and the classic spirits. This design is the work of some follower, done perhaps under M.'s eye, and almost certainly in his studio, after some slight sketch by himself like the pen-sketch at the B. M. (my 1504, Fig. 684), which may represent a different moment of the same subject and dates doubtless from the same time—1530 probably. [Possibly a third moment is reflected in Allori's drawing in the Uffizi (6655F, Fototeca 12951) representing Venus embraced by Cupid.] Who was the executant of this Oxford design I cannot tell. [If Mini's, as is my 1722 (Fig. 805), this more serious effort to imitate the master must date from the very end of his apprenticeship with M., as my 1722 was from the beginning.]

1719 No. 56—Head of lady. Certainly by Bandinelli and portrait of his wife, Jacopa Doni. [Other portraits of her by Bandinelli in the Louvre and in the Gathorne-Hardy Collection.] R. ch. 30.5 by 22.5. Braun 73841.

1720 No. 57—Jupiter embracing Ganymede (p. 263). Verso: Nude seen from behind, various
Fig. 831 masks, etc. (p. 263). Pen. 26 by 18.5. [*Boll. d'A.*, 1935/36, pp. 115 and 116.]
Fig. 830

Even Robinson questioned the authenticity of this drawing, not because it is in quality inferior to the others by the same hand which he accepted, but because in the Jupiter the Raphaelesque flavour is too strong to escape attention, and, as Robinson rightly declared, the Raphaelesque excludes M. In truth, this sheet is by the hand which has done so many of the drawings ascribed to M. at Oxford. It is the hand which I believe to be Montelupo's.

1721 (see 1568ᵇ)

1722 No. 60—Of the drawings on this mount we here have to consider No. 5 only. It is of a
Fig. 805 recumbent male figure looking away to the l., and of a smaller nude shooting (pp. 256, 364). Our reproduction shows only this sketch. Verso: Again the archer and a pilaster. R. ch. 14 by 33.5. [Frey, 245, 246.]

This drawing is inscribed in an old, although later, hand with the name of Antonio Mini, and its character and quality would rather confirm than contradict this attribution. [It would seem done after some slight sketch for one of the recumbent figures in the Medici Chapel, possibly for one of the River Gods or inspired by it. Represents a relatively early phase of Mini's career.]

1723 OXFORD, Ashmolean Museum, No. 66—Study for an attempted restoration of the Belvedere torso (p. 263). Pen over r. ch. 21 by 14. Robinson was inclined to deny the connection, but Heemskerck's sketches after this famous marble should remove any doubt (see E. Löwy, *Zeitschr. f. B. K.*, 1887/88, p. 77). The author of this one would seem to be Montelupo. A smoother bl. ch. version of the same sketch, perhaps by Daniele da Volterra, is in the Uffizi, where it used to be ascribed to M. himself (my 1653).

1724 No. 67—Verso: [Two studies for l. arm.] Scarcely by M. Bl. ch. 24 by 15. [Frey, 196. See my 1570 for recto by M. himself.]

1724A No. 73—Copy of Crucifix made in 1545 for Vittoria Colonna (p. 233). Bl. ch. 26 by 37.
Fig. 723 Frey, 160. The Malcolm version of it (No. 62) is reproduced also by Frey, 287.

1725 No. 79—Nude drunken faun and another nude on smaller scale (pp. 256, 364). Verso:
Fig. 800 Studies of limbs. R. ch. 33 by 23.

 Excellent copies after originals of about 1530. The quality seems too good for Mini, to whom I used to attribute them. It is conceivable, however, that Mini or somebody else in the studio began this drawing and that the torso and thighs of the larger figure were finished by M. himself.]

1725A No. 76—Composition of five figures, a woman, two children, a nude man, and another half
Fig. 702 effaced figure. 66 by 53.5.

 Mr. Daniel Thompson wrote to me as follows in a letter dated April 26, 1934: "It seems to be executed in brownish colour following an external slight drawing in ink upon a rugged pale green ground. The ground is laid thinly on a panel probably with a wooden blade or 'slice.' The result is a grained, drawn, pitted, irregular surface like a badly plastered wall. It is more painting than drawing certainly but I doubt whether it was ever meant to be completed." I am indebted to Mr. Kenneth Clark for the photo. and to Mr. Jan Robertson for information.

 It is tempting to give this sketch to M. himself in a phase between the Cavalieri compositions and the Last Judgement. Some students might find it easy to dismiss it as by Marcello Venusti. It probably is not by the great master himself and we should, of course, feel safer in thinking so if we could recognize it as done in the exact style of one or another of his few apprentices and innumerable followers. I am not able to do so. The resemblance to the large cartoon in the B. M. (my 1537, Fig. 719) is obvious. The question is whether it is derived from it or precedes it. If a derivation, it is odd that the forms are much more elegant, as in the Cavalieri designs, earlier certainly than the B. M. cartoon. If done before the B. M. cartoon we must grant that it is either M.'s own, which is unlikely, or a fairly accurate transcript of a drawing by him. In any case, this sketch demands attention. And what about the subject? Robinson thinks it represents the return from Egypt. Who then is the child that the woman holds onto by the sash thrown around its chest, and who is the nude middle-aged man who helps it to take its first steps? If this indeed is a sacred subject then perhaps it developes the theme of Raphael's Madonna del Passeggio (Bridgewater House) the woman would be Our Lady, the child Our Lord and the little boy the Baptist. And Joseph may be the dim figure above the last. Who then is the nude? But for the possible Joseph one might be tempted to fancy that the subject was not sacred but Medea with her two children and the pedagogue.

1726 No. 84—Sheet covered with large studies of hands. Certainly by Passerotti. Cf. my 1699. Pen.

1727 Christ Church, C. 15—Profile to l. of young woman, with sharp nose, thick lips, and highly elaborate coiffure. Bl. ch. 20 by 15. Ascribed to M., but, like most of these fanciful heads, by "Andrea di M."

1728 PARIS, Louvre, No. 109—Head of satyr in profile to l. drawn with the pen over a head of a woman
Fig. 793 in r. ch. (pp. 363, 366). 28 by 21. Pl. CLII of F. E. [Alinari 1335. Demonts, *M.*, 2. Brinck-
mann, 2. Popp, *Belvedere*, VIII (1925), opp. p. 15. Knapp, *M.*, pl. 17. *L'Arte*, 1935, p. 267.]

This brilliant sketch, made famous by Mariette, is well calculated to try the student's
patience and judgement. It is of splendid quality, in technique scarcely to be distinguished
from M.'s real work, and attributed to the great master on the strength of Mariette's au-
thority. Nevertheless, Morelli was almost right in declaring it a forgery. I would but add
that it is a forgery, or, to be more exact, an imitation of ancient date, made by some amazingly
clever imitator of M., most probably during the latter's lifetime. Who he was, I must
leave for others to determine. It is clear that he had made a most careful study of the
master's early style, and that he had in mind such heads as those, whether in ink or r.
ch., which are now chiefly at Oxford [my 1520 (Fig. 610), for instance]. It may not be
superfluous to point out that a hand certainly not M.'s is most clearly revealed in the
hard outline of the nose, in the sweeping strokes of the pen, and in the cross-hatching
on the side of the nose.

[Further study makes it seem likely that the head of the satyr is by "Andrea di M."]
The female profile in r. ch., over which this head was drawn, must have been like the
lower l.-hand one on a sheet in the Uffizi (my 1627, Fig. 778) [by "Andrea di M." Verso:
Fig. 802 In bl. ch. a stupid face, and in ink a geometric one, eyes of another, a dog biting his
tail, sketch after an antique statue, and a number of words in the handwriting of Antonio
Mini. *L'Arte*, 1935, p. 281.]

1729 No. 686—Man standing on r. leg, the l. bent back at knee. Bl. ch. 38.5 by 24. [Frey, 89.
Demonts, *M.*, 14. Alinari 1342. Giraudon 85.] Verso: Study for monument (pp. 210;
218, note). In the broader central niche sits the Virgin with the Child between her
knees. On the l., an erect draped male figure. Below, on flat sarcophagi, two reclining
figures. Also on the r., a terminal figure of a *putto* in profile to r., resembling the one
at the Uffizi [(my 1938A) that occurs] in the Windsor Children's Bacchanal (my 1618,
Fig. 691). [Frey, 90.]

This leaf with its faint sketches is not M.'s, whose qualities it entirely misses. The
nude is copied from the drawing on the back of the Windsor Tityus, with the omission
of the r. arm. As that design was made in 1533, it gives us the earliest possible date of
the leaf before us. The *putto* on the verso is copied from another design made by the
master at about this time, namely, the Children's Bacchanal. It should be observed [that
it was this study or another like it] rather than any sketch by M., or the finished works
themselves, which gave rise to such designs as those in the Louvre (my 1735, 1736, 1743A;
Figs. 649, 650), Vienna (my 1747, Fig. 651), Florence (my 1648A, Fig. 655) and Munich
(my 1697A, Fig. 653) which, until the other day, passed for the master's own. Their number
makes one ask whether they were not done to be sold. [I used to give this sheet to
Montelupo. It now seems likely that it is by Aristotile da San Gallo.]

1730 No. 694—Study of nude standing on l. leg, his r. resting on a pedestal, and the correspond-
Fig. 633 ing arm held out, seen in profile to l.; from the arm falls shadow drapery (pp. 201, 255).
Pen and ink closely hatched. 33 by 17. [Alinari 1332. Demonts, *M.*, 11. Brinckmann, 1.]
Braun 62042. Verso: Similar study, with head in profile to r., although he stands much
Fig. 634 more to l. (p. 201). Braun 62043. [Popp, *Belvedere*, VIII (1925), opp. p. 27. Knapp, *Klass.
d. Kunst*, p. XXIII.]

A comparison of these two sketches with those that remain for the Bathers, particularly
with the one there for the soldier who is having his armour buckled for him, leaves little
doubt that the originals of which they are the copies are of the same date. Only the
verso, however, could have been for the Bathers, while the recto was, in every probability,
for one of the slaves in the great work undertaken directly thereafter, the Tomb of Julius.
Who the copyist may have been is a question, perhaps Bandinelli. [The original of the
verso must have been a slightly modified variant of my 1594 (Fig. 588).]

1731 PARIS, Louvre, No. 696—Study for nude, standing on l. leg with r. bent at knee crossing it (pp. 256,
 364, 366). Bl. ch. 31 by 21. [Alinari 1352.] Verso: Half-draped figure in similar attitude,
 Fig. 799 and various studies for drapery (pp. 256, 364). Also a number of verses in a hand
 certainly not M.'s. Pen. [*L'Arte*, 1935, p. 273; Panofsky, *Zeitschr. f. B. K.*, 1927/28, p. 240.]
 Only three of the score or so of lines are published in Frey's *Dichtungen* (CLVI, 2),
 but they are three too many. A careful comparison with a letter reproduced in Carlo
 Pini's *Scrittura di artisti italiani,* vol. II, establishes beyond reasonable doubt that the
 writing is Antonio Mini's. The drawings are his also, of course, and, as the nude already
 suggests M.'s Tityus, we may safely assume that these sketches belong to the end of
 Mini's stay with the master.

1732 No. 699—Nude youth standing on l. leg, r. leg crossing it at ankle, arms lifted and bent
 Fig. 635 at elbow, head showing over l. shoulder (p. 202). Copy of identical nature and by same
 hand as my 1730 (Fig. 633), after study for one of slaves in the Tomb of Julius.
 Pen. 32.5 by 13. Giraudon 93. Braun 62044. [Alinari 1338.]

1733 (see 2496)

1733A No. 710—Tall nude old woman trudging along in profile l. with r. hand on staff and in l.
 a viol. Bl. ch. 37.5 by 13. Arch. Ph. Verso: Middle-aged female nude with head
 slightly to r., with a sash under her breasts and r. arm and hand only visible, the rest
 being cut off to r., the legs bent at knee. Bl. ch. and traces of ink. Arch. Ph. The old
 woman reminds us of a drawing by Rosso (Kusenberg, pl. 78, my 2450A) and must be by
 an artist close to that master. The younger female, despite a certain softness may be by
 the same hand.

1734 No. 715—Study after M.'s Madonna in the New Sacristy at S. Lorenzo, taken from l.
 Fig. 820 (p. 259). Pen. 37 by 25. Braun 62041. Giraudon 97. [Alinari 1333. Demonts, *M.,* 13.
 Boll. d'A., 1935/36, p. 109.] Verso: Hastier sketch of same, seen closely from r. Also a
 faun starting back, a dog's head, two masks, and two hands. [*Boll. d'A.*, 1935/36, p. 110.]
 These famous sketches, also put in vogue by Mariette, are not M.'s, nor, as Morelli
 believed, Bandinelli's. They are by Montelupo. See further under my 1701 (Figs. 814, 816).

1734A No. 737—Sarcophagus crowned by two volutes stands on a pedestal (pp. 210; 218, note).
 Fig. 666 On the volute l. a recumbent nude like the Twilight in the finished work. Below to r.
 and l. of pedestal nudes representing Arno and Tiber. Behind and above sarcophagus a
 niche with seated figure for one of the princes, and to l. a lamenting figure probably
 meant for Earth. Above the cornice two cowering mourners (Thode, *Kr. U.,* III, No. 494).
 Pen. 20 by 16. Arch. Ph. Copy or echo of an idea of M.'s for the Medici Tombs.
 On the r. scrawl in bl. ch., perhaps for a mourner and a few letters in ink in a cursive
 hand. By Aristotile da San Gallo or some one close to him.

1735 No. 837—Project of a tomb (pp. 207, note; 209; 218, note). Bl. ch. and bistre wash.
 Fig. 649 38 by 24. Giraudon 1309.
 Thanks to Baron de Geymüller I was able to add [in my first edition] that this design
 as well as its replica, my 1747A (Fig. 648), are variants of a drawing at Munich [since
 published in the *Renaissance Architectur,* VIII, fig. 20 (see my 1648A, 1697A; Figs. 655, 653).]

1736 No. 838—Kindred to last, and by same hand (pp. 207, note; 210). Note the passion for
 Fig. 650 the obvious as revealed in the addition of a moon to Night, of flames to Day, etc.
 Bl. ch. and bistre wash. 32 by 21. Giraudon 1310. [Popp, *M. K.,* 29. This design is
 an elaborated and overloaded copy of a sketch probably by Aristotile da San Gallo at
 Vienna (see my 1747, Fig. 651).]

1737 PARIS, Louvre, No. 702—Study of half-draped male figure standing on r. leg, his l. raised and resting
Fig. 582 on a pedestal, the head in profile to l. (pp. 189, 255). Pen. 37 by 14. Braun 62058.
This, which [may be] by Bandinelli—there is in the reserve of the Uffizi (No. 505) a
drawing of his singularly like it—is a copy of a study by M., in all probability for his
St. Matthew.

1738 No. 711—Outline sketch for fountain, with elaborate directions how it is to be enlarged
into a cartoon. The basin is half a hexagon, divided into three compartments. The top
is crowned with the Medici arms, flanked by mermaids holding water-jars. To r. and
to l. on bases in a line with the back of the fountain are reclining figures with water-jars,
representing Tiber and Arno. These are adaptations of M.'s Rivers for the Medici Tombs.
Above the fountain a figure in bl. ch., with r. arm lifted. Pen. 44 by 29. [Arch. Ph.]
 The author of this sketch is unknown to me. A person thoroughly acquainted with
the documents of the middle of the Cinquecento in the Florentine archives might easily
identify the hand, which is very legible, but not free from striking peculiarities.

1739 No. 713—Nude attacking with lance—Raphaelesque copy after figure with lance in
background of the Bathers. Bl. ch. 28 by 21. Braun 62061. [W. Köhler, p. 154.] Verso:
Figure moving from l. to r.—a poor scribble.

1740 No. 717—Study of l. hand spread out, and part of another hand drawing (p. 267). Soft
Fig. 839 quill and ink. 18 by 29.
 Another of Mariette's famous possessions. Ottley already saw that it certainly was
not M.'s, and ascribed it to Carracci. Wickhoff (Albertina Cat., I, i, Introduction) discovered
the real author in B. Passerotti.

1741 No. 719—Six heads of grotesque beasts (p. 267). Verso: Three similar heads. Pen. 27.5
by 21. The shading is done almost altogether with pothooks. This is a trick of Passerotti's,
to whom, for other reasons as well, I would attribute this sheet. It was of course an
attempt to draw in the spirit of M.

1742 No. 726—Young woman in profile to r. sitting on her heels, looking intently [at disk held
Fig. 605 in r. hand while her l. holds some nails] (p. 196, note). Pen. 27 by 15. [Alinari 1562.
Popp, Belvedere, VIII (1925), opp. p. 25. Toesca, E. I., p. 178.
 I used to give it to] Passerotti [but it now (1935) seems like the exact] copy [by a
Cinquecento engraver] of a study by M. for the woman in the N. G. Entombment who
sits on her haunches with her hands in pose of holding crown of thorns and nails.
 Verso: Nude [seen from back with head in profile, r. arm held up and the l. about
to throw a spear. Bl. ch. Arch. Ph.] Written in M.'s hand is the word "Alessandro."
 This may have been a drawing from M.'s studio which Passerotti [or whoever was
the author of the crouching female nude] picked up. [Doubtless it was done for the
background of the Bathers but discarded and replaced by the one in a similar attitude
only that he bears down with a pole instead of throwing a spear upwards. See my 1604
verso and my 1739.]

1743 No. 728—Lower part of male nude, an anatomical study highly elaborated by one of the
Carracci. Pen. 31 by 12.
 I recommend this sketch, than which the Bolognese never did better, to the prophets
of a revival of taste in Bolognese painting. Such a revival may indeed come, but it will
not be of good taste. How dry and laboured and dull is this compared, I will not say
with M. [as in my 1597 (Fig. 593)] but with any good second-rate draughtsman of the
"golden" and preceding age! True, one must have the mind's eye to see the difference!

1743A No. 844—Copy of study for one of slaves, as well as, in reversed direction and vertically
to chest, various small figures for slaves. Bl. ch. 35 by 15. Arch. Ph. Verso: Various

sketches connected with Tomb of Julius: part of cornice and below it Victory between slaves chained to pilasters drawn over outlines of a l. arm, and two legs bent at knees. Further to r. in same direction, a stumpy fat headless nude walking to r. and as if looking back, and a squirming nude.

The large figure is a poorer version of the original copied in my 1746 (Fig. 636). The Victory and the slaves are variants of my 1672 or of the original (if an original ever existed) which it copied. Front and back are probably by Aristotile da San Gallo.

1744 PARIS, LOUVRE, No. 2716—Study for Entombment (p. 265). Heroic nudes march in front with blazing
Fig. 837 torches in their hands, and, arriving at mouth of cave, stop and turn round to where four or five others are bearing the Dead Christ on their shoulders and in their arms. They are followed by still others who march in mournful silence, with heads downcast, and their arms crossed over their breasts. Bl. ch. 37 by 24.

The execution of this sketch is probably Daniele da Volterra's, but to no other than M. can belong the invention of this truly sublime design. I know no other treatment of this subject worthy to be compared with this one for impressiveness and majesty. Would that Sebastiano had had it to paint at the time he was doing the matchless Pietà at Viterbo!

1745 MR. WALTER GAY—Man running while carrying another thrown over his l. shoulder (p. 264).
Fig. 834 Supposed study for the demon carrying one of the damned in the Last Judgement, just above Charon's back. This group may have been suggested by the following lines in Dante's *Inferno*, XXI:

> "L'omero suo, ch'era acuto e superbo,
> Carcava un peccator con ambo l'anche,
> Ed ei tenea de' piè ghermito il nerbo."

Pen. 13.5 by 10.

This remarkable sketch is one, and perhaps the best, of a series of drawings, most of which may be seen in the Uffizi. There is good reason for believing that the real author was not M., but Leonardo Cungi, of Borgo S. Sepolcro [cf. my 1677, Fig. 808].

1746 [ÉCOLE DES BEAUX-ARTS], ARMAND-VALTON COLLECTION—Study for slave standing nearly
Fig. 636 to r., with l. foot and l. arm raised, his r. hand tied behind back (p. 202). Close to but scarcely a study for one of M.'s slaves now in the Louvre. R. ch. 32.5 by 20. Braun 65064. [*Dessins de M.*, 1911-12, No. 103. Venturi, *L'Arte*, 1921, p. 226, *Gr. A. I.*, pp. 195-197.]

The execution obviously is not by M., but being a faithful contemporary copy of a drawing for so important a work as the Tomb of Julius, this sketch is precious enough. It would seem to be by the same hand as that we find in the copy in the Malcolm Collection after the Haman (my 1690). The date of the original may have been 1512 or 1513. See my 1743A. [Verso: Leg of the figure on recto repeated and three small groups interpreted by Venturi (*ibid.* pp. 197, 227) as being for Jacob wrestling with the angel. Bl. ch. Arch. Ph.]

1746A RENNES, MUSEUM, Case 23.2—Slender male nude seen from back with r. arm raised over head. Pen. 35 by 13. In r. lower corner and in much later hand "A. Boscoli." Bulloz, and Arch. Ph.

The photo. seems to show on the verso a copy or imitation of my 1559 verso (Fig. 595). The nude is too slender for M. and the hatching, although so close to his, betrays the careful imitator. Probably by a contemporary after an original for the Bathers.

1746B TURIN, ROYAL LIBRARY, No. 15627—Head of Cumaean Sibyl. R. ch. 23 by 31.5. Steinmann, II, p. 649. Verso: Two draped seated figures. The one to l. in attitude like the woman
Fig. 811 in the Manasse and Amon lunette, the other perhaps for variant of same (Venturi, *M.*, 154). Photos. Pedrini. Probably not after original drawings but variants after the fresco of the sibyl and the seated woman in the fresco just below her done by a fairly capable draughtsman. Most likely Silvio Falconi.

1747 VIENNA, ALBERTINA, S. R., 145—Design for Tomb of Duke Lorenzo (pp. 210; 218, note). Inscribed
Fig. 651 apparently by same hand, "Sepoltura del Duca Lorenzo di mano di Michelangiolo." Pen
and bistre. 27 by 21. Schönbrunner & Meder, 873. [Albertina Cat., III, No. 137.]

This is close to, if not actually by, Aristotile da San Gallo. The affinity between it
and the Beckerath design (my 1623, Fig. 647) for the Tomb of Julius is striking, yet despite
the inscription on top of the sheet I do not hesitate to say that, as a record of a design by M., it
should not be taken too seriously. That artist would scarcely have condescended to crown a
structure with hermae shouldering shells and swinging garlands. It is, in fact, as much
of a variant upon M. as Aristotile's other design in the Uffizi for one of these tombs
(my 1631, Fig. 654, with which this should be compared), and was suggested apparently
by some such passing thought of the master's as is represented by my 1497 (Fig. 663)
(see also my 1736, Fig. 650). Returning to the writing, which seems Aristotile's if it is
not a deliberate forgery, which is unlikely, it could have been intended only to give an
idea of what M.'s tomb of Duke Lorenzo was to look like, as in my 1631 (Fig. 654), he
gives a similar idea of the tombs with two sarcophagi each.

[Verso: Study for fountain and for a woman from the antique. Also two inscriptions,
one saying: "Jacopo dela Sovino in Casalgrato Viti." And under the woman: "Nelorto
d'Agostino Chigi." These words tell an interesting tale. The drawing was evidently
copied from a sketch made by Jacopo Sansovino for a fountain to be done for the Altoviti
House, one known as of the *grafitti*.]

1747A S. R., 146—Sketch for Medici Tombs (pp. 207, note; 209; 218, note). Repetition with slight
Fig. 648 variations of my 1697A (Fig. 653). See also my 1648A, 1735 (Figs. 649, 655). The Madonna,
for instance, is much younger here. Pen and wash. 39 by 25.7. Albertina Cat., III, No. 138.
Popp, *M. K.*, 28. Braun 70030.

1748 S. R., 156—Memory sketch after cartoon of Bathers; behind the figures part of an arch with
Fig. 583 reliefs of Baptism and St. George (p. 190). Certainly not by M. The handwriting is definitely
not M.'s. Pen. 17 by 20. [Albertina Cat., III, No. 136. See also W. Köhler, p. 145, pl. XIV.]

1748A S. R., 155—Seated male nude turned to r. and studies for arms and hands. R. ch. and wh.
27 by 19. Braun 70036. Verso: Study for nude with folded hands and four more studies
of folded hands. Albertina Cat., III, Nos. 142 and 142R. Steinmann (II, pp. 595 and 620)
considers the recto to be a copy after an original drawing for the nude to l. over the
Persian Sibyl (see Venturi, *M.*, 94). Wickhoff regarded it as the work of a Flemish artist.

1748B WEIMAR, GRANDUCAL COLLECTION (formerly)—Highly finished study for the allegorical design passing
Fig. 693 under the title of Dream of Human Life (p. 227, note). Known in various painted
versions, e. g. one in the Uffizi perhaps by Allori and another in the N. G. Bl. ch.
40 by 28. Brinckmann, 50. Braun 79539. Thode, *Kr. U.*, III, No. 520. Painstaking and
exact copy of a design by M. made while he was doing the drawings for Cavalieri. See
Thode, *Kr. U.*, II, pp. 375-382. It would almost seem as if the uppermost l. group of
my 1571 (Fig. 683) were done from one of the couples here.

1749 WINDSOR, ROYAL LIBRARY—Study of dancing faun playing on tambourine. Bl. ch. 34 by 17.5.
Braun 79110.

This is a copy of my 1581, made by some follower of M.'s, who imitated his style
of about 1535-1545. Quite likely it is by the hand which made a number of the drawings
supposed to be for the Last Judgement.

1749A Headless male nude similar in attitude to my 1590 (Fig. 639) (see Steinmann, II, p. 631).
Slighter repetition of same nude to l., and to r. skeleton of pelvis. Below to l. a child seated
with l. hand held up and open mouth. Pen. 33 by 26.5. Copies after originals by M.

1750 WINDSOR, ROYAL LIBRARY—Study of demon resting on knee, the r. leg stretched out (pp. 230, note; 264, note). Bl. ch. 36 by 25. Braun 79106.

This figure is obviously connected with the demon who, pulling hard at a rope, is seen conspicuously in the lowest r.-hand corner of the Last Judgement. The differences may be due to its being an enlargment of a variant original sketch by M. himself.

1750A (former 1609) 12763—In ink, cowled figure seated in profile to l. looking down. In r. ch. two studies of relaxed figure and head of third, all presumably for a dead Christ. 26.5 by 16.5. [Frey, 204. Verso: In ink, a small crouching nude and vertically to it in r. ch. skirts of mantle for standing figure. Frey, 205. The cowled figure is by the hand that did my 1696A, 1704, 1705 (Figs. 789, 791, 792), possibly "Andrea di M." The chalk-sketches as well may easily be by him, particularly the one on the verso.]

Domenico di Michelino (pp. 5-6)

1751 LONDON, BRITISH MUSEUM—Statue of St. George in a niche (p. 6). Pen and bistre wash. 23 by 15.
Fig. 22 Braun 73038. Verso: Elderly grandee on horseback, and two heads of young monk almost
Fig. 23 in profile to l. (p. 6). The cavalier may have been a study for Domenico's Adoration of the Magi at Strassburg, and the heads for a Crucifixion.

1752 PARIS, LOUVRE, HIS DE LA SALLE COLLECTION, No. 47—Calling of the Apostles (p. 5). Bistre and wh.
Fig. 21 on pinkish prep. paper. 13.5 by 18. Pl. v of F. E. Verso: Perspective drawing of cloister. Pen.

1753 (number omitted in first edition)

Battista Naldini[1] (p. 321)

1754 (see 1759A)

1754A BERLIN, PRINT ROOM, No. 4626—Full-length male nude turned to r. with r. arm held out. Pen gone over with r. ch. 40.5 by 26. Voss, *Zeichn.*, pl. 6. Verso: Nude male bent double with head and arms resting on knees. Bl. ch. Photos. Museum. The recto was no doubt inspired by a Pontormo like the one at Rennes (see my 2336A).

1754B No. 5082—Sketch for altar-piece after Andrea's Madonna and Saints in the Berlin Museum (No. 246). Attr. Andrea. R. ch. 15.5 by 13.5. Berlin Publ., 33.

1754C No. 5151—Study for full-length John the Baptist. Bl. ch. and wh. 13 by 27.5. Photo. Museum. Attr. Andrea.

1754D No. 5153—Nude figure running forward and, in larger proportions, study for the head. 40.5 by 28. Photo. Museum. Attr. Pontormo. The foreshortening of the head reminds me of the woman kneeling in foreground in N.'s S. Maria Novella Presentation.

1754E No. 5716—Three studies of nudes, one standing with hands clasped, one running towards r. and one kneeling. 42 by 28.5. Photo. Museum. Attr. Pontormo.

1754F CAMBRIDGE, FITZWILLIAM MUSEUM, CLOUGH BEQUEST—Nude figure inspired by Michelangelo's Creation of Adam in the Sixtine Ceiling, and lower part of draped figure in similar attitude. R. ch. 21.5 by 33. Photo. Museum. Attr. Pontormo.

1. I shall not attempt to catalogue his many drawings, chiefly in the Uffizi, which are correctly assigned to him. I shall note a few only of those that pass under other names, particularly such as I have had occasion to speak of in connection with Andrea.

1754G CAMBRIDGE (Mass.), FOGG MUSEUM, LOESER BEQUEST, No. 143—Study for youthful half-nude draped figure, holding scroll in both hands. R. ch. 29.5 by 20.5. Verso: Pontormesque female head of the Certosa type, too poor for Pontormo himself and gone over with ink by a hand even later than N.'s. Also anatomical study for r. arm. Bl. ch.

1755 FLORENCE, UFFIZI, No. 646E —Sketch catalogued as for Andrea's Scalzo fresco representing the Preaching of the Baptist, but the drawing of the extremities and the touch are unmistakably N.'s (p. 279). R. ch. 23 by 28.5. Braun 76395. [Venturi, IX, i, fig. 409.]

1755A No. 16482F —Copy after Andrea's Scalzo fresco representing the Beheading of the Baptist. Bl. ch. Fototeca 4518.

1756 No. 16482AF—Copy by N. after Andrea's Scalzo fresco representing the Visitation. Bl. ch. 16.5 by 24.5. Morelli Dr., pl. VIII. This and the next drawing formerly belonged to Morelli, who believed they were Andrea's.

1757 No. 16482BF—Copy by N. after Andrea's Scalzo fresco representing the Presentation of the Baptist's Head to Herod. Companion to last. Morelli Dr., pl. VII.

1757A Nos. 10971F and 10972F—These two sketches (p. 293) put together form an interesting
Fig. 912 record of what Andrea's Vallombrosa altar-piece was meant to be like. Pen. Both together 11 by 14. Fototeca 4430. Di Pietro, fig. 69. Attr. Andrea.

1758 No. 231F—Dead Christ supported by figure behind Him, both nude. R. ch. 28 by 20. Ascr. to Michelangelo, of whose manner this sketch is a close imitation; but the extremities prove N.'s authorship. This study was probably drawn in preparation for the small fresco which N. painted on Michelangelo's tomb at S. Croce.

1759 No. 252F—Youthful nude looking down. R. ch. 35 by 22. Upper part squared. This graceful figure is, or was, ascribed to Michelangelo, although in a sense, like many other drawings of N.'s, it has more in common with Watteau.

1759A (former 1754) No. 311F—Sturdy nude walking forward to l. with face turned away, and holding
Fig. 857 dish with both hands (p. 279). R. ch. 40 by 25. Alinari 380. Verso: Study for seated Dead Christ and two for a nude, perhaps studies for head of apostle or prophet.

Catalogued as Andrea and the recto as a sketch for the executioner in the Scalzo Dance of Salome, but a copy by N. after a lost original by Andrea. N. betrays himself in the hands. Subsequent to my conclusion that this was N.'s, I found among the drawings ascribed to Pontormo (Uffizi 6524F) another version by N. of the same figure. The attribution of the second to Pontormo may count as a partial acknowledgement that both are N.'s.

1759B No. 315F—Study for kneeling female figure generally considered to be Andrea's sketch for the St. Margaret in the Cathedral of Pisa. R. ch. 19.5 by 14.5. Di Pietro, fig. 58. Uffizi Publ., IV, iii, 18.

1760 UFFIZI, SANTARELLI, No. 656—Two youthful figures, in ordinary dress, one leaning on club, the other seated. Ascr. to Andrea. R. ch. 28 by 40.5.

1761 No. 657—Nude seated, and on a much larger scale a head looking to l. Ascr. to Andrea. R. ch. 29 by 42.5.

1761A HAARLEM, KOENIGS COLLECTION, Inv. 112, 113, 113 verso, 114, 114 verso, 368, 368 verso, 373—Series of sketches in r. and bl. ch. inspired by Andrea's Scalzo frescoes. Published by Frau Fröhlich-Bum as by Andrea and illustrated in *Jahrb. K. H. Samml.*, 1928, pp. 164-170.

The likeness of these sheets to a drawing in the Uffizi representing the Adoration of the Magi and correctly ascribed to N. (Santarelli 743, Fototeca 15942) makes me suspect that they are by the same hand.

1761[B] HAARLEM, KOENIGS COLLECTION, Inv. 111—Study for Hercules clad in lion's skin and in smaller proportions torso and head of same figure turned to r. Attr. to Andrea. R. ch. and wh. 33 by 20.

1761[C] Inv. 265—Study for Announcing Angel in profile to l. Attr. to Andrea. R. ch. 38.5 by 26.

1761[D] Inv. 285—Study for youthful male nude in violent *contrapposto* and two separate studies for legs and abdomen of same figure. Verso: Studies for Christ in a Pietà. R. ch. 37.5 by 25.5. Published as Andrea's by Byam Shaw in *O. M. D.*, IV (1929/30), pp. 23-25, pl. 27.

1761[E] Copy of Andrea's finished fresco for Porta a Pinti (p. 283, note). R. ch. 19.5 by 12.
Fig. 872 Attr. to Andrea but having all the sign-marks of N. is inferior to the Heseltine drawing now in the B. M. (see my 138, Fig. 871).

1762 LONDON, BRITISH MUSEUM, 1893-7-31-16—Draped figure seated on ground in profile to r., holding huge book. R. ch. 25 by 31. Alinari 1663. Formerly ascr. to Andrea, but a highly characteristic N., based on some sketch by Andrea for the *Madonna del Sacco*.

1763 BRITISH MUSEUM, MALCOLM, No. 106—Draped youthful female looking to r., seated in attitude suggesting an allegorical figure placed on a spandrel over an arch. Italian ch. 31 by 22. Ascr. to Andrea, but the cloven foot, the wedgelike fingers, and the touch are N.'s.

1763[A] BRITISH MUSEUM, SLOANE, No. 5226—Sketch for Birth of Baptist inspired by Andrea's Scalzo fresco representing that scene. R. ch. 16.5 by 22. Photo. Macbeth. Alinari 1758.

1764 MUNICH, PRINT ROOM, No. 2206—Sketch of youth, in costume of the time, drawing sword from
Fig. 853 the scabbard (p. 279). R. ch. 39.5 by 19. Ascr. to Andrea, but copy after an original sketch for the executioner in the Scalzo fresco representing the Baptist seized in the presence of Herod.
 The hands and the touch betray N. It was with some satisfaction, nevertheless, that I discovered the exact replica of this drawing in the Uffizi, where it has always been attributed to N. (No. 14415[F]).

1764[A] No. 34951—Crouching figure draped in mantle which leaves breast and l. arm naked. R. ch. 15 by 12.5. Photo. Museum.

1765 PARIS, LOUVRE, No. 1677—Sketch for Pietà (pp. 287-288). R. ch. 17.5 by 15.5. Braun 62119.
Fig. 879 [Alinari 1277. Venturi, IX, i, fig. 448.] Ascr. to Andrea, but a copy by N. after a design by that master. N. betrays himself in the hands, and no less in the quality. A poor copy after the same original in the Uffizi (No. 635[E]) is also ascr. to Andrea.

1766 No. 1688—Design for Epiphany (p. 274). R. ch. Squared. 29.5 by 24. Braun 62123.
Fig. 850 Alinari 1266. Venturi, IX, i, fig. 443. Ascr. to Andrea. This is a copy after a sketch by that master.
 Two other copies are known to me, both in the Uffizi. One (No. 634[E]) may be an exact repetition of Andrea's original. The other (Santarelli 677) is a little more free. That this Louvre version is N.'s will not be discounted by any one acquainted with that draughtsman. The hand of the angel is as good as a signature.

1766[A] VIENNA, ALBERTINA, S. R., 300—Bust of curly-headed child looking up towards r. R. ch. 30.5 by 21.5. Albertina Cat., III, No. 165. Attr. Bacchiacca. Compare with the Child in foreground of N.'s S. Maria Novella Presentation. Verso by later hand.

1766[B] VIENNA, ALBERTINA, S. R., 312—Two tiny sketches for altar-piece with elaborate architectural background, the one to r. being possibly a first idea for N.'s S. Maria Novella Presentation. Verso: Study for head of woman kneeling in foreground of the Presentation and in r. upper corner another rapid sketch for the whole composition. R. ch., pen and bistre. 27.5 by 20. Attr. Pontormo. Albertina Cat., III, No. 219.

Neri di Bicci (p. 146, note)

1767 FLORENCE, UFFIZI, No. 157[E]—Virgin kneeling in profile to l. worshiping the Child, Who lies on
Fig. 400 the edge of her spreading mantle. Background of clouds and trees (p. 146, note). Pen and wh. on purplish brown prep. ground. [Seems to have been gone over later with ink.] 16.5 by 20.5. Pl. LXXIX of F. E. [Verso: Faint sketch of Madonna in niche with four saints and above tongues of flames and angels. More characteristic of Neri than the front. Fototeca 12622.] Ascr. formerly to Filippino.

 The type, the heavy build, and the draperies of the Virgin on the recto made the attribution to Filippino absurd. There was more reason in thinking of Fra Filippo, to whose period this sketch belongs; but the more I studied it—and I did study it for many years—the stronger grew my conviction that its real author was Neri di Bicci; not so much, I should add, the Neri of the tasteless large altar-pieces, as the painter of a number of smaller pictures, chiefly Madonnas, which, in the private collections, where usually they are found, pass under much greater names. In this sketch the most determining detail is the background with cloudlets that Neri seldom omits from his works.

1767[A] VIENNA, ALBERTINA, S. V., 2—Saint, probably Augustine, seated on ground with a scroll on his lap
Fig. 399 on which he is writing (p. 146, note). Bistre and wh. on purplish grey ground. 15 by 14. Photo. Frankenstein. Ascr. by Wickhoff to Alvise Vivarini and in Albertina Cat. III (No. 7) to the following of Lorenzo Monaco. It is so close to Bicci di Lorenzo that it may be by him but to me it looks even more like his son Neri's work done in his studio.

Fra Paolino [1] (pp. 163-164)

1768 AMSTERDAM, FODOR MUSEUM, No. 868—Head for Madonna turned to l. but looking down to r. Bl. ch. and (new) wh. Ascr., I believe, to Raphael.

1769 No. 869—Charming head for Madonna bending over to r. Bl. ch. and (new) wh. Ascr. to Raphael.

1770 BERLIN, PRINT ROOM, No. 5078—Holy Family (p. 164).* Cf. the design for an Adoration in the
Fig. 463 Uffizi (my 1786[A], Fig. 462) and the Annunciation at Vinci. Soft bl. ch. on brownish paper. 39 by 27.5. [Berlin Publ., 28.]

1770[A] No. 482—Kneeling monk embracing foot of cross. R. ch. 21.5 by 19. Gabelentz, II, pl. 33. Study for the Crucifixion in S. Domenico at Pistoia inspired by a sketch of Fra Bartolommeo's for a similar subject. Compare with my 212.

1770[B] (former 1822) CAMBRIDGE, FITZWILLIAM MUSEUM, CLOUGH GIFT—Study for apostles in an Assumption.* Bl. ch. and wh. 36.5 by 28.

1770[C] (former 1821) CAMBRIDGE (Mass.), FOGG MUSEUM—Female figure standing in profile to l.* Perhaps study for a St. Lucy. Bl. ch. and wh. 31 by 17.

1771 (see 216)

1. All drawings by F. P. ascribed to Fra Bartolommeo are marked with an asterisk after the title.

1771A CHELTENHAM, FITZROY FENWICK COLLECTION—Study for St. Michael. Pen and brown wash. 24.5 by 13. Verso: Fragment of study of drapery in r. ch. Very close to Fra Bartolommeo. The 19th century attribution to F. P. seems a very probable one and may be copied from an earlier inscription.

1772 (see 1786A)

1773 (see 1786B)

1774 (see 1787A)

1775 FLORENCE, UFFIZI, No. 456E—Careful study * after the Holy Family in the Corsini Gallery in Rome (p. 164). Bl. ch. and wh. pricked for transfer. 32 by 25. The type of the Joseph and something in the Virgin incline me to believe that this sketch is F. P.'s rather than Fra Bartolommeo's own. Its exact companion is my 1787.

1776 No. 466E—Copy of Fra Bartolommeo's Eternal with the Magdalen and Catherine at Lucca. The close hatching and the dryness are F. P.'s. Pen. 23 by 17.5. Brogi 1973.

1777 No. 477E—Holy Family with three angels.* Bl. ch. and wh. 35 by 27.5. [Alinari 93.]

1778 No. 557E—Copy after lower l. part of the S. Maria Nuova Last Judgement. Pen. 21 by 33. Brogi 1821. It is ascr. to Albertinelli, but the hatching, the draperies, and the dryness are F. P.'s. [Interesting because it reproduces accurately the donor no longer distinguishable in the fresco.] A companion copy after the upper part of the same fresco is at Venice.

1779 No. 1243E—Draped female with hands held out.* Study perhaps for a Crucifixion. Bl. ch. 27 by 16. Brogi 1951.

1780 No. 1263E—Madonna (p. 163).* Bl. ch. and wh. 22 by 15. Brogi 1437. [Very close to Albertinelli.]

1781 No. 1275E—Madonna seated with the two Holy Children.* Bl. ch. on pink ground. 12 by 11. Pretty but slovenly. Perhaps by F. P.

1782 No. 1276E—Annunciation.* Bl. ch. 13 by 14.5.

1783 No. 1277E—Assumption of Virgin.* Study by F. P. after Fra Bartolommeo's Assumption now at Naples (p. 163). R. ch. 32 by 21. Brogi 1941.

1784 No. 1278E—Study [for half-nude figure in attitude of] Virgin of the Naples Assumption.* Bl. ch. and wh. 24.5 by 20.5. Brogi 1952.

1785 No. 1279E—Another study after Virgin in same Assumption.* Bl. ch. and wh. 24.5 by 20.5. Brogi 1952.

1785A No. 1402E—Crucifixion (p. 164). Bl. ch. and wh. 40 by 23.5. Pl. xcvi of F. E. Design
Fig. 461 for a fresco painted in 1516, in the cloister of S. Spirito at Siena.

1786 No. 359F—Woman seated in profile to l. looking down at something she holds with both hands.* Bl. ch. Very pretty, and more probably F. P.

1786A (former 1772) No. 365F—Adoration of the Magi (p. 164). Study for the picture in S. Domenico at
Fig. 462 Pistoia, executed in 1526 (Vasari, IV, p. 214). Bl. ch. and wh. on greenish grey paper. 28 by 30.

1786B (former 1773) No. 366F—Resurrected Christ.* Bl. ch. 21 by 34. Copy after a lost original by Fra Bartolommeo, to whom this is ascr.

1787 FLORENCE, Uffizi, No. 388F—Very careful study after the Holy Family in the Cook Collection at Richmond. Bl. ch., squared and pricked. Certainly by the hand that did my 1775, and like that more probably F. P.'s than Fra Bartolommeo's.

1787A (former 1774) No. 391F—Assumption of the Virgin (p. 164). Study for the picture in the Madonna del Sasso, at Bibbiena, painted in 1519 (Vasari, IV, p. 213). Bl. ch. and wh. squared for enlarging. 44 by 28.

1788 No. 438F—Design for Pietà. Bl. ch. Verso: Study for Holy Family.

1789 No. 6795F—Study for Madonna and draped standing figure. Bl. ch. Verso: Various sketches for Madonna.

1790 No. 6800F—Deposition. Bl. ch. and wh. 29 by 21.5. Important and good.

1791 No. 6801F—Study for Holy Family. Bl. ch.

1792 No. 6802F—Study for Holy Family. Bl. ch.

1793 No. 6805F—Madonna and Saints. Bl. ch. and wh. 25.5 by 19. Verso: Madonna; *Noli me tangere.*

1794 No. 6809F—Study for composition representing a Disputation and Miracle. Bl. ch.

1795 No. 6811F—Head. Bl. ch. and wh. 27.5 by 25.5. Close to Fra Bartolommeo.

1796 No. 6813F—Christ as gardener. Copy of the figure in the Louvre *Noli me tangere.* Pen. 30 by 18.5.

1796A No. 6819F—Study for kneeling Madonna. Bl. ch. and wh. 21.5 by 20.5. May be, as Gabelentz suggests, copied from the Stuttgart Coronation.

1797 No. 6820F—Madonna for Annunciation. Bl. ch. and wh. on bluish paper.

1798 No. 6826F—Female head. Same model as in my 1795. Bl. ch.

1799 No. 6827F—Pietà. Bl. ch. and wh.

1800 No. 6832F—Christ on the Cross. Below, a number of kneeling figures. Bl. ch.

1801 No. 6846F—Pietà. Bl. ch. and wh.

1802 No. 6847F—Composition with various nudes. Bl. ch.

1803 No. 6848F—Profile of man to l. Bl. ch.

1804 No. 6854F—Studies of children. Bl. ch.

1805 No. 6856F—Nude erect in profile to r. Bl. ch.

1805A (former 1814) No. 14545F—Madonna for Annunciation. Bl. ch. and wh.

1805B (former 1815) No. 14546F—Three saints for Assumption.* Bl. ch.

1806 Uffizi, Santarelli, No. 229—Madonna with infant John. Bl. ch. and wh.

1807 No. 231—Study for St. Agnes holding lamb and book.* Bl. ch. 46.5 by 22.5.

1808 (number omitted in first edition)

1809 FLORENCE, Uffizi, Santarelli, No. 234—Draped figure holding hands to head.* More probably F. P. than Sogliani.

1810 No. 236—The Flood. Bl. ch.

1811 No. 237—Adam and Eve with their first children. Bl. ch. and wh.

1812 No. 252—Virgin seated on ground, Child in her lap, infant Baptist by her side. Bl. ch.

1813 No. 684—Head of young woman. Bl. ch. 28 by 19.5. Close to Fra Bartolommeo.

1814 (see 1805ᴬ)

1815 (see 1805ᴮ)

1816 LILLE, Musée Wicar, No. 35—Madonna in profile to r.* Bl. ch. and wh. 20.5 by 15.5. Braun 72028. Study after Fra Bartolommeo's Virgin in the Holy Family at the Corsini Gallery in Rome. Closer than usual to Fra Bartolommeo.

1817 LONDON, British Museum, Crackerode, F. f. 1-3—Study for altar-piece, suggested perhaps by some discarded design of Fra Bartolommeo's for the one now in the Louvre (No. 1154). In the foreground Francis and Dominic embracing as they kneel. Bl. ch. slightly touched with wh. Squared for enlarging. 31 by 26.

1818 British Museum, 1895-9-15-535—Study after Fra Bartolommeo's *Madonna della Misericordia* at Lucca (p. 164).* Bl. and wh. ch. on pale brown paper. 55 by 40. [Anderson 18757. Venturi, IX, i, p. 324.]

 This is doubtless an elaborate copy after the original (upon which, by the way, I believe F. P. painted more than a little) made by the modest and thrifty F. P. against a future need. As the present drawing is squared for enlarging, it would seem that at some later date he actually was about to paint a copy of the original.

1818ᴬ (former 1824) 1910-2-12-10—Sketch for Holy Family * for roundel. Of the same kind and quality as the Louvre Marriage of St. Catherine. Pen. 13.5 by 11.

1819 Oppenheimer Collection [(formerly), No. 255]—Large Madonna and Child. Almost of the same kind as the Holy Family at Berlin (see my 1770, Fig. 463) but a little earlier. Bl. ch. 40 by 27. Oppenheimer Sale Cat., pl. 32.

1820 (see 1827ᴬ)

1821 (see 1770ᶜ)

1822 (see 1770ᴮ)

1823 Charles Robinson Collection (formerly)—Design for Holy Family,* consisting of Madonna and Child, Joseph, Elizabeth, and infant Baptist. Pen. 12 by 11. [Sold at Christie's, May, 1902, No. 15.]

1824 (see 1818ᴬ)

1825 MUNICH, Print Room, No. 2170—Full-length figure of male saint.* Bl. ch. and wh. 37 by 21. [*Monatsh. f. K. W.*, 1909, p. 6.]

1826 No. 2162—Study for kneeling Magdalen.* Perhaps for Paolino's altar-piece in the Museum of S. Marco. Bl. ch. and wh. 29 by 17. Verso: Nude.

1827 MUNICH, PRINT ROOM, No. 2161—Head of woman in profile to r. (p. 163).* Study for the [Louvre Marriage of St. Catherine]. A charming sketch, almost worthy of Fra Bartolommeo. Slight bl. ch. but face highly finished in red. 30 by 21.5. Bruckmann 18.

1827A (former 1820) NEW YORK, MORGAN LIBRARY, No. 352—Design for altar-piece.* The Madonna enthroned holds the Child, Who is blessing. Below three children, two making music, the other playing with a dog. To r. stand five saints, one a female; above, God the Father and cherubs. Bl. ch. and wh. 36.5 by 27.5. Morgan Dr., IV, pl. 11. Close to Fra Bartolommeo and possibly his.

1827B Design for altar-piece. Copied from Fra Bartolommeo's Marriage of St. Catherine at the Louvre. Bl. ch. and wh. 37.5 by 29.5. Morgan Dr., I, pl. 29.

1828 PARIS, LOUVRE, No. 206—Marriage of St. Catherine (p. 164). Pen on wh. paper. 21.5 by 15.5.
Fig. 464 Braun 62029. Nothing could well be more characteristic of F. P. than this drawing.

1829 No. 10089—Baptism. Bl. ch. 26 by 19.

1830 ÉCOLE DES BEAUX-ARTS—Annunciation.* Copy of the drawing by Fra Bartolommeo in the Uffizi (my 245 verso). Scarcely, as Morelli says, a forgery. Pen on wh. paper. 16 by 22.5. Braun 65076.

1831 ROME, CORSINI, PRINT ROOM, No. 124172—Madonna. Said to be for a picture in the Gallery of Modena. Bl. ch. and wh. Squared. 33.5 by 26. [Venturi, IX, i, p. 394. Rusconi, *Emporium*, 1907, p. 271.]

1832 No. 124173—Head of young Woman (p. 163).* Bl. ch. and wh. 25 by 19.5. Pl. x of *Gallerie nazionali italiane*, vol. II. [Gabelentz, II, pl. 39. Venturi, IX, i, p. 302. Rusconi, *Emporium*, 1907, p. 267.] F. P.'s masterpiece.

1833 No. 125764—Female saint, full-length. Bl. ch. and wh. 39.5 by 26.

1834 No. 127648—Female saint seated in prayer. Bl. ch. and wh. 39.5 by 27.

1835 VENICE, ACADEMY—Copy after upper part of S. Maria Nuova Last Judgement. See my 1778. Pen. 26.5 by 39. Alinari 1149.

1835A No. 175—Study for Evangelist. Bl. ch. 20 by 14.

1836 (see 2382)

1837 WILTON HOUSE, LORD PEMBROKE (formerly)—Copy after Fra Bartolommeo's Holy Family [formerly in the Mond Collection, now at the N. G.]. Pen and bistre, squared for enlarging. 27 by 26. Pembroke Dr., pl. 61. [Sold at Sotheby's, July, 1917, No. 400.] The specialist has no difficulty in recognizing F. P. in the mannerism and handling of this sheet. Cf. my 1796, Christ as gardener, and kindred drawings.

Parri Spinelli (pp. 326-327)

1837A BAYONNE, BONNAT MUSEUM, No. 661—Variant of the Pembroke sketch now in the Metropolitan
Fig. 10 Museum (my 1837J, Fig. 7), after Giotto's Navicella (p. 326). Pen. 23 by 18. Arch. Ph. L. Venturi, *L'Arte*, 1922, p. 55.

1837B BERLIN, PRINT ROOM, No 466—Two monks singing and one blessing. Below, two sketches for fountain, and in early 16th century hand: "Guasparri Spinelli d'Arezzo." Pen. 28.5 by 20. Photo. Schwarz. Berlin Publ., 4. Verso: Monk holding a book and another blessing Photo. Schwarz.

1837^C CHANTILLY, Musée Condé, No. 1 bis—Calling of Peter copied from Giotto's mosaic now in the atrium of St. Peter's (p. 326). Pen. 25 by 39. Giraudon 924. L. Venturi, *L'Arte*, 1922, p. 51.

1837^D CHATSWORTH, Duke of Devonshire—Sketch for Christ and the Adulteress. Pen. 29 by 21. Verso: Adoration of a shrine. Vasari Soc., II, vi, 2 and 3.

1837^E FLORENCE, Uffizi, No. 8^E—Saint baptizing (p. 326). Pen. on wh. paper. 29 by 40. Verso: St. Paul standing and another apostle, Bartholomew perhaps, seated. Fototeca 5205 and 5206. Van Marle, IX, pp. 242 and 233.

1837^{E-1} . . . No. 23^E—Various draped figures, possibly study for apostles taking leave of Virgin (p. 326). Pen. 28 by 20. Fototeca 5207. Van Marle, IX, p. 241. Verso: Virgin seated taking leave of the apostles.

1837^{E-2} . . . No. 24^E— Angel in profile. Pen. 25.5 by 15.5. Verso: Two draped female figures and child.

1837^{E-3} . . . No. 25^E—St. Francis in prayer. Pen on pink paper. 28 by 18. Verso: Rough sketch of town gate and several lines of writing in late Gothic hand.

1837^{E-4} . . . No. 26^E—Monk seated on ground reading. Pen. 22 by 17. Verso: Stand for monstrance and drapery.

1837^{E-5} . . . No. 31^E—Half-length study of draped apostle with book in hand. Pen. 22 by 17.

1837^{E-6} . . . No. 32^E—Study for squirming male nude. Pen. 19 by 11. Fototeca 12490. Verso: Study of drapery.

1837^{E-7} . . . No. 34^E—Study for Christ in a Coronation. Pen. 34 by 14.5.

1837^{E-8} . . . No. 35^E—Fortitude. Pen. 27 by 16. Verso: Madonna and Child; in l. corner slight sketch of same subject. Fototeca 5208 and 5209. Van Marle, IX, pp. 239 and 237.

1837^{E-9} . . . No. 36^E—Saint standing with book in hand. Pen. 29 by 18. Verso: At top some writing; below, study for monk seated on ground, possibly companion of a St. Francis receiving the stigmata.

1837^{E-10} . . . No. 37^E—Draped female figure. Pen. 28 by 9. Van Marle, IX, p. 235. Fototeca 5210. Verso: High prismatic cliffs and vague indications of a bust in profile; possibly study for a St. Francis receiving the Stigmata.

1837^{E-11} . . . No. 38^E—Study for standing Madonna and Child; in l. corner smaller sketch of same subject. Pen. 29 by 20. Van Marle, IX, p. 234. Verso: Study for seated Madonna and Child; in l. corner slight sketch of same subject. Fototeca 5211 and 5212.

1837^{E-12} . . . No. 60^E—Standing draped figure. Pen. 16 by 7. Verso: Sketch for St. Jerome in prayer.

1837^{E-13} . . . No. 1101^E—Study for a Charity. Fototeca 12506. Pen. 22.5 by 14.5.
Fig. 9

1837^{E-14} . . . No. 1102^E—Half-length female figure holding sword. Several lines of writing. Pen. 15 by 14.5.

1837^{E-15} . . . No. 1104^E—Seated female figure with child standing by her knee. Pen. 30 by 21. Verso: Standing and sitting young women.

1837^{E-16} . . . No. 1106^E—Study for a Charity and two other female figures. Pen. 28.5 by 20.5. Verso: Three female figures.

1837^{E-17} . . . No. 6^F—Female bust. Pen. 6.5 by 6. Verso by another hand.

1837[E-18] FLORENCE, Uffizi, Santarelli, No. 22—Man on stumbling horse and three figures seen behind him. Pen. 22 by 10.

1837[F] HAARLEM, Koenigs Collection, No. 328—Fragment of study for Dormition (p. 327). Pen. 17.5 by 16.5. Pl. 49 of Drawings by Old Masters, Savile Gallery, London, 1929.

1837[G] LONDON, British Museum, 18-9-15-480, *Malcolm Ad.* 15—Study for St. Peter. Pen. 17 by 13. Photo. Macbeth 42123. Verso: Study for Christ Resurrected.

1837[H] MUNICH, Dr. Erwin Rosenthal—Study for St. Peter; in r. corner slight sketch of the saint's head. Pen. 28 by 17. From Pembroke'Collection. Repr. in Sotheby Sale Cat., May, 22, 1928, No. 91. Borenius, *Pantheon*, 1928, p. 268.

1837[I] NAPLES, Pinacoteca, No 103292—Marriage of Virgin. Pen. 14 by 10. Verso: Isaac and Jacob. Below, Isaac and Esau. Photos. S. I. Here Parri is close to his drawings after the Navicella and at the same time close to Rossello di Jacopo Franchi, as indeed he often is.

1837[J] NEW YORK, Metropolitan Museum, No. 43522—Former Pembroke drawing after original of Giotto's
Fig. 7 Navicella. On the side of the ship in a cursive late Gothic hand the words: *Per mano di Giotto.... Santo Pietro a Roma di Musaico* (p. 326). Pen and bistre. 23 by 32. Pembroke Dr., pl. 39. See L. Venturi, *L'Arte*, 1922, p. 50.

1837[K] NORTHAMPTON CASTLE ASHBY, Marquess of Northampton—Variant repetition of Pembroke
Fig. 8 drawing after Giotto's Navicella now in Metr. Mus. (p. 326). Pen. 27 by 37. Popham Cat., No. 1. Ottley, opp. p. 9. L. Venturi in *L'Arte*, 1922, p. 52. Verso: Two drawings of ships. Cooper 59226 and 59225. The one on r. with eagle and cross on forecastle seems already empty of men. The other is crowded with them and attacked by two boat loads. The Turkish crescent appears over the prow of the first, but does not belong to it. Clearly for the representation of a sea fight between Christians and Turks.

1837[L] PARIS, Louvre, No. 9841—Study for sleeping apostle in Agony in Garden. Pen. 18.5 by 12.5.
Fig. 11 Arch. Ph.

Pesellino (pp. 86-93)

1837[M] (former 1840) CAMBRIDGE (Mass.), Fogg Museum, Charles Loeser Bequest, No. 166—Sketch of
Fig. 183 young woman coming forward in profile to r. (p. 88). Pen and bistre. 20 by 12. Pl. xxxviii of F. E. [Morelli Dr., pl. iii.]

1838 FLORENCE, Uffizi, No. 121[E]—Studies of old man kneeling in profile to r., and of a young woman standing in profile to l. (p. 87). Bistre wash and wh. on brown prep. ground. 15.5 by 13.5. Ascr. to Benozzo. Pl. xxxvii of F. E. Braun 76251.

 [Van Marle (X, p. 424, note) points out the correspondence that has escaped me between the kneeling figure and the one on the l. in Fra Filippo's S. Ambrogio Coronation and assumes that therefore it is a sketch by that master. But the drawing is at once stiffer in some places and more slovenly in others, and remains P.'s The hands are clearly his.]

1838[A] (former 1846) No. 164[F]—Bishop and young saint (p. 92). Bl. ch. and wh. 25.5 by 10.5 Ascr. Fra
Fig. 182 Filippo. [Fototeca 4252. *L'Arte*, 1932, p. 377. I used to regard this drawing as a copy but attr. it now to P. himself.]

1838[B] No. 234[E]—Seated youthful figure heavily draped, almost profile r. with book in hand;
Fig. 186 study for apostle (p. 92). Bistre and brush on wh. paper. 23.5 by 16. Fototeca 13127. Ascr. to Baldovinetti. Braun 76251. *L'Arte*, 1932, p. 363.

1839 FLORENCE, Uffizi, No. 1117E—Cartoon for picture representing Marriage of St. Catherine (p. 88).
Fig. 181 Pen and bistre wash. Pricked for transfer. 26 by 20.5. Ascr. to Raffaellino del Garbo,
presumably because at one time supposed to be the design for an embroidery. Brogi 1885.
Braun 76218. [H. Mackowsky, *Zeitschr. f. B. K.*, 1899, opp. p. 81. O. H. Giglioli, *Riv.
d'Arte*, 1931, p. 521.]

1840 (see 1837M)

1841 PARIS, Louvre, No. 1434—Formerly exposed in Salle des Boites. Study elaborately coloured for
Fig. 179 Adoration of the Shepherds (pp. 86-87). Bistre on brown prep. paper; haloes golden, grass
and mountains green, sky blue. Bad condition. 16.5 by 18. Pl. xxxvi of F. E. [Giraudon.
Arch. Ph. Van Marle, X, p. 483. P. Toesca, *Dedalo*, XII, 1931/32, p. 90.]

1841A (former 1847) No. 9886—Study for (and not after, as I used to think) the bishop in the former Hol-
Fig. 184 ford miniature altar-piece (p. 88, note). Bistre wash and wh. on tinted paper. 13 by 8.
Braun 62503. Meder, *Handz.*, fig. 323. H. Mackowsky, *Zeitschr. f. B. K.*, 1899, p. 83.

1841B École des Beaux-Arts, Armand-Valton Bequest—Kneeling St. Bernardine in sharp pro-
Fig. 187 file l. (p. 92). Bistre and wash. 23.5 by 17. Squared for transfer. Retouched, the hands
particularly. Ascr. to School of Fra Filippo. Giraudon 14232.

School of Pesellino

1841C BERLIN, Print Room, No. 5165—Sketch for slender youthful nude standing on inverted cone of
Fig. 188 chiselled bronze head, in profile, his r. hand in attitude of Roman emperor but the long
staff in the hand of his bent r. arm makes an angle before it reaches the cone. His l.
hand holds a mantle against his hip. Pen and bistre. 26 by 10.
 This figure may be by a sculptor, but if by a painter it might be, considering the slender
proportions and the crisp hair, by the Carrand Master in the phase of the Montpellier
predella. Our 545A verso (Fig. 40) by Benozzo has a somewhat similar pose and pro-
portions but is in other respects very different.

1842 FLORENCE, Biblioteca Riccardiana (MS. 492)—Virgil Codex (p. 92). One of the uncoloured illu-
strations is reproduced in Mr. Colvin's *Florentine Picture Chronicle*, fig. 69. [Also in
T. de Marinis and Filippo Rossi's *Notice sur les miniatures du "Virgilius" de la Bi-
bliothèque Riccardi à Florence* in *Bulletin de la Société Française de Reproductions
de Manuscrits*, XIII, 1930, pp. 17-31.]

1843 A manuscript of Petrarch's Triumphs, containing full-page illustrations to each of the
five Triumphs (p. 92). These are free renderings of P.'s two panels now in the Isabella
Stewart Gardner Museum, Boston.

1844 (see 534A)

1845 (see 1846A)

1845A Uffizi, 10E—Christ seated slightly to l. blessing with His r. hand and His l. supporting
book on His knee. To r. two kneeling angels facing each other. Above, five words in
Quattrocento hand. Pen and bistre on grey paper, pricked for transfer. Some unintel-
ligible pricking to r. of Christ's head. 24 by 14. Fototeca 2094. Braun 76215. This little
cartoon for an embroidery is still ascr. to Agnolo Gaddi but must be a product of P.'s
shop if not of his own hand.

1846 (see 1838A)

1846^A (former 1845) FLORENCE, Uffizi, Santarelli, No. 82—Angel floating in kneeling posture, looking down to l. Bl. ch., pen and wash. 24 by 26. Alinari 174. Ascr. to Albertinelli, but copy after a Pesellinesque figure for, or in, a Nativity.

1846^B FRANKFURT a/M., Städel Museum, No. 5585—Study for erect figure of ascetic saint turning to l.
Fig. 185 (p. 91). Bistre height. with wh. on buff prep. paper. 26 by 9. Schönbrunner & Mader, 1279. *L'Arte*, 1832, p. 371. Ascr. Domenico Ghirlandajo and by G. Ludwing to P.

1847 (see 1841^A)

1848 VIENNA, Albertina, S. R., No. 47—Study for angel floating with extended wings, pointing upward
Fig. 178 over his shoulder with r. hand, and holding out his l. as if in protection. Pen, bistre and wash. 17 by 19. [Albertina Cat., III, No. 13.] Probably for an angel in an Annunciation to the Shepherds, a subject treated more frequently in the middle distance of a Nativity than independently. It is ascr. to Zanobi Strozzi but seems a faithful copy after P. by Maso Finiguerra.

 In discussing Mr. Colvin's admirable volume on that craftsman (p. 29, note) I offered the suggestion that he was greatly influenced by P. Further study of the question has convinced me that, in the phase at least wherewith his *Picture Chronicle* acquaints us, Maso was more indebted to P. than to almost any other of his contemporaries. In the drawing of the angel before us, we see him actually copying that painter. That he was the copyist will appear to any one who will note the obvious likeness between this angel and those in pls. 10 and 11 of Mr. Colvin's book, and observe the identity of technique—wash and hatching, together with an effect of spottiness—and the similarity in the folds, with all the figures in that same volum

Piero di Cosimo (pp. 150-154)

1848^A BAYONNE, Bonnat Museum—Head of clean-shaven elderly man seen full face. Bl. ch. and wh. 16.5 by 12. Arch. Ph.

 The superficial resemblance to the powerful head by Bramantino or perhaps Bramante at Lille (Delacre, pl. 2) should not mislead one. Ours is undoubtedly Florentine, from the earliest years of the Cinquecento, and is probably by P. d. C. As draughtsmanship it seems to anticipate his great pupil Andrea del Sarto.

1848^B No. 1213—Francis receiving the Stigmata. Pen. 23 by 31. Bonnat Publ., 1925, pl. i. Attr. to Giovanni Bellini.

 Close to my 1858 (Fig. 420) and 1859. It would be easy to spin variegated rhetorical threads between this sketch and Bellini's sublime picture now in the Frick Museum at New York, with which, however, it has little in common except the subject.

1849 (see 2509^{B-1})

1849^A BREMEN, Kunsthalle—Pen-sketch for an Immaculate Conception. On the r. a half-effaced sketch
Fig. 422 in bl. ch. of a kneeling figure embracing the legs of another figure slightly stooping toward the first. In l.-hand corner "Piero di Cosimo" written in later hand. 20 by 25. Prestel Publ., I, 9.

 Early if not first idea for the Uffizi altar-piece with the same subject (Van Marle, XIII, p. 361). The finished work is more vertical and more monumental, more archaic, in short. In the sketch the entire figures are in movement and seem like actors in a drama. In the picture expression is confined to the faces and to the heads. The material differences, as for instance the exchange in position of the two female with the two monastic saints and the rejuvenation of the Evangelist, may have been desired by the people who ordered the painting.

1849B CAMBRIDGE, FITZWILLIAM MUSEUM—Study for altar-piece with the Virgin and Child, St. Sebastian and the Evangelist. Sp. and wh. on prep. yellowish grey paper. 19.5 by 19. Vasari Soc., II, ix, 3.

Has the characteristics of the Credi-like drawings now accepted by most of us as P. d. C., and naturally like them has hitherto been ascribed to Credi. At the same time, we note a resemblance to the so-called Tommaso, and this sketch may serve as a stepping-stone between two phases of what is perhaps the same artistic personality. Needless to tell students of its close relation to Credi's Dresden altar-piece (Van Marle, XIII, p. 304), after which it is a copy, unless it be one after Credi's own drawing.

1849C CAMBRIDGE (Mass.), FOGG MUSEUM, LOESER BEQUEST, No. 131—Study for St. Joseph seated on
Fig. 421 his saddle reclining against a packing case, and a female figure seated on the ground in pensive attitude. Pen. 8.5 by 11.5. Probably for a rest in the Flight.

1849D CHELTENHAM, FITZROY FENWICK COLLECTION—Three studies for Madonna sitting or squatting, two in profile and one facing. Pen. 15.5 by 24.5. Fenwick Cat., pl. VII, as R. del Garbo. Verso: Four more studies for Madonnas in varying attitudes. Spirit, types, and pen-work all P. d. C.'s.

1850 FLORENCE, UFFIZI, No. 129F—Portrait of bald-headed man (pp. 38, 151, 158). Bl. ch. 25 by 20.
Fig. 405 Alinari 210. [Uffizi Publ., V, ii, 3. Van Marle, XVI, p. 109.]

1850A No. 168E—Joachim in the Temple (pp. 151, 152, 153). Pen. 17 by 19. Ascr. to Filip-
Fig. 410 pino. Braun 76276. [Uffizi Publ., IV, i, 4.]

1851 No. 169E—Joachim in the Temple (pp. 151, 153). Pen. 10 by 15.5. Braun 76274. [De-
Fig. 409 genhart, Münch. Jahrb., 1932, p. 97.] Ascr. to Filippino.

1852 No. 170E—Adoration of the Shepherds (p. 151). Pen. 10 by 20. Braun 76275. Ascr. to
Fig. 411 Filippino. Verso: Slight study for top of architectural composition.

1852A No 218E—Two draped female figures, elaborately hatched, and four smaller figures all but
Fig. 414 one in mere outline (p. 152). Bistre and wash and wh. 24.5 by 17.5. Brogi 1663. [Van Marle, XIII, p. 388.]

1852B (former 2513) No. 176E—Study for Madonna with the Child caressing a kneeling angel who plays
Fig. 431 on the viol. Pen. 10.5 by 8. Fototeca 4709. Uffizi Publ., IV, i, 8, where in the text it is considered as first sketch for the Madonna in the Uffizi No. 3885 (Fototeca 2198). But the drawing betrays acquaintance with Leonardo's Madonna with St. Anne and perhaps with Raphael, and may be later despite the similarity of theme.

1853 No. 286E—Study for Mary and Elizabeth in the Visitation [formerly] in the Cornwallis
Fig. 419 West Collection [and now in the S. H. Kress Collection, New York] (p. 153). Pen on yellowed paper. 18 by 14.5. Brogi 1657. [Uffizi Publ., IV, i, 3. First recognized as P. d. C.'s by F. Knapp, P. d. C., p. 37.] Verso: Saint at his desk reading; candelabra.

1854 No. 343E—Nativity (p. 153). Pen. Diameter 13 cm. Braun 76211. [Uffizi Publ., IV, i, 2.]
Fig. 417

1855 No. 552E—Study for the Immaculate Conception in S. Francesco at Fiesole (p. 154). R.
and bl. ch. on wh. paper. 28 by 28. Brogi 1819. Braun 76002. [Uffizi Publ., IV, i, 5. Ulmann, Jahrb. Pr. K. S., 1896, p. 47.]

1856 No. 555E—Six more than half-length figures of saints—study for the lower part of the same
Fig. 418 picture as my 1855. In the finished work the arrangement has been considerably altered (p. 154). R. and bl. ch. on wh. paper. 14 by 28. Brogi 1717. Braun 76004. [Uffizi Publ., IV, i, 6. Ulmann, Jahrb. Pr. K. S., 1896, p. 48.]

1857 (see 37ᴬ)

1857ᴬ (see 1329ᴮ)

1857ᴮ (former 2546) FLORENCE, Uffizi, No. 426ᶠ —Study for Madonna [enthroned with the Child seated on her r. knee and bending down to caress the kneeling infant Baptist. A kneeling angel to the r., another half-effaced figure, probably St. Elizabeth, behind the infant Baptist. Pen, wash, and wh. on greyish green paper. 16 by 15. Loeser, in Uffizi Publ., IV, i, 9, was the first to attribute it to P. d. C. Fototeca 4279. Late and anticipating Pontormo.]

1857ᶜ No. 6369ᶠ—Study of drapery over knees and faint outlines of lower part of child held
Fig. 424 over r. knee. Bl. ch. with a little wash on wh. paper. 22 by 19. Fototeca 15097. Verso:
Fig. 427 Various studies for a Madonna with the Child blessing and in two of them a figure kneeling to receive the blessing; on top an eagle fluttering. Bl. ch. Fototeca 14891.

I owe my acquaintance with this leaf to Dr. Degenhart (*Mitt. d. K. H. Inst. Florenz*, IV (1933), pp. 125-127), who recognized it as P. d. C.'s directly he saw it. It is from the artist's later years. The sketches for a Madonna have something vaguely Michelangelesque about them, which no doubt accounts for their official attribution to Montorsoli. The drapery study is still Leonardesque, but what appears of the Child suggests Signorelli. The toss of the folds recalls "Tommaso." It is more than likely that this cast of drapery is of a much earlier date, and the fact that only the lower part of the Child appears makes it probable that originally the leaf was higher and was a sketch for the entire figure of a Madonna.

1858 No. 7ᴾ—Cave at side of a jagged cliff in romantic wilderness, in front of which kneels
Fig. 420 St. Jerome (p. 154). Pen. 23.5 by 20. [Fototeca 4819.] The figure and the garrulous scribbling are characteristic of P. d. C. This sketch served as a study for the next. [Verso: Naked *putto* with r. leg in two different positions. Studies for coats-of-arms and various tags of Latin verse in contemporary writing. Fototeca 4820.]

1859 No. 403ᴾ—Same subject as last, but on much larger scale and greatly elaborated both at sides and below; on the whole, the most romantic and magnificent design for a landscape in the Florentine School. The chalk is used in a way most characteristic of P. d. C. Bl. ch. on wh. paper. 62 by 53. [Fototeca 4833. Giglioli, *Dedalo*, IX, 1928-29, p. 175.

This and similar studies may have been done in connection with paintings like the Jerome in the Horne Collection, Florence, and the landscape in the Liechtenstein Gallery at Vienna. Needless to say, they show acquaintance with Flemish landscapes.]

1859ᴬ LILLE, Musée Wicar, No. 269—Joachim in the Temple (pp. 151, note; 153). Bistre on reddish ground.
Fig. 412 19.5 by 23. Braun 72025. Ascr. to Ghirlandajo. Stands close to my 1850ᴬ (Fig. 410), of which it is a simplified and at the same time more dignified version.

1859ᴮ LONDON, British Museum, Pp. 1-30—Sheet with various studies. The principal one is of the
Fig. 413 Madonna kneeling as she embraces the Child, while kneeling saints and an angel surround her. Below, another group of a Madonna seated on the ground with kneeling saints (pp. 152, 153). Pen and bistre on paper tinted with bistre wash. 25 by 18. Ascr. to Credi. Pl. ʟxxxv of F. E. Both the motives point to a date scarcely earlier than 1500.

1859ᶜ 1902-8-22-6—Sketch for an Ariadne—at least so interpreted by Mr. Colvin; pasted on at
Fig. 415 either side a nude (pp. 152, 153). Pen and bistre. 14 by 25. [Vasari Soc., I, i, 5. Van Marle, XIII, p. 387. Meder, *Handz.*, 330.

This drawing may have been known to Ercole Roberti when he painted a *cassone* panel where we see a poet approaching a female nude reclining in a landscape (repr. on pl. xix of Twentieth Anniversary Exh. Cat., Cleveland Art Museum, 1936.]

1859D LONDON, BRITISH MUSEUM, 1910-7-16-16—Study for Madonna seated in profile to r. with the naked
Fig. 423 Child standing on her lap; her head disappeared when the leaf was shortened at the top.
Bistre and wh. on pearly brown prep. ground. 23.5 by 7.5. Photo. B. M.

Attr. to School of Credi, and correctly, of course. But one cannot avoid the temptation
to get closer to the author, I thought of Granacci, and even more of "Tommaso." If I
venture to settle – or is it only to perch – on P. d. C. it is because of the Child, Whose
proportions and expression seem more characteristic of that painter, and because of the
serpentine loops in the folds, which are identical with those in the Munich study for a
woman reading (my 1859G, Fig. 432). But this sketch for a Madonna remains so close to
"Tommaso" that it would contribute largely toward assimilating him and identifying him
with P. d. C.

1859E MISS ELEONORA CHILD—Three monks, one with hands joined in prayer, the second kneeling
Fig. 430 before him as if to kiss his l. foot, and the third watching the scene in devout attitude.
Pen and bistre. 19 by 20. Vasari Soc., I, x, 3. There Dr. Borenius rightly sees a resem-
blance in style between this drawing and P. d. C.'s altar-piece at the Innocenti in Florence.
Let me add that the action and sentiment suggest Chinese Buddhist compositions.

1859F WAUTERS COLLECTION (formerly)—Sketch for Madonna and Shepherd, both kneeling in
worship. The shepherd only in outline, the Madonna hatched. Pen. 7 by 6.5. Verso:
Two shepherds in outline; and closely hatched kneeling angel writing in the sand with
forefinger of his l. hand. Lees, figs. 2 and 12. Leonardo-Filippinesque and doubtless for
a Nativity, but the angel writing on the ground is unexplained.

1859G MUNICH, PRINT ROOM, No. 13072—Woman seated and visible down to knees, turned slightly to r.
Fig. 432 reading with book in both hands. Attr. dubitatively to Verrocchio. Sp. and wh. on brown
paper. 12 by 9.5.

The type and action inspire the attribution to P. d. C. The contours of the jaws and
chin are peculiarly his. And it may have been a sketch from life for a well-known work
of P. d. C.'s, the Baracco Magdalen now in Galleria Nazionale, Rome (Van Marle, XIII,
p. 354). This is a fancy portrait conventionalized and idealized almost to the extent of
the Courtezan with the crinkly hair resembling brass wire now at Frankfurt, which Barto-
lommeo Veneto painted some ten or fifteen years later. The differences between the drawing
and the painting need not disturb us. They may even have been deliberate so that a
gallant might enjoy the effigy with no danger either to her who sat for it or himself. The
attribution to Verrocchio although incorrect is not without a faint show of reason. The
looped folds on shoulder and sleeve recall close followers of the last-named master, and in
particular that *Doppelgänger* of Credi's, temporarily known as "Tommaso," whom it is
getting more and more tempting to take for a phase of P. d. C.

1859H MUNICH, PRINT ROOM, No. 34736—Sketch for an Assumption of the Virgin. Pen. 20 by 27. Photo.
Fig. 428 Museum. Attr. anonymous Italian. The faces of the Virgin and the cherubim as well as
the hatching seem to confirm the impression that this sketch may be a late P. d. C.

1859I NAPLES, PINACOTECA, PRINT ROOM, No. 103313—Profile to l. of young woman with elaborate head-
Fig. 406 dress. Bistre and wh. 21 by 17. Photo. S. I. Bad and late. Ascr. to Mantegna, but clearly
by P. d. C. as we know him in the Chantilly Simonetta (Van Marle, XIII, p. 349). Indeed
it may be the original sketch for that fascinating profile.

1859J NEW YORK, MR. ROBERT LEHMAN—Sketch for landscape with winding river, cliffs to l., and a clump
Fig. 429 of houses to r. In l.-hand corner seated figure writing, probably St. Jerome. Pen. Recalls
both Flemings and Japanese. Cf. my 1858 (Fig. 420), and 1859.

1860 PARIS, LOUVRE, No. 2345—Head of an old man (pp. 38, 151). Bl. ch. and wh. on tinted ground. 20.5
Fig. 407 by 16.5. Pl. LXXXIII of F. E. [Alinari 1608.] Ascr. to Leonardo.

1861 ROME, Corsini, Print Room, No. 630522—Head looking up (pp. 38, 150). Bl. ch. and wh. on ground washed yellow. 23 by 20. Anderson 2775. Pl. LXXXII of F. E. [Popham Cat., No. 101.] Verso: Profile of man on wh. paper. [Van Marle, XIII, pp. 385 and 386. Rusconi, *Emporium*, 1907, pp. 266, 267.] *Gallerie nazionali italiane*, II (1896) pls. VIII and IX, opp. pp. 152 and 153. Both ascr. Signorelli [but identified as P. d. C.'s by the late Gustavo Frizzoni.]

1862 TURIN, Royal Library, No. 15612—Head of an elderly, smooth-faced, bald-headed man, looking down
Fig. 408 a little to l. (p. 151). Bl. ch. 25 by 18. In the precise character of the other heads by P. d. C., and like most of them ascr. to Signorelli.

1862^A VENICE, Academy, No. 596—Heavily draped female figure very much in Credi's manner except for the pen-work, which is entirely like P. d. C.'s. Below, a kneeling figure in adoration as for a Nativity, which seems less close to Credi. Pen and bistre on wh. paper. 19 by 7. Fogolari, pl. 73.

1863 VIENNA, Albertina, S. R., 103—Study for a Nativity (p. 153). Pen on wh. paper. 15 by 17. Pl.
Fig. 416 LXXXIV of F. E. [Albertina Cat., III, No. 31. Ascr. to Credi.

 Considering there is a probability that "Tommaso" di Credi was only a phase of P. d. C., it is interesting to note that a picture corresponding nearly to this drawing exists and was formerly in the Stogdon Collection at Harrow (*Riv. d'A.*, 1932, p. 257). The Madonna's *contrapposto* was suggested, no doubt, by Leonardo in some such study for a Nativity as the one in the Metr. Mus. (my 1049^C, Fig. 484).]

1863^A Inv. 25436—Sketch for Madonna seated on ground in landscape with the two Children
Fig. 425 playing together. Pen and bistre. Diameter 14.5. Photo. Frankenstein. Albertina Cat., III, No. 32. The figures form a pyramid and compose in a way that betrays acquaintance not only with Leonardo but with Michelangelo as well.

1863^B HOMELESS—Elizabeth presenting infant Baptist to be blessed by Christ Child seated in His mothers
Fig. 426 lap; above, but forming one mass with them, Joseph reads reclining. Pen and wash. 14.5 by 16.5. Contours, types, feeling most intimately P.'s in full maturity.

School of Piero di Cosimo

1863^C CAMBRIDGE (Mass.), Fogg Museum, Charles Loeser Bequest, No. 125—Sketch for Minerva in
Fig. 433 fluttering draperies. Pen and bistre. 20 by 14. Cut out and pasted on along the contours. Probably a tracing after a lost drawing of P. d. C. in his Credi-like phase.

1863^D No. 269—Two angels kneeling holding between them a monstrance in shape of vase. Pen. 9 by 15.

 Too feeble and scratchy for P. d. C. but one is nevertheless tempted to connect it with the two angels swinging censers that the late Sir Claude Phillips bequeathed to Edinburgh and which may have crowned P. d. C.'s altar-piece at Borgo S. Sepolcro (*Burl. Mag.*, XXV, 1914, p. 276).

Alunno di Benozzo (pp. 11-13)

(Formerly *PIER FRANCESCO FIORENTINO*)

1864 BERLIN, Print Room, No. 4199—Copy of St. Bernard in Perugino's fresco of Crucifixion in S. Maria
Fig. 61 Maddalena dei Pazzi. Also his head repeated on larger scale, and [in more Benozzesque manner] a kneeling nun. Catalogued as School of Perugino. Pen and bistre, and a little wh. 21 by 26. [*Boll. d'A.*, 1931/32, p. 303.]

1864ᴬ (former 548) FLORENCE, Uffizi, No. 15ᴱ—St. Paul seated (p. 12). A not unimpressive figure. Copy after Benozzo like my 1866ᴰ, 1867ᴬ, 1867ᴮ, and 1867ᶜ. Pen, wash and wh. 33 by 17. [Van Marle, XI, p. 223. *Boll. d'A.*, 1931/32, p. 295.]

1864ᴮ (former 549) No. 45ᴱ—Four figures, one being St. Peter, and the others Franciscan monks, two of them cardinals. Bistre and wh. on pink prep. paper. 15 by 20. [Verso: Study for drapery of seated figure. Bistre and wash.]

1865 (see 1874ᶜ)

1866 No. 48ᴱ—Two heads of monks, very Benozzesque. Pen and bistre on brown paper. 20.5 by 16. [Fototeca 12494.]

1866ᴬ (former 659) No. 67ᴱ—Large head of man, small profile of another man, a lion's head and two feet (p. 12). Pen, bistre and wh. on tinted ground. 19 by 24.5. Brogi 1658. [*Boll. d'A.*, 1931/32, p. 297.] All have the uncouth aspect of barbarous bronzes. [The feet remind one of the studies after plaster casts of feet in the Koenigs sketch-book (my 558ᴮ, fol. 5ᴮ and fol. 6).]

1866ᴮ (former 550) No. 70ᴱ—Young Moorish king, with monstrance in l. hand. A child and a silly youth with a donkey feeding out of a dish. Bistre and wh., on brown paper. 18 by 22. [Fototeca 12617. *Boll. d'A.*, 1931/32, p. 304.]

The king and probably also the child are copies perhaps after the drawing in the Malcolm Collection (my 542, Fig. 32), or more probably after the finished figure, slightly varied, in a painting. [Types like that of the Moorish king and of the figures on my 1882, 1884, 1885, and 1886, among others, are so like those of Matteo da Gualdo's that it was to this Umbrian imitator of Benozzo's that I attributed A.'s Madonna with Jerome and Catherine at Perugia (No. 756, Alinari 5680) when in 1897 I published the first edition of my *Central Italian Painters*. As Professor Fischel has pointed out to me, the Moorish king is copied from a Flemish picture close to the Maître de Flémalle.]

1866ᶜ (former 535) No. 71ᴱ—Christ on the Cross, and below to r. the young Evangelist (p. 12). Bistre and wh. on brown prep. paper. 16.5 by 14.5. Fototeca 2100. Catalogued as anonymous, Florentine School. [Verso: Deposition (pp. 12, 13). Fototeca 12499. *Boll. d'A.*, pp. 293 and 294.

Fig. 53

The verso is a study for the painting in the collection of Mrs. Henry Coster of Florence. Rarely is there so complete a correspondence between a drawing, not a model or a cartoon, and a finished picture. As Professor Fischel has pointed out to me the Christ on the recto is taken straight from Gerard David. An almost identical Deposition by A. d. B. has recently been acquired by S. H. Kress, New York.]

1866ᴰ (former 551) No. 85ᴱ—Virgin and Baptist. Copies after figures in a Crucifixion (p. 12). Pen, wash and wh. on yellowish paper. 27 by 17.5. Braun 76253. [*Boll. d'A.*, 1931/32, p. 295. Van Marle, XIII, p. 457. The figure of the Virgin very close to the one in the Way to Calvary at Koenigsberg, attributed to Palmezzano.]

1867 No. 86ᴱ—Three music-making angels (p. 12). Pen and wh. on pink prep. paper. 16.5 by 16.5. Braun 76254. Brogi 1649. [*Boll. d'A.*, 1931/32, p. 296.] Catalogued as Benozzo's, and ascr. by Morelli to Fiorenzo di Lorenzo [and by Longhi to "Maestro Esiguo" (*Vita Artistica*, II, 1927, p. 69), one of the closest to Benozzo.]

Fig. 56

1867ᴬ (former 552) No. 87ᴱ—St. Catherine kneeling and two monastic saints standing. Copy after figures in an altar-piece (p. 12). Pen, bistre wash and wh. on yellowish paper. 24 by 12.5. Braun 76255. Verso: The Holy Face. Pen and ink.

1867^B (former 553) FLORENCE, Uffizi, No. 88^E—Monastic saint standing. After same work as last (p. 12). Pen, wash and wh. on pinkish paper. 21 by 9.5. Braun 76258.

1867^C (former 554) No. 89^E—Female saint standing. Companion to last (p. 12). Pen, wash and wh. on pinkish paper. 23 by 12. Braun 76257.

1867^D No. 122^E—Study for Madonna in an Assumption (p. 12). Sp. and wh. on pink prep. paper, the lower part gone over with ink. 23 by 12. Brogi 1651. *Boll. d'A.*, 1931/32, p. 296.

1867^E (former 2785) No. 124^E—Head of *putto* (p. 12). In upper r.-hand corner, profile of old man [same kind as on 1866^A], but better. Pen, sp., and wh. on buff prep. paper. 17.5 by 13.5. Brogi 1713. [Fototeca 12500. Van Marle, XI, p. 578. *Boll. d'A.*, 1931/32 p. 297.] Verso: [Nymph] with cornucopia riding on centaur. Pen. [Fototeca 12544.]

1868 (former 2786) No. 125^E—Woman's head, two heads of children, hand pointing and parts of faces
Fig. 55 (p. 12). Pen. 26 by 20. Brogi 1709. [Van Marle, XI, p. 579. *Boll. d'A.*, 1931/32, p. 297.] Ascr. to Verrocchio [and catalogued in the first edition as School of Verrocchio]. Verso: To r. an elderly man seated, in type and character resembling certain figures in Benozzo's frescoes at S. Gimignano. In the middle St. James in a niche. To l. a young king with a monstrance in his l. hand. Between him and St. James a more rapid sketch after one of the Dioscuri of Monte Cavallo. Behind the king a landscape with a youthful horseman. Above, four or five lines of writing in a hand still Gothic but close to Benozzo's own, containing phrases of religious import (p. 12). Pen and bistre wash. Pl. x of F. E. [Ascr. by Longhi to "Maestro Esiguo" (*Vita Artistica*, II, 1927, p. 69).]

1868^A (former 555) No. 235^E—Youth seated painting, seen from behind, resembling the figure in the drawing in the Victoria and Albert Museum, my 544. Bistre, wash and wh. 16 by 18.

1868^B (former 2384) No. 1092^E—Various studies for Crucifixion. Catalogued "Maniera di Gozzoli." Bistre wash and wh. 18.5 by 23. [Fototeca 12641. *Boll. d'A.*, 1931/32, p. 303.]

1868^C (former 2779) No. 1112^E—[Two youthful] nude shepherds [in landscape, one seen from the back leaning on a staff and the other dishevelled running excitedly up to him. Below him two dogs curled up, one of them asleep.] Pen bistre and wh. on pink washed paper. 17.5 by 23.5. [Fototeca 12642. Between Benozzo and Paolo Uccello.]

1869 No. 14^F—Study for a Visitation. Pen and wh. on brown paper. 15 by 13. [Fototeca 4227.]

1870 No. 15^F—Madonna seated with the Child on her r. knee, holding bird. To either side a saint, less finished. Below, the upper part of two heads. Ascr. to Baldovinetti. Pen and wash with touches of buff, on brown paper. 23.5 by 20. [Haloes and hair coloured.]

1871 No. 18^F—Head of child. Ascr. to Benozzo, and very Benozzesque. Bistre and wh. on pink prep. paper. 13 by 10.5.

1872 (former 556) No. 19^F—Head of saint, another of a bishop, two hands, youthful nude, and child (p. 12). Ascr. to Benozzo. Pen, bistre and bl. ch. height. with wh. on pink prep. paper. 20.5 by 23. [Fototeca 12509.] Verso: Head of monk, [Christopher in a medallion and scrawls of mitre. Fototeca 12510. *Boll. d'A.*, 1931/32, pp. 296 and 305.]

1873 (former 557) No. 22^F—Madonna and Child, head of child, and two naked children running (p. 12). Ascr. to Benozzo. Bistre and wh. on pink prep. paper. 18 by 24. [Fototeca 12511.]

1874 No. 23^F—Head of young woman in bistre wash, and several small figures in bl. ch. Pink prep. paper. 17.5 by 16. Ascr. to Benozzo. Verso: Head of child by poorer hand. Bl. ch. and wh.

1874A FLORENCE, UFFIZI, No. 26F—Study for prancing horse. Pen and ink on paper slightly rubbed with yellow. 20 by 14. Verso: Head of horse.

1874B (former 558) No. 28 F—Nude child, child's hand, and on larger scale a child's head and upper part of squatting child, with hands folded across his breast. Also adult's head lying on cushion (p. 12). Bistre and wh., on buff prep. paper. 23.5 by 17. [Fototeca 12512. *Boll. d'A.*, 1931/32, p. 294]. Verso: Saint, the head just barely discernible, blessing with his r. hand.

These drawings, particularly the one for the saint, come very close to Benozzo in his later phase, and are A.'s despite their [former] attribution to Uccello. [Venturi in *L'Arte*, 1910, reproduces the obverse on p. 289, ascribes it to Benozzo himself, and relates them quite correctly to figures in the lower l.-hand corner of the Camposanto Destruction of Sodom. They do not gain by being compared with the painting.]

1874C (former 1865) No. 46F—Baptist standing in niche, another sketch of same with scroll in his hand, and head of young monk. Pen and wh. 19 by 23. [Fototeca 12492.] Verso: Various studies for a Christ in the Garden. Pen and bistre. Catalogued as School of Fra Angelico. [Fototeca 12493. *Boll. d'A.*, 1931/32, p. 302.]

1875 No. 63F—Female saint kneeling turned to r., and doe looking up to her. Pen, height. with wh., pricked for transfer. 17 by 15.

1876 No. 64E—In courtyard, a youth [probably Joseph] being led away to prison (p. 13). Bistre
Fig. 59 height. with wh. on brown paper. 20 by 22. [Fototeca 12496. *Boll. d'A.*, 1931/32, p. 298.] Here there is a touch of Pintoricchio's influence, most clearly visible in the young officer.

1877 No. 110F—Profile of warrior, head of child, and two gladiators. Pen and bistre on brown paper. 16 by 24.5. [Fototeca 12513.]

1878 No. 121F—Elderly saint kneeling with arms folded over breast. Pen on pink prep. paper. 15 by 9.5.

1879 No. 136F—Angel Gabriel kneeling to r., and separate sketch for St. Augustine kneeling.
Fig. 57 Below head of Virgin and appearing from out a cloud the hand of the Eternal sending out the Holy Ghost to the Blessed Virgin (p. 13). [Possibly study for an Annunciation reproduced in *Dedalo*, 1932/33, p. 843.] Pen with wh. 10.5 by 13.5. Verso: Head of
Fig. 58 pretty young woman [almost Andrea del Brescianino's] (p. 13). Pen and bl. ch. [Fototeca 12502 and 13511. *Boll. d'A.*, 1931/32, pp. 302 and 299.]

These are almost the best of [A.'s] drawings, and have a delicacy of touch that is unusual, although his. The word *ghustino* in the author's hand may help to identify his historical personality.

1880 No. 138F—Sketch for young saint looking to l. with r. arm akimbo. Pen height. with wh., on brown paper. 11.5 by 8.

1881 No. 139F—Baptist in long mantle with cross in l. hand, pointing with r. Close to Benozzo. Cf. my 1874C. Pen and wash height. with wh. on buff prep. paper. 17 by 8.

1882 No. 141F—Sketch for meeting in a wood of the Infant Christ and Baptist, with a Child asleep on l. Pen height. with wh. on brown paper. 18 by 24. [Fototeca 12515. *Boll. d'A.*, 1931/32, p. 305.]

1883 No. 142F—Angel striding forward to r., being study for one sustaining a *mandorla* in the
Fig. 62 air. Also, on larger scale, head of same angel (p. 12). Pen height. with wh. on buff prep. paper. 18 by 15.5. [Fototeca 12650.]

1884 FLORENCE, Uffizi, No. 143^F—Tobias and angel. Study for a picture close to the one now at Pisa (Sala VII, 38. Brogi 21383). Also Madonna enthroned, in almost Sienese hieratic attitude, with the Child clothed touching her veil (p. 13). Pen, bistre and wh. on yellowish paper. 19 by 26.] Fototeca 12516. *Boll. d'A.*, 1931/32, p. 300.] Verso: Gabriel flying in with arms crossed—again a Sienese motive. [Fototeca 12504.]

1884^A (former 1898) No. 146^F—Michael between two female and two male saints (p. 13). Pen and bistre on
Fig. 54 brown paper. 16 by 24. [Fototeca 12651. *Boll. d'A.*, 1931/32, p. 300.
 Study for a picture at Chambéry published by Prof. Longhi in *Vita Artistica*, II, p. 68. As usual with artists his draughtsmanship runs ahead of his painting. That remains wholly Quattrocento, whereas in the sketch the Catherine might almost pass for a Beccafumi, and betrays the influence of Fra Bartolommeo.]

1884^B No. 155^F—Jerome kneeling to l. naked from waist up, with r. arm bent and held out, and l. clutching drapery. To r. and behind, a palm and entrance to cave. Pen wash and wh. on reddish paper. 17.5 by 13.5. Fototeca 12545.

1885 No. 1093^F—Virgin seated with arms folded on breast, leans forward as she receives message of Announcing Angel. He is on smaller scale. On much larger scale the angel's head in profile. Pen and wh. on brown paper. 20 by 16. [Fototeca 12507. *Boll. d'A.*, 1931/32, p. 306.]

1886 No. 1094^F—Three male saints, the middle one in a niche, the one to r. being Peter. Pen and wh. on pearly grey paper. 17 by 24.5. [Fototeca 12508.]

1887 No. 1097^F—Apostle Paul, in lackadaisical Umbrian pose. Pen height. with wh. 28 by 15.5. [Verso: Study for Matthew.]

1888 No. 1098^F—Study for Annunciation, with both the figures kneeling. Pen and wh. on pearly grey paper. 18 by 23.5.

1889 No. 1099^F—Bartholomew, and Matthew holding dagger, quite curiously archaic. Pen and wh. on brownish paper. 17.5 by 15.

1890 No. 1100^F—Female saint holding in r. hand palm of martyrdom (p. 13). [Inspired by Fra
Fig. 60 Bartolommeo.] Pen and wh. on brownish paper. 28 by 11.5. [Fototeca 12505. *Boll. d'A.*, 1931/32, p. 299.]

1891 (see 537^A)

1891^A No. 14505^F—Study for prancing horse in profile to r. Pen on yellow paper. 21 by 16. Verso: Winged *putto* and horned heraldic animal. Perhaps by another hand. Fototeca 12736 and 12737.

1892 No. 14507^F—Head and shoulders of child reaching out arms, no doubt study for Madonna and Child. Bl. ch. on brown paper. Pricked for transfer. 17 by 13.

1893 No. 14510^F—Bartholomew standing, holding open book in r. hand, and knife in l. Bl. ch., pen and wh. on brown paper. 28 by 18.

1894 No. 14511^F—Seated Evangelist. Bl. ch., pen and wh., on brown paper. 23 by 15.

1895 No. 14512^F—Youthful figure with open book and sword, intended for a St. Paul. Bl. ch., pen and wh. 19 by 13.

1896 FLORENCE, Uffizi, Santarelli, No. 79—Study for Madonna and Joseph seen to above knees adoring the Child, Who lies on parapet in exact attitude of a Lorenzo di Credi child. Pen height. with wh. on brown paper. 17.5 by 19. [Fototeca 12526. *Boll. d'A.*, 1931/32, p. 306.]

1897 LONDON, British Museum, 1882-8-12, 218, 219—Two drawings on same mount. Ascr. to Masolino. Two saints, each holding a book. Bistre and wh. 13.5 by 16. [Photo. B. M.] Three saints, one being Peter, and a kneeling donor. 13 by 26.5. [Photo. B. M.]

1898 (see 1884A)

Antonio Pollajuolo (pp. 16-29)

1898A BERLIN, Print Room, No. 472—Nude, for St. Sebastian probably, with hands behind his back in
Fig. 75 strangely Mantegnesque attitude. Pen on paper washed brown. 27.5 by 12. Verso: Writing and scribbled profiles of women to l. Photos. Museum. The head gone over by later hand, but the nude A.'s as is the writing.

1898B No. 5587—Nude in profile l. with r. hand dropping from wrist and l. on hip. Pen and bistre on yellowed paper. 28.5 by 12. Not easy to accept or reject. May be by A. but to a considerable extent gone over by another hand. Originally may have been on same sheet with last, and for same design.

1898C (former 1910) CAMBRIDGE (Mass.), Fogg Museum, Paul J. Sachs Collection—Fragment of original
Fig. 77 cartoon consisting of three figures on the extreme r. for the engraving executed by follower of A.'s, representing Hercules overcoming the giants (p. 27). Pen and bistre on dark background. 23.5 by 19.5. Pembroke Dr., pl. 17. [Popham Cat., No. 33. Van Marle, XI, p. 355. Buffalo Exh. Cat., pl. 8. See also John Walker's article in *Dedalo*, XI (1932/33), pp. 229-236; and F. Shapley in *Art Bulletin*, 1919/20, p. 85 and pl. 8. A photo. has been sent me by Dr. M. A. Goldstein of St. Louis of an outline drawing reproducing the composition of the Turin drawing rather than the Uffizi engraving. Pen. 35.5 by 50.]

1898D (former 1907) Fogg Museum, Charles Loeser Bequest, No. 132—Sketch for Sebastian in A.'s Martyrdom of St. Sebastian in London (N. G., No. 292) (p. 27). In the painting the position has been reversed. Pen and bistre. 23 by 9. Morelli Dr., pl. 2.

1899 CHANTILLY, Musée Condé—Head of oldish smooth-faced man, open-mouthed, and with a look of pain (pp. 26-27). Bl. ch. on brown paper. 19 by 14. Braun 65170.

1900 FLORENCE, Uffizi, back of No. 73—Cartoon for the Charity (pp. 22, 25-26). Bl. ch. height. with wh. on planed panel. 157 by 77. Pl. xv of F. E. reduced. [Uffizi Publ., I, iii, 4. Van Marle, XI, p. 341. Meder, *Handz.*, fig. 3.]

1901 No. 95F—Adam (pp. 26; 29, note; 31). Pen and bistre wash over bl. ch. 28 by 18. Pl. xvi of F. E. [Popham Cat., No. 31. Uffizi Publ., I, iii, 5. Van Marle, XI, p. 358.]

1902 No. 97F—Eve spinning. This and the Adam used to pass as Signorelli's, and were first
Fig. 76 ascribed correctly by Morelli (pp. 26; 29, note). Pen and bistre wash over bl. ch. 27.5 by 18.5. Pl. xvii of F. E. [Popham Cat., No. 32. Uffizi Publ., I, iii, 6. Van Marle, XI, p. 359.]

1902A (former 1927) No. 275E—Youth dressed in costume of the time looking up to r. in attitude of prayer or supplication (p. 29). Pen. 27.5 by 17.5. Brogi 1697.
 [I no longer see any reason for regarding it as a school copy after a lost original by A. It now seems by A. himself. The word "Antonio" at the top of the leaf is in his hand.]

1902ᴮ (former 1931) FLORENCE, Uᴹꜰꜰɪᴢɪ, No. 357ᴱ—Baptist supporting his head with l. hand and pointing
 Fig. 74 to skull with r. (p. 29). Pen and bistre. 34 by 23.5. Brogi 1705. [Uffizi Publ., I, iii, 8.
In poor preservation, for which reason, no doubt, I used to regard it as studio work; but
the drawing of head, legs, hand, and of the skin that the Baptist wears compel me now
(1935) to accept this design as an autograph by A. Verso: Various studies for Baptist.
Fototeca 12634. School copies after A. of the nature of my 1903.]

1903 No. 699ᴱ—Study for Baptist, and various separate sketches for hands and legs of same.
To proofs that Morelli gave when ascribing this drawing to A. may be added the fact that
at the bottom of the sheet are two or three words apparently in A.'s handwriting (pp. 25-26,
167). Pen and bistre, but one of the hands on a larger scale than the others, in bl. ch.
28 by 19.5. Pl. xɪᴠ of F. E. [Uffizi Publ., I, iii, 7. Meder, *Handz.*, fig. 151. Verso: Studies
of hands in lead-point. See *O. M. D.*, X, 1935/36, pp. 17-21 and pl. 20, where Emil Möller
ascribes these drawings to Salvestro di Jacopo. His only approach to a reason is that the
letters scribbled at the bottom spell out that name. There is no evidence that this brother
was an artist.]

1904 No. 942ᴱ—Study for reliquary or monstrance, signed "Antonio del Pollajuolo, horafo," p. 25).
 Fig. 79 Pen and bistre wash. 27 by 18.5. Braun 76319. [Verso: Salt-cellar in shape of two
harpies addorsed standing on Gothic base, their wings and entwined tails supporting
receptacle with cover opening from hinge in middle. Same medium and same signature,
but not of same quality. Fototeca 12725. Uffizi Publ., V, iv, 2 and 3. No doubt gone
over by later hand, leaving almost no trace of original.]

1905 LONDON, Bʀɪᴛɪsʜ Mᴜsᴇᴜᴍ, Fᴀᴡᴋᴇɴᴇʀ, No. 1510-8—Hercules and the Hydra (pp. 25, 167). Pen and
 Fig. 72 bistre. 23 by 16. Pl. xɪɪɪ of F. E. [Van Marle, XI, p. 367. Verso: Two dogs.
H. S. Ede in *Burl. Mag.*, XLV (1924), opp. p. 42, reproduces these dogs and proves
that the Hercules had at one time been put together inaccurately. He restores it and the
drawing gains, but it was always worthy of the admiration it received (our reproduction
shows the drawing unrestored). G. F. Hill in *L'Art dans les monnaies grecques* (Paris and
Brussels, 1927, pls. 42, 43) reproduces coins of Stymphalos and Phaestus embossed with
a Hercules, so like this one that one asks whether A. was not acquainted with them.]

1906 Bʀɪᴛɪsʜ Mᴜsᴇᴜᴍ, 1885-5-9-1614—Prisoner brought before judge. Eight nude figures (p. 27).
Pen and bistre on background coloured dark. 37 by 69.5. Pl. xᴠɪɪɪ of F. E. Vasari Soc.,
I, viii, 3ᴬ and 3ᴮ. Van Marle, XI, p. 357. F. Shapley, *Art Bulletin*, 1919/20, pl. 9.

1907 (see 1898ᴰ)

1908 MUNICH, Pʀɪɴᴛ Rᴏᴏᴍ—Study for monument to Francesco Sforza. Perhaps from Vasari's collection
(p. 27). Bistre and pen, on dark brown background. Lower l. corner missing. 23 by 21.
Bruckmann 143.

1908ᴬ NEW YORK, Mʀ. Pʜɪʟɪᴘ Hᴏꜰᴇʀ—One of the two studies for equestrian statue of Francesco Sforza
 Fig. 78 mentioned by Vasari, III, p. 297). Here he rides over the prostrate nude representing
Verona (p. 27, note). Bistre on darkened ground so that the figure looks as if reserved.
24.5 by 28. Pricked for transfer. Publ. and repr. by Simon Meller in a Miscellany in
honour of Aleksios Petrovic, Budapest, 1934. Buffalo Exh. Cat., pl. 9. The other study
for the statue is now in Munich (my 1908). The contours of the nude are sinuously plastic.

1908ᴮ PARIS, Mʀ. Wᴀʟᴛᴇʀ Gᴀʏ—Heavily draped youth, apparently asleep, seated on the floor with r. leg
drawn up and head leaning against the wall. Bistre wash and wh. on brown paper. 12 by 21.
Inscribed in 17th century hand " del Polaiolo."

The condition does not permit a decision, but probably an autograph by Antonio Pollajuolo. It will be noted how much the swinging curve of the draperies resembles those of the portrait until recently in the J. P. Morgan library (Van Marle, X, p. 372) that at one time I ascribed to Castagno but now would give to Antonio Pollajuolo.

1909 VIENNA, Albertina, S. R., 37—Two men conversing (p. 16). Pen and bistre wash. 27.5 by 21.5.
Fig. 73 Albertina Cat., I, ii, pl. 4. Albertina Cat., III, No. 15. It is possible that they were intended for a group of men conversing in an Adoration of the Magi (see my 1932 and 1937, Figs. 86 and 87).

1910 (see 1898^C)

School of Antonio Pollajuolo (pp. 28-29)

1910^A AMSTERDAM, Mensing Auction Room (June 15-16, 1926, No. 415)—Four male nudes kneeling and sitting with staves in hands. Pen on parchment. 16 by 26.5. No. 415 of Sale Cat. Ascr. to Pisanello, but perhaps by Ferrarese follower of P.

1910^B (Nov. 21, 1929, No. 24)—Hercules and Antaeus. Pen on tinted parchment. 31.5 by 21. No. 24 of Sale Cat. The design, the forms, and the handling are weak but Pollajuolesque. As I have not seen the original I can say no more.

1910^C (former 1950) BAYONNE, Bonnat Museum, No. 1269—Nude with folded arms (p. 29). Pen and
Fig. 82 bistre. 26 by 8. Pl. xxi of F. E. [Photo. Bulloz. Bonnat Publ., 1925, 9. All but and perhaps A.]

1910^D No. 691—Young man in profile r. with hands folded in prayer. Bistre and wash. 25 by 9.5.

1911 BERLIN, Print Room, No. 471—Nude archer, school copy, perhaps by the hand that did my 1933 after an original by A. (p. 29). Pen and bistre. 26 by 18. [Berlin Publ., 12.]
The original may have served for a Martyrdom of St. Sebastian, although scarcely for the picture in the N. G. In the Poldi-Pezzoli Museum at Milan there is a predella with that subject ascribed to A., wherein the action of this figure is copied exactly. This mediocre picture must have been painted by a person who had the felicitous idea of combining the styles of Pollajuolo and Credi. [The same bowman occurs in an Aesop printed at Venice in 1491 and reproduced as No. 328 opposite p. 120 in De Marinis, Sale Cat., Hoepli, Milan, Nov. 30-Dec. 3, 1925.]

1912 No. 5028—Copy of A.'s original cartoon for embroidery representing Baptist in wilderness preaching. Faithful but niggling, and almost mechanical (p. 16). Pen and bistre wash. 28 by 23.

1913 No. 5027—Copy with very slight variations after the Hercules only, in A.'s Hercules and Nessus of the Jarves Collection (No. 64) at New Haven. Pen and bistre wash, pricked for transfer. 39 by 26.5. [Berlin Publ., 13.]
That this is a copy treated in an almost frivolous, decorative spirit will have to be admitted by all who know A. in general, who know the painting in question, and have a feeling for line both as function and as rhythm. It seems to have passed unobserved that Albert Dürer in his Hercules and the Stymphalian Birds (Nüremberg, Germanic Museum, No. 205) used this figure without making any essential change. Nor it is improbable that his entire acquaintance with Pollajuolo's picture was derived from the sheet before us. [My impression in 1927 was something like this: originally in bl. ch. and pricked for transfer to the panel of the Jarves picture; afterwards gone over by a pupil who had more feeling for prettiness than for strength.]

POLLAJUOLO (ANTONIO) SCHOOL

1913^A CAMBRIDGE (Mass.), FOGG MUSEUM, CHARLES LOESER BEQUEST, No. 124—Youngish woman seated leaning over to our l. with hands folded on lap. Pen and bistre. 14.5 by 11. Probably studio of A. when he himself was closest to Baldovinetti and Pesellino, possibly by Maso Finiguerra.

1913^B DÜSSELDORF, ACADEMY, No. 7—St. Sebastian in profile l. with arms tied behind his back. Pen on grey prep. paper. 22 by 14.5. Düsseldorf Cat., No. 7. Almost Peruginesque.

1914 FLORENCE, UFFIZI, No. 78^E —Youthful nude in attitude of drawing bow. Ascr. to Piero, but done in imitation of A. [by much later hand]. Pen and bistre wash. 15.5 by 13.5.

1915 No. 98^F—Poor copy after original cartoon for embroidery now in the Opera del Duomo, representing the Expulsion from the Temple. Pen and bistre. 32.5 by 22.

1916 (see 1933^C)

1917 No. 110^E—Two nudes. Copy after A. Pen and bistre. 19.5 by 16.5.

1918 No. 246^E—Two nudes and child. Copy after A. Pen. 17 by 26. [Van Marle, XI, p. 435. Verso: Bl. ch. scrawls for candelabra.]

1919 No. 260^E—Four gladiators. Bistre and wh. on reddish buff ground. 19.5 by 27.5. Contemporary imitator but not a pupil of A., possibly David Ghirlandajo. [Van Marle, XI, p. 445.] Verso: Three nudes, one of whom is an archer. Brogi 1700 and 1808.

1920 No. 261^E—Sketch for allegorical figure of Justice (see my 1928). Pen and bistre wash. 10.5 by 8. Brogi 1704. [Van Marle, XI, p. 446.]

1921 No. 262^E—Sketch for allegorical figure of Prudence (see my 1928). Pen and bistre wash. 12 by 7.5. Brogi 1704. [Van Marle, XI, p. 447.]

1922 No. 263^E—Sketch for allegorical figure of Force (see my 1928). Pen and bistre wash. 10 by 7. Brogi 1704.

1922^A No. 264^E —St. Peter against side of lunette (see my 1924). Pen and bistre wash. 12 by 7.5. Brogi 1703.

1923 No. 265^E —St. Andrew in niche (see my 1924). Pen and bistre wash. 13 by 6. Brogi 1703. [Van Marle, XI, p. 448.]

1924 No. 266^E—St. James in niche. Pen and bistre wash. 13.5 by 8. Brogi 1703. This and the two last by some distant follower of the Pollajuolo.

1925 No. 267^E —Two male nudes erect, and one draped figure seated (p. 35). Pen. 19.5 by 24.5. [Degenhart, *Zeitschr. f. Kunstg.*, 1935, p. 116.] Verso: Four sketches of herma. Brogi 1699 and 1545. Perhaps by the hand which did my 1949.

1926 No. 269^E—Various nudes by hand that drew my 1925. Pen. 28 by 20.5. Brogi 1701. [Van Marle, XI, p. 434. Degenhart, *Zeitschr. f. Kunstg.*, 1935, p. 113.] Verso: Two nudes, faithful copies after admirable originals by A. [Degenhart, *ibid.*, p. 114.] The one on l. with ribbons in his hair, and his hand on shield, is close to one of the figures in the B. M. design of nudes. The one in profile to l. was copied by Pintoricchio as well and the copy occurs in the "Venice sketch-book" [Fischel, fig. 219].

1927 (see 1902^A)

1928 FLORENCE, Uffizi, No. 276E—Pope enthroned, blessing. Pen and bistre wash. 20 by 11.5. Brogi 1702.

This and my 1920-1922 are by the same hand, certainly not A.'s, and probably not Piero's. The figures seem like variations upon those on the Tomb of Innocent VIII, at St. Peter's in Rome. [This one in particular may be a copy after an original by A. for the statue of the Pope.]

1929 No. 278E—Angel from high platform pours out gold to beggars. One of the beggars has
Fig. 80 a child clinging to him, and on his shoulder another who reaches out for the coins. Another still hobbles up on his crutch and is followed by an angel. Pen and bistre. 12.5 by 17. Braun 76330. [Van Marle, XI, p. 439.] An excellent school version of an original that must have been of exquisite quality.

1930 No. 279E—Three nudes attacking centaur. Pen and bistre. 14 by 12. Braun 76331. [Van Marle, XI, p. 441.] Tame school version of an excellent motive by A.

1931 (see 1902B)

1932 No. 369E—Old king almost prostrate on ground, with negro boy holding up his train.
Fig. 86 Pen and bistre wash. 13 by 23. Copy of an admirable study for an Epiphany. [My 1937 (Fig. 87) copies another part of the same composition.]

1933 No. 370E—Two studies of a youthful male, dressed in costume of time. We see him once reclining, and the second time pensively seated. Pen and bistre. 37 by 29. Brogi 1807. [Van Marle, XI, p. 437.] Copy after lost original by A. [almost but not quite of the quality of my former 1927 which I now regard as an autograph (see my 1902A).]

1933A No. 45F—Thick-set middle-aged man with r. hand on small end of club and l. belled
Fig. 88 against hip. Pen and bistre on wh. paper. 20 by 18. Fototeca 12645. All but worthy of A. in his earlier years when close to Baldovinetti.

1933B No. 48F—Man in *lucco* on hexagonal stool seated in profile to l. writing on his knee. Pen and wash, cut out and pasted on brown paper. 25 by 10.5. Fototeca 12878.

Although on the surface resembling such drawings by Maso Finiguerra as Van Marle, XI, p. 422, it seems of much better quality and deserving to be classified with the studio work of A.

1933C (former 1916) No. 100F—Elderly male nude reclining on r. elbow, holding out l. arm. Pen and bistre wash. 21 by 25. Ascr. to Piero, but copy after lost original by A. [possibly by Granacci].

1934 No. 101F—Cartoon for a St. Jerome [originally most likely by A. himself] (p. 28). Pen and bistre, pricked for transfer. 37 by 53. [Fototeca 2050. N. Ferri, *Boll. d'A.*, 1909, opp. p. 376. Uffizi Publ., I, iii, 9.] This was engraved by an inferior contemporary of A.'s, and reproduction of the engraving may be seen in the second volume of A. da Morrona's *Pisa illustrata*.

1935 No. 102F—Young man in determined attitude, with arms folded, turns away, and is seen in less than profile to r. Bl. ch. 25 by 12. [N. Ferri, *Boll. d'A.*, 1909, p. 377. Fototeca 4239.] Copy after A.

1935A No. 104F—Two youthful figures in attitude of surprise. Pen on wh. paper. 27 by 17. Copy of study by A. for an Assumption.

1936 No. 109F—Decapitation of saint, probably the Baptist—a composition of five nude figures. School version of fine design by A. Sp. and wh. on greyish green prep. paper. 22.5 by 35.

1936A FLORENCE, UFFIZI, No. 118F—Youth seated drawing. Verso: Youth stands leaning on tall staff
 Fig. 84 and reading. Pen and wash. 18.5 by 12.5. Fototeca 4244. Van Marle, XI, p. 429.
 Fig. 85 Brogi 1423. Meder, *Handz.*, fig. 148. See next.

1936B No. 120F—Youth seated on beam bending over drawing on tablet supported on r. knee.
Pen and wash. 18 by 12. Fototeca 4245. Van Marle, XI, p. 430. Verso: Young man seated
on block with legs crossed writing. Fototeca 12487. This and my 1936A (Figs. 84, 85),
as well as my 1944C, are by the same hand, and close to A. But they have an elegance
and a suavity which do not occur elsewhere in his work. Possibly the originals of which
these sketches are studio versions were early and done under the influence of Domenico
Veneziano and Pesellino. The traditional attribution to Masaccio is senseless.

1936C No. 135F—Three female nudes, one with hands tied behind back embraced by another,
and third turning away. Bistre on wh. paper. 26.5 by 21. N. Ferri, *Boll. d'A.*, 1909,
p. 376. Uffizi Publ., I, iii, 10. Van Marle, XI, p. 399. Popham Cat., No. 34. Attractive
but not quite A. in conception and not at all his in handling. Conceivably by Piero.

1937 No. 2299F—Young king in profile to l., holding chalice in hand, and behind him three
 Fig. 87 men conversing. Pen. 33 by 26.5.
 Dry but accurate copy after part of a design by A. for an Adoration of the Magi,
a composition which we already have encountered in the copy of the old king prostrate
at the Virgin's foot (my 1932, Fig. 86). The figures now before us, more than any other
by A., recall Baldovinetti and even Pesellino, whence we may infer that the design
which they represent was a very early work.

1938 No. 14492F—Right arm. Pen. 11 by 6.

1939 No. 14493F—Male torso seen from behind. Pen. 20 by 13.

1940 No. 14494F—Three arms. Pen. 19 by 13. The three last drawings are by the same hand,
and no doubt copies after A.

1941 and 1942 Nos. 14531F and 14532F—Two fragments, wretchedly copying lost composition by A.,
representing, in many nude figures, battle of horse and foot. Pen, pricked for transfer.
No. 14531, 40.5 by 30; No. 14532, 39 by 29.5.

1943 UFFIZI, SANTARELLI, 58—Magnificently powerful head of bearded man, with high cheek
bones and firm mouth. Bistre wash. 14.5 by 10. [Fototeca 12678.]
 It is not easy to determine whether this drawing, which is probably a copy, was done
after an original by A. while under Castagno's influence, or as is less likely by the latter
master himself.

1943A HAARLEM, KOENIGS COLLECTION, Inv. 181—Five nudes in various attitudes of consternation gathered
around a headless nude lying prostrate. Pen on grey prep. paper. 18.5 by 19. Undoubtedly
after an original by A.

1944 HAMBURG, KUNSTHALLE—Combat of two centaurs (pp. 28-29). Pen and bistre on brown paper.
25 by 37. Pl. xx of F. E.

1944A LEIPZIG, BOERNER SALE (May 12, 1930) No. 19—Christ crowned with thorns, nude under mantle
with r. hand directed toward chalice on ground and l. to the wound on His r. side. Bistre
and wash. 16 by 7. Lees, fig. 10. Sale Cat., pl. 8. Copy of an A. that may have served
for an embroidery.

1944B LONDON, British Museum, 1885-5-9-1614—Three nudes in various attitudes and a l. arm. Pen and bistre on yellow parchment. 25.5 by 28. Degenhart, *Zeitschr. f. Kunstg.*, 1935, p. 117. [This is a duplicate of my 1949, which, however, completes the figure at the right and adds a r. arm, and is of finer quality.]

1944C 1895-9-15-440—Youth seated drawing, almost as in my 1936B. Pen and wash. 19.5 by 11.5. Van Marle, XI, p. 431. Verso: Youth almost in profile l. Study for drapery. Same hand as my 1936B.

1945 Hertford House—Studio copy—but one that could scarcely come nearer to being an
Fig. 81 original—after design, consisting of eleven nude figures, by A. for the mourning over a dead person (p. 28). An inferior copy may be seen at Munich. Pen and bistre wash. 27.5 by 44. See E. Fuchs, *Illustrierte Sittengeschichte*: *Renaissance, Ergänzungsband*, fig. 12, for German 16th century engraving from this composition (Bartsch, No. 30). Also *Burl. Mag.*, LXVII (1935), where both drawing and engraving are repr. opp. p. 217.

1946 MILAN, Ambrosiana, Libro Resta—Nude man bearing a mace. Pen and bistre. Faithful copy after A. by Maso Finiguerra.

1947 MUNICH, Print Room, No. 7065—Crucifixion. Elaborate composition with many figures [of quality
Fig. 89 and date of the Opera del Duomo embroideries]. Bistre and wash. 31.5 by 24.5.
The original must have been of the value almost of A.'s Combat of Nudes. The copy is faithful, but inferior to that of the design at Hertford House.

1947A No. 2145—Man seated wearing Florentine costume of about 1475. Ink and wh. on pink prep. paper. Pricked for transfer. 22 by 17. See O. Weigmann, *Monatsh. f. K. W.*, II (1909), p. 9. Studio copy after A. of very good quality.

1947B (former 1951A) NEW YORK, Metropolitan Museum, No. 26—Horse in profile to l., drawn in outline and annotated with indication of measurements and proportions. Ascr. to Verrocchio, but the handling connects it with A., and the quality with more than one other drawing of his school. Pen. 24.5 by 29. Pembroke Dr., pl. 58. Sirén, pl. 81B.

1947C Morgan Library—Nude to r., in attitude of drawing bow. Pen and bistre. 19 by 11. Morgan Dr., I, 4 (1). Faithful copy of A.

1947D Man in cloak to r. as if talking. Pen and bistre. 17.5 by 6. Morgan Dr., I, 4 (2).

1947E Nude seen from behind but almost in profile to l. blowing trumpet. Bistre wash and wh. on tinted paper, pasted on old mount. 18 by 8. Attr. Florentine School.

1948 OXFORD, Christ Church, A. 11—Full-length figure of Dante (p. 29). Pen and bistre. 26 by 9. Pl. xxii of F. E.

1949 PARIS, Louvre, No. 1486—Three nude figures, and two arms (p. 35). Pen. 35 by 26.5. Alinari 1467. [Van Marle, XI, p. 371.
A 16th century copy of the rightmost figure is Loeser Bequest 260 at the Fogg Museum.] Too feeble for originals, despite the almost contemporary inscription—*Antonii Jacobi excellentissimi ac eximii pictoris scultorisque praestantissimi hoc opus est.* [My 1944B is a slightly inferior version of the same original.]

1949A No. 2695—St. Christopher carrying Christ Child through stream (p. 24, note). Pen and
Fig. 90 water-colour on vellum. 23.5 by 15.5. Arch. Ph. Attr. anonymous Florentine School. Published by Byam Shaw as Botticini in *O. M. D.*, IX (1934/35), pp. 58-60 and pl. 62.
It is more likely by Pier Francesco Fiorentino and not impossibly a reminiscence if not as seems probable an out and out copy of Piero Pollajuolo's St. Christopher which

used to be on the façade of S. Miniato fra le torri. The fresco, by the way, in the Metr. Mus. (Van Marle, XI, p. 391) that some 40 years ago I tried to identify with this work seems to me now to be an early Domenico Ghirlandajo.

1949ᴮ PARIS, Louvre, No. 9861—Nude striding to r. with sickle in l. hand and r. held out at arm's length. Also study of leg. Pen. 27.5 by 20.5. Alinari 1468. Giraudon 18906. Verso: Study for seated female figure with r. hand over breast, twining snakes held out in her l. Arch. Ph. Cinquecento copies after A., the seated figure for such a design as we have in the Pollajuolo Virtues in the Uffizi. The copyist may have been one of the San Gallo.

1950 (see 1910ᶜ)

1950ᴬ TURIN, Royal Library, No. 15592—Hercules fighting the twelve giants. To r. prisoner running away to group of two women; one half-draped sitting mournfully, the other kneeling, while between them two figures embrace. Pen. 37 by 12. Repr. and discussed by John Walker in *Dedalo*, XI (1932-33), pp. 230-31.

Contemporary of a composition of which the well-known engraving (Van Marle, XI, p. 354) reproduces but half. It spreads out in a way that recalls Chinese and Japanese narrative painting. A post-Raphaelesque pen-and-wash variant at Windsor of all but the group on the r. has been brought to my notice by Mr. Kenneth Clark.

1951 No. 15591—Two nudes, one prostrate, the other trampling on his neck, and pulling his
Fig. 83 arm. Pen. 36.5 by 28. Anderson 9857. Studio version of fine design.

1951ᴬ (see 1947ᴮ)

1951ᴮ VENICE, Academy—In the so-called Venice sketch-book (Anderson 15126-15161). A number of drawings are obviously copies after A. Several of these are reproduced by Fischel, figs. 164, 165 (these two look like Finiguerra's), 218, 219, 223, 224, 242.

Piero Pollajuolo (pp. 17-24, 28)

1951ᶜ DUBLIN, National Gallery, No. 2233—Life-sized profile to l. of youth (p. 28, note). Bl. ch. pricked for transfer. Vasari Soc., II, xiii, 1. Although restored and sweetened almost beyond recognition there is a chance that it was done by P. Verso: Study for r. foot, perhaps for
Fig. 92 a Madonna or Virtue and undecipherable sketches for architecture and drapery. Same technique, much better preserved and almost certainly by P. himself although inscribed in nearly contemporary hand "Anto del Pallaiuolo." Photo. Museum.

1952 FLORENCE, Uffizi, No. 14506—Cartoon for head of Fides (pp. 21-22, 28). Bl. ch. rubbed with red
Fig. 91 and pricked for transfer. 20 by 17. Pl. xix of F. E. Uffizi Publ., I, iii, 11.

1953 No. 7630—Horse standing in profile to r. Below, hind parts of another horse, the head of bald, smooth-faced elderly man, ascr. to Verrocchio [but resembling the heads in the S. Gimignano Coronation] (p. 28). Sp. on pink prep. paper. 20 by 27.

1953ᴬ ROME, Corsini, Print Room, No. 13059—Profile to l. of youth (p. 28, note). Pen and bistre on dark prep. ground. 25 by 20. *Gallerie nazionali italiane*, II (1896), pl. VI. Popham Cat., No. 36. Van Marle, XI, p. 433. Would seem to be by the hand that painted the Poldi-Pezzoli and kindred profiles, and that hand now seems to have been P.'s.

Pontormo (pp. 300-321)

1954 BERLIN, Bekerath Collection (formerly)—Study of man seen slightly sideways. The finished parts in r. and the less finished in bl. ch. 36.5 by 23.5.

1954^A PRINT ROOM, No. 465—Nude male turned to l. with both arms lifted as if to strike with flail. Pen and bistre. 40.5 by 21.5. Verso: Sketch for one of the *putti* at Poggio a Cajano. Bl. ch. Photos. Museum. Published by Fritz Goldschmidt in *Amtl. Ber.*, 1914, pp. 85-88. Recto repr. Voss, p. 180.

 The recto is not easy to recognize as P., the hatching being so painfully Michelangelesque. And yet the swing of the contours seems to speak for him besides the fact that the other side is certainly by him.

1954^B (former 2392) No. 4195—Draped and hooded woman turned to r. and looking out towards l. R. ch. 33 by 20. [Photo. Museum. Kusenberg, pl. 66. Early, of the Annunziata Visitation period and not by Rosso, as catalogued in my first edition.]

1954^C BESANÇON, Museum, No. D. 1411—Draped bust of young man leaning on r. elbow and looking out to our l. R. ch. 19.5 by 14.5. Photo. Festas. Probably study for one of the Evangelists in the medallions at S. Felicita like my 2253^A. I owe acquaintance with this sheet to Mr. A. E. Popham of the B. M.

1955 BUDAPEST, National Gallery, No. 64—High lunette, within which we see a man holding a score, and three others reading out of it over his shoulder, all singing. Early. Ascr. to Andrea del Sarto. R. ch. 23.5 by 29. Pl. 473 of Schönbrunner & Meder.

1955^A (former 2249^A) CAMBRIDGE (Mass.), Fogg Museum, Charles Loeser Bequest, No. 342—Two nude youths, probably studies for a spandrel. Bl. ch. 44 by 29. Also slight sketch in r. ch. Verso: Rapid sketches in bl. ch., and two profile heads in r. ch.

1955^B No. 144—Male nude seen reclining to r. and lifting himself with both hands behind him, but looking straight out. R. ch. 30.5 by 20. Of rather poor quality and in all probability of the S. Lorenzo period although in attitude it might seem a study for the Christ at S. Felicita or even for a figure in the Certosa Deposition.

1956 CHANTILLY, Musée Condé, No. 103—Portrait of youngish woman seated turning slightly to l., but head seen full face. Her l. arm rests on her chair. Her r. hand touches her l. wrist. R. ch. 19.5 by 16. Braun 65086. [O. H. Giglioli, *Riv. d'A.*, 1936, p. 192.]

 It is ascribed to Andrea, and Morelli (*Kunstchr.*) attributed it to Puligo. Nevertheless it is distinctly Pontormesque, as the arrangement, the somewhat puffy modelling, and the folds go to prove. I am inclined to believe that it is by P. himself, although the drawing of the hands is far from exemplary. [Could be dated between 1525 and 1530.]

1957 CHATSWORTH, Duke of Devonshire—Portrait of youngish man with glove in r. hand,
Fig. 984 and l. hand resting on knee. The action seems inspired by Michelangelo's Duke Giuliano (p. 318). Bl. ch. 26 by 18. [Chatsworth Dr., pl. 16. Popham Cat., No. 234. The quality is of P.'s best.

 It turns out that this drawing undoubtedly served for the portrait of a man with a lute by Bronzino in the Uffizi (No. 1575, McComb, pl. 3). The easy inference is that both were from the same hand. Looked at closely we see that the sketch, although squared for transfer, could not have served for the cartoon of the painting. The differences are too many. The face in the drawing is broader, the nose fleshier and shorter, the whole cast of features more plebeian. In short the painting turns the rather thickset though still young mechanic into a humanist, a collector perhaps, a musician certainly. Then the

draperies in the drawing have an ease and the touch a freedom which are closer to P. than to Bronzino. There I must leave it for I have unfortunately not seen the original again and the reproductions differ widely. If Bronzino, this drawing must be early for if by P. it would be of the S. Felicita period. But it would not surprise me if not in spirit only but in material fact as well this study were by the older and greater master and that owing to some accident the painting was done by Bronzino. Perhaps the sitter wanted to be portrayed as more of a gentleman than P. would make him.]

1957A CHELTENHAM, FITZROY FENWICK COLLECTION—Study for youth seated with r. arm resting on parapet and l. hand supporting his chin. Verso: Study for St. Jerome in the Uffizi altar-piece No. 1538 (Venturi, IX, v, fig. 67). Grey ch. 40.5 by 28. Recto repr. in Vasari Soc., II, xii, 8, and probably made in connection with Poggio a Cajano while the drapery of the St. Jerome looks already Düreresque and is therefore somewhat later as is also the small altar-piece for which it served.

1958 (see No. 55H)

1959 DRESDEN, PRINT ROOM—Draped man in profile to l. kneeling. R. ch. 34 by 23. [Clapp, *Life*, fig. 3. Verso: Male nude walking towards l. and separate study of a hand.] This sheet belongs to P.'s earlier middle period.

1959A Sketch for the Expulsion from Paradise at S. Lorenzo (p. 321, note). Bl. ch. 38.5 by 14.
Fig. 998 Squared for transfer. See my 2198 (Fig. 997).

1959B EDINBURGH, NATIONAL GALLERY, No. 2330—A youthful nude stooping to grasp a little boy also nude. R. ch. Photo. Museum. The contours and accent are close to drawings for the S. Felicita Pietà. Possibly connected with an early and discarded idea for that masterpiece.

1959C (former 1984) FLORENCE, UFFIZI, No. 526E—The Eternal commanding Noah to build Ark. One of P.'s best pen-drawings. R. ch. 31 by 25. Brogi 1564. Verso: Study for flying *putto* holding ribbon between outstretched hands. The recto copied rapidly from the Raphaelesque composition in the Loggia of the Vatican.

1959D (former 1985) No. 654E—Child's head tossed back a little to l. and laughing. Study for Child in the altar-piece in S. Michele Visdomini. Bl. ch. 21.5 by 17. Braun 76388. [Photo. Mannelli. Uffizi Publ., I, i, 5. Clapp, *Life*, fig. 20.] Verso: Cast of drapery. R. ch.

1959E (former 1986) No. 671E—Five charming *putti*, two reclining and others flying. Pen. 40 by 28. Alinari 55. [Photo. Mannelli.] Verso: Four flying *putti*, a little more sketchy than the last. Doubtless for some ceiling decoration, perhaps, although not probably, for the one in the Pope's Chapel at S. Maria Novella, and at all events of that early date. [The penmanship seems very Michelangelesque.]

1959F (former 1987) No. 672E—Three nude youths in strange attitudes (p. 309). R. ch. 37.5 by 28. [Uffizi
Fig. 943 Publ., I, i, 4. Clapp, *Life*, fig. 43.] Mannered but admirable, with the quality and contours of such a modern artist as Manet. Fairly early.

1959G (former 1988) No. 675E—Three male nudes in cowering or sitting postures, suggested, perhaps, by certain figures in Michelangelo's Bathers. Noticeable are two of the faces, which seem hacked to pieces, an inexplicable trick which P. affected. R. ch. 21 by 26. Braun 76338. [Verso: Studies of drapery.]

1960 No. 122F—Head of morose youth. R. ch. 10 by 9.5.

1961 FLORENCE, Uffizi, No. 272F—Study of child, attributed to Andrea, and for his Dresden Madonna, but really P.'s, as the forms, the quality, and stroke prove. R. ch. 22.5 by 15. [Photo. Mannelli.] It is of course from his earlier years when he was nearest to Andrea.

1962 No. 300F—Study for Deposition in lunette. Christ reclines with His head and shoulders
Fig. 970 in the lap of a disciple, as in Andrea's Pitti Pietà. Another disciple, also nude, kneels behind. To r. is seen Mary fainting into the arms of two women. There is good action in this fine composition (p. 315). R. ch. 16.5 by 33. [Photo. Mannelli. Uffizi Publ., I, i, 2. Clapp, *Life*, fig. 39. Verso: Female figure seated on wall. Giglioli in *Dedalo*, VII (1926/27), p. 780, connects it with Poggio, which would make the recto a good deal earlier than I had considered it to be in my first edition. Clapp (*Dessins*, p. 87) had given it the same date as Poggio without having seen the verso.]

1963 No. 341F—Young nude female stooping slightly as she holds, joined over her loins, a
Fig. 937 slight drapery. With her r. hand she touches one of her tresses. Beside her, a lively child about to rush off to the l. (p. 276, note). R. ch. 39 by 18. Alinari 379.

This charming study is catalogued as a preparatory sketch by Andrea for his Scalzo Charity. But the stroke and modelling are far too feeble for him, and to the knowing eye every bit of this design so clearly betrays the hand of P. that it is surprising that it has never before been ascribed to him. The woman's face has the long oval that we know in his St. Veronica in the Pope's chapel at S. Maria Novella, in the Madonna formerly at S. Michele, in more than one figure in the Annunziata fresco, and elsewhere. The chubby child is P.'s typical one. But, better than a signature, are the hands, all three of them being, one more than the other, intimately characteristic of our artist. No doubt when making this design, P. had Andrea's Charity in mind, and indeed the action of the child is taken, although reversed, from one on the r. in that composition. It is not improbable, moreover, that our group was drawn while P. was still with Andrea in 1512-1513, and on acquaintance with the latter's original design for the fresco. As for the subject, it must be a Venus getting out of the bath, with Cupid gambolling by her side.

1964 No. 414F—Portrait bust of pleasant, although somewhat masculine, young woman, with
Fig. 978 l. arm resting on table and r. folded across other (p. 317). R. ch. 39 by 26.5. Pl. CLXXIII of F. E.

Owing doubtless to the arrangement of the arms, this splendid design was still catalogued as Leonardo's when my first edition appeared. Morelli (*Kunstchr.*) ascribed it to Bacchiacca, and German critics to Franciabigio. But many years ago its real authorship was recognized by Signor Enrico Costa. Indeed, this attribution is so obvious that nothing short of total ignorance of P. as a draughtsman and as a painter could fail to assign this portrait to him at sight. Who but he has just these hands and this ear? And who else has features modelled in exactly this manner? Its date can scarcely be before 1525.

1965 (see 2248A)

1966 (see 2248B)

1967 No. 440F—Study for portrait bust of middle-aged man, almost in profile to r. Two other studies for same subject may be seen in the Corsini Print Room in Rome (my 2349). R. ch. 19.5 by 15.5. [Clapp, *Dessins*, pl. VI.]

1968 No. 441F—Study for St. Jerome kneeling in fervent prayer. R. ch. 26.5 by 19.5. [Photo. Mannelli. Uffizi Publ., I, i, 17.] Verso: Nude female lying on her stomach, but with chest resting on her elbows. [Clapp, *Life*, figs. 109 and 110.]

The recto was suggested perhaps by Leonardo's picture now in the Vatican. The style points to about 1525 or later, and as the design is squared for enlarging, a painting

corresponding to it probably was executed. [As Clapp has pointed out, it comes very near to the figures in the S. Felicita chapel. See also W. Meinhof in *Rep. f. K. W.*, 1931, pp. 121, 123.]

1969 FLORENCE, Uffizi, No. 442F —Three magnificent male nudes, one of them seen from back, and all marching forward buoyantly to l. R. ch. 42 by 26. Braun 76336. [Photo. Mannelli. Clapp, *Life*, fig. 44. Early and admirable.]

1970 No. 443F —Portrait of youth down to knees, wearing flat cap and plain mantle falling from
Fig. 983 his shoulders, holding in r. hand a horn, upon which he has just been playing (p. 318). R. ch. 27 by 19.5. [Photo. Mannelli.] Very direct and sweet. Verso: Knee-length portrait of bearded ecclesiastic, with l. hand on breast, and his r. at side. Quiet and intimate.

1970A (former 2005) No. 444F —Slight sketch for reclining Venus seen from back, but showing her full face, a variant upon another jotting with the pen, my 1972. Bl. ch. 10 by 14.

1971 No. 445F —Study for one of floating angels in my 1959C, but more undisguisedly Raphael-esque. Pen. 16 by 27.

1972 No. 446F —Rapid and graceful jotting for reclining Venus with Cupid. See my 1970A. Pen and wash. 9.6 by 14.

1972A (former 2006) No. 447F —Two rather lackadaisical draped figures, one of them pouring water out of basin (p. 313, note). R. ch. 31 by 19. [Clapp, *Life*, fig. 89. Verso: Study of draped figure (p. 313, note). Fototeca 15477.] Both these sketches [see Giglioli in *Dedalo*, VII (1926/27), pp. 784 and 787] served for a composition, a sketch for which exists in this collection (my 2159A). It is for a Christ being nailed to the cross, and the pouring figure occurs there above on the l.

1973 No. 448F —Study for the Virgin in a fresco representing the Annunciation in the Capponi Chapel at S. Felicita. She stands by her desk with her l. hand upon it, and turns sharp round to the l. at the sound of the angel's voice. R. ch., squared for enlarging. 39 by 21.5. Clapp, *Life*, fig. 88. Popham Cat., No. 231. Uffizi Publ., I, i, 16. Voss, *Zeichn.*, p. 171 and pl. 5.

1974 No. 449F —Study for portrait bust of youth, leaning forward slightly, and with arms folded
Fig. 981 across his lap. He looks out of deep sweet eyes (p. 318). R. ch. 24.5 by 14.5. Pl. CLXXV of F. E. Clapp, *Life*, fig. 101. Verso: L. hand holding paper. Fototeca 12010. Seems to have been done for a double portrait belonging to Count Paolo Guicciardini. See Giglioli in *Dedalo*, VII (1926/27), pp. 777 and 784.

1974A (former 2007) No. 450F —Young man wearing short tunic standing with l. hand around staff. Bl. ch. 34.5 by 15.5. Photo. Mannelli. Verso: Rapid sketch for nude male figure resting l. arm on staff and with r. arm akimbo. Fototeca 15478. Giglioli, *Dedalo*, VII (1926/27), pp. 784, 786, 788.

1974B (former 2008) No. 451F —Study for bust of old woman with mantle draping her head and shoulders
Fig. 988 (p. 319). Bl. and wh. ch., on brown paper. 40.5 by 30. Uffizi Publ., I, i, 13. Fototeca 4169. Simplicity itself as composition, beautifully constructed, and boldly drawn.

1975 No. 452F —Study for knee-length portrait of youth, rather effeminate in dress, although
Fig. 980 scarcely in features or expression (p. 318). R. ch., squared for enlarging. 33 by 21. Foto-teca 11886. [Photo. Mannelli. Clapp, *Life*, fig. 38. Verso: Sketch for head of young

shepherd looking up towards l. at Poggio (p. 311, note). Fototeca 12011. See Giglioli in *Dedalo*, VII (1926/27), pp. 777 and 782.

The youth on the recto is of the type that appealed to Puligo, particularly in such cases as the knee-length young prelate, until recently in Lord Plymouth's Collection and the bust of another youth in the Abreo Collection of the Seville Museum.]

1976 FLORENCE, UFFIZI, No. 453F —Study for decorative composition in lunette for fresco at Poggio a
Fig. 940 Cajano (pp. 306, 311). See the next. Pen and wash. 19 by 38. [Photo. S. I. 4281. Clapp, *Life*, fig. 74. The heads recall the type of the latest Andrea frescoes at the Scalzo.]

1977 No. 454F —Another study for same purpose (pp. 306-307). Pen and wash. 19 by 38.
Fig. 941 Pl. CLXX of F. E. [Goldschmidt, pl. 1. Clapp, *Life*, fig. 73.]

I have said in the text regarding these two designs that they could not have been made for the lunette which was executed, and they must have been intended for the one opposite, taken in hand after the siege of Florence. To what I have there said in proof of the later date it should be added that the shield under the window in my 1976 (Fig. 940) has an advanced Cinquecento shape, and the further and more important comment that the style of drawing is late. The most obvious characteristic of P.'s middle period is the mannered way of giving accent to his figures by the excessive swelling of their limbs, a characteristic displayed in both these sketches, particularly in my 1977. [See, for instance, the extraordinary distortion of the forearm of the female figure in the lower r.-hand corner.]

1977A (former 2009) No. 458F —Study of winged *putti*, flying birds, and in a cartouche drawn with pen, six tiny *putti* flying one after the other. Altogether charming. Bl. ch. 17 by 26.

[See Clapp (*Dessins*, p. 102), who has excellent reasons for believing that these were to serve for the Careggi frescoes.]

1978 No. 459F —Elaborate study for complete picture representing infant Baptist sitting on draped rock in wood. Pen. 32 by 22.5. [Uffizi Publ., I, i, 14.] Verso: Virgin, sketch for a figure in a Crucifixion. [Very close to Fra Bartolommeo.]

1979 No. 460F —Study for the Louvre altar-piece, but without the cartouche containing the
Fig. 962 procession of the Florentine Government. St. Anne has the Madonna on her lap. To the r. stands St. Benedict with St. Philip appearing above him; to the l., St. Peter with St. Sebastian above him (p. 314). Pen and bistre, squared for enlarging. 24.5 by 18. Pl. CLXXI of F. E. [Clapp, *Life*, fig. 105.]

1980 No. 461F —Four draped female figures for a Visitation. Squared for enlarging. Later middle period. Bl. ch. 32 by 24. [Clapp, *Life*, figs. 111 and 112. E. Panofsky, *Belvedere*, XI (1927), opp. p. 47. Publ. in *Riv. d'A.*, 1904, pp. 13-18, by Carlo Gamba, who identified it as the sketch for the Visitation at Carmignano.]

1981 No. 462F —Various spectral figures sprawling and wriggling on ground, doubtless for fresco of the Resurrection painted in P.'s last years, in the choir of S. Lorenzo. Bl. ch. and wash. 15.5 by 28.

1982 No. 463F —Study for knee-length portrait of soldier in simple jerkin, with strap for belt
Fig. 987 and l. hand on pommel of sword (p. 318). Bl. ch. 25 by 20. [Uffizi Publ., I, i, 20. Clapp, *Life*, fig. 120.]

A remarkably personal yet direct presentment. Vasari speaks of a portrait of a Francesco Guardi in soldier's dress done during the siege of Florence. The person in our sketch has nothing of the professional military swagger, and the style of drawing would bear out the date of the siege. Possibly, then, this is the sketch for that painting.

1983 FLORENCE, Uffizi, No. 465F —Study for Creation of Eve. R. ch. 42 by 31.5. [Verso: Faint sketch of reclining figures.] Bl. ch.

Despite the pitifully inadequate treatment of the subject on the recto, as drawing, this design is not yet in P.'s latest manner [but may have been nevertheless used for S. Lorenzo. The nudes on the verso are certainly of that period.]

1984 (see 1959C)

1985 (see 1959D)

1986 (see 1959E)

1987 (see 1959F)

1988 (see 1959G)

1989 (see 2398)

1990 No. 1485F —Child resting on dolphin. R. ch. 14 by 20.

1991 No. 1564F —Design for arabesques. 27.5 by 19.5. Braun 76339. [Photo. Mannelli. The female profiles reduced to mere ornaments anticipate Cellini.]

1991A No. 6437F —Study of drapery for figure seated astride wall. Verso: Same figure seated sideways. R. ch. 26 by 24.5. Clapp (*Dessins*, p. 114) is perfectly right in thinking that both may be first ideas for Poggio.

1991B (former 2010) No. 6438F —Study for Madonna with Child to the l., and infant John to r. The types recall both the Corsini (Florence) and Louvre pictures. Ascr. to Andrea. R. ch. on pink prep. paper. 8 by 15.

1992 (see 2017A)

1993 (see 2017B)

1994 (see 2055A)

1995 (see 2086A)

1996 (see 2156A)

1997 (see 2159A)

1998 (see 2159B)

1999 (see 2159C)

2000 (see 2159D)

2001 (see 2175A)

2002 (see 2181A)

2003 (see 2211A)

2004 (see 2225A)

2005 (see 1970A)

2006 (see 1972A)

2007 (see 1974A)

2008 (see 1974B)

2009 (see 1977A)

2010 (see 1991B)

2011 FLORENCE, Uffizi, No. 6503F —[Two separate studies for costume and head] of elderly woman, the latter, although half effaced, is still full of spirit and individuality (p. 319, note). R. ch. 25 by 16.5. Latish. [The head of young girl on verso is of poorer quality and may be a copy by P.after a Quattrocento head. See for the sketches on the recto Jenö Lányi in *Mitt. d. K. H. Inst. Florenz*, IV, pp. 93-95. He attempts to prove that they were for the portrait of Maria Salviati at the Uffizi (No. 3565). The difficulty is that the head is so much older looking than in the painting and so much older than the woman under forty that Maria was in 1537 when she sat for this picture.

2012 No. 6504F —Summary, but large and splendid sketch of nude lying on his face with r. leg drawn back on r. side. The head is almost hidden by the arm (p. 311). [Clapp, *Life*, fig. 46.] Verso: Eight more or less spectral heads, two of them in ink, and a small nude. Bl. ch. 25 by 41.

2013 No. 6505F —Sprawling youthful male nude lying on his side and yelling. Bl. ch. 26.5 by 40.5. A caricature of Michelangelo's Tityus, but intended perhaps for the S. Lorenzo frescoes, and certainly of that date.

2014 No. 6506F —Study of lower part of very slender female, nude below pelvis, with r. leg
Fig. 945 resting on stone, and l. firmly planted on ground; also study for a foot (p. 310). R. ch. 39.5 by 26. [Photo. Mannelli. Clapp, *Life*, fig. 40.]

Perhaps P.'s masterpiece in r. ch. Not only have the limbs a tender grace, and an elegance as of Cellini's most finished bronzes, but a luminousness of a translucent substance—a quality obtained by the exquisite way in which the white of the paper has been used as a material. The contours have great charm although they lack the vivid, vital touch of an Andrea. The date is between 1520 and 1530.

Verso: Much hastier study for male nude with l. arm held up.

[Clapp (*Dessins*, p. 118) connects the recto with the St. Michael at Pontormo, and I admit that the action of the legs is like that figure, but the proportions are much nearer to the Galatea in the Barberini picture. It may have served for both as is the case of my 2225A, which seems to have been used for the St. Francis in the S. Michele Visdomini altar-piece and later on for the Pygmalion.]

2015 No. 6507F —Two youthful nudes, one leaning on staff, seen full face, and the other beside him in profile. Bl. ch. 41 by 26.5. [Photo. Mannelli.] These figures are in every way close to Andrea. Perhaps they were intended for an Adoration of the Shepherds. In lower corner, faint indication of head. Verso: Youthful nude seated on ground with arms stretched out as if groping. [Almost like the boy in the Annunziata Visitation although somewhat later.] In ink rapid sketches of a profile and of a female nude, seen from back.

2016 No. 6508F —Various limbs, and, on smaller scale, mannered nudes, representing the Eternal conversing with Noah. This is squared for enlarging, and was doubtless for the choir of S. Lorenzo (p. 321). Bl. ch. 27 by 14. Verso: Male torso seen from side.

2016A No. 6509F —Female nude seen from behind, seeming like a translation of the Medicean Venus into the corpulency of Rubens. Bl. ch. on pink prep. paper. 23 by 16.5.

2017 FLORENCE, Uffizi, No. 6510^F—Upper part of youthful figure, with arms as if flying, and face as
 if possessed. Also winged *putto* flying, and seated figure raising himself on his hands.
 Bl. ch. 26 by 18. [Clapp (*Dessins*, pp. 120-121) suggests that it may be a sketch for the
 Castello frescoes and is probably right.]

2017^A (former 1992) No. 6511^F—*Putto* straddling trunk of laurel, with l. hand held up in triumph, and
 every limb stretched to utmost (pp. 309-312). Bl. ch. 10 by 22.5. [Photo. Mannelli.] Done
 certainly in connection with the decoration of Poggio a Cajano, but in the one lunette that
 was painted it does not occur, although the sketch is squared for enlarging.

2017^B (former 1993) No. 6512^F—*Putto* seated on wall, with r. leg drawn up, and corresponding arm held
 Fig. 960 up. Companion to last (pp. 309, 312). Bl. ch. 22 by 11. [Fototeca 2070. Both this
 and the preceding sketch may have been, as the more mannered draughtsmanship would
 seem to imply, for the second lunette which was, I suspect, planned but never painted.]

2018 No. 6513^F—Study of nude seated with head tossed back in profile to l., with r. leg stretched
 out and l. drawn up, r. arm bent over head, and l. with fist doubled up held close to neck.
 R. ch. 36 by 22.5. Fine although angular contours, and excellent shading. Doubtless
 done in connection with Poggio a Cajano, but does not occur in the fresco. Verso: Cast
 of drapery.

2019 No. 6514^F—Study (probably from nude male model) for shepherdess reclining on extreme
 Fig. 949 r. in lunette at Poggio a Cajano (p. 310). R. ch. 34 by 25.5. [Clapp, *Life*, fig. 56.] The
 only difference is that in the painting the legs are extended on the ground, while here the
 nude lies on the parapet, with the l. leg hanging over it, and the other drawn up. The
 drawing before us is at all events one of P.'s most spirited and most vivid, and of singular
 brilliancy of touch. Verso: Rapid but large sketch for portrait head nearly in profile to l.
 Bl. ch.

2020 No. 6515^F—Rapid but most delightful sketch of youthful nude seated fronting us with
 Fig. 953 legs drawn up and r. hand shading face. Certainly for Poggio a Cajano, and perhaps for
 the figure seated on the ground on the extreme l. but turned sideways towards us. A
 smaller sketch for the same, various limbs, and a mere jotting for the figure seated on
 the parapet on the extreme l. in the fresco (pp. 311, 312). Bl. ch. 43 by 26.5. Verso:
 Hasty study from draped male model for shepherdess reclining on extreme r. in same
 fresco; my 2159^C (Fig. 957) offers a more elaborated version. [Clapp, *Life*, fig. 57].
 On the l. we see a leg which in the fresco belongs to the shepherdess seated on the parapet.
 This part of the composition was thus already fixed when P. drew this figure (p. 312).

2021 No. 6516^F—Hasty sketch of draped male youthful figure seen from behind. Bl. ch. 38 by 25.
 Verso: Three studies in varying sizes of male nude [lying face down as if drinking from
 stream. Photo. Mannelli. Clapp, *Life*, fig. 47.] Fairly early.

2022 No. 6517^F—*Putto*, perhaps infant Baptist, running with arms extended. Bl. ch. pricked
 for transfer. Ragged. Greatest height 35 cm., width 27 cm. [Early.]

2023 No. 6518^F—Study of man on horseback, and two draped figures seen from behind.
 Bl. ch. 39 by 28. [Clapp (*Dessins*, p. 127) is perfectly right in considering this to be a
 sketch for the background of the Adoration of the Magi in the Pitti Gallery (*Life*, fig. 33)
 and not for the Martyrdom of St. Maurice as I used to do.]

2024 No. 6519^F—Upper part of nude youth with r. arm held up. R. ch. 14 by 22. Perhaps
 for Poggio a Cajano. Verso: Drapery.

2025 FLORENCE, Uffizi, No. 6520^F—Three sketches in kindred but varying attitudes for Christ Child in the S. Michele altar-piece, but in less erect position than in the picture (p. 309, note). R. ch. 26 by 34. [Photo. Mannelli.] Verso: Cast of drapery.

2026 No. 6521^F—Anatomical study of skeleton. Bl. ch. 34 by 21. Late. Verso: Parts of skeleton.

2027 No. 6522^F—Various anatomical studies from skeleton. R. ch. 29 by 20. [Photo. Mannelli.]

2028 No. 6525^F—Nude youth with head in profile to l., holding with both hands a staff. Bl. ch. 40 by 11.5. Verso: Nude youth lightly seated, perhaps for Poggio a Cajano. R. ch. Both fairly early.

2029 No. 6526^F—Skeleton, squared for enlarging. R. and little bl. ch. 23 by 18. Verso: Parts of skeleton.

2030 No. 6527^F—Three or four legs. R. ch. 16.5 by 24. [Photo. Mannelli. For Dead Christ at S. Felicita (see Clapp, *Dessins*, p. 132).]

2031 No. 6528^F—Back of nude torso, and head and lifted arm of a nude, in bl. ch. Below,
Fig. 995 in r. ch., host of sprawling piled up figures perhaps for the Deluge, in the choir of S. Lorenzo, but probably earlier and far superior to most drawings for that work (p. 320; our reproduction shows only the lower part of the sheet). 42 by 22. [Fototeca 12949. Clapp, *Life*, fig. 146. Verso: Sketch for portrait of young Cosimo I now in the Museo Mediceo,
Fig. 985 painted in 1537 (p. 319, note).] Squared for transfer. [Fototeca 4359. Uffizi Publ., I, i, 25.]

2032 No. 6529^F—Rapid sketch of one nude reclining, and another standing by him. R. ch. 25 by 36. Verso: Two nudes seen sideways. Bl. ch. [For the Certosa fresco representing the Way to Golgotha (see Clapp, *Dessins*, p. 134).]

2033 No. 6530^F—Upper part of figure of rustic. Almost certainly intended for Poggio a Cajano, where, however, he is not to be found. R. ch. 28 by 21.5. Verso: Study for leg and drapery of shepherdess sitting on parapet in same work (p. 312). Bl. ch. and wh.

2034 No. 6531^F—Study for upper part of same shepherdess (p. 312). Bl. and wh. ch. 17 by 22.5.
Fig. 958 [Clapp, *Life*, fig. 63.]

2035 No. 6532^F—Study for Christ tied to the column. Poor and late. Bl. ch. Cut close to the outlines. 23 by 14.5. [In spite of its inferior quality it seems to me certainly by P. and not as Clapp and McComb suggest, by Bronzino.]

2036 No. 6533^F—Bust of nude youth holding child, apparently a reminiscence of Raphael's Sixtine Madonna, drawn soon after the completion of that masterpiece. R. ch. 15.5 by 15.

2037 No. 6534^F—Study of heroic female nude, reclining on her r. elbow, with book in r. hand,
Fig. 991 and with l. arm around child, who lies sucking at her breast as she looks down at him (p. 319). Bl. ch. 28 by 40.5. [Fototeca 12950.]

 This noble composition is but a variant, and I venture to believe a happier variant, upon Michelangelo's cartoon for a Venus embraced by Cupid, which P. coloured in 1531. This study must, however, have been drawn some years later, but it is still free from obvious attempts to imitate Michelangelo's over-finished style of draughtsmanship of these years.

2038 No. 6535^F—A nude, and, on smaller scale, one male nude striding along like St. Christopher, and one rather charming female nude lightly seated (p. 320). [Very Michelangelesque.] Squared for enlarging. Probably for S. Lorenzo. Bl. ch. 20.5 by 16. [Clapp, *Life*, fig. 143.]

2039 FLORENCE, UFFIZI, No. 6536F—Youth looking up with open mouth and clenched fist. Perhaps for Poggio a Cajano. R. ch. 22 by 16. [Photo. Mannelli. Voss, *Zeichn.*, p. 11.]

2040 No. 6537F—Study for cast of drapery over extended r. arm. not improbably for figure on extreme l. in the N. G. Story of Joseph. R. ch. 23.5 by 11.5.

2041 No. 6538F—Nude seated with legs crossed in profile to r. R. ch. 28.5 by 19.5. Impossible proportions and mannered. Late. Verso: `Part of skeleton, and of a nude.

2042 No. 6539F—Scrawl of boyish nude walking towards l. with head turned to r. and of cast of drapery [for headdress]. R. ch. 28 by 18.5. [Photo. Mannelli. Verso: Nude turned towards r. with arms lifted over head.]

2043 No. 6540F—Study for upper part of Dead Christ in sustained posture, probably for the Pietà at S. Felicita (p. 316). Bl. ch., on greyish green paper. 27 by 18. [Photo. Mannelli.] Verso: Lower part of nude figure, perhaps for the one in foreground of same work.

2044 No. 6541F—Nude lightly seated, with agonized face almost in profile to l., and hands joined as in prayer. R. ch. 39.5 by 25. Splendid quality, with contours almost worthy of Andrea. Probably for a saint on the r. in some altar-piece of 1520 or so.

2045 No. 6542F—Nude, with head in profile to r., lightly seated with legs drawn apart, his l. hand resting on r. knee, r. hand firmly on the settle. R. ch. 40 by 27. Verso: Youthful nude kneeling, with hands clasped in prayer. [Clapp (*Life*, figs. 7 and 28) has correctly identified the recto as being for the boy in foreground of the Annunziata Visitation (*ibid.*, fig. 5) and the verso for the Panshanger story of Joseph (*ibid.*, fig. 26).]

2046 No. 6543F—Nude seated on ground, with arm resting on bent l. knee, and another nude kneeling in profile to l. (p. 311). Of the same quality as the recto of the last, although somewhat later and probably already done in connection with Poggio. R. ch. 40 by 27. [Clapp, *Dessins*, pl. II.] Verso: Reclining figure seen from back, and two others crouching, one seen nearly front and the other sideways (p. 311). The two latter are almost certainly for the shepherd seated on the ground on the extreme l. of the Poggio a Cajano fresco.

2047 No. 6544F—Male nude reclining, study for the action of shepherdess reclining on ground
Fig. 955 on extreme r. in same fresco (pp. 302, 312). R. ch. 23.5 by 41. [Clapp, *Life*, fig. 59. Anticipates Michelangelo's later style of drawing.]

2048 No. 6545F—Rapid but delightful jotting for infant Baptist in the S. Michele altar-piece, but he is pointing down instead of up (p. 309). Bl. ch. and pen. 11.5 by 7. [Clapp, *Life*, fig. 18.]

2049 No. 6546F—Bust of Penitent Magdalen resting on her elbows with wrists crossed. R. ch. 23.5 by 18. [Fototeca 12504. Clapp, *Dessins*, pl. V.] Worthy of the Seicento [and indeed even of Goya].

2050 No. 6547F—Head. Bl. ch. 9 by 7. [Clapp (*Life*, fig. 64) connects it with Poggio a Cajano.]

2051 No. 6548F—Two swift and charming sketches in r. ch. for nude figure kneeling in profile to r., probably for the Creation of Eve (see my 2108). In bl. ch., one faint and another more elaborate sketch in imitation of one of Michelangelo's reclining figures in the New Sacristy at S. Lorenzo. R. ch., on pink prep. paper. 21.5 by 30. Verso: Two further studies for same kneeling figure, and, in bl. ch., a large demon shape, and a small female nude. Beginning of last manner.

2052 FLORENCE, Uffizi, No. 6549F—Study for leg bent at knee, and two kneeling nudes. Rather good and possibly for a Pietà. R. ch. on rough light brown paper. 26.5 by 20.

2053 No. 6551F—Child's head turned slightly to r., in bl. ch. Study of bent l. leg, and of knee in r. ch. 25 by 18. Verso: Study of drapery for young female head, excellent. R. ch. [Clapp, *Life*, figs. 16 and 17.] The child's head was for the decorative *putto* on the l. in the S. Michele altar-piece, the leg for the infant Baptist, and the female head probably for the Madonna in the same work.

2054 No. 6552F—Realistic bust of coarse, middle-aged female, kerchiefed, open-mouthed, with eyes turned up, and candle in r. hand. Bl. ch. 34.5 by 25.5. Middle years. Verso: Upper part of youngish nude female.

2055 No. 6553F—Christ on the Cross, the top of which is shaped like a triangle, against whose apex rests the Saviour's head. Copied, with slight variations, from the Crucifixion with a cross of similar shape, by Michelangelo at Windsor (my 1621, Fig. 724). Late. Bl. ch. 37 by 26. [I feel very doubtful about his sheet after seeing the original again. The old attribution to Battista Franco on the verso may hit the truth.]

2055A (former 1994) No. 6554F—Nude child pointing with r. hand, his l. hand touching knee. Study, but
Fig. 944 in reversed direction, for infant Baptist in the altar-piece at S. Michele Visdomini (p. 309). R. ch. 28.5 by 20.

2056 No. 6555F—Study from male nude, for reclining shepherdess on r. in the Poggio a Cajano fresco (pp. 302, 312). R. ch. 25 by 39. [Clapp, *Life*, fig. 60.] Similar to my 2047 (Fig. 955), but much nearer the action—is in fact, of the exact action—of the painted figure.

Both these drawings are deliberate imitations of Michelangelo's style of curvilinear draughtsmanship. Even the accent and the shorthand tricks suggest the greater master in his earlier phases, as, for instance, in the design of a warrior, perhaps for the St. Matthew (my 1399, Fig. 581). It is noteworthy, however, that, as is usual with imitators, P. in these drawings, outruns his master's style of the moment and, indeed, in some respects these two studies remind one of nothing so much as of a series of bl. ch. sketches in London, Windsor, and Lille, for the Last Judgement, done by some clever assistant of Michelangelo's at that date.

2057 No. 6556F—Study for drapery below the waist of slender female walking. Bl. ch. 33.5 by 24. [Clapp, *Life*, fig. 31.] Verso: Rapid sketch of middle distance of landscape in r. ch., and drawn over it in bl. ch. two hands and bit of drapery.

The study of drapery is almost certainly for the young woman in the Annunziata Visitation, carrying a basket on her head. One of the hands is for the old woman with the staff in her hand. Be it noted, however, that in the fresco the corresponding parts are reversed, which proves that, to begin with, P. intended having these female figures on the r., instead of on the l. The other hand may be the Virgin's or one now draped. [Clapp connects them with one of the Panshanger Joseph panels (*Life*, fig. 30). They may have served for either, both paintings being of nearly the same period.]

2058 No. 6557F—Youthful nude lying on r. side on ground, with lower leg bent at knee and
Fig. 950 upper leg folded back so that tip of toe reaches beyond head, also a slender youth lightly seated. Probably for Poggio a Cajano (pp. 309, 311). Bl. ch. 28 by 40.5. [Clapp, *Life*, fig. 54. Uffizi Publ., I, i, 9.]

No modern French draughtsman could have chosen a more audacious pose, and, what is more singular still, there is in this sheet very little that might not pass for the work of the best recent Parisian artists.

2059 FLORENCE, Uffizi, No. 6558F—Nude youth reclining on l. side. Head of youngish woman in profile to l. heavily draped, and a cast of drapery. Bl. ch. 42 by 28. Verso: Studies of a horse.

It is not improbable that all these sketches were done in connection with the Adoration of the Magi now in the Pitti, in which case they represent the first groupings rather than the final intention. The profile would thus be for the Madonna in a more traditional attitude than in the picture, the nude for the kneeling king, and the horses for those in the middle distance.

2060 No. 6559F—Study for l. arm draped above elbow, with hand shutting down on something. R. ch. 25.5 by 19. [Clapp (*Life*, fig. 70) correctly identifies the recto as being for the young man in the foreground at Poggio.] Verso: Legs. Bl. ch.

2061 No. 6560F—Youthful, rather epicene nude, reclining on l. side with arm folded over head. Bl. ch. 21 by 27.5. [Clapp, *Life*, fig. 148.] A late imitation of Michelangelo, the pose and action having been chosen with the object of getting certain plastic values out of the torso and arms.

2062 No. 6561F—Youthful nude kneeling and looking down, a delightful bit of drawing, and intended probably for youthful Baptist looking into fountain. R. ch. 22 by 16.5. [Clapp, *Life*, fig. 121. Verso: Outline of stone basin and repetition in larger proportions of sketch on recto.]

2063 (see 601A).

2064 No. 6563F—Nude in profile to l. kneeling in prayer. Bl. ch. and a little wh. 36 by 26.5. [Photo. Mannelli.] Study perhaps for a figure in a Pietà, for which we have the Dead Christ on my 2174 (Fig. 966).

2065 No. 6564F—Lad lightly seated on a stool, a very rapid but delightful early study from the model, full of colour, and of great freedom. R. ch. 34.5 by 19. [Photo. Mannelli.]

2066 No. 6565F—Sprawling dead nude, with legs and arms hanging limp from torso. Late. Bl. ch. 40 by 26.

2067 No. 6567F—Michelangelesque study of reclining male nude. Rather better than most. Late. Bl. ch. 19 by 24.

2068 No. 6568F—Three late Michelangelesque nudes, one floating up. To r., in pen, indication of a window. Doubtless for S. Lorenzo. Bl. ch. 25 by 11.5.

2069 No. 6569F—Dead nude falling backwards to l. Bl. ch. 22 by 16.5. Of same kind, and probably for same purpose (a Dead Christ) as my 2066.

2070 No. 6570F—Elegant, tall, female figure of classical inspiration, draped but revealing the nude, with r. arm held up from elbow, and l. sliding along rock against which she leans. It is in bl. ch., and partly drawn over the lower part of a female nude in r. ch. Squared with r. ch. 40.5 by 27.5. [Photo. Mannelli. Uffizi Publ., I, i, 19.] This was perhaps intended for some allegorical figure painted at about the same time that P. was doing the Louvre altar-piece. [Clapp (*Dessins*, pp. 159-60) connects it with S. Felicita Annunciation.] Verso: Male nude seen from behind, four busts, and two knees.

2071 No. 6571F—Study of bearded, thin, but heavily draped old man leaning against wall,
Fig. 935 writing on tablet which he holds to wall with l. hand. This is for the Evangelist in the early altar-piece at Pontormo (p. 308). Below studies for both hands—worthy of

Andrea—for the St. Michael in same work (p. 308). Bl. ch. but the hands in r. ch. 41 by 25. [Photo. Mannelli. Clapp, *Life*, figs. 35, 36 and 37. Uffizi Publ., I, i, 1.] Verso: Delightful study from model of youth in working clothes with head in profile to r. [Clapp, *Life*, fig. 45.]

2072 FLORENCE, Uffizi, No. 6572F—Torso seen from behind, in attitude recalling Michelangelesque studies after the Vatican torso, but with the l. arm bent back. Late. Bl. ch. on pink prep. paper. 22 by 15.5.

2073 No. 6573F—Half-length figure of elderly woman with ample cloak and kerchief, her hands
Fig. 989 resting over her waist (p. 318). Bl. ch. on grey-green paper, stained brown. 19 by 15.5. Pl. CLXXVI of F. E. [Photo. Mannelli.]

2074 No. 6574F—Male nude in profile to r. R. ch. on pink prep. paper. 21.5 by 15.5. Middle period; weak.

2075 No. 6575F—Youthful nude bending over to r., with entire weight on l. leg, looking at staff or mace which he holds with both hands. In inverse direction, a profile. R. ch. 40 by 26. [Photo. Mannelli.] Early, and admirable, possibly for Poggio a Cajano.

2076 No. 6576F —Charming male nude with drooping figure, and head bent down in profile to
Fig. 976 l.—study for pretty female in r. upper part of the Pietà at S. Felicita (p. 316). Bl. ch. 39 by 22. [Clapp, *Life*, fig. 100.] This is splendidly relaxed, supple, pliant, and in outline fluent. Verso: Male nude seen from behind but with head in profile to r. His hands are folded in prayer.

2077 No. 6577F—Male head, with wild eyes turned slightly to r., studied from life for foremost
Fig. 974 figure in the Pietà at S. Felicita (p. 316). R. ch., on pink prep. paper. 22 by 15.5. [Clapp, *Life*, fig. 95.]

2078 No. 6578F—Male head. Middle period. R. ch. 8 by 7.

2079 No. 6579F—Bust of bald-headed elderly man, study from model. R. ch. 18 by 11. [Clapp (*Life*, fig. 72) identifies it with the head of the peasant to the extreme l. at Poggio. Certainly one of the most contemporary of old master drawings.]

2080 No. 6580F—Female torso resting on hip, seen from behind. Smooth and late. Bl. ch. 20 by 19.

2081 No. 6581F—Old man's head tossed back a little to l., with expression of suffering. R. ch. 17 by 13. [Clapp, *Life*, fig. 22. Fototeca 12519. Photo. Mannelli. This head, which would seem to have been suggested by the Laocoön, occurs several times in P.'s early pictures. You may find it thrice at least in the N. G. Story of Joseph. This particular study (of fine plastic and colour effect, by the way) may have been for Joseph in the S. Michele Visdomini altar-piece. Verso: Curiously academic study for nude holding staff in l. hand. Clapp (*Life*, fig. 8) connects it with John Baptist for the Carro della Zecca. Unfortunately I have never been able to see these fragments of the Carro although they are supposed to exist.]

2082 No. 6582F—Rather slender nude, with arms held up almost as if floating upwards. Seen from behind. Late and Michelangelesque, but fair. Bl. ch. 26.5 by 17.

2083 No. 6583F—Two reclining torsos seen from behind, and one seen sideways. Late. R. ch. 20 by 27.

2084 FLORENCE, Uffizi, No. 6584F—Nude female reclining, seen sideways from behind, but with face to front, with r. hand at arm's length resting on edge of open book—study suggested by one of Michelangelo's reclining figures, and intended, perhaps, for a sibyl (p. 319, note). Bl. ch. 27 by 29.5. [Clapp (*Life*, fig. 132, and *Dessins*, p. 168) suggests that this and my 2086 (Fig. 994) may have been sketches for the frescoes in the Loggia of Castello.]

2085 No. 6585F—Male torso with head thrown back and hands behind. Late, and probably for some Dead Christ, as my 2066, 2069 [or for a Christ at the Column]. Bl. ch. 28 by 19.5.

2086 No. 6586F—Nude female of mature but majestic form reclining on pillows, with r. arm
Fig. 994 raised to head (which is in profile to l.), and l. arm stretched out with hand resting on globe (p. 319). Bl. ch. 16.5 by 15.5. Pl. clxxvii of F. E. [See my 2084. Brogi 1307. Uffizi Publ., I, i, 23A. Late. Clapp (*Life*, fig. 133) connects it with the frescoes for Castello or Careggi.]

2086A (former 1995) No. 6587F—Portrait bust of youngish man with head thrown back a little, study for head on extreme r. in the altar-piece at S. Felicita (p. 316). R. ch. 15 by 11. [Photo. Mannelli.]

2087 No. 6588F—Male nude kneeling to r., with hands held out. His head is seen almost from
Fig. 975 the back. Also head of person dead or asleep turned down to l., and head of elderly female (p. 316). Bl. ch. 38 by 26.

 These powerful studies were probably made in connection with the S. Felicita Pietà before it had taken final shape in P.'s mind. Thus the nude would be for the kneeling figure in the foreground, the face almost in profile for the Dead Christ, and the other head for one of the holy women.

2088 No. 6589F—Limp male nude, seen from behind leaning with head in r. hand on parapet. Bl. ch. 28 by 16.5. Middle period.

2089 No. 6590F—Seated nude, with legs apart and drawn up, leaning on r. elbow, his l. hand resting on staff, doubtless for one of shepherds at Poggio a Cajano, although he does not occur in the fresco (p. 311). Bl. ch., squared with r. 28 by 21.

2090 No. 6591F—Torso seen from behind. Late. Bl. ch. on pink prep. paper. 19 by 15.

2091 No. 6592F—Two nude youths in attitude of flying, probably for S. Lorenzo. 23 by 18. [According to Clapp more likely for the Loggia at Castello.]

2092 No. 6593F—Male nude seen from behind, and a head. Verso: Torso seen sideways. Bl. ch., on pink prep. paper. 22.5 by 16.5. Latish. [Clapp (*Life*, figs. 134 and 135) correctly identifies the recto as a sketch for one of the figures in the Quirinale tapestry representing Benjamin at the Court of Pharaoh.]

2093 No. 6594F—Nude youth, seen from behind but turned a little to l. and with head towards us, sits holding his leg. The back is admirably modelled. Also a torso and arm. R. ch. 39 by 26. Verso: Of same quality, a half-reclining, and a kneeling nude.

 These studies must have been done in connection with the fresco at Poggio a Cajano, although they do not occur there. They are at all events of that date, and among the best drawings of our master.

2094 No. 6595F—Nude youth sitting with knees crossed on stone settle, his head drooping, his l. arm drawn back over top of settle. R. ch. 39 by 27. Same quality and purpose as last.

2095 FLORENCE, Uffizi, No. 6596F—Nude youth seated on block, his torso seen almost sideways, with r. arm stretched out and resting on staff, his l. on a book, the head seen from behind. R. ch. 40 by 28.5. [Photo. Mannelli.] The modelling is truly splendid, and the effect of colour almost unsurpassable. This also may have been done in connection with Poggio a Cajano.

2096 No. 6597F—Nude youth lightly seated on branch, on which he leans with r. hand, while with l. he holds bowl to his mouth. R. ch. 40 by 26. [Clapp, *Life*, fig. 76.] This delightful nude is of the quality and style of the drawings for Poggio a Cajano, and probably was intended for a Baptist in the Wilderness.

2097 No. 6598F—Male nude with mad eyes, lightly seated with legs wide apart, pointing to l. Probably for Poggio a Cajano. R. ch. 40.5 by 27.5.

2098 No. 6599F—Nude squatting on ground, with r. leg bent at knee and raised, the l. folded
Fig. 952 back on ground, l. hand resting on ground, r. shading eyes (p. 311). R. ch. More rapid sketch of same in bl. ch. 39 by 28. Both these are variations upon my 2020 (Fig. 953), and like that were intended for Poggio a Cajano, probably for the shepherd on the ground to the l. Verso: Rough scrawl of torso. Bl. ch.

2099 No. 6600F—Nude youth of fabulous length seen from behind, with back of l. hand resting on table, and r. hand held out. R. ch. 43 by 20. Latish.

2100 No. 6601F—Nude youth seated sideways to r. with l. hand held out, a study for the same composition for a St. John that we find in my 1978. Another seated youth. Both drawn in bl. ch. over various scrawls in r. ch. 39 by 27. Verso: Two nudes seen sideways seated on their heels. All fairly early.

2101 No. 6602F—Highly finished design for a composition. Five Michelangelesque and at once
Fig. 990 antique nudes stand by a fire. One takes something out of a bag held by another as if to draw lots, while in his r. hand he holds a book. Several gesticulating figures in background (p. 319). Bl. ch. and bistre wash. 29 by 31. [Clapp, *Dessins*, pl. VII.
 It is for iconographers to say what this may mean. As a composition it is beautiful, and exhales delightful suggestions. The date may be about 1535 or later. [A comparison with Pollajuolo's nudes helps us to measure the distance travelled by the art of the Renaissance in about 70 years.]

2102 No. 6603F—Youthful nude seated sideways to r., and vaguer nude. R. ch. 40 by 25. Verso:
Fig. 936 Youthful nude of most charming quality standing sideways, showing most of back. His hands rest on parapet. [As Clapp (*Life*, fig. 6) points out, the sketch on the recto is for a woman seated on the steps to l. in the Annunziata Visitation. A most interesting somewhat Raphaelesque version of it used to be in the Geiger Collection (*Geiger Handz.*, pl. 13).]

2103 No. 6604F—Nude figure sitting on block pressing it down with l. hand while pointing to
Fig. 946 r., although facing to l. (p. 310). Bl. ch. and a little wh. 40.5 by 26. [Photo. Mannelli.]
 The attitude recalls Michelangelo's decorative nudes on the Sixtine Ceiling. The quality is excellent. Perhaps it is P.'s best sketch in bl. ch. [As it is more mannered than the sketches that can positively be connected with the Poggio a Cajano fresco, it may have been intended for the lunette that was not executed.]
 Verso: Female nude seen from behind.

2104 No. 6605F—Reclining nude seen from behind. Bl. ch. 23 by 29. Late.

2105 No. 6606F—Fat male nude seen from behind with r. arm curved around head, and l. doubled up from elbow. Bl. ch. 28 by 21. [Uffizi, Publ., I, i, 24.] Michelangelesque in motive, and late.

2106 FLORENCE, UFFIZI, No. 6607F—Nude of bad proportions seen sideways. Bl. ch. 41.5 by 26. Late.

2107 No. 6608F—Nude supporting another. The latter recalls my 2066 and 2069, and this drawing must have served same purpose as those. Bl. ch. 41 by 26.

2108 No. 6609F—Christ seated with hands held out in midst of various nudes, all caricatures of Michelangelo. Below the Christ an old man, representing the Eternal, is calling to life Eve from under the sleeping Adam (p. 321). Bl. ch. 32.5 by 18. [Brogi 1308. Gold-schmidt, pl. 4. Clapp, *Life*, fig. 138.] Certainly for S. Lorenzo. There is a touch of Blake in all this.

2109 No. 6610F—Nude youth seen [as if climbing down from rock] with l. leg stretched out and r. foreshortened, r. arm falling to side and l. stretched out. Bl. ch. 26 by 34. [Photo. Mannelli. According to Clapp (*Dessins*, p. 184) about 1520.]

2110 No. 6611F—Study for Dead Christ (p. 315). Bl. ch. 27 by 36. [Fototeca 4172.]
 Fig. 969 At first sight it might seem as if P. while drawing this interesting sketch had in mind the famous Warwick design for a Pietà (now in the B. M., my 2486, Fig. 753) ascribed to Michelangelo, or indeed that master's original jotting for this design. The purpose of the action in the two figures is almost identical, although P. betrays that he does not quite understand what he is doing. If he had, perhaps he would not have drawn back the l. leg. This is so uncalled for that I cannot help thinking that what he really had in mind was not the Warwick Pietà or its predecessors, but the attitude and action of Michel-angelo's—singular adaptation!—Leda.
 [Verso: Small sketch of male nude in same attitude as on recto, one for head and arms and another for legs and abdomen of male torso.]

2111 No. 6612F—Nude youth leaning on crutch which he holds under his l. elbow. A delightful early study for Poggio a Cajano perhaps, or indeed for a St. Christopher [of the same period]. R. ch. 28 by 16.5.

2112 No. 6613F—Admirable study for draped figure seated on ground with legs wide apart, the r. hand with scroll in it resting on parapet, l. held up as if reciting. He looks to l. with an inspired expression (p. 311). The attitude recalls my 2089, and like that, this sketch may have been done for Poggio a Cajano [but for the lunette that was never executed]. R. ch. 31 by 27. [Photo. Mannelli. Uffizi Publ., I, i, 10.] Verso: Nudes and legs, slight. [Clapp (*Life*, fig. 98) wants to connect these with S. Felicita but they seem to me earlier.]

2113 No. 6614F—Head of youth looking down a little to l. R. ch. 34 by 24.5. Loose. [Photo. Mannelli. Verso: Study for Dead Christ (p. 313, note), probably for the Certosa Pietà and done under Dürer's influence (see Clapp, *Dessins*, p. 187).]

2114 No. 6615F—A bald-headed nude leaning with both hands on a staff. Also a hand. Bl. ch. 29 by 21. Late Michelangelesque studies probably [for the Adam labouring the earth (see Clapp, *Dessins*, pp. 187, 188).] Verso: Various sketches for arms, shoulder, and hips.

2115 No. 6616F—Nude idiot boy. A head. Small and spirited sketch of a rape. R. ch. 29 by 19.5. Verso: Nude boy seen sideways.

2116 No. 6618F—Studies of leg and a nude, seen from behind. R. ch. 36 by 22. [Photo. Mannelli.] Rather early. Verso: Two studies of drapery of figure seen from back.

2117 No. 6619F—Study for Dead Christ in the Pietà at S. Felicita (p. 316). Mannered, although
 Fig. 972 not without qualities. R. ch. 35 by 28. [Uffizi Publ., I, i, 15. Clapp, *Life*, fig. 99.]

2118 FLORENCE, Uffizi, No. 6620F —Slender female nude seen from behind. R. ch. 29 by 20.

2119 No. 6622F —Rapid sketch for Pietà consisting of some nine figures. Suggested by Andrea's
Fig. 971 Pietà now in the Pitti Gallery (p. 315). R. ch. 12.5 by 10. Excellent. [Clapp (*Life*,
fig. 83) connects it with a Deposition planned but not executed for the Certosa.]

2120 No. 6623F —Late Michelangelesque nude in attitude of frog jumping backwards. Bl. ch.
16 by 19.5.

2121 No. 6625F —Charming small sketch for St. Christopher. R. ch. 10 by 6. A much larger
study for the same exists in the Corsini Gallery at Rome (see my 2366B).

2122 No. 6627F —Two charming female heads, one elder and more serious, the other more win-
Fig. 973 ning. For the holy women seen over the Virgin's r. arm in the Pietà at S. Felicita (p. 316).
R. ch. on pink prep. paper. 20 by 14. [Clapp, *Life*, fig. 94.]

2123 . . . No. 6630F —Pretty, effeminate nude youth reclining on l. arm, his r. held up. R. ch. 20 by 29.
[Uffizi Publ., I, i, 22. Late. Clapp thinks it may have been a sketch for Castello (*Des-
sins*, p. 194).]

2124 No. 6631F —Nude youth running. R. ch., but r. leg in bl. ch. 19 by 19. Late.

2125 No. 6632F —Youth, simply dressed, reclining on r. arm, his l. held up. He looks to r. In
bl. ch., faint scrawl [hard to decipher] of squatting figure, probably for shepherd on extreme
l. at Poggio a Cajano (p. 311). [See Clapp, *Dessins*, p. 195.] R. ch. 40 by 28.5. [Photo.
Mannelli. Uffizi Publ., I, i, 11.] Verso: Youth stretched out asleep on a parapet. Both
were probably drawn in connection with Poggio a Cajano.

2126 No. 6634F —Lower part of torso violently bent back. Bl. ch. 19.5 by 17. Late.

2127 No. 6635F —Male nude, chiefly torso, free and powerful. Seated, smaller nude. Bl. ch.
on pink prep. paper. 37.5 by 16. [Photo. Mannelli.] Rather early.

2128 No. 6636F —Studies of shoulders. Bl. ch. on pink prep. paper. 18 by 15.

2129 No. 6637F —Headless, youthful nude running. R. ch. 27 by 20.

2130 No. 6638F —Torso of reclining male nude, sketchy but strong. Bl. ch. 9.5 by 26.5. Verso:
Two nudes in outline. R. ch.

2131 (see 601C)

2132 No. 6640F —Nude male torso [perhaps for S. Lorenzo]. R. ch. on pink prep. paper. 20.5. by 15.
Verso: Younger nude seen sideways.

2133 No. 6641F —Reclining nude seen from behind, and a knee. Bl. ch. 26 by 16. Late.

2134 No. 6642F —Youthful female head, winning and pretty, on a torso barely indicated. More
vaguely, a larger head. Bl. ch. on pink prep. paper. 20.5 by 5.5. [Possibly for the Virgin
in the S. Felicita Deposition and at all events of that period.]

2135 No. 6643F —Two studies of legs, one in inverse direction to other. Bl. ch., on pink prep.
paper. R. ch. 22 by 15. Verso: Rapid sketch of stooping nude (p. 313, note). [Clapp
(*Dessins*, p. 201) has identified the verso as being for the man who helps Christ to bear
the cross in the Certosa fresco representing the Way to Calvary.]

2136 No. 6644F —Boy seen from below, holding with both hands a scroll above his head. Study
probably for some ceiling decoration. Part of torso seen from back. And in bl. ch. a

narrow spandrel with pretty female figure therein. R. ch. on pink prep. paper. 28 by 21. The date can scarcely be later than 1525. [According to Clapp (*Dessins*, p. 201) later and possibly for Castello.]

2137 FLORENCE, Uffizi, No. 6645F—Nude youth drinking out of bowl. R. ch. 22 by 15. [Clapp, *Dessins*, pl. I.] Hastier version of my 2096, and like that for a youthful Baptist.

2138 No. 6646F—Study for nude boy, meant to stride exultingly on parapet to r. of window at Poggio a Cajano, but not executed in precisely this way (pp. 309, 312). Bl. and wh. ch. 24 by 16. [Clapp, *Life*, fig. 65.] This *putto* differs but little in pose from the one in my 2017B (Fig. 960) and is even more spirited.

2139 No. 6647F—Torso of youth in profile to r., with hand held up to chin. Perhaps for one of the Evangelists in the Capponi Chapel at S. Felicita. Bl. ch. and pen. 19 by 25. Verso: Female head, possibly for the Madonna in the Pietà at S. Felicita.

Done in the most extraordinary technique with bistre on a ground rubbed with bl. ch., resulting in a freedom and force that are not easily surpassed in Renaissance draughts-manship. Indeed we are reminded of the Japanese and certain recent French men. [Clapp (*Life*, fig. 91, and *Dessins*, pp. 203-4) has another interpretation for what it served for.]

2140 No. 6648F—Headless seated figure, with clasped hands, draped (pp. 313-314). Bl. ch.
Fig. 961 25 by 17.5. [Fototeca 4148.] The folds are of purely Northern character, and here we have witness to P.'s attempt at adopting not only the ideas but the manner of Dürer. Doubtless for some figure in the Certosa frescoes. [Verso: Slight sketch of figure running and perspective outline of two gates; in r. upper corner sketch of gate reminding us of the one in the Certosa fresco representing Christ in the garden (p. 313, note).]

2141 No. 6649F—Nude pretty youth sitting sideways. R. ch. 52 by 17. Verso: Vaguer study of nude seated facing us. Fototeca 9859, 9858. [Soon after S. Felicita.]

2142 No. 6650F—Reclining nude seen sideways, but with head facing, in attitude resembling some of lower figures in Michelangelo's Last Judgement. Another head touched up with pen. Bl. ch. 21 by 26.5.

2143 No. 6651F—Dashing study of boy straddling parapet while pulling up something with l.
Fig. 954 hand (p. 312). Bl. ch., squared with r. 27 by 18. [Photo. Mannelli. Popham Cat., No. 229. Clapp, *Life*, fig. 69.] This motive betrays, what otherwise we might not have suspected, that the idea of these *putti* for Poggio a Cajano came to P. from Michelangelo's nude lads in the Sixtine Ceiling.

2144 No. 6652F—Nude youth with head in profile to r. stands looking at object in r. hand. R. ch. 31 by 19. Very powerful contours, as if undercut in bronze, yet of marvellous effect as colour. [Perhaps done after Michelangelo's *bozzetto* for the David of c. 1517.] Verso: More rapid and probably later study of wild-looking youth fluttering behind him a drapery which he holds with both hands close to his head. [Clapp, *Dessins*, pl. IV.]

2145 No. 6653F—Sketch for angel in fresco of the Annunciation at S. Felicita. Bl. ch. and wash, on pink prep. paper. Squared for enlarging. 39 by 22. [Photo. Mannelli. Clapp, *Life*, fig. 87. Voss, *Zeichn.*, p. 171 and pl. 5.]

2146 No. 6654F—Torso turned to l. with arm hiding face. Bl. ch. 14.5 by 9. Late.

2147 No. 6656F—Male nude seated sideways seen from behind (p. 313, note). R. ch. 29 by 21. [Verso: Friar standing and facing front with both arms hanging down (p. 313, note). Clapp (*Life*, figs. 82, 84, and *Dessins*, p. 209) has proved that both these sketches are for the Supper at Emmaus.]

2148 FLORENCE, Uffizi, No. 6657^F—Nude in profile, but head turned away. He has a sword in his r. hand, and his l. arm is held out. R. ch. 33 by 21. [Clapp (*Dessins*, p. 210) has connected this with the Nailing on the Cross, planned for the Certosa.]

2149 No. 6658^F—Two seated Nudes, each with his head in his hand looking up as if in reverie. R. ch. 18 by 25.

2150 No. 6659^F—Torso and arm of figure looking down to l. R. ch. 22 by 15. Verso: Nude figure [in violent *contrapposto*].

2151 No. 6660^F—Rapid but masterly sketch of male nude leaning backward, with r. arm held up
 Fig. 942 and half hiding face. Partly drawn over this, an equally telling sketch of a nude seen more from the front. Also scrawl of a shoulder, and of a child. All for Poggio a Cajano (pp. 306, 310). Bl. ch. 44 by 27.5. Verso: Mapping out of the lunette at Poggio a Cajano
 Fig. 939 (pp. 306, 310). Youthful figures, for which the two on the front were sketches, lean against the top of the round window holding ensigns. Between them a panoply. Near the window below, vague indication of a figure on either side. Then outside this scheme, rapid sketch of the two *putti* back to back, and more firm, indeed very decisive study of two *putti* clinging sturdily one to the other, and standing on a pedestal. Both these groups of *putti* are imitations of those Michelangelo placed on the pedestals in his Sixtine frescoes. The mapping out in bl., the figures in r. ch. [Clapp, *Life*, fig. 53. Fototeca 4364 (detail).]

2152 No. 6661^F—*Putto* striding laurel bush, earlier and more spirited version of my 2017^A, and like that done in connection with the frescoes at Poggio a Cajano. Squared. Bl. ch. with a touch of wh. 22 by 15.5. [Clapp, *Life*, fig. 66.]

2153 No. 6662^F—Masterly, vigorous sketch for the child angel on our r. in the S. Michele altar-piece. Repetition of part of same figure. Charcoal and a little wh. on brown paper. 40.5 by 26.5. [Clapp, *Life*, fig. 21.] Verso: Seated male nude, with r. hand pressing down on bench, and l. held out. Child's head. [Done perhaps for same work before it took final shape. Clapp, *op. cit.*, fig. 62.]

2154 No. 6664^F—Nude St. Jerome kneeling in penitence. Poorer version of my 1968. R. ch. Cut around the outlines. 24 by 15.

2155 No. 6665^F—Study in bl. ch. and wash for disproportionately long figure of Christ in attitude of being nailed to cross. Also in reverse direction a more youthful head with r. arm stretched up, no doubt for same purpose. The bust and r. arm are drawn in r. ch. roughly, and the head alone more elaborately, and from the model. 24 by 38.5. [Photo. Mannelli. Clapp, *Life*, fig. 86.] This sketch certainly served for the fine composition representing the Nailing to the Cross for which my 2159^A gives us the design.

2156 No. 6666^F—Nude bust of youth with long face and staring round eyes. Verso: Drapery for torso with l. arm akimbo. R. ch. 16.5 by 14.5. [See Clapp, *Life*, fig. 93, and *Dessins*, p. 217.]

2156^A (former 1996) No. 6667^F—Study for portrait of boy seen from side but turning face towards us.
 Fig. 982 Smaller sketch for the action of head, very graceful and flowerlike (p. 318). R. ch. 29.5 by 27. [Clapp (*Life*, fig. 102) dates it 1525-30. Verso: Studies for nude and for cast of drapery.]

2157 No. 6668^F—Head of man of thirty or more, with short beard, and worn, expressive face in profile to l. (p. 318). R. ch. on pink prep. paper. 19.5 by 15. Verso: More summary profile to l. of youngish man (p. 318). Both these profiles have an almost Holbeinesque precision.

2158 FLORENCE, Uffizi, No. 6669F—Four *putti* in various attitudes, two of them only partly visible. R. ch. 38 by 40. [Popham Cat., No. 228. Clapp, *Life,* fig. 67.] Verso: *Putto* seated on ground, with r. hand on it and l. leg stretched out. [Clapp, *Life,* fig. 68.]

These sketches may have served for the charming *putto* in the foreground of P.'s Annunziata fresco. They were all done probably from the model which was rapidly sketched in various attitudes more and more approaching the one in the painting. The quality of the drawing, so singularly angular and yet so fluent, has never been surpassed by our artist. [Clapp (see *Dessins,* p. 219) connects them with the drawings for Poggio with which indeed they have more in common. It is interesting to note that the attitudes remain nearer to Andrea while the technique has already left him behind.]

2159 No. 6670F—Fine study of sleeping figure and of head of same, for Dead Christ (p. 315),
Fig. 968 for which my 2174, 2175 verso, 2175A (Figs. 966, 967) also served. R. ch. 27 by 40. [Fototeca 12667. Sinibaldi, *L'Arte,* 1925, p. 157, fig. 9.] Verso: More rapid study of same figure.

2159A (former 1997) No. 6671F—Arched composition for fresco, the lower r. corner of which overhangs door. It represents, in many small figures, Christ being nailed to the cross, and is interesting as an arrangement, full of freakishness and originality (p. 313, note). It is squared for enlarging [and was planned for the Certosa but never executed]. Bl. ch. 17 by 16.5. [Clapp, *Life,* fig. 85, and *Dessins,* pp. 222-223. See in connection with it my 1972A, 2148, 2159, 2171, 2174, 2175A, 2177 (Figs. 968, 966, 967).]

2159B (former 1998) No. 6672F—Numerous small nudes for composition representing the Rape of the Sabines. Very close to Andrea, and quite early. R. ch. 18 by 28.5. Fototeca 4366. It seems to me now (1934) nearer to Michelangelo, particularly the two straggling groups to our r.

2159C (former 1999) No. 6673F—Study for reclining shepherdess, the one next to the window on our r. in
Fig. 957 the lunette at Poggio a Cajano (pp. 309, 312). Bl. ch. 25 by 34.5. [Photo. Mannelli. Clapp, *Life,* fig. 55. Marie Stscherbatscheva in *Belvedere,* 1934/36, fig. 200.] Verso:
Fig. 956 Study for reclining shepherdess to r. of the one for which the last is study (p. 312). Both are free and powerful as draughtsmanship. [This one seems a more elaborated version of my 2020 verso (Fig. 953). Fototeca 4367. Clapp, *op. cit.,* fig. 58.]

2159D (former 2000) No. 6674F—Half-length figure of curly-headed youthful nude leaning on r. elbow and looking out a little to l. Perhaps study for one of the Evangelists in the Capponi Chapel at S. Felicita. Bl. ch. 20 by 16.5. [Photo. Mannelli.]

2160 No. 6675F—Old sibyl pointing out to a knight a youthful cavalier on horseback (p. 315).
Fig. 965 Bl. rubbed with wh. ch. and squared for enlarging. 28.5 by 28.5.

The rider occurs in the Martyrdom of St. Maurice, and the entire sketch may have been made while P. was preparing for enlarging that picture. The study is of remarkable pictorial effect, energetic and yet graceful [giving us a slight foretaste of Greco.] Bl. and wh. have seldom been used to greater profit.

2161 No. 6676F—Elderly nude seated, looking to r., with r. leg drawn back, holding staff in r. hand. R. ch. 40 by 26. [Photo. Mannelli.] Verso: Slender nude lightly seated, and two rapid sketches of old man's head. [Clapp, *Life,* fig. 4.] The purpose of this sheet is unknown to me. Early.

2162 No. 6677F—Nude kneeling to l. in attitude of prayer, holding staff in closed r. hand, his l. drawn back and below the same model reclining. R. ch. 40.5 by 27. [Photo. Mannelli. Very likely as Clapp suggests (*Dessins,* p. 227) for an Adoration of the

Shepherds.] Verso: Three youthful nudes reclining, one of them pointing with his l. hand. Excellent. [Fototeca 10594. Clapp, *Life,* fig. 78. Several years later than the recto, the principal figure distinctly "Michelangelo-Raphaelesque."]

2163 FLORENCE, Uffizi, No. 6678F —Study of *putto* seated, with r. hand pressing on bench, and l. lifted up. R. ch. 28 by 20. [Photo. Mannelli.] Verso: Boy half kneeling and pointing. Reminiscent of Andrea's studies (my 131, Fig. 891) for the Madonna and Angels now in the Wallace Collection. Probably for a young Baptist. [Fototeca 8492.] This and the *putto* must have served for some such picture as the small altar-piece in the Uffizi still ascribed to Rosso.

2164 No. 6679F —Nude youth reclining, with r. arm over head, out of which his eyes look at us aghast. Late and Michelangelesque. Bl. ch. 28 by 17. [Clapp, *Life,* fig. 149.]

2165 No. 6680F —Bust of middle-aged lady wearing widow's headdress (p. 317). Bl. ch.
Fig. 979 20 by 12.5. Simple, straightforward, direct, and dignified. From later middle period. [Conceivably for the portrait of Maria Salviati at the Uffizi, where she is considerably "stylized."]

2166 No. 6681F —Pretty but somewhat over-elaborated head of young woman, leaning a little to l., wearing kerchief (p. 314, note). R. ch. 15 by 11.5. Perhaps for the Madonna in the Louvre altar-piece.

2167 No. 6682F —Heavily draped, melancholy youth, seated against table with head in his hand, lost in reverie. R. ch. on pink prep. paper. 20 by 16. [Clapp, *Life,* fig. 49.] An absurdly Wertherish or even Byronic young man, most charmingly drawn. [Verso: Lower part of male nude reclining on r. side. Bl. ch. See Giglioli in *Dedalo,* VII (1926/27), pp. 781-83.]

2168 No. 6683F —Reclining nude. Bl. ch. 20 by 32. [Fototeca 4173.] Late, although not of the latest.

2169 No. 6684F —Demon pulling at arm of torso. Bl. ch. 20 by 25.5. Doubtless for S. Lorenzo. Verso: Nude in attitude of Michelangelo's Day, but absurdly exaggerated. [Brogi 1311.]

2170 No. 6685F —Nude seated on his heels with legs drawn up, shading himself with r. hand.
Fig. 951 Yet another study for the seated shepherd on the extreme l. in the Poggio a Cajano fresco (p. 311). Bl. ch. 40 by 25.5. [Uffizi Publ., I, i, 8. Clapp, *Life,* fig. 71.] Verso: Two more scratchy studies for same. Bl. and wh. ch.

2171 No. 6686F —Nude figure seated on ground with r. hand held out eloquently and legs stretched out. Bl. ch. Clipped. 28 by 33.5. Probably a study for a Christ about to be nailed to the cross, and for the composition for which my 2159A is the design. [Of poor quality but not, as Clapp thinks, too poor to be by P.]

2172 No. 6687F —Bust of nude man. Date of S. Felicita Pietà. R. ch. on pink prep. paper. 15.5 by 9.5.

2173 No. 6688F —Upper part of youthful nude looking to r., study perhaps for young Baptist in an altar-piece. Verso: Similar study. R. ch. 13 by 12. Early.

2174 No. 6689F —Several excellent studies of various stages and degrees of elaboration for a
Fig. 966 Dead Christ, two very small ones being in bl. ch. (pp. 309, 315). R. ch. 28 by 40.5. [Photo. Mannelli.] They all would seem to have been done, like my 2159, 2175 verso, and 2175A (Figs. 967, 968) in preparation for a Pietà. Verso: Kneeling nude looking at us as if craving sympathy, another nude more bent, an arm and a leg. Doubtless for same work. [See *L'Arte,* 1925, p. 157, fig. 10, where Giulia Sinibaldi points out the great

likeness between this and the other studies (see my 2159, 2159A, 2175, 2175A, 2177; Figs. 968, 967) and the Dublin Pietà. I cannot help doubting whether so important a set of studies would have been prepared for a small predella panel. Perhaps another larger composition of the same type did exist and is lost to us.]

2175 FLORENCE, UFFIZI, No. 6690F—Study from male model of nude in profile to l., bending over, staff in hand, with r. foot lifted, and touching a platform. Done perhaps [for an Adoration of the Shepherds. Cf. my 2162.] R. ch. 40 by 25.5. [Clapp, *Life,* fig. 29. Verso: Study of Dead Christ (p. 315), for the composition sketched in my 1962, 2159 and 2175A (Figs. 970, 968, 967). Clapp, *op. cit.,* fig. 9. Sinibaldi, *L'Arte,* 1925, p. 157, fig. 8. Fototeca 1267.]

2175A (former 2001) No. 6691F—Study from model of sleeping male nude propped up with pillows, r. arm
Fig. 967 extended, and l. falling on lap. Also two smaller sketches for figure in somewhat similar position, but closer to Michelangelo's reclining figures on the Medici Tombs (p. 315). R. ch. 26.5 by 41.5. [Photo. Mannelli. Sinibaldi, *L'Arte,* 1925, p. 157, fig. 11. Alinari 239.] Obviously this sketch was for a Dead Christ, and probably for the work for which we have other sketches here, for instance my 2174 (Fig. 966). Verso: Male nude walking forward with head tossed back and r. arm held out. Singularly close to Andrea, although of course more perfunctory.

2176 . . . No. 6692F—Youth loosely draped but with legs bare, looks down, r. arm akimbo, l. held out. R. ch. 41 by 25. Verso: Young man in long mantle turning towards us. This sheet, like to some degree my 2175 and to a greater degree the following number show P. in a phase where it is easy to confound him as a draughtsman with his brilliant follower Naldini. [Clapp (*Life,* figs. 25 and 32, and *Dessins,* p. 239) connects them with the Panshanger Joseph series.]

2177 . . . No. 6693F—Kneeling nude looking toward us, evidently for same figure as in my 2174 verso. R. ch. 40 by 26. [Fototeca 12670. Photo. Mannelli. Sinibaldi, *L'Arte,* 1925, p. 158.] Verso: Kneeling youth for same purpose in r. ch.; and in bl., bust of young Baptist. Both the nudes must have been drawn in connection with the Pietà sketched in my 2174, 2175 and 2175A (Figs. 966, 967).

2178 . . . No. 6694F—Upper part of rapidly sketched draped female figure. R. ch. Clipped. 21 by 22. [Clapp, *Life,* fig. 12.] Inscribed in eighteenth century hand "S. Cecilia che è a Fiesole." It must therefore be the sketch for the fresco mentioned by both Vasari and Borghini. See also my 2336F.

2179 . . . No. 6695F—Bust of nude youth with head turned to r., and l. arm akimbo. Bl. ch. on brown ground. 19 by 27. Verso: Peacock. R. ch. Late.

2180 . . . No. 6696F—Upper part of figure wearing cowl and mask of the Misericordia, holding scroll with l. hand. Bl. ch. 17.5 by 14.

2181 . . . No. 6697F—Various slight sketches in r. ch., as of a reclining nude, a fleet of ships, etc., over which is drawn in bl. ch. a nude figure seen from behind. Bl. ch. 41 by 28. Verso: Scrawl for a Holy Family.

2181A (former 2002) No. 6698F—Sketch for portrait of man in artisan's clothes sitting with l. arm on table, and r. hand resting on his knees. Also a separate sketch for a l. hand holding a bit of folded paper (p. 317). Bl. ch. 38.5 by 25.5. Pl. CLXXIV of F. E. [Popham Cat., No. 233. Uffizi Publ., I, i, 18.] Distinguished, yet without stiffness. From P.'s middle years.

2182 . . . No. 6699F—Three flying *putti.* Verso: Two more. Pen. 28 by 39. [Photo. Mannelli.]

2183 FLORENCE, Uffizi, No. 6700F —Elaborate study of skeleton walking forward to l. Bl. ch. 42 by 28. [Fototeca 4371.] Late.

2184 No. 6701F —Portrait of charming youth seen down to knees, dressed in the military
Fig. 986 costume of the time, leaning on his lance, which he holds in r. hand, while his l. rests on his hip (p. 318). R. ch. 21 by 17. [Venturi, IX, v, fig. 103.] Verso: Youthful nude seen from behind.

 [Since the publication of my first edition the portrait has turned up for which the recto of this sheet is a study. See Giglioli in *Dedalo*, VII (1926/27), pp. 789-790. It is interesting to compare the drawing with the finished work, which has been dosed with no little modish elegance.]

2185 No 6702F —Study of seated *putto*. R. ch. 29 by 19. [Uffizi Publ., I, i, 12.] Verso: Scrawl for a Pietà. R. and bl. ch.

2186 No. 6703F —Long, gawky, melancholy youth, study perhaps for Baptist. R. ch. 41 by 24. Dating from P.'s earlier middle period, and delightful in colour.

2187 (see 601D)

2188 No. 6705F —Nude child asleep. R. ch. Torn. 16.5 by 20. Pretty.

2189 No. 6706F —Nude boy reclining. R. ch. Torn. 15 by 18.

2190 No. 6707F —Reclining youthful nude seen from behind. Bl. ch. on green paper. 22 by 19.

2191 No. 6708F —Male nude staggering backwards. Bl. ch. on green paper. 20 by 25.5. [Of S. Felicita period.]

2192 No. 6709F —Skeleton seen from behind, striding forward to l. Bl. ch. 43 by 29. [Fototeca 4372.]

2193 No. 6710F —Skeleton staggering along. Bl. ch. 41 by 28.

2194 No. 6711F —Skeleton in profile to l., taking huge strides forward. Bl. ch. 43 by 28.5.

2195 No. 6712F —Study of flayed male nude. R. ch. Good. Verso: The same. Bl. ch. 28.5 by 20.

2196 No. 6713F —Studies for anatomy of leg. Verso: Anatomy of r. leg. R. ch. 29 by 22.

2197 No. 6714F —Reclining nude, a gross exaggeration of Michelangelo. Bl. ch. 21.5 by 30.5. [Fototeca 4175. Verso: Human skeleton.]

2198 No. 6715F —Youthful female nude for Eve in an Expulsion from Paradise, probably for
Fig. 997 S. Lorenzo (p. 320). Bl. ch. 29 by 21. [Clapp, *Life*, fig. 137.] Late and Michelangelesque, but yet pleasant, and even fine.

2199 No. 6716F —Five flayed torsos. Bl. and r. ch. 28 by 43.

2200 No. 6717F —Head. Bl. ch. 11 by 7.

2201 No. 6718F —Remarkable study, having certain qualities of imagination and breadth which recall some of the finest Japanese draughtsmen, of the bust of a man with his face turned up, reduced to a degree of emaciation which approaches the skeleton. Bl. ch. 35 by 23. [Clapp, *Life*, fig. 117.]

2202 No. 6719F —Portrait bust of youngish man. R. ch. 12 by 7. Fairly early.

2203 FLORENCE, Uffizi, No. 6720F —Male nude, seen from behind, bending to l., perhaps back view of uppermost figure in the Pietà at S. Felicita. Outline in bl. ch., but shading in bistre and wash. 39 by 16.

2204 No. 6721F —Male nude seen in profile to l. R. ch. Clipped. 39 by 14. Early and excellent.

2205 No. 6722F —Fine study for youthful horseman with l. arm akimbo, and part of same
Fig. 964 horse (p. 315). Bl. ch. 41 by 22. [Uffizi Publ., I, i, 6. Clapp, *Life,* fig. 34.] Verso: Large sketch for same, but with horse turned more to l. Both were done in connection with the Martyrdom of S. Maurizio [and as Grecolike as my 2160 (Fig. 965).]

2206 No. 6723F —Youthful nude, kneeling on r. knee, holding out l. hand, and looking up in ecstasy. Bl. ch. 40.5 by 26. [Clapp, *Life,* fig. 113.] Good and fairly early. [Verso: Female figure seated with hands folded in lap, wearing kerchief. See Giglioli in *Dedalo,* VII (1926/27), p. 779.]

2207 No. 6724F —Various fragments of nudes, and three or four smaller reclining ones. Bl. ch. 23 by 33. Late and smooth, but not unpleasant.

2208 No. 6725F —Male nude, seated in profile to r. R. ch. 25 by 21. Mannered.

2209 No. 6726F —Youngish nude, seated to r. but bending down with r. arm across his legs, and l. hand on staff. Below, in charming outline, upper part of boyish nude with bowl in hand, study, perhaps for St. John, that we have already encountered more than once. R. ch. over sp. 41 by 29. Verso: Various scrawls of nudes. This is a sheet dating from the period when P. was at work at Poggio a Cajano.

2210 No. 6727F —Nude boy seated, with torso thrown back and legs wide apart, points with r.
Fig. 947 hand (p. 310). R. ch. 41 by 26.5. [Photo. Mannelli. Clapp, *Dessins,* pl. III.] This would seem to have been drawn in connection with the frescoes at Poggio a Cajano, and is of admirable quality.

2211 No. 6728F —Effective scrawl for young woman with two children on her lap, a sketch for a Charity perhaps. Bl. ch. 32.5 by 27.5. Rather early. [Verso: Study for leg dangling from wall and for child's head. For Poggio a Cajano.]

2211A (former 2003) No. 6729F —Half-length figure for Madonna holding the Child. Squared for enlarging and probably executed. Bl. ch. 25 by 19. [Clapp, *Life,* fig. 24. Fototeca 7685. Photo. Mannelli.] The painting must have resembled such a picture as the small altar-piece in the Uffizi (No. 1538) still ascribed to Rosso (Venturi, IX, v, fig. 67). Verso: Two spectral heads, one in bl. and one in r. ch. [See *Belvedere,* 1934/36, pp. 179-184, where Marie Stscherbatscheva publishes and reproduces (fig. 196) a newly discovered Madonna by Pontormo for which the sketch on the recto of our sheet (rep. *ibid.* as fig. 197) was made. Another drawing there reproduced (as fig. 199) as for the Child in this composition seems to me more likely by Naldini than by P.

2212 No. 6730F —Studies for clothing of upper and lower parts of male figure. R. ch. 33 by 12.5. [Clapp (*Life,* fig. 97) connects it with S. Felicita.]

2213 No. 6731F —Study for drapery of lower part of shepherdess sitting on parapet in the fresco
Fig. 959 at Poggio a Cajano (p. 312). Bl. ch. 40 by 27. [Clapp, *Life,* fig. 61.]

2214 No. 6732F —Study for mantle of figure kneeling, turned to r. Doubtless for a saint in an altar-piece. R. ch. on pink prep. paper. 25 by 19. Early [and a little tight.]

2215 No. 6733F —Male nude with head reclining on his crossed wrists. Bl. ch. 22 by 29. [For S. Lorenzo. See Clapp, *Dessins,* p. 265.]

2216 FLORENCE, Uffizi, No. 6734F —Reclining nude with arms held up. R. ch. 21 by 28.

2217 No. 6735F —Upper part of male nude seen in profile. Bl. and wh. ch. on pink prep. paper. 22 by 18.5. Verso: Mannered female nude. R. ch. on same.

2218 No. 6736F —Female nude bending in profile to l. Bl. ch. 23 by 17. Pleasant.

2219 No. 6737F —Seated torso seen in profile. Bl. ch. on pink prep. paper. 19.5 by 15.5. Verso: Torso.

2220 No. 6738F —Two nudes stooping, with their heads touching. R. ch. 11 by 25.5.

2221 No. 6739F —Composition for a wall to our l. of a window. Cain slaying Abel, and, above,
Fig. 996 the Sacrifice of Abel (p. 321). Bl. ch. 41 by 22. [Clapp, *Life*, fig. 141. Brogi 1313. Voss, p. 173 and *Jahrb. Pr. K. S.*, XXXIV (1913), p. 317.] As figures, crudely Michelangelesque, but magnificent as arrangement and with no little anticipation of Blake. Clearly for S. Lorenzo.

2222 No. 6740F —Male nude seated to l. with bent head, his r. hand falling over l. knee, l. hand grasping edge of bench. This is a larger and finer version of my 2209. R. ch. 41 by 29. [Photo. Mannelli. Uffizi Publ., I, i, 7.] Verso: Scrawl in bl. ch. of boyish nude lightly seated, and in r. ch. fine study of nude stooping down to a pool to dip up water. [Fototeca 4374.] All these studies were probably for a young Baptist in the Wilderness.

2223 No. 6741F —Nude, seen from behind, looking down to l., with r. arm raised (p. 310).
Fig. 948 R. ch. 40.5 by 28. [Photo. Mannelli.] Verso: Study from model for reclining male figure (p. 310). Both these sketches probably—the one on the verso almost certainly— served for Poggio a Cajano.

2224 No. 6742F —Study, perhaps from model, of nude youth lightly seated on rock, which he touches with both hands, while his head is seen in profile to l. Bl. ch. 40 by 26.5. [Photo. Mannelli.] Verso: Nude in profile to l. with hands joined in supplication and l. leg bent back from knee.

 Both these admirable drawings may have served for the S. Michele altar-piece in a more primitive phase, the one on the recto for the Evangelist, the one on the verso for the St. Francis. But it is possible that these also were done in connection with Poggio a Cajano, and this is more likely, for the window there seems indicated on this sheet.

2225 No 6743F —Reclining elderly male nude seen from behind, but with his bald head in profile to r., touches the ground with l. hand. R. ch. 26 by 39. Study for shepherd reclining on ground at extreme l. of the fresco at Poggio a Cajano, but nearer the figure in the designs, my 1976, 1977 (Figs. 940, 941), than to the one in the painting, although certainly of the date of the fresco.

2225A (former 2004) No. 6744F —Sketch from model for nude male kneeling in profile to l. with hands clasped. Study for draped St. Francis in the altar-piece at S. Michele Visdomini [or more likely still for Pygmalion in the Barberini picture]. Bl. ch. and wh. 28 by 21. [Photo. Mannelli. Clapp, *Life*, fig. 23.] Verso: Study but in reversed order for infant Baptist in the same picture. Identical with the r. ch. study my 2055A (fig. 944), but much bolder. [Fototeca 4375.]

2226 No. 6745F —Torso seen from behind. Bl. ch. 20 by 17. Late.

2227 No. 6746F —Male torso with arm lifted across the chest in Michelangelesque attitude. Bl. ch. 26 by 13.5. [According to Clapp (*Life*, fig. 142) for the lost S. Lorenzo fresco **representing the slaying of Abel**.]

2228 FLORENCE, Uffizi, No. 6747F —Nude seen from behind. Middle period. R. ch. 27 by 16.5.

2229 No. 6748F—Three Graces dancing. R. ch. 29.5 by 21. [Clapp, *Life*, fig. 122. Fototeca 4176. Uffizi Publ., I, i, 21.] Slightly mannered and somewhat masculine, but still delightful.

2230 . . '. . No. 6749F—[Moses receiving the Tablets of the Law, and not, as I used to think] Noah conversing with the Lord (p. 321). Bl. ch., squared for enlarging. 38.5 by 15. [Photo. Mannelli. Clapp, *Life*, fig. 139, and *Dessins*, p. 276. Intensely Michelangelesque.]

2231 No. 6750F—Tall panel with figures of prophets or apostles, and angel blowing trumpet, doubtless for the Last Judgement at S. Lorenzo. Bl. ch., squared for enlarging. 41 by 17.5. [Clapp, *Life*, fig. 140. Fototeca 4177. Photo. Mannelli.] Here P. as a draughtsman although so intensely Michelangelesque in design has a touch almost as palsied as Bronzino's.

2232 No. 6751F—Charming design of five flying *putti* of almost Raphaelesque or even Correggiesque grace. Bl. ch., with touches of r. on brown paper, squared for enlarging. 34 by 26. Probably sketch for some scheme of decoration.

2233 No. 6752F—Pile of dead or dying nudes, for the Deluge or perhaps Last Judgement at S. Lorenzo. Bl. ch. 16 by 24.5. [Fototeca 12503.]

2234 No. 6753F—Nudes for the same as last. Bl. ch. 14 by 31. [Brogi 1315. Clapp, *Life*, fig. 144.]

2235 No. 6754F—Larger group for the same. Bl. ch. 26 by 40.5. [Fototeca 4178. Clapp, *Dessins*, pl. VIII.]

2236 No. 6756F—Nude *putto* roguishly leaning with both elbows against parapet. R. ch. 28.5 by 20.5. Early and excellent.

2237 (see 2370B)

2238 (see 2370C)

2239 No. 6759F—Two sketches for female nude figure. Bl. ch. 26 by 18. Late, but pleasant.

2240 No. 6760F—Elderly male nude, asleep with arm bent over head. Bl. ch. 24.5 by 18.5. [Clapp (*Life*, fig. 153) identifies it as being for S. Lorenzo. Verso: Profile of youth to l. in r. and bl. ch. See Giglioli in *Dedalo*, VII (1926/27), p. 780.]

2240A No. 7322F—Bust of woman with hands crossed over waist with dishevelled hair, looking up to r. perhaps towards a Madonna. Bl. ch. 19 by 16. Fototeca 4380. May have been a study for an altar-piece of his middle period and has the same Seicento feeling as my 2049.

2240B No. 7452F—Study for figure seated on wall with r. leg drawn up and looking over l. shoulder. Bl. ch. 31 by 19. Verso: Youth walking towards l. Both are studies for the S. Michele Visdomini altar-piece, one for the infant Baptist, the other for the St. James. See Clapp, *Dessins*, pp. 281-82.

2240C No. 13861F—Fourteen figures playing *calcio*. Bl. ch. 39.5 by 70. According to Clapp (*Dessins*, p. 284) for the second series of decorative frescoes planned for Poggio a Cajano.

2241 No. 14433F—Male torso. R. ch. 28 by 12. May be dated about 1530.

2242 No. 15661F—Study for Christ in Michelangelesque Pietà. Bl. ch. 23 by 17. Late.

2243 No. 15662F—Flying *putto*. Bl. ch. 23 by 18. Rather early.

2244 FLORENCE, Uffizi, No. 15665F —Nude. Bl. ch. 21 by 27. Late, and probably for S. Lorenzo.

2245 No. 15666F —Nudes for S. Lorenzo. Bl. ch. 20 by 25.

2246 No. 17410F —Nude for S. Lorenzo. Bl. ch. 26 by 20.

2247 No. 17411F —Various nudes piled upon each other in agonized attitudes. Probably for the Deluge in S. Lorenzo. Bl. ch. 24.5 by 18. [Uffizi Publ., I, i, 23B.] Verso: Torso of nude beggar. Fototeca 4138. [Almost a caricature of Michelangelo's drawings for the Last Judgement.]

2248 No. 17769F —Half-length portrait of youngish woman, refined, elegant, even stately, vividly
Fig. 977 recalling the splendid portrait of a lady at Frankfort. She wears a turban, and a low-necked dress. The face is highly finished, but the rest is summary (p. 317). R. ch. 23 by 17. Fototeca 11885.

2248A (former 1965) No. 417O—Design for oval decoration, containing the arms of Pope Leo X supported by one male nude and one draped female figure, each bending away from the other. Doubtless done in connection with that Pope's famous visit to Florence in 1515. Pen. 18 by 21.5. Pl. CLXIX of F. E.

2248B (former 1966) No. 418O—St. Philip and another saint leaning away from one another. Between them, over a chalice, the Medici arms. Design of the same kind as the last. Pen. Oval. 15.5 by 18.

2248C Uffizi, Santarelli, No. 8976 —Naked boy seated with one leg drawn up, holding with both hands a pipe on which he is blowing. Bl. ch. 34 by 19.5. Verso: Studies for nude figures meant to decorate a spandrel. Fototeca 4665 and 4666. Clapp in *Dessins* (p. 282) gives credit to Di Pietro for having recognized these sketches which passed as by Correggio and connects them with Poggio, for which they are obviously intended to serve.

2249 No. 436—Tall arched composition containing a most original treatment of the Epiphany. The huddled train of the Magi winds up the foreground, and turns to l., where by a rock, under a shed lighted by a window on the l., the first of the kings kneels and embraces the foot of the Christ Child, Who struggles in the hands of His mother as she stoops, holding Him at arms' length. To her r. and l., St. Anne and St. Joseph. Under Joseph, the infant Baptist addressing the crowd below. R. ch. 42 by 31.5. [Brogi 1264. Ascr. to Rosso. The handling is free and bold, and worthy of the originality of the conception. I agree with Clapp in dating this design soon after 1520. It anticipates Tintoretto in the Scuola di S. Rocco.]

2249A (see 1955A)

2250 FRANKFURT a/M., Städel Museum, No. 4288—Two large male nudes peering into a glass, and a child seated on l. Bl. ch. slightly height. with wh. on prep. greyish green paper. 42 by 27. [Clapp, *Life*, fig. 77. *Stift und Feder*, 1927, pl. 80.] Powerful, and doubtless a study for a fresco; but for which of the many decorations whereof no trace remains, I cannot determine.

2250A HAARLEM, Koenigs Collection, No. 293—Sketch for portrait of Florentine lawyer seated in armchair. Bl. ch. 38.5 by 26.5. Lees, opp. p. 87. Amsterdam Exh. Cat., No. 619.

2250B No. 1149 (former Oppenheimer Collection)—Study of a nude male with his r. hand pointing forward, the left arm extended to the r. R. ch. 28.5 by 20. Inscribed Pontormo. Popham Cat., No 232. Verso: Study of two monks. From the Certosa period. Indeed it is likely

that the two monks were done for the Feast of Emmaus originally painted for that monastery, but now in the Florence Academy (Clapp, *Life,* fig. 82). The older monk in our study appears on the left in the painting.

2251 HAMBURG, KUNSTHALLE, No. 21147—Young saint with a staff. Bl. ch. 40.5 by 24. Ascr. to Cigoli.

2252 No. 21253—Study of about size of the painting for the Martyrdom of St. Maurice and the
Fig. 963 Theban Legion, painted for Carlo Neroni, and now in the Uffizi (No. 1187) (p. 315). R. ch. Arched. 42 by 37. Pl. CLXXII of F. E. [Clapp, *Life,* fig. 108.]

2252A No. 21173—Seated female nude twisting in strong *contrapposto* to r. and holding large
Fig. 993 disc on drawn-up l. knee. In lower l.-hand corner a small and even more twisted nude
 (p. 319, note). Bl. ch. 39.5 by 26. Photo. Rompel. Prestel Publ., pl. 19. Verso: Male
Fig. 992 torso straining up to r. and vertically to it sketch for Madonna seated holding the Child asleep in her lap (pp. 319; 365, note). Photo. Rompel.

 In the text to the Prestel publication it is suggested that the female nude was made in connection with the allegorical frescoes at Careggi, 1538-1543. Nowhere else is P. more successfully and more magnificently Michelangelesque whether in the contour drawing of the monumental Madonna or the highly finished work of the allegorical figure, only that the last has at the same time a deliberate elegance that anticipates the French followers of Rosso and Primaticcio.

2252B LILLE, MUSÉE WICAR, 162—Three nude men walking towards l. R. ch. 41 by 27. Publ. and repr. by Delacre in *Bulletin des Musées de France,* 1931, p. 139. Verso: Study for seated woman and for some draperies. The same sketch as on the recto occurs in the Uffizi (442F; my 1969; Clapp, *Life,* fig. 44) and is of somewhat better quality.

2252C LONDON, BRITISH MUSEUM, 1933-8-3-13—Heavily draped seated female figure. R. ch. 29 by 20.5. Verso: Two studies for the torso and one for the head of the Christ in the S. Felicita Deposition. Photos. Museum. First published by A. E. Popham in the *B. M. Quarterly,* VIII, p. 66, and the recto repr. opp. p. 65. The recto, by the way, looks somewhat earlier, of the time of the Certosa frescoes.

2253 Pp. 1-57—Three immeasurably long nudes, ascr. to Michelangelo, but certainly by P., and probably for the Deluge at S. Lorenzo. One female sits on a rock trying to draw herself up. Another seated, tries to support a third. R. ch. 20 by 27.5.

2253A Pp. 2-102—Head and torso of youth framed in by swirl of drapery. R. ch. 24 by 22. [According to Clapp (*Dessins,* p. 295) for one of the Evangelists in the vaulting of the Capponi Chapel at S. Felicita.]

2254 Pp. 2-101—Study for Madonna looking to l. while the Child clings to her, and the infant John stands by. R. ch. 22 by 18.5.

2255 1860-6-106-107—Study for the decoration of a wall. It was to have been divided by pilasters and cornices into six main compartments, the three below being higher than those above them. These three lower ones represent one scene, possibly the Death of Seneca in his Bath. In a lunette in the upper middle compartment we see Leda stretched out reclining, fondling her children and the swan. In the side compartment in each lunette is a bust, and above it a *putto* in dashing attitude supporting a shield with the Medici arms. R. ch. 47.5 by 50. [Vasari Soc., I, i, 22. Meder, *Handz.,* fig. 120.]

 The style of this design is clearly of P.'s earlier, although not earliest, years. That being so, and considering the Medici crest, we may assume that the design was intended for one of the villas of these magnates that was being decorated towards 1520. The one that absorbed at that time the energies of some of the most famous Florentine artists then

alive was Poggio a Cajano. There Andrea painted his Tribute to Caesar, and Franciabigio his Triumph of Cicero. There also P. was to have had a leading part, and indeed did leave a lunette of almost unsurpassable beauty as decoration. What more likely than that the wall under this lunette was intended to contain the most signal deed in the life of Seneca, a hero scarcely less of a favourite in the Cinquecento than Cicero himself.

[The interpretation as Death of Seneca has found no favour but remains to me more satisfactory than the idea that it represents an athlete's bath. As the composition still looks as if intended for the great hall at Poggio a Cajano, the intention must have been to commemorate some heroic or glorious episode in Roman history.]

2256 LONDON, Captain G. Fenwick Owen—Nude boy walking towards l. with arms lifted, and study for arm and shoulder of reclining figure with head barely indicated. R. ch. 38 by 23.5. Photo. Cooper. Popham Cat., No. 230. Verso: Nude male figure in half-kneeling posture leaning on a staff. Photo. Cooper. Popham (Cat., p. 64) compares the recto to my 2153 (Clapp, *Life*, fig. 21) for the S. Michele Visdomini altar-piece.

2256A MARSEILLES, Musée de Longchamps—Nude bending down as if to support or carry a weight with both arms. In r. lower corner another fainter sketch for upper part of same figure (p. 313, note). Bl. ch. Attr. Michelangelo. If by P., then possibly for the figure bending down at Christ's feet in the Certosa Deposition (see Venturi, IX, v, fig. 77).

2256B MUNICH, Print Room, No. 11125—Study for youth kneeling in profile to l. Verso: Two hands resting on a staff and study of a r. hand. R. ch. 22 by 15. Photo. Museum. Very fine, and of about 1530. The kneeling figure may be a sketch for the Pygmalion in the Barberini Gallery.

2256C No. 34948—Middle-aged man in ample cloak seated a little towards r., his head pensively resting on l. hand. Bl. ch. on greyish green paper. 24 by 16. Photo. Museum. Done in P.'s Düreresque phase.

2256D No. 34949—Study for sleeve with vague indications for back and shoulder. Bl. ch. 14 by 12.5. Photo. Museum. Done in P.'s Düreresque phase.

2256E NAPLES, Pinacoteca, Print Room, No. 0242—Study in r. ch. for l. arm with heavily draped sleeve over elbow. 24 by 10.5. Photo. S. I. Attr. to P. and probably his, though much gone over.

2256F No. 0283—Study for horse seen frontally in r. ch. and for hand with fingers bent inside in bl. ch. 28 by 21.5. Photo. S. I. Probably of the Certosa period. A similar drawing, although somewhat later in date, representing a horse and a horse's head has been published in the *Connoisseur* for May, 1923, p. 5, and was then in the A. G. B. Russel Collection.

2256G (former 2370) NEW YORK, Metropolitan Museum—The Virgin on rock platform, seated on her heels, stoops to t. Elizabeth, while between them the two Holy Children are at play. On the l. a half-nude female martyr looks sentimentally at St. Francis, who kneels with his back towards us, talking to her of the infant Baptist, to whom he is pointing. R. ch. 27 by 27.5. Pl. 26 of Pembroke Dr.

[A very remarkable copy of this drawing exists in the Louvre Print Room under No. 1991, ascribed to Vanni. Arch. Ph.] A singularly mannered composition of about 1530. [It now seems to me at least ten years earlier.]

2257 OXFORD, Christ Church, B. 29—Highly finished study for Pietà, perhaps for S. Felicita. Bl. ch. [Bell, pl. 91.]

2258 B. 30—Reclining female and part of another woman, as well as a male head (for S. Lorenzo (p. 312, note). Bl. ch. 28 by 21. Verso: Capitals and vases.

[This and the three following studies are considered by Bell (p. 76) and by Clapp

(*Dessins*, pp. 298 and 299) as copies after the S. Lorenzo frescoes. The nudes like, for instance, the one in my 2261 seem to them too highly finished to be by P. himself. If they are right, these copies must have been done by some close follower, perfectly conversant with his method as a draughtsman, like Bronzino or his pupil Allori.]

2259 OXFORD, Christ Church, N. 31—Two female nudes reclining, seen from back (p. 321, note). Bl. ch. 20 by 27. See my 2258. [Verso: Landscape with man drawing in foreground not necessarily by same hand but probably contemporary. At any rate the character of the writing seems to be of the 16th century.]

2260 B. 32—Nude seen from over a rock, and head of old man (p. 321, note). Bl. ch., bistre and colours. 27.5 by 19.5. See my 2258. Sketch for the more finished Uffizi study of the Lord addressing Noah. For S. Lorenzo. Verso: Horse's head.

2261 B. 33—Female figure bending over, and vague outlines of a torso (p. 321, note). Bl. ch. 28 by 21. See my 2258.

2262 (see 2265)

2263 (see 2327)

2264 (see 2267)

2265 PARIS, Louvre, No. 947—Jumble of nudes, doubtless for S. Lorenzo. R. ch. 12.5 by 19. Arch. Ph.

2266 No. 951—Crouching nude. R. ch. 13.5 by 19.

2266A No. 952—Lot and his Daughters (p. 321, note). Bl. ch. 21 by 36. Arch. Ph. Of the last period. Mannered and singularly like Blake. See Giglioli in *Boll. d'A.*, 1934/35, pp. 341-343, where this sheet is reproduced at p. 342 and proved to be a copy after P.'s cartoon in the Uffizi.

2267 No. 954—Nude youth with twisted legs. Bl. ch., slightly washed. 19 by 15.

All the following were in Baldinucci's collection, and most of them, as the uniformity of measures would indicate, come out of two sketch-books.

2268 No. 958—Nude *putto* about to climb over wall. Probably for the lunette at Poggio a Cajano. Below, a youth in the costume of the time. Slight bl. ch. and wash. 23 by 16. [Cf. my 2184 (Fig. 986).]

2269-2277 (numbers omitted in first edition)

2278 No. 959—Nude figures [for part of decoration]. Pen. 8 by 11.

2279 No. 961—Two men and a woman. Slight bl. ch. and wash. 22 by 17. Late studies. Verso: Elaborate antique interior, with statue in niche.

2280 No. 962—Study of centaur. Pen. 10 by 23.

2281 No. 963—Two men walking. Slight bl. ch. and wash. 22 by 15. [Verso: Shepherd on hillside.]

2282 No. 964—A Turk. Slight bl. ch. and wash. 22 by 16. [Verso: Study of round building.]

2283 No. 965—Satyr with cymbals. Copy after the antique. R. and bl. ch. 22 by 16. [Verso: Study for ornate bronze tethering-ring and hook. Bl. ch.]

PONTORMO

2284 PARIS, LOUVRE, No. 969—Study of mother and terrified child. Slight bl. ch. 22 by 16.

2284A-2325 . . Nos. 970—1011 are leaves out of the same sketch-book as the last few, and contain various studies, some in pen and ink, others in bistre and wash, of architectural and decorative motives. [The Arch. Ph. have 12 of these studies.]

2326 No. 1017—Nude seated turning slightly to r., but head looking a little to l. R. ch. 41 by 29. [Arch. Ph.]

2327 No. 1018—Male nude with head in hand, and r. foot resting on pedestal. R. ch. 40 by 20.

2328 No. 1020—Nude sitting with r. hand touching foot, l. arm around leg, and r. leg bent back. R. ch. 42 by 29.

2329 No. 1021—Nude with sword lifted with both hands over his head. R. and bl. ch. 42 by 29.

2330 No. 1022—Two nudes in strained attitudes. R. ch. 42 by 29.

2331 No. 1023—Nude youth with r. arm resting on young female nude. R. ch. 42 by 29.

2332 No. 1024—Anatomical studies. R. ch. 42 by 29. [Verso: Architectural studies with Medici ducal arms, and *putti*.]

2333 No. 1025—Elaborate design of old man, a young woman and cupid. Bl. ch. 26 by 14. Late.

2334 R. F. 496 (1870)—Head of young woman looking at us with roguish smile. R. ch. 23 by 17. Braun 63019. Ascr. to Andrea, but too clearly P.'s to need a word of demonstration.

2335 . . . BIBLIOTHÈQUE NATIONALE, B. 3,2 rés. No. 12—Nude boy. Bl. ch. 24 by 20.

2336 No. 14—Nude back. Bl. ch. 25.5 by 14.5.

2336A ÉCOLE DES BEAUX-ARTS, No. 3337—Nude boy seated with r. hand pressing ground and l. arm held out. Vertically to him a partially draped male nude walking to l. Bl. ch. 39.5 by 26.5. Verso: Nude boy crouching and with arm bent as if pointing and three other less finished sketches of boys in various attitudes. Bl. and r. ch. Arch. Ph. Early works connected with the S. Michele altar-piece or with Panshanger Joseph series.

2336B No. 10907—Male torso seen in profile to r. with r. arm raised and head faintly indicated. R. ch. and touches of wh. 23.5 by 13.5. Arch. Ph. Perhaps a first idea for the Christ in the S. Felicita Deposition (Clapp, *Life*, fig. 92) but foreshadows drawings of the S. Lorenzo period.

2336C DROUOT SALE OF RODRIGUES COLLECTION (November 28-29, 1928), No. 208—Head of young man with high cap. Attr. Andrea. Bl. and r. ch. 23.5 by 17. Sale Cat., pl. xv.

2336D DROUOT SALE OF MME. X COLLECTION (May 23, 1928), No. 42—Study for nude female figure seated towards r. and turned towards l. Bistre, wash and r. ch. height. with pen. 25 by 11. Sale Cat., pl. 5. Possibly for Poggio.

2336E RENNES, MUSEUM, Case No. 38—Nude male figure in profile to l. with r. arm held out, and l. arm pointing down. R. ch. 40 by 23. Publ. and repr. by M. Delacre in the *Bulletin des Musées de France*, 1931, p. 140.

2336F (former 2355) ROME, CORSINI, PRINT ROOM, No. 124161—In lunette: Draped figure of woman crouching, head enveloped in folds, l. arm extended, r. arm folded under l. Angel's head. R. ch. 23 by 40.5. Anderson. Rusconi, *Emporium*, 1907, p. 270. Identified by Clapp (*Life*, fig. 11)

as study for the fresco no longer existing at S. Cecilia in Fiesole. Verso: Nude male figure, upright, face looking over r. shoulder. Sketch of leg in l.-hand corner.

2336^G (former 2349) ROME, CORSINI, PRINT ROOM, No. 124162—Study for portrait. Three-quarters-length figure of man seated in chair, holding pen (?) in l. hand. R. ch. 28.5 by 19. Verso: Sketch of same much less elaborated. Both these are of the person that we find in my 1967 and 2368^A.

2337 No. 124163—Three heads of young child in different positions. R. ch. 16 by 26.5. [After seeing this again (1934) I cannot understand why I ever attributed it to P.]

2337^A (former 2344) No. 124228—Male [torso seen from back, slightly turned to l.] R. ch. on red-washed paper. 21.5 by 15.5. [Early.]

2337^B (former 2356) No. 124229—Group of draped figures, two female figures on l., one holding babe in arms, whom the other, seated a little above, is taking from her. Man seated below. Infant angel flying down in the middle. One other male figure [and a female figure carrying child] approaching from r. From about 1530. Bl. ch. on red-washed paper. 22 by 15.5. Anderson 2822. Rusconi, *Emporium*, 1907, p. 271. [Possibly, according to Clapp (see *Dessins*, p. 335), a first idea for the S. Michele Visdomini altar-piece. The intention may have been to represent that very rare subject in Italian art, the *Heilige Sippe*.] Verso: Sketch of two male busts, one apparently draped, the other nude, drawn one under the other. R. ch. on red-washed paper. [Possibly also for S. Michele altar-piece.]

2337^C (former 2347) No. 124230—Torso of seated figure, very muscular. Smaller sketch of same figure in in r.-hand corner. R. ch. on red-washed paper. 21 by 15. [Clapp, *Life*, fig. 96. Perhaps to be connected with the figure supporting the Dead Christ in the S. Felicita Deposition.]

2338 No. 124231—Head and shoulders of boy. R. ch. on red-washed paper. 11.5 by 15.5.

2338^A (former 2346) No. 124232—Seated nude figure with r. leg and foot very much lifted, l. leg stretched back, l. arm dropping between legs. Bl. ch. and wh. on red-washed paper. 22 by 15.5. [Clapp (*Life*, fig. 14, and *Dessins*, p. 336) connects it with the infant Baptist in the S. Michele Visdomini altar-piece.]

2338^B (former 2342) No. 124233—Study of male bust with head violently thrown back. R. ch. on red-washed paper. 21.5 by 15.5. [Magnificently grotesque.]

2338^C (former 2357) No. 124234—Two nude recumbent figures of infants, one winged. R. ch. on red-washed paper. 21.5 by 15. [Very close to Fra Bartolommeo.] Verso: Two r. arms, muscles emphasized. One in r. ch. The other bl. ch. on red-washed paper.

2339 (see 2367)

2340 (see 2366^A)

2341 (see 2361^B)

2342 (see 2338^B)

2343 (see 2362^A)

2344 (see 2337^A)

2345 (see 2363^A)

2346 (see 2338^A)

2347 (see 2337ᶜ)

2348 (see 2363ᴮ)

2349 (see 2336ᴳ)

2350 (number omitted in first edition)

2351 (see 2366ᴬ)

2352 (see 2366ᴮ)

2353 (see 2366ᶜ)

2354 (see 2368ᴬ)

2355 (see 2336ᶠ)

2356 (see 2337ᴮ)

2357 (see 2338ᶜ)

2358 ROME, Corsini, Print Room, No. 124235—Three sketches of r. arms, very muscular. R. ch. on red-washed paper. 21.5 by 15.5. Verso: Shoulders and breast of male figure. [Early.]

2359 No. 124236—Male nude figure down to knees, arms gathered up over breast under chin. Verso: Sketch of raised r. arm, with line of bust and head. R. ch. on red-washed paper. 21.5 by 14.5.

2360 No. 124237—Male torso, faint indication of head looking over r. shoulder. R. ch. on red-washed paper. 21.5 by 15.5. Verso: Powerful male nude from head to knees. [Early and perhaps connected with Panshanger series.]

2361 No. 124238—[Nude boy] seated on ground, smiling face, looking over r. shoulder. R. ch. on red-washed paper. 21.5 by 15. Verso: Back of male nude, outline of face looking over r. shoulder.

2361ᴬ (former 2351) No. 124239—Male torso seen in profile to l. R. ch. on red-washed paper. 21 by 15.5. Verso: Nude child seen from back, lying down and leaning on elbow. R. ch. [Early.]

2361ᴮ (former 2341) No. 124240—Male nude with r. arm uplifted, and legs stretched far apart, study for Baptist. R. ch. on red-washed paper. 21.5 by 15. [Between 1515 and 1518.]

2362 No. 124241—Partially draped female figure, standing erect, l. foot raised and resting at back of r., r. arm uplifted holding drapery above head, l. hand holding it together below waist. R. ch. on red-washed paper. 21.5 by 15. [I agree with Clapp in connecting the pose with the one of the Barberini Galatea.] Verso: Studies for children seated on ground.

2362ᴬ (former 2243) No. 124242—Draped female head and shoulders, for a Madonna. R. ch. on red-washed paper. 21.5 by 15.5.

2363 No. 124243—Two nude figures of infants (similar to my 2338ᶜ) seated, one winged. R. ch. on red-washed paper. 21.5 by 15.5. Verso: Very sketchy figure of female nude [which Clapp (*Dessins*, p. 342) connects with the figure seated on wall holding down a branch in the Poggio a Cajano fresco.]

39

2363^A (former 2345) ROME, CORSINI, PRINT ROOM, No. 124244—Seated nude figure, with r. arm stretched out. L. arm drooping between parted legs. R. ch. on red-washed paper. 21.5 by 15. [Clapp (*Life*, fig. 15) connects it with the infant Baptist in the S. Michele Visdomini altar-piece and is perfectly right.]

2363^B (former 2348) No. 124246—Powerful [male torso] seems to be pulling back with strain. R. ch. on red-washed paper. 22.5 by 15. [Looks to me very close to the drawings for S. Felicita. Clapp dates it ten years earlier and may be right.]

2363^C No. 124247—Male torso and r. hip in profile. Verso: Rapid sketch for shoulder and arm and in smaller proportions for naked bust and head. R. ch. on red-washed paper. 22 by 15.5.

2364 No. 124248—Bl. ch. strokes on red-washed paper. Undecipherable, might be seated figure. 21.5 by 15. Verso: Merest indication of r. arm with hand curved in, slight outline of drapery at elbow.

2365 No. 124249—Muscular r. shoulder and forearm. R. ch. on red-washed paper. 21.5 by 15.5. Verso: Sketch of r. arm with hand curved in, slight outline of drapery at elbow (same as my 2364 verso).

2366 No. 124250—Male torso, r. arm uplifted. R. ch. on red-washed paper. 21.5 by 15. Verso: [Male torso seen from back.]

2366^A (former 2340) No. 124251—Powerful knee and legs. R. ch. on red-washed paper. 21.5 by 15.5.

2366^B (former 2352) No. 124254—St. Christopher with Child on r. shoulder holding globe. A smaller sketch for the same is in the Uffizi (see my 2121). R. ch. 40.5 by 26. Alinari 1231. [Of Certosa period.]

2366^C (former 2353) No. 124259—Three drawings of same female figure, head bent down and in profile. Bl. ch. 26 by 20.

2367 No. 125769—St. Jerome praying. Draped only round loins. Ascr. to Schiavone. R. ch. on brownish paper. 43 by 28. Verso: A few undecipherable strokes in bl. ch.

2368 No. 127689—Sheet covered with sketches; various nudes running and throwing, nude back, r. arm thrown back as if to strike, repeated four times. On r. of sheet: group of draped figures, man, woman, two children. [According to Clapp (*Dessins*, p. 346) for a Holy Family.] Very faint sketch of nude figure on l. of sheet.

2368^A (former 2354) No. 130559—Study for portrait. Head and shoulders of man, a cap on his head; paper cut round with frame of India ink. R. ch. *Tondo*, diam. 11. Same sitter as my 2336^G. Verso: [Study of hands.]

2368^B VENICE, ACADEMY, No. 550—Two nudes embracing over two crouching ones making a compact group, in his advanced Michelangelesque style. Bl. ch. 29 by 19. Braun 78029. Clapp, *Life*, fig. 147.

2368^C VIENNA, ALBERTINA, S. R., 202—Study for female portrait. Bl. and r. ch. 39 by 24.5. Albertina Cat., III, No. 220. *Pantheon*, 1932, p. 301.

2369 S. R., 450—Splendid study after Michelangelo's Duke Lorenzo. Bl. ch., with touches of r. on brown paper. 29 by 18. Albertina Cat., III, No. 217.

2369ᴬ VIENNA, Sale of Klinkosch Collection (April 15, 1889), No. 825—Very fine study for more than half-length figure with draped head and eyes cast down, showing l. arm and hand. Bl. ch. Repr. in Sale Cat. as Andrea del Sarto. The type of face is not unlike the Virgin's in the S. Felicita Deposition, but the folds are almost Düreresque and more like the Certosa frescoes.

2369ᴮ WASHINGTON CROSSING (Pa.), F. J. Mather Collection—Bust of clean-shaven man slightly turned towards l., wearing high cap. R. ch. 34.5 by 21. May have been the sketch for a portrait not unlike the one in the Palazzo Bianco at Genoa (Clapp, *Life*, fig. 41). The tall cap accounts perhaps for the Quattrocento impression made by this sketch at first sight.

2370 (see 2256ᴳ)

School of Pontormo

2370ᴬ BREMEN, Kunsthalle, No. 1475—Sketch for portrait of bearded man standing with legs crossed leaning and l. arm resting on table and looking to l. The inscription underneath, "AB il suo ritratto di mano propria" (Angelo Bronzino ?), by later hand. Photo. Stickelmann.
　　The rather inferior quality reminds me of the two following numbers (Uffizi 6757, 6758) which I used to give to P. himself. All three may turn out to be early Bronzinos. The pose recalls Moretto or Moroni rather than a Florentine.

2370ᴮ (former 2237) FLORENCE, Uffizi, No. 6757ᶠ—Heavily draped statuesque male figure. R. ch. 20.5 by 10. See my 2370ᴬ.

2370ᶜ (former 2238) No. 6758ᶠ—Draped figure. R. ch. 20 by 9. See my 2370ᴬ.

2370ᴰ LONDON, Sotheby Sale (May 22, 1928), Lot 68—Sketch for portrait of young woman. Sp. on pinkish grey paper. 17.5 by 13.5. Repr. in Sale Cat. Ascr. to Credi, but certainly much closer to P.

2370ᴱ STOCKHOLM, Print Room, Inv. 123—Two studies for male nude, seen once in profile to l. with a kind of drapery in both hands and once from back. Between the two figures slight sketch of two wings. R. ch. 27 by 17.5. Attr. to Andrea del Sarto's school in Sirén's catalogue (No. 86, p. 28) but close to the P. of about 1540.

Puligo (pp. 295-297)

2370ᶠ ASCHAFFENBURG, Museum, Z. II. 88—Sketch for Last Supper. R. ch. 11 by 29. See *Münch. Jahrb.*, 1932, p. 87, where O. Weigmann ascribes it to Fra Bartolommeo.

2371 FLORENCE, Uffizi, No. 271ᶠ—Figure of youth seated. R. ch. 21 by 12.5. Ascr. to Andrea, but the look, the forms, and the stroke are P.'s.

2372 No. 468ᶠ—Sketch for Judgement of Solomon (p. 297). R. ch. 17.5 by 20. Pl. CLXVII
Fig. 926 of F. E.

2373 No. 470ᶠ—Study of youthful male figure standing draped; in r. hand, which is lifted to his shoulder, a pen; in his l. a book. R. ch. 39 by 20.

2373ᴬ No. 6427ᶠ—Nude figure lying back in profile to l., probably study for Pietà. R. ch. 23 by 30. Cut out and remounted.

2374 FLORENCE, UFFIZI, No. 6365^F—Study of nude, almost without arms, but in attitude of crucified figure. R. ch. 40 by 23. Certainly P.'s, although unusually firm.

2375 No. 6422^F—Youthful saint wearing shirt only, with arms folded over breast. Ascr. Andrea. R. ch. 28 by 10. Fototeca 15927.

2375^A No. 16480^F—Landscape with rocks and walled town; one of town gates repeated to r.; to l. naked figure with arms tied behind back, possibly study for St. Sebastian inspired by the Laocoön group. Vague outlines of other figures. Bl. ch. 27.5 by 40. Fototeca 9193. The picturesque buildings suggestive of Sicilian architecture may be copied from a South Italian or Flemish picture.

2375^B MARUCELLIANA LIBRARY, No. 150 of Vol. A—Sketch for St. Martin and the beggar. R. ch. and wh. 24 by 19. N. Ferri, *Boll. d'A.*, 1911, p. 293, as Bacchiacca.

2375^C HAARLEM, KOENIGS COLLECTION, No. 201—Lightly draped female figure running from l. to r. holding an oval object in both hands. R. ch. 16.5 by 12.

 Feeling and proportions are Giorgionesque. They occur in Andrea del Sarto and his followers in their best moments. The features recall Granacci but still more Puligo, for which reason among others the attribution to him. I owe the acquaintance with this sheet to Professor Oskar Fischel.

2376 LONDON, BRITISH MUSEUM—Bust of young woman (pp. 290, 297). R. ch. 33.5 by 21. Braun 730, 733.
Fig. 927 Alinari 1774. [Venturi, IX, i, fig. 445.] Ascr. to Andrea.

2377 PARIS, LOUVRE, No. 1674—Study for Evangelist (p. 297). R. ch. 35 by 22.5. Braun 62117. [Ali-
Fig. 929 nari 1276.] Ascr. to Andrea.

2378 No. 236—Sketch for Holy Family. Verso: Saint with hammer. Bl. ch.

2379 No. 1676—Design for altar-piece, representing Madonna enthroned between St. Peter and
Fig. 928 St. James (p. 297). R. ch. 41 by 30. [Alinari 1366.] Ascr. to Andrea.

2379^A No. 2712—Study for naked figure inspired by the Laocoön group. R. ch. 28 by 10.5. Close to Fra Bartolommeo.

2380 No. 2713—Study for Madonna. Labelled "École flor. XVI siècle." R. ch. 17 by 12.

2380^A ÉCOLE DES BEAUX-ARTS—Heavily draped and cowled young man leaning with l. arm on a stone parapet and supporting his head with l. hand. Bl. ch. and wash on blue greyish paper. 31 by 22.5. Attr. to Puligo in Lavallée's Exh. Cat., 1935. Probably for a lunette. The attribution seems plausible.

2380^B (former 2383) [MONSIEUR MARIGNANE]—Design for Adoration of the Shepherds (p. 297). R. ch. 23 by 17. Pl. 56 of Pembroke Dr., where it is catalogued as "attributed to Correggio," but it cannot escape the attention of any competent student of Italian art that this drawing is of the School of Andrea del Sarto, and the specialist will not fail to recognize therein the spirit of Andrea's admiring follower, P. The Infant Christ and the young shepherd have P.'s unmistakable types. The trees on the hillside are no less characteristic of this master. Most characteristic of all is the flickering, flimsy, yet not unpleasant handling. P.'s most charming drawing.

2381 ROME, CORSINI, PRINT ROOM, No. 130492—Sketch for fresco decorating tabernacle. Above, God the Father between two angels. Below, on one side of a door, Tobias with the angel, on the other side a female saint. Pen and bistre wash.

2381A TURIN, Royal Library, No. 15619—Study for Pietà. Like my 2754ᴺ inspired by Fra Bartolommeo. Handling and types are closer to P. than to any other of the *frate's* followers. Bl. ch. 34 by 23. Anderson 9807. Venturi, IX, i, fig. 236.

2382 (former 1836) VIENNA, Albertina, S. R., 113—Study for Madonna and Child. Ascr. to Fra Bartolommeo. Bl. ch. on grey paper. 29 by 20.5. [Schönbrunner & Meder, 373. Albertina Cat., III, No. 162.]

2383 (see 2380ᴮ)

Cosimo Rosselli (pp. 146-150)

2384 (see 1868ᴮ)

2385 LONDON, British Museum, 1885-5-9-33—Design for Madonna appearing to St. Bernard. He sits
Fig. 401 under a shelving rock, writing. The Virgin is accompanied by two angels. To the r., below, a monk in profile, with a rosary on his wrist (pp. 147, 148, 153). Pen and bistre. 17 by 21. Pl. LXXXI of F. E. [*Boll. d'A.*, 1932/33, p. 541.]

 A few words will suffice, I trust, to establish the attribution of this sketch to C. R., instead of to his pupil's pupil, Fra Bartolommeo. Let us begin with the types. We note the extravagant bottle-noses. Who that has C. R.'s figures in mind can fail to recognize these also as his? You will find their like in any of his works, in the best as well as in the worst, in the Sixtine frescoes no less than in the Breslau Nativity. Indeed, the Madonna in the last-named painting is almost identical with the Virgin in our drawing. Next consider the draperies. On the Virgin they hang in long-drawn, unfunctional folds, which awkwardly display the leg. This is characteristic of C. R., and examples are numerous. In the Sixtine fresco representing the Golden Calf it occurs more than once. Another point to observe is the extreme slenderness of the hands. This is peculiar to Rosselli, and in almost any work of his you may meet with it. Striking instances may be seen in the Berlin altar-piece No. 59, and in the excellent panel representing St. Catherine promulgating the Rules of her Order [formely Butler Collection, now Edinburgh N. G. No. 1030]. Finally, the action of the monk, the precise bend of his body, are easily paralleled in C. R.'s paintings. An instance is the old man on the extreme r. in the Sixtine Sermon on the Mount.

2386 1902-8-22-5—Bishop standing and reading in book. Sp. 17.5 by 7. Anderson 18918. [Popham, *O. M. D.*, XI (1936/37), p. 18 and pl. XIV.] The type of face and kind of folds are characteristic of the late work of C. R. [As Mr. Phil. Pouncey has pointed out, this drawing was done in connection with the Ercolano in Signorelli's Perugia altar-piece of 1484. It still looks to me like the work of some one very close to C. R. Is it a copy by the young Piero di Cosimo? The head would suggest it.]

2386A (former 2390) PARIS, Louvre, R. F. 433—Youthful draped figure in profile to r. (p. 150). Pen, wash
Fig. 402 and wh. on prep. paper. 27.5 by 15.5. Giraudon 708. Steinmann, I, p. 417. *Boll. d'A.*, 1932/33, p. 547. B. Degenhart, *Burl. Mag.*, LXI (1932), opp. p. 11. This study would seem to have been made for the attendant at extreme l. in C. R.'s Sixtine Chapel fresco representing the Last Supper (Van Marle, XI, p. 601). When it came to the painting a portrait head replaced the one in the sketch. The artist was in this instance a better draughtsman than painter.

2387 (see 529ᴮ)

School of Cosimo Rosselli

2387[A] BUDAPEST, Museum of Art—Sketch for altar-piece with Madonna enthroned, Blaise, and hermit saint. Pen and bistre. 17 by 30. Photo. Museum 305.

Attr. to Raffaellino del Garbo. Probably by a pupil of C. R. copying or imitating a composition of Perugino. The stroke and hatching are like C. R.'s. The figures, attitudes, and spacing Perugino's. The catalogue mentions studies for nude figures on verso which it describes as being close to Perugino.

2388 FLORENCE, Uffizi, No. 175[F]—Study for altar-piece representing in the presence of other saints, the
Fig. 403 Vision of St. Bernard (pp. 147, 148). Pen and bistre on wh. paper. 24 by 24. [Fototeca 12656. *Boll. d'A.*, 1932/33, p. 542. Scharf, fig. 199.] Ascr. to Piero di Cosimo [but looks like a faithful copy of a drawing by C. R.]

2388[A] No. 112[F]—St. James the Elder with pilgrim's staff in r. hand and book in l. Bistre on wh. paper. 27 by 10.5. Seems later than Uffizi 1562, where a St. James occurs. The influence of Credi is evident. Careful contemporary copy of original drawing.

2389 No. 113[F]—Design for Last Judgement, which in some respects anticipates Fra Bartolommeo's
Fig. 404 fresco (pp. 147, 149). Bistre and wh. Arched. 40.5 by 28.5. [Fototeca 4241. G. Bernardini, *Boll. d'A*, 1910, p. 151. *Boll. d'A.*, 1932/33, p. 546.] A school copy after a lost original by C. R.

2390 (see 2386[A])

2391 (see 41[B])

Rossello di Jacopo Franchi (p. 327, note)

2391[A] FLORENCE, Uffizi, No. 17[E]—Female saint in Gothic niche (p. 327, note). Bistre wash. 19.5 by 10.5.
Fig. 16 Fototeca 12727. Attr. Lorenzo Ghiberti.

2391[B] PARIS, Louvre, No. 1231—Study for young saint in niche (p. 327, note). Tempera and gold on
Fig. 14 linen. 69 by 30. Alinari 1420. Arch. Ph. Attr. Lorenzo Ghiberti.

Rosso Fiorentino (pp. 322-323)

2392 (see 1954[B])

2392[A] BAYONNE, Bonnat Collection, No. 144—Sketch for l. half of lunette: Bishop incensing altar. Pen and bistre. 33 by 26. Arch. Ph. Kusenberg, pl. 57.

2393 BERLIN, Print Room, No. 4196—Old woman seated holding book. Ascr. to Andrea. Bl. ch. 27 by 16. [Kusenberg, pl. 66.]

2393[A] CAMBRIDGE (Mass.), Fogg Museum, Loeser Bequest, No. 153—Three immeasurably long and slender nudes forming decorative group with their arms lifted to carry a weight. Similar motives occur in an engraving and a tapestry done after R.'s designs for Fontainebleau (see Kusenberg, pls. 61 and 65).

2393[B] CHANTILLY, Musée Condé, No. 2—Profile of Dante Alighieri. Attr. to Baldovinetti. R. ch. and wh. on pink prep. paper. Perhaps done after vanished Baldovinetti in S. Trinita.

2393[C] EDINBURGH, National Gallery, No. 776—Old man in ample cloak and high cap seated sideways. R. ch. on buff paper. 25.5 by 16.5. Looks vaguely like Michelangelo. The angular folds of the draperies, as if they were creases in paper, suggest the Pontormo of the Certosa period.

2393D EDINBURGH, NATIONAL GALLERY, No. 601—Human skeleton kneeling with l. leg on rock and lifting r. arm dramatically to heaven. Pen and sepia. Cf. with Uffizi Allegory of Death (my 2428).

2394 FRANKFURT a/M., STÄDEL MUSEUM, No. 523—Young and old sibyl with saint. Ascr. to Parmigianino. R. ch. 20 by 30.5.

2395 (see 2399A)

2396 (see 2399B)

2397 (see 2402A)

2398 FLORENCE, UFFIZI, No. 1210E—Study for Dead Christ. Ascr. to Pontormo, but the touch and the hands are R.'s. R. ch. 15 by 22.5.

2399 No. 1211E—Woman seated in profile to l., reading. R. ch. 17.5 by 12.5.

2399A (former 2395) No. 473F—Sketch for Holy Family. The Virgin in profile to r. holds the Child erect on a cushion, while St. Joseph sits fast asleep. R. ch. 13.5 by 12. [Fototeca 4170.]

2399B (former 2396) No. 474F—Slight but delightful sketch for legendary or mythological composition. R. ch. 7 by 11.

2400 No 476F—Nude athletes or gladiators slightly sketched, arranged in various groups [those above washing and cleansing themselves and those below wrestling]. R. ch. 23 by 32. [Fototeca 14353.]

2401 No. 477F—Number of male and female nudes grouped about edge of parapet, some
Fig. 1009 leaning against it or sitting upon it, others standing, and others still reclining on the ground (p. 323). R. ch. 36 by 26.5. Pl. CLXXX of F. E. Venturi, IX, v, fig. 125. Uffizi Publ., IV, iv, 16. Probably fragment of a design for mythological composition, not unlike the painting at the Louvre representing the Challenge of the Pierides.

2402 No. 478F—Study for nude St. Sebastian. R. ch. 40 by 15. [Fototeca 6101. Kusenberg, pl. 11.] Academic and cold. The figure occurs in R.'s altar-piece in the Pitti Gallery.

2402A (former 2397) No. 479F—Design for altar-piece. Virgin enthroned, with Joseph to r. and Baptist to l. Below, Sebastian and Margaret (p. 323). Bl. ch. 33 by 25.5. Constrained attitudes, but elegant, and done with spirit. [Perhaps an early project for the Pitti altar-piece.]

2402B No. 1487F—Nude figures pressing out grapes inside a wooden barrel while naked *putti* offer wine to a reclining nude figure. Pen. 23 by 25.5. Photo. S. I. 11998. Giglioli, *Boll. d'A.*, 1936/37, p. 538. The hatching does not seem to be original and may have been gone over by a later hand.

2403 No. 6469F—Various anatomical studies of knees. Verso: Rapidly sketched nude figure that has suddenly knelt in profile to r., as if for an Annunciation. R. ch. 28 by 18.5. [Brogi 1299.]

2404 No. 6470F—Sketch for Meeting of Joachim and Anne, with one male and one female attendant. It should be noted that although drawn with the pen and wash, the effect of largely and strikingly contrasted light and shade is the same as in the r. ch. drawings. 28 by 21.5. [I agree with Kusenberg (see p. 152) in not attributing this to R. any longer.]

2405 No. 6471F—Virgin seated on ground embracing the Child, Who puts His arms about her neck. Delicate feeling, and fair drawing. R. ch. 16 by 18. [Fototeca 14356.] Verso: Michelangelesque rapid sketch of seated figure.

2406 FLORENCE, Uffizi, No. 6473^F—Nude youth bending forward in profile to r., with l. foot on pedestal. Suggested perhaps by the antique. R. ch. 40 by 23. Verso: Elderly nude in profile to r., with his wrist on a stump. Pen. [Brogi 1300. Looks to me now more like Bandinelli than R.]

2407 No. 6475^F—Sketch for Holy Family, with Elizabeth and Infant John. Spirited. Bl. ch. 16 by 12. [Verso: Anatomical study.]

2408 No. 6476^F—Various small figures, most of them female, walking about, in an empty space, casting long shadows. R. ch. 16 by 17.5. [Fototeca 14357.] Dainty and entertaining [and curiously Pompeian in arrangement, proportions and shadows.]

2409 No. 6477^F—Nude seen from back. Feeble. R. ch. 37 by 19.

2410 No. 6478^F—Nude female of about thirty standing nearly sideways to l. with r. arm held out, but facing front with l. arm held up. R. ch. 36.5 by 18. [Brogi 1301. Uffizi Publ., IV, iv, 19. [Unmistakable and rare] instance of an attempt to work from the female nude. [The hatching seems curiously close to Battista Franco.]

2411 No. 6479^F—Profile to l. of smooth-faced male head with open mouth. R. ch. 34 by 23. This recalls the famous profile of a satyr in the Louvre ascribed to Michelangelo, but which I would attribute to Bandinelli. It is likely that the two heads were drawn by artists who knew one another.

2412 No. 6480^F—Upper part of two youthful figures. Good. Bl. ch. 14 by 8.

2413 No. 6482^F—Four small draped figures, one of them a fashionable youth. Feeble. R. ch. 14 by 20.5.

2414 No. 6483^F—Number of rapidly sketched small figures for sacred or legendary composition. Pen. 10 by 15.5. [Verso: Study for floating *putti*.]

2415 No. 6484^F—Two studies of lower part of figure, profile and back. R. ch. 28 by 19.

2416 No. 6485^F—Nude looking to r., and pointing both up and down. Verso: Five pretty curly heads. Bl. ch. 39 by 25. [Very close to Pontormo.]

2417 No. 6486^F—Upper part of male, partly draped figure looking down to l. R. ch. 20 by 14.5. [Early.]

2418 No. 6487^F—Nude seated with back toward us leaning against table. R. ch. 38 by 26.

2419 No. 6488^F—Upper part of a draped figure of saint blessing. R. ch. 19 by 20.

2420 No. 6489^F—Nude lightly seated with r. foot curled under l. knee. He looks out and points with l. hand. Good. R. ch. 39.5 by 20.

2421 No. 6490^F—Youthful nude, with r. knee on rock, looks to r. and points across his breast to l. Very pleasant. R. ch. 40 by 23. Verso: Two rapidly sketched nudes, one in r. the other in bl. ch.

2422 No. 6491^F—Story of Apollo and Daphne. Pen and bistre wash. Verso: Lower part of sprawling nude. R. ch. 18 by 24.5. I owe the explanation of the subject on the recto to Dr. W. Stechow. See his *Apollo and Daphne* (Leipzig, Teubner, 1932), p. 25, note 1.

2423 No. 6492^F—Young woman seated in niche, with knees crossed under her dress, throws
Fig. 1008 up hands in astonishment while turning head sharply to r. R. ch. 36.5 by 27. Brogi 1303.

It is curious to note in this allegorical figure the derivation from Michelangelo's Sibyls, while the actual impression is almost that of an eighteenth century French figure. All in all, this is one of R.'s most interesting sketches.

2424 FLORENCE, Uffizi, No. 6493ᶠ —Draped figure holding his head in his hand as if sobbing. [For the Deposition of 1521 at Volterra (see Kusenberg, p. 140).] Also a porcupine done with the pen. R. ch. 27 by 19. [Brogi 1304. Kusenberg, pl. 9. Verso: Horsemen camping before a town. By another and considerably later hand.]

2425 No. 6494ᶠ —Draped figure, standing in profile to r. with bare r. arm doubled up to his beard. Mannered. R. ch. 38.5 by 13.5.

2426 No. 6495ᶠ —Male nude, running forward with staff in l. hand. R. ch. 38 by 24. [Brogi 1305.]

2427 No. 6497ᶠ —Grossly disproportioned male nude, with demoniac expression, stands with hands joined high above head, near a standard planted in ground. R. ch. 41.5 by 20.

2428 No. 6499ᶠ —Number of spectral figures chiefly of emaciated old men, all in attitude of wonder or contrition, crowded, kneeling or standing around skeleton lying on rock. Over the reclining skeleton Death with wings, holds open a book, inviting a tall emaciated old man to look into it. On extreme r. fantastical nude old man leans on club and holds at arm's length a scroll with the date 1517. Close by him, on a rock, an almost completely effaced inscription, in which *Augustinus* can still be traced. This proves that the design was made for Agostino Veneziano, who, indeed, engraved it in the following year (p. 323). See Bartsch, Vol. 14, p. 320, No. 424. R. ch. 32 by 50. [Uffizi Publ., IV, iv, 14. Fototeca 14360. Kusenberg, pl. 5.] It is almost incredible that anything so spectral, so mannered, so crowded, so merely the modern illustration, was designed by a Florentine as early as 1517. But it is a fact.

2429 No. 6500ᶠ —Rapid jotting for tall composition in arched frame, representing the Adoration of the Magi. Bl. ch. 11.5 by 7.

2430 No. 6501ᶠ —Lovely draped female, kneeling in profile to l., with book in r. hand. R. ch. 34 by 22. [Uffizi Publ., IV, iv, 15.] For a figure in the Sposalizio at S. Lorenzo of 1523 and charming.

2430ᴬ No. 6755ᶠ —Nude figure seated with r. leg drawn up and foot resting on a block and r. arm held out. L. arm and leg barely indicated. R. ch. 28 by 33. Verso: Sketches for circular building. Pen and r. ch.

2430ᴮ No. 6926ᶠ —Tall nude old man kneeling with r. leg on a draped stump or rock and with l. arm stretched out. R. ch. 36 by 26. Ascr. to Bandinelli. Of the same quality as my 2428 and not impossibly a sketch for the same composition.

2431 No. 13849ᶠ —Pretty nude youth, standing in studied attitude in profile to r. R. ch. 26.5 by 10.5. [Fototeca 6128. The attribution seems to me no longer very convincing.]

2432 No. 14610ᶠ —Meeting of Isaac and Rebecca (p. 323). R. ch. 34 by 23. [Venturi, IX, v, fig. 120. Uffizi Publ., IV, iv, 18. Brogi 1272.

A singularly mannered composition of extraordinarily slender, elegant, haughty figures. Parmigianino at his worst is not so mannered in his elegance as R. is here. Although the technique and forms are close to R. this sheet has a tumultuousness of action and an insolence of expression which make me ready to accept the suggestion of Kusenberg (p. 153) that it is by Salviati.]

ROSSO FIORENTINO

2433 FLORENCE, Uffizi, No. 14673F —Youthful female nude, standing with face in profile to r. On the back of her head, like a cap, she wears the mask of an older face. In her l. hand she holds a disc. Below, on r. a *putto* in attitude of shooting downwards. Above, on l. a mask. R. ch. 35.5 by 24.5. An allegory of Michelangelesque inspiration.

2433A No. 17762F —Cupid nude, represented as a mincing sentimental youth. You could believe he was singing an *aria* (p. 323). R. ch. 29 by 15.5.

2434 No. 17805F —Male nude, standing open-mouthed, with both hands on pommel of his sword, whose point touches the ground. R. ch. 34.5 by 14. Probably for the executioner in a Decapitation of the Baptist.

2435 No. 17806F —Nude youth, staggering, with r. hand to head. R. ch. 29.5 by 23.

2436 No. 17807F —Nude, looking to l., and holding hand against l. knee. R. ch. 33 by 18.5. Probably for the same composition as the one mentioned in my 2434.

2437 No. 17815F —Nude, walking forward to l., with l. arm held up. R. ch. 41 by 20.

2438 No. 17816F —Male nude, reclining on r. arm, looking up. R. ch. 20.5 by 31.

2439 (see 604A)

2439A (former 2448) No. 20763F —Design for the Sposalizio at S. Lorenzo. Pen. 26 by 17.5. [Fototeca 4568. Kusenberg, pl. 14. G. Frizzoni, *Rass. d'A.*, 1904, p. 115.]

2440 Uffizi, Santarelli, No. 649 —Youthful draped figure looking up to l. R. ch. 32 by 22. Ascr. to Andrea, but the lights and shadows and the hands are R.'s.

2441 No. 652 —Kerchiefed head of old woman looking up in profile to l. Bl. ch. 19.5 by 14. Ascr. to Andrea, but, as the shadows and the fusion show, the author was R.

2441A No. 678 —Study for friar in profile. R. ch. 27.5 by 18.5. See Kusenberg, p. 142.

2442 No. 689 —Copy of kneeling saint, and lower part of executioner in Pesellino's Martyrdom of Cosmas and Damian in the Florence Academy. R. ch. 26 by 19. [Brogi 1267. Close to Andrea, but probably by R.]

2442A No. 1109 —Reclining nude with arms tied together behind back. Ascr. to Salviati. R. ch. 18.5 by 25.

2442B HAARLEM, Koenigs Collection, Inv. 391 —Sketch for Madonna standing and supporting Child on r. arm. Verso: Sketch of curly-headed girl and study for a hand. R. ch. 29 by 21.5. Attr. to Pontormo.

2443 HAMBURG, Kunsthalle —Madonna with Infant John. Pen and bistre.

2444 LONDON, British Museum, Pp. 5 —Female nude lying in Michelangelesque attitude, fast asleep. R. ch. 12.5 by 24.

2444A Pp. 1-60 —Man seated in profile to r. bending bow over r. knee. R. ch. 28 by 30. Braun 73012. Frey, pl. 17. Alinari 1751. Brinckmann 90. The features recall Michelangelo and may help to account for the traditional attribution to him.

2444B Pp. 1-119 —Elaborate design for tabernacle with four seated prophets in niches, six female figures as caryatides and an Annunciation in the centre. Pen and wh. on prep. greyish green paper. 47 by 33.5. Kusenberg, pl. 75. Inspired by ideas of Michelangelo for tomb of Julius.

314

2445 (see 2448ᶜ)

2446 LONDON, Jᴀᴍᴇꜱ Kɴᴏᴡʟᴇꜱ Cᴏʟʟᴇᴄᴛɪᴏɴ (formerly)—Female nude bending over slightly to r. 27 by 14.

2446ᴬ Vɪᴄᴛᴏʀ Kᴏᴄʜ Cᴏʟʟᴇᴄᴛɪᴏɴ—Rapid sketch for two figures, one seated in profile to r., the other standing and pointing downwards with l. hand. R. ch. 21 by 17.5. Publ. by Kusenberg in *Gaz. d. B. A.*, 1933, ii, p. 160, and in *Zeitschr. f. B. K.*, 1931/32, p. 88.

2446ᴮ Sᴏᴛʜᴇʙʏ Sᴀʟᴇ (April 27-28, 1885) No. 275 (former Gʀᴀʜʟ Cᴏʟʟᴇᴄᴛɪᴏɴ, Vienna)—Joseph of Arimathea supporting Dead Christ in his arms. R. ch. 24 by 18.5. Kusenberg, pl. 2 and p. 147. Early.

2447 MILAN, Mᴜꜱᴇᴏ Cɪᴠɪᴄᴏ—Sketch for Holy Family (p. 323). Admirable. Bistre wash. Pl. xi of
Fig. 1005 Morelli Dr. [Kusenberg, pl. 73.]

2448 (see 2439ᴬ)

2448ᴬ NAPLES, Pɪɴᴀᴄᴏᴛᴇᴄᴀ, Pʀɪɴᴛ Rᴏᴏᴍ, No. 763—Shivering male nude with arms folded over breast. R. ch. 26.5 by 13. Photo S. I. Copy after one of Masaccio's figures in the Carmine fresco representing St. Peter baptizing the idolaters. Interesting as a proof that Masacccio was still being studied.

2448ᴮ No. 782—Armless male nude seen from back. Head and legs seem to have been cut off. R. ch. 25 by 17.5. Photo S. I.

2448ᶜ (former 2445) NEWBURY, DONNINGTON PRIORY, Gᴇᴏꜰꜰʀᴇʏ E. Gᴀᴛʜᴏʀɴᴇ-Hᴀʀᴅʏ—Bust of lady. Verso: Three busts, one full face, the others profile. Pen. In the spirit of the S. Lorenzo altar-piece, but imitative of Leonardo, even to technique.

2448ᴰ NEW YORK, Mᴏʀɢᴀɴ Lɪʙʀᴀʀʏ—Four female figures, one carrying a child and one crouching as if to fill a jug. Attr. to Pontormo. Ch., pen and wh. 24.5 by 11. Morgan Dr., IV, pl. 20. Early and of R.'s best.

2448ᴱ Two separate studies of hand and arm. Attr. to Pontormo. R. ch. 7.5 by 16.5 and 7.5 by 13.5. Morgan Dr., IV, pl. 21.

2449 OXFORD, Cʜʀɪꜱᴛ Cʜᴜʀᴄʜ, B. 12—Magdalen and two other female saints. Copied from l. side of unknown altar-piece by Fra Bartolommeo. Verso: Draped male figure copied from some Masacciesque painting, and head of young woman wearing diadem, suggesting some Graeco-Egyptian original. R. ch. 26.5 by 21.5.

2450 PARIS, Lᴏᴜᴠʀᴇ, No. 189—Group of four women and a man (p. 323). R. ch. 28 by 18. Pl. cʟxxɪx
Fig. 1004 of F. E. [Alinari 1367. Kusenberg, pl. 68.]
 The attribution of this sheet to Pontormo is most unwarranted. The types are so unmistakably R.'s that in Paris of all places they should not have escaped recognition. The structure also is very characteristic of him, as for instance the lengthy proportions and almost rectangular torso of the seated female. The touch is also his.

2450ᴬ No. 1084—Aged woman in hood and fluttering scarf walking towards l. and carrying bouquet of flowers in r. hand and a viol and bow in l. Attr. to Piero di Cosimo. R. ch. 31 by 18.5. Arch. Ph. Kusenberg, pl. 78.

2451 No. 1604—Design for casket. Pen and wash on parchment. 42 by 49. Giraudon 1351.

2452 No. 1577—The Escape from Troy, being a number of figures chiefly nude, many of them carrying sacks on their heads. Most conspicuous are two nudes carrying one an old man,

and the other an old woman, both nude. Bl. ch. 21 by 28. [Kusenberg regards this as a copy after the fresco at Fontainebleau representing the destruction of Catania, and may be right. See pl. 36.]

2453 PARIS, LOUVRE, No. 1579—The Mother of Mercy holding her mantle over a group of people; perhaps
Fig. 1006 the design that belonged to Vasari, of which he says that it was made for a picture for Arezzo, which, however, was never painted (p. 323). R. ch. 30 by 27. Alinari 1484. [Kusenberg, pl. 25. Voss, *Zeichn.*, pl. 7.]

2454 No. 1580—Seven nude warriors, one of whom blows a trumpet. Background of trees. R. ch. 32 by 25. Braun 62077. [Kusenberg, pl. 71.] In kind and quality this resembles the beautiful sketch in the Uffizi (my 2401, Fig. 1009).

2455 No. 1592—Rapid sketch for the Sposalizio at S. Lorenzo. Pen. 28 by 21. [Kusenberg, pl. 14.]

2455A No. 1595—Studies of nudes for the Louvre Challenge of Pierides. Pen. 20.5 by 26.
Fig. 1007 Arch. Ph. Kusenberg, pl. 22. Unusually Michelangelesque in technique. And possibly after, rather than for, the painting.

2455B No. 1719—Highly finished study for female saint kneeling in profile to r. Bl. ch. 29 by 21.5.

2456 No. 1971—Sketch after the larger part of Paolo Uccello's fresco representing the Flood. R. ch.

2456A No. 2706—Male nude walking in profile to l. and carrying heavy weight with both arms on his back. R. ch. 40.5 by 18. Kusenberg, pl. 70. A likely but not very satisfactory attribution.

2457 No. 10014—Study for Holy Family. Bistre wash. 25 by 19.

2457A BIBLIOTHÈQUE NATIONALE, Dessins de l'École de Fontainebleau, B. 5—Sketch for figure in masquerade. Pen and bistre. 30.5 by 19.5. Arch. Ph. Kusenberg, pl. 76. Almost like Stefano della Bella.

2458 ÉCOLE DES BEAUX-ARTS, No. 2843—The labours of Hercules. Pen and bistre wash. 24 by 30.5.

2458A ÉCOLE DES BEAUX-ARTS, HIS DE LA SALLE GIFT—Sketch for the Fontainebleau fresco representing the Education of Achilles. Pen and bistre. 38.5 by 45.5. Giraudon 4239. Kusenberg, pls. 38 and 52.

2458B ÉCOLE DES BEAUX-ARTS, COLLECTION MASSON—A sorceress and two young women before an antique building. Pen and bistre. 42 by 29.5. Kusenberg, pl. 74 and *O. M. D.*, III (1928/29), pl. 53.

2458C No. 34886—Pandora opening her box. Pen and bistre. 24 by 39.5. Giraudon 14249. Kusenberg, pl. 77.

2458D ANDRÉ HEVESY COLLECTION—Young man distributing alms on steps of building. Bl. ch. 24 by 21. Kusenberg, pl. 72.

2458E VIENNA, ALBERTINA, S. R., 138—Sketch for the Christ in the Deposition at Borgo S. Sepolcro. Pen. 22 by 38.5. Kusenberg, pls. 23 and 24, and *Zeitschr. f. B. K.*, 1931/32, p. 87. Albertina Cat., III, No. 140. Despite the exact correspondence perhaps not by R. but by Battista Franco. The notation is characteristic enough of the latter, but scarcely of the former.

School of Rosso Fiorentino

2458[F] CAMBRIDGE (Mass.), Fogg Museum, Charles Loeser Bequest, No. 216—Two naked kneeling figures in *contrapposto* inspired by Michelangelo's Slaves. R. ch. 27.5 by 21. Perhaps R.'s but more safely catalogued as by an artist of the same following.

2458[G] No. 139—Sketch for Annunciation. Later, but inspired by R.

2458[H] FLORENCE, Uffizi, No. 6624—Copy of Michelangelo's David seen from back. R. ch. 40 by 13.5.

2459 No. 15559[F]—Various nudes and one draped figure, old copy of fragment of pleasant mythological design for lunette. Bl. ch. 37 by 27. [Kusenberg, *Gaz. d. B. A.*, 1933, ii, p. 161. Brogi 1273. Uffizi Publ., IV, iv, 17. Venturi, IX, v, fig. 126.
Kusenberg (see p. 141) considers this as R.'s sketch for the fresco ordered of him in 1528 for the Madonna delle Lacrime at Arezzo, and never executed. It seems to me too feeble to be an original sketch.]

2459[A] GIJON, Instituto Jovellanos, No. 28—Two groups of angels separated by bank of clouds. Attr. to Michelangelo. R. ch. 30 by 22. Gijon Dr., pl. 5. Close affinities with R. and probably by a Florentine of the same tendencies.

2459[B] NAPLES, Pinacoteca, Print Room, No. 103227—Draped young woman turned to r. clasping knees and looking to l. at a *putto*. Another *putto* to her r. R. ch. Cut off at lower corners. Between R. and Andrea del Sarto, to whom it is attributed.

2459[C] NEW YORK, Metropolitan Museum—Two small circular drawings representing the Adoration of the Shepherds and the Adoration of the Magi. Pen, bistre and wash. Diameter 6.5. Photo. Museum. Ascr. to Forentine School, 16th century. Perhaps by Rosso himself.

2460 PARIS, Louvre, No. 1575—Venus and Mars. Pen and wh., on greyish brown ground. 43 by 34. Giraudon 314. Braun 62116. Old copy of a famous drawing made for Pietro Aretino.

2460[A] TURIN, Royal Library, No. 16007—Group of sea monsters and nereids. Attr. to Pontormo. Pen. 10 by 18.5. Anderson 9859.

2460[B] WASHINGTON CROSSING (Pa.), F. J. Mather Collection—Sketch for the group so frequently occuring in a Crucifixion, of the fainting Madonna supported by the disciples and Mary Magdalen. Pen. 17.5 by 15.

Giuliano and Antonio da San Gallo (pp. 100-101)

2461
Fig. 218
FLORENCE, Uffizi, No. 192[E]—Giuliano: Study for angel in profile to l., and of St. John. Bistre on wh. paper. 19.5 by 21.5. Braun 76143. [Photo. Mannelli. Van Marle, XII, p. 279.] Ascr. to Botticelli, after one of whose angels in the Florence Academy Coronation the one here is a copy. But the technique, the dimples in the angels' draperies, the flutings in John's mantle, and his features, betray G.'s hand.

2462
Fig. 219
. . . . No. 262[F]—Antonio: Woman giving bowl to man, with two children playing on ground between them. To r. a woman with one child on her shoulder, and another running beside her. Pen and wh. on pink prep. paper. 28 by 39. [Fototeca 11921. Byam Shaw, *O. M. D.*, VI (1931/32), pl. 36. Very Botticellian. Verso: Architectural profiles and some writing: "adì 26 di magio 1525 di una chorona mano de Matio" etc.]

2463 No. 278[A]—Giuliano: Design for façade, perhaps for S. Lorenzo. Pen and ink. 57 by 62. [Fototeca 12611-13.] Interesting to us because of the bas-reliefs.

2464 FLORENCE, Uffizi, No. 279ᴬ—Giuliano: Design for façade, perhaps again for S. Lorenzo. Pen. 59.5 by 69.5. [Fototeca 12614 (detail).] Interesting for the Filippinesque drawing of the statues.

2465 No. 155ᶠ—Antonio: Full-length figure of Jupiter wielding thunderbolt. Bistre washed with wh. and touched with pink. 39 by 27.5. [Fototeca 11920. Byam Shaw, *O. M. D.*, VI (1931/32), pl. 35.] Kind and quality of the Albertina Judith.

2466-2468. . . Nos. 259, 260, 261ᶠ—Antonio: Seven figures after Donatello's apostles in the Sacristy of
Fig. 213 S. Lorenzo. Pen, height. with wh. on prep. pink paper. Each 28 by 39. [Fototeca 11922, 12660, 22661. Folds Botticellian. Verso: Nude, perhaps for fountain. Pen. Fototeca 11923. Byam Shaw, *O. M. D.*, VI (1931/32), pl. 38.]

2469 No. 1567ᴬ—Antonio: Verso: Copy after female figure on extreme l. of Botticelli's fresco
Fig. 215 originally at the Villa Lemmi, and now in the Louvre, representing Giovanna Tornabuoni, and four Virtues (p. 101). Pen and bistre height. with wh. 26 by 19.5. Pl. xlviii of F. E. Brogi 1431.

2469ᴬ No. 616ᴼ—Giuliano or Antonio (?): Group of warriors discussing and running towards tent. Bl. ch., pen and bistre washed with wh. 34 by 27. Verso: Slight sketches in sp. and pen on pink rubbed ground.

2470 No. 1799ᴼ—Giuliano: Verso: Bacchanal. Pen. 28 by 38.5. [Fototeca 12773. *Jahrb. Pr. K. S.*, 1902, p. 197. On p. 204 of same article Von Fabriczy traces classical origin of some of these figures.]

2471 ROME, Barberini Library—In Giuliano's sketch-book (among many other interesting studies) design
Fig. 214 for *tondo* containing Madonna and angels (p. 101). Stylus and ink. Diameter of sketch, 18. Von Fabriczy, *Jahrb. Pr. K. S.*, 1902, opp. p. 198, and pl. 2, verso of C. Hülsen's *Il Libro di Giuliano da San Gallo*, Leipzig, 1910.]

2472 SIENA, Public Library—Giuliano: Study for Judith (p. 100). Pen. 18 by 12. Pl. xlvii of F. E.
Fig. 216 [Von Fabriczy, *Jahrb. Pr. K. S.*, 1902, p. 199. Byam Shaw, *Belvedere*, 1931, i, fig. 98. Pl. 32 of R. Falb's *Taccuino Senese di Giuliano da San Gallo*, Siena, 1902.]

2473 VIENNA, Albertina, S. R., 54—Antonio: Study for Judith (p. 100). Catalogued by Bartsch as Giu-
Fig. 217 liano's. See his catalogue of the Prince de Ligne's collection, Vienna, 1794. Bl. ch., pen, brownish wash, and touches of wh. Schönbrunner & Meder, 33. [Albertina Cat., III, No. 20. Byam Shaw, *Belvedere*, 1931, i, fig. 97 and *O. M. D.*, VI (1931/32), pl. 34.]

2474 S. R., 55—Historical subject. In Antonio's Botticellian style. Sp., brown and grey wash. 34 by 27. Schönbrunner & Meder, 1372. Verso: Plan of a niche for the Laocoön. A. Venturi, *Archivio storico dell'arte*, 1889, p. 99. [Albertina Cat., III, Nos. 201, 201ᴿ.]

Sebastiano del Piombo [1] (pp. 238-250, 355-356)

2474ᴬ (former 2500) BAYONNE, Bonnat Museum, No. 123—Study for Adam and Eve (pp. 247-248). R. ch.
Fig. 766 28 by 19. Braun 65063. [Bannat Publ., 1926, pl. 3.]

2474ᴮ No. 650—Rapid sketch with many figures for Entombment. R. ch. 19.5 by 30. Arch. Ph.
Fig. 773 Venturi, *L'Arte*, 1921, pp. 224-225, and *Gr. A. I.*, pp. 190-194. Verso: Reclining nude somewhat like the Adam in the Sixtine Ceiling and on smaller scale a tangle of figures,

1. Unless otherwise indicated, the drawings catalogued under this name are all attributed to Michelangelo. As it is only in connection with this master that S. finds a place here, the student must expect nothing like a complete list of his drawings.

e. g. a prostrate woman, another with gesture of sheltering a child in her arm, and still another stepping out of a basin.

This suggested to Adolfo Venturi that it was a sketch for the Deluge on the Ceiling, and if the sketch were by Michelangelo it could be so read. It is scarcely that, but both sides are S.'s if my 2502 (Fig. 750) and the other studies here catalogued as his, are by him. The verso may be a memory impression of M.'s Adam and Deluge, but at the same time suggests a vintage scene of *putti*, as for instance the one at Modena ascr. by Venturi (*Storia*, IX, vi, p. 583) to Alberto Fontana.

2474C BAYONNE, BONNAT MUSEUM, No. 682—Studies for Resurrection of Lazarus (p. 355). R. ch. 19.5
Fig. 744 by 32.5. Arch. Ph. Attr. to Michelangelo.

 Certainly the best and probably the earliest of S.'s studies for the figure of Lazarus (my 2483 and 2484, Figs. 742, 741). The figure on our l. draws up his l. leg as if to settle down comfortably on the sarcophagus, instead of flexing the r. leg sharply at the knee in readiness to rise and walk. The purpose of the nude on our r. is not obvious. Conceivably it is for Lazarus already on his feet and darting forward to His Saviour. His hand, by the way, is close to the one of a woman seated in my 1746B verso (Fig. 811), a sheet that may be, I suggest, by Silvio Falconi.

2475 BERLIN, PRINT ROOM, No. 5056—Study for Juno in the Farnesina lunettes, and for another female
Fig. 768 figure seated on the ground, with her r. arm stretched out along her side and l. hand resting on a tall slim vase [like a lecythus] (p. 249). Pen. 19 by 23. [Berlin Publ., 82.] This does not occur in the frescoes, although presumably drawn for them. Ascr. to S.

2476 No. 5055—Design for Birth of the Virgin in the Chigi Chapel at S. Maria del Popolo in Rome. Bistre and wash on bluish green paper. 37 by 26.5. [Berlin Publ., 83. Ascr. to S. It is not by S. but an interesting variant by a hand not unlike Salviati's. A copy after the same picture has recently been reproduced by Professor Panofsky in *O. M. D.*, II (1927) as pl. 35. It has no interest for our studies.]

2477 CHATSWORTH, DUKE OF DEVONSHIRE—Head larger than life of Pope Leo X (p. 245, note). Charcoal on dark grey paper, torn at edges. 41 by 29.5. Braun 74024. [Chatsworth Dr., pl. 40.

 I no longer believe this to be by S. but rather by Raphael himself as it has always been considered (1934). It was used by Giulio Romano for the head of Clement I in the Sala di Costantino of the Vatican. It has shrivelled in the process, the conception being far too overpowering for Giulio, and the execution too direct.]

2477A Small pen-sketch for portrait of Clement VII (p. 250). 8.5 by 10.5. Braun 74198. Scar-
Fig. 769 cely earlier than 1525. Formerly attributed to Titian and by Morelli (*Kunstchr.*) to S.

2478 Reclining figure looking up to l., and holding up with l. hand a drapery as if to shade his eyes—study for one of the apostles in the Transfiguration at S. Pietro in Montorio (p. 356). Bl. ch. and wh. on greenish paper. 23.5 by 44.5. Braun 74190. [Popham Cat., No. 238. Chatsworth Dr., 47.] Ascr. to S.

 With full knowledge of the difficulty that accompanies every effort to identify under a given old master's general types any specifically individual likeness, I venture to state what seems likely, that the profile of this figure is identical with that of the donor in S.'s N. G. (formerly Northbrook) Holy Family. Should my suggestion prove acceptable, it would enable us to identify this donor as the patron of the chapel where S. painted the Transfiguration, namely Pier Francesco Borgherini, who is otherwise known to us as the friend of Michelangelo, the employer of Andrea del Sarto, Pontormo and Granacci, and as the husband of the lady who so bravely defended her pictures from the mercantile zeal of a Florentine agent of the King of France. Now it would appear from a letter written to Michelangelo by Pier Francesco's relative Leonardo Sellajo (Frey's *Briefe...*, p. 63), dated March 1, 1517, that S. was just about to begin the chapel at S. Pietro in Montorio, and

that at the same time Pier Francesco was in despair over a picture Andrea del Sarto had painted for him; whereupon S. assured him that with the assistance of a design by Michelangelo he would undertake to do something that would satisfy him. I can not here and now go into the ins and outs of the question, but it seems probable that the N. G. Holy Family was the result of this offer. That it was done relatively early in S.'s Michelangelesque career, we may infer from the fact that the donor here is presented in decidedly Giorgionesque fashion, as S. surely would not have done later. Then, no other works by this Venetian are so close to the picture in question as the prophets in the spandrels above the arch of the S. Pietro chapel. These were doubtless begun early in March, 1517, and when completed S. must either have begun, or made preparations for beginning the Transfiguration within the vaulted apse of the arch. At all events the N. G. picture and the Chatsworth drawing before us were made at no great distance of time from one another, which further tends to give substance to the hypothesis that the head of the donor in the one and of the apostle in the other, were drawn after the identical model, and that that model was Pier Francesco Borgherini.

2478A DÜSSELDORF, ACADEMY, PRINT ROOM, No. 575—Study for Pietà. The Virgin still on her knee in profile r. is about to receive in her lap the Dead Christ, who is carried by two or three figures. To the l. one and perhaps more female figures. Bl. ch. 17 by 18. Photo. Söhn. Catalogue, pl. 84.

The figure of Our Lady is noble and pathetic. Our Lord's head and the action of the principal figures are not satisfactory. The attribution to S. is the most plausible, and it is not unlikely that he did it while searching and fumbling for a composition like the Warwick Pietà (my 2486, Fig. 753). The contours of the nude, of His arm particularly, and the shape of the hand suggest the studies for a Dead Christ at Christ Church, Oxford (my 2492, Fig. 756).

2479 FLORENCE, UFFIZI, No. 1792E—Head of youngish bearded man, probably for Christ, and dating scarcely earlier than 1520. Bl. ch. and wh. sadly retouched. 27 by 18.5.

2479A UFFIZI, SANTARELLI, No. 194—Dead Christ supported by His Mother. Bl. ch. 24 by 11.5. Photo. S. I. 4594. Brogi 1257. Bernardini, p. 41. Almost copy of a group on the same sheet with the Descent from the Cross at Haarlem (my 2480, Fig. 747). The relaxation of the nude is rendered better than there, the contours have a flow and the chiaroscuro a flicker that suggest a later date.

2479B FRANKFURT a/M., STÄDEL MUSEUM, No. 399—Study for woman behind Lazarus in the N. G. Resurrection and of the group of women behind her. Bl. ch. 28 by 23.5. First publ. by Hans Tietze, *Jahrb. d. K. H. Inst.*, 1911, p. 6. Städel Dr., II, 7. Looks later, and in that case after the painting rather than for it.

2480 HAARLEM, TEYLER MUSEUM, No. 19—Sketch for Deposition from the Cross (p. 241, note). At the
Fig. 747 side three more hasty sketches of figures connected with the same composition. At r. angles to it, two other sketches: one, more hasty, shows Christ still on the cross, and two figures just beginning to take Him down; while in the other, more finished, Christ is supported on the ground by one figure, as in Michelangelo's much later Rondanini group, while another standing by beckons to the r. R. ch. 26 by 18. [Frey 330. Brinckmann 89. Amsterdam Exh. Cat. No. 594.] Haarlem Publ., pl. XIX. Verso: Heavily draped female figure stoops
Fig. 809 down in profile to l. with hands stretched out –perhaps for an Entombment. At r. angles to her, five heads of friars (pp. 365-366) [copied from Giotto's fresco at S. Croce representing an apparition of St. Francis (first identified by Wilde in *Belvedere*, XI (1927), opp. p. 145).] Haarlem Publ., pl. XX. [Frey, 331. *L'Arte*, 1935, p. 277.]

Like most of the other drawings here enumerated, this sheet is ascribed to Michelangelo, and his authorship has to my knowledge never been questioned. Nevertheless, it

certainly is by S., and so certainly that I venture to believe that no one who has followed my arguments in the text, and trained his eye accordingly, will dispute this attribution. A few words of demonstration must be given for form's sake. To begin with, to the discriminating eye the mere aspect of these sketches is not of drawings by M. There is in the shading, front and back, something not even quite Florentine, but a manner well known to us in the other studies that we have ascribed to S. Indeed, the small profile [seemingly female] on the back is of that ultra-classical type which is rarely found except among Venetians. Or take the stooping figure on the same side—it is inconceivable that Michelangelo ever could have done anything so dumpy, so devoid of form, so vague, so woolly as this. It exaggerates all the un-Michelangelesque traits that we found in the drawing for a figure in the Visitation on the back of the Windsor Madonna (my 2504, Fig. 754). And while we are on this figure, let us note that its profile resembles one on the extreme r. in the larger Vienna Pietà (my 2503, Fig. 752), and that the arms and hands are matched in the Oxford Domestic Subject (my 2493, Fig. 757), in the Windsor figure of a Kneeling Mourner (my 2506), and in the Louvre Madonna (my 2495 verso, Fig. 761). The sketches for a Deposition are so singularly like—except that the figures are smaller—to those for a Crucifixion and a Flagellation (my 2485, 2487; Figs. 746, 745), that instead of arguing at length about the attribution of the Haarlem studies, I invite the reader to compare them with the others, and let them pass with those. If the latter are a little looser, it is because their figures are on a larger scale. But the small sketch at Haarlem for the Christ still on the cross is quite as loose as any of the others.

Finally, I would invite the student before condemning my hypothesis, to re-examine carefully all the other drawings which I have ascribed to S., particularly the Warwick and Albertina Pietàs (my 2486, 2503, Figs. 753, 752). I am aware that this sketch for a Deposition has been brought into connection with various extant small reliefs of the same subject ascribed to M. I would suggest that the resemblance is due not to identity of hand but of source, for I would not deny that the inspiration of this as of most of S.'s drawings was M., and that the latter originated the composition. It must be noted, however, that the likeness between the drawing and the various reliefs is confined to the action of the figures engaged upon the cross—the part of the theme where S. would have felt himself most helpless and most constrained to imitate the master—while in the lower groups it is entirely different. What a study by M. himself for this composition looks like we know, for we have it in the B. M. (my 1514) in a sketch for the group in the lower left-hand corner of the various reliefs. This Haarlem sketch, however, is earlier than and quite independent of the reliefs. M. changed little in his idea of composition, and was capable of giving the same theme to S. before 1520, and to some one else after 1530.

[The verso is not by S. himself but by a draughtsman who possibly may have been Pietro Urbano. Here he seems singularly close to S., to the point even of translating a Giotto male profile into what looks like a Venetian female one. The interesting fact, however, is that this verso must have been part of a larger sheet with a more extensive composition by this Pietro Urbano or whoever he was, and that the author of the Descent on the other side, in my opinion S., trimmed it down to suit his own design. Sheets of paper were handed about too freely between the pupils, apprentices, foremen and followers of M. to make the proceeding seem unusual in this instance. It may, however, witness to a personal relation between the author of the sketch on the one side and the draughtsman who did the other side. As Pietro spent the greater part of 1521 (Thode, I, 382-3) in Rome he could scarcely have avoided meeting S. The latter's drawing could have been made at any time afterwards, but I suspect not long after 1525.]

2480ᴬ KREMSIER (Austria), LIBRARY OF THE PRINCE PRIMATE—Study for one of the prophets at S. Pietro in Montorio. In the curved space under the prophet, faint sketch of seated figure. Soft pencil and bl. ch. height. with wh. 25 by 36.5. Publ. by Hans Tietze in *Jahrb. d. K. H. Inst.*, 1911, p. 4, pl. II. In every way as good as the painting, but perhaps suspiciously brilliant.

2481 LILLE, Musée Wicar—Upper part of figure of faun, seen in profile to r. (p. 249). Pen. 12 by 12.5.
Fig. 764 Braun 72039. [Delacre, pl. 6.] Ascr. to Titian.

This is obviously but a fragment, and just enough appears to show that the whole figure must have been seated. He holds his pipes between his r. hand and l. arm, and looks out yearningly and sentimentally. No doubt the fragment of a study for the Polyphemus, painted no later than 1512 by S. at the Farnesina. Interesting to note how Venetian is not only the handling of this drawing, but its spirit, and its way of entering into the sentiment of a classic myth. The ear and the hand offer us, as they did Morelli, who first correctly attributed this sketch, sufficient proof that it is S.'s.

2482 LONDON, British Museum, 1860-6-16-1—Virgin seated looking down upon the two Holy Children
Fig. 767 at play (pp. 248, 249). The probable date of this design is about [1520]. Bl. ch. 31 by 20. Pl. cxlix of F. E. [Vasari Soc., I, vii, 6]

2483 1860-7-14-2—Study for Lazarus held erect on his tomb by two attendants; below, several
Fig. 742 drawings of feet and ankles (pp. 239, 244, 355). R. ch. 25 by 11.5. Braun 73007. [Thode, III, p. 546.]

2484 1860-7-14-1—More hasty and later study for the same three figures for the Raising of La-
Fig. 741 zarus (pp. 239, 241; 241, note; 244, 246, 355). R. ch. 25 by 14.5.

2485 1860-6-16-3—Study for Crucifixion (pp. 240-241, 244). The crosses are high and tower im-
Fig. 746 pressively over the groups below. The middle one, which rises a little above the others, is shaped at the top like an inverted A, as in several of M.'s own later studies for the same subject. On the l., a group of horsemen. Below, various attendants on the fainting Virgin, and figures looking up. R. ch. 39 by 27.5. Braun 73017. [Thode, III, p. 679.]

The inspiration and imitation of M. appear in every detail. This design could scarcely have been executed [much] after 1520, and yet there are things here which in M. himself we find only in his later years. Thus, the figure on the cross to the l. is hung in a way recalling the Greek statue of Marsyas, and suggesting the Florentine's last studies for a Crucifixion. The figure on the other cross is drawn in a style which brings to mind the Casa Buonarroti sketch for the Last Judgement. The action of the figure standing with arms held up to the neck, above the woman with outspread hands, reminds us of the figures in the design for the Fall of Phaeton.

What we infer from these facts is that certain types and attitudes which we, owing to our fragmentary acquaintance with the master, know in M.'s later years only, existed in his mind long before. Another reflection we are led to by the loose handling, which anticipates M.'s later manner, is that, as is exemplified so frequently, the imitator is apt not only to take his start from the point at which he first finds his master, and to travel forward in the same direction with the increased velocity of a fresh energy; but also that the imitator, running a necessarily shorter orbit around the same ideal, passes more rapidly through its phases, and thus at times anticipates some of those to which every definite manner or style once taken up, automatically, and inevitably leads.

2486 1896-7-10-1—Study for Pietà (pp. 243-244, 245, 247, 249, 356). Acquired at the Warwick
Fig. 753 sale. Bl. ch. 28 by 27. Pl. cxlvii of F. E. [Verso: Athletic nude with arms bound behind him, his bearded head drooping and l. leg bent at knee. Perhaps for Flagellation. Does not look by the same hand as the recto or indeed by S. in any other phase known to me, but much more as if by some Michelangelesque follower of a later generation, like Al. Allori.

Several compositions by Eugène Delacroix remind us of this Pietà by S. See Moreau-Nélaton, Eugène Delacroix, figs. 128, 186, 240. It is possible that Delacroix was acquainted with this and similar studies by S. It would be more interesting still if it could be proved that Delacroix invented the pattern and action for himself because he too was, despite all differences, a master of the nude.]

322

2487 LONDON, British Museum, Malcolm, No. 63—Study for the Flagellation executed in fresco at
Fig. 745 S. Pietro in Montorio (pp. 240, 247). R. ch. 22.5 by 23.5. Pl. cxlvi of F. E. [Thode, III,
p. 549.] I do not believe that S. actually began this work until he had finished his paintings
at the Pace which seem to have taken up the whole 1521. This study is of scarcely
earlier date.

2488 No. 366[1]—Study for Christ in the Flagellation at S. Pietro in Montorio (pp. 240, 248).
Fig. 743 Ascr. to S. Bl. height. with wh. ch. 27.5 by 14.5. [Tolnay, Münch. Jahrb., 1928, p. 77.]

2489 [Oppenheimer Collection (formerly)]—Study for Holy Family (p. 247). Within a room
Fig. 763 between a drawn curtain and window, the Madonna holds the Child with her l. arm on
her lap, while with her r. hand she holds something like a garland over a vague figure,
who may be Joseph. R. ch. 12.5 by 9. [Heseltine Cat., 1913, No. 6.]
 In the action of the Madonna there is a close resemblance to the female in Roman
costume, turning away with her hands held up, in the Raising of Lazarus. The elegance
and daintiness would point to a slightly later date than that work. In spirit it is not unlike
the Holy Family at [Burgos] although somewhat earlier.

2490 Sir Charles Robinson (formerly) [sold at Christie's May 12, 1902, No. 264]—Study for
Fig. 748 Crucifixion (p. 241, note). A broad pictorial composition, with the cross to one side and
Christ seen upon it sideways, as in one of the Haarlem sketches for a Deposition. On the
l. a group surrounding the prostrate Virgin. All around, soldiers, horse and foot, with
lances and flags. R. ch. 18.5 by 21.5.
 Although attributed to M., this is in every way the most Venetian composition that
can be ascribed to S. Its extension in breadth is significant enough, and the whole
treatment is so pictorial as to suggest Pordenone or Romanino rather than any Florentine,
and least of all its least pictorial one. Then nowhere can you find an approach to a clear
outline, but only broad massing, and vagueness. Nothing could be more characteristic than
the touch throughout, or the shading, or the spindle legs, or the fantastic horses. It must
be a drawing preceding any others of the kind by S., even the famous one in the B. M.
The latter must have arisen after M.'s criticism upon such an one as this,[2] wherein his
influence is as yet scarcely perceptible. A comparison of the two gives us a vivid idea
of what S. was to start with and what M. endeavoured to make of him.

2490A (former 1700) OXFORD, Ashmolean Museum, No. 14—Copy after the Madonna and Angels in the
Venice Academy there ascribed to M., but really, as already recognized by Prof. Wickhoff,
by S. Bl. and wh. ch. 35 by 26.

2491 No. 37—Study of eight or nine figures for Deposition or Pietà (pp. 242, 246). I should think
Fig. 751 about 1515-1518 to be the proper date for this design. R. ch. 36.5 by 27.5. Braun 73477.
[Frey, 150. Colvin, II, pl. 13. Venturi, M., 291. Knapp, M., pl. 101. The female figure
must have been known to Rosso Fiorentino before 1521, the date of his Volterra Descent
from the Cross, in which there is one reminiscent of her.]

2492 Christ Church, B. 20—Various studies for the Dead Christ in the Viterbo Pietà (pp. 242,
Fig. 756 244, 246). Bl. ch. on brown paper. 18 by 17. [Bell, pl. 85. Vasari Soc., I, x, 7. There
is here a touch of Florentine dryness almost as of the late Pontormo, Bronzino and even
Allori. Conceivably by G. P. Rossetti for his Volterra Deposition of 1551 (Venturi, IX,
v, p. 289).]

2493 B. 21—(cf. Robinson's Michelangelo and Raffaello, Oxford, p. 103). Study for a domestic
Fig. 757 subject, probably a Holy Family (pp. 246, 247). R. ch. 20 by 27. [Bell, pl. 71. Colvin,
II, pl. 12. Steinmann, Kunstchronik, 1922/23, p. 835.]

1. I cannot quite accept No. 365, a male head, and its verso, the figure of a woman, as S.'s, although it has found favour with
critics of note. To me these drawings would rather seem to be by a Roman imitator of the Venetian.
2. Another drawing, an intermediate stage of the same composition, is represented by a copy at Oxford (my 1708).

This must be early, perhaps as early as 1512-13. Colvin says the left-hand child is playing with a mask according to the well-known classic motive. [The length of the neck makes it probable that this sketch was done some few years later, and othes features and traits have enough in common with the few drawings that may be by Pietro Urbano (my 1444, 1661^B verso, 2480 verso; Figs. 803, 804, 809) to make one suspect the same hand here also (see Appendix XV).] For verso see my 1578^A.

2494 PARIS, Louvre, No. 691—Study for Madonna in profile to l. with the sleeping Child between her
Fig. 759 knees (pp. 246, 247). R. ch. 19 by 10.5. Braun 62050. [Alinari 1350. Demonts, 15. Brinckmann, 36. D'Achiardi, fig. 69.] As early perhaps as 1514.

2495 No. 692—Study for Madonna in profile to l., holding the Child at arm's length, and in the
Fig. 760 background another figure (pp. 246-247, 248). Braun 62052. [Alinari 1334. D'Achiardi, fig. 70.] Verso: Study for Raphaelesque Holy Family [with Infant John, or rather for
Fig. 761 a Rest in the Flight] (p. 247). R. ch. 29 by 21. [The verso is in the style which recalls drawings of the Pietro Urbano-Mini type.]

2496 No. 703—Madonna seated with the Child asleep in her arms (p. 253). R. ch. 17 by 11.
Fig. 765 Braun 62056. [Alinari 1349. Brinckmann, 37.]

This rapid, fumbling sketch, ascribed to Michelangelo, is by S., and done, like several others, under the inspiration of the figures in the lunettes of the Sixtine Ceiling. The next-of-kin to this are two other drawings for the Madonna in this collection (my 2494 and 2495; Figs. 759, 760). One should note the shading that serves as drapery over the knees. As nearly always in S.'s sketches of this period, the head is very tall. The faltering, almost aimless line, is also characteristic. [The length of neck would suggest a later date, after 1520.]

2497 No. 5051—Study for the entire figure of the Virgin and the upper part of St. Elizabeth
Fig. 749 (pp. 241, note; 242, note; 244, 248). Bl. ch. on greyish green paper. 38 by 23.5. Braun 62424. Alinari 1441. [D'Achiardi, fig. 34. Bernardini, p. 26.]

This was ascribed by M. Reiset, in the Louvre catalogue, to S., but stated to be a study for the Louvre Visitation. It is not for that work, but for a later Visitation done [for S. Maria della Pace] (note length of Virgin's neck), the fragments of which now belong to the Duke of Northumberland at Alnwick.

2498 (see 1592)

2499 PARIS, École des Beaux-Arts, Vallardi Collection—Study for Madonna and Child (pp. 250, 356).
Fig. 770 She sits a little sideways on a parapet upon which the Child stands. Bl. ch. and wh. on dark grey paper. 34 by 23. Braun 65210. [E. D. B. A. Exh. Cat., opp. p. 40.]

The action is intimately Michelangelesque, and the motive magnificent, but the handling is sufficiently independent of M. to account for the fact that this noble design already bears the name of S. Both as motive and as style this study stands between the [former] Oppenheimer sketch for a Holy Family, and the painting of the same subject at Naples. This picture, by the way, is not, as both Cavalcaselle and Morelli agree, an early, but, on the contrary, a relatively late work, being, despite its Raphaelesque motive, treated in an advanced Michelangelesque fashion, and painted in that cool grey manner which in S. we discover first in his various portraits of Clement VII. [It was done, as a matter of fact, for the Holy Family at Burgos, which corresponds in every way with what has been said about the character and dating of the drawing. First connected with the Burgos picture by Prof. Panofsky (O. M. D., II (1927), pp. 31-33 and pl. 34).]

2499^A Sketch for portrait of lady scarcely thirty turned somewhat to r. although her look is almost frontal. She is seen down to knees, has a kerchief on the back of her head, wears a dress with puffed sleeves like the N. G. St. Agatha, and a scarf that falls in a

loop from r. shoulder to her arm (p. 250). Bl. ch. 23 by 17. Giraudon 34699. Exceedingly pictorial modelling of face, in which respect it is remote from Michelangelo and even Pontormo. The only surviving sketch for a portrait. Note how much more "bourgeois" in character than any of the finished works.

2500 (see 2474A)

2500A ROME, CORSINI PRINT ROOM—St. Agatha carrying her breasts on a tray in r. hand and holding up her draperies with l. Also study for a hand. Bl. ch. on bluish grey paper, squared for transfer. Alinari 1234. Apparently for an altar-piece of which, however, we have no further knowledge. It may have been done toward 1523.

2501 VENICE, ACADEMY, No. 199—Study for Madonna in profile to l., with the Child beside her, and
Fig. 755 three angels in background (pp. 245, 246, 247, 248, 249). Bl. ch. 37 by 25. [Fogolari, No. 56. C. Loeser, *Rass. d'A.*, 1903, p. 183. D'Achiardi, fig. 67.] Anderson. [Done somewhat earlier than my 2482 (Fig. 767).] This design must have been much esteemed, for two good contemporary copies of it exist, one in the Louvre (Louvre catalogue, No. 115, Alinari 1339, [D'Achiardi, fig. 68]) and the other at Oxford (my 2490A). Verso: Head of elderly woman of decided Venetian type, with almost Bellinesque oval. The hand is certainly the one that did the Madonna, and the Venetian character of the head thus confirms the various arguments brought forward in the text for attributing this sheet to S. [It now seems likely that the Madonna is some years later than I used to believe. There are slight affinities with "Andrea di Michelangelo" but one should resist any temptation to ascribe it to him. If this sheet and its like, e. g. my 2482 (Fig. 767), 2509 etc., are not by S. they must return to M.]

2502 VIENNA, ALBERTINA, S. R., 136—Study of eight or nine figures for a Pietà (pp. 241, 244, 246, 248).
Fig. 750 R. ch. 32 by 25. This may be as early as 1514-1517. Verso: Study of legs, and drapery. Pen. [Albertina Cat., III, 135 and 135R. Poor, but in technique] closer to M. than recto.

[To what is said in the text I should now (1934) like to add that nothing can be less sculptural than the figure of the Madonna prostrate in a faint, piercing as it were the group and extending inward into space. Michelangelo, as I conceive him, could not have done a head like the one upon which Christ's head rests, or an old woman like the one clinging to His legs, who, by the way, anticipates S.'s prophets at S. Pietro in Montorio and the old woman in the Chigi Birth of the Virgin at S. Maria del Popolo in Rome.]

2503 S. R., 137—Dead Christ supported by His Mother (pp. 243, 244, 248). Of somewhat later
Fig. 752 date than the last. R. ch. 41 by 24. Schönbrunner & Meder, 63. Albertina Cat., III, 134.

2503A VITERBO, PINACOTECA—On back of S.'s Pietà: A number of sketches in bl. or r. ch., pell-mell
Fig. 758 one over the other (pp. 245, note; 356). I can attempt to ascribe only the most easy to decipher. The largest, taking up the greater part of the space, is the head with the curling, streaming locks of a youthful figure asleep. The high lights done with white. Apparently it was first drawn with small open eyes. Than came a tall nude stretching from top to bottom of panel, sketched after the lay figure with its l. arm extended. From above the hip of this nude seems to emerge something that could be taken for a queer leg bent at the knee. But the upper part of this looks more plausibly like a much enlarged eye of the head first mentioned, this time seemingly with the lid closed in sleep; what seems to be the foot may be the head possibly of a seated nude at r. angles to the tall one. Finally, the other eye was enlarged to match the first one, turning the face into a sleeping one. On our l. we see two studies for the seated Virgin in the Pietà. Photo. Minist. Repr. Andrea Scriattoli, *Viterbo nei suoi monumenti*, p. 368.

Owing to the unevenness of surface it is very difficult to obtain a satisfactory reproduction of these sketches and scarcely anything appears of the detail so characteristic

of S. as, for instance, the excrescent ankles and the elongated forefingers. It is to be assumed that no one will dispute that these scrawls are by S. Michelangelo is of course out of the question if only for the fact that he was at Florence or the Tuscan seaside while this Pietà was being designed and painted. If these sketches were on paper some students would try to convince us that they were by "Andrea di M.", Mini or Silvio Falconi, perhaps even Daniele da Volterra or Venusti. Finding them on the back of a picture finished about 1517, none of these attributions are chronologically possible except to Silvio, and there is no reason to assume that this person was in any way attached to S. as an apprentice who might conceivably have been allowed to do these scrawls. But there is no sheet of sketches catalogued here as S.'s which contains more incitations to the student to attribute those on the back of this Pietà to the various authors just mentioned. The sleeping face would not easily escape being taken for Daniele, the heads of the two Madonnas done so geometrically would be given to the omnibus Mini comprising my "Andrea," the historical Mini and perhaps Pietro Urbano. The cipher like a tilted 6 that does for nose and mouth of the tall nude occurs on the famous drawing of a Dragon (my 1555, Fig. 794), the back of which is certainly by "Andrea," while the dragon may be his as well.

2504 WINDSOR, ROYAL LIBRARY, No. 12773 —Study for Madonna holding the Child, with the Infant
Fig. 754 John by her side (pp. 245, 247, 248, 284). Bl. ch. 31.5 by 20.5. Pl. CLXVIII of F. E.
 [Wickhoff, *Jahrb. Pr. K. S.*, 1899, p. 205.]

Although showing great kinship with M.'s figures in the spandrels and lunettes of the ceiling, this design may yet be considerably later, but scarcely later than 1520. The resemblance of her head to that of the person supporting the Virgin in the Leningrad Pietà makes it likely that it is in fact as early as 1517. It curiously answers to the description given in a letter of no earlier date than 1532, addressed by Sernini to Giovanni Mahona, of one of two subjects that S. could paint for the latter's master, Don Ferrante Gonzaga. It reads thus: "Una Nostra Donna bella con Figliuolo in braccio et un San Giovanni Battista che faccia seco un poco da moreschina come il più delle volte si sogliono dipingere" (Campori, *Sebastiano del Piombo e Ferrante Gonzaga*, p. 5). It is possible that being asked to give an idea what subject he might paint, S. pulled out this very design.

Verso: Study of the Virgin for a Visitation. R. ch. Wickhoff, *op. cit.*, p. 206.

This is so strikingly and manifestly Venetian that I am not a little surprised at its not having long since put students on the track of the real author of the sheet. The draped figure resembles nothing else so much as some of the most Hellenizing bits of the most Hellenizing of the Lombardi in their famous reliefs at St. Antony of Padua. It is just possible that it is a study for the Louvre Visitation, which would agree with the date one should give to the Madonna. But the style is far too Venetian for such a date (1521), and the fact that the sheet has been cut at the top, decapitating the figure, would point to the conclusion that, done earlier, it accidentally turned up when the artist was looking for blank paper, whereupon he used the other side, and then trimmed the sheet to suit the Madonna and Child. [It escaped me when I was writing about this sheet more than thirty years ago that this sketch copies a figure in an Attic funeral stele of the 4th century.]

2505 No. 12772—Study for Madonna, tenderly embracing the Child (p. 247). Bl. ch. and
Fig. 762 [formerly] gilt all around the edges. [Action and drapery seem close to the woman
 holding a child in the lunette of Simon, Boas and Obet.] Perhaps as early as 1514-1515.
 Verso: A madrigal in M.'s handwriting written with bl. ink, and then cancelled with
 brown. [Frey, 34 and 35B. For writing see Frey, Text, pp. 22-23.]

2505A No. 4813—Study for Holy Family with Donor (pp. 250, 356). Bl. ch. 26.5 by 22.5. Verso:
Fig. 771 Study of Infant Christ on the recto in sp. and wh. and "Fra Basto del Piombo" in a

late 16th century hand. Publ. and repr. by Kenneth Clark in *O. M. D.*, V (1930/31), p. 63 and pl. 42. Probably after 1530 and for a Holy Family like the one now at Naples (No. 149, Venturi, IX, v, p. 60). The profile of the donor suggests Clement VII.

2505^B WINDSOR, ROYAL LIBRARY, No. 4815—Study for the Eternal floating through the air (p. 250). Bl. ch. 30 by 23 5. Publ. and repr. by Kenneth Clark in *O. M. D.*, V (1930/31), p. 63 and pl. 43.

On March 25, 1532, Sebastiano writes to Michelangelo begging drawings for a "Nativity with God the Father in the midst of Angels" (Milanesi, *S. d. P.*, p. 88). This sketch was more than probably done by S. on M.'s indication for the Eternal in the altar-piece still to be seen at S. Maria del Popolo (Venturi, IX, v, p. 57) but discarded for a more purely Sebastianesque figure. Our sketch is well on the way to Tintoretto in all except technique.

2506 No. 12769—Kneeling male figure, and in vague outline several others. The purpose of this sketch would remain obscure, if a copy thereof in the B. M., ascribed to Daniele da Volterra [but more likely by a later Florentine], did not make it clear that it was for a Pietà. Bl. ch. Verso: Windows, scarcely S.'s; perhaps M.'s. [Frey, 206 and 207.

The kneeling figure was added later and may be for a Nativity rather than, like those in outline, for a Pietà. It no longer seems likely that they are by S. One may hazard the guess that they are by a Florentine follower of M. working in Rome and acquainted with S.'s work. The windows or niches and architectural outlines on the verso are certainly M.'s and most probably of his last Roman period.]

Attributed to Sebastiano del Piombo

2506^A AMSTERDAM, RIJKSMUSEUM, PRINT ROOM, A. 1403—Study for Flagellation originally in bl. ch. The Christ, the column, the cornice, the platform and part of two figures inked over freely. The executioners and spectators remain as pricked outlines only. 44.5 by 35.5. Popham in *O. M. D.*, IV (1929/30), p. 37, pl. 41.

It seems natural to take this sheet as a study for S.'s fresco at S. Pietro in Montorio. Mr. Popham rightly remarks that the "penwork is characteristically Venetian," and it could be argued that when first asked to paint the fresco S. freely designed a Flagellation and a Venetian composition was the spontaneous result. In the Christ there is something of the Giorgionesque S. as at S. Bartolommeo in Rialto, and of the young Titian as in St. Mark Enthroned at the Salute, both in Venice. On the other hand, the earliest possible date for this sketch is 1517 and in every probability considering how dilatory a worker S. was, it may be two or three years later. But even in 1517 S. should give signs of contact with M. Here there are none. There are traces of quite another influence, namely Signorelli's. The proportions and the action of the pricked figures are reminiscent of the latter. So perhaps is the outlining by pricking. One is reminded of drawings by Signorelli like my 2509 N-1, 2509 E-1, and 2509 A-3. And the attitude of Christ reminds us not at all of M. but of Signorelli's figure for the Morra Flagellation, my 2509D-11 (Fig. 112). But nowhere else in S. is there a touch to witness that S. had ever looked at Signorelli.

Turning for a moment to the penwork, I find on comparing it with the Berlin and Lille drawings (my 2475, 2481; Figs. 768, 764) that the notation although so Venetian, yet is not the same as in those. The line tends to be more ductile, more sweeping as suits an engraver, or one destined to become one. Now there was a Venetian roaming about Central Italy in the fourth or fifth decade of the 16th century who was an imitator of M., who could easily have known S.'s and Signorelli's Flagellations and whose penwork has a closer resemblance to that in this design that has S.'s. This Venetian was Battista Franco, and I wonder whether he was not the author of the Amsterdam sheet. In the Museum of Rennes there is (cadre 29) a pen-drawing (27 by 18) after the Christ in the Flagellation, in the Museum of Besançon another in bl. ch. (No. D. 1624). I mention them to forestall their attribution to S. himself.

2506^B HAARLEM, Koenigs Collection, Inv. 378—Study for old bearded man in attitude of despair and of two other figures with heads turned in profile, one to r. and one to l. Bl. ch. 35.5 by 26.
Supposed to be for the background figures in S.'s Raising of Lazarus. Neither their expression nor action suit that subject particularly, and in the handling there is little to compel one to ascribe this sheet to S. rather than to one of many other followers of M., as for instance Vasari or even Tibaldi.

2506^C LONDON, British Museum, No. 1935-7-13-2—Study for the group of women in the Visitation painted for S. Maria della Pace, the fragments of which now belong to the Duke of Northumberland at Alnwick. Bl. ch. 33 by 16. Photo. Museum. Popham, *B. M. Quarterly*, X (1935), pp. 47-48, pl. xix. Important for what it tells us about the finished work but scarcely an autograph.

2506^D OXFORD, Christ Church, B. 22—Seven figures fairly elaborated and several others barely indicated for an Ascension or possibly (but less likely) a Descent of the Holy Spirit. Pen and bistre. 24 by 21. Vasari Soc., I, ix, 9. Too agitated and too sentimental for S., to whom it is attributed. The forms and the penwork are scarcely his. An excellent but later drawing. Perhaps Venetian.

2506^E NEW-YORK, Metropolitan Museum, No. 12363^G—Head of pathetic old woman in profile r. Pen on buff paper. 20.5 by 16.5. Photo. Museum. No small resemblance to the Anna in the Louvre Visitation. Yet the sentiment is not S.'s, and the penwork more like Battista Franco's. It may be the latter's or by a later imitator.

Jacopo del Sellajo (p. 102)

2507 LILLE, Musée Wicar, No. 291—Study for St. Luke, ascribed to Fra Filippo (p. 102). Pen, bistre wash and wh. on prep. tinted paper. 21 by 24. Braun 72002. [Fischel, p. 85 and fig. 91, ascribes this sketch to Perugino. He is probably right.]

2508 LONDON, British Museum—Design for Nativity (p. 102). Bistre and wash on vellum. 29.5 by 22. Pl. liii of F. E. Ascr. to Ghirlandajo.
[The attribution to S. no longer convinces me. The landscape, the boy Baptist, and even the angels might be by him when closely imitating Pesellino. The Madonna and Joseph are Verrocchiesque in a way that suggests the young Perugino. Is it possible that this Nativity is a copy of a design by the great artist? Another artist whom a number of features in this Nativity recalls is the Castello Master.]

2509 British Museum, Malcolm, No. 17—Two studies, one for seated and the other for
Fig. 220 kneeling Madonna (p. 102). Sp. height. with wh. on dark pinkish prep. paper. 21 by 31. Ascr. to Ghirlandajo.

Luca Signorelli (pp. 30-45)

2509^A BAYONNE, Bonnat Museum, 148—Nude from behind with legs apart turning vehemently to r. with r.
Fig. 98 hand clenched over l. shoulder and. l. held down and spread its full span in a gesture of indignation or loathing (p. 33). Bl. ch. gone over with coloured wash. 37 by 12. Bonnat Publ., 1926, 14. *Gaz. d. B. A.*, 1932, i, p. 184. Must have been done in connection with Orvieto frescoes, but does not seem to have been used.

2509^{A-1} . . . No. 1297—Nude seen from behind with legs wide apart carrying another nude in his arms. Bl. ch. and bistre wash. Cut out and pasted on (p. 33). 27 by 17. Bonnat Publ., 1924, 7. Arch. Ph. *Gaz. d. B. A.*, 1932, i, p. 182. Study for demon in foreground extreme l. in Orvieto fresco representing the Damned (Dussler, 100).

2509^{A-2} BAYONNE, BONNAT MUSEUM, No. 1298—Nude in helmet strutting to r. with r. arm stretched its full length and l. at side with hand half clenched (pp. 35, 38). R. ch. 40 by 27. Verso: R. legs, arms and hands and head in r. ch. In bl. ch. three slight sketches from model, two in costume of time, and third nude. Arch. Ph. *Gaz. d. B. A.*, 1932, i, p. 194. From S.'s later years, perhaps for some Roman subject.

2509^{A-3} . . . No. 1299—Two knights jousting. In upper l.-hand corner the inscription in contemporary hand: "Luca Signorelli cortonensi famoso pittor." Bistre wash and wh. pricked for transfer (p. 38). 18.5 by 22.5. Bulloz, Arch. Ph. Verso: In opposed direction, knight riding away to l.

2509^B BERLIN, PRINT ROOM, No. 5091—Two nudes, one seen from front carrying a young woman astride on his r. shoulder, the other seen from back with naked youth riding on his r. shoulder (p. 42). Bl. ch. height. with wh. and washed with water-colours. Patched and restored. 35.5 by 28. Pl. 36 of Berlin Publ. Meder, *Handz.*, fig. 152 (detail). No doubt connected with the Orvieto fresco representing the Damned where, however, these precise figures do not occur.

2509^{B-1} (former 1849) No. 2381—Head of man facing front. Bl. ch. and wh. 23.5 by 15.5. [A. v. Beckerath,
Fig. 96 *Burl. Mag.*, VI (1904/5), p. 235. Berlin Publ., 38. *Gaz. d. B. A.*, 1932, i, p. 202.

As the spare features and long face have some resemblance to Dante and as he wears leaves on his cap we have here in all probability a study by S. for a portrait of the poet. Perhaps it was for Orvieto where however Dante is represented in profile. It has taken me a long time to get over feeling that this sketch was by Piero di Cosimo. I see now that it is too plastic and too decided for the latter.]

2509^{B-2} . . . HOLSTEIN AND PUPPEL AUCTION (May 6, 1929)—Youthful horseman seen from behind riding
Fig. 107 inward to r. (pp. 35, 38). R. ch. Ascr. to Uccello. Repr. *Kunstwanderer*, Sept., 1931, p. 19, and there ascribed to Raphael, but characteristic of S. in what may be called his Raphael-esque mode. Its nearest parallel is at Orvieto the youthful horseman on the pedestal from which Antichrist is preaching (Dussler, 90).

2509^{B-3} CHELTENHAM, T. FITZROY FENWICK COLLECTION—Nude struggling to get up from ground on which he rests with knee while l. leg is bent and pushing against the leg of another nude who beats him (p. 33, note). Bl. ch. and wh. on brown paper. 29 by 20. Vasari Soc., II, xii, 4. Fenwick Cat., pl. XII.

Mr. Kenneth Clark in publishing this drawing correctly relates it to Orvieto frescoes and remarks that the figures do not occur there. It is possible, however, that this gave place to a drawing of which the B. M. has a faithful copy (my 2509^N.) It is less likely, but conceivable, that this same study represents an earlier phase of two nudes in the scene in hell (Dussler, 100).

2509^{B-4} . . . Youthful male nude seen from behind with upper part only of r. arm indicated, shaggy head in profile to r. (pp. 41-42). Bl. ch. 27 by 13.5. Fenwick Cat., pl. XIII. *Gaz. d. B. A.*, 1933, ii, p. 283. Of excellent quality and from artist's best years. Perhaps for soldier standing with arm akimbo in the fresco at Monte Oliveto Maggiore representing St. Benedict receiving Totila (Dussler, 67).

2509^{B-5} . . . Sketch or cartoon of head of archangel extreme r. in fresco of the Damned at Orvieto
Fig. 120 (Dussler, 100) (p. 42). Bl. ch. height. with wh. on brown paper. Fragmentary, longest diameter 23.5. Fenwick Cat., pl. XIII. *Gaz. d. B. A.*, 1933, ii, p. 285.

2509^{B-6} DIJON, MUSEUM—Two nudes, one carrying the other. Undoubtedly for the Orvieto fresco of Damnation although not to be identified in completed work (p. 42). Water-colour, damaged. 30 by 16. *Gaz. d. B. A.*, 1933, ii, p. 286.

2509[C] DRESDEN, Print Room—Four nudes lying or crouching in various position (pp. 34, note; 36). Bl.
Fig. 110 ch. on pink tinted ground. Verso: Crouching nude with his head between his hands.
Braun 67044. Hanfstängl. *Gaz. d. B. A.*, 1932, i, pp. 189 and 188). Probably done in
connection with Orvieto frescoes. They are nearest to the prostrate figures in foreground
of the Coming of the End. Never again is S. so Michelangelesque.

2509[D] FLORENCE, Uffizi, No. 50[E]—Youth in costume of about 1500 standing lightly with feet apart
as if preparing to stride to r. while looking down to l. His r. hand at arm's length as if
clenching pommel of sword, his l. held out (p. 35). Bl. ch. 25 by 17. *Gaz. d. B. A.*, 1932,
i, p. 192.

Looks like study for a Michael or a youthful warrior in general but I have not been
able to discover the painted figure at Monte Oliveto or Orvieto or elsewhere. Comes nearest
to Archangels at last-named place in fresco of the Damned (Dussler, 100). It is not likely
to have served for the second youth left in the Uffizi predella representing the Epiphany
(Dussler, 42).

2509[D-1] . . . No. 53[E]—Youngish woman seated heavily draped, looking down with r. hand over bosom,
and l. under it. Bistre and wh. on paper coloured grape purple. Gone over with ink,
perhaps by S. himself. 19.5 by 14. Alinari 195. The hatching is curiously like Michel-
angelo's. The faint *contrapposto* of the figure marks it as dating toward 1500. Probably
for a Virgin Annunciate or for one of the saints in the ceiling at Orvieto. It is not impos-
sible that it was intended for the Madonna in the slightly earlier Descent of the Holy
Spirit at Urbino.

2509[D-2] . . . No. 1246[E]—Four male nudes. To l. one tramples over back of another who as he bites
Fig. 115 the dust, has his arms tied behind him by the first. In foreground a third steps out as
if to get away while a fourth binds his arms as well behind him (p. 35). Bl. and r. ch.
28.5 by 21. Uffizi Publ., V, ii, 2. Schönbrunner & Meder, 75. Popham Cat., No. 98.
Dussler, p. **xxxv**. Van Marle, XVI, p. 107. Alinari 211.

Kind and quality of nudes at Orvieto. If done in connection with the frescoes there,
it need not have been, as generally assumed, for the one representing the Damned but
rather for the one depicting the misdeeds of Antichrist. There we see men being taken
prisoners, although we cannot find the exact counterpart of the drawing. Or again there
are scenes in the grisailles illustrating the great poets of antiquity. Above the medallion
of Perseus and Andromeda there is a rectangular composition representing three demons
attacking as many nudes (Dussler, 114). The action is close to our sketch but on a lower
and less heroic scale of vitality. The same is true of the nudes in the medallions ac-
companying Lucian (*ibid.*, 110).

2509[D-3] . . . No. 130[F]—Lucretia plunges dagger into her r. breast and faints into arms of female who
Fig. 105 dashes forward to grasp her (p. 32). On l. another in stupified surprise. Bl. ch. 19 by 14.
Alinari 251. Verso: Another study for same subject and an Apollo playing on violin
Fig. 106 (p. 32). *Gaz. d. B. A.*, 1932, i, pp. 180 and 181. The tumultuous draperies suggest the
predella to the scattered polyptych formerly in S. Agostino at Siena dating from 1498
(Dussler, 78-80).

2509[D-4] . . . No. 131[F]—The Sacred Face. Long, perfectly frontal, with hair parted over forehead and
Fig. 93 falling smoothly but in undulations down to shoulders, where it ends in curls (p. 31). Bl. ch.,
water-colour and wh. on brown paper. 24.5 by 20.5. Fototeca 13512. *Gaz. d. B. A.*,
1932, i, p. 175.

This highly elaborate study must be a trifle later than the Boston, Oxford, and Villa-
marina Madonnas, which, along with faint traces of frescoes on the Bell Tower of Città
di Castello, are the earliest extant works of S., when still under Piero della Francesca's

influence, before his apprenticeship to Pollajuolo. The date can scarcely be later than 1475.[1] Although so different, this Head is reminiscent of Piero's Resurrected Christ at Borgo S. Sepolcro, and of his Saviour at Città di Castello. The subject with its variants was curiously popular in the middle decades of the 15th century, particularly in the Low Countries. It would be interesting to know why.

2509D-5 FLORENCE, UFFIZI, No. 133F —Female nude stretched on ground, fainted or asleep, with head and
Fig. 104 shoulders supported between legs of another female nude seated and looking up to r. to third female nude who plucks circular things floating in a basin offered eagerly by satyr. Under last two kneels a youth in attitude of squeezing a sponge into another basin, which rests on ground just above fainted woman's knee (p. 35). Bl. ch. 21 by 24. Fototeca 4131. *Gaz. d. B. A.*, 1932, i, p. 197. Study for a mythological or allegorical composition like the grisaille at the Uffizi (Dussler, 161) and dating from about 1510.

2509D-6 . . . No. 134F —Male nude seen from behind with l. hand on hip, his r. between thighs of limp
Fig. 100 body he is carrying slung over his shoulders (pp. 30, 33, 42). This body is only outlined with the style, while the carrier is highly finished with ink, water-colour, and wh. to imitate pink flesh. On pinkish grey ground. 34 by 18.5. Fototeca 12501. A more plastic version of my 2509H-2 (Fig. 102), partaking more of the qualities and notation of S. as a painter than as a draughtsman.

2509D-7 . . . No. 15817F —Nude stooping on r. foot pointing upward with r. hand and with l. appealingly
Fig. 108 open over thigh (p. 34). Bl. ch. 25.5 by 20.5. Fototeca 12671. *Gaz. d. B.A.*, 1932, i, p. 186. In every probability for Orvieto and possibly for the Resurrection, but to be discovered neither in that nor in any other fresco.

2509D-8 . . . No. 17820F —Madonna seated with head bent in profile to r. with the two Holy Children
Fig. 116 in her lap, embracing (pp. 37-38). Squared for enlarging. Bl. ch. 27 by 21. Verso: Profile head of smooth-faced elderly man looking intently to l. (p. 38). Fototeca 12672 and 12673. *Gaz. d. B. A.*, 1932, i, p. 200 and 198.

Neither the monumental Madonna, manifestly inspired by Leonardo's Virgin with St. Anne, nor the splendid profile occurs in any paintings known to me, yet both are characteristic and typical of S. The profile comes nearest to that of Joseph in the Naples Nativity, where, however, he is younger although bearded. It is even closer to the last head l. in the Morra Deposition (Alinari 4248), but not close enough. The Madonna is closest to the one formerly in the R. A. Benson Collection, almost close enough to have served for a picture of which the Benson Madonna might be an autograph abbreviation.

2509D-9 . . . No. 18708F —Head of youngish woman turned slightly to r. with pupils of eyes rolled up (pp. 38, 43). Bl. and r. ch. 37 by 26. Fototeca 12771. *Gaz. d. B. A.*, 1932, i, p. 199. Nearest to leftmost head in choir of Virgins at Orvieto (Dussler, 88), but probably later.

2509D-10 . . . No. 18709F —Head of young woman with hair in net down to shoulders, turning a little
Fig. 119 to r. to look down (pp. 38, 43). Bl. and r. ch. 35.5 by 24. Fototeca 12772. *Gaz. d. B.A.*, 1932, i, p. 201. Companion to last. Turned around it might almost have served for the St. Eligius at Borgo S. Sepolcro (Dussler, 133) but is certainly later.

2509D-11 . . . UFFIZI, SANTARELLI, No. 224 —Study for Christ at the column. In the lower corner r. the
Fig. 112 monogram that occurs several times on these drawings (p. 37). Bl. ch. 34.5 by 15.5. Fototeca 13149. G. Mancini, *Vita di L. Signorelli* (Florence, 1903), p. 236. *Gaz. d. B. A.*, 1932, i, p. 187.

The nude has an unusually short-looking torso for the length of the legs, resulting in

1. See my "Early Signorelli in Boston," in *Art in America*, XIV (1925-6), pp. 105-117.

some measure from its recoil under the lash. These proportions may have contributed to getting it ascribed to Sebastiano del Piombo. Recognized as S.'s by Mancini, and as for the Flagellation at Morra (Dussler, 5). In the fresco, a work, by the way, of the master's maturest years, executed between 1508 and 1510, the figure was reversed, looking down to our l. instead of to r. and standing on his l. instead of r. foot. In the abbreviated studio variant of the fresco, the Franchetti panel in Venice (Dussler, 162), Christ faces as in this sketch.

2509D-12 THE HAGUE, F. LUGT COLLECTION—Nude in attitude of drooping from the shoulders. Study for the Saviour in the Umbertide Deposition of 1515 (p. 36). Bl. ch. 28 by 18. Dussler, p. XLVII. Popham Cat., No. 100. *Revue de l'Art*, XXVII (1910), p. 338. *Gaz. d. B. A.*, 1932, i, p. 187.

2509D-13 HAARLEM, KOENIGS COLLECTION, Inv. 263—Head of beardless man bending down almost profile r. Nose prominent, chin cleft, mouth open with lower lip curled. Curiously realistic (pp. 35,38). Bl. ch. 9.5 by 9.5. Drouot Sale Cat., May 23, 1928, No. 131, pl. XXVII. Looks in the reproduction as if of the Orvieto period and perhaps for one of the heads there.

2509E LONDON, BRITISH MUSEUM, 1860-6-16-28—Loosely sketched nude in profile r. with head and arms
Fig. 99 in position of one playing the flute, and a female with drapery over l. arm and thigh only, holding a lily and bending her head pensively (p. 31). Bl. ch. 36 by 24. Photo. Macbeth. *Gaz. d. B. A.*, 1932, i, p. 178.

One is tempted to connect this sketch, worthy of the greatest draughtsman, with the Berlin Pan. It is larger and bolder than are the figures in even that composition. Not infrequently artists in moments of inspiration dash ahead of themselves, so to speak, by decades and land in mid-career of their successors. Thus, in some ways the contours and handling of this sketch anticipate the ageing Michelangelo. The inscription in the lower l.-hand corner is probably by Baldinucci and reads "di Pier di Cosimo."

2509E-1 1860-6-16-93—Three horsemen, the central one shaded, the others in outline only (p. 37). Bl. ch. Pricked for transfer. 34 by 27. Photo. Macbeth. Ottley, opp. p. 17. Same kind as the horseman in the Morra fresco of the Crucifixion (Dussler, 6) and like that from the later years of the master, toward 1510.

2509E-2 1885-5-9-40—Four male figures, the one leftmost fully draped and in profile r. looking up, the one next turning to last, and naked below waist, the other two nude, one shading his eyes (pp. 31, 43). Bl. ch. Squared as is for enlarging and pricked for transfer. 34 by 25.5. Photo. Macbeth. *Gaz. d. B. A.*, 1932, i, p. 176.

The attitude and expressions as well as the perspective suggest an Ascension or Assumption. The pricking may indicate that the composition being of the same scale was intended for a predella or even for an embroidery. Probably soon after 1490. The figure extreme r. is almost the one with the lily in my 2509E (Fig. 99), but reversed, and that is of about the date just proposed.

2509E-3 1885-8-9-41—Four figures illustrating opening of 33rd canto of Dante's *Inferno*. The poet and Virgil look down to l. at two nudes, one with his hands tied behind him sitting stretched on the ground, while the other holds the first down by the neck and points to his open skull. The one who is talking is Count Ugolino and the other is the Archbishop Ruggieri (p. 35). Bl. ch. 34 by 25.5. Photo. Macbeth. Vasari Soc., II, xi, 4.

It is usually assumed that the sketch was made for the Dante illustrations at Orvieto. If that is so it would suggest that S.'s first idea—or that of his employer—was to take subjects from the entire Divina Commedia and not, as finally decided, from the Purgatory only. On the other hand, it is possible that this design was done without thought of Orvieto, where, by the way, the compositions are circular or oblong and not, as here,

vertical, and as the too small head of Virgil suggests, at a later date. The Ugolino episode may perhaps be descried in the fresco representing Hell (Dussler, 104) but treated quite differently.

2509E-4 LONDON, BRITISH MUSEUM, 1895-9-15-602—Sketch for the two kneeling shepherds, for the one
Fig. 97 standing over leftmost, and for an angel in the Mancini Nativity now in the N. G. (Dussler, 48) painted in 1496 or later (p. 32). Bl. ch., squared for transfer, some of the squares crossed diagonally. 28 by 34. Photo. Macbeth. *Gaz. d. B. A.*, 1932, i, p. 179. Verso: Kneeling bishop.

2509E-5. . . . 1895-9-15-807—Male nude accompanied by slightly draped female expatiates on "Father Time" who pushes a satyr down to the ground with his l. hand while pointing upward with his r. Between the male and female peeps a face sparkling with curiosity. Pen, bistre and wash. 21 by 18. O. Kurz, *O. M. D.*, XI (1937), pl. 9. Framed by Vasari as a Carpaccio.

The types, the proportion, the spirit are so Signorellesque that the only excuse for questioning that it is by Signorelli himself is that the touch is rather niggling. Yet it is far too good to be by any of his followers and I venture to believe that it is his autograph, done probably about 1510 and for a series of mythological and allegorical scenes of which we have another example in my 2509D-5 (Fig. 104).

2509E-6. . . . 1901-4-17-28—Fragment with face of middle-aged man looking down in profile r. (p. 38). Bl. ch. 15 by 18. Photo. Macbeth. After 1500. Perhaps for an Adoration of the Shepherds.

2509E-7. . . . EARL OF HAREWOOD—Four horned male nudes, striding along to r. The foremost turns to the others as he holds up half-open book at arm's length. They seem surprised and stare at the pages, the hindmost adjusting glasses to his nose (pp. 35-36). Bl. ch. 35 by 29. Vasari Soc., II, iii, 1. Popham Cat., No. 97. Dussler, p. XLI. *Gaz. d. B. A.*, 1932, i, p. 193. No doubt devils intended for the Orvieto frescoes, where, however, this group does not occur. Was it perhaps for Dante illustrations?

2509E-8. . . . MRS. SELWYN IMAGE (now deposited in B. M.)—Fleshy nude seen from behind dragging himself along with bent back and l. hand pointing upwards (p. 34, 34, note). Bl. ch. 26 by 14. Vasari Soc., I, vi, 8. *Gaz. d. B. A.*, 1932, i, p. 186.

Ascr. to Timoteo, but same hand as my 2509D-7, 2509E-9 (Figs. 108, 109) and 2509H-9, and imagined turned round almost identical with the first of these numbers and in treatment with the last. The resemblances in action to the guard in the foreground l. of Raphael's Liberation of Peter (Gronau, *Raphael*, in *Kl. d. K.*, p. 97) can have no bearing on the attribution. It probably was done in connection with the Orvieto frescoes, perhaps for the Resurrection of the Dead.

2509E-9. . . . OPPENHEIMER COLLECTION (formerly), No. 328—Male nude in turbanlike cap, leans over to l.
Fig. 109 with both hands on staff and looks to r. (p. 34). Bl. ch. 30 by 20. *Gaz. d. B. A.*, 1932, i, p. 183. Oppenheimer Sale Cat., pl. 46. Perhaps for the Resurrection at Orvieto. This kind of drawing has been at times attributed to Timoteo Viti and even the youthful Raphael, but is far too accomplished for the first, and too hard for the second.

2509E-10 . . . MESSRS. THOMAS AGNEW & SONS—Youthful athletic nude seen from behind, head in just less than profile l. with arms and legs in position of one about to hurl something. Bl. ch., wash, and wh. 28 by 18. Repr. Cat. Gustav Nebehay, Berlin, IV (1930), No. 153.

I have not seen the original. The pose suggests a figure for a Stoning of Stephen and the technique, the modelling, and the proportions point to the Orvieto frescoes. Perhaps it was intended for a predella to an altar-piece done during those years, and possibly for an episode in the fresco recounting the Misdeeds of Antichrist (Dussler, 90). The figure that comes closest is the soldier in the End of the World (*ibid.* 96, 97).

2503E-11 LONDON, MOND COLLECTION—Male figure stretched out on ground. Bl. ch. 14.5 by 26.5. Mond Cat., pl. xlii.

2509F NEWPORT (R. I.), JOHN NICHOLAS BROWN COLLECTION—Nude bust of young man with head thrown
Fig. 94 back and mouth open as if in ecstasy. Bl. ch. on brown paper. 22 by 17. Sotheby Sale Cat., May 22, 1928, No. 89. Undoubtedly for the Orvieto frescoes and probably for the head of a youth forming a group with a woman embracing another man, just under r. foot of trumpeting angel l. in the fresco of Resurrection (Dussler, 98). Perhaps reminiscent of Perugino, as was more than one other S. drawing of this period.

2509G NEW YORK, MR. ROBERT LEHMAN—Profile bust of man in advanced middle years looking down to l. with mouth half open as if in surprise. Probably for a Nativity dating from the first decade of 16th century. Originally bl. ch. and pricked but gone over with ink by later hand.

2509G-1 OXFORD, ASHMOLEAN MUSEUM, R. 35—Horseman charging to l. bending down in profile with r.
Fig. 117 arm in position of brandishing sword, his l. hidden by buckler, a cloak fluttering from his shoulder (pp. 39-40). Sp. and wh. on egg-shell grey ground cut close to outlines and stuck onto brown paper. 26 by 23. Photo. Museum. *Gaz. d. B. A.*, 1933, ii, p. 281. For a St. George, but neither for the fresco grisaille at Orvieto nor for the panel in the Vom Rath Collection, Amsterdam. Probable date 1505-1510.

2509H PARIS, LOUVRE, No. 1870, 45—Two youthful nudes, one supporting himself on r. knee and hand with his l. to his head, and the other facing him but sprawling on ground with l. leg tucked under r. (p. 34). Bl. ch. 14 by 21. Arch. Ph. Fischel, fig. 327. *Gaz. d. B. A.*, 1932, i, p. 196.

Apparently for the Resurrection of the Dead at Orvieto (Dussler, 98), where we find figures closely resembling these although not identical with them. In quality this drawing recalls my 2509E-9 (Fig. 109), formerly in the Oppenheimer Collection, and like that suggests Timoteo and even more Raphael.

2509H-1 . . . No. 342—Apostle or other saint standing as if suddenly turning to r. with head bent back
Fig. 103 in sharp profile, and hands folded over chest. Attitude and gesture express surprise but contemplative, perhaps happy, certainly not indignant (p. 32). Bl. and r. ch., and wh. pricked and squared for enlarging or transfer. 46.5 by 25.5. Alinari 1570. Popham Cat., No. 96. K. Clark, *Burl. Mag.*, LVI (1930), p. 183. *Gaz. d. B. A.*, 1932, i, opp. p. 208.

The size and the pricking for transfer suggest a smallish picture. It is possible it was squared for enlarging not by the master at the time but afterwards by assistants who used it for an altar-piece. Perhaps earlier than the frescoes at Monte Oliveto and Orvieto, possibly for some such painting as the Urbino Crucifixion or Pentecost, or the Berlin Meeting of the Two Holy Families (Dussler, 46, 47, 81).

2509H-2 . . . No. 347—Male nude seen from behind with l. hand on hip and r. around l. thigh of limp
Fig. 102 naked body that he carries slung over his shoulders (pp. 33, 42). Water-colour and wh. on greenish grey ground. 35.5 by 25.5. Braun 62142. Alinari 1572. *Gaz. d. B. A.*, 1932, i, opp. p. 204.

For the frescoes at Orvieto, where the limp body turned around and the shoulders only of its bearer appear in the lower r.-hand corner in the composition of the Damned (Dussler, 102). My 2509D-6 (Fig. 100) is a study for a similar one. There is another sketch of the same nature in Berlin. In quality the painting nearest to this nude is the figure taking off his shirt in the fragment of the Baptism now in the Cook Collection, Richmond (Dussler, 76).

2509H-3 . . . No. 1794—Four nudes. On r. two males, one vociferating and the other with his hand
Fig. 111 on the shoulder of the first trying to calm him. On l., one female dragging another away from the males. Extreme r. a huge mask with slanting eyes and small mouth. Landscape

with near and low skyline. The monogram lower l. is interesting (p. 35). Bl. ch. 29.5 by 37. Arch. Ph. Alinari 1569. Popham Cat., No. 99. Ede, 56.

No doubt for Orvieto frescoes, and for the Misdeeds of Antichrist rather than the Damned, but occurring in neither. Curiously reminiscent of the nudes in my 1925 and 1949. Is it only a coincidence? Seldom does S. come so close as here to Pollajuolo.

2509[H-4] PARIS, LOUVRE, No. 1795—Two saints heavily draped, both to l. Bl. ch. height. with wh. and touched with red. 39 by 35.5. Arch. Ph. Alinari 1567. Van Marle, XVI, p. 104. One of these figures was done for a Francis and the other perhaps for a Joseph in some such altarpiece as the one of 1491 at Volterra (Dussler, 44) but of slightly later date.

2509[H-5] . . . No. 1797—Male nude to l. with hands joined above head in posture of person about to Fig. 113 strike with lash or whip. In upper corner r. small sketch for same. The monogram below to r., if we may judge by the stroke, must have been added later (pp. 36, 37). Bl. ch. 41 by 25. Braun 62140. Alinari 1568. Meder, *Handz.*, fig. 166. *Gaz. d. B. A.*, 1932, i, p. 191.

For an executioner in a Flagellation, a subject occurring a number of times in S.'s extant paintings from the early masterpiece in the Brera to the late composition at Altenburg (Dussler, 4, 174). This drawing must have been done for the fresco at Morra (*ibid.*, 5, c. 1510), where it appears with little change in action and none in proportion. In the abbreviated version of the same design, the panel in the Franchetti Collection at Venice (*ibid.*, 162) this nude is not omitted.

2509[H-6] . . . No. 1798—Magdalen heavily draped stands with head bent a trifle to our r. and looks down, Fig. 114 holding vase in her r. hand and with l. the folds of her mantle (p. 37). Bl. ch. 35.5 by 21.5. Squared for enlarging. Alinari 1571. *Gaz. d. B. A.*, 1932, i, p. 192.

Close to the Magdalen of 1504 at Orvieto (Dussler, 127), but there are significant differences in spirit, in action, and in draping, the painting suggesting something at once more Peruginesque and more provincial.

2509[H-7] . . . No. 1799—Two male nudes, one with hand on his l. hip turning his head to his l. while the other in profile r. faces him coaxingly with his l. arm already over the r. shoulder of the first. This nude's feet and legs cast shadows to our l. diagonally across the ground (p. 36). Bl. ch. squared for enlarging. 41 by 26.5. Ede, pl. 58. Braun 62141. Alinari 1566. *Gaz. d. B. A.*, 1932, i, p. 193. Van Marle, XVI, p. 106. Probably for the Resurrection at Orvieto, representing one fully awake trying to persuade another who is not yet aware of his bliss. The exact group does not occur, but perhaps the man and woman embracing (middle distance r.) has taken its place.

2509[H-8] . . . No. 1800—Design for tumultuous group of horsemen surrounding the cross, of which only the lower shaft is visible with the Magdalen embracing it, and below the group of the Virgin in a faint attended by three women (pp. 37, 43). Bl. ch. gone over with ink, squared for enlarging. 50.5 by 83. Arch. Ph.

This can be only one of two things: an original design for the Morra fresco of about 1510 (Dussler, 6) or a later copy of such a sketch. The ink with which this later hand retouched the initial chalk lines has so effaced or disguised these lines that they no longer bear clear witness to the hand that drew them. In every probability it was S.'s own.

2509[H-9] . . . ÉCOLE DES BEAUX-ARTS—Youthful nude almost in profile r. with l. hand held out and r. on hip, looks up as if shouting (pp. 34; 34, note; 35, note). Bl. ch. 33.5 by 18.5. Braun 65017. *Gaz. d. B. A.*, 1932, i, p. 190.

Possibly for the Crowning of the Blessed at Orvieto (Dussler, 105), foreground r. and l. and in the style of my 2509[H]. It, however, is much vaguer as well as softer than that drawing, softer in a Raphaelesque way and nearest to drawings by Timoteo Viti.

2509H-10 PARIS, M. E. RODRIGUES COLLECTION (sold Hôtel Drouot, Nov. 28 and 29, 1928), No. 212—Head of youngish man, three-fourths to l., slightly leaning forwards (pp. 35, 38). Bl. ch. 12.5 by 9. Sale Cat., pl. XXXV.

> Known only in this poor reproduction, but seems probable, and of kind attributed by some to Timoteo Viti. If authentic, it is of the Orvieto period and perhaps for one of the heads there, although I have not succeeded in identifying it.

2509H-11 . . . MONSIEUR MARIGNANE—Young man with curly locks standing in profile l. wearing heavy
Fig. 118 mantle, which he holds up with folded arms. Below reclining head of sleeping young woman (pp. 40-41). Bl. ch. 38 by 21.5. *Gaz. d. B. A.*, 1933, ii, p. 282. Resembles the woman on the r. in the N. G. Circumcision (Dussler, 45) although it was scarcely intended for that figure. Undoubtedly both are of the same date, say 1486-8.

2509I STOCKHOLM, PRINT ROOM, Inv. 9—Head of youth with long curls falling down to shoulders, mouth
Fig. 95 open, and eyes turned up in ecstasy (p. 31). Bl. ch. on yellowish paper. Pricked for transfer. 25 by 24. Schönbrunner & Meder 1051. Dussler, p. XIX. *Gaz. d. B. A.*, 1932, i, p. 173. For John the Baptist in Perugia altar-piece of 1484 (Dussler, 40).

2509J WINDSOR, ROYAL LIBRARY—Two male nudes wrestling, one lifting the other from ground by midriff,
Fig. 101 and the other struggling to get free and choking (p. 31). Bl. ch. Braun 79177. *Gaz. d. B. A.*, 1932, i, p. 177. Motive and treatment Pollajuolesque. Perhaps toward 1490. Close analogies with Volterra altar-piece of 1491 (Dussler, 43, 44).

School of Luca Signorelli

2509K CHANTILLY, MUSÉE CONDÉ, No. 22—Demon hurling himself on prostrate nude whose head he seizes between his hands. Corresponds to the group in lower corner r. in fresco of the Damned at Orvieto (Dussler, 100). A nude falls on his l. leg while his hands are being tied behind. Occurs, in same fresco, in almost middle of foreground. Bistre and wh. on blue-grey paper. 19 by 25. Braun 65018. Lower l.-hand corner has the letters T. V. in square advanced 16th century hand. Copies after the fresco rather than of drawings for it, almost contemporary, perhaps Umbrian.

2509K-1 CHELTENHAM, FITZROY FENWICK COLLECTION—Head in profile to l. looking down slightly (pp. 42-43). Bl. ch. 30 by 16.5. *Gaz. d. B. A.*, 1933, ii, p. 287. On the back in rather childish scribbling: "Carisimo Padre, carisimo ed amatissimo" and similar inscriptions.

> Might have served for a Visitation like the one in Berlin (Dussler, 81), but occurs repeatedly in S.'s works of the first decade of 16th century, e. g. Urbino Crucifixion (Dussler, 46), Orvieto (*ibid.*, 105), Cortona (*ibid.*, 124). A good pupil of those years could perhaps have achieved enough mastery to approach the teacher as closely as here, before sinking into provincial mannerisms, like the Papacello Prof. Salmi not long ago brought to our notice (*Boll. d'A.*, 1923, pp. 167 *et seq.*).

2509K-2 . . . Copy of central group in Orvieto Resurrection (p. 43). Pen over an incised outline on the l.-hand group, over a pricked outline on the r. Underneath, studies of base of column in r. ch. 28.5 by 41.5. *Gaz. d. B. A.*, 1933, ii, p. 288. Similar in quality to my 2509N-1.

2509K-3 . . . Copy representing the fresco painted by Signorelli about 1512 for the Petrucci Palace,
Fig. 121 Siena (pp. 43-45). Bistre. Ruined by damp and outlines gone over, also some heightening with wh. added later. 29 by 37. *Gaz. d. B. A.*, 1933, ii, p. 290. Fenwick Cat., pl. XIV.

2509L FLORENCE, UFFIZI, No. 132F—Monumental Madonna seated by window under canopy with head bending down profile l. over Child, Who sits on her r. knee sucking at her breast. Pen. 26.5 by 20. Fototeca 13144. In type and feeling it comes nearest to the woman listening

to the preaching of Antichrist (Dussler, 91). Verso: Horseman brandishing scimitar. Poor mid-Cinquecento copy but valuable as record of a great lost picture painted about 1500.

2509M LILLE, Musée Wicar, Nos. 507 and 508—Various school-boy copies after S.: Madonna seated amply draped bending over the naked Child in her arms—after some fairly early work of the master. Two sketches for youthful Baptist, one with angular draperies as in the Loreto frescoes and slightly later in N. G. Circumcision (Dussler, 45). Whirling half-draped figure suggesting one of the angels in the cupola of the sacristy at Loreto (*ibid.*, 7-13). Pen. 30 by 23. Braun 72016 and 72017. Verso: Copies of three nudes in startled attitudes, after originals done no doubt for Orvieto, and more particularly for the End of the World (*ibid.*, 96, 97). I cannot identify the other sketches on the recto. One however, the profile of a youth wearing a broad starched collar, is obviously of the 17th century and leads to the question whether the whole sheet is not of the same period.

2509N LONDON, British Museum, Malcolm, No. 164—Demon hurls himself on a nude who falls on one knee howling, with his r. hand to his ear (p. 33). Bistre-shaded drawing with the point of the brush on light brownish yellow prep. ground. 35.5 by 23.5. Braun 65016. *Gaz. d. B. A.*, 1932, i, p. 185. Copy of study for two figures in foreground l. in fresco of the Damned at Orvieto (Dussler, 100). The original must have been of the elaborate, rather delicate quality of my 2509H-2 (Fig. 102). This almost contemporary copy looks fairly exact.

2509N-1 . . . Nos. 166 and 167—Two fragments of design for Flagellation—seven figures in all (p. 37). Bl. ch. 32 by 23 and 32 by 28. Photos. Macbeth. Both spoiled by pricking and in outline only so that it is hard to do justice to these figures. They probably were never more than copies nearly contemporary, of an original drawing by S. himself for the Flagellation of about 1510 at Morra (Dussler, 5).

2509O MUNICH, Print Room, No. 3070—Nude with hair curling down to his shoulders walks with eyes closed as in trance to l. with r. arm held up and a ribbon caught and held in his hands (p. 38). Ink over bl. ch., squared for transfer. 27 by 15. *Gaz. d. B. A.*, 1932, i, p. 203.
Perhaps this was to begin with by S, and a fine performance with Pollajuolesque pen contours. The later hatching makes it hard to decide. It is perhaps a trifle too elegant, too Peruginesque for S. Nevertheless, there is great resemblance to such a nude as the one on the extreme l. in the Orvieto Crowning of the Blessed (Dussler, 105).

2509P NEW YORK, Morgan Library—Nude seated on ground from l. to r. but facing us, and with his l. hand at arm's length grasping staff. Bl. ch. 17.5 by 20. Morgan Dr., I, pl. 13. Ascr. to Timoteo, whose name in 18th century hand appears in lower l.-hand corner. Close to the other drawings ascribed to Timoteo which we attribute to S., but the lighting and the stroke seem to betray the hand of a deliberate imitator.

2509Q PARIS, Monsieur Marignane—Draped middle-aged man turning away to r. Bl. ch. 21.5 by 8. Close to S. in his last phase and perhaps by Papacello.

2509R WASHINGTON CROSSING (Pa.), F. J. Mather Collection—Profile to r. of young man wearing round cap with soft crown. Bl. ch. and wash.

Sogliani (pp. 164-165)

2509S (former 2739) AMSTERDAM, HESELTINE AND RICHTER SALE (Müller, May 27-28, 1913), No. 360—Portrait of sentimental youth resting head on r. hand. Bl. ch. 37 by 26. Repr. Sale Cat., pl. 54, as Raphael.

2509T BELLINGHAM-SMITH SALE (Müller, July 5-6, 1927), No. 150—Head of young woman turned to l. with eyes bent down. Bl. ch. 26.5 by 20. Repr. Sale Cat. as Fra Bartolommeo.

2509T-1 BAYONNE, BONNAT MUSEUM—Study for full-length St. Anthony of Padua. Bl. ch. Arch. Ph. The pose seems Umbrian, but S. is eclectic enough to have felt Perugino's influence.

2509U No. 1360—Study for Christ Crucified seen from back in profile to r. Bl. ch. 30.5 by 17. Arch. Ph.

2510 BERLIN, PRINT ROOM, No. 5549—Cartoon for Child in the Madonna by S., absurdly ascr. to P. del Vaga, in the Cathedral at Pisa (Alinari 8861). Bl. ch. 22 by 15.5.

2510A PRINT ROOM, No. 5119—Charming head of young woman, slightly inclined to r. R. ch. on pink paper, later touched up with wh. 18 by 24. Attr. to Gerino da Pistoia.

2510B No. 5133—Full-length figure of youth turned to r. and holding book with both hands. Bl. ch. 37 by 16.5. Berlin Publ., 34. Attr. to Andrea del Sarto.

2510C BESANÇON, MUSEUM, D. 1003—Copy of Fra Bartolommeo's St. Bartholomew in the Uffizi Marriage of Catherine (Gabelentz, I, fig. 11). Pen. Photo. Festas. I owe acquaintance with this and the following sheet to Mr. A. E. Popham of the B. M.

2510D D. 1041—Two studies for drapery over knee of seated figure. Bl. ch. Photo. Festas. Very close to Credi in quality, yet obviously later and therefore very likely by S.

2510E CAMBRIDGE (Mass.), FOGG MUSEUM—Study for full-length St. Anthony of Padua. Bl. ch. Verso: Faint sketches for two full-length saints, the one to the r. gone over later with ink. Inspired by Perugino.

2510F FOGG MUSEUM, PAUL J. SACHS COLLECTION—Ornamental sketch for winged *putto* holding up baldachin with both hands. Sp. on grey prep. paper. 19 by 13. Verso: Scribble for nude over architectural drawing for a window or niche. R. ch.

2510G FOGG MUSEUM, LOESER BEQUEST, No. 150—Sketch of baby's head turned and slightly inclined to l. Bl. ch. 19.5 by 18. Vasari Soc., I, iv, 4. *L'Arte*, 1910, opp. p. 393.

2510H No. 136—Profile of middle-aged close-shaven man with soft cap turned lo l. looking down. Bl. ch. and wh. on pink prep. paper. 25 by 23.

2510I EDINBURGH, NATIONAL GALLERY, PRINT ROOM—Two studies for Madonnas: one seated in profile to r. with the Child nestling up to her (cf. my 2531 and 2755C). The other standing in slight *contrapposto* and holding up the Child on a pedestal. Sp. and wh. 13 by 13. Photo. Museum. The standing Madonna looks like a sketch for the Madonna in the Cathedral of Pisa.

2511 FLORENCE, UFFIZI, No. 81E—Head of youth with long hair (p. 165). Sp. and wh. 19 by 14.
Fig. 465 Brogi 1642. Ascr. to Credi, but the features, the hair and the smoothness betray S., of course in his earliest phase.

2512 FLORENCE, Uffizi, No. 83^E—Head of girl. Companion to my 2511. Sp. and wh. 19 by 13. Brogi 1641.

2513 (see 1852^B)

2514 No. 281^E—Female figure with dish in hand. Bl. ch. 28.5 by 21. Ascr. to Andrea del Sarto, and supposed to be a study for the Salome in the Decapitation of the Baptist at the Scalzo, but really a free copy after that figure. The look and the handling point to S.

2514^A No. 336^E—Young woman in billowing draperies walking towards l. Pen. 18.5 by 11.5. Undoubtedly inspired by the antique.

2515 (see 2543^A)

2516 (see 2545^A)

2517 (see 2545^B)

2518 (see 2548^A)

2519 No. 434^E—Study for drapery of figure kneeling to l., the head, l. shoulder and arm slightly indicated. Umber and wh. on linen. 28 by 19. Brogi 1869. E. Jacobsen, *Jahrb. Pr. K. S.*, 1904, p. 188.

It is ascribed to Leonardo, of whose quality it has nothing. The folds might tempt one to give this sketch to Granacci, but a comparison with the kindred sheet by S. in the Malcolm Collection (my 2732) obliges us to assign it to the same master. [An early drawing, under the influence of Credi and the earlier works of Fra Bartolommeo.]

2520 (see 2551^A)

2521 No. 440^E—Head of man almost in profile to l. Sp. and wh. on pinkish ground. Diameter 15 cm. Brogi 1623. Ascr. to Leonardo, but the types, the ear, and the expression prove that it is S.'s.

2522 No. 460^E—Head of child (p. 165). Bl. ch. 19 by 17. Brogi 1444. Ascr. to Fra Bartolommeo, but the large eyes, the ear and the modelling suffice to establish that it is by S. [Verso: Draped male figure.]

2523 No. 461^E—Head of young woman. Bl. ch. 20 by 17. Alinari 48. Uffizi Publ., IV, iv, 11. Ascr. to Fra Bartolommeo.

2524 No. 551^E—Sketch for ciborium, probably study for the design in my 2723^A, and, like that, ascribed to Albertinelli. R. ch. 22 by 17. Brogi 1719.

2525 No. 553^E—Visitation (p. 165). Study for the Standard at S. Niccolò al Ceppo, inspired by the famous picture of Albertinelli, to whom, therefore, this is ascribed. R. ch. 25 by 22. Braun 76001. Pl. 137 of Schönbrunner & Meder. [Venturi, IX, i, p. 366.] Verso: Christ in the Garden, a note after Perugino's picture in the Florence Academy.

2526 No. 554^E—Madonna seated with infant John. Pen. 19 by 9. Brogi 1826. Ascr. to Albertinelli, but the spirit and the stroke are S.'s. [Seems like the echo of a late composition of Leonardo's.]

2527 No. 592^E—Madonna with infant John (p. 165). Bl. ch. and wh. 30.5 by 34.5. Pricked
Fig. 467 for transfer. Alinari 1. Catalogued as "Scuola Lombarda," for which, except possibly in the children, there is no justification. To me it seems most probably S.'s. The Madonna's entire figure and the landscape are clearly his.

2527A FLORENCE, UFFIZI, No. 623E—Head of woman facing front. Bl. ch. 25.5 by 23. Photo. Mannelli. Close to Fra Bartolommeo.

2528 (see 2723A)

2529 No. 643E—Draped figure of monastic saint, with book in r. hand. R. ch. 22.5 by 15. Braun 76398. Inspired by Andrea del Sarto, to whom it is ascribed.

2530 No. 1166E—Angel pulling aside curtain. Bl. ch. 18.5 by 14. Ascr. to Filippino, but more probably by the young S.

2531 No. 1198E—Madonna seated in profile to l. holding the Child. Ascr. to Credi. Sp. and wh. on bluish grey paper. 17 by 13.5. Brogi 1895. [Fototeca 7722. E. Sandberg Vavalà, *Burl. Mag.*, LV (1929), p. 5. Other versions of this are at Edinburgh and in the Albertina (see my 2510I and 2755C).]

2532 No. 1200E—Life-size profile to l. of middle-aged man. Sp. on purplish ground. 29 by 21.5. Ascr. to Credi, but perhaps an early S.

2533 No. 1266E—Study for youngest of the Magi receiving chalice from kneeling servant, in S.'s Adoration at S. Domenico di Fiesole. Bl. ch. 29.5 by 13.5. Brogi 1946. Ascr. to Fra Bartolommeo.

2534 No. 1268E—Study of monk standing in profile to l. Bl. ch. and wh. 30 by 16. Brogi 1960. Ascr. to Fra Bartolommeo.

2535 No. 1272E—Rapid sketch for Madonna with infant Baptist playing at her feet. Bl. ch. and wh. 15 by 9. Brogi 1439.

2536 No. 1783E—Full-length figure of St. Dominic. Bl. ch. and wh. 1 m. 66 by 98. Ascr. to Fra Bartolommeo.

2537 (see 2564A)

2538 (see 2564B)

2539 No. 184F—Head of cherub. Sp. and wh. on buff ground. Oval, 10 by 8. Ascr., like the next, to Credi, but like that a study for a head in the Academy Conception.

2540 No. 188F—Head of cherub. Sp. and wh. on buff ground. 10.5 by 9. See the last.

2541 No. 213F—Christ with Precious Blood. Bl. ch. 31 by 21.5.

2541A No. 290F—Head of woman with kerchief. Bl. ch. 29 by 26. Very close to the Madonna attr. to Pierino del Vaga in the Cathedral of Pisa.

2542 No. 342F—Head of youngish woman looking to l. R. ch. 28 by 20. [Photo. Mannelli.] Formerly ascr. to Raphael, and now to Andrea, but obviously S.'s.

2543 No. 351F—Head of young woman looking down with eyes almost closed. Bl. ch. 24 by 28. [Gabelentz, II, pl. 40.]

2543A (former 2515) No. 354F—Profile head of youth, looking up to l. Ascr. to Fra Bartolommeo, but S.'s forms and smoothness. Bl. ch. 22 by 19. Alinari 237. [Gabelentz, II, pl. 13. Cf. with the much later S.'s, for instance, my 2564B.]

2544 No. 355F—Full-face head of youth. Bl. ch. Ascr. to Fra Bartolommeo.

2545 FLORENCE, Uffizi, No. 375ᶠ—Head of young woman almost in profile to l. Bl. ch. 39 by 28.5. Ascr. to Fra Bartolommeo.

2545ᴬ (former 2516 and 223) No. 377ᶠ—Bust of youngish woman (p. 165). Bl. ch. and wh. 40 by 29. Alinari 353. [Uffizi Publ., II, ii, 6.] Good, and very close to Fra Bartolommeo, to whom it is attributed; but compare this with the head of the Madonna in the Duomo at Pisa.

2545ᴮ (former 2517) No. 392ᶠ—Head of child. Ascr. to Fra Bartolommeo. Bl. ch. 17.5 by 13.5. Alinari 19. [Gabelentz, II, pl. 41.]

2545ᶜ (former 2545ᴬ) No. 423ᶠ—Study for shepherd in a Nativity. Bl. ch.

2546 (see 1857ᴮ)

2547 No. 427ᶠ—Study for prophet. Bl. ch. and wh.

2548 No. 428ᶠ—Portrait head of oldish bearded man, wearing flat cap. Bl. ch.

2548ᴬ (former 2518) No. 429ᶠ—Head of man in profile to l. Bl. ch. on brown paper. 21 by 16.5.

2549 No. 430ᶠ—Half-nude male with cup in hand. Bl. ch. 40 by 22.

2550 No. 431ᶠ—Madonna with infant John. Bl. ch.

2551 No. 432ᶠ—Head of child. Bl. ch.

2551ᴬ (former 2520) No. 434ᶠ—Three women seated, and child. Bl. ch. 17 by 20.

2552 No. 439ᶠ—Head of Saviour. Bl. ch. 24.5 by 15.

2553 No. 1336ᶠ—Portrait head of youngish woman, turned somewhat to l. Catalogued as "Scuola Umbro-Romana." Bl. ch.

2554 No. 6449ᶠ—Cartoon for St. Francis, almost in profile to l., with his r. hand to his heart. Bl. ch. 81.5 by 38. Close to Andrea.

2555 No. 6452ᶠ—Kneeling saint in profile to l. Bl. ch. Slight and close to Andrea, to whom it is attributed.

2556 No. 6617ᶠ—Oblong composition with some forty figures, representing perhaps the Miracle of Loaves and Fishes. Bl. ch. squared for enlarging. 26.5 by 66.5.
 Until now ascribed to Pontormo. No wonder! for the touch is singularly free, and the types have the elegance of Rosso. Indeed, this design must have been made under the inspiration of the last-named artist.

2556ᴬ No. 6663ᶠ—Study for Madonna with the two Children. Bl. ch. gone over with r. ch. 40 by 27. Verso: Nude male seen from the back. Inspired by Michelangelo's cartoon of the Bathers, and not necessarily by S. Bl. ch. Fototeca 4365.

2557 No. 6761ᶠ—Sketches for Annunciation. Bl. ch. and wh.

2558 No. 6762ᶠ—Draped female kneeling, facing front. Bl. ch. and wh.

2559 No. 6763ᶠ—Study for Madonna in Annunciation. Bl. ch. and wh.

2560 No. 6764ᶠ—Elegant youngish woman kneeling, looking to l. and pointing to r. Bl. ch. Very close to Fra Bartolommeo.

SOGLIANI

2561 FLORENCE, Uffizi, No. 6765F—Draped woman seated on her heels, study perhaps for Miracle of Loaves and Fishes. Bl. ch. and wh. See my 2556.

2562 No. 6766F—Man standing in profile to l., touching a book with his r. hand and pointing upward with his l. Bl. ch. and wh.

2563 No. 6767F—Study for Virgin in Visitation at S. Niccolò al Ceppo. Bl. ch. and wh.

2564 No. 6768F—Portrait head of man (p. 165). Coloured ch. 28 by 21.5.

2564A (former 2537) No. 6769F—Head of bearded man. Bl. ch. 26 by 17. Alinari 44. [E. Jacobsen, *Jahrb. Pr. K. S.*, 1904, p. 191.] Late and poor.

2564B (former 2538) No. 6770F—Head of young man in profile to l. Bl. ch. and wh. on yellowish paper. 25.5 by 19.5. Alinari 30. Study from the life for the St. Bernard in the Conception, formerly at the Gallery of S. Maria Nuova, and now in the Academy. Cf. my 2543A.

2565 No. 6771F—Study for half-nude figure in profile to l. in Crucifixion of S. Arcadius (1521), now at S. Lorenzo. Bl. ch.

2566 No. 6772F—Study for Resurrected Christ. Bl. ch. and wh.

2567 No. 6773F—Madonna seated, fondling Child. R. ch.

2568 No. 6774F—Madonna for Annunciation. Bl. ch.

2569 No. 6775F—Study of saint with book. Bl. ch. and wh. Verso: Sketch for Dead Christ. R. ch.

2570 No. 6776F—Head of bearded man. Bl. ch. and wh. 24.5 by 21.

2571 No. 6777F—*Putto*, and an arm. Verso: *Putto*. Bl. ch.

2572 No. 6778F—Almost life-size bust of youngish woman. Bl. ch.

2573 No. 6779F—Head of bearded man. Bl. ch.

2574 No. 6780F—Head of man with long hair. Bl. ch.

2575 No. 6781F—Head of man in profile to l. Bl. ch.

2576 No. 6782F—Study of head, probably for St. James in the Madonna with that saint, St. Anne and another saint in S. Spirito at Prato. Bl. ch.

2577 No. 6783F—Six figures in procession, four of them in long robes. R. ch.

2578 No. 6786F—Head of old man for the St. Nicholas at S. Niccolò al Ceppo. Bl. ch.

2579 No. 6789F—Ecclesiastic standing in profile to l.

2580 No. 6792F—Study for drapery of kneeling St. Jerome. Torso and arms left bare. Bl. ch. and wh.

2581 No. 6793F—Draped male figure in profile to r., with hands in attitude of surprise. Bl. ch.

2582 No. 6794F—Study for Baptist. Bl. ch.

2583 No. 6796F—Saint with book and staff. Study for the St. James in the Trinity with that saint, the Magdalen and St. Catherine in the Academy (No. 4647). Bl. ch.

2584 FLORENCE, Uffizi, No. 6797F—Head of woman. Bl. ch.

2585 No. 6798F—Study of two hands. Bl. ch.

2586 No. 6799F—Reclining nude. Bl. ch.

2587 No. 6803F—Two saints. Bl. ch.

2588 No. 6804F—Man kneeling in profile to l. Bl. ch.

2589 No. 6806F—Annunciation with St. Michael and female saint. Bl. ch.

2590 No. 6814F—Two men seen from behind. Bl. ch. and wh.

2591 No. 6815F—Saint in profile to r. Bl. ch.

2592 No. 6817F—Madonna with the two Children. R. ch., squared.

2593 No. 6818F—Seated draped figure for Washing of the Feet. R. ch. [Verso: Outline of two figures out through: one stooping and one kneeling.]

2594 No. 6821F—Warrior sheathing his sword over prostrate figure. Bl. ch. and wh. on bluish ground.

2595 No. 6822F—Bearded saint in profile to r., holding book. Bl. ch.

2596 No. 6823F—Nude. R. ch.

2596A No. 6828F—Two studies for kneeling saint. Bl. ch.

2597 No. 6830F—Madonna and four saints. Bl. ch.

2598 No. 6831F—Study for St. Bernard in the Conception, formerly at S. Maria Nuova, now in the Academy (No. 3203). Bl. ch. and wh.

2599 No. 6834F—Study of draped torso. Bl. ch.

2600 No. 6835F—Two saints. Bl. ch.

2601 No. 6836F—Saint, in profile to l., pointing up. Bl. ch.

2602 No. 6838F—Kneeling saint in profile to l. Bl. ch.

2603 No. 6839F—Young saint in profile to r. with book in hand. Bl. ch.

2604 No. 6840F—Study for a Baptist. Bl. ch. and wh.

2605 No. 6842F—Kneeling female saint in profile to l., perhaps for a *Noli me tangere.*

2606 No. 6849F—Sketch for portrait of man sitting with folded hands. Bl. ch.

2607 No. 6851F—Three draped figures. Bl. ch. and wh. Verso: Study for a St. Paul.

2608 No. 6853F—Man in profile to l., pointing to his mouth. Bl. ch.

2609 No. 6855F—Saint with book in r. hand. Bl. ch.

2610 No. 6860F—Kneeling male figure in mantle. Bl. ch.

2611 No. 6862F—Cast of drapery.

2612 FLORENCE, Uffizi, No. 14416F —Two rapid sketches for saints. Bl. ch. and wh. on pinkish ground. Verso: Figures in profile to l.

2613 No. 14539F —Shepherd kneeling for Nativity. Bl. ch. Verso: Studies of drapery.

2614 No. 14540F —Draped study for St. James. Bl. ch. and wh. Verso: Figure standing in profile to r.

2615 No. 14541F —Head of child in profile to r. Bl. ch. Verso: Male torso seen from behind.

2616 No. 14542F —Portrait bust of young woman—a study for a saint. Bl. ch. and wh.

2617 No. 14547F —Head of inspired-looking youth. Rather early. Bl. ch.

2618 No. 14548F —Study for kneeling woman, probably Veronica, in Way to Golgotha, now in the Uffizi (No. 3212). Excellent. Cf. my 2702. Bl. ch.

2619 No. 14454F —Study for figure on extreme l. in the S. Marco fresco representing St. Dominic fed by angels. Bl. ch.

 A book filled entirely with drawings by S. They seem to have been pasted onto the leaves of this volume by some person in the seventeenth century who knew them to be S.'s. Otherwise we may be sure that most of them would now be passing as Fra Bartolommeo's. The size of each page is 34 by 23. Most of the drawings fill nearly the whole page. Where no other indication is given they are in black chalk heightened with white on greyish or brownish ground.

2620 No. 16989F —Study for saint with scroll in the Conception formerly at S. Maria Nuova and now in the Academy (No. 3203).

2621 No. 16990F —Study for figure on extreme l. in picture just mentioned.

2622 No. 16991F —Study for third seated figure on r. in the S. Marco fresco representing St. Dominic and his companions fed by angels.

2623 No. 16992F —Study for fourth seated figure on l. in same fresco, and, on a larger scale, the hands.

2624 No. 16993F —Study for first seated figure on l. in same fresco.

2625 No. 16994F —Study for fourth seated figure on r. in same.

2626 No. 16995F —Second on r. in same.

2627 No. 16996F —First on r. in same.

2628 No. 16997F —Fifth on r. in same.

2629 No. 16998F —Second on l. in same. The superiority of this and the preceding figures to the corresponding ones in the painting is noteworthy.

2630 No 16999F —Nude figure. Perhaps study for angel in same.

2631 No. 17000F —Study for young king in profile to l. in the S. Domenico Adoration. Its great superiority to the painted figure may be due to the fact that the picture was not finished by S. but by Santi di Tito.

2632 No. 17001F —Monk almost in profile to l., holding large book to his side.

2633 FLORENCE, Uffizi, No. 17002F—Slender nude draped as with fluttering gauze, pointing upward with l. hand, and to r. with r. hand.

2634 No. 17003F—Study for St. Peter holding up keys in r. hand. He stands in profile to r., and touches a book with his fingers.

2635 No. 17004F—Youngish man with book and lance.

2636 No. 17005F—Study for Baptist.

2637 No. 17006F—Study for Baptist.

2638 No. 17007F—Study from model, of woman kneeling to l., with l. hand to her breast. Quite pleasant.

2639 No. 17008F—Study for St. Bernard in the Conception now in the Academy (No. 3203).

2640 No. 17009F—Draped youthful figure turning to l. but pointing to r.

2641 No. 17010F—Kneeling youngish woman.

2642 No. 17011F—Magdalen kneeling in profile to r.

2643 No. 17012F—Man seated in profile to r. Study from the model for a figure in my 2556.

2644 No. 17013F—Man kneeling in profile to l., reading book.

2645 No. 17014F—Study for Madonna with two youthful saints. The Child separately. Here S. in nearer Credi.

2646 No. 17015F—Madonna and Child, study for the large altar-piece with St. Barbara kneeling in the foreground, in the Cathedral of Pisa (Brogi 2812). Fototeca 4521. Hitherto this picture has passed unquestioned as Pierino del Vaga's.

2647 No. 17016F—Monk kneeling in profile to r.

2648 No. 17017F—Study for third figure on l. in the Conception now in the Academy.

2649 No. 17018F—Youthful draped figure holding book.

2650 No. 17019F—Youthful draped figure with book and scroll.

2651 No. 17020F—Baptist, study perhaps for the large Pisa altar-piece with St. Barbara. R. ch.

2652 No. 17021F—Sketch for Madonna holding Child on pedestal, in the Cathedral of Pisa, where it passes unquestioned as Pierino del Vaga's. R. ch. [Fototeca 2050. G. Bernardini, *Boll. d'A.*, 1910, p. 152.]

2653 No. 17022F—Draped figure with book and scroll.

2654 No. 17023F—Nude in profile to r. in attitude of attack.

2655 No. 17024F—Study of man with r. hand to breast, and l. holding book.

2656 No. 17025F—Study for St. Bernard in the Conception now in the Academy.

2657 No. 17026F—Study for St. Benedict.

2658 No. 17027F—Study for Evangelist in the S. Marco fresco of the Crucifixion.

44

2659 FLORENCE, Uffizi, No. 17028F—Virgin with Child in lap.

2660 No. 17029F—Draped young saint looking to l. and pointing to r.

2661 No. 17030F—Saint facing to l.

2662 No. 17031F—Study for St. John Gualbert.

2663 No. 17032F—Study for foremost nun in the St. Bridget picture, formerly at S. Maria Nuova, and now in the Uffizi (No. 3202). Also rapid sketch after the nude for Bridget herself.

2664 No. 17033F—Study from model for saint kneeling in foreground of a picture, looking toward us and pointing toward Madonna. [Fototeca 4601. G. Bernardini, *Boll. d'A.*, 1910, p. 153, where it is connected with the Adoration of the Magi at S. Domenico.]

2665 No. 17034F—Virgin for Annunciation.

2666 No. 17035F—Draped male saint turning to l.

2667 No. 17036F—Study for saint directly under Virgin in the Conception.

2668 No. 17037F—Female half draped.

2669 No. 17038F—Study for second figure on l. in the Conception.

2670 No. 17039F—Study from nude for the St. George in the large altar-piece with St. Barbara, in the Cathedral of Pisa. [Fototeca 4524.]

2671 No. 17040F—Youthful nude striding, with arms held out. On bluish ground.

2672 No. 17041F—Sketch for Baptism. Small.

2673 No. 17042F ⎫
2674 No. 17043F ⎬—Two very small sketches for Visitation. See my 2525.

2675 No. 17044F—Study for Christ kneeling over basin, for a Washing of Feet. On wh. paper.

2676 No. 17045F—Rapid pen-sketch for the same.

2677 No. 17046F—Baptist pointing to r.

2678 No. 17047F—Study for foremost monk in the St. Bridget picture, now in the Uffizi.

2679 No. 17048F—Study for Madonna in the S. Marco fresco of the Crucifixion. This is drawn over several lines of writing in which occurs the date 1521.

2680 No. 17049F—Baptist kneeling in profile to l.

2681 No. 17050F—Virgin seated on ground playing with Child. Also head of Child in profile to r. Copy of drawing by Leonardo. Pen and wash. 10.5 by 11.5.

2682 No. 17051F—Virgin holding Child, Who turns to l. Repetition of the Child's torso and legs, and the Virgin's arm. Also copy of a drawing by Leonardo. Pen and wash. 10 by 11.5.

2683 No. 17052F—Virgin seated on ground with Child playing between her knees. Copy of a drawing by Leonardo.[1] Pen and wash. 8 by 11.5.

1. The originals of these three last sketches may have been connected with the two Madonnas upon which Leonardo was working at Florence in 1508. The types, particularly of my 2682, resemble such a Madonna of Boltraffio's as the one in the Poldi Museum at Milan.

2684 FLORENCE, Uffizi, No. 17053^F—Draped figure looking down.

2685 No. 17054^F—Study for Madonna with Child standing by her knees, infant John, Joseph, and two music-making angels.

2686 No. 17055^F—Another study for young Mage standing in profile to l. in the Adoration at S. Domenico di Fiesole. See my 2631.

2687 No. 17056^F—Sketch for Madonna seated, with Child caressing infant John. R. ch.

2688 No. 17057^F—Various sketches for children. R. and bl. ch.

2689 No. 17058^F—Kneeling figure in profile to r., perhaps study for kneeling youth in lower left-hand corner of the S. Domenico Adoration.

2690 No. 17059^F—God the Father in midst of cherubs blessing. Sp. and wh. on greyish ground. Early and nearer to Credi than most of the drawings in this volume. Perhaps a study for the Annunciation of S. Maria Nuova, now in the Innocenti Chapel, still ascribed to Albertinelli.

2691 No. 17060^F—Angel in profile to r., being a study for the St. Dominic fed by angels in the fresco at S. Marco.

2692 No. 17061^F—Two figures kneeling, studies perhaps for the larger altar-piece at Pisa.

2693 No. 17062^F—Sketch for Miracle of Loaves and Fishes. Energetic and pictorial. See my 2556, which is the more finished design.

2694 No. 17063^F—Man seated in profile to r., and woman in profile to l., with child in her arms—studies for the same composition.

2695 No. 17064^F—First sketch for the S. Domenico Adoration, all the figures being nude. Delicate, almost Raphaelesque. R. ch. [Fototeca 4525. G. Bernardini, *Boll. d'A.*, 1910, p. 155].

2696 No. 17065^F—Sketch for seated groups in Miracle of Loaves and Fishes. See my 2556. R. ch.

2697 No. 17066^F—Free rendering of Christ, Evangelist, and Peter in the Cenacolo di Foligno at Florence.

2698 No. 17067^F—Another figure in same.

2699 No. 17068^F—Judas in same.

2700 No. 17069^F—Several rapidly sketched youthful figures in r. ch.

2701 No. 17070^F—Sketch for Flagellation and Way to Golgotha, formerly at S. Maria Nuova, and now in the Uffizi (No. 3212). [Fototeca 4526. G. Bernardini, *Boll. d'A.*, 1910, p. 156.]

2702 No. 17071^F—Woman kneeling in profile to l., in attitude of Veronica for Carrying of Cross. Cf. my 2708.

2703 No. 17072^F—Similar study but more elegant.

2704 No. 17073^F—Sketch for upper part of the Conception, formerly at S. Maria Nuova, and now in the Academy (No. 3203).

2705 No. 17074^F—Study for figure lying asleep in foreground of same picture.

2706 FLORENCE, UFFIZI, No. 17075^F—Sketch for Annunciation.

2707 No. 17076^F—Three figures, two erect and nude, the other draped, kneeling.

2708 No. 17077^F—Two rapidly sketched kneeling figures for foreground of altar-piece, perhaps the large one at Pisa. One of them is repeated on a smaller scale in ink. R. ch.

2709 No. 17079^F—Apostle kneeling to l. Smaller draped figures, and two busts of youths. Pretty. R. ch.

2710 UFFIZI, SANTARELLI, No. 228—Study of saint standing to l. Bl. ch.

2711 No. 238—Baptist kneeling. R. ch.

2712 No. 239—St. Francis kneeling. R. ch.

2713 No. 243—Young man marching with lance on shoulder. Bl. ch. and wh. 29.5 by 19.

2714 No. 248—Portrait head of friar. Bl. ch. and wh.

2715 No. 250—Inspired youthful saint writing. Bl. ch. and wh.

2716 No. 251—Holy Family. Bl. ch.

2717 No. 254—Madonna between two saints. Bl. ch.

2718 No. 254^{bis}—Head of inspired-looking boy, perhaps for youthful Christ. Bl. ch. and wh.

2719 No. 255—Life-size head of man looking up. Close to Granacci. Bl. ch.

2720 No. 260—Draped male figure. Bl. ch.

2721 No. 262—Old man walking along with basket in hand. Bl. ch. and wh.

2722 No. 264—Life-size portrait profile to l. of woman. Bl. ch.

2723 No. 447—Sacrifice of Noah. Bl. ch. and wh.

2723^A (former 2528) No. 621O—Study for ciborium. R. ch. 37 by 23.5. Lithograph, Alinari 554. Ascr. to Albertinelli, but the types, the stroke, and the touch are S.'s.

2723^B FRANKFURT a/M., STÄDEL MUSEUM, No 450—Study for St. Bartholomew. Bl. ch. 17 by 7. *Stift und Feder*, 1927, No. 34.

2723^C HAARLEM, TYLER MUSEUM, No. 103—Head of monk in profile to r. Bl. ch. and wh.

2723^D KOENIGS COLLECTION, No. 15.—Studies for two *putti*: one naked and winged standing in profile to l. the other half draped and seated towards l. Bl. ch. 24 by 23.5.

2724 LILLE, MUSÉE WICAR, No. 38—[Studies of heads and hands.] R. ch. 19.5 by 15.5. Verso: S. Antonino blessing. Braun 72030. Ascr. to Fra Bartolommeo, by whose St. Vincent at the Florence Academy the verso was inspired.

2725 No. 44—Head of monk in profile to r. Bl. ch. 21.5 by 17.5. Braun 72027. [Verso: Studies for a Madonna and saints.] Ascr. to Fra Bartolommeo.

2726 No. 604—Madonna enthroned. R. ch. 39 by 28. A rather charming design by some follower of Fra Bartolommeo, who also must have studied Granacci. The author may thus be S.

SOGLIANI

2726A LIVERPOOL, WALKER ART GALLERY, No. 4—Study for male head. Bl. ch. 27 by 19. Venturi, IX, i, p. 301.

2727 LONDON, BRITISH MUSEUM, 1860-6-16-6—Nativity with angels, Francis and Joseph, in frame with medallions representing Annunciation, and below, Dead Christ. Bl. ch. on yellowish paper. 35 by 24.5.

Ascr. to Credi as is the Nativity in the Olivella at Palermo so close to this, but certainly by S., and, like that, among his pleasantest achievements. Here he is already under the influence of Fra Bartolommeo. The Virgin's eyes are characteristic. [One might be tempted to take this sketch for a study for the Nativity by Tommaso di Stefano in the chapel of the Villa Capponi at Arcetri, Florence, but in the last-named work we see a pupil of Credi's under the influence of Ridolfo Ghirlandajo, an artist who seems to have left S. entirely untouched.]

2728 1862-2-32—Portrait head of youngish bearded man (p. 165). Bl. ch. 39.5 by 22. Verso:
Fig. 466 Tall youth, standing in statuesque pose, nude, but for mantle that falls over shoulders. Pl. XCVII of F. E.

2729 1862-10-11-192—Portrait head of nun, turned slightly to l. Bl. ch. 36 by 25. [Photo. Macbeth.] Ascr. to Domenico Ghirlandajo, but clearly of inferior quality and later date. The handling suggests the school of Fra Bartolommeo, and the loose touch is S.'s.

2730 1839-8-6-307—Copy after little girl warming herself at fire, in Andrea's fresco at the Annunziata, representing Birth of Virgin. Bl. ch. 18 by 12.5. Ascr. to Andrea, but the handling and touch are S.'s.

2731 1897-4-10-7—Saviour crowning His mother. Bl. ch., squared for enlarging. 26 by 32. [Photo. Macbeth. Listed also under my 987 in F. E.]

2731A BRITISH MUSEUM, MALCOLM, No. 41—Study of drapery for Christ as Judge. Tempera on linen. 30.5 by 21. Degenhart, *Münch. Jahrb.*, 1934, p. 226.

One of those studies in bistre on fine linen usually ascribed to Leonardo and not easy to attribute. This one has been published by Mr. Popham (Vasari Soc., II, xiii, 6) as by Fra Bartolommeo for his fresco of the Last Judgement. But the torso can scarcely be the handiwork of so good a draughtsman, and something in the face and hands almost suggests Brescianino. We may compromise on S., with similar studies by whom it may be compared. See my 2732 and 2519.

2732 No. 50—Study of two draped kneeling figures, probably for St. Jerome and Virgin. Chiaroscuro in distemper on fine lawn. 32 by 27.

Ascribed to Leonardo for no other reason, apparently, than that the technique is one usually identified with Leonardo's. The heads suffice to prove that this sheet is S.'s. A companion sheet is in the Uffizi, also ascribed to Leonardo (my 2519).

2733 No. 95—St. George in armour. Bl. and wh. ch. on brown paper. 35 by 16.

Catalogued as a sketch by Fra Bartolommeo for a corresponding figure in the Pitti Madonna and Saints. But, in so far as the present condition of the sketch permits of an opinion, it seems a copy after that figure by S. The hands and the draperies are his.

2734 No. 104—Sketch for female donor, kneeling in profile to r. Bl. ch. 28.5 by 18.5.

2735 No. 180—Draped male figure, standing in profile to l. Bl. ch. 38 by 23.

2735A BRITISH MUSEUM, SALTING BEQUEST—Highly finished copy of Judas in Perugino's Cenacolo, also vague indications for another figure from same fresco. Bistre and wh. on pearly paper. 23.5 by 18.

SOGLIANI

2736 LONDON, Mr. Herbert F. Cook—Head in profile to r. for angel. Bl. ch. and wh. 20 by 16.

2737 Mr. G. M. Gathorne-Hardy—Full-length Madonna standing, holding the Child. Pen. The type and the draperies still recall Credi, but the pen-stroke is in the manner of Fra Bartolommeo.

2737A Mond Collection—Female figure kneeling in prayer. Bl. ch. 26 by 14.5. Mond Cat., pl. IB.

2738 Oppenheimer Collection (formerly)—Madonna. Sp. and wh. on red paper. 14.5 by 9.5. Charming, early, done under the inspiration of Leonardo, but S. betrays himself in the quality and the stroke.

2739 (see 2509S)

2739A Newton Robinson Collection (formerly)—Sketch for female saint or donatrix kneeling in profile to l. with hands folded. Bl. ch. Typical handling.

2739B A. G. B. Russell Sale (Sotheby, May 9, 1929), Lot 23—Sketch for Madonna enthroned turning half round towards l. Bl. ch. and wh. on brown paper. 33 by 17. Repr. Sale Cat. One of his best. Compare with my 2646.

2739C Savile Gallery, Exhibition of Drawings by Old Masters (1929), No. 38—Head of woman slightly turned to l. Bl. ch. 26 by 19. Repr. Cat.

2739D MADRID, Accademia de S. Fernando—Head of woman in profile looking up to r. Attr. to Raphael.

2739E MILAN, Rasini Collection—Head of woman turned to l., looking down. Sp. on wh. paper. 18.5 by 15. Pl. II of Morassi, *Disegni antichi della Collezione Rasini*, Milan, 1937. Very close to Credi, to whom Morassi attributes it.

2740 Morelli Collection (formerly)—Head of young woman in profile to r. Bl. ch. 24.5 by 18.5. Morelli Dr., pl. v. Ascr. to Fra Bartolommeo, but type as well as execution point to S.

2740A (former 440)—Head of young woman looking out slightly to l. Bl. ch. 25 by 19.5. Imitation of some such drawing as my 319.

2740B MOSCOW, Museum of Fine Arts—Nude male figure slightly turned to l. with r. arm raised. R. ch. 29 by 15. Verso: Nude male figure facing front, holding a sword or stick in r. hand. Publ. and repr. by A. A. Sidorow in *Handzeichnungen alter Meister im Mus. der sch. K. in Moskau*, 1923, pls. 1A and 1B. Close to Albertinelli.

2741 MUNICH, Print Room, No. 2157—Head of bearded monk, full face. Bl. ch. and wh. 39 by 27. Ascr. to Fra Bartolommeo.

2741A Nos. 2213, 2214—Two studies for St. Francis. Ink and r. ch. 8 by 6 and 8 by 5.5.

2242 OXFORD, Christ Church, In turn-stand—Baptist and St. Dominic. Ascr. to Andrea del Sarto. R. ch. 23 by 16.

2743 No. 225—Study for one of saints, turned to r. while holding book, for Conception of S. Maria Nuova, now in the Academy. Bl. ch. 29 by 12.5.

2744 PARIS, Louvre, No. 6—Figure kneeling, and child. Ascr. to Albertinelli. Colours on oiled paper. 27 by 22.

2745 No. 1627—Head of monk turned slightly to l. Bl. ch. and wh. 20.5 by 15.

2746 PARIS, LOUVRE, No. 199—Head of child, turned a little to l. (p. 165). Bl. ch. and wh. 21 by 20. Braun 62184.

> Ascr. to Fra Bartolommeo, and by Morelli to Credi, which is an amusing decomposition of S. into his chiefest elements. Very close to this is the head of the child near St. Nicholas at S. Niccolò al Ceppo in Florence.

2747 No. 5—Eternal blessing, and woman seated (p. 165). Pen and bistre. 26 by 21. Braun 63523. Verso: Young woman in profile seated, Sts. Jerome and George and Dragon (p. 165). Ascr. to Albertinelli.

2747^A No. 215—Bust of youngish monk with lifted hands looking down towards r. Bl. ch. and wh. 12.5 by 12.5.

2748 No. 231—Madonna enthroned with Jerome, Bartholomew, and two other saints. Finished sketch for an altar-piece. Late, in Andrea's manner. Bl. ch. and wh. and washed with bistre. Pricked. 25.5 by 22. Braun 63520. [Venturi IX, i, p. 519.]

2749 Fig. 468 No. 680—Judith with head of Holofernes (p. 165). Study perhaps for the picture mentioned by Vasari as having been sent to Hungary. Bistre and a little wh. on pinkish ground. 27 by 19. [Arch. Ph.]

> In no other work does S. appear more eclectic. His spirit and his stroke are here, but the action is almost copied from the Uffizi drawing of a Lucretia by Granacci, ascribed to Botticelli. [At the Ambrosiana (Resta Collection, No. 28) there is an old copy of this drawing.]

2750 No. 1018—Sketch for Massacre of the Innocents. Bl. ch. and wh.

2750^A No. 1774—Two naked *putti*, one asleep, the other reaching out towards r. Bl. ch. 23.5 by 20. Ascr. School of Andrea. Arch. Ph.

2750^B No. 1807—Elaborate study for Child in Nativity. Bl. ch. and wh. on brown paper. 29 by 39. [Degenhart, *Münch. Jahrb.*, 1932, p. 116.]

> Ascr. to S. already by Baldinucci, from whose collection the drawing comes. It is unlikely that he would have done so without a firm tradition and thus it confirms the reconstruction of S.'s early phase.

2751 No. 2741—Head of smiling *putto* turned a little to l. Pen and bl. ch. 22 by 19. [Arch. Ph.] Close to Fra Bartolommeo.

2751^A No. 9872—Conversion of St. Paul. R. ch. and pen. 22 by 19.

2751^B Study for Joseph in Nativity. Bl. ch. Verso: Draperies for kneeling Madonna. Bl. ch. and some scrawls in ink.

2752 No. 9878—Curly-headed profile to l. Bl. ch. and wh. 25 by 20.

2753 No. 9893—Angel in profile to l. Bl. ch. 20 by 18.

2754 No. R. F. 1870, 463—Madonna almost identical in every respect with the one formerly in the Oppenheimer Collection (my 2738). Ascr. to Credi. Sp. and wh. on red paper. 14.5 by 9.5.

2754^A (see 2754^D)

2754^{A-1} . . . ÉCOLE DES BEAUX-ARTS, GATTEAUX COLLECTION—Heavily draped male figure walking towards l. Bl. ch. and wh. 35 by 16.5. Giraudon 14245. Verso: Same subject.

2754A-2 PARIS, ÉCOLE DES BEAUX-ARTS, No. 35651—Two youths walking towards r. and carrying trays. Possibly a first idea for the steward carrying in a dish in the Anghiari Last Supper. Verso: Draped seated figure perhaps for Madonna Annunciate. Under the drawing the pricked outline of nude bearded male figure with r. arm slung around a tree or more likely a cross. Bl. ch. 42 by 26. Giraudon 28121 and 28122.

2754B (see 2754E)

2754B-1 ROME, CORSINI, PRINT ROOM, No. 127621—Study of four heads, child, elderly bearded monk, two profiles of monk. R. ch. 33.5 by 14. Attr. to Andrea. Anderson 31339. The bearded man is a portrait of an artist perhaps.

2754B-2 SYRACUSE, MUSEUM, Codice del Paladino—Head of young woman turned towards l. Bl. ch.

2754C (see 2754G)

2754D (former 2754A) STOCKHOLM, PRINT ROOM, Inv. 44 and 42—Madonna and two angels adoring Holy Child. Also smaller sketch for Madonna. Pen and bistre. 20.5 by 23. [Schönbrunner & Meder, 1098 and 1095. Sirén, *Dessins*, opp. p. 30. Attr. to Granacci (Sirén, Cat., 51 and 52).]

2754E (former 2754B) Nos. 105 and 107—Three soldiers conversing, while another addresses them from platform. [This last seems curiously close to Bandinelli.] Also two nudes. Pen and bistre. 19 by 23. Verso: Copies after Perugino of Virgin for Annunciation, and of female saint. Ascr. [to Granacci—Sirén, Cat. 53 and 54] but unmistakably by the hand which did the next.

2754F Inv. 55—Draped bearded man in profile to l. with r. hand raised in gesture of blessing and l. hand pointing down. Pen and bistre. 20.5 by 10.5. Attr. to Filippino in old writing, to Granacci in Sirén's catalogue (No. 56). Like the soldier on my 2754E very close to Bandinelli.

2754G (former 2754C) Inv. 108—Study for Flagellation, and, on much larger scale than the seven figures for that subject, a youthful Michelangelesque nude. Pen and bistre. 21 by 25. [Ascr. like the last to Granacci (Sirén, Cat., 55)] but the types and handling are S.'s.

2754H Inv. 92—Study for monastic saint standing in profile to l. looking upwards with crucifix in r. hand. Bl. ch. and wh. on blue greyish prep. paper. 27.5 by 13.5. Squared for transfer. Sirén, *Dessins*, opp. p. 47 as Fra Bartolommeo. Attr. to S. in Sirén's catalogue as No. 88.

2754I Inv. 104 and 106—Study of nude male figure; underneath, woman walking with arms crossed over breast. Pen. 22.5 by 17. Verso: Head of young girl and flying dove. Ascr. to Granacci in Sirén's catalogue (Nos. 58 and 59).

2754J Inv. 110—Warrior in armour holding shield. Pen and bistre. 24 by 16. Ascr. to Granacci in Sirén's catalogue (No. 57).

2754K TURIN, ROYAL LIBRARY, No. 15614—Head of young woman. Bl. ch. 27 by 20.

2754L (former 507) No. 15616—Study for altar-piece: Madonna, saints and various figures below. Bl. ch. 27 by 18. Verso: Two studies for hand.

2754M (former 508) No. 15617—Head of bearded young saint. Bl. ch. gone over with the pen. 30 by 21.

2754N No. 15618—Study for Pietà. Reminiscent in quality of the Nativity in the B. M. (my 2727), so close to Tommaso di Stefano. Bl. ch., squared for enlargement. 28 by 33. Anderson 9806.

2754O TURIN, Royal Library, No. 15777—Head of smooth-faced man looking down, possibly for shepherd in a Nativity. Bl. ch. 22 by 16. Ascr. to Perugino.

2755 VIENNA, Albertina, Inv. 25295—Study for the Visitation at S. Niccolò al Ceppo. Bl. ch. on brownish paper. 31 by 24. Pl. 481 of Schönbrunner & Meder. [Albertina Cat., III, No. 157].

A more advanced study than my 2525, which is but a copy after Albertinelli. The sketch before us is of better quality, more obviously S.'s (cf. my 2533), and in the style of Fra Bartolommeo. Hence its attribution to the latter.

2755A S. R. 40, Inv. 36—Madonna seated turned slightly to l. holding Child on her l. knee; to l. study of drapery, underneath in later writing "Phil. Lippi." Pen, bistre and grey on blue greyish prep. ground. 17.5 by 12.5. Albertina Cat., III, No. 146. E. Sandberg Vavalà, *Burl. Mag.*, LV (1929), p. 8. Attr. to Fra Bartolommeo.

2755B S. R. 70, Inv. 58—Head of monk looking towards l. Bl. ch. 23 by 18.5. Albertina Cat., III, No. 158.

2755C Inv. 24702—Madonna seated in profile to l. with Child nestling up to her. Sp. and wh. on blue prep. paper. 17 by 15.5. Albertina N. F., II, pl. 37; Cat., III, No. 147. E. Sandberg Vavalà, *Burl. Mag.*, LV (1929), p. 5. Attr. to Fra Bartolommeo. Compare with my 2531 and 2510 G.

2756 (see 734B)

Spinello (pp. 324-326)

2756A LONDON, British Museum, 1860-6-16-52—Six women in two groups (p. 325). Pen on wh. paper.
Fig. 6 15 by 16.5. Ottley, opp. p. 11. Verso: Draperies of lower part of seated figure. Probably study for Madonna.

The ladies were probably intended for the fresco of a Paradise or possibly Last Judgement. One may be tempted to ascribe them to Nardo di Cione and even to Altichiero, but Spinello has the best claim. The much looser sketch on the back must originally have been for an enthroned Madonna, and at the top there seem to appear draperies of a child. The touch is almost Parri's.

2756A-1 . . . 1895-9-50-680—Christ and the woman of Samaria. Pen, wash, and white on tinted paper. 27.5 by 20. Verso: Christ healing a blind man. Both sides framed in by Vasari and inscribed " Galante da Bologna." Very close to Spinello.

2756B MILAN, Municipal Museum—Five heads of boys sketched from life. Between the two uppermost
Fig. 4 the head of a sheep. Just under this the word *agnus* in Gothic script and below it the monogram for *Christi* (p. 325). Pen on parchment. 15 by 19. Repr. by Sirén, who publ. it as by Agnolo Gaddi in *Jahrb. Pr. K. S.*, 1906, p. 211. Verso: Crouching woman, perhaps for the Washing of the Child in a Nativity, seated monk reading, another monk standing.

2756C NEW YORK, Morgan Library—Model for fresco filling half a lunette representing the capture of a youthful king and his martyrdom. Ascr. to school of Giotto (pp. 324-325). Brush drawing on prep. paper, height. with wh., background coloured red. Morgan Dr., I, pl. I.

2756D Pope Alexander III in Council (p. 325). Pen and bistre. Morgan Dr., II, pl. 70. Study
Fig. 2 for the fresco (1408-1410) in town hall of Siena (Anderson 21361).

It may have seemed too dependent upon Ambrogio Lorenzetti's fresco at S. Francesco, and figures turning their backs to spectator may have offended the emerging dramatic sense of the dawning Quattrocento. So it was discarded for a better staged composition.

2756[E] PARIS, LOUVRE, No. 1251—Two scenes from legend of Evangelist (p. 325). Pen on pinkish paper.
Fig. 5. 27 by 18. Arch. Ph. Repr. by Sirén, who first published this in *Jahrb. Pr. K. S.*, 1906, p. 213. Verso: Allegorical figure with bowl held out in l. hand, sitting on throne with Saviour appearing above her, against a background of Gothic buildings and towers, among them that of Florentine Palazzo Vecchio. Below, blacksmith at his anvil and friar seated beside him (p. 325). Sirén, *ibid.*, p. 216.

2756[F] No. 2664—Sketch for two apostles seated and turning toward each other (pp. 325-326). Bistre and wh. on green ground. 21 by 18.5. Repr. by Sirén, who published it as by Niccolò di Piero in *Jahrb. Pr. K. S.*, 1906, p. 220.

2756[G] ÉCOLE DES BEUAX-ARTS, No. 34, 777—Studies for martyrdom of youthful saint (p. 325). Same scene repeated thrice with variations in number and action of figures. Pen. 27 by 19. Verso: Martyrdom of female saint. Recto published by O. Kurz, *O. M. D.*, XLV (1937), pl. 1, and in Ottley, opp. p. 7, as Cimabue. Catalogued formerly as school of Giotto and now as anonymous Florentine.

Vincenzo Tamagni (pp. 142-143)

2756[H] LONDON, BRITISH MUSEUM, MALCOLM, Nos. 36 and 37—Study for meeting of Joachim and Anne
Fig. 365 (p. 142). Pen and bistre. 17 by 13. Verso: Variant of same subject (p. 142).

2756[I] MILAN, FRIZZONI COLLECTION (formerly)—Madonna seated nursing the Child. Pen on pink prep.
Fig. 364 paper. Of the kind almost of the Morgan St. Catherine healing the sick, see my 2756[M] verso (Fig. 368).

2756[J] Actaeon with two huntsmen and a dead stag behind him stumbles on Diana and her
Fig. 369 nymphs bathing (p. 143). Pen and bistre.

2756[K] Actaeon trying to run away from Diana and her nymphs (p. 143). Pen and bistre.

2756[L] MUNICH, PRINT ROOM, No. 2357—Study for Meeting of Joachim and Anne; below a friar approaching
Fig. 366 a sick man (p. 142). Pen and bistre. 31 by 20. Verso: Study for an altar. Photos. Museum. Ascr. to Sodoma.

2756[M] NEW YORK, MORGAN LIBRARY—Study for a Procession to Calvary (p. 142). Bl. ch. and wh.
Fig. 367 28 by 26.5. Morgan Cat., I, pl. 102. Verso: St. Catherine of Siena healing the sick man
Fig. 368 and at bottom of sheet three vases. All these in pen and bistre. Between them in sp. the sick man on a couch with several attendants (p. 142). Morgan Cat., IV, pl. 188.

2756[N] PARIS, LOUVRE, No. 1246—Mass of St. Gregory (p. 142). Pen and bistre. 29 by 21.5. Arch. Ph.
Fig. 363

2756[O] No. 1248—Fainting youthful nude on couch, and two attendants; below, two studies for kneeling St. Roch. Pen and bistre. 27 by 21.5. Arch. Ph. Probably for the same composition as the Morgan Library drawing. See my 2756[M] verso (Fig. 368).

2756[P] VIENNA, ALBERTINA, S. R., 133—Study for a Christ falling under the cross with Veronica holding up her napkin (p. 143). Bl. ch. and wh. 28 by 20. Schönbrunner & Meder, 644. Albertina Cat., III, No. 429.
An altar-piece with this subject by V. T. no longer exists but there is at Narbonne a predella that I do not hesitate to ascribe to him where there is a Procession to Calvary based upon this as well as on the Morgan drawing.

" Tommaso " (pp. 76-79)

2757 BERLIN, Print Room, No. 5039—Study for a St. Luke (p. 77). Bistre and wh. on brownish prep.
Fig. 157 linen. 26.5 by 17.5. Degenhart, *Münch. Jahrb.*, 1934, p. 224.

> [A certain resemblance in pose between this figure and a St. Luke on the ceiling of the S. Fina chapel at S. Gimignano has led to its attribution to Dom. Ghirlandajo. In other respects the drawings are as different as work of the same school can be. There is no suggestion of Leonardo in the fresco, whereas the sketch is coloured with his sentiment and his grace, the l. hand is like a copy after him and the folds have his edge. It would be more plausible to ascribe it to him than to Ghirlandajo. The folds, in fact, have much more in common with those on the mantle of the Virgin in P. di Cosimo's altar-piece at Borgo S. Lorenzo. Now between this painter and T. the connection is enigmatically close. The angel is nearer to the one in T.'s St. Sebastian in the Fitzwilliam Museum, Cambridge, than to any of Ghirlandajo's.]

2757[A] CAMBRIDGE (Mass.), Fogg Museum, Charles Loeser Bequest, No. 128—Lower part of draped figure turned to l., the r. forearm and hand showing. Sp. and wh. on purple prep. ground. 25 by 21. More probably T. than Credi or any other follower of Leonardo and Verrocchio.

2758 FLORENCE, Uffizi, No. 422[E]—Study for a Madonna (p. 77). Umber and wh. on greyish prep.
Fig. 158 linen. 42 by 25.5. [Fototeca 12635.] Ascr. to Leonardo.

2759 No. 431[E]—Head almost in profile to r. of woman bending down. Ascr. to Leonardo (p. 77).
Fig. 155 Umber and wh. on fine greyish linen. Brogi 1873. [E. Jacobsen, *Jahrb. Pr. K. S.*, 1904, p. 189. Degenhart, *Münch. Jahrb.*, 1934, p. 222. Verso: Faint outlines of female bust in profile to l. holding a flower to her nose. Not unlike some of P. di Cosimo's profiles.]

2760 No. 432[E]—Study for child throwing up his arms. Ascr. to Leonardo (p. 77). Umber and wh. on greyish prep. linen. 22.5 by 15. Brogi 1874. Verso: Study for Madonna and
Fig. 156 *putti* (p. 77). Brogi 1875. [Fototeca 12444.]

2760[A] No. 1201[E]—L. arm of child and drapery over l. knee. Sp. and wh. on greyish tinted paper. Brogi 1897. Of same kind and quality as following.

2761 No. 1202[E]—Two studies of child's arm, and drapery for leg of nude figure about to kneel
Fig. 163 down. Sp. and wh. on greyish tinted paper. 20 by 26. Brogi 1892. The rectangular or flowing folds and the general quality persuade me that these sketches are not Credi's as attributed, but T.'s.

2762 No. 190[F]—Bit of drapery. Bistre and wh. 8 by 10. Ascr. to Credi, but more probably T.'s.

2762[A] No. 271[F]—Head of young woman looking down slightly to r. from half-shut eyes (p. 78).
Fig. 159 Bl. ch. on pink rubbed paper. 16.5 by 13.5. Fototeca 7080. *Riv. d'A.*, 1932, p. 255. Mackowsky, *O. M. D.*, 1930/31, p. 32 and pl. 13, ascribes it to Credi. Besides the other reasons given in the text, it is too sketchy and too pictorial for him.

2762[B] GÖTTINGEN, University Museum—Three heads of elderly men (p. 79). Stylus and wh. on paper tinted greyish green. 39 by 29. Verso: ... ad full-face of elderly man on large scale (p. 79).
Fig. 162 *Riv. d'A.*, 1932, pp. 260 and 261. I owe acquaintance with this sheet to the kindness of Dr. Wolfgane Stechow.

2762[C] HAARLEM, Koenigs Collection, No. 457—Study for naked Child no doubt for a Madonna in whose invisible lap He is supposed to sit with legs drawn up and head almost in profile to r. with His l. arm doubled and its hand touching His own cheek. Sp. and wh. on pinkish buff prep. ground. 13.5 by 10. Pl. 3 of Geiger, *Handz.* Attr. to Credi but much more like T.'s, as the lighting alone would tend to prove.

2763 LILLE, Musée Wicar, No. 193—Study of drapery for kneeling figure. Sp. and wh. on bluish ground. 29 by 10.5. [Degenhart, *Münch. Jahrb.*, 1932, p. 127.]

2763ᴬ (former 695) LONDON, British Museum, Malcolm, No. 23—Study of drapery for lower portion of
Fig. 165 seated figure [a copy of the Leonardo drawing in the Louvre, my 1061 (Fig. 530)] probably for a Madonna (p. 64, note). Highly finished in bistre, shaded with point of brush and height. with wh. on pinkish prep. ground. 26.5 by 22. Braun 65059. [*Boll. d'A.*, 1933/34, p. 254.]

2764 Sir Charles Robinson (formerly)—Head and draperies of Madonna for Nativity. She kneels in front of rock in landscape. Bistre wash and wh. 20 by 14.5. Ascr. to Raphael, but its affinities with Credi are obvious, and the more intimate characteristics are T.'s.

2764ᴬ RENNES, Museum, Case IV, 1—Study of folds in heavy mantle draping chiefly l. side of erect male
Fig. 164 figure standing in assertive attitude. Faint indication of head looking down to our r. (pp. 63, 79). Bistre wash and wh. on linen. 31 by 20. *Riv. d'A.*, 1932, p. 259. *Boll. d'A.*, 1933/34, p. 252. Seems by same hand, as it is in same technique, as my 2757 (Fig. 157) and the somewhat later study for a Madonna (my 2758, Fig. 158) but earlier than either.

2764ᴮ STOCKHOLM, Print Room, Inv. 95—Head of woman bent slightly to l. with pathetic look (p. 78).
Fig. 160 Brush, bistre and wh. on pink prep. paper. 21.5 by 15.5. *Riv. d'A.*, 1932, p. 250.
Ascr. by Sirén to Bartolommeo di Giovanni, but perhaps no other drawing that we ascribe to T. is so certainly by him. The type, so close to Credi but at once rougher and more expressive, and the flickering light are both highly characteristic.

2764ᶜ Inv. 97—Head of man thrown back to l. rather provokingly (p. 78). Possibly inspired by
Fig. 161 antique. Same technique, kind, and quality as last. *Riv. d'A.*, 1932, p. 254.

2764ᴰ TURIN, Royal Library—Study for cast of drapery covering l. side of standing figure, with l. hand showing almost horizontally (p. 79). Bistre and wh. on paper. *Riv. d'A.*, 1932, p. 258. Anderson 9850.
Ascr. to Credi, and close to him but less clear and more pictorial, as is nearly always the case with T. Compare, for instance, with Credi's study for a Bartholomew (my 715).

2765 (see 508ᴬ)

Paolo Uccello (pp. 14-15)

2766 FLORENCE, Uffizi, No. 28ᴱ—Life-size profile to l. of smooth-faced man of about fifty, wearing the
Fig. 65 turban-like headdress of second quarter of fifteenth century (p. 15). Bistre wash on wh. paper. Background coloured dark brown. 29 by 20. Pl. xii of F. E. [Uffizi Publ., I, iii, 3. Popham Cat., No. 30. Van Marle, X, p. 241.]

2767 No. 31ᶠ—Sketch for equestrian statue of Sir John Hawkwood in the Cathedral of Florence (p. 14). Greenish wash, and touches of wh. on purplish background. Squared for enlarging. 45 by 32. Condition bad; in part gone over. [Popham Cat., No. 28. Uffizi Publ., I, iii, 1. Van Marle, X, p. 215. G. Pudelko, *Art Bulletin*, 1934, p. 230.]

2768 No. 1758ᴬ—Perspective study of basin on pedestal, almost bafflingly complex and geometrical, yet done with an artist's touch (p. 331). Pen. 29 by 24.5. [G. L. Kern, *Jahrb. Pr. K. S.*, 1915, p. 22.]
This must be a fair example of the kind of work that absorbed U.'s best energies. In the small hours of the night, when his wife would ask him to go to bed, he would ejaculate for an answer: "Oh, what a glorious thing is perspective!"

2769 FLORENCE, Uffizi, No. 14502F—Armed knight on horseback, charging at full speed (pp. 14-15).
 Fig. 64 Bl. ch. with touches of wh. on turquoise prep. paper. Squared for enlarging. 30 by 33.
 Pl. xi of F. E. [Uffizi Publ., I, iii, 2. Popham Cat., No. 29. Van Marle, X, p. 223.]

2770 No. 1756A—Study in perspective (p. 331). Pen. 9 by 24. [G. L. Kern, *Jahrb. Pr. K. S.*, 1915, p. 20.]

2771 No. 1757A—Study in perspective (p. 331). Pen. 10 by 27. The last two are of the kind and quality of my 2768. [G. L. Kern, *Jahrb. Pr. K. S.*, 1915, p. 21.]

School of Paolo Uccello (p. 331)

2772 BERLIN, Print Room, No. 5047—Kneeling shepherd, woman seated, and another kneeling (p. 331).
 Fig. 66 See next. Pen, bistre and wh. on greyish-green paper. 19.5 by 31. [Photo. Treue. W. Boeck, *O. M. D.*, VIII (1933/34), pl. 1.]

2773 FLORENCE, Uffizi, No. 29E—Two studies of young woman seated on ground (p. 331). Bistre and wh. on greyish-green paper. 25.5 by 14. Verso: Erect male figure with staff in r. hand, l. arm akimbo, looking alertly to l. [Fototeca 4700 and 12873.]
 This, the last sheet at Berlin, and my 2774, 2776, 2777, 2778 [and 2779F (Fig. 67)] are identical in technique, quality, and kind. I have not the courage to ascribe them, as they have been traditionally ascribed, to U. himself. But thanks to Mr. Horne, I persuaded myself that the frescoes in the Chiostro Verde at S. Maria Novella representing the Creation of the Animals and of Man, and the Temptation, are early works of U. Between these frescoes and the drawings we are now considering there is no impassable gulf. Yet to my eye the drawings seem too inferior to even these relatively crude early frescoes to permit my believing that they were done by the same hand. For the present, and until we know more of U.'s beginnings, it is safer to regard them as copies, made by a pupil after early sketches by U.

2774 No. 30E—One male nude and three females draped, all seated in various attitudes (p. 331). The nude may have been done from the model. Pen, bistre, and wh. on greyish-green paper. 26 by 23.5. [Fototeca 12541.] Verso: Four draped female figures, seated in various attitudes. See my 2773.

2775 No. 65F—Poor old copy, after portrait profile of man by U. Pen and bistre on wh. paper, but background washed. 25 by 18.5.

2776 No. 1107E—Two nudes, one standing, the other seated. See my 2773. Bistre and wh. on greenish-grey paper. 22 by 26. [W. Boeck, *O. M. D.*, VIII (1933/34), pl. 2.] See my 2773.

2777 No. 1108E—One nude seated, and another carrying a third on his back (p. 331). Bistre and wh. on greenish-gray paper. 17 by 13.5. [Fototeca 4765.] Verso: Woman kneeling and another reclining. See my 2773.

2778 No. 1109E—Three male figures, one kneeling and the others reclining. Pen, bistre, and wh. on greyish-green paper. 22 by 22. Verso: Male figure erect. See my 2773.

2778A No. 29F—Almost nude figure sitting with head in profile to l. facing some sort of machine. Bistre and wh. on prep. paper. 18.5 by 14.5. N. Ferri, *Boll. d'A.*, 1909, opp. p. 373. Fototeca 4230. Perhaps it was to start with by U. himself.

2778ᴮ FLORENCE, Uffizi, No. 30ᶠ—Male and female nudes, probably for Adam and Eve just after the Temptation. Pen and wh. on yellowish paper. 19 by 10. Fototeca 4231 and 4232. Close enough to U.'s earlier phase to make one ask whether, before it was retouched by much later hand, it may not have been by the master.

2778ᶜ No. 1302ᶠ—Study for angel with outspread wings flying in profile to r. holding scabbard
Fig. 68 of sword in l. hand. Over lower part of figure is drawn a geometrical design in style of U. for font (see my 2768) (p. 331). Sp. and wh. pricked for transfer. Fototeca 4604. W. Boeck, *O. M. D.*, VIII (1933/34), pl. 3. In all probability study for an Expulsion from Paradise. Too stiff and jerky for U. himself. Perhaps by the Carrand master.

2779 (see 1868ᶜ)

2779ᴬ (see 2779ᴵ)

2779ᴮ (see 2779ᴶ)

2779ᶜ No. 14508ᶠ—Very slender nude with arms above his head facing us (p. 331). Pen, bistre, and wh. on yellowish ground. 29 by 10. Fototeca 12882.

2779ᴰ GIJON, Istituto Jovellanos, Nos. 4-5—Two studies for nude youth, one facing us, the other seen from behind (p. 331). Sp. and wh. on bluish paper. 25 by 13. Attr. to Masaccio. In type close to Maso Finiguerra group.

2779ᴱ PARIS, Louvre, No. 1256—Nude youth lying on back with arms folded. Attr. to Filippino. Bistre and wh. on greenish paper. 6 by 20.5. Arch. Ph. Verso: Fragment of torso of young man seen from behind with hand on hip. 13.5 by 10. (See my 1382ᴮ for drawing in same frame.)

2779ᶠ No. 2688—Three youths, one seated in chair, another brandishing mace, and third seated
Fig. 67 on stool and apparently sewing (p. 331). Wash and wh. on grey blue paper. 18 by 32. Arch. Ph. W. Boeck in *O. M. D.*, VIII (1933/34), pl. 4. Attr. to Italian school 16th century. See my 2773.

2779ᴳ Louvre, Edmond Rothschild Bequest—Youthful draped figure looking down to l. Bistre and wash on green tinted paper. 23 by 11. Between Bicci di Lorenzo and Uccello.

2779ᴴ Hôtel Drouot Sale (April 11, 1924), No. 69—Profile bust of young man wearing turban. Below, small boy seated seen from back. To r. female with naked bust leaning against pedestal—after the antique. Pen. 28 by 18. Sale Cat., No. 69. In touch not unlike Maso Finiguerra's.

2779ᴵ (former 2779ᴬ) STOCKHOLM, Print Room, Inv. 47—Three young men, one with sling, one standing, and one sitting (p. 331). Each a separate leaflet of about 28 by 14. Brush, bistre, and wh. on greyish-green paper. The first is repr. opp. p. 22 of Sirén's *Dessins*. [Also G. Gronau, *O. M. D.*, IV (1929/30), pl. 57. Schönbrunner & Meder, 964 and 976. Meder, *Handz.*, fig. 149.]

2779ᴶ (former 2779ᴮ) Inv. 48—Two naked youths. Brush, bistre, and wh. on greyish-green ground. 22 by 21.5.

2779ᴷ Inv. 11—Number of nudes, mostly youthful, in various poses on steps and wall of low polygonal structure like a font (p. 331). Bistre wash and wh. on greenish ground. 17 by 35.5. Schönbrunner & Meder, 1089. Meder, *Handz.*, fig 304. By a close imitator of U., probably by same hand as my 2773, etc.

2780 VIENNA, Albertina, S. R., 53—Somewhat later copy after lost original design by U. for profile of youth. Pen and bistre wash. 23.5 by 18. [Albertina Cat., III, No. 12. Schönbrunner & Meder, 588. Meder, *Handz.*, fig. 199. Close to, although not for, a head in the Drunkenness of Noah in the Chiostro Verde (Brogi 2279).]

2780^A S. R., 52—Later copy probably restored in 18th century of laurel-wreathed profile to l. representing, as inscription at bottom says, "Leonardo darezo," that is to say the famous humanist and historian Leonardo Aretino. Sp. and wh. and brown wash. 40.5 by 29.5.

Giovanni Battista Utili da Faenza (pp. 69-70)

2780^B CHATSWORTH, Duke of Devonshire—Design for sculptured tabernacle attributed to school of Verrocchio (p. 69). Bistre and wash. 40 by 25. Chatsworth Dr., pl. 17. *Riv. d'A.*, 1933, p. 24.

2780^C (former 2797) FLORENCE, Uffizi, No. 1254^E—Female head almost in profile (p. 69). Study for
Fig. 132 Madonna formerly belonging to Lady Henry Somerset, at the Priory, Reigate [now in the National Museum at Dublin]. Pen and bistre height. with wh., pricked for transfer. 23 by 24. Brogi 1476. [Van Marle, XI, p. 535. *Riv. d'A.*, 1933, p. 22.] Ascr. to Verrocchio.

2780^D (former 202) UFFIZI, Santarelli, No. 1—Small but crowded composition representing Crucifixion,
Fig. 131 and the Virgin fainting away in the midst of her attendants (p. 70). Bistre and wash. 23.5 by 17. [Fototeca 20451. Ferri, *Boll. d'A.*, 1909, p. 375. *Riv. d'A.*, 1933, p. 30.] This probably goes back to an original by Baldovinetti.

Andrea del Verrocchio (pp. 46-66)

2780^E (former 2784) BERLIN, Print Room, No. 5093—Head of angel looking up to l. (pp. 48, note; 59).
Fig. 126 Bl. ch., rubbed, and slight touches of wh. on wh. paper, pricked for transfer. 18.5 by 16. Popham Cat., No. 52. Meder, *Handz.*, fig. 246. Verso: Upper part of face of angel. [Berlin Publ., 14^A and 14^B. Both heads were made no doubt for a Madonna with Angels designed soon after the earlier Berlin panel (Van Marle, XI, p. 527).]

2781 FLORENCE, Uffizi, No. 130^E—Head of angel (p. 47). Bl. ch. gone over later with ink, pricked.
Fig. 124 21 by 18. Pl. XXIV of F. E. [Popham Cat., No. 53. Ede, pl. 45. Uffizi Publ., I, iii, 12. Van Marle, XI, p. 515.]

2782 LONDON, British Museum, Malcolm, No. 338—Head of woman with hair elaborately dressed
Fig. 125 (pp. 47, 48, 55, 75). Bl. ch. and bistre, height. with wh., on pale brown paper. 32.5 by 27. Pl. XXV of F. E. [*Boll. d'A.*, 1933/34, p. 202. Verso: Head of woman looking down slightly to l. Bl. ch. with touches of wh. Alinari 1776 and 1777. Van Marle, XI, pp. 530 and 531. Popp, *O. M. D.*, II (1927/28), pl. 38.]

2782^A (former 2800) OXFORD, Christ Church, A. 5—Life-size head of a woman with elaborate coiffure,
Fig. 127 looking down to l., almost in profile (pp. 48, note; 59). Bl. ch. and wh., pricked for transfer. [Popham Cat., No. 51. Van Marle, XI, p. 533. Bell, pl. 124. Colvin, III, pl. I.
 It must be the fragment of a cartoon for a Nativity which V. designed between the early Berlin Madonna (Van Marle, XI, p. 527) and the Butler Altmann one now in the Metr. Mus. (Van Marle, XI, p. 525).]

2783 PARIS, Louvre, No. 2 R. F.—Sheet with drawings on both sides of *putti* in various attitudes
Fig. 122 (p. 46). Pen and bistre on wh. paper. 14.5 by 20. Pl. XXIII of F. E. [Van Marle, XI,
Fig. 123 p. 532.]

School of Verrocchio

2783^A BAYONNE, BONNAT MUSEUM, No. 1270—Sketch for nude David with look of fatigue in face but triumph in the swing of his youthful body, steps with l. foot on head of Goliath. Pen. 14.5 by 10. Photo. Bulloz. Ede, pl. 21. Venturi, *Studi*, p. 53

2784 (see 2780^E)

2785 (see 1867^E)

2786 (see 1868)

2787 FLORENCE, UFFIZI, No. 131^E—Various nudes and *putti* (p. 48, note). Pen and slight touches of wh. 18 by 28. Brogi 1708. [Van Marle, XI, p. 575. Degenhart, *Zeitschr. f. Kunstg.*, 1935, p. 110.] Ascr. to V. Verso: Reclining female nude, male nude seen from back, and an eagle. [Degenhart, *ibid.* Probably by Francesco di Simone.]

2787^A (former 576) No. 208^E—Study for Fides (pp. 21, note; 54). Bl. ch., wash and wh. on pinkish prep. paper. 21.5 by 15. Braun 76136. [Photo. Mannelli. Schönbrunner & Meder, 140. Van Marle, XI, p. 516.
　　Copy of sketch by V., made in competition with P. Pollajuolo in autumn of 1469 (J. Mesnil, *Miscellanea d'Arte*, 1903, p. 43) and identified by Miss Crutwell as for that design, only that she took it for an original which its quality and its size make improbable—the original must have been larger (*Rass. d'A.*, 1906, pp. 8-11).]

2788 (see 674^A)

2789 No. 217^E—Studies for Madonna and *putti* (p. 48, note). Pen and bistre, but *putto* in lower l.-hand corner in bl. ch. on paper slightly pinkish. 17 by 15.5. Brogi 1711. [Degenhart, *Zeitschr. f. Kunstg.*, 1935, p. 106. Ascr. to V. Perhaps by Francesco di Simone.]

2790 (see 1014^A)

2791 (see 1015^A)

2792 (see 1015^B)

2793 (see 1015^C)

2794 No. 433^E—Madonna seated with Child on her lap (p. 65). Bl. ch. 22.5 by 15.5. Brogi 1715.
Fig. 128　[Uffizi Publ., I, iii, 13. Van Marle, XI, p. 521.] Ascr. to V.

2795 No. 444^E—Madonna seated with Child on her r. knee (p. 65). Bl. ch. 28 by 19. Brogi 1710.
Fig. 324　[Fototeca 5995. Van Marle, XI, p. 519. Uffizi Publ., I, iii, 14. Sirén, pl. 15. Degenhart, *Riv. d'A.*, 1932, p. 271.] Ascr. to V. but possibly early Domenico Ghirlandajo.

2796 No. 445^E—Madonna with infant Baptist and two angels (pp. 65, 66). Sp. on pinkish prep. paper. 19 by 19. Brogi 1714. [Uffizi Publ., I, iii. 15. Sirén, pl. 16^A. *Boll. d'A.*, 1933/34, p. 256. Degenhart, *Riv. d'A.*, 1932, p. 272.] Ascr. to V. but possibly early Domenico Ghirlandajo.

2797 (see 2780^C)

2798 No. 212^F—Face of curly-headed girl looking down to l., study for angel (p. 65). Sp. on pale buff prep. paper. 28 by 20. [Van Marle, XI, p. 517.] Ascr. to V. but possibly early

Domenico Ghirlandajo. Verso: Head and bust of child (p. 65). Concentrated and bold. [Uffizi Publ., I, iii, 16 and 17. Comm. Vinc., I, 7 and 8. Fototeca 4258 and 4259. *Boll. d'A.*, 1933/34, p. 255.]

2799 (see 1037A)

2799A THE HAGUE, F. LUGT COLLECTION—Various studies for a Madonna and Child: one seated, with the Child on her lap and an angel near her; two behind a parapet, with the Child seated on it. Also slight sketch for the Child leaning against a sack or pillow. Pen. 20.5 by 15. Halfway between Verrocchio and Perugino and not unlikely by the young Domenico Ghirlandajo.

2800 (see 2782A)

2801 (see 1067A)

2801A ROME, CORSINI, PRINT ROOM, No. 130525—Head of curly-headed youth. Verso: Sketch for hind-quarters of horse. Sp. and wh. on pink prep. paper. 14.5 by 14.

46

ADDITIONS AND CORRECTIONS

ADDITIONS

Vol. II

No. **853**[A] OXFORD, CHRIST CHURCH, Large Portfolio—Verso: Two sheets of sketches on one mount: (1) Four nude male figures and two heads. (2) One nude male figure, two draped; an ear. Colvin, IV, 4 and 5. O. Kurz, *O. M. D.*, XLV (1937), p. 14. Each sheet has been pieced together from two fragments. Ascr. to Filippino Lippi. For the recto, which is by Filippino, see my 1355[B].

No. **1048**[B] MILAN, RASINI COLLECTION—Skirmish of galloping horses to l. and man fallen to ground on r. Lead pencil gone over with ink. 10 by 13. A. Morassi, *Disegni antichi della Collezione Rasini*, Milan, 1937, p. 24 and pl. IV. In all probability for Battle of the Standard and similar to the Venice and Windsor studies of that type. Verso: Faint sketch in r. ch. of a horse, not by L.

CORRECTIONS

Vol. I

Page 15, note 7—This portrait is now in the Mellon Collection, Washington.

„ 23, note 4—*for* No. 3358 *read* No. 3388.

„ 47, last line of note 4—add parenthesis after *et seq*.

„ 48—The relationship between Utili and Francesco di Simone noted in the last part of note 3 is through oversight repeated in note 1 of page 70, where, however, the error in the Anderson numbers is corrected.

„ 74, line 5—*for* my *read* may.

„ 82, line 37—*for* 1387[A] *read* 1387.

„ 85, line 2—*for* 1387[A] *read* 1387.

„ 88, line 1—*for* minifested *read* manifested.

„ 90, line 10—add parenthesis after 155.

„ 103, line 1—*for* Flippino *read* Filippino.

„ 105, line 6—*for* aritist *read* artist.

„ 108, line 2 from bottom—*for* Raffaelino *read* Raffaellino.

„ 116, line 18—*for* then *read* ten; line 24—*for* in *read* is.

„ 118, line 4—Perugino's Pietà is in the Uffizi, not in the Academy.

„ 125, line 3 from bottom—*for* he *read* be.

„ 133, line 7—*for* assitants *read* assistants.

„ 144, line 19—*for* Uffiizi *read* Uffizi.

„ 153, last line—This Visitation now belongs to Mr. S. H. Kress, New York.

„ 177, line 17—*for* distintion *read* distinction.

„ 189, line 12 from bottom—*for* Mathew *read* Matthew.

„ 195, line 3—*for* colossaly *read* colossally.

„ 201, line 26—*for* your *read* you.

„ 211, line 3—*for* Bargello *read* Palazzo Vecchio.

„ 230, last line of notes—add parenthesis after Fig. 714.

„ 239, line 12—*for* indentify *read* identify.

„ 241, note 1, line 4—*for* last *read* first.

„ 243, line 10 from bottom—*for* and and *read* and.

„ 246, line 10 from bottom—*for* in *read* is.

„ 263, line 6 of note 1—*for* of *read* or.

ADDITIONS AND CORRECTIONS

Page 264, line 4 of note 3—*for* atill *read* still.

„ 276, line 17—*for* indisuptably *read* indisputably.

„ 281, line 22—*for* thesaying *read* the saying.

„ 310, line 4 from bottom—*for* left hand *read* right hand.

„ 312, line 27—*for* posses *read* possess.

„ 315, line 20—The Pietà at the Academy is now attributed by the author to Bronzino.

„ 361, line 22—*for* Sebestiano *read* Sebastiano.

VOL. II

Page 4, line 5 from bottom—*for* pp. 336-338 *read* pp. 335-337.

„ 41, line 19—*for* 559F *read* 459F.

No. 113—Fig. 911 illustrates recto, not verso.

„ 440A is reproduced also in Mond Cat., pl. III.

„ 502—The Marco d'Oggiono here mentioned as in the Mond Collection is now in the National Gallery.

„ 534C—*for* pp. 329-330 *read* pp. 328-329.

„ 544A—This drawing now belongs to Mr. F. Lugt, The Hague.

„ 558C—This drawing has recently been acquired by the Cleveland Museum of Art. Both recto and verso are reproduced in the *Bulletin of the Cleveland Museum* for Oct., 1937, pp. 121-125, and in the *Art News* for Oct. 23, 1937.

„ 728—The Adoration of the Shepherds here mentioned is in the Uffizi, not in the Academy.

„ 928 and 930—The altar-piece referred to as being reproduced by Venturi 'is the one reproduced by G. Fiocco in *Rivista d'Arte*, XIII (1931), opp. p. 110.

„ 933—The drawing described as on the recto is on the verso, and those described as on the verso are on the recto.

„ 1403A—See also in connection with the design for Cecchino Bracci's tomb Mond. Cat., p. 39, pl. XXIII.

„ 1444, line 2—*for* nnde *read* nude.

VOL. III

Fig. 693—*for* aster *read* after.

GENERAL INDEX

Considering the Table of Contents, the page headings, and the fact that the Catalogue Raisonné is itself an elaborate index, it has not been thought necessary to index over again those sections of the Text where a given artist is discussed. On the other hand, the attempt has been made to index every item concerning an artist which occurs in sections where information regarding him might not be looked for. Page numbers refer to the Text (Vol. I), the other numbers to the Catalogue Raisonné (Vol. II). Where a publication is referred to it means that not only the reproductions, but the opinions of the writer or the author's indebtedness to him are mentioned in Text or Catalogue.

Additions and corrections, pp. 363-364 of Catalogue (Vol. II).

Agnolo di Donnino, pp. 343-345.

Agostino Veneziano, pp. 190, 191, 287, 288, Nos. 113ᴬ, 161, 1476, 2428.

Alberti, Leon Battista, p. 54.

Albertinelli, pp. 161-163; in relation to other artists, p. 165, Nos. 245, 286, 486, 508ᴬ, 547ᴬ, 1780, 2525.

Allori, Alessandro, pp. 191, 263 note, 280, 283 note, 304, 347, Nos. 55ᴮ, 593ᶜ, 594ᴬ, 595, 605ᴱ, 1504, 1544ᴬ, 1614 note, 1653, 1718, 1748ᴮ, 2258, 2486, 2492.

Allori, Cristofano, p. 226.

Altichiero, p. 324, No. 2756ᴬ.

Altrocchi, R., p. 6 note.

Alunno di Benozzo, pp. 11-13, 330, Nos. 537ᴬ, 544, 544ᶜ.

Alunno di Domenico, pp. 123-130, 157; as book illustrator, p. 128; in relation to other artists, Nos. 859ᴵ, 887, 1341ᴬ; real name Bartolommeo di Giovanni, p. 129 note.

Amico di Sandro, pp. 335-337.

Ammannati, Bartolommeo, Nos. 1686, 1686ᴬ.

Andrea da Firenze, p. 325.

Andrea di Giusto, Nos. 172, 178ᴬ.

Andrea di Michelangelo, pp. 250-252, 297, 298, 357-367, Nos. 1555, 1608, 1617, 1623ᴮ, 1626, 1627, 1630, 1655, 1655ᴬ, 1661ᴬ, 1664, 1669, 1680, 1685, 1688, 1689, 1694, 1695, 1704, 1705, 1712, 1728, 1750ᴬ, 2504ᴬ.

Andrea del Sarto, pp. 269-294; habits of work, pp. 269, 270, 281, 289. Lost works: Adoration of Magi, p. 274, No. 1766; Altar-piece of Madonna, St. Ambrose and Baptist, p. 286, No. 117ᴬ; Madonna of Porta a Pinti, pp. 271, 275, 280, 283, Nos. 138, 141ᴮ, 1761ᴱ; Pentecost, p. 291 note; Pietà, pp. 287, 288, No. 113ᴬ; Three Traitor Captains, p. 293, Nos. 118ᴬ-118ᶜ, 125. Andrea in relation to Naldini, see Naldini catalogue; in relation to other artists, pp. 36, 144, 151, 165, 241, 296, 297, 300, 303, 304, 305, 308, 313, 314, 315, 319, 321, 322, Nos. 747ᴬ, 754, 998ᴬ, 1059, 1168, 1561, 1634, 1848ᴬ, 1961-1963, 1976, 2014, 2015, 2044, 2119, 2158, 2159ᴮ, 2163, 2175ᴬ, 2255, 2375ᶜ, 2380ᴮ, 2442, 2478.

Angelico, Fra, pp. 4-6; in relation to other artists, pp. 6-10, 96, 132, 149, 330, Nos. 530, 534ᴮ, 537, 545ᴮ, 545ᴰ, 546, 558ᴮ, 904, 917, 956, 1068.

Antique, Drawings after the, by Ammannati, Nos. 1686, 1686ᴬ; Andrea, Nos. 55ᴮ, 119ᶜ; Bandinelli, p. 255, No. 1679; Fra Bartolommeo, Nos. 278, 528ᴬ; Benozzo School, No. 559ᴷ; Daniele da Volterra, No. 1653; David Ghirlandajo, Nos. 781, 807; Domenico Ghirlandajo, No. 864; Granacci, Nos. 928ᴬ, 946, 969ᴰ; 982ᴬ, 986, 996; Leonardo, p. 174, Nos. 1010ᶜ, 1121, 1144, 1145, 1148; Filippino Lippi, pp. 103, 105, 107,

338, 339, Nos. 1322-1326ᶜ, 1329ᴬ, 1341ᶠ, 1352, 1382ᶜ; Michelangelo, Nos. 1397, 1513, 1522, 1588, 1613; Montelupo, pp. 260, 262, No. 1723; Pontormo, Nos. 2081, 2283; Rosso, Nos. 2406, 2449; the Sangallo, Nos. 2470, 2474; Sebastiano, No. 2504; Sogliani, No. 2514ᴬ; "Tommaso", No. 2764ᶜ; Uccello, No. 2779ᴳ. Influence of the antique on Renaissance art, p. 271.

Antoniazzo Romano, pp. 24 note, 340,

Aragon, Alfonso of, King of Naples, p. 81.

Aretino, Leonardo, No. 2780ᴬ.

Aretino, Pietro, No. 2460.

Artistic ideal versus temperament, pp. 156, 158, 159, 249, 279, 286, 355.

Artistic versus historical personality, pp. 107, 108, 112-119, 129 note, 259, 335, 343-345, 357, 366, 367.

Ashby, Thomas, No. 1457.

Avalos, Alfonso d', Marchese del Vasto, No. 1396ᴬ.

Bacchiacca, pp. 297-299; in relation to other artists, pp. 251, 252, 296, Nos. 235, 1475, 1490, 1561, 1626, 1627, 1705, 1964.

Baldinucci, Filippo, pp. 24, 84, 260, 264, 344, 364, Nos. 41, 2267 note, 2750ᴮ.

Baldovinetti, Alesso, pp. 18, 92, 131-132, 146, Nos. 1913ᴬ, 1933ᴬ, 1937, 2393ᴮ, 2780ᴰ; engravings after, p. 70.

Balfour, Henry, p. 3 note.

Bandinelli, Baccio, pp. 190, 193 note, 201, 223, 224, 238, 254-255, 267, 309, 310, Nos. 604ᶜ, 1526, 1571, 1677, 1679, 1681, 1685, 1687, 1719, 1728, 1730, 1732, 1734, 1737, 2411, 2754ᴱ, 2754ᶠ.

Baroque, Filippino's tendency towards the, pp. 103, 105, 335.

Bartolommeo, Fra, pp. 155-161; in relation to other artists, pp. 13, 147, 148-150, 151, 153, 162-164, Nos. 5, 990, 1034ᴮ, 1059, 1978, 2338ᶜ, 2379ᴬ, 2381ᴬ, 2385, 2389, 2449, 2519, 2527ᴬ, 2560, 2726, 2729, 2731ᴬ, 2733, 2737, 2755 (see also Fra Paolino's catalogue). Lost work: Christ at the Well, Nos. 281, 409, 448, 490.

Bartolommeo della Gatta, p. 38 note.

Bartolommeo di Giovanni, p. 129 note.

Bartolommeo Veneto, No. 1859ᴳ.

Baudelaire, C. P., p. 201.

Beccafumi, pp. 13, 142, 356, Nos. 314, 505, 1884ᴬ.

Beethoven, p. 96.

Bell, C., p. ix, Nos. 994ᴬ, 1009ᶜ, 2258.

Bellini, Gentile, p. 274.

Bellini, Giovanni, pp. 50, 63, 67, 364, Nos. 669ᴬ, 1237, 1848ᴮ.

Bellini, Jacopo, No. 196ᴳ.

Beltrami, Luca, No. 1049.

Benedetto da Rovezzano, p. 344 note.

Benozzo Gozzoli, pp. 6-11, 328-330; in relation to other artists, pp. 11-13, 83, 87 note, 92, 93, Nos. 161A, 164C, 176, 178, 178A, 906A, 1841C, 1864, 1864A, 1866, 1866B, 1867, 1868, 1868C, 1871, 1874B, 1881. Lost frescoes at Viterbo, p. 10 note.

Berlioz, Hector, p. 96.

Bernardini, G., No. 2664.

Bernardino di Piero Basso, p. 365 note.

Bertini, Domenico, p. 365 note.

Bicci di Lorenzo, p. 13, Nos. 1391G, 1767A.

Billi, Antonio, No. 1316.

Blake, William, pp. 303, 320, 321, Nos. 2108, 2221, 2266A.

Boccatis da Camerino, No. 558B.

Bode, Wilhelm von, No. 1016.

Bodmer, Heinrich, p. 172, Nos. 1031, 1044A, 1059, 1067B, 1089, 1101, 1124, 1194, 1204. See also note at beginning of Leonardo catalogue.

Boltraffio, Giov. Ant., p. 168, Nos. 1024, 1027, 2683 note.

Bonasone, Giulio, p. 235, Nos. 1623C, 1697B note.

Bonfigli, Benedetto, pp. 328-329, Nos. 534C, 545C, 559B.

Bonifazio Veronese, Nos. 1341E, 1701.

Borenius, Tancred, No. 1859C.

Borgherini, Giovanni, p. 294 note, No. 127.

Borgherini, Pier Francesco, p. 144, No. 2478.

Borghini, Vincenzo, p. 296, No. 2178.

Botticelli, pp. 93-98, 334-335, 336-338; in relation to other artists, pp. 21, 68, 71, 81-82, 100, 101, 103, 106, 109, 110, 120, 121, 124-127, 130, 138, 143, 144, 145, 150, Nos. 40A, 196G, 438, 642C, 760, 765, 766, 887, 922, 974, 996, 1167A, 1289, 1364A, 1366G, 1396, 1469, 2461, 2469, 2474; School of, pp. 98-100.

Botticini, Francesco, pp. 53, 70-73, 337; in relation to other artists, Nos. 706, 1362A.

Botticini, Raffaele, p. 145 note.

Boucher, Fr., p. 338.

Bouguereau, W. A., p. 57.

Bramante, see preface to Michelangelo catalogue, and No. 1848A.

Bramantino, No. 1848A.

Brandi, Cesare, No. 1383A.

Brescianino, Nos. 1170, 1879, 2731A.

Brinkmann, A. E., No. 1463.

Bronzino, p. 321; in relation to other artists, pp. 197, 265, 316, 318, 347, Nos. 1396A, 1957, 2035, 2231, 2258, 2370A.

Brunelleschi, p. 20.

Bugiardini, pp. 228, 253-254, 276 note; in relation to other artists, Nos. 250, 254, 297, 1577, 1600, 1666A.

Buonarroti, Buonarroto, No. 1579.

Buonarroti, Leonardo, pp. 236, 253 note.

Buoninsegni, Domenico, pp. 212 note, 353, No. 1445.

Burckhardt, Jakob, p. 2 note.

Burne Jones, pp. 75, 99,

Burroughs, Bryson, Nos. 1049B, 1544D.

Cagnola, Guido, No. 1272A.

Calvaert, Guido, p. 238, No. 1705.

Cambiaso, Luca, pp. 238, 268, No. 1545 note.

Campori, Giuseppe, No. 2504.

Caporali, Bartolommeo, Nos. 175D, 547A, 559D.

Capponi, pp. 112, 115, 119.

Career of artists and their length, p. 13.

Carli, Raffaellino di, pp. 107, 111-119, 121-123; in relation to other artists, Nos. 570C, 581, 660A, 669B, 771A.

Carnesecchi, Pietro, p. 296 note.

Carondelet, Cardinal, Nos. 299, 353.

Carpaccio, V., pp. 10, 11 note, 325, Nos. 1350A, 1718.

Carracci, The, pp. 238, 266, Nos. 1740, 1743.

Carrière, Eugène, p. 289.

Casio, Girolamo, No. 281.

Castagno, Andrea del, pp. 15-16, 332; in relation to other artists, pp. 71, 72, 138, 139, 343, Nos. 246, 558B, 1161B, 1943.

Catena, Vinc., p. 286.

Cavalcaselle, pp. 17 note, 19, 71, 81 note, 119, 136, 275 note, 276 note, No. 937.

Cavalieri, Tommaso, Michelangelo's drawings for, pp. 225-228, 262, 264, 359, Nos. 1462A, 1471, 1489, 1507, 1535, 1571, 1601, 1606, 1611-1618, 1634, 1655 note, 1716, 1748B.

Cellini, Benvenuto, pp. 18, 70, 300, 301, 310, Nos. 1571, 1991, 2014.

Cesare da Sesto, p. 165, No. 1237.

Cézanne, Paul, pp. 34, 348, No. 536A.

Chalk, black or red, as used by Andrea, pp. 158, 269; Andrea di Michelangelo, pp. 361, 367; Fra Bartolommeo, pp. 158, 159; Leonardo, p. 167; Michelangelo, pp. 185, 231; Piero di Cosimo, p. 154; Pontormo, pp. 308, 310; Rosso, p. 322; Signorelli, pp. 30, 35, 38.

Chéret, Jules, p. 322.

Chiaroscuro, pp. 26, 31, 32, 36, 37, 39-43, 226, 242, 244, 290, 322, 323.

Chisel as used by Michelangelo, p. 186.

Cianfanini, Giovanni, p. 77 note.

Cigoli, Lud., p. 308.

Cimabue, pp. 1, 324.

Clapp, F. M., pp. 304 note, 313 note, 319 note, 320 note, (see also Pontormo catalogue).

Clark, Kenneth, pp. ix, 29 note, 172, 356, Nos. 567B, 669B, 734A, 906A, 1117 note, 1725A, 1950A, 2505A, 2505B, 2509B-2.

Clement VII, see Medici family.

Colonna, Vittoria, pp. 232, 235, 236, 250, Nos. 1396A note, 1514, 1529, 1530, 1598A, 1621, 1622, 1623C, 1724A.

Colour, pp. 280, 308, 315, 322, Nos. 538, 544C, 628, 1062.

Colvin, Sidney, pp. 29 note, 199, Nos. 1055, 1522, 1537, 1848, 2493.

Compagno di Pesellino, p. 89.

Composition as treated by Andrea, pp. 272, 278; Pontormo, p. 307; Michelangelo, pp. 196, 223; modern painters, p. 272 note.

Condivi, pp. 201, 208, 232, 235, 236, 364.

Coner, Andrea, No. 1457.

Constable, W. G., p. 53 note.

Conventionalization in art, p. 270.

Cook, Sir Herbert, p. 175.

Copies and imitations versus originals, pp. 28-29, 30 note, 37, 43, 44-45, 66, 67, 90-92, 93, 94, 101, 104 note, 163, 164, 168, 179, 180, 181, 186, 189, 190-192, 196 note, 201, 205-210, 213 note, 235, 246, 247, 252, 255, 257, 258, 262, 263, 264, 266, 267, 274, 275, 279, 298, 326, 330, 339, 342.

Copying, Law of successive, p. 3 note, 308, 321.

Cornelis van Haarlem, p. 347.

Corrections, Additions and, pp. 363-364 of Catalogue (Vol. II).

Correggio, pp. 34, 39, 47, 285, 290 note, 300, Nos. 1123, 1399J, 2232.

Corvinus, Matthias, No. 1272A.

Cosini, Silvio, p. 352.

Cossa, Francesco, p. 23 note, No. 536A.

Costa, Enrico, No. 1964.

Costume and fashion, pp. xiii, 358, 359.

Courajod, A., p. 173 note.

Credi, Lorenzo di, pp. 66-68, 73-76, 89-90; in relation to other artists, pp. 56-58, 76-79, 143, 150-152, 162, 165, 338, Nos. 592, 886, 910, 927, 930, 932, 934, 937-939, 974, 981, 989, 994A, 995, 996B, 1002, 1082B, 1274B, 1359A, 1849B, 1859D, 1862A, 1863C, 1896, 1911, 2388A, 2519, 2690, 2727, 2737, 2746, 2761, 2762, 2762A, 2764, 2764B, 2764D.

Cubism, p, 43.

Cungi, Leonardo, pp. 264, 303, Nos. 1673, 1745.

Curtius, Ludwig, p. 260.

Daniele da Volterra, pp. 192 note, 263 note, 264 note, 265, 355, 356, Nos. 1274B, 1470, 1471, 1544A, 1544E, 1598D, 1645A, 1723, 1744, 2504A, 2506.

Dante, character of his poetry, pp. 96-97; illustrated by Botticelli, pp. 95-98, 182, 334, Nos. 561, 570; illustrated by Michelangelo, p. 230, Nos. 1508, 1745; portraits of, Nos. 604E, 1948, 2393B; illustrated by Signorelli, pp. 35, 36, 37, Nos. 2509E-3, 2509E-6.

Daumier, Honoré, p. 36.

Decline of Florentine art, pp. 300, 301.

Degas, pp. 177, 193, 272 note, 349, preface to Michelangelo catalogue, No. 1409F.

Degenhart, Bernhard, Nos. 196E, 706, 974, 1857C.

Dei, Matteo di Giovanni, No. 37A.

Delacre, Maurice, Nos. 859K, 1473, 1519A, 2252B, 2336E.

Delacroix, Eugène, p. 201, preface to Michelangelo catalogue, No. 2486.

Della Bella, Stefano, No. 2457A.

Della Robbia, Luca, p. 288.

Delli, Dello, p. 1.

Desiderio da Settignano, pp. 61, 270, Nos. 1396, 1481, 1631.

Diamante, Fra, pp. 82, 85.

Diderot, Denis, p. 212 note.

Dimier, Louis, No. 1473.

Di Pietro, pp. 292 note, 294 note, Nos. 113, 113D, 747A, 2248C.

Dolci, Carlo, pp. 300, 308.

Domenico Veneziano, pp. 18, 87 note, 88, 92, 333, Nos. 164C, 190, 196, 1161B, 1936B.

Donatello, pp. 82, 189, 270, Nos. 667, 668, 847, 1399, 1502, 2466-2468.

Donato di Simone, No. 1579.

Doni, Angelo, p. 142, No. 901A.

Dorez, Léon, p. 235.

Doria, Andrea, pp. 243, 244, 245.

Drapery as treated by Alunno di Domenico, p. 124; Botticelli, pp. 94, 97, 98, 334; Carli, p. 112; Credi, pp. 64, 89; Degas, p. 177; the Ghirlandajo, pp. 134, 137, 140; Granacci, p. 145; Leonardo, pp. 60-64, 176, 177; Filippino Lippi, pp. 104, 106; Filippo Lippi, p. 82; Perugino, p. 91; Pesellino, p. 87.

Draughtsmanship, essentially an art of line and impro-visation, p. 226; versus conception, pp. 166, 211, 301; versus painting, pp. xii, 26, 39, 142; early habits of, pp. 30, 166, 300; draughtsmanship of linealists, p. 81.

Drawings, habitually enlarged for pictures, p. 19 note; destruction of, pp. xii, 93, 156, 184, No. 890B; documents about, pp. xi, 8 note, 21, 81, 254 note (see also under Vasari). Finished drawings versus spontaneous sketches, pp. 192, 225-227, 269. Drawings in relation to corresponding paintings, pp. xii, 4, 7, 16, 26, 36, 41, 42, 69-72, 81, 82, 84, 90-92, 95, 104, 105, 119, 122, 133, 134, 135, 136, 141, 144, 150, 153, 154, 158, 159, 164, 165, 169, 170, 171, 172, 174, 176, 196 note, 198, 199, 229, 230, 239, 250, 271, 273, 279, 280, 281, 282, 285, 288, 290-294, 295 note, 297, 298 note, 306, 311, 312, 315, 316, 318, 325, 326, 328, 330, 336, 340, 341, 342, 349, 356; in relation to corresponding sculptures, pp. 188, 189, 213, 216-223, 353; furnished to sculptors and jewellers, p. 70; reproductions of, p. xii, preface to Michelangelo catalogue; writings on, pp. xi, 79, 83, 84, 203, 216, 250, 256, 260-263, 342, 343-345, 357, 358, Nos. 55E, 560, 826, 845, 859M, 1326D, 1701, 1709, 1731.

Duccio di Buoninsegna, pp. 80, 367.

Dürer, pp. 44, 178, 313, 314, Nos. 55F, 1913, 1957A, 2113, 2140, 2256C, 2256D, 2369A.

Eastern art, compared with Fra Bartolommeo, No. 268; Botticelli, pp. 97, 333; Leonardo, pp. 168, 170, No. 1237; Michelangelo, p. 204, No. 1557; Piero di Cosimo, Nos. 1859E, 1859J; Pollajuolo, p. 25; Pontormo, Nos. 2139, 2201; the Sienese, p. 80 note; Spinello Aretino, p. 325.

Eclectics, Florentine: Alunno di Benozzo, pp. 11-13; Bacchiacca, p. 298; Carli, p. 112; Ghirlandajo, David, pp. 140, 343. Giusto d'Andrea, pp. 92, 93; Granacci, p. 143; Master of the Carrand Triptych, p. 332; Piero di Cosimo, pp. 150, 153.

Ede, J., p. 3 note, No. 1905.

Egger, H., No. 893C.

Egyptian art, p. 351.

Embroideries, Drawings for, pp. 18, 24, 99, 122, 130, 298, 335, Nos. 39, 39A, 180A, 572, 576A, 582, 608B, 617, 632A, 642, 642D, 645-655, 866A, 905C, 905D, 1839, 1845A, 1915, 1944A, 1947.

Engravings in relation to drawings, pp. 18, 27, 70, 154, 178, 190, 191, 225, 235, 251, 287, 288, 297, Nos. 37A, 113A, 161, 196G, 203C, 203E, 569, 629, 690, 1064, 1277E, 1277F, 1326D, 1396A note, 1476, 1545, 1613, 1615, 1617, 1618, 1623C, 1697B note, 1898C, 1934, 1945, 1950A, 2428, 2473.

Ephrussi, Ch., No. 1069.

Este, Isabella d', pp. 177, 178, No. 1062.

Eusebio di S. Giorgio, p. 115.

Fabriczy, K. von, p. 100 note, No. 2470.

Falconi, Silvio, pp. 252, 355, 356, Nos. 1622B, 1661C, 1702, 1703, 1746B, 2474C, 2504A.

Fattucci, G. F., pp. 197, 204, 217, 220, No. 1709.

Ferri, Nerino, Nos. 1399D, 1399F, 1399G, 1399G-3, 1649.

Finiguerra, Maso, pp. 29 note, 132 note, Nos. 196F, 203C, 203G, 1848, 1913A, 1933B, 1946, 2779D, 2779G.

Fiocco, Giuseppe, pp. 35 note, 332.

Fiorenzo di Lorenzo, p. 90, No. 1867.

Fischel, Oskar, pp. x, 30, 34 note, 39, 40, 84, 91, 245 note, Nos. 159ᴀ, 439ᴀ, 463ᴀ, 880, 886, 1390ᴀ, 1866ᴮ, 1866ᶜ, 2375ᶜ, 2507.

Flemish school of painting, Nos. 658ᴀ, 1706, 1723, 1866ᴮ, 1866ᶜ.

Fontainebleau school of painting, p. 322, No. 2252ᴀ.

Fontana, Prospero, No. 2474ᴮ.

Foppa, Vincenzo, p. 183.

Forain, J. L., p. 36.

Forgers of Michelangelo's drawings, pp. 266-267.

Form in line, p. 323.

Fragonard, J. H., p. 339.

Francesco di Giorgio, p. 74.

Francesco di Simone, pp. 48 note, 64, 70 note, Nos. 2787, 2789.

Francia, Francesco, No. 629.

Franciabigio, pp. 294, 295; in relation to other artists, pp. 144, 275, 290, Nos. 108ᴮ, 901ᴀ, 1561, 1964, 2253.

Francis I, King of France, No. 1118.

Franco, Battista, pp. 265, 363, Nos. 1108, 1396ᴀ note, 1473, 1545, 1624ᶜ, 1637, 1707, 2055, 2410, 2458ᴇ, 2506ᴀ, 2506ꜰ.

Francovich, G., No. 40ᴀ.

French modern painters, pp. 31, 34, 36, 57, 177, 193, 201, 272 note, 289, 322, 323, 348, Nos. 1558, 1959ꜰ, 2058, 2139.

Fresco, its influence on Florentine colour, p. 280.

Frey, Karl, pp. 193, 357, 366, preface to Michelangelo catalogue, Nos. 1399ɢ-1, 1403ᴀ, 1405, 1409ᴀ, 1410, 1411, 1420, 1425, 1429, 1434, 1435, 1454, 1455ᴀ, 1457, 1463, 1483, 1496, 1521, 1525, 1526, 1529, 1543, 1545, 1573, 1579, 1593, 1599, 1614, 1615, 1622ᴮ, 1661ᴮ, 1684, 1702, 1703.

Frizzoni, Gustavo, p. 26, Nos. 1237, 1861.

Fröhlich- Bum, L., Nos. 55ᴮ, 1761ᴀ.

Fuchs, Eduard, No. 1945.

Fry, Roger, pp. 15, 81 note, No. 459ꜰ.

Gabbiani, p. 191 note, Nos. 1399, 1564.

Gabelentz, H. von, Nos. 316, 337ᴀ, 375, 376ᴀ, 390ᴰ, 415, 453ᴀ, 470, 486. See also note at beginning of Fra Bartolommeo's catalogue.

Gaddi, Agnolo, p. 80, No. 2756ᴮ.

Gaddi, Taddeo, pp. 2, 3, 324, 325.

Gainsborough, Th., p. 359.

Gamba, Carlo, Nos. 558ᴮ, 594ᴀ, 1396ᴀ note, 1980.

Garbo, Raffaellino del, pp. 107-111, 119-121; in relation to other artists, pp. 81, 100, 114, 116, 118, 122, 123, 130, 136, Nos. 610, 625, 631ᴀ, 1009ᶜ, 1277ᴮ, 1278, 1279, 1316, 1319, 1366ᴀ, 1839.

Gatti, Saturnino, pp. 340, 343 note.

Gaugain, Paul, p. 31.

Generations, Length of artistic, p. 2 note.

Genga, Girolamo, No. 1660ᴮ.

Gentile da Fabriano, No. 559ᶜ.

Géricault, J. L., No. 1558.

Gerino da Pistoia, p. 115.

German art and its influence, pp. 278, 313, 314.

Geymüller, H. von, p. 353, Nos. 1649, 1697ᴀ, 1735.

Ghiberti, Lorenzo, pp. 327, 329, No. 176ᴀ.

Ghirlandajo, Benedetto, pp. 139, 140, Nos. 896ᴀ, 898ᶜ.

Ghirlandajo, David, pp. 136-141, 343-345; in relation to other artists, pp. 124, 129, 143, 144, 331, 339, 342, Nos. 24, 40ᴀ, 907, 909, 939, 946, 957, 991, 1008, 1311ᴮ, 1355ᴮ, 1382ᶜ, 1919.

Ghirlandajo, Domenico, pp. 56 note, 65-66, 132-136, 340-342; in relation to other artists, pp. 24 note, 56, 60, 63, 64, 66, 67, 68, 124, 125, 127, 129, 131, 136-141, 142, 143, 144, 343, Nos. 618, 642ᶜ, 800, 855ᶜ, 937, 939, 946, 989, 993, 996, 1167ᴀ, 1277, 1286, 1391ᴍ, 1393, 1394, 1397, 1475ᴀ, 1521, 1585, 1949ᴀ, 2757.

Ghirlandajo, Ridolfo, p. 142; in relation to other artists, pp. 115, 117, Nos. 529ᴀ, 928ᴀ, 988, 1009ᶜ, 2727.

Gianpietrino, p. 180 note.

Gié, Maréchal de, p. 187, No. 1585.

Giglioli, O. H., pp. ix, 84, Nos. 180ᴀ, 221ᴮ, 221ᶜ, 1281, 1962, 1972ᴀ, 1974, 1975, 2167, 2184, 2206, 2240, 2266ᴀ.

Giorgione, pp. 239, 244, 277, 290.

Giotto, pp. 1, 2, 80, 176, 186, 195, 325, 326, 342, Nos. 1522, 1544, 1587, 1837ᴀ, 1837ᶜ, 1837ᴶ, 1837ᴷ.

Giovanni delle Corniole, No. 1615.

Giovanni di Francesco, p. 332.

Giovanni da Milano, pp. 147, 324.

Giovanni da Nola, p. 352.

Giovanni da Udine, No. 1614.

Giulio Romano, pp. 34, 245 note, Nos. 996, 2477.

Giusto d'Andrea, pp. 92, 93.

Gnoli, Umberto, p. x, No. 559ᴇ.

Goldschmidt, F., No. 1954ᴀ.

Gomez Moreno, No. 570ᶜ.

Gonzaga, Ferrante, Duke of Mantua, p. 241, No. 2504.

Gonzaga, Giulio, p. 359.

Gothic tradition, pp. 131, 324-327, 332.

Goya, Fr., No. 2049.

Granacci, pp. 143-145; in relation to other artists, pp. 142, 253 note, 297, 299, 345, 369, Nos. 1369ᴀ, 1475ᴀ, 1561, 1859ᴰ, 1933ᶜ, 2375ᶜ, 2519, 2719, 2726, 2749.

Greco, El, Nos. 2160, 2205.

Greek art compared with Florentine, pp. 42, 64, 157, 175, 222, 234, 326, 341, 351, No. 1522.

Gronau, Georg, pp. x, 47 note, 48 note, Nos. 531ᴀ, 545ᶜ.

Grotesque, The, as treated by Leonardo, Nos. 1048ᴀ, 1082ᶜ, 1114, 1122, 1137, 1163ᴀ, 1164, 1169, 1169ᴀ, 1263, 1263ᴀ; Filippino Lippi, p. 107, Nos. 1322-1326ᶜ; Michelangelo, p. 223, Nos. 1475, 1490, 1576, 1610; Passerotti, No. 1741.

Gruyer, Gustave, p. 128.

Guardi, F., p. 104.

Guercino, Il, p. 266.

Guido Reni, p. 266.

Halm, P., No. 1329ᴀ.

Hals, Franz, p. 319.

Handwriting, pp. xi, 13, 255, 256, 261, 264, 366, 367, Nos. 982ᶜ, 1599, 1669ᴀ, 1701, 1731, 1738, 1868, 1902, 1902ᴮ.

Heemskerk, M. van, p. 348, Nos. 1706, 1723.

Hennequin, E., p. 3 note.

Henry VII, King of England, p. 40.

Heseltine, J. P., p. 142, No. 901ᴀ.

Hewlett, Maurice, p. 110 note.

Hill, G. F., No. 1905.

Hind, A. M., pp. ix, 132 note, Nos. 161ᴀ, 559ᴘ, 629, 905ᶜ, 905ᴰ.

Hokusai, p. 25.

Holbein, p. 318, Nos. 1034ᴮ, 2157.

Horne, H. P., pp. 15 note, 17 note, 24 note, 71, 72, 96 note, 116 note, 118, 125 note, 336, Nos. 1038, 2773.

Horses, as treated by Leonardo, p. 173; as treated by Michelangelo, p. 193.

Hülsen, C., Nos. 506ᴬ, 893ᶜ.

Illustration of books, p. 128; of writing through sketches, pp. 166-167.

Impressionist painting, p. 323.

Instruments (see under Chalk and Pen).

Jacobsen, E., Nos. 958, 1399ᴰ, 1399ꜰ, 1399ᴳ, 1399ᴳ-2, 1399ᴳ-3.

Jacopino del Conte, No. 1462.

Jacopo da Empoli, p. 313.

Juan de Borgoña, No. 898ᶜ.

Julius II, p. 201, Nos. 1399ᴮ, 1598ᴰ.

Justi, Carl, p. 212 note.

Keats, J., p. 98.

Knapp, F., Nos. 113ᴱ, 114, 115, 117, 117ᴮ, 120ᴬ, 123, 128ᴬ, 242, 243, 1674, 1853.

Köhler, Wilhelm, p. 346.

Kristeller, Paul, p. 128.

Kusenberg, K., Nos. 604ᴬ, 2404, 2424, 2432, 2446ᴬ, 2446ᴮ, 2452, 2459.

Landscape, as treated by Andrea, p. 273, 274, 275 note; Baldovinetti, p. 20; Fra Bartolommeo, p. 157; Benozzo, No. 538; Credi, pp. 57, 67; Leonardo, pp. 20, 22, 52, 56, 59, 168, 181, Nos. 1017, 1238-1260ᴬ; Piero di Cosimo, pp. 124, 126, Nos. 1858, 1859; Pollajuolo, pp. 20, 22, 23 note; Sodoma, p. 273; Verrocchio, pp. 20, 53.

Lanyi, Jenö, p. 319 note, No. 2011.

Last Judgement, Treatment of, pp. 148-150.

Last Supper, Treatment of, pp. 173-175, 280, 281.

Left-handedness, pp. 168, 261, 262, 263.

Leo X (see under Medici family).

Leonardo, pp. 51, 52, 55-64, 166-183; habits of work, pp. 167, 168; symbolism of, pp. 181, 182; writings of, pp. 166, 167, 181. Lost works: Gipsy Captain, p. 178, No. 1050; Leda, p. 180, Nos. 1013ᴬ, 1020ᴬ, 1123, 1155-1158; Sforza monument, pp. 172, 173, Nos. 1044ᴬ, 1211, 1214; Standard, Battle of the, pp. 178, 179, 189, 193, Nos. 1011, 1012, 1029, 1031, 1044ᴬ, 1052, 1056, 1080ᴬ, 1089, 1095-1098, 1100, 1104, 1106, 1111, 1123, 1128ᴬ, 1191ᴰ, 1194, 1224, 1225, 1225ᴬ, 1227ᴬ, 1228ᴬ, 1229 (see also under Additions and Corrections, No. 1048ᴮ); copies of the Battle of the Standard, by Raffaele del Colle, Raphael, Rubens, and Sodoma, p. 179; Trivulzio monument, Nos. 1210, 1212, 1215, 1216, 1220, 1224ᴬ. Imitations of Leonardo, p. 168, Nos. 1261ᴬ-1266; and Leonardesque motives in relation to other artists, pp. 38, 47-49, 51, 52, 59, 67, 68, 79, 104, 138, 150, 151, 156, 157, 179 note, 183, 193, 222, 280, 281, 314, 317, 333, 340, Nos. 235, 433ᴮ, 438, 449, 502, 670ᶜ, 671ᴬ, 679ᴬ, 685ᴬ, 721, 731, 742ᴬ, 837, 868, 880, 896ᴬ, 938, 946, 955, 970ᴮ, 1319, 1326ᴱ, 1399ᴬ, 1561, 1688, 1852ᴮ, 1857ᶜ, 1859ꜰ, 1863, 1863ᴬ, 1968, 2445, 2509ᴰ-8, 2526, 2681, 2682, 2683, 2731ᴬ, 2732, 2738, 2757, 2757ᴬ, 2763ᴬ. Milanese followers of Leonardo, pp. 38 note, 67, 144, 169, 183, Nos. 1136, 1148.

Leonardo da Pistoia, Nos. 177, 904.

Leoni, Leone, p. 351, No. 1702 note.

Licinio, Bernardino, p. 38.

Linealists, pp. 80, 81; preference for pen, p. 81; Botticelli as, pp. 97, 98; Garbo as, p. 80; Lippi as, p. 80.

Lippi, Filippino, pp. 103-107, 335-337, 338-339, 344; in relation to other artists, pp. 72, 108, 109, 110, 120, 121, 123, 124, 126, 127, 136, 137, 138, 147, 148, 151, 152, 153, 279, 306, 334, 343, Nos. 567ᴬ, 610ᴬ, 642ᶜ, 766ᴬ, 770ᴬ, 772ᴴ, 772ᴶ, 794ᴮ, 794ᶜ, 807, 808, 820, 824, 834ᶜ, 855ᶜ, 855ᴰ, 859ꜰ, 859ᴷ, 887, 917, 981, 996, 1046, 1767, 1859ꜰ, 2464.

Lippi, Fra Filippo, pp. 81-84; in relation to other artists, pp. 85, 86, 92, 95, 98, 102, 103, 124, 147, 278, 329, 332, Nos. 567ᴮ, 744ᴬ, 866ᴮ, 905ᶜ, 917, 970ᴰ, 998ᶜ, 1059, 1068, 1767, 1838.

Lippmann, F., Nos. 561, 570.

Lodovico il Moro, No. 1164ᴬ.

Loeser, Charles, Nos. 5, 559ᴹ.

Logan, Mary, p. 24 note.

Lombardi, The, No. 2504.

Longhena, B., p. 351 note.

Longhi, Roberto, p. 330, Nos. 1867, 1868, 1884ᴬ.

Lorenzetti, The, p. 80, No. 2756ᴰ.

Lorenzetto, pp. 73, 74.

Lorenzo da San Severino, p. 13 note.

Lorenzo Monaco, pp. 80, 86, 98, 324, 327, 332.

Lorenzo the Magnificent (see under Medici family).

Lotto, Lorenzo, pp. 155, 290 note, 313, Nos. 506, 1504.

Lucas van Leyden, pp. 251, 297.

Ludwig, Gustav, p. 91, No. 1846ᴮ.

Lunette as problem in decoration, pp. 197, 305, 349.

Mackowsky, H., pp. 56 note, 78.

Maclagan, Sir Eric, No. 1042.

Mainardi, Bastiano, pp. 65, 67, 135, 136, 139, 140, 142, No. 898ᶜ.

Malaguzzi Valeri, F., No. 1214.

Manet, E., No. 1959ꜰ.

Manfredi, Bartolommeo, pp. 238, 268, No. 1714.

Mannerists, Bolognese, pp. 238, 266-268.

Mannerists, Florentine, pp. 300-302.

Mantegna, Nos. 1101, 1898ᴬ.

Manuscripts, Illuminated, pp. 71, 92, Nos. 1842, 1843, 1911.

Marcantonio, pp. 190, 191.

Marchese, P. Vincenzo, p. 7 note, No. 281.

Marcuard, F. von, No. 1463 note.

Mariani, Valerio, Nos. 605ᴬ, 605ᴮ.

Mariette, J. P., pp. 210, 238, 364, Nos. 1728, 1734, 1740.

Masaccio, pp. 5, 134, 135, 138, 176, 186, 332, Nos. 178ᴬ, 1474, 1522, 1544, 1545, 1602, 1663.

Masolino, pp. 138, 332.

Master of the Bambino Vispo, pp. 324, 327.

Master of the Carrand Triptych, Nos. 175ᴬ, 190, 558ᴮ, 1841ᶜ, 2778ᶜ.

Master of the Castello Nativity, Nos. 165ᴬ, 2508.

Master of the Jarves Cassoni, p. 92.

47

Master of the Rinuccini Chapel, p. 147.

Master of S. Miniato, pp. 92, 101, 102.

Matisse, H., p. 24 note.

Matteo da Gualdo, No. 1866ᴮ.

McComb, Arthur, Nos. 595, 601ᴬ, 601ᴮ, 2035.

Meder, Joseph, No. 1491.

Medici arms, Nos. 2248ᴬ, 2248ᴮ 2255, 2332.

Medici family: Cosimo I, pp. 236, 304, 319, Nos. 1655 note, 2031; Francesco I, No. 605ᴱ; Giovanni di Cosimo, No. 1385; Cardinal Giulio, later Clement VII, pp. 204, 205, 213, 214, 217, 223, 229, 353, Nos. 1445, 1494, 1598ᴰ, 2477ᴬ, 2499, 2505ᴬ; Ippolito, No. 1615; Leo X, pp. 205, 245 note, 304, 312, Nos. 1118, 1445, 2248ᴬ, 2477; Lorenzo the Magnificent, pp. 18, 126 note, 185, 328, 341.

Meissonier, J. L., p. 193.

Meller, Simon, p. 62 note, No. 587ᴬ, 1908ᴬ.

Melozzo da Forlì, pp. 60, 340.

Melzi, Fr., pp. 168, 177, 183 note, Nos. 1098ᴬ, 1109ᴬ, 1163ᴬ, 1164ᴬ, 1169ᴬ, 1261ᶜ, 1261ᴰ, 1263ᴬ, 1264ᴬ.

Method of attribution, pp. xi, xii, 16, 17, 238, 357, 358, see also preface to Michelangelo catalogue.

Michelangelo, pp. 184-237, 346-354, preface to Michelangelo catalogue; in relation to his pupils and followers, pp. 238-268, 271-273, 277-278, 283-286, 294, 295, 301, 302, 303, 306-310, 312, 314, 315-321, 323, 345, 355, 356, 357-367, Nos. 2444ᴬ, 2444ᴮ, 2455ᴬ, 2458ᴴ, see also catalogues of Pontormo, Sebastiano del Piombo and Michelangelo School; his influence through the ages, see preface to Michelangelo catalogue; in relation to other artists, pp. 2, 5, 30, 31, 32, 36, 42, 155, 179, 185, 186, 187, 189, 193, 195, Nos. 200, 932, 954, 956, 984, 996ᴬ, 998ᴮ, 1013ᴮ, 1129ᴮ, 1189, 1190, 1271ᴴ, 1754ᶠ, 1758, 1857ᶜ, 1863ᴬ, 2509ᶜ, 2509ᴰ⁻¹, 2509ᴱ, 2556ᴬ; as decorator, p. 197; as draughtsman, pp. 186, 188, 231; as a human being, pp. 184 note, 211, 214, 228; habits of work, pp. xiv, 185, 187, 188, 192, 193, 211, 212; ideal of composition, pp. 195, 223, 243, 244, 301, 317; possible portraits of himself, Nos. 1598ᴰ, 1683; reason for relative scarcity of drawings, p. 184. His works: Apollo, No. 1556; Annunciation, pp. 236, 237, Nos. 1519, 1534, 1575, 1644, 1696; Bathers, pp. 190-194, 346-347, Nos. 1397ᶜ, 1399ᴶ, 1409, 1418, 1463, 1464, 1476,1478, 1479, 1481, 1521, 1556-1560, 1584, 1594, 1597, 1598, 1604, 1605, 1624ᴬ, 1624ᶜ, 1645ᴬ, 1645ᴮ, 1659, 1676ᴮ, 1739, 1746ᴬ, 1748, 1959ᴳ; Bruges Madonna (see under Bruges); Cavalieri drawings (see under Cavalieri); Centauromachia, p. 190, No. 1564; Christ, Marble (see under Rome, Minerva); Christ and the Money Changers, p. 232, Nos. 1398, 1401ᴬ, 1403, 1515, 1516, 1517, 1569, 1571, 1573; Christ in the Garden, p. 232, Nos. 1572ᴬ, 1645; Crucifixion, pp. 232-234, Nos. 1514, 1529, 1530, 1574, 1578, 1582, 1583, 1595, 1598ᴬ, 1621, 1622, 1675, 1708, 1724ᴬ, 2055, 2485; Cupid (see under London, South Kensington Museum); Danae, p. 225, Nos. 1409ᴬ, 1409ᴱ; David, Bronze, p. 187, Nos. 1474, 1487, 1545, 1585, 2144; David, Marble (see under Florence, Academy); Deposition (see under London, National Gallery); Doni Madonna (see under Florence, Uffizi); Dream of Human Life, Nos. 1571, 1669ᴬ, 1748ᴮ; Hercules and Antaeus, pp. 223, 224, Nos. 1472, 1490, 1526, 1593, 1611, 1664, 1712; Hercules and Cacus, pp. 223,

360, Nos. 1412, 1571, 1688; Holy Family, p. 231, No. 1537; Leda, pp. 225, 256, Nos. 1399ᴶ, 2110; Matthew (see under Florence, Academy); Noli me tangere, pp. xiv, 228, Nos. 1396ᴬ, 1473; Pauline Chapel (see under Rome, Vatican); Pietà, pp. 196 note, 231, 234-236, Nos. 1416, 1572, 1586, 1623ᶜ, 1697ᴮ (see also under Florence, Cathedral; Rome, St. Peter's, and Rondanini Palace); Porta Pia (see under Rome); Resurrection, pp. 227, 228, 353, Nos. 1407, 1413, 1507, 1507ᴬ, 1523, 1570 note, 1580, 1612, 1615, 1616, 1676ᴬ, 1713; Sacrifice of Isaac, p. 232, No. 1417; Samson and Delilah, pp. 224, 225, Nos. 1504, 1718; Samson and the Philistines, pp. 224, 360, Nos. 1401ᴬ, 1412, 1544ᴱ, 1571; San Lorenzo, Sacristy and Library (see under Florence); Sixtine Chapel (see under Rome, Vatican); St. Peter's Cupola, No. 1469; Tityus, pp. 227, 228, 256, Nos. 1399ᴵ, 1615, 2013; tomb of Julius, sketches for, pp. 194, 200-212, 351-352, Nos. 1399ᴳ⁻¹, 1399ᴳ⁻³, 1404, 1470, 1487, 1489, 1491, 1501, 1521, 1543ᴬ, 1562, 1589, 1607, 1622ᴮ, 1622ᴰ, 1623, 1632, 1649, 1730, 1743ᴬ, 1746 (see also under Rome, S. Pietro in Vincoli); tombs of Medici (see under Florence, San Lorenzo); marble tondi (see under Florence, Bargello; and London, Royal Academy); Venus (see under Florence, Uffizi); Victory (see under Florence, Palazzo Vecchio).

Michele di Ridolfo, Nos. 694, 904ᴮ, 905, 979.

Michelino, Domenico di, p. 6, Nos. 164ᶜ, 175ᴮ, 175ᶜ, 176, 178.

Milanesi, Gaetano, pp. 118, 119, 204 note, 264, 275, 276, Nos. 1502, 1614.

Millet, J. F., preface to Michelangelo catalogue.

Mini, Antonio, pp. 225, 255, 256, 355, 358, 360, 364, 366, Nos. 1444, 1502, 1528, 1555, 1599, 1602, 1653ᴬ, 1660ᴮ, 1662, 1663, 1665, 1668, 1694, 1702, 1718, 1722; 1725, 1728, 1731, 2495, 2504ᴬ.

Mino da Fiesole, No. 1274ᴮ.

Möller, Emil, No. 1903.

Monet, C., p. 289.

Montagna, Bart., No. 669ᴬ.

Montaiglon, A. de, No. 1585.

Montefeltro, Guidobaldo da, p. 40.

Montelupo, Raffaello da, pp. 238, 256-263, 267, 365, Nos. 1623ᴬ, 1640, 1642, 1643, 1659, 1664, 1668, 1697, 1701, 1710-1713, 1715-1717, 1720, 1723, 1729, 1734.

Montorsoli, St. Peter at S. Piero a Sieve, No. 1399.

Morassi, Antonio, No. 2739ᴱ (see also under Additions and Corrections No. 1048ᴮ).

Moreau-Nélaton, E., p. xi.

Morelli, Giovanni, pp. 47, 48, note, 73, 74, 76, 77, 87, 119, 121, 123, 130, 136, 168, 240, 241, 247, 250, 251, 252, 268, 295 note, 298, Nos. 390ᴮ, 464, 562, 566, 728, 886, 887, 1015ᴬ, 1155, 1265, 1274ᴮ, 1278, 1288, 1289, 1299, 1300, 1305, 1316, 1387, 1475, 1490, 1545 note, 1587, 1593, 1603, 1604, 1626, 1627, 1678, 1681, 1682, 1728, 1734, 1756, 1757, 1867, 1901, 1902, 1903, 1956, 1963, 2477ᴬ, 2746.

Moretto, No. 2370ᴬ.

Morone, Fr., No. 1718.

Moroni, G. B., No. 2370ᴬ.

Mosaics, pp. 326, 343, Nos. 1837ᶜ, 1837ᴶ, 1837ᴷ.

Müller-Walde, P., pp. 172, 180 note, No. 1016.

Müntz, E., p. 180 note.

Murray, C. Fairfax, p. 325.

Naldini, pp. 274, 279, 283 note, 287, 321, Nos. 2176, 2211ᴀ.
Nanni di Banco, p. 327 note.
Nardo di Cione, No. 2756ᴀ.
Naturalists, Florentine, pp. 14, 80, 131.
Neck, length of, pp. 359, 361.
Nelli, Suor Plautilla, pp. 156, 165.
Neri di Bicci, pp. 72, 92, 146 note, 329.
Neroccio di Landi, p. 80.
Niccolò da Foligno, No. 547.
Niccolò di Piero, No. 2756ꜰ.
Northern sculptors, p. 26.
Nude, The, as treated by Fra Angelico, No. 176; Andrea, pp. 270, 272; Fra Bartolommeo, pp. 157, 159, Nos. 373, 459ꜰ; Franciabigio, pp. 270, 295 note; Leonardo, p. 182; Lippi, Filippino, p. 106; Pollajuolo, p. 24; Pontormo, pp. 302, 303, No. 2101; Rosso, p. 323, No. 2410.

Oggiono, Marco d', p. 168 note, Nos. 502, 728.
Orcagna, p. 1.
Ottley, pp. 252, 325, 326, 364, No. 1740.
Ovid, p. 37.

Pacchiarotto, p. 367.
Paduan-Florentine influence, p. 183.
Painting versus draughtsmanship, pp. xii, 16, 26, 142.
Palma Vecchio, pp. 32, 239.
Palmieri, Matteo, p. 71, No. 588.
Panofsky, E., Nos. 1408, 1416, 1468, 1586, 2476, 2499.
Paolino, Fra, pp. 160, 163, 164; in relation to Fra Bartolommeo, Nos. 275, 291 (see also Fra Paolino's catalogue).
Paolo Veronese, pp. 278, 283, No. 1341ᴇ.
Papacello, No. 2509ᴷ⁻¹.
Papini, R., p. 10 note.
Parker, K. T., pp. 343-345, No. 560.
Parmigianino, pp. 300, 359.
Parri Spinello, pp. 324, 326, 327, No. 190.
Passerotti, Bartolommeo, pp. 238, 266, 267, 362, Nos. 1638, 1639, 1646-48, 1650-52, 1661, 1696ᴀ, 1698, 1699, 1704, 1705, 1726, 1740-42.
Pater, Walter, p. 146.
Pen and ink, as used by Andrea di Michelangelo, pp. 361, 362, 367; Fra Bartolommeo, pp. 147, 156; Botticelli, p. 81; Leonardo, pp. 167-170, 172; Filippino Lippi, pp. 103, 107; Filippo Lippi, p. 82; Michelangelo, p. 185; Montelupo, pp. 257, 258; Passerotti, p. 267; Piero di Cosimo, pp. 151, 153; Pollajuolo, p. 26; Pontormo, p. 314; Cosimo Rosselli, pp. 147, 152, 153; Signorelli, p. 38; Spinello, p. 325.
Penni, G. F., p. 165.
Pérate, A., No. 559ᴇ.
Perugino, in relation to Florentine artists, pp. 35, 37, 52, 54, 60, 62, 75, 76, 90, 91, 150, 251, 297-299, Nos. 40ᴀ, 635-638, 678, 743ᴀ, 758ᴀ, 880, 933, 944, 970ᴀ, 1326ᴇ, 1359ᴀ, 1364ᴀ, 1864, 1913ᴮ, 2387ᴀ, 2507, 2508, 2509ᴳ, 2509ᴴ⁻⁶, 2509ᴼ, 2509ᵀ, 2510ᶜ, 2525, 2697, 2735ᴀ, 2754ᴇ, 2799ᴀ.

Pesellino, pp. 86-92; in relation to other artists, pp. 92, 93, Nos. 164ᶜ, 534ᴀ, 559ᴾ, 917, 956, 1474, 1913ᴀ.
Petrarch, Nos. 1588, 1843.
Phillips, Claude, No. 1272ᴀ.
Pier Francesco Fiorentino, pp. 11-12.
Pierin del Vaga, pp. 157, 264, 298.
Pierino da Vinci, p. 224.
Piero di Cosimo, pp. 150-154; in relation to other artists, pp. 38, 68, 77, 79, 99, 124, 126, 145, 148, 155, 156, 158, 251, 252 note, 274, 295, Nos. 5, 7, 37ᴀ, 107, 294ᴀ, 508ᴀ, 577, 898ᶜ, 1002, 1320ᴀ, 1329ᴮ, 1366ᴴ, 2386, 2757, 2759.
Piero della Francesca, pp. 18, 30, 31, 32, 41, 172, Nos. 536ᴀ, 746, 761, 2509ᴰ⁻⁴.
Pietro di Domenico da Montepulciano, No. 1391ᴷ.
Pietro del Donzello, No. 736.
"Pietro Jachomo da Furlì," No. 537.
Pini, Carlo, p. 13 note, Nos. 1701, 1731.
Pintoricchio, pp. 12, 45, 197, Nos. 40ᴀ, 1876.
Poccetti, Bern., p. 208.
Poggi, Giovanni, p. 332, Nos. 1385ᴀ, 1385ᶜ.
Poliziano, Agnolo, pp. 98, 157.
Pollajuolo, The, pp. 17-29; embroideries, pp. 18, 24; sculptures, p. 18; in relation to other artists, pp. 15, 16, 29, 30, 35, 60, 139, 167, 169, 193, 224, 272, 278, 294, Nos. 196ᴳ, 203ᴮ, 567ᴮ, 574, 846, 997ᴀ, 1202, 1326ᴇ, 1366ᶜ, 1619, 2509ᴰ⁻⁴, 2509ᴴ⁻³, 2509ᴶ, 2509ᴼ, 2787ᴀ.
Pollajuolo, Piero, pp. 19, 20, 21, 22, 23, 24, 28, 178, No. 1062.
Pontormo, pp. 300-321; his draughtsmanship, pp. 302-304; in relation to other artists, pp. 159, 197, 228, 265, 274, 296, 298, 322, Nos. 601ᴀ, 603, 604ᴀ, 1288, 1328, 1396ᴀ, 1504, 1508, 1561, 1607 note, 1754ᴀ, 1754ᴳ, 1759ᴀ, 1857ᴮ, 2416, 2492, 2556; as portraitist, pp. 316-318. Lost works: frescoes at Careggi, Castello, and Fiesole, p. 319 note, Nos. 1977ᴀ ,2017, 2084, 2086, 2091, 2123, 2136, 2178, 2252ᴀ, 2336ꜰ; Pietà, Nos. 1962, 2064, 2110, 2174, 2175ᴀ, 2177; Portrait of Francesco Guardi, p. 318, No. 1982; St. Jerome, No. 1968.
Popham, A. E., pp. x, 39, 338 note, Nos. 558ᴮ, 593ᴮ, 753ᴀ, 1108, 1277ᴇ, 1473, 2252ᶜ, 2506ᴀ, 2731ᴀ.
Popp, A. E., pp. 206 note, 225, 349, 350, 353, 357, Nos. 1408, 1409ᴀ, 1424, 1445, 1491, 1499, 1551, 1580, 1608, 1664, 1669.
Pordenone, No. 1484.
Portraiture in Florentine art, pp. 15, 38, 76, 126 note, 135, 142, 177, 178, 183 note, 197, 274, 289, 294, 295, 296, 314, 316-319, 341, 358, 359.
Poulsen, Fr., No. 969ᴰ.
Poussin, G., p. 31.
Predis, Ambrogio da, pp. 172, 359, No. 1112ᴮ.
Primaticcio, p. 225, No. 1473.
Provincialism of artists, pp. 11, 37.
Pseudo-Pier Francesco Fiorentino, p. 12.
Puligo, pp. 296, 297; in relation to other artists, Nos. 415, 754, 1975.

Quality, Importance of a sense of, pp. xiv, preface to Michelangelo catalogue, No. 1544ᴰ.
Quaratesi, Andrea, p. 357.
Quercia, Jacopo della, pp. 70, 193.

Raffaele del Colle, p. 179.

Raffaellino, see Carli and Garbo.

Rankin, William, p. 23 note.

Raphael and Raphaelesque motives in relation to Florentine artists, pp. 32, 33, 34, 35, 36, 39, 40, 117, 142, 143, 148-150, 157, 169, 245 note, 247, 273, 275, 278, 285, 295, 298, 300, 305, 307, 316, 361, Nos. 5, 161, 282, 318, 459D, 608, 669E, 757, 901, 928A, 1059, 1069, 1129A, 1170, 1228, 1486, 1598, 1599, 1613, 1720, 1725A, 1739, 1852B, 1959C, 1971, 2036, 2102, 2162, 2232, 2477, 2495, 2499, 2509B-1, 2509E-7, 2509E-8, 2509H-9, 2695.

Reiset, M., p. 187.

Rembrandt, pp. 25, 40, 319.

Ricci, Corrado, pp. 292 note, 293 note.

Richter, J. P., pp. 126 note, 172, 178, 181 (see also note at beginning of Leonardo catalogue).

Ripanda, Jacopo, p. 35 note.

Robert, Hubert, p. 53.

Robertet, Florimond, p. 235 note, No. 1585.

Roberti, Ercole, p. 27, No. 1859C.

Robertson, Jan, No. 1725A.

Robetta, Crist., Nos. 690, 1277E, 1326D.

Robinson, Sir Ch., pp. 39, 47 note, 240, 252, 262 note, Nos. 1545 note, 1564, 1571, 1572, 1702, 1703, 1709, 1725A.

Rococo designs, p. 340.

Rogers, Ch., p. 364, No. 1545.

Rolland, Romain, p. 184 note.

Romanesque tradition, pp. 148-150.

Rosselli, Cosimo, pp. 146-150; in relation to other artists, pp. 10, 12, 68, 71, 72, 151-154, 155, Nos. 41B, 196E, 529B, 559P.

Rossellino, Bernardo, p. 66.

Rossello di Jacopo Franchi, pp. 324, 327 note, Nos. 1391D, 1837I.

Rossetti, Dante Gabriel, p. 96.

Rossetti, G. P., No. 2492.

Rossi, Adamo, p. 8 note, No. 537.

Rosso Fiorentino, pp. 322, 323, 361; in relation to other artists, pp. 159, 225 note, 300, 301, 302, 361, Nos. 505, 604C, 992, 1399J, 1733A, 2556.

Rost, Jan, No. 180A.

Roy, Maurice, p. 225 note.

Rubens, pp. 47, 159, 289, 339, Nos. 1129A, 2016A.

Sacro Volto, p. 31, Nos. 1305, 2505D-4.

Salai, Andrea, pp. 168, 177, 183 note, Nos. 1261C, 1261D, 1264A.

Salmi, Mario, Nos. 558B.

Salterello, Jacopo, No. 1124.

Salviati, Fr., pp. 260, 323 note, 352, 361, Nos. 1552, 2432, 2476.

Salviati, Maria, p. 319, Nos. 2011, 2165.

Sambon, L., No. 459F.

San Gallo, Antonio and Giuliano da, pp. 100-101, Nos. 1383A, 1422, 1949B.

San Gallo, Aristotile da, pp. 206 note, 208 note, 210, 213 note, 218, 219 note, Nos. 1564, 1631, 1648A, 1649, 1697A, 1729, 1734A, 1735, 1743, 1747, 1747A.

San Severino, Galeazzo da, No. 1122.

Sansovino, Andrea, detto il, p. 214.

Sansovino, Jacopo da, p. 351, Nos. 126, 1747.

Santi di Tito, No. 2631.

Sargent. J. S., p. 38.

Sassetta, pp. 70, 327 note, No. 545C.

Sassetti family, pp. 126 note, 341.

Savonarola, p. 156, No. 285.

Scaramuccia, Captain, p. 178, No. 1050.

Schaarschmidt, F., p. 290 note.

Scharf, Alfred, p. 103 note.

Schiavone, Lo, p. 241.

Schmarsow, Aug., pp. 205, 206.

Schottmüller, F., No. 1387D.

Scognamiglio, N., No. 1124.

Sculpture versus drawings, pp. 188, 189, 213, 216-223.

Scythian bronzes, No. 1533.

Sebastiano del Piombo, pp. 238-250, 355-356, 358-359, 365; his mannerisms, pp. 240-242, 244-246, 248, 249; and Michelangelo, pp. 162, 200, 235, 361, 362, Nos. 1507, 1522, 1555, 1586, 1599, 1614, 1635, 1663, 1708, 1744; traces of Venetian training, pp. 239, 240, 242, 245, 249, 250, 356, Nos. 2477A, 2481, 2490, 2501, 2504, 2506A.

Segni, Antonio, No. 1117.

Seidlitz, W. von, No. 1101.

Sellajo, Jacopo del, pp. 101-102.

Sellajo, Leonardo, No. 2478.

Sforza, Francesco, p. 27, No. 1908A.

Sforza, Galeazzo, p. 23.

Shakespeare, p. 98.

Shapley, F., p. ix, Nos. 1898C, 1906.

Shaw, J. Byam, p. 100 note, Nos. 39A, 41A, 559N, 669A, 859I, 1949A.

Sienese art, influence on Florentine, p. 80.

Sienese artist copying Giotto, p. 2; Signorelli, p. 45.

Signorelli, Luca, pp. 30-45; in relation to other artists, pp. 8 note, 22 note, 26 note, 150, 151, 152, 234, 287, Nos. 1857C, 1861, 1862, 2506A; his mannerisms, p. 43.

Simone Martini, pp. 80, 326.

Sinibaldi, Giulia, No. 2174.

Sirén, O., pp. 72, 325, 327, Nos. 545B, 559L, 905B, 1366A, 1366B, 1391A, 1391C, 1391G, 1391K, 2756A, 2756E, 2756F, 2764B.

Sodoma, pp. 47, 142, 143, 179, 180 note, 273, 356, No. 1155.

Soggi, Niccolò, No. 1059.

Sogliani, pp. 164, 165; in relation to other artists, Nos. 390C, 454, 529A, 547A, 732A, 990, 1024, 1261A, 1608.

Solario, Andrea, pp. 67, 169, 174.

Solmi, E., No. 1038 note.

Spagna, Lo, pp. 115, 117, 291, No. 142.

Spinello Aretino, pp. 324-326.

Springer, Anton, pp. 190 note, 201, 206.

Starnina, p. 1.

Stechow, W., Nos. 2422, 2762B.

Stefano di Tommaso, pp. 217, 255, 367, No. 1709.

Steinmann, Ernst, Nos. 1399D, 1401, 1403A, 1417, 1483, 1486, 1537, 1544A, 1544D, 1584, 1598B, 1661C, 1684, 1748A.

Stradano, Giov., p. 232 note.

Strozzi, Zanobi, No. 164C.

Strzygowski, J., No. 570.

Stscherbatscheva, M., No. 2211A.

Symonds, J. A,. pp. 190 note, 195.

Taine, H., p. 2 note.

Tamagni, Vincenzo, pp. 142, 143.

Tanagra figures, pp. 157, 222, 326.

Tauzia, B. de, No. 1069.

Thausing, M., pp. 190, 191.

Thiis, Jens, pp. 62, 151.

Thode, H., Nos. 1396A, 1412, 1498, 1634, 1748B, 2480.

Thompson, Daniel, No. 1725A.

Tibaldi, P., No. 2506B.

Tietze, H., Nos. 55F, 2479B, 2480A.

Tintoretto, pp. 32, 36, 157, Nos. 2249, 2505B.

Titian, pp. 47, 240, 245, 250, 266, 283, 290, 313, 317, Nos. 1601, 2506A.

Toesca, P., p. 184 note.

Tolnay, C., pp. 212 note, 353, Nos. 1400, 1413, 1435, 1462A, 1543A, 1666, 1696A, 1713.

"Tommaso," pp. 76-79; in relation to other artists, pp. 63, 64 note, Nos. 7, 508A, 1859D, 1859G, 1863.

Tommaso di Stefano, pp. 76, 77, Nos. 528B, 2727, 2754N.

Tourguenieff, p. 216.

Trecento artists, pp. 1-3, 324-327; their followers in the Quattrocento, pp. 80, 98.

Tribolo, Il, pp. 214, 215, 216.

Trivulzio, Gian Giacomo, p. 183 note.

Trombetti, Anna, No. 738.

Uccello, Paolo, pp. 14-15, 331, 332; in relation to other artists, p. 172, Nos. 558B, 560, 1868C, 1874B, 2456.

Ulmann, H., pp. 17 note, 24 note, 137, 145, 154 note, Nos. 569A, 1278.

Umbrian influence, pp. 107, 109, 111-118.

Urbano, Pietro, p. 366, Nos. 1702, 2480, 2493, 2495, 2504A.

Urbino, servant of Michelangelo, p. 364, Nos. 1535, 1575, 1702.

Utili, G. B., pp. 48 note, 62, 69-70.

Valentiner, W., No. 1020C.

Valori, Baccio, No. 1556.

Van Marle, R., pp. 328, 330, Nos. 545A, 1838.

Vanni, Fr., No. 2256G.

Vasari, collection of drawings, pp. 1, 14, 27 note, 48 note, Nos. 55E, 142A, 390, 399, 464A, 720, 760, 890B, 1114, 1275, 1355A, 1355B, 1908, 2453; value of his attributions, p. xi; as a painter, No. 2506B. Vasari on Agnolo di Donnino, p. 344; Andrea, pp. 269, 270, 271, 275, 276, 281, 283, 288; Fra Bartolommeo, p. 157, No. 318; Bronzino, p. 321; Bugiardini, No. 1600; Castagno, p. 332; Cimabue, p. 1; Credi, pp. 74, 77 note; Cungi, p. 264; Daniele da Volterra, No. 1470; Franciabigio, pp. 270, 295; Battista Franco, p. 265; Garbo, pp. 109 note, 110, 111, 112, 114, 116, 122; David Ghirlandajo, pp. 129, 137 note; Leonardo, pp. 178, 179, Nos. 1050, 1117; Leone Leoni, No. 1702

note; Filippino Lippi, No. 1360; Filippo Lippi, p. 81; Michelangelo, pp. 184, 185, 192, 201, 202, 215, 216, 223, 224, 229, 236, 265, Nos. 1475A, 1602, 1618; Montelupo, pp. 261, 262, No. 1717; Pierino da Vinci, No. 1571; Piero di Cosimo, p. 150; Pollajuolo, pp. 17, 18, 19, 20, 22, 23, 27 note, No. 1908A; Pontormo, pp. 314, 315, 320, Nos. 1982, 2178; Properzia de Rossi, No. 1655 note; Rosso, p. 322, No. 2453; Sebastiano, p. 243 note; Sogliani, p. 165; Tommaso di Stefano, No. 528B; Verrocchio, p. 46.

Venetian influence, pp. 155, 157, 158, 286 (see also under Sebastiano).

Venturi, Adolfo, pp. 90, 335, Nos. 566A, 731, 1401, 1479, 1600, 1746, 1874B, 2474B.

Venturi, Lionello, pp. 146, 326.

Venusti, Marcello, pp. 227 note, 228 note, 236, 237, 265, Nos. 1517, 1519, 1534, 1614, 1623C, 1644, 1645, 1683, 1696, 1725A, 2504A.

Verini, Ugolino, pp. 17, 46.

Verrocchio, pp. 46-55, 58-61; in relation to other artists, pp. 12, 65, 66, 68, 69, 70, 71, 73, 74, 75, 79, 90, 139, 167, Nos. 567B, 834A, 859I, 866C, 880, 886, 995, 1015A, 1020C, 1026, 1035, 1059, 1396, 1688, 1868, 2508, 2757A; the Verrocchio sketch-book, pp. 47 note, 48 note.

Vico, Enea, No. 1618.

Virgil, pp. 37, 92, No. 1842.

Vision of St. Bernard, pp. 147-148.

Visual memory, p. 271.

Vitelli, Alessandro, No. 1396A.

Viti, Timoteo, pp. 33, 34, Nos. 2509E-8, 2509H-9, 2509H-10, 2509P.

Voragine, Jacopo da, No. 576A.

Voss, H., No. 605E.

Walker, John, pp. 39, 326, Nos. 37A, 40A, 690, 1326D, 1898C, 1950A.

Watteau, A., No. 1759.

Weigmann, O., No. 758A, 2370F.

Whistler, J. M., p. 261.

Wickhoff, F., pp. 16, 238, 240, 241, 244, 245, 266, 267, 284, 362, Nos. 41B, 161, 179, 183, 509, 861A, 1696A, 1699, 1704, 1705, 1714, 1748A, 2490A.

Wilde, Joh., pp. 356, 365, Nos. 1413, 1470, 2480.

Wölfflin, H., pp. 188, 189, 194, 195, 197, 198 note, 209, 307 note, Nos. 1482, 1483, 1562.

Woodcuts, Florentine, p. 128; German, No. 55F.

Wright, E., p. 180.

Yriarte, Ch., No. 1062.

Zoppo, Marco, No. 669A.

GENERAL PLACE INDEX

In this index Florentine drawings are mentioned only where they stand in some special connection with a given work of art discussed in the Text or Catalogue. Page numbers refer to the Text (Vol. I), the other numbers to the Catalogue Raisonné (Vol. II). The numbers in parentheses are of drawings by some other painter than the author of the work of art to which they are related. Where the name of the artist follows directly upon that of the town, the public gallery is to be understood.

AIGUEPERSE—Parish Church—*Benedetto Ghirlandajo*: Nativity, pp. 139, 140, 351, No. 896A.

ALNWICK—Duke of Northumberland—*Sebastiano*: fragments of a Visitation, Nos. 2497, 2506D.

ALTENBURG—Lindenau Museum—*Signorelli*: Flagellation, No. 2509H-5.

AMSTERDAM—Royal Museum—*Michelangelo* (?): Model for bronze David, p. 187.

Vom Rath Collection—*Signorelli*: St. George, p. 40, No. 2509G-2.

ANCONA—Arch of Trajan, No. 781.

ANGHIARI—Collegiata—*Sogliani*: Last Supper, No. 2754A-2.

AREZZO—*Rosso Fiorentino*: Madonna of Mercy, No. 2453.

Madonna delle Lacrime—*Rosso Fiorentino*: projected fresco, No. 2459.

S. Francesco—*Piero della Francesca*: frescoes, pp. 26 note, 31, 32.

ASSISI—S. Francesco—*Giotto School*: frescoes, pp. 2, 326. *Simone Martini*: single saints, p. 326.

ATHENS—Acropolis—Erechtheum, p. 351.

BALTIMORE—Walters Gallery—*Alunno di Domenico*: cassone, p. 126.

Mr. J. Epstein—*G. B. Utili*: Madonna, p. 69.

BARCELONA—Cambò Collection—*Alunno di Domenico*: cassone, pp. 125, 126 note. *Botticelli*: cassone, No. (974). *Sebastiano del Piombo*: portrait of lady, p. 358.

BELLPUIG (Catalonia)—Parish Church—*Giovanni da Nola*: tomb of Roman Folch de Cardona, p. 352.

BERGAMO—*Raphael*: St. Sebastian, p. 13 note.

BERLIN—*Andrea*: altar-piece, pp. 292, 293, Nos. 96, 113, 133, 150, (1754B); portrait of his wife, p. 289. *Fra Bartolommeo*: Assumption, p. 160. *Botticelli*: St. Sebastian, pp. 17 note, 21, 22. *Botticini*: Crucifixion, p. 71. *Castagno*: Assumption, p. 332. *Domenico Veneziano*: predella panel, No. (196). *Garbo*: tondo, pp. 109, 111; bust of young man, 110. *David Ghirlandajo*: Judith, pp. 140, 342, No. 866B; Madonna with St. Francis and Bishop, pp. 112, 140; Resurrection, pp. 140, 141, Nos. 835, 836. *Domenico Ghirlandajo*: Meeting of youthful Baptist and Boy Christ, p. 63. *Granacci*: Madonna with St. Michael and Baptist (see Halle); Madonna with St. Francis and Jerome, p. 144, Nos. 970B, 982B. *Leonardo School*: Resurrection, No. 1016. *Filippino Lippi*: tondo, p. 109; Crucifixion, No. (610A). *Filippo Lippi*: Infancy of St. Ambrose, p. 84. *Michelangelo* (ascribed to): S. Giovannino, p. 207. *Michelangelo School*: marble bust of old man, p. 352. *Piero di Cosimo*: Nativity, p. 151. *Pollajuolo*: Annunciation,

pp. 20, 21; David, p. 23. *Raphael*: "Terranova Madonna," p. 109. *Cosimo Rosselli*: altar-piece, No. 2385. *Sebastiano del Piombo*: St. Dorothy, p. 358. *Signorelli*: Pan, pp. 31, 41, 44, 45, Nos. (910) 2509E; Meeting of the two Holy Families, No. 2509H-1; Visitation, No. 2509K-1. *Verrocchio*: terra-cotta putto, pp. 46, 47, No. 2783; early Madonna, pp. 50, 51, 57; later Madonna, pp. 53, 54, 57, 58, 60, 63.

Schloss Museum—*Filippino Lippi School*: two altarpieces, pp. 108, 109, Nos. 1270, 1278.

Print Room—*Lorenzo Monaco*: miniatures, p. 324 note.

Kaufmann Collection (formerly)—*Carli*: saints, p. 118.

BESANÇON—Cathedral—*Fra Bartolommeo*: altarpiece, p. 160.

BIBBIENA—Madonna del Sasso—*Fra Paolino*: Assumption, No. 1787A.

BOLOGNA—*Bugiardini*: altar-piece, p. 253; young Baptist, pp. 253, 254.

S. M. della Vite—*Niccolò dell'Arca*: Pietà, p. 26.

BORGO SAN LORENZO—*Piero di Cosimo*: altar-piece, No. (2757).

BORGO SAN SEPOLCRO—*Signorelli*: processional banner, No. 2509D-10.

Orfanelle—*Rosso Fiorentino*: Deposition, No. 2458E.

BOSTON—*Signorelli*: Madonna, No. 2509D-4. *Verrocchio School*: Madonna and angel, bas-relief, p. 65.

Isabella Gardner Museum—*Pesellino*: Triumphs, pp. 87, 88, No. 1843. *Pollajuolo*: profile of lady, pp. 23, 169.

BOURGES—Cathedral—jubé, p. 147.

BRESLAU—*Cosimo Rosselli*: Nativity, No. 2385.

BRUGES—Notre Dame—*Michelangelo*: Madonna, pp. 188, 195, 295, 347, Nos. 1397, 1479, 1481, (1645A).

BRUNSWICK—*Cornelis van Haarlem*: Deluge, p. 348; Baptism, p. 348.

BUDAPEST—*G. B. Utili*: altar-piece, pp. 69, 70.

BURGOS—Cathedral—*Sebastiano del Piombo*: Holy Family, pp. 250, 356, 358, Nos. 2489, 2499.

CAGLI—Chiesa della Congregazione—Timoteo Viti: Noli me tangere, p. 34.

CAMBRIDGE—Fitzwilliam Museum—*Alunno di Domenico*: cassone, pp. 126, 127 note.

CAMBRIDGE (Mass.)—Fogg Museum—*Fra Diamante*: St. Jerome, p. 85. *Domenico Ghirlandajo*: Virgin Annunciate, p. 63.

CANNES—Von Zur Mühlen Collection—*Maestro del Bambino Vispo*: Nativity, No. 1391J.

CAPETOWN—Joseph Robinson Collection—*Alunno di Domenico*: cassone, p. 126.

CASTELFIORENTINO—*Benozzo* and *Alunno di Benozzo*: frescoes, pp. 12, 329, Nos. 531, 543, 544C, 558B.

— PIEVE DI GAMBASSI—*Carli*: altar-piece, p. 117.

CERQUETO (Perugia)—*Perugino*: St. Sebastian, p. 91.

CHAMBÉRY—*Alunno di Benozzo*: five saints, p. 13, No. 1884A.

CHANTILLY—MUSÉE CONDÉ—*Botticelli School*: Abundance, p. 94. *Castagno School*: John Baptist, p. 332. *Filippino Lippi*: Story of Esther, pp. 336, 337, Nos. 1271G, 1364A. *Lombard School*: cartoon after La Gioconda, p. 177. *Pesellino*: Madonna and saints, pp. 86, 87. *Piero di Cosimo*: Simonetta, No. 1859I.

CHARTRES—portal of the Virgin, p. 147.

CHICAGO—*Botticini*: Adoration of Magi, p. 72.

CITTA DI CASTELLO—*Granacci*: Coronation, No. 937. *Signorelli*: Martyrdom of St. Sebastian, pp. 22 note, 41, 42.

BELL TOWER—*Signorelli*: traces of fresco, No. 2509D-4.

CLEVELAND—*Botticini*: Madonna, p. 72. *Filippino Lippi*: S. Angelo tondo, pp. 105, 108, 109, 111, No. 1365.

EXHIBITION, 1936—*Ercole Roberti* (?): allegorical scene, No. 1859C.

CORTONA—*Fra Angelico*: predella, p. 5 note. *Signorelli*: paintings, p. 44, No. 2509K-1.

S. NICCOLO—*Signorelli*: Pietà, p. 287.

CRACOW—*Leonardo*: portrait of lady, Nos. 1082C, 1168.

DALKEITH—LORD LOTHIAN—*Filippino Lippi*: Coronation (recently transferred to S. H. Kress Collection, New York), No. 1321A.

DARMSTADT—*Holbein*: altar-piece, No. (1034B).

DETROIT—MRS. A. G. WILSON—*Domenico Ghirlandajo*: Madonna, pp. 56 note, 65.

DRESDEN—*Andrea*: Marriage of St. Catherine, pp. 276, 290 note, No. (1961); Sacrifice of Isaac, No. 119C. *Bacchiacca*: Story of Joseph, p. 299. *Botticelli*: Legend of St. Zenobius, p. 334. *Carli*: Madonna and saints, pp. 117, 118, 123. *Cossa*: Annunciation, p. 23 note. *Credi*: Madonna and two saints, Nos. 708, (1849B); copy after Leonardo, Madonna and Children, pp. 57, 66, No. 685A. *Giorgione*, after: Horoscope, p. 260. *Piero di Cosimo*: Holy Family, pp. 151, 153. *Daniele da Volterra*: Moses breaking the Tablets of the Law, No. (1471). *Franciabigio*: David and Bathsheba, p. 295 note, No. 750A. *Garbo*: Madonna, No. 771. *Raphael*: Sixtine Madonna, pp. 109, 148, No. (2036). *Rubens*: Judgement of Paris, No. (1397).

DUBLIN—*Pontormo*: Pietà, No. 2174. *G. B. Utili*: Nativity, p. 69, No. 2780C.

DÜSSELDORF—*Carli*: Madonna, p. 117.

EDINBURGH—*Piero di Cosimo*: lunette, No. 1863D. *Cosimo Rosselli*: St. Catherine, No. 2385.

EMPOLI—OPERA DEL DUOMO—*Botticini*: authenticated works, p. 71.

ENGLEWOOD (N. J.)—D. F. PLATT COLLECTION—*Castagno School*: Baptist and St. Paul, p. 332.

FARINGDON (Bucks)—LORD FARINGDON—*Botticelli School*: Nativity, p. 95 note.

FIESOLE—S. CECILIA—*Pontormo*: lost fresco, Nos. 2178, 2336F.

S. DOMENICO—*Sogliani*: Adoration of Magi, Nos. 2533, 2631, 2664, 2686, 2689, 2695.

S. FRANCESCO—*Piero di Cosimo*: Conception, p. 154, Nos. 1855, 1856.

FLORENCE—ACADEMY—*Albertinelli*: Trinity, p. 162, No. 13. *Alunno di Domenico*: pilasters, pp. 126, 127; predella, Sts. Jerome and Francis, and Entombment, p. 127 note; predella, Pietà and four saints, p. 125; St. Jerome, p. 127. *Fra Bartolommeo*: Madonna appearing to St. Bernard, pp. 148, 160, No. (1034B); St. Vincent, No. (2724). *Bronzino*: Pietà, p. 315 (where wrongly attributed to Pontormo). *Credi*: Nativity, p. 77. *Ghirlandajo*: Visitation, p. 63. *Granacci*: altar-piece, p. 145; predella, p. 145, No. 992. *Master of Rinuccini Chapel*: Vision of St. Bernard, pp. 147, 148. *Michelangelo*: David, pp. 186, 195, Nos. 1399C-3, 1547, 1585, 1607; St. Matthew, pp. 187, 188, 195, 196, 201, Nos. 1396, 1399, 1521, 1593, (1645A, 1737); Slaves, No. 1399G; Torso, No. 1498. *Pontormo*: Christ at Emmaus, Nos. 2147, 2250B. *Sogliani*: Conception, Nos. 2539, 2564B, 2598, 2620, 2621, 2656, 2667, 2704, 2705, 2743; Trinity, No. 2583.

BAPTISTERY, View of, No. 982.

BARDINI MUSEUM—*Pollajuolo*: St. Michael, p. 25 note.

BARGELLO—*Alunno di Benozzo*: Madonna and saints, p. 13 note. *Matteo di Giovanni Dei*: engraved plate, No. 37A. *Donatello*: St. John reading, p. 26. *Michelangelo*: "Apollo," Nos. 1556, 1662; tondo, p. 186, Nos. 1397, 1493 note. *Pollajuolo*: Hercules and Antaeus, p. 31. *Verrocchio*: bust of lady, p. 58; David, pp. 54, 58, No. (995); terracotta Madonna, pp. 46, 50, 61. *Verrocchio School*: Resurrection No. (1020C); Madonna p. 65.

BIGALLO LOGGIA, View of, No. 982.

CASA BUONARROTI—*Battista Franco*: Noli me tangere, Nos. (1396 note, 1473). *Michelangelo*: Centauromachia, p. 190. *Michelangelo*, after: Holy Family, No. 1537.

VIA CALZAIOLI, View of, No. 982.

CASTAGNO MUSEUM (S. Apollonia)—*Castagno*: frescoes, p. 332. *Castagno School*: fresco, p. 16. *David Ghirlandajo*: Crucifixion, pp. 139, 140, No. 785.

CENACOLO DI FOLIGNO—*Perugino*: Last Supper, Nos. (2697-2699, 2735A).

HORNE MUSEUM—*Benozzo Gozzoli*: Deposition, No. 540A. *Leonardo*, after: Battle of Anghiari, p. 179. *Piero di Cosimo*: Jerome in Wilderness, p. 154, No. 1859. "*Tommaso*:" Nativity, p. 77.

INNOCENTI (GALLERY)—*Ghirlandajo* and *Alunno di Domenico*: altar-piece, pp. 123, 124, 127, 128, 129, 342. *Piero di Cosimo*: altar-piece, No. 1859E.

LIBRARY OF S. LORENZO—*Michelangelo*, p. 225, Nos. 1423, 1429, 1439, 1444, 1446, 1455A, 1467, 1500, 1527, 1528, 1600, (1664). *Matteo Palmieri*: Città di Vita, pp. 71, 72.

LOGGIA DEI LANZI, View of, p. 341.

S. LORENZO, NEW SACRISTY—*Michelangelo*: pp. 201, 203, 207, 209-223, 248, 257, 259, 302, 318, 349, 353, 354, 360; architecture, Nos. 1434, 1436, 1439,

1441, 1490, 1499, 1566; Madonna, Nos. 1424, 1493, 1561, 1579, 1589, 1603, (1645ᴬ, 1734); Medici tombs, Nos. 1399ᶜ, 1419, 1434, 1435, 1436, 1438, 1440, 1467, 1476ᴬ, 1491, 1494-1497, 1498, 1538, 1548, 1549, 1551, 1566, (1648ᴬ, 1671, 1697ᴬ, 1708, 1709, 1710, 1712, 1722, 1734ᴬ, 1735, 1736, 1738, 1747, 1747ᴬ, 1957, 2051, 2169, 2175ᴬ, 2369). *Raffaello da Montelupo*: St. Damian, p. 262.

S. Marco Museum—*Albertinelli*: Last Judgement, Nos. 14, 15. *Fra Angelico*: Last Judgement, p. 149. *Baldovinetti*: small panels, p. 132. *Fra Bartolommeo*: unfinished altar-piece, pp. 157, 160; Last Judgement, pp. 149, 161, Nos. (1778, 1835, 2389, 2731ᴬ); head of Madonna, No. 252. *Domenico di Michelino*: Madonna, p. 5. *Fra Paolino*: altar-piece, No. 1826; Pietà, No. (291). *Sogliani*: St. Dominic fed by angels, Nos. 2619, 2622-2630, 2691; Crucifixion, Nos. 2658, 2679.

Opera del Duomo—*Pollajuolo*: embroideries, pp. 16, 17, 18, Nos. 1912, 1915, 1947. *Verrocchio*: Decapitation of Baptist, pp. 58, 178, No. (1035).

Palazzo Vecchio—*Allori*: Pearl Fishers, p. 347. *Bandinelli*: Hercules and Cacus, No. 1571. *Bronzino*: Crossing of the Red Sea, p. 347, Nos. 601ᴮ, 601ᴰ. *The Ghirlandajo*: frescoes, pp. 124, 125, 138, 140, 141 note, No. 895. *Jacopo da Empoli*: copies of Pontormo's Certosa frescoes, p. 313. *Michelangelo*: Victory, pp. 202, 203, 208, 211, Nos. 1489, 1497, 1589. *Verrocchio*: Putto with Dolphin, p. 58.

Pitti—*Albertinelli*: Nativity, No. 7. *Andrea*: Annunciation and angels, pp. 276, 286, Nos. 55ᶜ, 87; Annunciation (lunette) p. 291, Nos. 108ᶜ, 159ᴮ; Assumptions, pp. 291, 292, 294, Nos. 110ᴷ, 111, 113ᴰ, 116, 118, 120, 123, 138ᴬ, 153, 159ᶜ; Baptist, No. 130; Disputa, Nos. 108, 130; Madonna in Glory and four saints, pp. 291-293, Nos. 110ᴳ, 141ᶜ, 141ᴰ; Madonna in Glory and six saints, p. 292, Nos. 110ᴰ, 115; Pietà, pp. 272, 287, 288, 289, 290, 291, Nos. 94, 98, 147, 155, 159, 160, (1962, 2119); Madonna with the two Children, Nos. 110ᴵ, 141ᴳ; Story of Joseph, p. 291. *Fra Bartolommeo*: Pietà, pp. 158, 160; Salvator Mundi, p. 160; St. Mark, p. 160. *Botticelli*: Bella Simonetta, No. (1167ᴬ). *Botticini*: Nativity, p. 72. *Bronzino*: Holy Family, No. 601ᶜ. *Battista Franco*: Battle of Montemurlo, No. (1545 note). *Granacci*: Holy Family, p. 145, Nos. 955, 979. *Fra Filippo Lippi*: tondo, p. 83, Nos. 1385ᴬ, 1389. *Parmigianino*: Madonna, p. 359. *Pontormo*: Adoration of Magi, Nos. 2023, 2059; Martyrdom of St. Maurice, p. 314, Nos. 2023, 2160, 2205. *Raphael*: Madonna del Granduca, pp. 109, 117. *Rosso Fiorentino*: Madonna and saints, Nos. 2402, 2402ᴬ. *Salviati*: Three Fates, p. 260. "*Tommaso*:" Nativity, p. 77.

Riccardi Palace—Museo Mediceo—*Filippo Lippi*: Madonna, p. 83, No. 1385ᶜ. *Pontormo*: Cosimo I in his youth, p. 319 note, No. 2031.

—Chapel—*Benozzo*: frescoes, pp. 8, 10, 93, Nos. 537ᴬ, 544ᴮ, 558ᴮ, 559ᴺ.

S. Salvi Museum—*Andrea*: Last Supper, pp. 280-82, Nos. 104, 105, 106, 110ᶠ, 113, 113ᴮ, 119ᴬ, 154. *Sogliani*: altar-piece, p. 165. "*Tommaso*:" allegorical figure, p. 77.

Chiostro dello Scalzo—*Andrea*: frescoes, pp. 270,

271, 275-280, 282, 290, Nos. 55ᴳ, 55ᴴ, 97, 99, 100, 110ᴮ, 110ᴰ, 110ᶠ, 115ᴮ, 119ᴰ, 120ᴬ, 141ᴬ, 141ᴱ, 142ᴬ, 145, 152, (1755, 1755ᴬ, 1756, 1757, 1759ᴬ, 1761ᴬ, 1763ᴬ, 1764, 1963, 1976, 2514). *Franciabigio*: Baptism, pp. 275, 294.

School in Via della Colonna—*Carli*: fresco, p. 116.

School in Via Luigi Alemanni (Pope's Chapel)—*Pontormo*: frescoes, p. 302, Nos. 1959ᴱ, 1963.

Florence—Uffizi—*Albertinelli*: Visitation, p. 162; Nos. 3, (245, 2525). *Allori*: Dream of Human Life, No. (1748ᴮ); Venus and Cupid, No. (1504). *Alunno di Domenico*: two scenes from Life of St. Benedict, p. 127 note. *Andrea*: Madonna delle Arpie, pp. 271, 276, 290, 291, 297, Nos. 56, 88, 118ᴰ, 142; Lady with Petrarch, p. 289, No. 159ᴬ; Noli me tangere, No. 108ᴮ; Vallombrosa altar-piece, pp. 292, 293, Nos. 93, 110ᶜ, 110ᴵ, 117ᴮ, 132, (1757ᴬ). *Bacchiacca*: tapestry designed by him, No. 180ᴬ. *Fra Bartolommeo*: Annunciation (small), No. 236; Circumcision, p. 160; Job, p. 160; Marriage of St. Catherine, p. 160. *Bonifazio*: Conversion of St. Paul, No. (1701). *Botticelli*: Adoration of Magi, pp. 145, 171 note, 334; Calumny, p. 334; Coronation, pp. 117 note, 334; Fortezza, p. 21 note, Judith, p. 100; Madonna, saints and angels, p. 95; Magnificat, p. 109; Medallist, p. 95; Pallas, p. 95; Spring, pp. 24, 93, 94; Venus rising from the sea, pp. 93, 94, 334, No. 577ᴬ. *Francesco Botticini*: Tobias and the Archangels, p. 53. *Raffaele Botticini*: Pietà, p. 145 note. *Bronzino*: lute player, p. 318 note, No. (1957). *Bugiardini*: La Monaca, p. 254, No. 607. *Carli*: altar-piece from S. Maria Nuova, pp. 113, 114. *Credi*: Adoration of Shepherds, Nos. 710, 728; Annunciation, pp. 74, 75; Venus, No. 713. *Domenico Veneziano*: Madonna and saints, p. 88, No. (196). *Franciabigio*: Madonna del Pozzo, pp. 253, 294; San Giobbe altar-piece, p. 295, No. 747ᴬ; temple of Hercules, No. 754. *Garbo*: Resurrection, pp. 110, 111, 119, Nos. 625, 631ᴬ. *Domenico Ghirlandajo*: altar-piece, p. 64. *Ridolfo Ghirlandajo*: Funeral of S. Zanobi, p. 142, No. 902. *Granacci*: Story of Joseph, pp. 144, 145, Nos. 974ᴬ, 974ᴮ, 974ᴰ, 992. *Leonardo*: Adoration of Magi, pp. 59 60, 62, 104, 138, 170-172, 173, 179, 333, Nos. (837, 938), 1010ᶜ, 1014, 1015, 1016, 1020, 1023, 1036, 1044ᴬ, 1044ᴰ, 1056, 1058, 1065, 1068, 1069, 1081, 1187, 1213, 1214, 1225; Annunciation, pp. 50, 52, 54-56, 58, 60, 61, 66, Nos. (731), 1054, 1082ᴮ; Baptism, pp. 51, 69. *Filippino Lippi*: Epiphany, pp. 104, 120, 336, Nos. 1269ᴬ, 1281, 1288ᴬ, 1313, 1351; Madonna and saints, p. 111. *Fra Filippo Lippi*: Madonna, p. 83, Nos. 1385ᴮ, (744ᴬ, 917); Coronation, p. 84, No. (1838ᴮ); Nativity, p. 84. Medici Venus, Nos. (1397, 2016ᴬ). *Michelangelo*: Doni Madonna, pp. 195, 225, Nos. 1396, 1400, 1491, 1599; Venus painted by Pontormo, Nos. 1504, 2037. *Perugino*: bust of youth, p. 75, portrait of Francesco dell'Opere, p. 76; Pietà, No. (758ᴬ). *Pesellino*: Nativity, pp. 86, 87 note; predella panel, Nos. (956, 2442). *Piero di Cosimo*: Andromeda, p. 153; Conception, p. 150, No. 1849ᴬ; Madonna with angel, No. 1852ᴮ. *Pollajuolo*: Combats of Hercules, pp. 16, 18, 19,

48

No. 1905; portrait of Galeazzo Sforza, p. 23; the Virtues, pp. 21, 22, 26, Nos. 1900, 1952. *Piero Pollajuolo*: profile of lady, p. 23. *Pontormo*: altar-piece (small), Nos. 1957A, 2163, 2211A; Martyrdom of St. Maurice, p. 314, Nos. 2023, 2160, 2205, 2252; Venus and Cupid, No. 2037; Maria Salviati, p. 319 note, Nos. 2011, 2165. *Ercole Roberti*: St. Sebastian, p. 17. *Sebastiano*: Death of Adonis, p. 239; Fornarina, p. 358. *Sodoma*: St. Sebastian, p. 180. *Soggi*: Madonna with the two Children No. (1059). *Signorelli*: Madonna with nudes in background, p. 42; monochrome allegory, No. 2509D-5. *Sogliani*: Flagellation and Way to Golgotha, No. 2701; St. Bridget and nuns, Nos. 2663, 2678. *Uccello*: battle-piece, p. 15 note. *Verrocchio*: Baptism, pp. 47, 51, 69.

UFFIZI MAGAZINE—copy of Fra Bartolommeo's Last Judgement, p. 161 note. *Raffaele del Colle* (?): Battle of Anghiari (after Leonardo), p. 179. *Leonardo School*: Madonna with the two Children, No. 1049C. *Pontormo*: fragments from Carro della Zecca, No. 2081.

UFFIZI PRINT ROOM—*School of Cimabue*: illuminations, pp. 1, 324. *Perugino*: young saint, p. 90.

FLORENCE—PRIVATE COLLECTIONS:

BARDINI COLLECTION (formerly)—*Bacchiacca*: Gathering of Manna, p. 298, No. 182A.

BIGAZZI COLLECTION (formerly)—*Carli*: Madonna enthroned between Sts. Peter and Paul, p. 118.

DUCA DI BRINDISI (formerly)—*Carli*: cassone, p. 118 note.

PRINCE CORSINI—*Carli*: Madonna and saints, pp. 112, 113, 114, 117 note.

MRS. C. H. COSTER—*Alunno di Benozzo*: Pietà, p. 13, No. 1866C.

GUICCIARDINI PALACE—*Pontormo*: double portrait, No. 1974. *Filippino Lippi*: tondo, p. 106, Nos. 1279, 1318, 1356. *Pontormo*: Madonna, No. 1991B. *Cosimo Rosselli*: Nativity, p. 146.

MANNELLI RICCARDI COLLECTION (formerly)—*Alunno di Domenico*: Deposition, pp. 127, 130, No. 20A.

DE' NOBILI COLLECTION (formerly)—*Piero di Cosimo School*: Adoration of Magi, p. 151 note.

NUTI VILLA (formerly)—*Botticelli School*: Madonna, p. 109.

PANCIATICHI COLLECTION (formerly)—*Albertinelli*: Holy Family, p. 162 note. *Alunno di Domenico*: Adoration of Magi, pp. 127, 130.

CASA PUCCI (formerly)—*Garbo*: tondo, p. 120.

FLORENCE—CHURCHES:

S. AMBROGIO—*Carli*: altar-piece, p. 117. *Cosimo Rosselli*: fresco, p. 146.

SS. ANNUNZIATA, View of, No. 385A. *Andrea*: Cloister frescoes, Filippo Benizzi series, pp. 271, 273, Nos. 151, 550; Procession of Magi, pp. 270, 274, 276, Nos. 119, 126; Nativity of Virgin, p. 275, Nos. (998A, 1168, 2730); copy of frescoes, p. 274; Madonna del Sacco, pp. 271, 275, 280, 284, 285, Nos. 140, 143, (1059, 1762). *Baldovinetti*: fresco, p. 132. *Pontormo*: Visitation, Nos. 2015, 2045, 2057, 2102, 2158; Madonna and saints, p. 302, No. 1963. *Cosimo Rosselli*: fresco, No. 196E.

BADIA—*Filippino Lippi*: Vision of St. Bernard, pp. 104, 147, Nos. 1273, 1277, 1282, 1285, 1347, 1378.

BUONOMINI DI S. MARTINO CHAPEL—*David Ghirlandajo*, pp. 136, 137, 140 note, 141 note, Nos. 772F, 806.

CAMPANILE—*Donatello*: sculptures, p. 189.

CARMINE—*Filippino Lippi*: frescoes, pp. 106, No. 1277. *Masaccio*: frescoes, pp. 186, 365, Nos. 1544, 1602.

CATHEDRAL—*Michelangelo*: Pietà, pp. 231, 236, Nos. 1572, 1574, (1697B). *Uccello*: equestrian portrait, p. 14, No. 2767.

CESTELLO (see S. Maria Maddalena dei Pazzi).

S. CROCE—*Desiderio*: tomb of Marsuppini, No. (1631). *Taddeo Gaddi*: fresco, pp. 2, 325, No. 758. *Giotto*: Ascension of St. John, p. 186, No. (1587); Apparition of St. Francis, p. 365. *Mainardi*: frescoes, No. 1393. *Master of the Rinuccini Chapel*, p. 147. *Naldini*: fresco over Michelangelo's tomb, No. 1758.

S. FELICE IN PIAZZA—*Botticelli School*, No. (760).

S. FELICITA—*Pontormo*: Annunciation (fresco), Nos. 1973, 2070, 2145; Evangelists, Nos. 2139, 2159D, 2253A; Pietà, pp. 314, 315, 316, Nos. 1968, 2030, 2043, 2077, 2086A, 2087, 2117, 2122, 2134, 2139, 2203, 2252C, 2257, 2336B, 2337C.

S. GIOVANNINO ALLA CALZA—*Franciabigio*: Last Supper, p. 294, No. 753A.

INNOCENTI CHAPEL—*Sogliani*: Annunciation, No. 2690.

S. LORENZO—*Desiderio da Settignano*: tabernacle, No. (1481). *Donatello*: Sacristy doors, Nos. (667, 847, 2466-2468). *Fra Filippo Lippi*: Annunciation, p. 162. *Pontormo*: frescoes (whitewashed), pp. 320, 321, Nos. 2013, 2038, 2068, 2091, 2132, 2169, 2215, 2221, 2227, 2240, 2244-2246, 2258, 2260, 2265; Creation of Eve, Nos. 1983, 2051, 2108; Deluge, Nos. (605A, 605B), 2031, 2233-2235, 2247, 2253; Expulsion from Paradise, Nos. 1959A, 2198; God conversing with Noah, Nos. 2016, 2260; Last Judgement, Nos. 2231, 2233-2235; Resurrection, No. 1981. *Rosso*: Sposalizio, Nos. 2430, 2439A, 2455. *Sogliani*: Crucifixion of St. Arcadius, No. 2565.

S. MARCO—*Fra Bartolommeo*: altar-piece, p. 161.

S. MARIA MADDALENA DEI PAZZI—*Carli*: saints, pp. 117, 118. *Perugino*: Crucifixion, No. (1864).

S. MARIA NOVELLA—*Andrea da Firenze*: frescoes in Spanish Chapel, p. 325. *Bugiardini*: Martyrdom of St. Catherine, p. 228, No. 1600. *Cosini*: tomb of Antonio Strozzi, p. 352. *Domenico Ghirlandajo*: frescoes, pp. 113, 124, 129, 133-135, 137, 140, 141, 340, 342, Nos. 866, 869, 871-873, 878, 883, 884, 891, 893, (898B, 984, 1167A); assisted by David, pp. 140, 141, Nos. 789, 791. *Filippino Lippi*: frescoes, pp. 103, 105, 106, 306, 338, 339, Nos. 1274, 1275, 1277E, 1286, 1287, 1297-1299, 1305, 1311, 1341I, 1343, 1353A, 1354, 1362B note, 1366A. *Naldini*: Presentation of Virgin, Nos. 1754D, 1766A, 1766B. *Orcagna*: fresco of Paradise, p. 1. *Uccello and School*: frescoes in Chiostro Verde, p. 331, Nos. (2456), 2773, 2780.

S. MARIA NUOVA—*Bicci di Lorenzo*: fresco, p. 13.

S. MICHELE VISDOMINI—*Pontormo*: altar-piece, p. 309, Nos. 1959E, 1963, 2014, 2025, 2048, 2053, 2055A, 2081, 2153, 2224, 2225A, 2240B, 2256, 2336A, 2337B, 2338A, 2363A.

S. MINIATO AL MONTE—*Baldovinetti*: Annunciation, pp. 17, 19 note. *Antonio Pollajuolo*: angels, pp. 17, 25 note. *Piero Pollajuolo*: Sts. James, Eustace and Lawrence, p. 20.

S. Miniato fra le Torri—*Antonio* and *Piero Pollajuolo*: destroyed fresco of St. Christopher, pp. 23, 24, No. 1949A.

S. Niccolò oltr'Arno—*Piero Pollajuolo*: Assumption, p. 25 note.

S. Niccolò al Ceppo—*Sogliani*: Visitation, p. 165, Nos. 2525, 2563, 2578, 2746, 2755.

Ognissanti—*Botticelli*: St. Augustine, pp. 94, 95. *David Ghirlandajo*: fresco of Deposition, p. 140, No. 780.

Or San Michele—*Credi*: St. Bartholomew, p. 57. *Ghiberti*: St. Stephen, p. 327 note. *Nanni di Banco*: St. Philip, p. 327 note. *Orcagna*: tabernacle, p. 1. *Verrocchio*: bronze group, pp. 54, 58, 61.

S. Proculo—*Carli*: Visitation, p. 113.

S. Spirito—*Carli*: altar-pieces, pp. 111 note, 112, 113, 114, 115, 116, 118, 121, 122, 123, No. 618. *Pietro del Donzello*: Annunciation, No. (736). *Granacci (?)*: Trinity, No. 1009C. *Filippino Lippi*: Madonna and donors, pp. 105, 108, Nos. 1277, 1287, 1316, 1359B; sketch for glass window, No. 1316. *Stradano*: Christ and the Money Changers, p. 232 note. "Tommaso:" altar-piece, p. 78.

S. Trinita—*Domenico Ghirlandajo*: altar-piece, p. 132; frescoes, pp. 124, 125, 126-127, 132, 135, 137, 140, 340, 341, Nos. 864A, (1167A).

FLORENCE (Environs)

Arcetri—Villa Capponi—*Tommaso di Stefano*: Nativity, p. 77, Nos. (528B, 2727).

Torre del Gallo—*Pollajuolo*: frescoes, pp. 24, 27.

Brozzi—S. Donnino—*Carli*: fresco, p. 118 note.

Carmignano—Parish Church—*Pontormo*: Visitation, No. 1980.

Certosa—*Pontormo*: frescoes, p. 313, Nos. 2032, 2113, 2119, 2135, 2140, 2148, 2159A, 2256A, 2256F. *Bronzino*: fresco, No. 604A.

Montesenario, p. 274.

Pian di Mugnone—S. Maria Maddalena—*Fra Bartolommeo*: Annunciation, p. 161.

Poggio a Cajano—*Allori*: Feast of Scipio, p. 263 note. *Andrea*: fresco of Tribute to Caesar, pp. 280, 282-284, 306, Nos. 55B, 134, 148, 150A, 152, 2255. *Filippino Lippi*: lost fresco, pp. 338, 339 note, Nos. 1329A, 1341F. *Franciabigio*: Triumph of Cicero, No. 2255. *Pontormo*: lunette, pp. 302, 304-312, 319, Nos. 1954A, 1957A, 1962, 1975, 1976, 1977, 1991A, 2017A-2020, 2024, 2028, 2033, 2034, 2039, 2046, 2047, 2050, 2056, 2058, 2060, 2075, 2079, 2089, 2093-2095, 2097, 2098, 2103, 2111, 2112, 2125, 2138, 2143, 2151, 2152, 2159C, 2170, 2210, 2211, 2213, 2223-2225, 2240C, 2248C, 2268, 2336D, 2363.

Settignano—Villa Michelangelo—*Michelangelo*: fresco, No. 1462A.

Valdarno, p. 168.

Val di Mugnone, p. 274.

Villamagna—Parish Church—*David Ghirlandajo*: Madonna and saints, No. 834A.

FONTAINEBLEAU—Castle of *Primaticcio*: frescoes, No. 1473. *Rosso*: frescoes, Nos. 2452, 2458A.

FORLÌ—*Marcello Venusti*: copy of Michelangelo's Resurrection, p. 227 note.

FRANKFURT a/M. *Bartolommeo Veneto*: fancy portrait, No. 1859G—*Botticelli School*: female head, No. 581. *Pontormo*: portrait of lady with lap-dog, pp. 197, 316, 317, No. 2248.

GENOA—Palazzo Bianco—*Pontormo*: portrait of nun, No. 2369B. Balbi Piovera Collection—copy of Michelangelo's Christ in Garden, No. 1572A.

GIRGENTI—Greek temple, p. 351.

GLASGOW—*Garbo*: tondo, pp. 111, 121. *Titian*: Christ and the Adulteress, p. 240.

GÖTTINGEN—*Botticini*: Nativity, p. 72.

GRANADA—Cathedral—Capilla Real—*Botticelli*: Christ in the Garden, No. (570C).

HALLE—*Granacci*: altar-piece, pp. 143, 144, Nos. 928, 930.

HAMPTON COURT—*Allori*: Venus and Cupid, No. (1504). *Marco d'Oggiono*: the two Holy Children, No. 502.

HARROW—Stogdon Collection (formerly)—"Tommaso:" Nativity, p. 78, No. (1863.)

HOLKHAM—Earl of Leicester—*Michelangelo*: copy after the Bathers, pp. 190-192, 346, Nos. 1594, 1597, 1624A.

HORSMONDEN—Heirs of Mrs. Austen—*Alunno di Domenico*: cassone fronts, p. 126. *Botticelli School*: Nativity, p. 95 note.

KINGSTON LACY—Mr. Ralph Bankes (formerly)—*Titian*: Judgement of Solomon, p. 240.

KOENIGSBERG—*Alunno di Benozzo*: Christ carrying Cross, No. 1866D.

LENINGRAD—*Andrea*: Madonna with St. Elizabeth, pp. 290, 297. *Fra Bartolommeo*: Madonna, p. 161. *Raffaele Botticini*: Nativity, p. 145 note. *Granacci*: Nativity, No. 922. *Leonardo*: Benois Madonna, pp. 50, 55-58, 64, Nos. 1027, 1069; Litta Madonna, Nos. 1027, 1038, 1067C, 1129E, 1261C. *Milanese follower of Leonardo*: version of Gioconda, p. 178. *Pontormo*: Holy Family with infant Baptist, No. 2211A. *Puligo*: St. Barbara, p. 296; Holy Family, p. 297, No. 2376. *Sebastiano*: Pietà, p. 241.

LILLE—"Tommaso:" Madonna, p. 78. *Bramante (?)*: head of man, No. 1848A.

LOCKO PARK—Drury Lowe Collection (formerly)—*Carli*: Baptist, and Pietà, p. 118 note.

LONDON—Royal Academy—*Michelangelo*: tondo, pp. 186, 187, No. 1481.

British Museum—engraving B. XIII, No. 559P. Parthenon sculptures, p. 64, No. 1613. Seated Demeter, p. 64.

National Gallery—*Bacchiacca*: Story of Joseph, pp. 298, 299, Nos. 181, 185-187, 189. *Baldovinetti*: profile of lady, p. 15. *Fra Bartolommeo*: Mond Holy Family, p. 161. *Botticelli*: Adoration, No. 567B; Nativity, p. 95; Legend of St. Zenobius, p. 334. *Botticelli School*: tondo, pp. 100, 101; profile of lady, No. 573. *Botticini*: Coronation, pp. 71-72, Nos. 591B, 591C; Tobias and the Angel, pp. 53, 70-71; St. Jerome, p. 72, No. 587A. *Bugiardini (?)*: Madonna and angels, pp. 254, 276

note. *Gozzoli*: Rape of Helen, pp. 88 note, 329, No. 545ᴮ. *Fra Filippo Lippi*: two lunettes, p. 84; Vision of St. Bernard, p. 147. *Filippino Lippi*: Adoration of Magi, p. 336. *Lorenzo Monaco*: altarpiece, No. 1391ᴬ. *Mainardi*: Madonna, p. 67. *Michelangelo*: Deposition, pp. 195, 196, 234, Nos. 1572, 1599ᴬ, (1742). *Michelangelo School*: Dream of Human Life, No. 1748ᴮ. *Domenico di Michelino*: Adoration of Magi, p. 5. *Marco d' Oggiono*: the two Holy Children, No. 502. *Pesellino*: Trinity, pp. 89, 90, 91, 92. *Piero di Cosimo*: Death of Procris, p. 153. *Pintoricchio*: Penelope, p. 45. *Pollajuolo*: Apollo and Daphne, p. 23; Martyrdom of St. Sebastian, pp. 22-24, 29, Nos. 1898ᴰ, 1911. *Pontormo*: Story of Joseph, Nos. 2040, 2081. *Ambrogio da Predis*: copy of Leonardo's Virgin of the Rocks, pp. 172, 176, No. 1175. *Cosimo Rosselli*: Combat of Love and Chastity, p. 146. *Rosso Fiorentino*: Leda, p. 225 note, No. 1399ᴶ. *Sebastiano*: Holy Family and donor, pp. 244, 245, 365 note; donor identified with Pier Francesco Borgherini, No. 2478; Lazarus, pp. 239, 240, 243, 244, 245, 246, 355, Nos. (1522, 1599, 1635), 2474ᶜ, 2479ᴮ, 2483, 2484, 2489, 2506ᴮ; St. Agatha, p. 358. *Signorelli*: Circumcision, p. 41, No. 2509ᴴ⁻¹¹; Nativity, p. 32, No. 2509ᴱ⁻⁴; Story of Coriolanus, p. 45; Story of Esther, p. 41; Triumph of Chastity, p. 45. *Uccello*: battle-piece, pp. 14, 15. *Marcello Venusti*: Christ expelling the Money Changers, Nos. 1515-1517. *Verrocchio*: Madonna, pp. 46 note, 51-55, 58, 59, 60, 63, 65, No. 2783.

VICTORIA AND ALBERT MUSEUM—*Credi*: terracotta, pp. 73, 74. *Michelangelo*: Cupid, p. 200, No. 1484. *Verrocchio*: St. Jerome, p. 61.

WALLACE COLLECTION (HERTFORD HOUSE)—*Andrea*: Madonna and angels, p. 290, Nos. 131, (2163).

LONDON—Private Collections:

BRIDGEWATER HOUSE, LORD ELLESMERE—*Raphael*: Madonna del Passeggio, No. (1725ᴬ).

MRS. MARK HAMBURG—*Milanese School*: version of Leonardo's Gioconda, p. 178 note.

HENRY HARRIS COLLECTION—*Leonardo School*: Madonna adoring the Child, No. 1049ᶜ.

LADY LUDLOW—*Filippino Lippi*: Madonna, No. 1280. *Michelangelo* (?): Model for bronze David, p. 187.

LORD PLYMOUTH (formerly)—*Puligo*; portrait, No. (1975).

LORD ROSEBERY—*Credi*: St. George, Nos. 675, 731.

SIR H. B. SAMUELSON—*Filippino Lippi*: cassone, Nos. 1272ᴬ, 1382ᴬ.

LORD SPENCER—Lombard imitation of La Gioconda, p. 178.

MR. CHARLES TIMBALL (formerly)—copy after Leonardo's Battle of Anghiari, p. 179.

LADY MARGARET WATNEY—*Botticelli School*; cassone, p. 125.

WOODWARD COLLECTION—*Ghirlandajo*: fragment of Nativity, pp. 63, 65.

LONGFORD CASTLE—EARL OF RADNOR—*Sebastiano*: portrait of lady, p. 359.

LONG ISLAND—ROSLYN—MR. CLARENCE MACKAY—*Verrocchio*, Madonna, p. 53.

LONGLEAT—MARQUESS OF BATH—*Alunno di Domenico*: cassone front, p. 126.

LORETO—CASA SANTA—SACRISTY—*Signorelli*: frescoes, p. 32.

LUCCA—MUSEO—*Fra Bartolommeo*: God the Father appearing to saints, pp. 158, 161, No. (1776); Madonna of Mercy, pp. 158, 159, 161, 164, No. (1818). *Ghirlandajo*: altar-piece, p. 125.

CATHEDRAL—*Alunno di Domenico*: predella, pp. 125, 128, No. 36ᴬ. *Fra Bartolommeo*: Madonna and saints, pp. 158, 159, 161.

S. MICHELE—*Filippino Lippi*: four saints, pp. 106, 108, Nos. 1318, 1347.

MADRID—*Andrea*: altar-piece, p. 292, Nos. 91, 114, 117, 128ᴬ, 149, 159ᴰ. *Fra Angelico*: predella of Annunciation, No. 174. *Leone Leoni*: bust of Charles V, p. 351. *Raphael*: Madonna dell'Agnello, p. 285; Spasimo, p. 143, No. (161).

MILAN—AMBROSIANA—*Botticelli*: tondo, No. 565.

BRERA—*Signorelli*: Flagellation, p. 41, No. 2509ᴴ⁻⁵. *Timoteo Viti*: altar-piece, p. 34.

POLDI-PEZZOLI MUSEUM—*Boltraffio*: Madonna, Nos. (1024, 1027). *Botticelli*: embroidery, No. 576ᴬ. *Carli*: tondo, p. 117. *Imitator of Credi and Pollajuolo*: St. Sebastian, No. 1911. *Francesco Morone*: Samson and Dalilah, No. (1718). *Pollajuolo*, profile of young woman, pp. 169, 178, Nos. (1062), 1953. *Utili*: Madonna, p. 69.

OMENONI PALACE—*Leone Leoni*: sculptures, p. 351.

MARCHESE CASENDI (formerly)—copy of Leonardo's Leda, p. 180.

CRESPI COLLECTION (formerly)—*Bacchiacca*: Adoration of Magi, No. 235.

MELZI D'ERIL COLLECTION (formerly)—*Leonardo School*: Madonna, No. 1049ᶜ.

SETTALA COLLECTION (formerly)—*Milanese School*: version of Gioconda, p. 178 note.

S. MARIA DELLE GRAZIE—*Leonardo*: Last Supper, pp. 62, 171 note, 174, 175, 176, 178, Nos. 1034, 1065, 1107, 1113, 1140-1146, 1176, 1188; copy of Last Supper by Solario, p. 174 note.

MIRADOLO (Pavia)—NARDI COLLECTION (formerly)—*Bonifazio Veronese*: Conversion of St. Paul, No. (1701).

MODENA—*Fra Paolino*: Madonna, No. 1831.

MONTEFALCO—S. FRANCESCO—*Benozzo*: frescoes, pp. 7 note, 8-11, Nos. 544ᴬ, 545ᴮ, 545ᴰ, 558ᴮ.

MONTEOLIVETO MAGGIORE—*Signorelli*: fresco, p. 42, No. 2509ᴮ⁻⁴. *Sodoma*: frescoes, pp. 179 note, 273.

MONTEPULCIANO—*Carli*: tondo, p. 118.

MONTPELLIER—*Allori*: Venus and Cupid, No. (1504). *Master of the Carrand Triptych*: predella, No. 1841ᶜ.

MORRA (Città di Castello)—S. CRESCENZIANO—*Signorelli*: frescoes, pp. 36, 37, 43, Nos. 2509ᴰ⁻⁸, 2509ᴰ⁻¹¹, 2509ᴱ⁻¹, 2509ᴴ⁻⁵, 2509ᴴ⁻⁸, 2509ᴺ⁻¹.

MOULINS—mausoleum of the Duke of Montmorency, No. 1497.

MUNICH—Aeginetan marbles, No. 1613. *Garbo*: Pietà, pp. 111, 118, 120, 121, 122, Nos. 758ᴬ, 765. *Granacci*: Saints and Nativity, p. 145. *Leonardo*: Madonna, pp. 50, 52, 54-58, 64, 67. "*Tommaso*," Nativity, p. 77.

NEMES COLLECTION (formerly)—*Melzi*: Madonna, No. (1098ᴬ).

NANTES—*Perugino*: two saints, p. 91.

NAPLES—*Fra Bartolommeo*: Assumption, p. 163, Nos. (1783-1785). *Brescianino* – Madonna with infant John, No. (1170). *Garbo*: tondo, pp. 111, 116. *Filippino Lippi*: Annunciation, p. 106. *Sebastiano*: Holy Family, pp. 243, 246, Nos. 2499, 2505ᴬ. *Signorelli*: Nativity, No. 2509ᴰ-8. Pompeian painting of Laocoön, No. 1329ᴬ. *Venusti*: copy of Last Judgement, No. 1683.

CATHEDRAL—CARAFA CHAPEL, p. 222.

NARBONNE—*Tamagni*: Procession to Calvary, No. 2756ᴾ.

NARNI—*Alunno di Domenico*: predella, p. 125 note. *Domenico Ghirlandajo*: Coronation, pp. 125 note, 140, 141 note, Nos. 877, 889.

NEUWIED—CASTLE OF SEGENHAUS—*Giampietrino*: copy of Leonardo's Leda, p. 180 note.

NEW HAVEN—JARVES COLLECTION—*Master of Jarves Cassoni*, p. 92. *Pollajuolo*, p. 23 note, Nos. (1366ᶜ), 1913.

NEW YORK—METROPOLITAN MUSEUM—*Andrea*: Borgherini Madonna, p. 294 note, Nos. 98, 127, 128ᴬ. *Botticelli*: Communion of St. Jerome, p. 95; Legend of St. Zenobius, p. 334. *Ghirlandajo*: St. Christopher, p. 24 note, No. (1949ᴬ). *Fra Filippo Lippi*: Alessandri triptych, pp. 84, 87 note. *G. B. Utili*: Story of Joseph, pp. 48, 70 note. *Verrocchio*: Madonna, pp. 50, 51, 54, 57, 60.

FRICK MUSEUM – *Giovanni Bellini*: Stigmatization of St. Francis, No. 1848ᴮ.

GOODHART COLLECTION – *Alunno di Benozzo*, p. 13.

MR. AND MRS. HARKNESS—Pesellino, pp. 87 note, 88 note, 91, 92, No. 1841ᴬ.

MR. FRED. HOUSEMAN—*Filippino Lippi*: Benson Pietà, No. 1349ᴬ.

HURD COLLECTION—*Garbo*: Benson tondo, pp. 109, 110, 111, 120.

KLEINBERGER GALLERIES EXHIBITION, 1917, No. 37ᴮ.

S. H. KRESS COLLECTION—*Alunno di Benozzo*: Deposition, No. 1866ᶜ. *Bacchiacca*: birth plate, No. (1705). *Piero di Cosimo*: Visitation, pp. 150, 153, No. 1853. *Filippino Lippi*: Tobias and the Archangel, No. 1271ᴮ; Coronation (formerly Dalkeith, Lord Lothian), No. 1321ᴬ.

MRS. PAYSON—Copy of *Ghirlandajo*: Madonna, No. 879.

STILLMAN COLLECTION—*Pontormo*: Halberdier, p. 318 note.

PERCY STRAUS COLLECTION—*Carli*: tondo, p. 117 note. *Garbo*, profile of lady, p. 110.

NIJMEGEN (Holland), VICELAND—JÜRGENS COLLECTION—"*Tommaso*:" Pietà, p. 78.

NÜREMBERG—GERMANIC MUSEUM—*Dürer*: copies of Pollajuolo, No. 1913.

ORVIETO—CATHEDRAL—*Fra Angelico* and *Benozzo*, pp. 7, 8. *Signorelli*: frescoes, pp. 32-35, 37, 38, 39, 41-43, Nos. (1601), 2509ᴬ, 2509ᴬ-1, 2509ᴮ-5, 2509ᴰ-1, 2509ᴰ-2, 2509ᴰ-6, 2509ᴰ-7, 2509ᴰ-9, 2509ᴰ-13, 2509ᴱ-3, 2509ᴱ-7, 2509ꜰ, 2509ᴴ, 2509ᴴ-2, 2509ᴴ-3, 2509ᴴ-7, 2509ᴴ-9, 2509ᴴ-10, 2509ᴷ, 2509ᴷ-1, 2509ᴷ-2, 2509ᴸ, 2509ᴹ, 2509ᴺ, 2509ᴼ.

OPERA DEL DUOMO—*Botticelli*: embroidery, No. 576ᴬ. *Signorelli*: Magdalen, p. 37, No. 2509ᴴ-6.

OTTOWA—*Puligo*: Magdalen, p. 296 note.

OXFORD—ASHMOLEAN—*Signorelli*: Madonna, No. 2509ᴰ-4.

PADUA—ARENA CHAPEL—*Giotto*: Crucifixion, p. 342. IL SANTO—Lombardi reliefs, No. 2504.

PALERMO – BARON CHIARAMONTE BORDONARO—*Alunno di Domenico*: St. Jerome, p. 127. *Botticelli School* Madonna, p. 109.

OLIVELLA—*Sogliani*: Nativity, p. 164, No. 2727.

PALLANZA—MR. W. KAUPE—*Milanese School*: version of Gioconda, p. 178 note.

PANSHANGER—LORD COWPER—*Fra Bartolommeo*: Holy Family, p. 161. *Pontormo*: Story of Joseph, Nos. 2045, 2057, 2176, 2336ᴬ, 2360.

PANZANO (Greve)—S. MARIA—*Michele di Ridolfo*: Annunciation, No. 905.

PARIS—LOUVRE—*Alunno di Domenico*: cassone panels, p. 126 note. *Andrea*: Charity, pp. 275, 291, 298, Nos. 90, 157; Madonna with infant Baptist, No. 110ᴵ. *Fra Angelico*: predella to Coronation, Nos. 173ᴬ, (956). *Fra Bartolommeo*: Annunciation and saints, p. 161; Marriage of St. Catherine, pp. 161, 163, Nos. (1817, 1818ᴬ, 1827, 1827ᴮ); Noli me tangere, p. 161, No. (1796). *Botticelli*: Villa Lemmi frescoes, pp. 93, 101, 334, No. (2469). *Botticini*: Nativity, pp. 73, 146 note. *Bronzino*: Noli me tangere, No. (1396ᴬ). *Carli*: Coronation, pp. 116, 117, 122, 123. *Credi*: altar-piece, Nos. 684, 693, (994ᴬ). *Credi* and *Leonardo*: Annunciation, pp. 57-60. *Domenico Ghirlandajo*: Visitation, p. 135, No. 876; old man and grandson, p. 341, No. 890ᴮ; Madonna ascribed to Mainardi, p. 65. *Ridolfo Ghirlandajo*: Coronation, p. 117. *Leonardo*: Annunciation, pp. 57, 58-59; La Gioconda, pp. 22, 50, 175, 177, 182, No. 1173; Virgin of the Rocks, pp. 46, 47 note, 50, 67, 172, 178, Nos. 1059, 1067, 1084, 1139, 1175, 1226; Virgin and St. Anne, pp. 50, 175, 176, 179, Nos. 1039, 1045, 1063, 1070, 1102, 1109ᴬ, 1129ᴮ, 1152, 1177-1182, 1185, (1852ᴮ, 2509ᴰ-8); Bacchus, No. 1133; St. John, No. 1227. *Mainardi*: tondo, p. 136, No. 1392. *Mantegna*: Parnassus, No. (1101). *Michelangelo*: Slaves, pp. 188, 196, 201, 202, 206, Nos. 1487, 1494, 1562, 1632, 1746. Copy of *Michelangelo*: bronze David, p. 187. *Perugino*: tondo, p. 52. *Piero di Cosimo*: Madonna, p. 153. *Pontormo*: altar-piece, Madonna and saints, p. 314, Nos. 1979, 1991ᴮ, 2070, 2166. *Raphael*: Belle Jardinière, No. (1170); portrait of youth, p. 298; Madonna of Francis, I, p. 361, No. 1599. *Rosso Fiorentino*: Challenge of the Pierides, Nos. 2401, 2455ᴬ, sculptures from porch of Incantada, p. 351. *Sebastiano*: Visitation, pp. 239, 241 note, Nos. 2497, 2504; portrait of lady, p. 359. *Signorelli*: Adoration of Magi, p. 41. *Solario*: Vierge au Coussin Vert, p. 169. *Tamagni*: Mass of St. Gregory, p. 142.

MUSÉE ANDRÉ—*Botticini*: altar-piece, p. 71 note. *Francesco di Simone*: allegorical figure, p. 64. *Perugino*: Madonna, pp. 54, 90. *Uccello*: St. George, p. 15 note.

Musée de Cluny— *David Ghirlandajo* : mosaic, pp. 140, 343.

Artaud de Montor Collection (formerly)—*Alunno di Domenico*, p. 127 note. *Carli*, p. 127 note.

Gustave Dreyfus Collection (formerly)—*Credi* : Madonna, pp. 66-68, 73.

Heugel Collection—*Botticini* : Nativity, p. 73.

Malmaison Collection (formerly)—Variation of Leonardo's Leda, p. 180 note.

M. E. Richtemberger (formerly)—*Carli* : tondo, p. 117 note. *Granacci* : Nativity, p. 144 note, Nos. 909, 939, 1002, 1006.

Baron Edmond de Rothschild (formerly)—*Garbo* : female profile, p. 110.

Spiridon Collection (formerly)—copy of Leonardo's Leda, p. 180.

PARMA—S. Paolo—*Correggio* : frescoes, No. (1123).

PAVIA—Certosa—*Filippino Lippi* : projected altar-piece, No. 1360.

PERUGIA—*Alunno di Benozzo* : Madonna, No. 1866ᴮ. *Fra Angelico* : altar-piece, p. 5 note. *Bonfigli* : frescoes, pp. 328, 329, No. (534ᶜ). *Perugino* : S. Bernardino panels, pp. 54, 90 ; Adoration of Magi, pp. 90, 91. *Pintoricchio* : polyptych, p. 109 note. *Lo Spagna* : altar-piece, p. 109.

Opera del Duomo—*Signorelli* : altar-piece, p. 31, Nos. (2385), 2509ᴵ.

Cambio—*Perugino* : heroes, No. (1204ᴬ).

S. Ercolano, View of, No. 534ᶜ.

S. Severo—*Raphael* : fresco, p. 149.

PHILADELPHIA—Johnson Collection—*Fra Bartolommeo*, Adam and Eve, p. 161.

Widener Collection—*Castagno* : David, p. 15.

PISA—*Alunno di Benozzo* : Tobias and the Archangel, No. 1884. *Carli* : altar-piece, p. 113. *David Ghirlandajo* : Sts. Sebastian and Roch, pp. 140, 141 note

Camposanto—*Benozzo* : frescoes, pp. 12, 328, Nos. 534, 536ᴬ, 537ᴬ, 558ᴬ, 558ᴮ, 559ᴱ, 559ᶠ, (1874ᴮ). *Orcagna* : frescoes, formerly attributed to, p. 1.

Cathedral—*Andrea* : saints, pp. 291, 292, Nos. 115ᴬ, 119ᴮ, (1759ᴮ). *Sogliani* : paintings, Nos. 2510, 2510ᴵ, 2545ᴬ, 2646, 2662, 2670, 2692, 2708.

S. Matteo—*Carli* : predella, pp. 113, 115.

PISTOIA—Cathedral—*Credi* : altar-piece, pp. 48 note, 49, 54, 57, 58, 59 notes, 67, 89, Nos. 725, 738. Forteguerri monument, pp. 46, 55, 66, 68, 73, 74, No. 691.

S. Domenico—*Fra Paolino* : Adoration of Magi, p. 164, No. 1786ᴬ ; Crucifixion, No. 1770ᴬ.

S. Paolo—*Fra Paolino*, p. 164.

PONTE CASALE (Padua)—*Sansovino* : chimney-piece, p. 351.

PONTORMO (environs of Empoli)—Parish Church—*Pontormo* : altar-piece, p. 308, Nos. 2014, 2071.

PRATO—*Carli* : tondo, p. 117 note. *Fra Diamante* : Madonna, saints and donor, Madonna della Cintola, Nativity, p. 85. *Giovanni da Milano* : predella panel, p. 147.

Carmine (formerly)—*Fra Diamante* : St. Thecla and the Baptist, p. 85.

Cathedral—*Fra Diamante* : Funeral of St. Jerome, upper part, p. 85 ; Annunciation, p. 85. *Fra Filippo Lippi* : frescoes, pp. 82, 85 note, Nos. (745, 866ᴮ, 970ᴰ, 998ᶜ), 1386.

S. Spirito—*Fra Diamante* : Circumcision, p. 85. *Sogliani* : Madonna and saints, No. 2576.

Tabernacle at Street Corner—*Filippino Lippi* : copy, No. 1373.

RICHMOND—Doughty House—*Alunno di Domenico* : altar-piece, No. 20ᴬ. *Fra Angelico* : Adoration of Magi, Nos. 176 note, (1068). *Bacchiacca* : Holy Family, No. 184. *Fra Bartolommeo* : Holy Family, Nos. 455, (1787). *Botticelli School* : Pentecost, p. 99. *Fra Filippo Lippi* : two saints, p. 81. *Sebastiano* : Magdalen, p. 239. *Signorelli* : fragment of Baptism, p. 41, No. 2509ʜ-2.

ROME—Barberini (formerly)—*Pontormo* : Galatea, Nos. 2014, 2225ᴬ, 2256ᴮ, 2362.

Borghese—*Andrea* : Holy Family, p. 276. *Bacchiacca* : Story of Joseph, p. 298, Nos. 182, 188. *Correggio* : Danae, p. 47. *Credi* : tondo, Nos. 669ᴰ, 735ᴮ, *Perugino* : Crucifixion, p. 90. *Piero di Cosimo* : Nativity, p. 153 note. *Pontormo* : portrait of a Cardinal, p. 316. *Puligo* : Magdalen, p. 296. *Follower of Raphael* : fresco of Gods shooting at Herm, No. 1613. *Sodoma* : copy of Leda, p. 180 note. " Tommaso :" Nativity, p. 77.

Capitol, Senator's Palace, staircase, No. 1403ᴬ.

Castel S. Angelo—*Montelupo* : chimney-pieces, p. 262, No. 1717. Papal Chapel, No. 1653ᴬ.

Colonna—*Alunno di Domenico* : two cassone fronts, pp. 124, 126.

Corsini—*Fra Bartolommeo* : Holy Family, p. 164, Nos. 459ᶜ, 471, (1775, 1816). *Franciabigio* : Madonna, p. 295. *Piero di Cosimo* : portrait, No. 1859ᴳ. *Marcello Venusti* : Annunciation, p. 236, No. 1534.

Doria—*Pesellino* : predella panels, pp. 86, 87 note. *Sebastiano* : portrait of Andrea Doria, pp. 243, 244, 245.

Palazzo Farnese—courtyard, No. 1653ᴬ.

Farnesina—*Sebastiano* : frescoes, p. 249, Nos. 2475, 2481.

Palazzo Venezia—*Girolamo da Treviso* : frescoes, p. 24 note. *Puligo* : Madonna, p. 296.

Arch of Constantine, p. 141.

Monte Cavallo (Piazza Quirinale)—Dioscuri group, Nos. 986, 1868.

Porta Pia—*Michelangelo*, No. 1469.

Palazzo Quirinale—*Pontormo* : tapestries, No. 2092.

Palazzo Rondanini—*Michelangelo* : Pietà, pp. 196 note, 236, 243, No. 1572.

Palazzo Rospigliosi—Pallavicini Collection—*Botticelli* : " La Derelitta," p. 335. *Lotto* : Triumph of Chastity, No. (1504).

Simonetti Collection (formerly)—*Carli* : tondo, p. 117.

Villa Albani—*Perugino* : triptych, p. 52 ; antique relief, p. 260.

Visconti Venosta, Marchese Carlo—*Fra Bartolommeo* : tondo, Nos. 212ᴰ, 315.

VATICAN, Pinacoteca—*Alunno di Benozzo* : Pietà, pp. 12, 330. *Fra Angelico* : predella panels, p. 5 note. *Fra Bartolommeo* : St. Paul, pp. 158, 161 ; St. Peter, p. 161. *Benozzo* : predella to altar-piece, No. 534. *Leonardo* : St. Jerome, p. 179, No. 1968.

Vatican Sculpture Gallery—Belvedere Apollo,

p. 255, No. 1382ᶜ. Laocoön group, p. 339, Nos. 119ᶜ, 2081, 2375ᴬ, 2379ᴬ; the "torso," pp. 257, 263, Nos. 1513, 1653, 1723, 2072.

VATICAN—BORGIA APARTMENTS, SALA DEI MISTERI—frescoes, No. 40ᴬ.

VATICAN—LIBRARY—*Ghirlandajo*: frescoes, p. 136.

VATICAN—LOGGIE—*Raphael*: Noah building Ark, No. (1959ᶜ).

VATICAN STANZE—*Raphael*: School of Athens, p. 295, No. (757); St. Peter led out of prison, No. 2509ᴱ⁻⁸; Disputa, pp. 149, 150. *Giulio Romano*: Clement I, p. 245 note, No. (2477).

VATICAN—NICHOLAS V CHAPEL—*Fra Angelico*: frescoes, pp. 4, 5 note, Nos. 161ᴬ, (177, 904).

VATICAN—PAULINE CHAPEL—*Michelangelo*: pp. 193, 231, 264; Nos. 1403, 1468, 1544ᴬ, 1544ᴮ, 1569, 1574, 1577, 1600.

VATICAN—SIXTINE CHAPEL—*Botticelli*: Children of Korah, No. (1289); Temptation of Christ, p. 94. *Ghirlandajo*: frescoes, pp. 132, 340. *Michelangelo*: Last Judgement, pp. 212, 229, 230, 255, 264, 364, 365, Nos. 1395ᴮ, 1395ᶜ, 1399ᴰ, 1399ᴴ, 1399ᴷ, 1403ᴬ, 1406, 1409ᶜ, 1409ᴳ, 1413, 1416, 1468, 1510-1513, 1523, 1536, 1542, 1568ᴬ, 1568ᴮ, 1569ᴬ, 1619, 1620, (1628, 1639, 1657ᴬ, 1660ᴬ, 1665ᴬ, 1667, 1673, 1677, 1678, 1683, 1684, 1691, 1692, 1745, 1750, 2056, 2142, 2247); Ceiling frescoes (in general), pp. 179, 188, 189, 193-195, 197-200, 201, 250, 252, 254, 265, 310, 349, Nos. 1399ᴬ⁻¹, 1409ᴰ, 1413, 1416, 1482, 1483, 1551, 1552, 1553, 1579, (1624ᴮ, 1702, 1703); Ceiling frescoes (in detail): Creation of Adam, Nos. 1396, 1399ᴱ, 1411ᴮ, 1465, 1466, 1483, 1488, 1519ᴬ, 1522, (2474ᴮ); Deluge, Nos. 1399ᴬ⁻², 1550, 1584, 1586, (1639, 1661, 2474ᴮ); Temptation of Eve, Nos. 1409ᴬ, 1478; Expulsion from Paradise, No. 1409ᴮ; Drunkenness of Noah, No. 1585 note; Fall of Haman, Nos. 1405, 1477, 1487, 1543ᴬ, 1590, 1598, (1657, 1670, 1690); Judith, No. 1579; Fiery Serpent, Nos. 1403, 1408, 1564, 1573, (1654ᴬ); lunettes and spandrels, Nos. 1399ᴱ, 1399ᶠ, 1401, 1480, 1563, 1579, 1589, 1592, 1596, 1608, (1645ᴬ, 1652, 1705, 1746ᴮ, 2496, 2504, 2505); medallions, Nos. 1545, 1556 note, 1601; Nudes, Nos. 1399ᴮ, 1399ᴰ, 1399ᴱ, 1465, 1466, 1484, 1489, 1543ᴬ, 1567, 1588, 1598ᴮ, 1599ᴬ, (1638, 1661ᶜ, 1663ᴬ, 1668ᴬ, 1681, 1748ᴬ, 2103, 2143); Prophets, sibyls and putti, Nos. 1399ᴳ, 1400, 1401, 1410, 1470, 1485, 1486, 1544ᴰ, 1562, 1584, 1588, 1592, 1599, (1624ᴮ, 1650, 1651, 1668ᴬ, 1682, 1704, 1746ᴮ); Sacrifice of Noah, No. 1585 note; Separation of Earth from Water, No. 1466. *Perugino*: frescoes, p. 116; destroyed fresco, No. (1413). *Cosimo Rosselli*: frescoes, p. 150, Nos. 2385, 2386ᴬ. *Salviati*: ruined fresco, p. 352.

S. ANDREA DELLA VALLE—tombs of Pius II and Pius III, p. 204.

SS. APOSTOLI, Vestibule—Roman relief, No. 559ᴷ.

ARACOELI—tomb of Cecchino Bracci, No. 1403ᴬ.

S. GIOVANNI IN LATERANO—*Marcelli Venusti*: Annunciation, pp. 236, 237, Nos. (1519), 1644.

SS. GIOVANNI E PAOLO, View of, No. 506ᴬ.

S. MARIA SOPRA MINERVA—*Fra Angelico*: tomb, p. 8. *Filippino Lippi*: frescoes, pp. 104, 340, Nos. 1274, 1277ᴰ, 1277ᶠ, 1281, 1313, 1333ᴮ, 1344, (1378, 1382, 1383ᴬ). *Michelangelo*: Christ, pp. 213, 314,

357, Nos. (1013ᶜ), 1543, 1603; tomb of Leo X, No. 1499.

S. MARIA MAGGIORE—Chapel of the Sacrament, p. 222.

S. MARIA DELLA PACE—*Venusti*: Annunciation, No. 1696. *Sebastiano*: frescoes (formerly), see Alnwick.

S. MARIA DEL POPOLO—*Pintoricchio*: ceiling, p. 197. *Sebastiano*: Birth of Virgin, pp. 245, 250, Nos. 2476, 2502, 2505ᴮ.

ST. PETER'S, View of, No. 885. *Giotto*: Navicella mosaic, p. 326, Nos. (1837ᴬ, 1837ᶜ, 1837ᴶ, 1837ᴷ). *Michelangelo*: cupola, No. 1469; Pietà, pp. 234, 302, Nos. 1271ᴴ, 1482, 1561. *Pollajuolo*: tombs of Popes, p. 19 note, No. 1928.

S. PIETRO IN MONTORIO—*Sebastiano*: frescoes, pp. 240, 243 note, 356, Nos. 2478, 2480ᴬ, 2487, 2488, 2502, 2506ᴬ.

S. PIETRO IN VINCOLI—tomb of Julius II (see General Index, under Michelangelo).

S. TRINITÀ DEI MONTI—*Daniele da Volterra*: Deposition, p. 356.

SALAMANCA—CATHEDRAL—*Dello Delli*: p. 1 note.

S. GIMIGNANO—COLLEGIATA—*Pier Francesco Fiorentino*, p. 12. *Ghirlandajo*: frescoes, pp. 132, 135, No. (2757). *Piero Pollajuolo*: Coronation, pp. 18-20, 28, No. 1953.

 S. AGOSTINO—*Benozzo*: frescoes, p. 83, Nos. 529ᶜ, 531ᴬ, 545ᴮ.

S. MINIATO AL TEDESCO—*Giusto d'Andrea*: altarpiece, p. 93.

S. PIERO A SIEVE—*Montorsoli*: St. Peter, No. 1399.

SARASOTA (Florida)—RINGLING MUSEUM—*Carli*: Mass of St. Gregory, p. 114.

SERRES (Macedonia)—Byzantine fresco, No. 1014.

SEVILLE—ABREO DONATION—*Puligo*: portrait, No. (1975).

SHEFFIELD—*Verrocchio* and *assistant*: Nativity, pp. 46 note, 53, 54, 69, No. 2783.

SIENA—PALAZZO PUBBLICO—*Beccafumi*: Stigmatization of St. Catherine, No. (314). *Spinello*: frescoes, No. 2756ᴰ.

 PALAZZO PETRUCCI—*Signorelli*: destroyed frescoes, pp. 44, 45, No. 2509ᴷ⁻³.

 S. AGOSTINO (formerly)—*Signorelli*: predella, No. 2509ᴰ⁻³.

 BAPTISTERY—font, p. 327 note.

 DUOMO—LIBRARY—*Pintoricchio*: frescoes, p. 45.

 S. MARIA DEGLI ANGELI—*Carli*: altar-piece, pp. 113, 115, 117, 118.

 S. SPIRITO—*Fra Paolino*: fresco of Crucifixion, p. 164, No. 1785ᴬ.

SPOLETO—*Fra Diamante*: frescoes, p. 85.

STAGGIA (Siena)—PARISH CHURCH—*Piero Pollajuolo*: Assumption of Mary of Egypt, p. 25 note.

STRASSBURG—*Domenico di Michelino*: Adoration of Magi, p. 6, No. 1751.

STUTTGART—*Albertinelli*: tondo, p. 165. *Fra Bartolommeo*: Coronation, p. 160, Nos. 287, 408, (1796ᴬ).

TOLEDO—*Raffaele Botticini*: Nativity, p. 145 note.

TORNIMPARTE (Aquila)—*Saturnino Gatti*: paintings, p. 343 note.

TURIN—*Botticelli School*: Madonna p. 109. *Credi*: Madonna, p. 57. *Filippino Lippi*: Tobias and the Archangel, pp. 53, 337, No. 1271B. *Pollajuolo*: Tobias and the Archangel, pp. 22, 53. *Cosimo Rosselli*: Triumph of Chastity, p. 146. *Sogliani*: Madonna, p. 165.

UBEDA (Andalusia)—SAN SALVADOR—*Sebastiano*: Pieta, p. 241, No. 1586.

UMBERTIDE—SANTA CROCE—*Signorelli*: Deposition, p. 36, No. 2509D-12.

URBINO—*Signorelli*: Descent of Holy Spirit, Nos. 2509D-1, 2509H-1; Crucifixion, No. 2509H-1. *Timoteo Viti*: altar-piece, p. 34. *Uccello*: predella, p. 331.

 S. GIOVANNI—*Lorenzo da San Severino*, p. 13 note.

VALLOMBROSA—*Carli*—altar-piece, p. 117.

VENICE—ACADEMY—*Paolo Veronese*: Madonna, p. 284.

 CA' D'ORO—*Botticini*: Nativity, p. 73. *Pordenone*: Pietà, No. (1484). *Signorelli*: Flagellation, 2509H-5. *G. B. Utili*: cassone, pp. 48, 70 note.

 GIOVANNELLI COLLECTION (formerly)—*Bacchiacca*, p. 251.

 MANFRINI COLLECTION (formerly)—*Verrocchio*: Nativity, p. 53.

 FRARI—*Titian*: Assumption, p. 245. *Longhena*: tomb of Giovanni Pesaro, p. 351 note.

 GESUITI—*Titian*: Martyrdom of St. Lawrence, No. (1601).

 PIAZZA SS. GIOVANNI E PAOLO—*Verrocchio*: Colleoni monument, pp. 46, 58, 74.

 S. GIOVANNI CRISOSTOMO—*Sebastiano*: altar-piece, p. 239.

 S. MARIA MATER DOMINI—*Catena*: altar-piece, p. 286.

 SCUOLA DI S. ROCCO—*Tintoretto*, No. (2249).

 SALUTE—*Titian*: St. Mark Enthroned, No. (2506A).

 SEMINARIO—*Filippino Lippi*: Christ and the Samaritan, No. 1348A.

 S. ZACCARIA—*Castagno*: frescoes, p. 332.

VIENNA—*Andrea*: Pietà, p. 288, No. 136. *Fra Bartolommeo*: Circumcision, p. 161. *Bugiardini*: Rape of Dinah, p. 161. *Raphael*: Madonna del Prato, p. 275, Nos. 1168, 1170.

 LANCZKORONSKI COLLECTION—antique relief, No. 1352. *Sogliani*: Maiden with Unicorn, No. (1024).

 LICHTENSTEIN GALLERY—*Franciabigio*: Madonna, p. 290. *Leonardo*: female portrait, pp. 50, 51, 54-56, 58, No. 1173. *Filippino Lippi*: Esther panels, Nos. 1271G, 1364A. *Piero di Cosimo*: landscape, No. 1859.

 WITTGENSTEIN COLLECTION—*Alunno di Domenico*: tondo, p. 127.

VINCI (Empoli)—*Fra Paolino*: Annunciation, No. 1770.

VITERBO—*Sebastiano*: Pietà, pp. 235, 242, 245 note, 246, 356, 358, Nos. (1555), 2492, 2503A.

VOLTERRA—MUNICIPIO—GHIRLANDAJO: altar-piece, pp. 113, 136, No. 892. *Leonardo da Pistoia*: altar-piece, No. (903). *G. P. Rossetti*: Deposition, No. 2492. *Rosso Fiorentino*: Deposition, No. 2424. *Signorelli*: altar-piece, Nos. 2509H-4, 2509J.

 CATHEDRAL—*Albertinelli*: Annunciation, p. 162, No. 7. *Carli*: altar-piece, pp. 112, 117, 122.

VUIPPENS, Castle of (Fribourg)—MONSIEUR SCHNEELI—*Botticelli*: Coronation, p. 95.

WANTAGE (Berks)—LOCKINGE HOUSE—MR. A. T. LOYD—*Pesellino*: cassone panel, pp. 87 note, 88.

WASHINGTON—ANDREW MELLON COLLECTION—*Pollajuolo*: portrait, pp. 15, 16. *Raphael*: St. George, p. 40, No. (1228).

WEIMAR—*Solario* (?): copies from heads in Leonardo's Last Supper, p. 174 note.

WELWYN (Herts)—TEWIN WATER—LADY BEIT—*Sebastiano*: portrait, p. 358.

WIESBADEN—*Bacchiacca*: Madonna, p. 298.

WILTON—PEMBROKE COLLECTION—sketch for Holy Family, p. 290 note.

WINDSOR—ROYAL LIBRARY—portrait of Bandinelli, p. 363.

WORCESTER (Mass.)—MR. TH. T. ELLIS—*Credi*: predella panel, p. 59 note.

WYE—Kent (Olantigh)—ERLE DRAX COLLECTION (formerly)—*Carli*: Pietà, pp. 117, 118. *Sebastiano*: copy of triptych, p. 242 note.

PLACE INDEX OF DRAWINGS

This Place Index is to be used in connection with the Catalogue (Vol. II), where the artists are arranged alphabetically and where citations to the Text (Vol. I) will be found. Drawings of which the present location is unknown are here listed (as in the Catalogue) under the collections in which they were formerly, or under *Sales* or *Homeless*.

AMSTERDAM—FODOR MUSEUM—*Albertinelli, Leonardo, Fra Paolino.*
> RIJKSMUSEUM—*Attr. to Sebastiano.*
> SALES—*Fra Bartolommeo, Michelangelo School, Pollajuolo School, Sogliani.*

ASCHAFFENBURG—*Baldovinetti School, Garbo, Puligo.*

BAYONNE—BONNAT MUSEUM—*Andrea, Fra Bartolommeo, Botticelli School, Carli, Credi, David Ghirlandajo, Domenico Ghirlandajo, Leonardo, Filippino Lippi, Mainardi, Michelangelo, Michelangelo School, Parri Spinelli, Piero di Cosimo, Pollajuolo School, Rosso, Sebastiano, Signorelli, Sogliani, Verrocchio School.*

BERLIN—BEKERATH COLLECTION (formerly)—*Pontormo.*
> NEBEHAY COLLECTION (formerly)—*Fra Filippo Lippi School.*
> PRINT ROOM—*Albertinelli, Alunno di Benozzo, Andrea, Fra Angelico School, Fra Bartolommeo, Benozzo School, Botticelli, Botticelli School, Bronzino, Carli, Credi, Garbo, Giovanni da Milano, Giusto d' Andrea, David Ghirlandajo, Domenico Ghirlandajo, Granacci, Filippino Lippi, Fra Filippo Lippi School, Maestro del Bambino Vispo, Michelangelo, Michelangelo School, Naldini, Fra Paolino, Parri Spinelli, Pesellino School, Antonio Pollajuolo, Antonio Pollajuolo School, Pontormo, Rosso, Sebastiano, Signorelli, Sogliani, "Tommaso," Uccello School, Verrocchio.*
> SALES—*Botticelli School, Signorelli.*

BERN—LUDWIG ROSENTHAL—*Leonardo.*

BESANÇON—MUSEUM—*Bronzino, Michelangelo School, Pontormo, Sogliani.*

BIRMINGHAM—INSTITUTE OF ARTS—*Fra Bartolommeo.*

BLENHEIM—DUKE OF MARLBOROUGH—*Fra Bartolommeo.*

BOSTON—ISABELLA GARDNER MUSEUM—*Filippino Lippi, Michelangelo School.*
> MUSEUM OF FINE ARTS—*Credi, Filippino Lippi School.*

BREMEN—KUNSTHALLE—*Piero di Cosimo, Pontormo School.*

BRUNSWICK—MUSEUM—*Fra Bartolommeo, Filippino Lippi School.*

BUDAPEST—MUSEUM—*Fra Bartolommeo, Francesco Botticini, Leonardo, Filippino Lippi, Pontormo, Cosimo Rosselli School.*

CAMBRIDGE—SIR SIDNEY C. COCKERELL—*Fra Angelico School.*
> FITZWILLIAM MUSEUM—*Fra Angelico, Fra Bartolommeo, Botticelli, David Ghirlandajo, Michelangelo, Piero di Cosimo.*
> FITZWILLIAM MUSEUM, CLOUGH BEQUEST—*Benozzo, Credi, Naldini, Fra Paolino.*

FITZWILLIAM MUSEUM, RICKETTS AND SHANNON COLLECTION—*Andrea, Credi.*

CAMBRIDGE (Mass.)—FOGG MUSEUM—*Fra Filippo Lippi, Lorenzo Monaco School, Fra Paolino, Sogliani.*
> FOGG MUSEUM, LOESER BEQUEST—*Andrea, Fra Bartolommeo, Fra Bartolommeo School, Benozzo, Bronzino, Bugiardini, Castagno School, Filippino Lippi, Michelangelo School, Naldini, Pesellino, Piero di Cosimo, Piero di Cosimo School, Antonio Pollajuolo School, Pontormo, Rosso, Rosso School, Sogliani, "Tommaso."*
> FOGG MUSEUM, PAUL J. SACHS COLLECTION—*Alunno di Domenico, Fra Bartolommeo, Benozzo School, Domenico Ghirlandajo School, Filippino Lippi, Antonio Pollajuolo, Sogliani.*

CASSEL—HABICH COLLECTION (formerly)—*Filippino Lippi.*

CHANTILLY—MUSÉE CONDÉ—*Fra Bartolommeo, Benozzo, Botticelli School, Domenico Ghirlandajo, Filippino Lippi, Filippino Lippi School, Michelangelo, Michelangelo School, Parri Spinelli, Antonio Pollajuolo, Pontormo, Rosso, Signorelli School.*

CHATSWORTH—DUKE OF DEVONSHIRE—*Fra Bartolommeo, Garbo, David Ghirlandajo, Domenico Ghirlandajo, Granacci, Leonardo, Filippino Lippi, Parri Spinelli, Pontormo, Sebastiano, G. B. Utili.*

CHELTENHAM—FITZROY FENWICK COLLECTION—*Andrea, Carli, Garbo, David Ghirlandajo, Leonardo, Filippino Lippi, Michelangelo, Michelangelo School, Fra Paolino, Piero di Cosimo, Pontormo, Signorelli, Signorelli School.*

CHESTERFIELD—BARLBUROUGH HALL—*Michelangelo.*

CLEVELAND—MUSEUM—*Filippino Lippi, Michelangelo.*

COLOGNE—WALLRAF RICHARTZ MUSEUM—*Leonardo.*

COPENHAGEN—PRINT ROOM—*Fra Bartolommeo, Domenico Ghirlandajo.*

CRACOW—CZARTORYSKI MUSEUM—*Andrea.*

DARMSTADT—LANDESMUSEUM—*Andrea, Fra Bartolommeo, Benozzo, Botticelli School, Credi, Credi School, Domenico Ghirlandajo.*

DETROIT—INSTITUTE OF ARTS—*Michelangelo School.*

DIJON—MUSEUM—*Andrea, Fra Bartolommeo, Botticelli School, Signorelli.*

DRESDEN—PRINT ROOM—*Alunno di Domenico, Fra Bartolommeo, Benozzo, Carli, Credi, David Ghirlandajo, Domenico Ghirlandajo, Filippino Lippi, Filippino Lippi School, Pontormo, Signorelli.*

DUBLIN—NATIONAL GALLERY—*Fra Bartolommeo, Credi, Michelangelo School, Piero Pollajuolo.*

DÜSSELDORF—ACADEMY—*Andrea, Baldovinetti School, Castagno School, Credi, David Ghirlandajo, Fra Filippo Lippi School, Maestro del Bambino Vispo, Antonio Pollajuolo School, Sebastiano.*

PLACE INDEX OF DRAWINGS

EDINBURGH—National Gallery—*Benozzo, David Ghirlandajo, Pontormo, Rosso, Sogliani.*
ESCORIAL—Library—*Domenico Ghirlandajo School.*

FLORENCE Archives—*Fra Filippo Lippi.*
 Casa Buonarroti—*Bugiardini, Michelangelo, Michelangelo School.*
 Laurenziana—*Francesco Botticini.*
 Marucelliana—*Credi, Puligo.*
 Museo Mediceo, Palazzo Riccardi—*Fra Filippo Lippi.*
 Pitti—*Fra Filippo Lippi.*
 Riccardiana—*Botticelli School, Pesellino School.*
 Uffizi—*Albertinelli, Alunno di Benozzo, Alunno di Domenico, Andrea, Fra Angelico School, Bacchiacca, Baldovinetti, Baldovinetti School, Fra Bartolommeo, Fra Bartolommeo School, Benozzo, Benozzo School, Bicci di Lorenzo, Botticelli, Botticelli School, Bronzino, Bugiardini, Carli, Castagno School, Credi, Credi School, Fra Diamante, Franciabigio, Garbo, David Ghirlandajo, Domenico Ghirlandajo School, Ridolfo Ghirlandajo, Ridolfo Ghirlandajo School, Granacci, Leonardo, Leonardo imitations, Filippino Lippi, Filippino Lippi School, Fra Filippo Lippi, Fra Filippo Lippi School, Lorenzo Monaco, Lorenzo Monaco School, Maestro di San Miniato, Mainardi, Michelangelo, Michelangelo School, Naldini, Neri di Bicci, Fra Paolino, Parri Spinelli, Pesellino, Pesellino School, Piero di Cosimo, Antonio Pollajuolo, Antonio Pollajuolo School, Piero Pollajuolo, Pontormo, Pontormo School, Puligo, Cosimo Rosselli School, Rossello di Jacopo Franchi, Rosso, Rosso School, Antonio da San Gallo, Giuliano da San Gallo, Sebastiano, Signorelli, Signorelli School, Sogliani, "Tommaso," Uccello, Uccello School, G. B. Utili, Verrocchio, Verrocchio School.*
 Uffizi—Santarelli—*Alunno di Benozzo, Bacchiacca, Baldovinetti, Baldovinetti School, Fra Bartolommeo, Franciabigio, David Ghirlandajo, Ridolfo Ghirlandajo School, Granacci, Filippino Lippi, Michelangelo, Michelangelo School, Naldini, Fra Paolino, Parri Spinelli, Pesellino School, Antonio Pollajuolo School, Pontormo, Rosso, Sebastiano, Signorelli, G. B. Utili.*
FLORENCE (Settignano)—Villa Michelangelo—*Michelangelo.*
FRANKFURT a/M.—Städel Museum—*Fra Bartolommeo, David Ghirlandajo, Filippino Lippi, Michelangelo School, Pesellino School, Pontormo, Rosso, Sebastiano, Sogliani.*

GENOA—Palazzo Rosso—*Alunno di Domenico.*
GIJON—Instituto Jovellanos—*Benozzo School, Rosso School, Uccello School.*
GÖTTINGEN—University Museum—*Botticelli School, "Tommaso."*

HAARLEM—Koenigs Collection—*Fra Angelico School, Fra Bartolommeo, Benozzo School, Bronzino, Credi, David Ghirlandajo, Ridolfo Ghirlandajo, Granacci,*
Leonardo, Filippino Lippi, Michelangelo School, Naldini, Parri Spinelli, Antonio Pollajuolo School, Pontormo, Puligo, Rosso, Attr. to Sebastiano, Signorelli, Sogliani, "Tommaso."
 Teyler Museum—*Fra Bartolommeo, Carli, Filippino Lippi, Michelangelo, Michelangelo School, Sebastiano, Sogliani.*
THE HAGUE—Fritz Lugt Collection—*Andrea, Fra Bartolommeo, Credi, Domenico Ghirlandajo School, Leonardo imitations, Filippino Lippi, Signorelli, Verrocchio School.*
HAMBURG—Kunsthalle—*Fra Bartolommeo, Botticelli, David Ghirlandajo, Granacci, Leonardo, Filippino Lippi, Fra Filippo Lippi, Antonio Pollajuolo School, Pontormo, Rosso.*
HOMELESS—*Baldovinetti School, Piero di Cosimo.*

KREMSIER (Austria)—Library of the Prince Primate—*Sebastiano.*

LEIPZIG—Museum—*Filippino Lippi.*
 Sale—*Benozzo School, David Ghirlandajo, Antonio Pollajuolo School.*
LENINGRAD—Stroganoff Collection (formerly)—*Baldovinetti School.*
LILLE—Musée Wicar—*Fra Bartolommeo, Carli, Franciabigio, David Ghirlandajo, Domenico Ghirlandajo School, Ridolfo Ghirlandajo, Granacci, Filippino Lippi, Michelangelo, Michelangelo School, Fra Paolino, Piero di Cosimo, Pontormo, Sebastiano, Sellajo, Signorelli School, Sogliani, "Tommaso."*
LIVERPOOL—Walker Art Gallery—*Sogliani.*
LOCKO PARK—Drury Lowe Collection (formerly)—*Andrea.*
LONDON—Agnew—*Signorelli.*
 British Museum—*Albertinelli, Alunno di Benozzo, Andrea, Fra Angelico School, Bacchiacca, Baldovinetti School, Fra Bartolommeo, Benozzo, Francesco Botticini, Carli, Credi, Garbo, David Ghirlandajo, Domenico Ghirlandajo, Giusto d'Andrea, Granacci, Leonardo, Filippino Lippi, Michelangelo, Michelangelo School, Michelino, Naldini, Fra Paolino, Piero di Cosimo, Antonio Pollajuolo, Antonio Pollajuolo School, Pontormo, Puligo, Cosimo Rosselli, Rosso, Sebastiano, Attr. to Sebastiano, Sellajo, Signorelli, Sogliani, Spinello.*
 British Museum, Crackerode—*Granacci, Fra Paolino.*
 British Museum, Fawkener—*Andrea, Filippino Lippi, Antonio Pollajuolo.*
 British Museum, Malcolm—*Fra Angelico, Fra Angelico School, Fra Bartolommeo, Benozzo, Botticelli, Botticelli School, Carli, Credi, Fra Diamante, Domenico Ghirlandajo, Ridolfo Ghirlandajo, Giusto d'Andrea, Granacci, Leonardo, Leonardo imitation, Filippino Lippi, Fra Filippo Lippi, Michelangelo, Michelangelo School, Naldini, Parri Spinelli, Sebastiano, Sellajo, Signorelli School, Sogliani, Tamagni, "Tommaso," Verrocchio.*
 British Museum, Payne-Knight—*Credi.*
 British Museum, Salting Bequest—*Credi, Sogliani.*
 British Museum, Sloane—*Naldini.*

386

PLACE INDEX OF DRAWINGS

Miss Eleonora Child—*Piero di Cosimo.*
Colnaghi & Co.—*Filippino Lippi.*
Capt. Colville—*Leonardo.*
Lord Spenser Compton—*Fra Bartolommeo.*
Herbert F. Cook—*Sogliani.*
Brinsley Ford—*Michelangelo.*
G. M. Gathorne-Hardy—*Sogliani.* (See also under
 Newbury, Donnington Priory.)
Earl of Harewood—*Benozzo, Signorelli.*
Hon. A. Holland-Hibbert (formerly)—*Leonardo.*
Mrs. Selwyn Image—*Signorelli.*
James Knowles Collection (formerly)—*Rosso.*
Victor Koch Collection—*Rosso.*
Mond Collection—*Leonardo, Michelangelo School,
 Signorelli, Sogliani.*
National Gallery—*Botticelli.*
Oppenheimer Collection (formerly)—*Alunno di Do-
 menico, Andrea, Fra Bartolommeo. Fra Bartolom-
 meo School, David Ghirlandajo, Fra Filippo Lippi,
 Lorenzo Monaco School, Michelangelo School, Fra
 Paolino, Sebastiano, Signorelli, Sogliani.*
Capt. J. Fenwick Owen—*Pontormo.*
Mrs. W. M. H. Pollen—*Leonardo,*
Ricketts & Shannon Collection (formerly)—*Fra
 Bartolommeo.*
Sir Charles Robinson (formerly)—*Michelangelo,
 Michelangelo School, Fra Paolino, Sebastiano, "Tom-
 maso."*
Newton Robinson Collection (formerly)—*Sogliani.*
Royal Academy, Diploma Gallery—*Leonardo.*
C. R. Rudolf—*Filippino Lippi.*
Sales—*Andrea, Fra Bartolommeo, Carli, Ridolfo
 Ghirlandajo, Pontormo School, Rosso, Sogliani.*
Savile Gallery—*Benozzo, Sogliani.*
Dr. Bullingham Smith—*Granacci.*
Arnett Stibbert—*Franciabigio.*
Victoria & Albert Museum—*Credi.*
Victoria & Albert Museum, Dyce Bequest—*Be-
 nozzo, Bronzino.*
Victoria & Albert Museum, Forster Collection—
 Leonardo.
Wallace Collection (Hertford House)—*Antonio
 Pollajuolo School.*
Wauters Collection (formerly)—*Piero di Cosimo.*
Sir Robert Witt—*Michelangelo, Michelangelo
 School.*
Mrs. Michael Wright—*Credi.*
LUZERN—Sale—*Bronzino.*

MADRID—Accademia de S. Fernando—*Sogliani.*
MARSEILLES—Musée de Longchamps—*Pontormo.*
MELBOURNE (Australia)—Museum—*Andrea.*
MILAN—Ambrosiana—*Fra Angelico School, Bacchiacca,
 Fra Bartolommeo, Botticelli, David Ghirlandajo,
 Granacci, Leonardo, Filippino Lippi, Antonio Pol-
 lajuolo School.*
Brera—*Leonardo.*
Frizzoni Collection (formerly)—*Filippino Lippi,
 Tamagni.*
Morelli Collection (formerly)—*Sogliani.*
Museo Civico—*Rosso, Spinello.*
Rasini Collection—*Sogliani.*

MONTECASSINO—Library—*Franciabigio.*
MOSCOW—Museum—*Sogliani.*
MUNICH—Print Room—*Alunno di Domenico, Andrea,
 Fra Angelico School, Fra Bartolommeo, Benozzo,
 Bronzino, Credi School, Franciabigio, Domenico
 Ghirlandajo, Domenico Ghirlandajo School, Mi-
 chelangelo, Michelangelo School, Naldini, Fra Pao-
 lino, Piero di Cosimo, Antonio Pollajuolo, Antonio
 Pollajuolo School, Pontormo, Signorelli School,
 Sogliani, Tamagni.*
Erwin Rosenthal (formerly)—*Baldovinetti School,
 Parri Spinelli.*
Jacques Rosenthal Collection (formerly)—*Lo-
 renzo Monaco School.*

NAPLES—Pinacoteca—*Andrea, Fra Bartolommeo, Mi-
 chelangelo, Parri Spinelli, Piero di Cosimo, Pon-
 tormo, Rosso, Rosso School.*
NEWBURY—Donnington Priory, G. E. Gathorne-
 Hardy—*Filippino Lippi, Michelangelo, Michel-
 angelo School, Rosso.* (See also under London,
 G. M. Gathorne-Hardy.)
NEWPORT (R. I.)—J. N. Brown Collection—*Leonardo,
 Signorelli.*
NEW YORK—Philip Hofer—*Antonio Pollajuolo.*
Robert Lehman—*Fra Bartolommeo, Carli, Castagno
 School, Garbo, Piero di Cosimo, Signorelli.*
Metropolitan Museum—*Fra Bartolommeo, Garbo,
 Leonardo, Filippino Lippi, Michelangelo, Parri
 Spinelli, Antonio Pollajuolo School, Pontormo,
 Rosso School, Sebastiano.*
Morgan Library—*Andrea, Fra Bartolommeo, Bot-
 ticelli, David Ghirlandajo, Filippino Lippi, Mi-
 chelangelo, Fra Paolino, Rosso, Signorelli School,
 Spinello, Tamagni.*
NORTHAMPTON—Castle Ashby, Marquess of Nort-
 hampton—*Parri Spinelli.*

OXFORD—Ashmolean Museum—*Andrea, Fra Barto-
 lommeo, Bicci di Lorenzo, Botticelli School, Carli,
 Leonardo, Fra Filippo Lippi, Michelangelo, Mi-
 chelangelo School, Sebastiano, Signorelli.*
Christ Church—*Bacchiacca, Fra Bartolommeo, Be-
 nozzo School, Credi, Garbo, David Ghirlandajo,
 Granacci, Granacci School, Leonardo, Filippino
 Lippi, Filippino Lippi School, Michelangelo, Mi-
 chelangelo School, Antonio Pollajuolo School, Pon-
 tormo, Rosso, Sebastiano, Attr. to Sebastiano, So-
 gliani, Verrocchio.*

PARIS—Comtesse de Béhague—*Leonardo.*
Bibliothèque Nationale—*Pontormo, Rosso.*
École des Beaux-Arts—*Andrea, Fra Bartolommeo,
 Benozzo School, Bronzino, David Ghirlandajo,
 Granacci, Leonardo, Pontormo, Puligo, Rosso,
 Signorelli, Sogliani, Spinello.*
École des Beaux-Arts, Gatteaux Collection—
 Sogliani.
École des Beaux-Arts, His de la Salle Gift—
 Filippino Lippi, Rosso.
École des Beaux-Arts, Masson Collection—*Rosso.*

PLACE INDEX OF DRAWINGS

ÉCOLE DES BEAUX-ARTS, VALLARDI COLLECTION— *Sebastiano.*

ÉCOLE DES BEAUX-ARTS, VALORI COLLECTION— *Alunno di Domenico.*

ÉCOLE DES BEAUX-ARTS, ARMAND-VALTON COLLECTION—*Andrea, David Ghirlandajo, Michelangelo School, Pesellino.*

WALTER GAY COLLECTION—*David Ghirlandajo, Filippino Lippi School, Michelangelo School, Antonio Pollajuolo.*

M. GUSTAVE GRUYER (formerly)—*Credi.*

ANDRÉ HEVESY COLLECTION—*Rosso.*

INSTITUT DE FRANCE—*Leonardo.*

LOUVRE—*Albertinelli, Andrea, Bacchiacca, Fra Bartolommeo, Benozzo School, Botticelli School, Francesco Botticini, Bronzino, Bronzino School, Carli, Credi, Credi School, Franciabigio, Taddeo Gaddi, Garbo, David Ghirlandajo, Domenico Ghirlandajo, Domenico Ghirlandajo School, Giusto d'Andrea, Granacci, Leonardo, Filippino Lippi, Filippino Lippi School, Maestro del Bambino Vispo, Mainardi, Michelangelo, Michelangelo School, Naldini, Fra Paolino, Parri Spinelli, Pesellino, Piero di Cosimo, Antonio Pollajuolo School, Pontormo, Puligo, Cosimo Rosselli, Rossello di Jacopo Franchi, Rosso, Rosso School, Sebastiano, Signorelli, Sogliani, Spinello, Tamagni, Uccello School, Verrocchio.*

LOUVRE, HIS DE LA SALLE—*Fra Bartolommeo, David Ghirlandajo, Michelino.*

LOUVRE, BARON EDMOND DE ROTHSCHILD BEQUEST—*Baldovinetti School, Fra Bartolommeo, Benozzo, Uccello School.*

MANZI COLLECTION (formerly)—*Benozzo School.*

M. MARIGNANE—*Puligo, Signorelli, Signorelli School.*

M. E. RODRIGUES COLLECTION (formerly)—*Signorelli.*

BARON EDMOND DE ROTHSCHILD—*David Ghirlandajo, Leonardo* (recently transferred to Louvre).

SALES—*Michelangelo, Pontormo, Signorelli, Uccello School.*

PISA—MUSEO CIVICO—*Benozzo School.*

PLYMOUTH—ART GALLERY—*Andrea.*

RENNES—MUSEUM—*Credi, David Ghirlandajo, Domenico Ghirlandajo, Granacci, Leonardo, Fra Filippo Lippi, Michelangelo School, Pontormo, "Tommaso."*

ROME—BARBERINI LIBRARY—*Giuliano da San Gallo.*

CORSINI PRINT ROOM—*Albertinelli, Andrea, Fra Bartolommeo, Benozzo School, Carli, Credi, Garbo, David Ghirlandajo, Domenico Ghirlandajo, Ridolfo Ghirlandajo, Granacci, Leonardo, Filippino Lippi, Michelangelo, Fra Paolino, Piero di Cosimo, Piero Pollajuolo, Pontormo, Puligo, Sebastiano, Sogliani, Verrocchio School.*

VATICAN LIBRARY—*Botticelli, Michelangelo.*

ROTTERDAM—MUSEUM BOYMANS—*Benozzo.*

SIENA—PINACOTECA—*Filippino Lippi School.*

PUBLIC LIBRARY—*Giuliano da San Gallo.*

STEYNING—WISTON PARK, MR. CH. CLARKE—*Leonardo.*

STOCKHOLM—PRINT ROOM—*Fra Angelico School, Baldovinetti, Fra Bartolommeo, Benozzo, Benozzo School, Francesco Botticini, Raffaele Botticini, Credi, Garbo, David Ghirlandajo, Domenico Ghirlandajo, Domenico Ghirlandajo School, Filippino Lippi, Maestro del Bambino Vispo, Pontormo School, Signorelli, Sogliani, "Tommaso," Uccello School.*

SYRACUSE—MUSEUM—*Sogliani.*

TURIN—ROYAL LIBRARY—*Fra Bartolommeo, Botticelli School, Leonardo, Filippino Lippi, Michelangelo School, Piero di Cosimo, Antonio Pollajuolo School, Puligo, Rosso School, Sogliani, "Tommaso."*

VENICE—ACADEMY—*Fra Angelico School, Fra Bartolommeo, Benozzo, Benozzo School, Carli, Credi, Credi School, Granacci, Leonardo, Leonardo imitations, Michelangelo, Fra Paolino, Piero di Cosimo, Antonio Pollajuolo School, Pontormo, Sebastiano.*

VIENNA—ALBERTINA—*Alunno di Domenico, Andrea, Fra Angelico School, Bacchiacca, Baldovinetti School, Fra Bartolommeo, Benozzo School, Bicci di Lorenzo, Credi, Franciabigio, Garbo, David Ghirlandajo, Domenico Ghirlandajo, Granacci, Leonardo, Filippino Lippi, Maestro del Bambino Vispo, Michelangelo, Michelangelo School, Naldini, Neri di Bicci, Pesellino School, Piero di Cosimo, Antonio Pollajuolo, Pontormo, Puligo, Rosso, Antonio da San Gallo, Sebastiano, Sogliani, Tamagni, Uccello School.*

SALE—*Pontormo.*

VITERBO—PINACOTECA—*Sebastiano.*

WASHINGTON CROSSING (Pa)—F. J. MATHER COLLECTION—*Ridolfo Ghirlandajo School, Pontormo, Rosso School, Signorelli School.*

WASHINGTON, D. C.—CORCORAN GALLERY, W. A. CLARK COLLECTION—*Baldovinetti School.*

WEIMAR—GRANDUCAL COLLECTION (formerly)—*Michelangelo School.*

LIBRARY—*Carli.*

WILTON—PEMBROKE COLLECTION (formerly)—*Leonardo, Fra Paolino.*

WINDSOR—ROYAL LIBRARY—*Fra Angelico, Fra Bartolommeo, Benozzo, Credi, David Ghirlandajo, Domenico Ghirlandajo, Leonardo, Leonardo imitations, Filippino Lippi, Fra Filippo Lippi School, Michelangelo, Michelangelo School, Sebastiano, Signorelli.*

END OF VOLUME II

388

Date Due

JUN 16 1982			